Purposes of Art

reproduced on the cover:
Fernand Léger. *The City* (detail). 1919.
Oil on canvas, entire work 7′7″ × 9′8½″ (2.31 × 2.96 m).
Philadelphia Museum of Art (A. E. Gallatin Collection).

cover design:
Marlene Rothkin Vine

Purposes of Art

fourth edition

An Introduction to the History and Appreciation of Art

Albert E. Elsen

Walter A. Haas Professor of Art History
Stanford University

Holt, Rinehart and Winston

New York Chicago San Francisco Philadelphia
Montreal Toronto London Sydney
Tokyo Mexico City Rio de Janeiro Madrid

To Matthew, Nancy,
and Katherine

Library of Congress Cataloging in Publication Data

Elsen, Albert Edward, date
 Purposes of art.

 Bibliography: p.
 Includes index.
 1. Art—History. 2. Art—Themes, motives.
3. Art appreciation. I. Title.
N5303.E45 1981 709 80-26290
ISBN 0-03-049766-3

Address correspondence to:
383 Madison Avenue,
New York, N.Y. 10017

Printed in the United States of America
Composition and camera work by York Graphic Services, Inc., Pennsylvania
Printing and binding by Capital City Press, Vermont
Published simultaneously in Canada
1 2 3 4 138 10 9 8 7 6 5 4 3 2 1

CBS COLLEGE PUBLISHING
Holt, Rinehart and Winston
The Dryden Press
Saunders College Publishing

Preface

Premises The full title of this book could well be *Purposes of Art and Humanity's Hope.* The chapters that follow are based on the premise that art's great purposes have included *giving esthetic form to humanity's hopes and fears for its well-being.* Even before science, art took its place as one of the great civilizing forces in history. To this end, artists have assisted humanity in coming to terms with its several environments as well as in the understanding and reproduction of the self. For most of art's history, artists depicted the good life, while their profession was generally looked down upon. In more recent times, in place of the illustration of collective values, the artist's example of creativity in a mass society has come to symbolize well-being for thousands. This phenomenon reflects the broad historical secularization and democratization of the good life and the increased inclusiveness of the artist's profession itself. Further, our views of art's great purposes do not support the notion of qualitative progress in art. Historically, there has been an increase in the ways and means by which artists can express themselves, but this accumulation of skills, knowledge, and options does not guarantee quality superior to that of earlier periods. Scientists would agree that Einstein's contributions to science were more important than those of Aristotle or Copernicus, but art historians would not unite in proclaiming Picasso a greater artist than Rembrandt or Michelangelo.

Approach *Purposes of Art* is a book that seeks to evade chronarchy, the tyranny of time. At the expense of strict linear chronology, it follows important themes and ideas separately by doubling back into history so as to avoid encountering them scattered throughout a text whose structure is dictated by a timetable and a map. It is an approach promising the delight and intellectual satisfaction possible in analogy and juxtaposition. The plan is also an antidote to the art appreciation survey that, like an anatomy text, "objectively" dissects works of art into "elements" and "principles," thereby giving a piecemeal exposure to what was intended by the artist to be a unified expression of a complete experience. As much as possible, each work of art is here treated as an integrated whole and given a historical or topical context. In scope, *Purposes of Art* is a fragmentary history, a mosaic of themes arranged within themselves or, where natural, as a group, so as to follow a chronological and geographic evolution. The art history we carry in our heads is in fragments, a condition that no teacher or writer can hope seriously to change, but that, once developed, can make the thematic approach more memorable and useful to the reader. When, for example, we look at a church or a still life, we tend to associate and compare each with others of the same genre. It is instinctive to make analogies and comparisons, to telescope time and in a museum enjoy simultaneously an African and a modern sculpture, a Baroque and an Oriental landscape. A thematic inquiry allows writer and reader to reconsider the art of a period or painter several times instead of just once, a process that is true to our life experience of art. In developing the themes, however, I have used chronology as the main principle of organization not only in the internal composition of chapters but also in the sequential relationships of chapter to chapter.

Defining Art When it comes to defining art, the historian has as much difficulty as the biologist who must define life. As John Ciardi points out in *How a Poem Means,* or as one might be told by many painters and sculptors when asked to explain what art is, the language of experience is not that of classification. When trying to define their subject, art historians recognize that they are concerned with images in caves and the structure of cathedrals, saltcellars and ceiling paintings, the large and small, the ephemeral and durable in staggering ranges. They must concern themselves both with cultures that did not have the word *art* in their language and, more recently, with many young artists throughout the world who

want to redefine it totally. For the last century art has been viewed as something exclusively man-made, but in earlier ages, dating back to the Renaissance, art was also thought to reside in nature, where the artist had to discover it. To satisfy readers who insist that an author begin by defining his terms and until the next revision of *Purposes of Art,* this formulation is offered as functional for most of the works to be discussed: *Art is a skillful and imaginative process of expression that historically has led to the creation of objects by artists who intended an aesthetic response.* These "objects," in the broadest sense, may have originally been practical or simply useless except as things to view with pleasure. In recent years many artists have stressed the *work* of art, the process of making as art, and denied its exclusive residence in or necessity for a physical object, as well as the imperative of appealing to taste. Such activities have led to the not implausible view that art is what artists make and intend to be art.

Why We Care About Art This book is intended to help readers better appreciate art by increasing their awareness, understanding, and tolerance. The full enjoyment of art presupposes these conditions of mind. They should also be accompanied by *caring* about art's preservation. Daily, the news media remind us of art in danger. Victims of the wrecker, jackhammer, and bulldozer range from Native American burial sites and petroglyphs to 19th-century homes and office buildings of artistic distinction. The Acropolis in Athens has been closed because of the corrosive effects of urban smog, fractures caused by sonic booms, and the wear and tear of the millions of visitors who have tramped on its steps and the Parthenon's foundations. Stonehenge can no longer be entered, a victim of souvenir hunters and graffiti. The caves of Lascaux are permanently closed to the public because of bacterial threats to their murals. The Sphinx is crumbling because of not just weather but also faulty chemical solutions injected into its sandstone, which have accelerated rather than retarded deterioration. Venice may no longer be sinking into its lagoon at this writing, but its sculpture is being erased by atmospheric pollution. Stone disease and sonic booms have jeopardized many European medieval cathedrals. Since World War II, well over fifty thousand works of art have been stolen from inadequately guarded Italian museums and churches. Our own country has only one full-time, specially trained art detective to help recover thousands of stolen art objects. In countries such as Turkey, Italy, Egypt, Mexico, and Guatemala, the looting of ancient architectural sites and tombs, with their concomitant destruction, has been a profession for generations because of the world art market demand for antiquities. "Artnapping" and vandalism by political dissidents and the senseless attempts by mentally disturbed individuals to destroy Michelangelo's *Pietà,* Rembrandt's *Night Watch,* and Van Gogh's *Self-Portrait* have caught the eyes of news editors and made headlines that dismayed the world. The counterfeiting of art is increasing. With its love-hate relationship to experts, the public is rarely angered by art forgers, whom it equates with jewel thieves and who are seen only as "ripping off" the wealthy and fooling the "elite." People do not understand that the harm of fakes and forgeries is to truth, to the reputations of artists and cultures, and to the public's right to be educated by and to enjoy authentic art. Culture-wide, we are becoming prone to accepting substitutes for the real thing. Though smaller than nature, as Ernst Gombrich reminds us, the world of art is in equal peril.

We care about art because we value cultural history as much as biological history. From its beginnings on the rude walls of caves, art has given tangible and aesthetic form to the most cherished values of civilizations, and its preservation is essential to knowledge and wisdom. For scholars and scientists, as an example, even a minor work from the past may encapsulate the religious, political, social, and technological systems of its time and place of origin. Art can also exist out of time and be an ageless testimony to beauty, inspiring new art. This is but one of many reasons why the health and responsible leadership of art museums is of

national importance. A nation's sense of its spirit and creative genius is manifest in its artistic past. Countries all over the world—but not the United States—have enacted laws to protect their artistic heritage from destruction and unauthorized export. Art is valued as a country's identity card and passport to the future. In most countries, cultural nationalism provides a stronger unity than political ideologies.

Testimonies to the international language of art and its use for good will in foreign diplomacy are the great "blockbuster" museum exhibitions from China, Egypt, Ireland, and East Germany. Though dead for more than 3,000 years, the young Egyptian pharaoh Tutankhamen has done an important service for his country by creating greater American sympathy for Egypt in its struggle for peace with Israel. There is no question but that the way to genuine international good will is through not just treaties and statesmen's speeches but also freer access to the arts of every nation. It is not only minority groups who search for their "roots"; humanity in general wants the answer to John Steinbeck's question in *The Grapes of Wrath,* "How will we know it's us without our past?" The most eloquent statement of why we care about art and what happens when we don't is found in the 1954 Hague Convention, established to protect cultural property in time of war, which our government has unreasonably failed to sign: "Damage to cultural property of any people whatsoever means damage to the cultural heritage of all mankind, since each person makes his contribution to the culture of the world."

The Fourth Edition This revision of *Purposes of Art* reflects an attempt to benefit from recent research by art historians in such areas as the history of the artist's profession, notably on the subject of women artists; interpretations of prehistoric cave art and the world view of African artists; new material on the Gothic cathedrals and their economic history; how the artist's audience in 15th-century Italy looked at art; the compelling new interpretation of Michelangelo's *Last Judgment* that shows it to have been heretical in the artist's day; discovery of moralizing themes in what had been viewed simply as Baroque genre art; and so on. To the section on the architecture of authority have been added analyses of the U.S. Capitol building and the Saarinen arch known as The Gateway to the West, and reintroduction of a comparison of Palladio's Villa Rotonda and Frank Lloyd Wright's Falling Water. In the chapter on art and nature important modern sculptures have been added, along with a section on Christo's *Running Fence.* One of the most important additions has been that of eleven photographic portraits to the chapter on portraiture. Much of the material in the chapters on Picasso and abstraction has been rewritten, as has the entire Coda. Overall, an attempt has been made to keep up with the correcting of our understanding of such major artists as Rembrandt, Michelangelo, and Picasso. Finally, a clarification and sharpening of the book's thesis have been worked into the rewriting or addition of many summaries to the chapters.

Acknowledgments The bibliography at the end of this book suggests the many historians to whom I am indebted for ideas and information. Not always thus acknowledged but deserving of gratitude are the teachers at Columbia University under whom I studied many years ago, among them Meyer Schapiro, Julius Held, Howard M. Davis, and the late William Bell Dinsmoor, Emerson Swift, and Millard Meiss. Former colleagues at Indiana University, Henry R. Hope, Roy Sieber, Bertrand Davezac, John Jacobus, and the late Diether Thimme, were always generous in helping me reduce errors of fact and in supplying sources of information for the second edition. Present colleagues at Stanford, Lorenz Eitner, Isabelle Raubitschek, Suzanne Lewis, Kurt Forster, Dwight Miller, Paul Turner, and Alex Ross and the library staff were of great assistance during the preparation of the third and fourth editions in bringing me up to date in their fields and calling my attention to important new publications. The constructive criticisms offered by Creighton Gilbert of Cornell University and Alfred Moir and Corlette Walker of the University of

California at Santa Barbara strongly influenced the second edition. For the third edition I was the beneficiary of critiques by Don Murray of the University of Florida, Gainesville, and John Paoletti of Dartmouth College. For this new edition, Madlyn Kahr of the University of California at San Diego offered useful advise, especially on the Rembrandt chapter, and Kit Monroe and Leo Holub were of much help in preparing the new section on photography. Important criticisms of the manuscript for the fourth edition were supplied by Martha B. Caldwell of James Madison University, Roy Lambert of the University of Florida, Edward E. Menges of St. Louis Community College at Florissant Valley, and Harold Zisla of Indiana University at South Bend. Annually the development of *Purposes of Art* has received considerable impetus from the many good graduate students with whom I have taught, formerly at Indiana University and since 1968 at Stanford University. Those whose contributions I can recall with gratitude are Peggy Gilfoy, now at the Indianapolis Museum of Art, Mazelle Kirkpatrick, Jan and Gerald C. Maddox at the Smithsonian Institution, Ellen and George Bauer of the University of Minnesota, Millard Hearn of the University of Pittsburgh, Reinhold Heller of the University of Chicago, Wilma Stern of Pennsylvania State University, Bradley Nickels of the University of Tampa, Arthur Stevens of Scripps College, Harry Gaugh of Skidmore College, Lou Anne Culley of Kansas State University, Paula Harper of Mills College, Kirk Varnedoe of the New York University Institute of Fine Arts, and Bette Talvacchia.

Stanford, California A.E.E.
November 1980

Contents

Chapter 1

The Artist's Profession

Rather than follow the textbook convention of commencing with a general discourse on art and thereafter saying little or nothing about those who made it, this book begins and ends with the artist. In between, it is about art as well as its purposes. Any definition of art must take into account that it comes from those who have had the intention as well as the skill to make it. Because we tend to focus on art itself and have simplistic notions about artists, we are often unaware that their profession has an important and interesting history. Even a summary account of this history rewards the attention of thinking people.

The Stereotypes The popular image of the artist today, created by novels, films, and cartoons, presumes that artists are male and white. While acknowledged to have certain technical skills, they are viewed as "flaky" and "alienated." The artist is seen as a type. The "artistic" temperament is equated with instability or being governed by emotions rather than reason. Artists are variously thought of as egocentric, eccentric, manually skilled but not well educated—hence inarticulate, insecure, irresponsible, and impractical. As a group, they are often classed as untrustworthy, not just in financial matters, such as honoring contractual agreements, but as citizens, parents, spouses, and lovers. Their supposed absentmindedness is tolerated as part of the otherworldliness associated with the profession. "Mad" or "lazy" artists are familiar stereotypes, as are "poor" or "starving" ones. Artists are supposed to be neglected during their lives and acclaimed after their deaths,

preferably by suicide. The clichés have it that artists are bad-mannered, foul-mouthed, and given to excesses in drinking and sex. Their supposed indifference to dress codes and casual life-style are two of their more endearing characteristics.

In 1977, an international poll on occupational prestige ranked the artist the lowest of the professions, but above most occupations. Despite all the stereotypes, the artist stands out as the grudgingly respected model of personal and professional *freedom*. What lawyer, doctor, banker, minister, or scientist, for example, wants the professional label of "free spirit"? While almost all of these stereotypes have a long history and individually may not be exclusive to the artist's profession, historically there are too many exceptions for these generalizations to stand. There are, to be sure, some artists today who act out the stereotype because they think it is expected of them by the public and their peers or because it satisfies their concept of professional identity. What does seem to set the artist apart are aptitudes for conceptualizing or visualizing projects, forming and joining things, and acquiring certain skills. Otherwise, history does not support the image of the artist as a constitutional type. Nor does the record substantiate the view that before the French Revolution the artist was "unfree" and thereafter a "totally free" professional.

The Artist's Gods and Heroes From at least antiquity, the artist's profession has had its gods and legendary heroes. At the time of the building of the pyramids, according

1

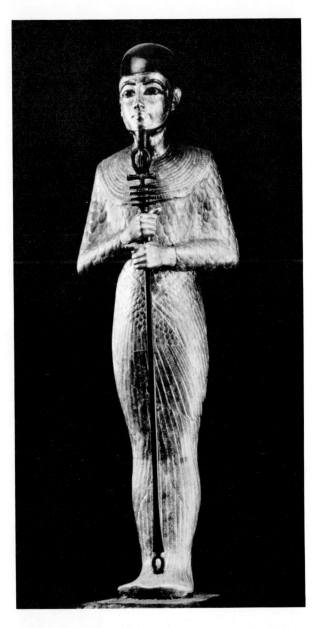

left: 1. *Ptah,* from Egypt.
18th Dynasty, reign of Tutankhamun, 1334–1325 B.C.
Egyptian Museum, Cairo.

below: 2. The Foundry Painter. *Bronze Foundry,*
detail of Attic kylix. c. 470 B.C.
Terra cotta, height 4¾″ (12 cm).
Staatliche Museen, West Berlin.

to Egyptian theologians, the arts were personified by the God Ptah (Fig. 1), who brought gods, people, animals, and in fact, the world into being. A statue found in the tomb of Tutankhamen shows the feather-shrouded god standing perfectly erect and grasping an animal-headed scepter that stood for life and stability. The conventional immobilized pose was appropriate for a creator who brought beings into existence by *naming* them. His tongue was guided by intelligence, which the Egyptians located in the heart. Ptah's high priest wore the inscription "Greatest of those who undertake a craft." The ancient Greeks likened Ptah to Hephaestus (called Vulcan by the Romans) as the patron deity of artists and craftsmen.

One of the twelve Olympian gods, Hephaestus was an ugly blacksmith, creator of all that was beautiful and mechanically wondrous on Mount Olympus. He was a benevolent god and skilled in the peaceful arts. Hephaestus and the goddess Athena were viewed as the promoters of civilization and city life. In ancient Athens, his temple was located in the *agora,* or civic center, amid the foundries of the bronze workers. In a dispute with Zeus, Hephaestus was lamed when he was thrown out of Olympus. Bronze workers were often injured in their hazardous occupation, and their ugly, crippled deity was not inappropriate (Fig. 2). Hephaestus was also the protector of fire on Olympus, which Prometheus stole for mankind. After his grand theft,

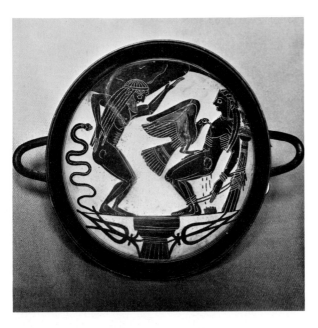

above: 3. *Prometheus Being Attacked by the Eagle.*
Black-figured Cyrenaic vase.
Vatican Museums, Rome.

below: 4. Maze pattern symbolizing Daedalus'
labyrinth on Crete.
Roman, 1st century A.D.
Mosaic, 11'1'' × 6'5¼'' (3.41 × 1.98 m).
Musée de la Maison Carrée, Nimes.

Zeus ordered the reluctant smith to forge the bonds of the demi-god Prometheus, who was condemned to be eternally bound to a rock, his liver nightly devoured by an eagle (Fig. 3). Prometheus was taught many arts by Athena, who was herself probably the first goddess of the artist's profession. Myth has it that Prometheus created the first human being by modeling an image from water and clay, into which Athena breathed life. Though Prometheus could not escape disaster himself, he was endlessly inventive in humanity's behalf. His name lives in the adjective *promethean,* signifying heroic productivity and skill.

From the Greeks came the first recorded legendary mortal heroes of artists. Daedalus of Athens was reputedly a marvelous blacksmith credited with inventing such tools as the axe, awl, and bevel, and with improving architecture. He was taught art by Athena. In one of the earliest recorded instances of artists as their own worst enemies, Daedalus murdered his inventive nephew Talus out of jealousy. Banished to Crete for the crime, Daedalus built for King Minos a labyrinth to confine the Minotaur, a creature half human and half animal. This monster was born from the union of a bull, sent to Crete by the sea god Poseidon, and the king's daughter, Pasiphae. In order to effect this mating, Daedalus built for Pasiphae a cowlike disguise. Presumably it was this invention that caused Minos to imprison Daedalus and his son, Icarus, in the labyrinth (Fig. 4). They es-

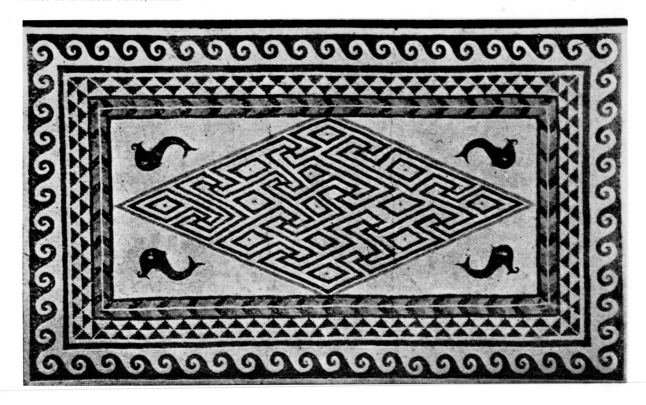

caped, using wings made of wax by the father, but Icarus, despite parental warning, flew too near the sun and suffered his famous fall. As honored by Greek artists as the gods, Daedalus was also credited with making marvelous lifelike statues of wood. In the Middle Ages, he was the legendary hero of the Christian architects who built the great cathedrals and sometimes honored Daedalus by inscribing a labyrinth in the nave floor.

As durable in the esteem of artists as Daedalus was the legendary sculptor Pygmalion. A king of Cyprus, Pygmalion reportedly was disgusted by the corruption of women. To honor the goddess Aphrodite, he created a beautiful ivory statue of the perfect woman, Galatea. Touched by his devotion, the goddess caused Galatea to come to life and marry her maker. The "Pygmalion dream" came to signify the artist's dream of perfection, of having unsurpassed skill and rivaling the gods in creating life.

For Christians, there was no question as to who was the first artist. As recorded in Genesis, it was God. For some sculptors, such as Michelangelo, he was a carver, but for many more, such as Rodin, he was a modeler. For architects, God was the supreme builder (Fig. 116). In the apocryphal Gospels, Christ was recorded as a child artist who made clay birds, into which he breathed life. (The term *inspiration* means to breathe life into.) The patron saint of Christian painters from the Middle Ages onward was the Evangelist Luke, who according to legend painted the Virgin from life (Fig. 8). Many painters' guilds were named in his honor, and if the ancient Greeks had had guild equivalents, Daedalus would have been St. Luke's counterpart. In modern times, the heroes of the artist's profession have been secular and mortal. Van Gogh, for instance, became comparable to a saint because his tragic life was seen by many artists as a martyrdom for his art. Cézanne's lifelong anguish over trying to realize the impossible in painting caused his veneration by many artists, such as Picasso.

The Artist in Antiquity Throughout most of history, the artist has suffered low social status because of usually being born into the lowest class and working with his hands—for money. Of the three conditions, it was principally the manual nature of artistic work that stigmatized the artist. Physical labor of any sort was looked down upon by the ruling classes in the ancient Near East, Greece, and Rome, and it was not until the coming of Christianity and the making of religious art by monks, many of whom had been noblemen, that there was an improvement in attitude. We may never know exactly when this prejudice against the physical work of art began. Just how were prehistoric artists rated socially in their tribes? Early circumstantial evidence

5. *Egyptian Craftsmen at Work.* c. 1400 B.C. Wall painting. Tomb of the sculptors Nebamun and Ipuki, Thebes.

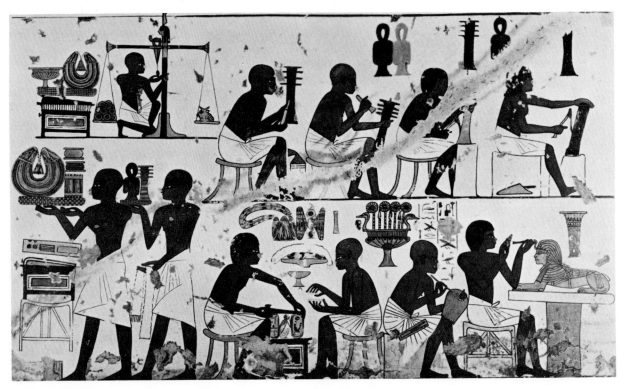

does suggest other aspects of the profession, however, such as the probable existence of art training. Some cave drawings seem to have been corrected by other hands. Although we know little about them, the first art schools may have been established in Egypt over five thousand years ago. Models of sculpture and painting that students were trained to imitate have survived. Undoubtedly, the apprentice system and workshop production prevailed. Egyptian wall paintings show craftsmen, artists' assistants, and master artists at work on projects for the royal palaces, temples, and tombs (Fig. 5). Since "high" art, as distinguished from village handcrafts, was the prerogative of royalty and the priests, the best artists were in their service. Art collecting, as Joseph Alsop has pointed out, has been found only in those few cultures in which art was divorced from magical, religious, or practical functions. Individual artists were remembered in their culture for excellence, and theoretical and critical writings and a sense of history existed. These conditions did not obtain in Egypt. With some few exceptions, basic formulas and styles of art hardened at an early date and persisted for almost three millennia. Artists were enjoined to repeat what already existed or to work close to the tradition. Originality was unthinkable, other options unavailable. This relatively static condition was linked with, if not caused by, the preservation of the pharaoh's political authority and the power of the priests; art schools probably ensured artistic continuity. While a very few artists signed their work, and their names appear in tombs, they did not receive critical adulation. That was to come in another culture, which did begin the collecting of art.

The Greek Artist Greek artists as a group stand out in the ancient world for manifesting the earliest historical consciousness; frequent innovations as they strove for greater accuracy in rendering the human figure; competitiveness, expressed in contests for civic commissions as well as in excellence; and conceptualizing about art, shown in theoretical writing. But for some rare exceptions in Egyptian art, it was the Greeks who first began to sign their paintings and sculptures, attesting to their individuality, mastery of technical problems, and right to be remembered. This was in the 7th century B.C. Thereafter, the signatures are neither constant nor always associated with art of high quality. Theodorus of Samos, who in the 6th century B.C. reportedly cast a bronze self-portrait with a file, is claimant to being the earliest self-portraitist. In the late 6th century, Smikros painted himself enjoying the good life (Fig. 6). In the 5th and 4th centuries, some outstanding artists wrote theoretical treatises, which differed from earlier craft handbooks on practical matters whose origins probably go back to the Egyptians. Polykleites wrote a famous treatise and made a sculpture called *The Canon* (both lost), in which he demonstrated his views on ideal proportions and harmony. From the 3rd century also derived the first extant chronology of artists, or art history, and the first recorded biogra-

6. Smikros. *Self-Portrait at a Symposium.* c. 510–500 B.C. Terra cotta; height 15′′ (39 cm), diameter with handles 15¼′′ (39 cm). Musées Royaux d'Art et d'Histoire, Brussels.

phies of artists, written by Douris of Samos. The earliest recorded self-taught artist, the 4th century sculptor Lysippus, prided himself on making his own rules and working from life. Ancient writers, while taking note of eccentrics such as an artist who was obsessed with perfection and dined only on beans to keep his mind pure, show little interest in detailed biographies, personalities, or temperaments. Despite the new self-image of the Greek artist, no distinction was made between artists and artisans.

The economic status of artists in Greece and Rome seems to have been relatively low. Individual artists of distinction, however, such as the sculptor Phidias and the painter Apelles, were well paid and appreciated by the cities or rulers who competed to employ them. Commencing in the 3rd century B.C., the works of earlier famous artists were sought by private purchasers (the first art collectors), and thus began the despicable practice of forgery. Unlike poets, great artists were at no time in antiquity credited with genius, inspiration, or insight. Artists might be taught their crafts by gods, but thereafter the gods supposedly did not intervene. The outstanding artist was seen to have excep-

tional skill (*techne* for the Greeks; *ars* for the Romans, the word from which art derives). From ancient times until after the Renaissance, artists lived with the stigma attached to manual labor and receiving money for their work. As exemplified by Plato's views, the ancients saw the artist as dealing with the artificial rather than the real and not engaged in the pursuit of wisdom or speculation on universal truths. *Admiration for the art but not the artist was the norm among the ancients.* As a writer in Imperial Rome, Lucian of Samosata, put it, "If you become a stone cutter you will be nothing more than a workman doing hard physical labor You will be obscure, classed as worthless by public opinion, neither courted by friends, feared by enemies, nor envied by your fellow citizens, but just a common workman, a craftsman, a face in a crowd, one who makes his living with his hands."

In Greece, the artist's profession was often hereditary. Slaves and freemen had equal economic footing in learning and practice. The apprenticeship method prevailed, and often master artists had workshops in which students gained practical experience. Artists usually worked where they lived, and workshops for sculptors had to be movable to permit working on distant sites. Paintings of ancient artists and their workshops are rare, and some that survive stress the presence of tools and their use in the making of art and give no indication of the hazards of the sculptor's profession, for example (Figs. 1, 2). A hierarchy developed within the artists' profession in antiquity. Architects were the most esteemed, followed by painters, and finally sculptors. This hierarchy survived into modern times despite the brilliant achievements of individual sculptors. The few Roman emperors such as Nero who were artists chose the less arduous demands of painting. Painting and sculpture were classed with the mechanical rather than the liberal arts until the 15th century. To rule and to fight were the full-time occupations of leaders.

The names of relatively few artists of ancient Rome have survived. Many of these artists were Greek, and after the Republic, they were increasingly drawn from the slave class. The artist was useful to the state for purposes of propaganda and decoration of public buildings, and to private collectors for making copies of Greek originals as well as objects of ostentation. A few women artists are recorded, and Iaia (116–27 B.C.) should rank as a heroine of the profession. This lifetime "virgin" painter was renowned for having the quickest hand for portraiture and receiving higher prices than more famed artists. (She is supposed to have done a portrait looking at herself in a mirror.) Art was a big industry in Rome, and it is recorded that there were factories of slaves in which there was a division of labor for production in quantity, as well as small workshops all over the Empire. Derived from Greek prototypes was the *collegium* (a group bound together by laws and the source of our word for college), to which artists could belong. Ancestor of both the modern union and the medieval guild, the collegium, which could own property and goods, functioned to: ensure the proper religious rituals honoring a patron deity; provide members with burials and welfare for widows and their children; and give members a voice in government through a powerful patron, such as a senator, who would protect their economic interests. Organized primarily for religious and social reasons, collegia did not set standards (that was left to master artists) or provide regulations on the training of apprentices. Collegia officers were freemen, but the membership sometimes included women and slaves. In return for favorable taxation, the state could demand certain services of the collegium on major projects. Artists as a group ranked with the lowest or plebian class.

Medieval Artists From the 4th to the 12th centuries, the monasteries were the great learning centers and producers and repositories of books. Monastic scribes did not suffer the stigma of engaging in the inferior occupation of writing, as did their counterparts in antiquity. The actual construction of the monasteries and their occasional adornment with art as well as the art in the illustrated book depended far more, however, on secular artists than on the monks themselves. Those relatively few monks who were builders, painters, and sculptors had usually learned their craft outside the monastery and before joining an order. (The exceptions might have been in the early centuries of the monasteries.) The ratio of artists who were monks to those who were not was generally very low, and many monastic orders did not approve of monks engaging in the craft of art. There are many signatures on medieval manuscripts, and artists also occasionally signed their sculptures, so that pious anonymity of the medieval artist is a myth propagated by 19th-century churchmen. Gislebertus signed his name just below Christ's feet in the Autun tympanum of the *Last Judgment,* and Nicola Pisano wrote a long inscription extolling his skill on a pulpit in Pisa. Some artists created images, if not self-portraits, of themselves at work. Medieval texts show that exceptional work in all media was enjoyed aesthetically, apart from its function, and important artists were well known and sought after during their lives, but apparently forgotten thereafter. While esteemed higher than ploughmen, the medieval artists were low paid and low in rank. As craftsmen, their profession remained among the mechanical arts (mechanical derives from the word adultery). Before, during, and after the Middle Ages, artists enjoyed the greatest affluence, upward social mobility, and renown when they were attached to a court or were the personal friend of a ruler and part of his retinue. There is no evidence that medieval artists who worked for monasteries or rulers believed themselves unfree, for without such patronage many would have been free to starve or work at other occupations. Throughout history, powerful patrons afforded artists the opportunity of showing their skill and achieving recognition. Until the second half of the 18th century, there is no evidence that painters and sculptors chafed under the

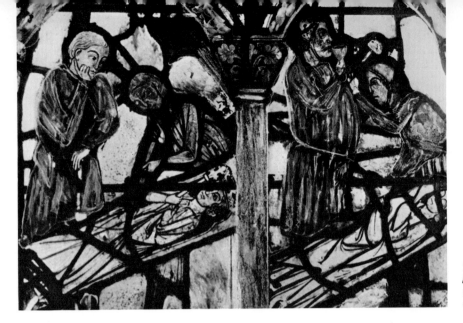

7. *Sculptors Carving Statues
for Chartres Cathedral,*
detail of north apse window.
c. 1225. Chartres Cathedral.

religious or political systems they worked for, as there were no alternatives.

Lodge, Guild, and Workshop Of great importance in the history of art is the transition, during the 12th and 13th centuries, from the making of art by monks in monasteries to secular artists working in cities, who also made religious art. During this period, the *lodge* form of artists' organization and artisans' cooperative came into being in conjunction with the building and decorating of the great cathedrals. The lodge hierarchy consisted of the supervising master architect, who directed the general artistic program, master artists, and journeymen masons and carvers. Senior members were free to come and go, but usually a nucleus of lodge members remained to finish an assignment and then often moved on as a group to a new project. The activities of the lodge were coordinated by one supervisor, who followed specifications set down by the Church. The organization was thus intended to facilitate and harmonize the various special tasks of these great undertakings.

In the 11th and 12th centuries, the decorative carving and painting were executed directly on the building, with artists working from scaffolds. Gradually, in the 12th and 13th centuries, the painters and sculptors quite literally "detached" themselves from the architecture and began to make the sculpture and paintings in workshops located near the site or elsewhere in the town (Fig. 7). This change was reflected in and eventually altered the character of the relationship of painting and sculpture to architecture (with the first two becoming more independent). The craftsmen who worked in the lodge proper, which was usually a building attached to or near the cathedral, were committed to live on the premises and were subject to strict regulations regarding their pay and standards of workmanship.

It was not until the 14th and 15th centuries, when for the first time in history a broad middle class had enough money and incentive to commission painting and sculpture on its own, that it became economically feasible for artists to set up their own workshops in a city. With the growing wealth and the increasing demand of the urban populace for both religious and secular art, the lodge organization gave way to the guilds of painters and sculptors. Other professions had, in general, organized into guilds earlier than the artists, though in Italy, one finds artists associated in guilds as early as the 13th century. Whether or not the guilds were revivals of the collegia is debated by historians. In northern Europe, artists' guilds became numerous in the 14th and 15th centuries, with some of the earlier ones being formed in Ghent (1339), Tournai (1341), and Bruges (1351).

The purposes of the guilds were to protect members from outside competition and to instill and ensure pride, respectability, skill, and loyalty by providing and enforcing standards for the professional and personal welfare of their members. With the exception of royal commissions, which were outside such regulation, in many cities, only guild members were allowed to work at painting and sculpture. The organization of the guild was hierarchical, consisting of a board of overseers responsible for the observance of rules, master artists, journeymen (or paid assistants), and apprentices, and each group had its own spokesmen. Regulations for training, for performance, and for promotion to the different grades were set forth in writing. The guild often solicited customers, determined the just price of a finished work, and decided whether or not its quality met the required standards. Defective work could be confiscated and delinquent members fined or expelled. Prices were largely determined on the basis of the cost of materials and the time involved, sometimes on the size of the area to be painted. Artists were expected to be able to do an acceptable amount of work in a given period of time.

The guilds placed emphasis not on artistic theory but on more matter-of-fact technical considerations, such as the making of tools and the use of recipes for the successful employment of high-quality materials. The guilds also oc-

cupied themselves with providing codes of morality for members and ensuring fair labor practices, such as the proper housing of apprentices. In addition, they were responsible for burial insurance, widows' pensions, and the saying of Masses for deceased members. Organized artists also participated effectively in local political affairs and occupied such civic posts as town councilman and tax collector. Both in Italy and in the Netherlands, guilds themselves were at times patrons of art and commissioned paintings and sculpture for their guild halls and chapels. As an attempt by artists to achieve some measure of collective security, the medieval guilds had no counterpart in antiquity until the founding of the collegia.

The guilds were not always confined to painters and sculptors, but often included other professionals and artisans such as saddlemakers, pharmacists, and glass blowers. Artists were also called upon to decorate banners, armor, ships, furniture, and other household objects. This alliance with the crafts did not raise the social status of artists as a group, though some outstanding individual painters and sculptors did achieve public recognition and

played important roles in their city's history. At the height of the system, nonetheless, it was held that the honor of the guild was to be placed above all by its members.

The patron saint of many artists' guilds throughout Europe was St. Luke the Evangelist, who was believed to have been an artist and to have done a portrait of the Virgin. A 15th-century panel painting by the Flemish artist Rogier van der Weyden (Fig. 8) depicts the Evangelist sketching the Virgin and the Christ child; considering the subject, this painting may have been a guild commission. Of particular interest to the history of the artist is the strong likelihood that Van der Weyden painted himself as St. Luke. Beginning in the 14th century, artists and their secular patrons left their own images in religious works of art; in earlier times, a monk or abbot would have at most signed a work as being by his hand or through his commission.

Van der Weyden's painting and conceivably even his likeness would have passed guild inspection and won approval primarily in these respects: the preparation and quality of the wood of the panel; the priming coat of a plasterlike substance; the quality of the pigments purchased and then

8. Roger van der Weyden.
St. Luke Drawing the Virgin. c. 1435.
Oil on panel, 4'6¼'' × 3'7⅞''
(1.38 × 1.11 m). Museum of Fine Arts, Boston
(gift of Mr. and Mrs. Henry Lee Higginson).

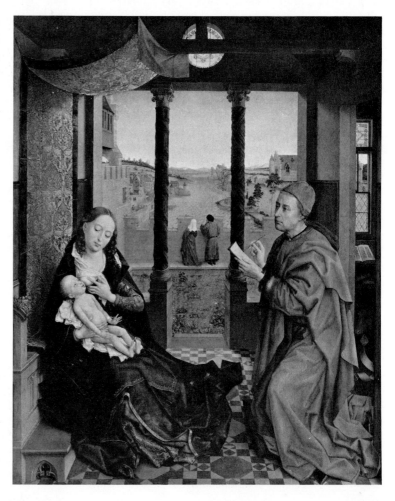

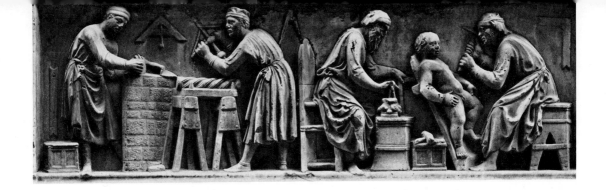

ground either by the artist himself or by an apprentice; the clarity and purity of the glazes laid over the paint; and the appropriateness and decorum of the symbols and figure types, as well as their setting. From the guild, an artist would learn about the lives of the saints and their symbols—in other words, all the elements suitable for a religious painting. Artists who inherited their profession, and many did, were often schooled from childhood by the guild in many areas directly and indirectly connected with their profession.

Artistic Genius and Official Patronage During the Middle Ages, a few artists, such as Giotto, enjoyed the status of cultural heroes and were acclaimed for their individuality. Generally, however, medieval artists were thought of as producers, and not until the Renaissance did the image of the artist as creator gain currency. It was during the 15th-century in Italy that the most important steps were taken to elevate art from the lower, craft status of the mechanical arts to that of the liberal and theoretical arts. What impeded a general improvement of the artists' social condition in Italy during this century were the age-old considerations of their low birth—with the exception of a very few artists such as Alberti and Leonardo—and their training in a workshop as craftsmen. Until the end of the century, with the advent of the art of Michelangelo, large painting and sculpture commissions were expected to be collaborative efforts (Fig. 9). It was not unheard of for artists to gain handsome financial reward and great civic admiration; but when they did, it was often because they had managed to resist the guild monopoly by undertaking important commissions for the Church or official court circles, enterprises that permitted them to move more or less freely from town to town and to be exempted, at least temporarily, from guild membership and regulations. It was not until the end of the 16th century that Italian artists could begin to legitimize their independence from the guild as legally recognized individual professionals, not attached to the courts.

In 1455, the sculptor Lorenzo Ghiberti published the first artist's autobiography. It appeared after the successful completion of his second pair of bronze doors for the Baptistery of Florence, the *Gates of Paradise,* on which he had the temerity to include his own portrait (Fig. 10), not as an artisan, which he had done on his first set of baptistery doors (Fig. 11), but as a well-dressed citizen and man of property. This change is described in his autobiography,

above: 9. Nanni di Banco. *Sculptor's Workshop,* detail of the *Tabernacle of the Four Saints.* c. 1410–14. Marble. Or San Michele, Florence.

below: 10. Lorenzo Ghiberti. *Self-Portrait.* c. 1435. Detail from *Gates of Paradise,* Baptistery, Florence.

bottom: 11. Lorenzo Ghiberti. *Self-Portrait.* c. 1403–24. Gilded bronze. North Doors, Baptistery, Florence.

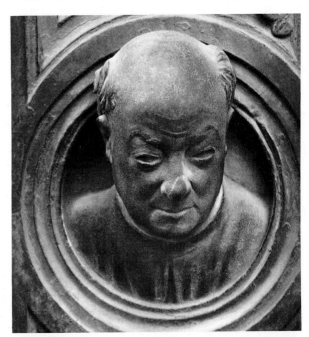

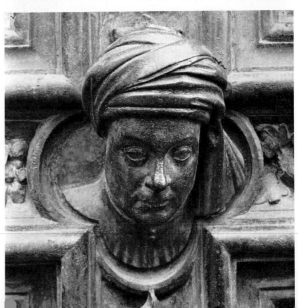

where Ghiberti not only proudly proclaims his accomplishments and his stature as an inventive rather than an imitative artist, but also describes what he feels the education of the new artist of his day should include. His insistence upon the liberal arts, still acquired in the context of a workshop such as he himself operated, is symptomatic of the changing status of the artist. Ghiberti wrote, "The sculptor—and the painter also—should be trained in all these liberal arts: Grammar, Geometry, Philosophy, Medicine, Astronomy, Perspective, History, Anatomy, Theory of Design, Arithmetic." Ghiberti thus equated the artist with the scholar; the idea of the artist as a man of learning was taking shape. It was the High Renaissance masters, Leonardo (Fig. 12), Michelangelo, and Raphael, who were most responsible for putting Ghiberti's advice into practice. By working independently, they achieved great respect for themselves and new recognition for their profession in the early 16th century. Leonardo established nature, rather than a workshop master, as the true source and guide of artistic inspiration.

Leonardo believed that painting was a science that depended upon direct observation of nature as well as on an understanding of perspective. He criticized the guilds for not coupling practice with theory and defended painting as superior to science and poetry. (Painting was called mute poetry; Leonardo, therefore, called poetry blind painting and argued that it was better to be mute than blind.) He also argued for the inventiveness of the artist, comparing the powers of the artist with those of God in creating the world. For Leonardo, the artist was a scientific observer and imaginative *generator* of images. A contemporary of Leonardo's, Albrecht Dürer, wrote of the godlike attributes of the gifted artist and his role as a creator. Dürer's engraving of 1514, entitled *Melencolia I* (Fig. 13), is a spiritual self-portrait that illustrates, in an appropriately esoteric way, the new concept of the artist as a genius, albeit a melancholy one. By means of symbol and allegory, in keeping with the practice and intellectual taste of his time, Dürer shows genius or the creative gift in terms of a superior feminine winged being who is reduced to a state of inaction amid the symbols of the arts and sciences. In Dürer's time, people of melancholy disposition (hence of unpleasant and unstable nature) were considered superior. Born under Saturn, they were thought to have the gift of imagination, but to be limited in attainment in such higher fields as metaphysics. Dürer used the inactive, despondent pose and the varied array of objects to indicate that, although inspired by transcendent visions, his own limitations as a human being prevented him from realizing his hopes. After having mastered the skills and the geometry required by his art, he was trapped by their very inadequacies. It was in the 16th century that the concept of artistic "genius" achieved widespread acceptance, when important artists such as Dürer, Michelangelo, and Titian gained intellectual recognition and helped substantially to upgrade their profession. It was

also from the time of Dürer that collectors came to value drawings as finished and significant works of art in themselves, especially important in that they intimately reflect the hand of the artist who made them. By the end of the century, the term *studio,* derived from the ruler's or scholar's "study," came into currency and began to replace "shop."

For all the Humanists' help, it was the economics of a great demand for the limited output of famous artists that changed the superior artist's status and self-image after 1500. Raphael could write, "I am well paid for my work whatever sum I deem fitting." By the beginning of the 16th century, artists such as Dürer and Raphael had established the work of art as their *intellectual* property. Important artists could determine the subject of *private* commissions; in contrast to the implication of 15th-century contracts, art was no longer too important for artists to decide upon. The hand that wielded the brush was more important than the cost of materials. Later in the 16th century, the patronage base contracted to the courts, and artists had to attach themselves more frequently to the politically powerful.

12. Leonardo da Vinci. *Self-Portrait.* 1510–13. Red chalk, 12 × 8¼″ (30 × 21 cm). Bibliotèca Reale, Turin.

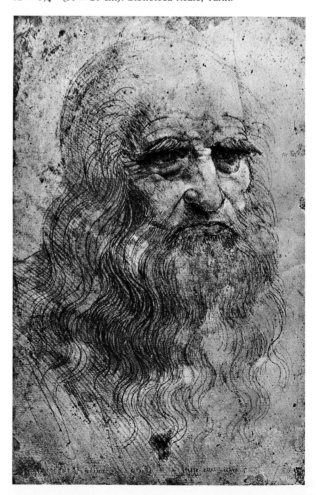

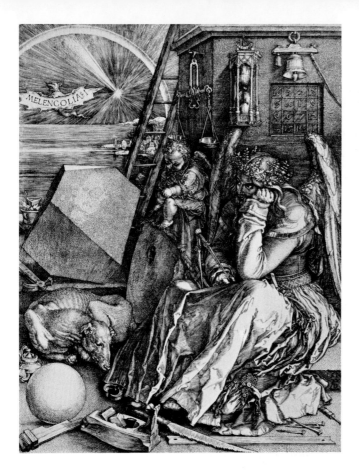

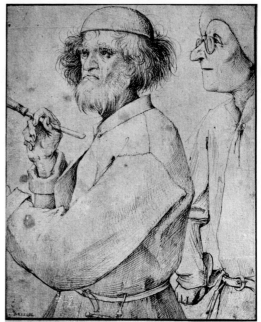

left: 13. Albrecht Dürer. *Melancolia I.*
1514. Engraving, $9\frac{1}{4} \times 6\frac{5}{8}''$ (24 × 17 cm).
National Gallery of Art, Washington, D.C.
(Rosenwald Collection).

above: 14. Pieter Bruegel the Elder.
The Painter and the Connoisseur. c. 1565.
Pen and ink, $9\frac{5}{8} \times 8\frac{1}{2}''$ (24 × 22 cm).
Albertina, Vienna.

below: 15. Hendrik Goltzius. *Hans Bol.* c. 1593.
Engraving, $10\frac{1}{4} \times 7''$ (26 × 18 cm).
New York Public Library (Astor, Lenox, and
Tilden Foundations).

In the annals of the 16th century, it is not uncommon to read of the great artists' acceptance in intellectual circles as well as at court. Pieter Bruegel the Elder, for example, kept company with some of the most learned men in Europe. His drawing of the 1560s (Fig. 14), in which he had the self-confidence and courage to satirize those who purchase art, may have been a spiritual self-portrait in the manner of the Dürer engraving. Bruegel shows an artist intent upon his work as a bespectacled buyer fumbles for the money to buy the painting. The drawing is a calculated contrast in human types and in vision. The artist frowns at that which clearly pleases the foolish patron. (The Flemish word for spectacles also signified "fool.") The strong, sure hand of the artist emphasizes the awkward gesture of the patron. Both Bruegel and Dürer tell us that the artist's vision is inaccessible to us and that the making of art involves problems that the ordinary person cannot recognize.

The homely dress of Bruegel's artist is deceptive in regard to the way the successful artist of his century and thereafter might be expected to appear in public. Innumerable prints and paintings from the 16th and 17th centuries have survived in which artists pay homage to other artists and affirm that in dress and manners they could be gentlemen. Upon the death of the Flemish artist Hans Bol, his friend Hendrik Goltzius did an engraving (Fig. 15) in which the dead man was accorded the symbolic funerary honors of an important person. Bol is shown as a well-groomed

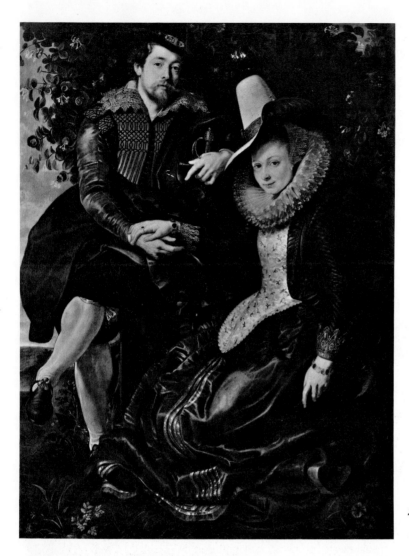

16. Peter Paul Rubens.
Self-Portrait with Isabella Brandt.
1609–10. Oil on canvas, 5′9½″ × 4′5½″
(1.77 × 1.36 m). Alte Pinakothek, Munich.

and handsomely attired gentleman, his effigy surrounded by attributes of his profession as well as those of death.

During the 17th century, Peter Paul Rubens attained not only great artistic fame in northern Europe but also renown as a diplomat in the service of the Spanish king. He amassed great wealth as a consequence of the quality and productivity of his large workshop (run not unlike that of a medieval artist) and acquired a palatial house in Antwerp, which he filled with works of art and antiquities. On their wedding day, he painted himself and his bride in their honeysuckle bower (Fig. 16). Rubens and his wife are seen dressed in the height of fashion, and their good looks and bearing help to create what might well be an aristocratic image.

Artists had served kings since the time of the pharaohs, usually being attached to the court but assigned an inferior status. By the 16th century, however, famous artists who had made their reputations as independent figures were often honored by kings and given titles and special prerogatives. One of the great paintings in the history of art involving the work of the artist at court was done by Diego Velázquez, who in the 17th century held the office of chamberlain to Philip IV, King of Spain. Originally titled *The Royal Family,* the painting reproduced as Figure 17 later came to be called *Las Meninas* because of the young ladies-in-waiting grouped around the Infanta Margarita, the King's blond daughter. The scene is in a high-ceilinged, sparsely furnished room of the royal palace with paintings from the King's collection filling the walls. A mirror on the far wall reflects the images of the King and Queen as if they are in the position of viewers looking at the scene. Velázquez, standing at the left before a tall canvas seen from the back, is attired in court dress and wears at his belt the key of his office. The foreground focus is shared by the Infanta,

her attendants, a dwarf, and a dog. Mindful of his station and prerogatives, Velázquez discreetly portrays himself in a position that is logical in both the context of the painting and the courtly world of rank.

This great painting is important to the history of the artist's profession because it was such powerful propaganda for art. It exalts patrons and artists by showing that the fame of each depends upon the other and the realization of the work of art. To justify rulers' interest in art, Velázquez shows himself in the royal picture gallery surrounded by his famous predecessors, one of whom was Apelles, the favored painter of Alexander the Great. Unlike many of his Dutch contemporaries, who depicted themselves actually hard at work in their studios in order to impress clients with their industriousness, Velázquez shows himself cogitating, thinking before acting, thereby affirming the intellectual dignity of his calling. Reportedly, the decoration on the

painter's tunic, a very high Spanish order, was painted on by the King after the artist's death. Membership in this order required that the candidate never have worked for money. Thus Velázquez had sought to remove from himself the stigma of being a mercenary.

From Art Clubs to the Academies Leonardo protested in his writings against the guild method of education, in which children would begin at about twelve years of age as apprentices, learning the craft by cleaning and repairing brushes, grinding pigments, preparing the canvas, and then imitating the drawing and painting of the master until the novices could complete a work from a sketch given to them. During this period, which might last as long as six years, apprentices would perform a variety of other, non-artistic services for the master. The journeyman period involved working for other artists in various locations, until

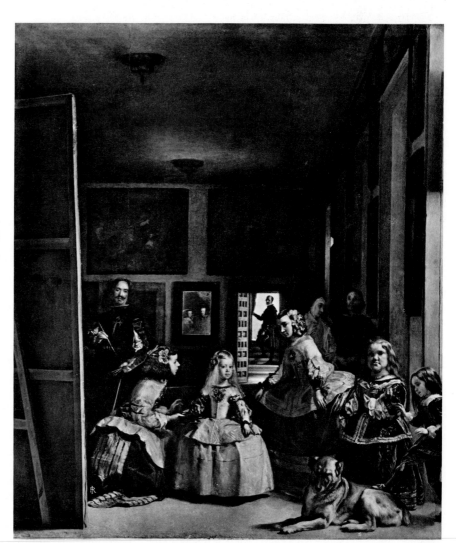

17. Diego Velázquez.
The Maids of Honor (Las Meninas).
1651. Oil on canvas, 10′5″ × 9′
(3.18 × 2.74 m). Prado, Madrid.

18. Eneas Vico
(after Baccio Bandinelli).
Artist and Apprentices.
c. 1550. Engraving, 12¼ × 19''
(31 × 48 cm).
Private collection.

the journeymen were proficient enough to join a guild or company in some city, where they then settled down. Leonardo wanted aspiring artists to study science, especially perspective, so that by such theoretical learning, painting as a creative effort might be divorced from mere craft. Michelangelo avoided the rigors and regimentation of the guild system, since he was given the opportunity to study ancient works of art under the guidance of an old sculptor at the court of Lorenzo de' Medici. Michelangelo's subsequent refusal to accept pupils or to employ assistants for his important work exemplified a new ideal of individuality and deepening of the artist's self-image.

In the first half of the 16th century, several artists' clubs were formed in Italy. An engraving by Eneas Vico from a drawing by Baccio Bandinelli, a sculptor and rival of Michelangelo's, shows a group of artists of various ages gathered in a room, where they have come to draw or watch others draw and to discuss theories and the work being done (Fig. 18). Not an art school in the sense of students executing a problem under the direction of a teacher, this group was rather an informal gathering of apprentices and artists in a room of the Vatican provided for Bandinelli by the Pope.

One of the earliest art academies was founded in Florence in 1561 by the artist Giorgio Vasari, celebrated for his *Lives of the Artists,* which is the foundation of art historical writing. His Accademia del Disegno, which brought together outstanding artists in an organization under the patronage of the Grand Duke of Florence, Cosimo I de' Medici, provided an alternative to the guilds. Vasari's academy planned for young artists a more enlightened education, which would include lectures on such subjects as geometry. Students were to be encouraged to learn from studying the works of artists such as Michelangelo, imitating his figures or whole compositions. In reality, however, Vasari's academy did little more than create a new artists' guild,

though it did make some contribution to elevating the social status of the profession.

The most important and influential of the early academies was that called the Accademia di San Luca, founded in Rome in 1593. It received papal encouragement because of concern over the poor quality of art produced for the Church by inadequately trained young artists. Although there seems to have been a substantial emphasis on abstract theory, guided by the artist Federigo Zuccari, a definite educational program was outlined whereby students would be taught to draw from plaster casts of ancient sculpture and from life. Their work was to be corrected by instructors and prizes occasionally awarded. While the academy was not a great success—and, in fact, did not finally rival the guilds or sustain a system of course instruction—its ideas, like those of Leonardo and Vasari, were to influence the future training of artists. At the beginning of the 17th century, small groups of artists in various Italian cities such as Genoa and Bologna often assembled in one of the artists' studios or a room provided by a patron for purposes of studying together and drawing from a live model. This idea was exported from Italy to northern Europe, where it was first put into practice on a small scale in the Netherlands in the late 16th and the 17th centuries. Rembrandt, for example, taught his pupils to draw from life; he also urged them to study older art for its lessons.

The most famous and influential of all art academies was that founded in France in 1648, which under Louis XIV came to be known as the Académie Royale. In the preceding century, the idea of an academy had been developed to allow artists greater freedom from the guilds; but under the King and his prime minister, Colbert, the royal academy of painting and sculpture was closely tied to the absolutist centralization of government and culture in France. As a consequence, while the artists or academicians attained greater social security and prestige, they sacrificed their in-

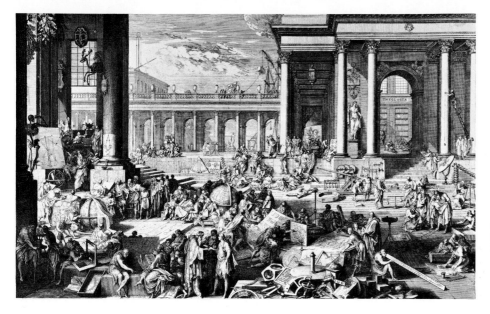

19. Sebastien Leclerc. *Academy of the Fine Arts and Sciences.* 1700. Engraving, $9\frac{1}{2} \times 14\frac{7}{8}''$ (24×38 cm). New York Public Library (Astor, Lenox, and Tilden Foundations).

dependence. The leading French artists were obliged to become members, and a definite schedule of teaching and courses was established—even to a timetable for each week's instruction held in a wing of the Louvre. There was an elaborate hierarchy of graded membership, and assigned duties included attending workshop services and business meetings, selecting and posing the model, providing examples of art to be drawn from, and correcting student work. The chief aim of the Académie Royale was to teach students to draw, model, and paint in the officially approved court style. Drawing from a live model was a right reserved to the royal academy. Colbert had seen that through such officially sponsored academies, all forms of culture could be harnessed to the aims of the King.

The academy's artistic monopoly extended even to the area of printmaking, so that engravings had to carry the notice *cum privilège du roi.* This inscription is found in Sebastien Leclerc's engraving of 1700 (Fig. 19), in which he shows an ideal academy of fine arts and sciences. The Leclerc vision is an enactment of the ideals of Leonardo, Alberti, Ghiberti, and other earlier artists who were concerned with joining the visual arts with the liberal arts. In the engraving, small groups of teachers and students are disposed throughout a courtyard and arcades of an academically approved style of architecture based upon precepts of the Renaissance and antiquity. In this splendid setting, students are being instructed in natural science, perspective, astronomy, geography, palm reading, heraldry, architecture, painting, drawing from ancient sculpture, measuring, building, mechanics, and theology. The students and instructors are shown in ancient costume, as if Leclerc were reconstructing some mythical academy from antiquity, but very likely he was also showing an academician's distaste for contemporary costume. It was the art of antiquity that set the norm for subjects, postures, figure type, and dress.

In actuality, students at the Académie Royale did listen to lectures on art theory, particularly with regard to perspective, anatomy, proportion, decorum (the proper appearance and conduct of painted figures), drawing, and composition. Canons, or definite rules, of art were established and taught. Often the lectures were based upon analysis of officially approved paintings and sculpture, thereby anticipating the modern teaching of art history. After four years of schooling in the academy and successful passage of examinations, the more promising students were allowed to work in Rome for four years and to send back to France copies of Roman art. When by satisfactorily completing various tests a student finally achieved the rank of academician, he could still choose to ally himself with some company of painters in a town, and he was assured of royal patronage. Art continued in the 17th and 18th centuries to be a hereditary profession, and the sons of academicians were given preferential treatment of various kinds when they entered upon their formal schooling.

In the 18th century, the King's authoritarian rule of the Académie Royale was relaxed. Despite a subsequent decline in power, after 1750 the French academy became the basis for similar academies sponsored by royalty throughout Europe, as a means of bringing art into its service and improving the economy. Craftsmen as well as artists could benefit from the artistic training, which was based on the French model of drawing from other drawings, then from casts, and finally from the live model. It was in the 18th century, however, that the term *fine arts* was used by the Royal Academy to separate theoretically inspired or high art from the crafts.

Business interests saw a greater accessibility of art education as a means of improving their products and stimulating trade. Tuition-free art schools and other schools dedicated only to the crafts emerged in the 18th century. The French royal academy did not undergo serious alteration in

its makeup until the time of the Revolution, when its concept of art in the service of the state was challenged. From the time of the academy's founding and in its subsequent history, artists continued, after the fashion of the Middle Ages, to learn much of their profession under master artists, from whom a letter was required to gain admission to the academy.

English art academies of the 18th century, like those of 16th-century Italy, were started in private artists' studios. Unlike the European royal academies, which functioned under official auspices, those in England were private schools where studies centered on drawing from the live model. Artists in Holland, though allied to the old guilds, had the greatest independence—and the least financial security—of any European artists. Unlike French academicians, who worked for lucrative commissions on grandiose but circumscribed projects issuing from a narrow patronage base in the court, Dutch painters sold small-scale easel

20. Sofonisba Anguissola. *Self-Portrait.* 1554.
Oil on panel, 7 × 9⅜″ (18 × 24 cm).
Kunsthistorisches Museum, Vienna.

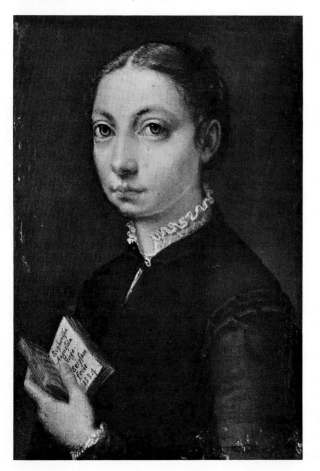

paintings either out of their studios or to dealers who served a broad middle-class clientele. (The first art dealers appeared in the 15th century in the southern Netherlands, but as a profession they became more numerous and international in the 17th century.) Thus the precedent for the modern artist who works on an independent basis is to be found in the wider sources of patronage in 17th-century Holland.

Women Artists The writing of a serious history of women artists was pioneered in the 1970s by Linda Nochlin and Ann Harris. From their research and that of others, it is apparent that before 1900 women came to the profession under severe handicaps resulting from society's expectations of their sex and the prejudice of male artists. Unless women chose to be single, their careers suffered from the burdens of marriage, family, and domestic needs. After antiquity, the first recorded woman artist, Ende, is known to history for her brilliant signed work on an Apocalypse manuscript in the 10th century. Thereafter, in the Middle Ages, a few women who were nuns or ran workshops in cities like Paris illuminated manuscripts. Women achieved recognition for embroidery and weaving, such as the great 11th-century Bayeux Tapestry. From the 15th to the 19th century, painting was acceptable in the education of upper-class women, but they often came to art from families in which the father was an artist (Artemesia Gentileschi, for example) and there were no sons, or they married artists, thereby gaining an apprenticeship. Generally, they were limited to second-class training. In these four centuries, a few women, beginning with Sofinisba Anguissola (1532/35–1625), won tribute as portraitists (Fig. 20). In the 18th century, Rosalba Carriera developed the pastel portrait, and Vigée Lebrun's portraits and teaching won her great fame. Fede Galizia was one of the first still-life painters in Italy, and at seventeen, Clara Peeters was painting excellent still lifes in 17th-century Holland. Portraits and still lifes were not considered competition to male artists. Many guilds permitted women active membership, but the academies restricted them to separate and unequal training and status. Angelica Kauffmann (Fig. 21) was a founder of the British Royal Academy, but her membership was really honorary. Until the late 19th century, women were prevented from drawing and teaching from nude models, denied the formal study of perspective, limited in access to theory, excluded from prize competitions, and restricted in their physical mobility. They therefore rarely took on prestigious figural and historical competitions or landscapes. Either to protect their virtue or to keep them in their place, male artists and patronizing critics did much to curtail women's ambitions and ensure their second-class training. Before 1800, there were no women architects and printmakers, and rarely were there women sculptors. Into this century, it was a prevailing prejudice that women lacked genius or were incapable of the serious artistic judgment required by great art.

Independence The 19th century saw the greatest proliferation and enrollment in art academies throughout Europe; yet this was also the century of their decline in importance. There were two major reasons for this change: the large size of many academies, such as the École des Beaux-Arts in Paris (which continues today, as successor to the Académie Royale); and the routine and methods of instruction, which were felt to be impersonal, old-fashioned, or inimical to the development of young artists with talent and originality. Moreover, the alliance of the academies, be it formal or indirect, with conservative political forces aroused the antipathy of many artists. Academic training and its apparatus for exhibiting and selling works of art did not change with the new ideals of individualism that were sweeping Europe in 19th-century art, nor did it make effective provision for exhibition and sale of works by thousands of painters and sculptors to the newly expanding middle-class market.

In a series of 19th-century French paintings, one can see significant changes in the history and status of the artist. The first, by an artist named Massé (Fig. 22), depicts a scene in the private art school of Baron Gros, in which a group of students are shown drawing from a female model posed in the manner of an ancient sculpture or drawing of Venus. On the wall are displayed the palette and a profile portrait in plaster relief of the painter Jacques Louis David, whose school Gros had taken over when David was forced

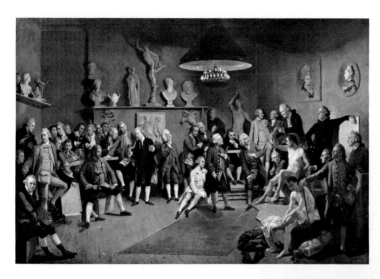

left: 21. Johann Joseph Zoffany.
The Academicians of the Royal Academy. 1772.
Oil on canvas. Reproduced by permission of the Lord Chamberlain's Office (copyright reserved). Angelica Kauffmann is represented by her portrait on the wall at the right.

below: 22. Charles Massé. *The Studio of Baron Gros.* 1830. Oil on canvas, 33½ × 39¼'' (85 × 100 cm). Musée Marmottan, Paris.

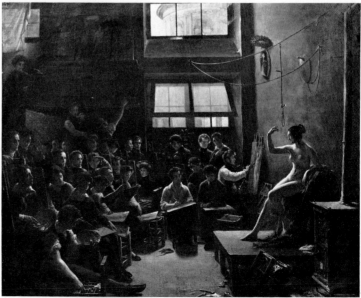

to flee France for political reasons. During the French Revolution, David, though a product of the Académie, had attacked its leadership, drastically curbed its powers, and liberalized the opportunities for artists to exhibit under its auspices. David and Gros, like other important 19th-century artist-teachers, continued the long-established master-pupil relationship but introduced into their studio schools teaching methods derived from the academies, such as courses

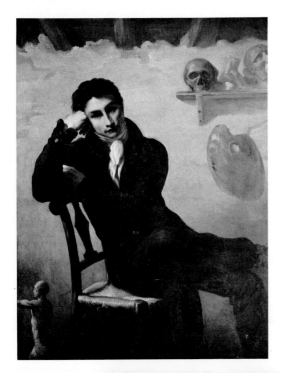

in drawing from master drawings, casts, and the live model. Instead of the faculty of several instructors found in the academies, however, in these schools, the artist himself guided his pupils. The private art school was the source of many important 19th- and early-20th-century painters, such as Manet, Degas, Toulouse-Lautrec, and Matisse.

A portrait by the French painter Théodore Géricault (Fig. 23) shows a fellow artist alone in his studio, flanked by a plaster model of a figure used for studying anatomy, the artist's palette, and a skull. The inactive, reflective pose of the artist suggests, like Dürer's *Melencolia,* the dilemma of the artist who must work alone, guided by his own genius, achieving freedom, but also suffering from indecision, doubt, or unattainable visions. In France as well as in Germany, the new Romantic concept of artistic genius and the need for its free expression meant that the artist had to work outside the academic tradition, whereas for Dürer the artist of genius could still work effectively within the guild system.

In 1855, Gustave Courbet painted a large picture entitled *The Studio, A Real Allegory of the Last Seven Years of My Life* (Fig. 24). Because this work was not accepted by the official jury that determined who would show in the great annual exhibitions, or Salons, Courbet borrowed money to

left: 23. Théodore Géricault (?).
Portrait of an Artist in His Studio. c. 1810–12.
Oil on canvas, 4′9⅛″ × 3′8⅛″ (1.45 × 1.12 m).
Louvre, Paris.

below: 24. Gustave Courbet.
The Studio: A Real Allegory of the Last Seven Years of My Life.
1855. Oil on canvas, 11′9¾″ × 19′6⅝″ (3.6 × 5.96 m).
Louvre, Paris.

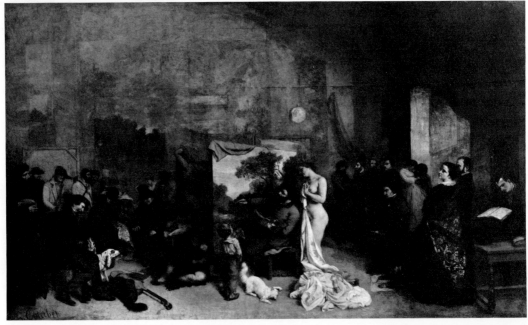

present the first one-man exhibit in art history. His painting is not only a manifesto of the type of art he had given up and of how he worked, it also conveyed an attitude toward the artist's place in society. Unlike Velázquez, Courbet does not show himself at court or even in the home of a patron; representatives of society come to his studio to seek out the artist and his work. He divides them into two groups: at the left are those who are mercenary or gain from others, often through their suffering; and at the right are those who support the artist, including writers such as the poet Baudelaire, Courbet's patron, and other friends. Literally and symbolically, the artist situates himself in the middle of his world; he is the fulcrum, the heart and creative center of modern society. As a young student, he had studied at a provincial branch of the academy, and in the background of the studio can be seen hanging a figure of St. Sebastian, indicative of the art-school milieu and its problems. For several years, Courbet had worked under the inspiration of literature and from his imagination, in the tradition of older artists. In this painting, however, he shows himself painting a landscape from memory, with nature, like the nude model standing behind him, serving as his inspiration. In a letter to some prospective students, Courbet voiced the feelings of many artists.

> I cannot teach my art, nor the art of any school, since I deny that art can be taught. . . . art is completely individual, and that talent of each artist is but the result of his own inspiration and his own study of past tradition. (1861)

For many of the important independent 19th-century artists, personal study in the museum, where they freely chose the works they would copy, replaced the academic insistence upon a steadfast focus on the antique. They could not accept the definitions, laws, or regulations of the academy but insisted instead upon personal empirical experience in art. Some older independent artists, such as Delacroix and Ingres, had large groups of formal students; others, such as Corot and Pissarro, had quite informal but intimate teaching relationships with younger painters. (Pissarro learned from Corot, and Cézanne from Pissarro, for example.) In France, the old guild or master-apprentice instruction in craft had died out with the Revolution and with the dissolution of the old Paris guild or Compagnie de St-Luc. Thereafter, artists had to learn craft techniques from one another or by themselves, and Degas spent a lifetime regretting the absence of this older tradition yet constantly experimenting with various media on his own.

With the Impressionists, mutual stimulation by the artists in the form of informal café discussions, studio visits, and outings together to paint served to further the artist's education and were, in fact, continuations of practices that go back at least to the time of Baccio Bandinelli and his evening drawing sessions. Frederic Bazille's painting of his studio in 1870 (Fig. 25) captures the relaxed life-style and mutually supportive relationships that existed among the Impressionists and their friends. At the far right, an amateur musician, Edmond Maître, plays the piano, while on the stairs the writer Emile Zola is speaking to Renoir, seated below. Before the easel, Manet stands looking at the painting, while Monet looks over his shoulder. When Bazille, who shows himself standing beside the easel, had finished this picture, Manet painted in his friend's face. The light-colored walls, the uncluttered living and working arrangement, even the architecture, became the model for the modern studio apartment found in every city, which today most artists cannot afford to live in.

25. Frédéric Bazille. *The Artist's Studio.* 1870. Oil on canvas, 38⅞ × 47'' (99 × 119 cm). Louvre, Paris.

26. Asmus Jakob Carstens. *Self-Portrait.*
Oil on canvas, 13¼ × 8⅜'' (33 × 21 cm).
Kunsthalle, Hamburg.

In the 19th century, especially in France, the art critic and the art dealer did much to fill the breach caused by the separation of the serious artist from the academy and from state patronage. Writers such as Baudelaire and Zola not only commented on exhibitions by the academic painters but they also criticized or praised the younger, independent artists. The critic's role has continued and grown in the 20th century as an influence both on the buying public and on artists. The great market for paintings that developed with the prosperity of the middle class in 19th-century France, England, Germany, and the United States led to a revival of art dealing in the late 1850s, and consequently artists such as the Impressionists were able to reach the public and eventually to support themselves. The emergence of non-academically trained artists who supported themselves and achieved personal freedom through their art is related to another modern phenomenon, that of young men relinquishing their training or practice in law, medicine, and business professions to convert themselves into artists, with Manet, Degas, Gauguin, and Van Gogh as notable examples.

It was in the late 18th and early 19th centuries that writers and artists began to proclaim the sovereignty of artists over their art, the absence of any obligation by the artist to create work on commission and serve crown or altar, prince or cardinal, when called upon. In the Renaissance, only those on the craftsman level produced or reproduced work for the general public; even the greatest artists such as Michelangelo and Raphael worked solely on commission. In the 17th century, Dutch artists produced paintings in large quantity for unknown or potential buyers, but they geared their work to the market by specializing in portraits, still lifes, landscapes, genre, or animal pictures. The last great artist who willingly devoted his talents to the service of his government on a large scale was Delacroix, who died in 1863.

Just how far the artist had come since the time of the pharaohs with regard to his own self-image can be found in a letter written on February 20, 1796, by the Danish painter Asmus Jakob Carstens (Fig. 26) to the Prussian Minister of Fine Arts, explaining why he was breaking a contract and not returning to the Berlin Academy after a three-year state-supported stay in Rome:

> I must tell you, Excellency, that I belong to Humanity, and not to the Academy of Berlin. . . . It is only here that I can properly train myself surrounded by the best works of art in the world. . . . I renounce all benefits, preferring poverty, an uncertain future, and perhaps an infirm and helpless old age . . . in order to do my duty to art and fulfill my calling as an artist. My capabilities were entrusted to me by God . . . so that when He asks me to give an accounting of myself, I shall not have to answer: Lord, the talent you entrusted to me I have buried in Berlin.

Chapter 2

Art as a Matter of Life and Death

Throughout the world, from the beginnings of civilization to the present, art has been made for many social and religious purposes, but it has always satisfied some need and desire for beauty as well. Magical and symbolic purposes of art have not, however, required beauty for their efficacy. Nonliterate peoples as well as those with rudimentary written languages may not have had specific words for *beauty* and *art,* but both are virtually universal concepts. Recent research among nonliterate Stone Age peoples in Africa and the South Pacific has shown that, contrary to long-standing Western views, these societies do have a strong appreciation of artistic quality and of the importance of the artist. Even in cultures of which only the art survives, such as pre-Columbian Mexico and Latin America, the practical purposes for which sculpture, for example, was made cannot explain the rich variety and sophisticated form of the works. Contemporary views of creativity—which for many has come to mean individuality and originality—make it difficult to understand the making of art in the societies discussed in this chapter. In these cultures, the artists were recognized and esteemed for their skill. In societies strongly committed to tradition, adherence to the conventions of ritual or of previous forms of art was not experienced by artists as a restriction on their creativity. While we cannot fully re-create the cultural context that brought these works of art to life, the fact that we are moved by their quality and beauty links us, if only superficially, with the past and with the peoples from whom they came. Thus art still serves the timeless purpose of unification.

What distinguishes the art in this chapter from that of our own culture is that it was seriously involved with life and death, closely interwoven with all phases of human existence. Whether magical or symbolic, this art was intended to secure for humanity well-being in this life and hereafter. In early as well as late phases of many societies, art performed the vital function of assisting people to control their environment, whether human or natural, and to intervene in the course of events. Magical art was and is "primitive" societies' science. Anthropologists and art historians have found in African and Oceanic cultures that this type of art was an agent of control over those things people could not govern fully by themselves—rain, the growth of crops, the fecundity of animals, health, childbirth, what might broadly be termed "success" in life, as well as life after death.

In general, art gives us a history of how men and women have interacted with their environments, and from this we learn that there are no absolutes for beauty and reality—both are man-made and susceptible to change. To approach sympathetically an art derived from religious beliefs or social customs different from one's own involves a willing suspension of disbelief, a setting aside of one's own cultural frame of reference. In the words of the late distinguished anthropologist Melville Herskovits, "In art, familiarity breeds appreciation, which is to say that it takes time and experience to perceive, internalize and respond to the aesthetic values of peoples whose culture differs from one's own."

Prehistoric Cave Art

The serious study of prehistoric art, created between 100,000 and 30,000 B.C. in more than two hundred caves, mostly on the Franco-Spanish border, began only in this century. The more research that is done, the more controversies arise over the art's varied purposes. All interpretations must be conjectural because of the lack of contextual evidence and uncertainty about the relevance of studying present-day Stone Age peoples. No single interpretation of the purpose of cave art, for example, explains the 65 animal, human, and sign motifs that make up thousands of paintings and engravings found on ceilings, walls, and occasionally floors. We remain ignorant about how the caves were used: whether for living, storage, sanctuaries, or other special purposes. We are not sure about original locations of many cave entrances. Not all caves received imagery, and while horses and bison prevail in those that did, not all show the same repertory of subjects.

Paleolithic art has its own art history stretching over thousands of years. It was made by different people of varying skills with probably diverse intentions, but in a somewhat homogeneous style. Representations can be found in lighted areas near cave mouths, in large chambers, and in deeply situated tunnels through which one must crawl and view the art inches away while on one's back. Using crude oil lamps made of bone or stone and having wicks, artists at times etched and painted images under the most cramped conditions, when the same cave complex afforded empty areas more convenient of access. In some caves, dozens of images are superimposed in the same area and date from different periods. Some scholars believe this indicates a special or sacred spot. Others argue indifference of one generation of artists toward the work of another. Animals are depicted that were often not native to the region of the cave artists. Often improbable mixed herds of horses, bison, and mammoths are shown. There are representations of human beings, usually more schematic than those of animals. Cryptic signs have been variously interpreted as traps, clan emblems, and male and female symbols. The presence of stenciled human hands and handprints, mostly those of women and children, has prompted such diverse readings as indications of prayers, evidence of punitive mutilation, sexual symbolism, or simple fascination with self-reproduction.

Older interpretations saw cave art as exclusively magical: to give the hunter sympathetic magic or power over his prey and to assure increase of the food supply and tribe itself. While some relief and painted images of animals appear to have been assaulted by sharp instruments, the known staple of diet and economy, the reindeer, is statistically a minor motif. Vegetation, whose berries were essential to life, is not shown at all. Stone Age peoples precariously subsisting on a limited food supply do not have large families and at times practice infanticide. The old view that artists wanted to enjoy their skill is still credible, but that they practiced "home decoration" is not. Recent interpretations of the cave art in large chambers see the paintings as backdrops for rituals involving living actors, with vegetation possibly brought in as stage props. Totemism, or identification of a group with an animal, is still recognized and important. The revolutionary views of Leroi-Gourhan and Laming hold that systematic analysis of the location and frequency of motifs in the caves leads to the tentative conclusion that instead of disconnected motifs, there are scenes reflecting an overall thematic unity, a planned complex system of beliefs. These myths and symbols, still to be completely deciphered, center around the concept of fecundity, expressed by the opposed and complementary nature of the two sexes. Leroi-Gourhan believes "that paleolithic people represented in the caves the two great categories of living beings, their corresponding male and female symbols, and the symbols of death which feeds the hunter." Laming also sees the horse and bison as the chief representatives of sexual polarity, but disagrees with her colleague on which are male and which are female. She believes the reliefs showing pregnant women and painted animals are conceivably related to love and an attempt through personification to understand life by linking humans to animals and nature. It now seems probable that cave art represents a rich tradition of beliefs and myths, and we should recognize there may have been purposes for art we will never know.

Techniques for painting were as varied as the resulting quality. Paint from earth pigments accounts for the range of ochres from red, through brown, to yellow. Manganese oxide, charcoal, and soot provided black. Blue and green

27. Paleolithic cave painting, left gallery of chamber A. 15,000–10,000 B.C. Lascaux, Dordogne, France.

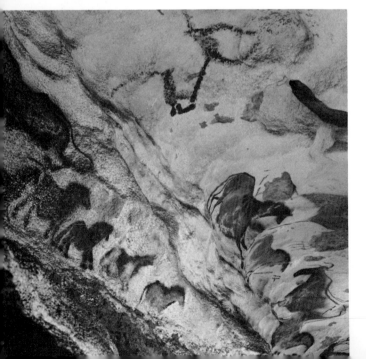

are absent, even though vegetable dyes may have been known. The image was begun by drawing with the fingers or some sort of brush or tampon. Usually the outline was continuous, varying from sharp to fuzzy. Graduated shading for modeling moved inward from the outline, and usually the main body of the animal was blank. Outlines were also made by dots, and two or three colors might fill in a body, as at Lascaux (Fig. 27; Pl. 1, p. 55). Paint itself varied from powder, to paste, to liquid. Powdered paints may have been applied with a hollowed bone used as a blow pipe.

What little can be said with certainty about cave art has to do with its form, but even here there are unanswerable questions. The images are found on unprepared ground, the living rock surface itself. (The present-day counterpart would be graffiti on natural rather than artificial surfaces.) No depictions of topography have been found. There are never any horizontal lines or frames—in short, no artificial delimitation of the field on which the artist worked. To what extent the natural shape of a rock surface inspired an image is difficult to say. At times, artists seem to have taken advantage of the conformation or projection of the surface to enhance the sense of the animal's bulk, as in the shoulder area. More often than not, they seemed indifferent to such a device. There are frequent inconsistencies of scale, axes, or orientation of the images in a series. Whether larger size was indicative of potency we don't know. A line of animals is not always vertical or horizontal with respect to the cave floor. When shown on ceilings, the animals may be in a rotational arrangement, with no fixed viewing point. Narrative seems absent to our eyes. Usually, the animals appear isolated, but there are sequences of animal profiles closely grouped in series and of overlappings that imply conscious compositions. Some paleolithic artists demonstrated a knowledge of perspective by drawing animals in true profile with foreshortening of some features. At Lascaux, for instance, certain artists imparted a strong sense of movement or animal power. Just how much of the unpainted area around animals was intended for expressive effect is hard to say. This varied and contradictory nature of paleolithic art encourages belief in a more intellectually sophisticated early ancestor of the human race than was previously supposed to have existed.

Art for the Dead: Egyptian Tomb Art

The ancient cultures of Egypt and China were but two of many in which at an early historical stage rulers or important personages were buried not only with foodstuffs, jewelry, and equipment, but also with some of the living who had served them. One of the most important civilizing purposes of art was its substitution for human sacrifice. (A second, comparably noble purpose was the use of precious art by such cities as Rome and Constantinople to bribe besieging armies to spare citizens from the sword.)

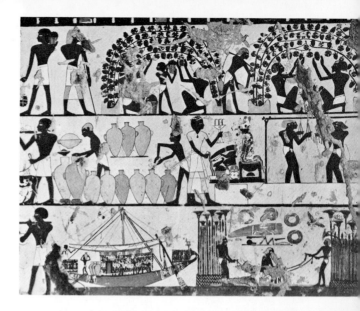

top: 28. Egyptian wall painting. c. 1500 B.C. $29\frac{1}{2} \times 41\frac{1}{4}''$ (75 × 105 cm). Tomb 261, Thebes.

above: 29. View of south walls, Tomb of Nakht, Thebes. c. 1422–1411 B.C.

Created thousands of years after the cave paintings of Lascaux, the private tomb paintings and reliefs of ancient Egypt are a very different form of art, but one still essential to well-being (Figs. 28, 29). Their purpose was to serve the dead in the hereafter. Those images containing food must have had some kind of magical intent—perhaps to ensure sustenance for the deceased. Early in Egypt's history, actual food offerings were placed at the tombs, but this practice too often strained the local food supply. A wall painting from the Tomb of Nakht seems to depict the ritual of presenting food at the tomb entrance. In that same tomb painting, distinguished by their great size, are the deceased man and wife, flanked by smaller scenes of everyday life. It is

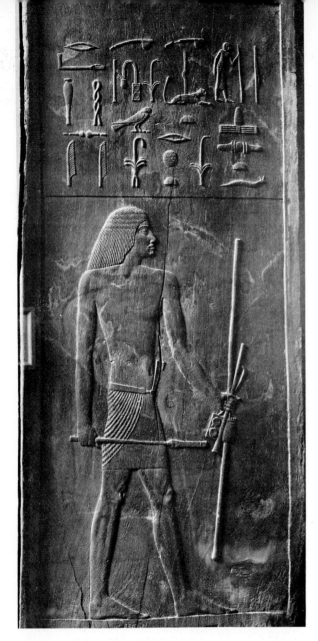

30. Panel from the Tomb of Hesire, Saqqara. Third Dynasty, c. 2650 B.C. Wood, height 4′7½″ (1.41 m). Egyptian Museum, Cairo.

ment of smooth-surfaced pottery and architecture. The artificial, smooth surface, or field, on which the artist could work, which today we take for granted, was a giant step from rough cave walls and became the basis for subsequent art right down to the motion picture screen. Precisely when, why, and how the regularized field came about at such a late moment in human civilization is both complex and unclear. The Egyptians were among the first to use a prepared ground and then to subdivide it into horizontal registers. These lines served as figure support or ground, and later as horizon lines. They helped to unite the axes of the figures and to give them direction, while assisting in composition. The separate picture frame as we know it was a later development, coming at the end of the Middle Ages. The Egyptians early painted decorative borders at the ends and tops of walls to emphasize a delimited field, but these borders do not give a sense of depth because the overall painting was not illusionistic—evoking projection in depth. (Part of the history of the picture frame was the development of depicted borders or frames for a figure or scene that appeared in Mesopotamian painting in the early 2nd millennium, and these may have derived from doorways and windows.) The background in Egyptian painting and reliefs is problematic, mostly solid or flat, but at times transparent. Illusion of depth was the exception. Like the Assyrians and Chinese, the Egyptians introduced pictographic writing within the field. This was possible because the pictographs and the imagery had a common basis. Furthermore, Egyptian artists, unlike their Roman and Renaissance counterparts, were not concerned with consistency of illusion. The prepared ground was the historical basis for the later use in Western art of systematic perspective and projection of the three-dimensional world onto a flat surface.

The Egyptian relief and painting figures of the dead are *synthetic* in form. That is, they are not depicted from the viewpoint of an observer nor are their parts joined according to any three-dimensional coordination. The profiling of the head, arms, and legs in combination with the frontal view of the upper torso and the eye, prohibited any suggestion of the figure engaging in vigorous movement. It is hard to say whether the figure of *Hesire,* which is the oldest one in private tomb art, is striding or standing (Fig. 30). This type of synthetic figure became the rule in Egyptian art. It was consistent with the concept of the deceased as a watcher rather than a doer. That Egyptian artists did know how to render true foreshortening can be seen in drawings on stone blocks for sculptors to carve, but it remained for later cultures, such as the Assyrian and the Greek, to depict actual events and dramatic tension between participants, scenes that invoke the viewer's imagination.

Tribal Art

The tribal art of Africa, the south Pacific, and Northwest Coast Indians challenges our notions of what is beautiful,

believed that these scenes of various common activities, in later art are called *genre* subjects, were supposed to give joy to the dead (see Chap. 10). For most of Egyptian art history, the glorified dead were only spectators or watchers of the living and did not participate in the scenes. (They may smell or touch food or flowers, but are never shown eating.) Their link with ephemeral life was considered vital.

The form of Egyptian painting was as momentous a change from the art of the caves as its human-oriented subject matter. The prepared ground for painting and reliefs came into being in Egypt and the Near East probably in the late fourth or early third millennium B.C., with the develop-

real, and civilized. Our society's standards of beauty, for example, have been strongly influenced by the art of Classical Greece and modern film and photographic images of the cosmetically ideal. Reflecting the impact of science, the real for many of us is determined by verifiability and, mistakenly or not, the photograph is often the arbiter of truth. Tribal art shocks by its nonconformity to our physical, aesthetic, and intellectual standards. For this reason, and because there is no written tradition, tribal art is unfortunately not credited with representing a unified life-attitude. Comic books, novels, and old Tarzan movies have imposed on many generations the stereotype of the dumb, superstitious, idol-worshiping native and propagated the view that tribal art is "primitive." Extensive and increasingly sophisticated field research is developing a more credible and respectable image of what tribal art represents and how pervasive are its functions in helping to realize the good life for its people. Unlike art in our own culture, tribal art in many areas still provides the model and means for right living, social status, stability, and harmonious coexistence with the past or the invisible. Through cultural relativism, we can learn to be aware, understanding, and tolerant of the art of peoples whose standards and world view are different from our own.

The Concept of the Cool One of the most important contributors to our knowledge about tribal art is Robert Thompson, who proposes that "Cool philosophy is a strong intellectual attitude affecting incredibly diverse provinces of artistic happenings. . . . It is an all important mediating process, accounting for similarities in art and vision in many tropical African societies." He believes the criterion for coolness unites and animates the rules by which tribal art is made. In 35 African languages, he has found that the concept of the cool connotes: "calm, beauty, tranquility of mind, peace, verdancy, reconciliation, social purification, purification of the self, moderation of strength, gentleness, healing, softness, . . . silence, discretion, wetness, rawness, newness, greenness, freshness, proximity to the gods." Thus the African concept of the cool goes far beyond our own associations with self-control.

Through his studies of African dance as well as languages, Thompson has been able to interpret figural sculpture as the embodiment of correct physical and mental deportment, essential to realizing the highest African ethical standards of the good life. Carved figures we may see as stiff, the African sees as spiritual and upright—representing a strong personality and the way he or she lives with the world, standing up "alive from dawn to dusk" (Fig. 31). As many standing and sitting figural sculptures are of ancestors or spirits, it is fitting they be given lordly or commanding postures. Where we see rigid frontal symmetry, with the weight carried equally on both legs, to those it serves tribal carving is a reminder of stability, buoyancy, flexibility, and suppleness. Arms are usually bent, and fingers are always parallel and strictly aligned (Fig. 32), imparting the ethical model of cold hands to go with a cool head against a hot body. This contrast equates with moral balance and moderation. In tribal dances, the feet strike the earth in a flat-footed manner as opposed to the Western style of landing

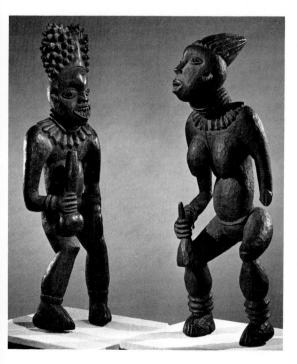

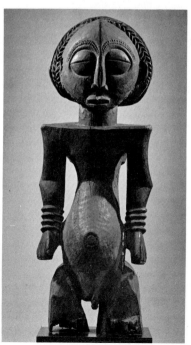

far left: 31. left: King or First-Born Prince figure. Bangwa tribe, Cameroon, 19th century. Stained wood, 33¼ × 10 × 10¾″ (84 × 25 × 27 cm). right: Dancing Queen figure. Bangwa tribe, Cameroon, 19th century. Stained wood, 34½ × 10½ × 8″ (88 × 27 × 20 cm). Both Collection Franklin Family, Beverly Hills, Calif.

left: 32. Male figure. Buye tribe, Zaire. Wood and kaolin, height 30½″ (78 cm). Metropolitan Museum of Art, New York (Michael C. Rockefeller Memorial Collection of Primitive Art, gift of Nelson A. Rockefeller, 1964).

on the balls of one's feet; hence the sculptural stance parallels the tribal mode of dance rather than employing the asymmetrical posture and stylized instability celebrated in Western art from Classical Greece onward. African carvers do not stress bones, but boniness or firmness as well as suppleness. Just as African music firmly emphasizes every beat, so the sculpture stresses the clarity and strength of every part and their equal emphasis. This translates into being "alive and vital," having drive and strength. Nothing should evoke weakness. Sculpture is expected to be strong expression.

The African ethical ideal of moderation means the sculptor will not aim for individual likeness. Africans equate Western realism with excess and lack of self-control by the artist. Tribal sculpture stresses a generalized humanity rather than individualism and personal ambition. For the Yoruba, one of the largest African tribes with a long and great tradition of sculpture, art means becoming civilized or making civilization. Thus, although they differ in balance, proportion, and shaping, tribal figures impart ideals comparable to those found in Classical Greek images of Apollo (Figs. 54, 55, 57–59), which for many Westerners still represent moral and physical perfection. For both the ancient Greeks and Africans, art separates man from nature and is a means of coming to terms with nature.

African Ancestor Sculpture In Africa as in Oceania, there is the belief that the living are surrounded by the dead and that ancestors play a significant role in the continuing life of the tribe. African ancestor figures are symbols and spirit abodes of the deceased. It is the hope of the carver and his patron that sculpture made for an ancestor will please that ancestor by its fine quality (*good* and *beautiful* are synonymous in many tribes) and that the markings, coiffure, and other tribal and individual attributes will be recognized by the ancestor as appropriate for the spirit dwelling place. Ancestors can make their power accessible to the living—during ceremonies held to evoke this power, they may pass it on to those who attend their effigies. Besides expressing veneration for the dead, ancestor sculpture constitutes a surrogate for the living with the forces or powers controlling life. Sieber refers to these ancestral statues as "lobbyists," by means of which the living call upon their ancestors to intervene on their behalf with the appropriate spirits. Because the ancestor dwelling within is believed able to see, the eyes of these carved figures may have slits. Stress is often placed on the head, as the seat of power both in life and in death, and the faces are benign rather than aggressive, because ancestors are considered friendly.

Art is intensely real to Africans, even when it seems to bear little resemblance to human or animal forms in nature. High African cultures, however, such as the Nigerian, which knew a monarchical system and pyramidal social structure, produced magnificent bronze heads and figures of royalty that have a naturalistic appearance and an ideal of Classical

composure (Fig. 33). Probably dating from the 12th to the 14th century—the equivalent of the medieval period in Europe preceding the Renaissance in Italy—heads such as that of an Oni, or supreme chief, were cast in bronze, presumably to commemorate the dead ruler. Experts such as Bernard Fagg strongly doubt that these were actual portrait likenesses of specific individuals. This degree of idealization within a context of naturalism has a counterpart in the portraits of European rulers discussed in Chapter 12. The Ife king is shown wearing the appropriate plumed and beaded crown; the perforations around the mouth and chin may have been for insertion of beads or hair. Whether or not the vertical striations covering the face depict actual scarification practice is not known. We can speculate that these bronze effigies, too, served as spirit dwellings and were placed in shrines or honored locations.

The Ife heads readily draw our appreciation because the physical subject naturalistically rendered is in itself handsome. To many Africans, this head epitomizes the cool. Ancestor figures such as those of the Baule tribe (Fig. 34), on the other hand, derive their beauty in the eyes of those sympathetic to African art from the visual rightness of the rhythms and proportions of the parts in relation to the whole work. In the eyes of the Baule themselves, however, the large head and elongated torso, the emphasized navel, and the short squat legs all correspond to ideals of correctness and beauty prescribed for an ancestor figure. Again, the head is stressed as the seat of power both in life and in death, and the emphasis on the navel and phallus confirms the powers of fertility. Studies of ethnic physical types in Africa show not only that they are tremendously varied, but also that there is often some correspondence between sculptural and human proportion in various regions. The Baule figure bears the stylized headdress and scarification marks appropriate to this tribe. The immobility of the figure is conditioned as much by the irrelevance of motion to the ancestor portrayal as by the fact that it was carved directly from a round log, with perhaps some thought to preserving its natural quality. In African sculpture, *connoisseurship*—the descrimination of excellence—is similar to that for any other art. Only when hundreds of sculptures from a given region are patiently examined can an outsider grasp why tribal members esteem certain carvings above others.

Kota Skull Guardians The use of sculptures as guardians of the dead was as widespread as the making of ritual funerary objects. Tomb guardians in the form of human or supernatural figures and animals have been found as far east as China. In Africa, the Kota tribes have for centuries been remaking variations on the basic design of a figure that is literally tied to a container of human skulls (Fig. 35). Just as the configuration of this skull guardian has been altered within general limits by successive generations, so has the oral tradition from which its meaning is known undergone change. One interpretation is that this is a mother

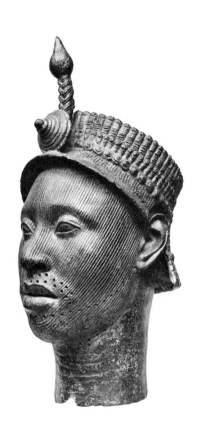

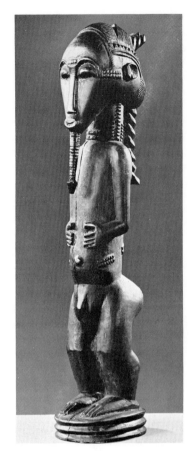

right: 33. Head of a king. Ife, Nigeria, c. 12th–14th centuries. Bronze, beads in crown painted carnelian; height 14½'' (37 cm). British Museum, London (reproduced by courtesy of the Trustees).

far right: 34. Ancestor figure. Baule, Ivory Coast, early 20th century. Wood, height 16½'' (42 cm). University Museum, Philadelphia.

below right: 35. Skull guardian. Kota, Equatorial Guinea. 19th–20th centuries. Wood covered with copper and brass, height 30'' (76 cm). Ethnographic Collection, University of Zurich.

goddess who reigns over the dead; another, that the figure defends the living from an evil spirit. There is also a question of whether the lower part of the figure is a schematic representation of the arms or a contraction for the torso and legs. (The part below the face is intended to be buried in the ground along with the container of skulls, but in ceremonial dances, it is sometimes carried by the performers.) The guardian figure is made of brass attached to a wooden frame—an indication of its importance, since metal is not a common material in this area. The many surviving Kota grave guardians show a decided variation in the treatment of the face, with the older examples being more naturalistic. Some Kotas refer to the horizontal crescent surmounting the head as a "moon," while others call it a "headdress"; the panels flanking the central oval have been described as cheeks or as continuations of the face. Archaeologists have pointed out, however, that tribal hairdos and ornaments may have inspired these lateral shapes. The original meaning of the guardian figure may be lost or obscure to the present-day tribe and its artists, but it is significant that continuity with the past through repetition of what has proved to be an effective protection for the dead is still valued. Tolerance of deviation from a norm in this Kota art

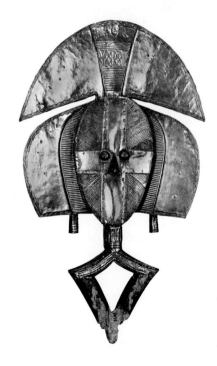

allows a gifted artist to impart his own interpretation to the conventional theme as long as an accepted resemblance to its tribal model is preserved.

New Ireland Funerary Art The islands of New Ireland lie east of New Guinea, which in turn is just north of Australia. Every year from May to July, the rites for the recently deceased and for ancestors long dead are performed in New Ireland. These rituals and the accompanying dances and art forms are known, collectively, as *malanggan* (Figs. 36–38). Every year the art must be renewed, for when the *malanggan* rites are completed, the masks, poles, reliefs, and statues of dead kings that were used are all destroyed or sold. The ostensible purpose of the rites is to offer memorials to ancestors, but the sculpture employed does not seem intended to influence or even please the dead. As a matter of

pride and prestige, clans made up of men from different villages who have a common ancestry take it upon themselves to re-create these ritual objects, which are so elaborate as to require months of preparation. The *malanggan* rites furnish annual occasion for renewing unity among the clan members, both living and dead. To prevent a loss of face in the eyes of other clans, each clan tries to outdo the others in the skill and beauty of its objects, and there is no exact repetition of motifs from one year to the next. Each clan has its own symbols and designs, and the artists are urged to elaborate upon or re-create their works within these traditions. Although the repertory from which the artists work is general (sea life, snakes, birds, the human form, and decorative patterns) and there are no set meanings, many of the *malanggan* works do commemorate specific individuals, whose generalized biographies are sum-

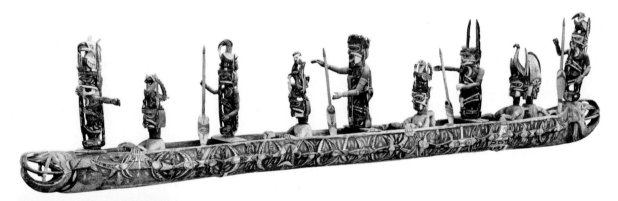

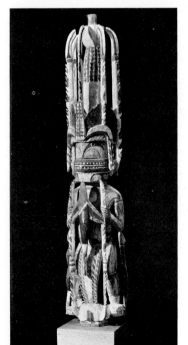

above: 36. *Malanggan* spirit boat, with figures representing deceased ancestors. New Ireland. c. 1890. Painted wood, length 19′1¾″ (5.89 m). Lindenmuseum, Stuttgart.

left: 37. *Malanggan* pole showing ancestor with shark. New Ireland, 19th century (?). Painted wood with shells, height 6′¾″ (1.85 m). Photo © Sotheby Parke Bernet 1980.

below: 38. Cult house with *malanggan* style masks. Medina, New Ireland, collected 1932. House of wood, bamboo, palm, and croton leaves; figures of painted wood; 8 × 16′ (2.44 × 4.88 m). Museum für Völkerkunde, Basel.

marized on the poles and reliefs. (With their appearance during the ritual, the name of the deceased is called out, and he is mourned.) Clan members who are specialists at making these objects work under the scrutiny of elders in secret places or areas fenced off to keep out the women and children.

New Ireland artists employ a wider variety of materials than probably any other group of artists in Africa or Oceania. Characteristic of their style is a desire for splendor, which is achieved largely by brilliant polychrome applied in small, clearly delimited areas and in strong juxtaposition. Often the sculptures are carved from logs, but some are constructed of small pieces of wood, shells, bark, roots, fruit rind, feathers, or bits of cloth. Great care and precision goes into the joining of the parts. Many of the sculptures have a solid core that appears to be suspended within a cage or open framework. The great ornamental poles were probably intended to be seen from all sides, since every square inch of surface is given over to patterning, much of which may have lost its original symbolic meaning. As public testimony to his skill, the *malanggan* ritual objects are as much a tribute to the living artist as to the honored deceased—a fact that has been confirmed by anthropologists. The appearance of *malanggan* in the rituals has strong psychological effects and stimulates emotional participation by the audience. While serving religious ends, these objects also evoke strong aesthetic response.

New Guinea Ancestor Skulls Along the Sepik River in New Guinea, certain tribes employ actual skulls of the deceased for ancestor spirit abodes (Fig. 39). Over a skull that has been cleaned and dried, clay is applied and modeled to resemble the dead person as closely as possible. Ornamentation is added, in designs appropriate to the deceased's social rank and similar to what was worn while the person was alive. Shells are sometimes used to replace the eyes. These embellished skulls are often set atop mannequins and manipulated like puppets before the women of the tribe during fertility rituals. Both in Oceania and Africa, ancestor worship is linked with fertility rites, on the premise that the dead members are sympathetic to the tribe's increase. Since it is believed that the dead still need sustenance, offerings of food are also made to the ancestor skull.

Fertility Art

The making of fertility images is a global phenomenon, which should not be surprising in view of the fundamental importance of reproduction to all peoples. Stone Age figure sculpture is rare. The famous *Venus of Willendorf* (Fig. 40), an object less than 5 inches (12.5 centimeters) in height, is probably one of the oldest sculptures made to promote fertility. Support for this conjecture comes wholly from the suggestive proportions of the feminine figure; the reproductive areas of the body are exaggerated, while the face and

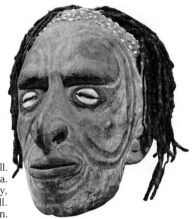

39. Ancestral skull. Middle Sepik River, New Guinea. Face modeled in clay, eyes of shell. Übersee-Museum, Bremen.

the thin arms resting across the breasts are minimized. Judged against anthropological reconstructions of what women may have looked like anywhere from 12,000 to 15,000 years ago, the sculptor's bodily exaggeration may not have been too great. The natural configuration of the small stone may also have aided or suggested the final shaping of the figure. The small scale allows it to be held in the hand; but this is about all that can be said concerning its original use.

The concept of an all-powerful creator god or spirit arose long before the Judeo-Christian God was first worshiped. Some religions forbade the making of an image of their most important god; this proscription has been generally true in African cults, as well as in Jewish, Moslem, and sometimes Christian religions. One of the most unusual

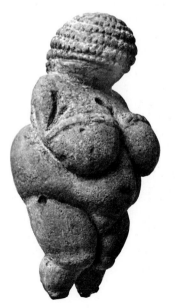

40. *Venus of Willendorf.* Paleolithic, c. 30,000–10,000 B.C. Limestone, height 4⅜'' (11 cm). Naturhistorisches Museum, Vienna.

works of art giving form to a supreme deity is also a unique sculpture from its geographical area. Carved sometime in the 18th or 19th century on one of the Austral Islands in the South Pacific was the pale hardwood figure of Tangaroa, a Polynesian sea god (Fig. 41). According to tradition, at the time when the world was in chaos, Tangaroa created gods and men. Although committed to a human figure for his god, the unknown artist made of the head a great flat circular form, which like the smooth expanses of the rest of the body may have evoked associations with the sea. The god is shown giving birth to creatures that seem to rise out of his body through its surface. Just as they take their form from Tangaroa, by their placement they seem to define his features, being located where the god's eyes, nose, and mouth would be. The sculpture is hollow, with figures carved on its back and small figures found inside. The male genitals are attributes of the Polynesian supreme god's creative power. What is amazing about this sculpture is that it was made in a geographical area where the figural tradition was not strong. Unless some precedent for it is discovered, this work apparently contradicts the generalization in tribal art that the sculptor invariably worked from some established prototype.

Along the Atlantic western coast of Africa in Guinea, the Baga peoples employ a large shoulder mask, known as a *nimba,* as protection for pregnant women (Fig. 42). When the mask is being worn, the body of the wearer is covered by a raffia dress, and the carved headpiece itself rests on the shoulders. Members of a secret society known as the Simo Society are entrusted with carrying the mask in ceremonies while the women dance around it. The raised ridge on the head probably relates to the tribal hairdress. The large, protruding nose is a fertility symbol. When not being worn on ceremonial occasions, the *nimba* is placed in a hut and set off by trees at a crossroads, where it serves as protection for the village. It is possible that the *nimba* re-

below left: 41. Tangaroa, Polynesian god of the ocean. 18th/19th centuries. Hollow wood closed at back with lid, height 44½'' (113 cm). British Museum, London (reproduced by courtesy of the Trustees).

below right: 42. *Nimba* dance headdress with carrying yoke (Baga, Simo Society). Guinea, 19th century. Wood, height 46½'' (118 cm). Metropolitan Museum of Art, New York (Michael C. Rockefeller Memorial Collection of Primitive Art, gift of Nelson A. Rockefeller, 1964).

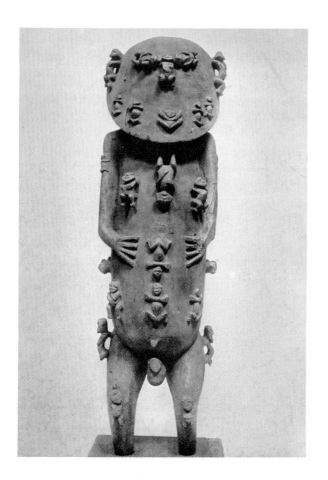

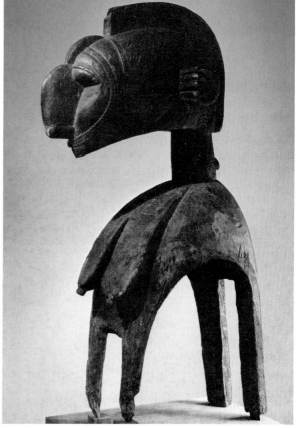

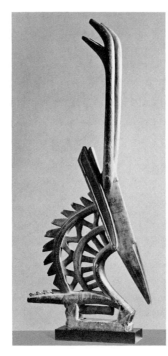

43. Ancestor figure.
Bambara, Mali.
19th–20th centuries.
Wood, height 4⅝'' (12 cm).
Metropolitan Museum of Art,
New York
(Michael C. Rockefeller
Memorial Collection
of Primitive Art,
gift of Nelson A. Rockefeller,
1964).

presents the wife of Simo, the great spirit from whom the cult takes its name. Along with the nose, the swelling profile of the *nimba* in general may also allude to ripeness and fecundity.

Some of the most striking African animal carvings used as headdresses in rites for ensuring fertility of the soil, ample rain, and good crops are those made in the western Sudan by Bambara people (Fig. 43). Before the rainy season, men belonging to agricultural societies prepare the carved antelope headpieces and then begin their rites in the dried fields. Their faces are covered with red masks, their bodies with fiber costumes. Upon their return to the villages, offerings and dances are conducted around the privileged performers, who imitate the movements of antelopes. The carvings represent both the male and the female antelope and are distinguished by curved horns for the former and straight horns for the latter. Intended to be seen from all sides and from some distance, the masks are given horns that extend extravagantly into space, and the mane is carved in an elaborate open-work pattern. Both the combative nature and the elegant grace of the animal are preserved. What seems an arbitrary schematization of the antelope into a succession of repeated rhythmic curves results from modeling sculpture more after other sculpture than after nature.

The Mask

Masks and disguises link us with our tribal counterparts. Role-playing is universal; all cultures employ the mask in various ways, either the actual object or in the form of facial decoration, ranging from tattoos to cosmetics. Masks thus give the face importance, dignity, and status, and are an important example of nature transformed into culture, but masks also gratify our dualistic nature, enabling us to dramatize our repressions and our play instinct. Halloween parties and other masquerades remind us of the effects of wearing a face mask: it permits us to assume a new identity emanating from the character of the mask itself, and it allows some wearers to cast off inhibitions and social responsibility.

These possibilities of having fun, of becoming another being and playing a new role are in some ways related to the various purposes served by the mask throughout the world in Stone Age cultures. Among tribal societies in Africa, the Northwest Coast Indians, and peoples of the South Pacific, the mask has a tradition as the symbol or locus of supernatural forces. The acts performed by the mask or directives attributed to it carry the authority of a particular spirit or power. That supernatural power can be embodied in a face mask without presenting the entire figure is explainable in terms of the widespread belief that the head is the prime residence of such power. When movement is necessary for the mask to fulfill its proper function, it is worn by a dancer as part of a ritual. Therefore, to hang a mask on a museum wall is to distort its original purpose. In most societies, important masks, when not in use, were enshrined as cult objects, kept out of sight, or often destroyed. Although we tend to think of the variety possible in human features as depending upon individual differences evident in living persons, primitive masks that are not likenesses of the living manifest a comparable rich variety. In addition, they demonstrate the strong emotion and imagination called upon to make these supernatural forces tangible and impressive in the eyes of their tribes.

Masks have had long and notable histories of fulfilling serious and varied functions for the living. Besides dealing specifically with religious life, they have been regarded as important agents for good by helping to guarantee social order, fertility of crops and herds, health, victory in battle, and desirable solutions to various other crises in life. They have helped as well to maintain a general equilibrium among the living and the dead and the spirit world.

In *Homo Ludens: A Study of the Play Element in Culture*, Johan Huizinga observed that the mask is the result of an imagination that is both poetic and playful and that it is crucial to the community's interpreting, grasping, and representing the purposes of rituals, which themselves are indispensable for the well-being of any community, its social development and understanding of the world. Tribal peoples' rites are closely associated with serious play. They involve a unity of belief and disbelief, being in "sacred earnest" but also in the spirit of make-believe or fun.

Tribal peoples know full well that masks are paid for, made of familiar materials, carved, and worn by members

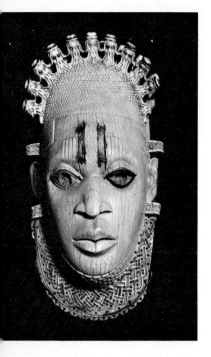

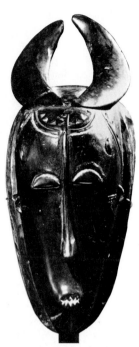

above left: 44. Belt mask. Benin. Ivory. British Museum, London (reproduced by courtesy of the Trustees).

above right: 45. Face mask, Guro, Ivory Coast. 20th century. Wood, height 11½″ (29 cm). Seattle Art Museum (Katherine White Collection).

below: 46. Owl mask. Baining, New Britain. Acquired 1922. Cane and bark cloth, height 31¼″ (79 cm). Museum für Völkerkunde, Basel.

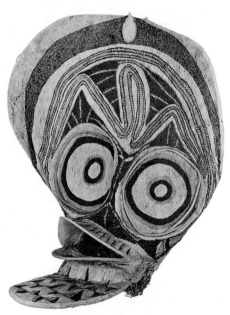

of their own groups, but this knowledge does not weaken the drama or potency of the masks. Masks usually are made in secret and the rituals attended with respect. Although those who wear the masks are generally considered to have cast off their previous identities, they do not have license to shed social responsibility, and dancers and other performers in the rites are trained to observe conventions governing their movements and general mien. In the "old days," certain maskers had a license to kill. To wear a mask is to assume a different and more important social responsibility, and mask wearers share magically in the power of the spirit or force they represent. Masks still play a vital religious and social role in many parts of the world, but any further generalization about masks would be difficult to make. The selection offered here is a meager sampling of the manifold purposes masks serve and the infinite ways in which they have been made and decorated.

The word *mask* is a Western invention, a neutral term, whereas in Africa masks have names such as "spirit head" or "face of a forest spirit." The name embodies the living personage, and the mask is active, powerful, and very real—signifying that a spirit has returned to a village, if only temporarily. These spirit presences can magically intervene in human affairs. The wearing of the mask in ritual is sometimes described as "the spirit rides the head."

Masks are an expression of the spirit that possesses the wearer, and this spirit can be good or evil. When the mask is meant to evoke high moral attainment, as the Benin ivory belt mask (Fig. 44), the artist must represent equanimity of mind, insight, transcendence of human limitations—the gaze must be controlled and not shifty-eyed. The big eyes and intensity of their expression suggest ancestral possession. The closing of the eyes and the cold facial features can relate to death; as Thompson writes, "an act of joy to cool searing heat of death . . . closed eyes are a way of transending the pathos of mortality." Such is the expression of a Senufo mask (Fig. 45), also endowed with upturned horns, which may be intended to symbolize the power of nature or great energy.

Many types of masks have a protective function. On New Britain, off the coast of New Guinea, an owl mask made of cane and bark cloth is used to give supernatural protection to children (Fig. 46). The eyes alone relate to our experience of an owl, and only by learning the formal (visual) language of this tribal society, as we would master its verbal language, could we come to recognize all that is meaningful in such art. Because the owl of the natural world has been assimilated into, or transmuted by, certain artistic conventions compounded of symbols and decoration, the children of the tribe must be *taught* that this is an owl. Our acquaintance with any type of head makes the radically asymmetrical structure of the face most disturbing. Too, we are not accustomed to art in which a minimal resemblance to physical reality is sufficient to conjure effectively the presence of an animal or a human being.

The "Fire Spitter" helmet masks made by the Senufo tribes of the Ivory Coast have several animal derivations, none of which relates to their purpose. The long-horned, open-jawed head with tusks (Fig. 47) comes from the water buffalo, the wart hog, the antelope, and the crocodile. Hornbill birds symbolizing fertility perch between the horns. The open jaws generously fitted with teeth create a ferocious apparition, for the mask is meant to inspire fear. The "Fire Spitter" performs the function of driving off or destroying "soul-eating" spirits. Its sacred character is enforced by the scrupulous treatment given it by the secret-society member who wears it and who is hidden behind a sacklike garment (Fig. 48). Brought forth at night, the mask is worn horizontally on top of the head so that the jaws and horns are parallel to the ground. The villagers sacrifice to it to ensure its good will. The mask wearer calls out incantations and also blows sparks through the jaws of the mask or showers them about his person. Believed to have superhuman powers because he has fused his being with the demon of the mask, the mask wearer can also walk or sit on burning coals. As in many other areas of Africa, the "Fire Spitter" is used for varied functions, such as initiation rites for secret societies, funerals, and agricultural ceremonies.

The widespread conversion of African tribes to the religions and legal systems of the modern Western world has created serious problems, some of which arise from loss of the power previously invested in sculpture. This transition can be understood more easily from an example of a mask that had played a dominant role in the civil procedures of a Nigerian tribe presently undergoing Westernization. On one of many field trips to Nigeria, the art historian Roy Sieber studied the purposes of Egu Orumamu, or the "chief of masks," among the eastern Igala peoples (Fig. 49). He wrote of its extensive use as an agent of social control:

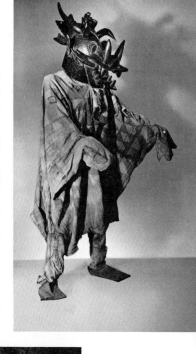

above: 47. "Fire Spitter" helmet mask. Senufo, Ivory Coast, 19th–20th centuries. Wood, length 35⅝" (90 cm). Metropolitan Museum of Art, New York (Michael C. Rockefeller Memorial Collection of Primitive Art, gift of Nelson A. Rockefeller, 1964). *right:* 48. Man wearing double helmet mask with costume. Nebunyonkaa Village, Senufo region, Ivory Coast. 1930–39 (?). Ethnographic Museum, Antwerp. *below:* 49. Egu Orumamu mask. Eastern Igala tribe, Nigeria. 1940. Wood, height 23" (58 cm). Museum Jos, Nigeria.

> Its power apparently is derived from the ancestors and it oversees the general well-being of the village. Certain of its appearances, for instance, are related to agriculture. More pertinent . . . is its judicial role in cases of murder and petty civil offenses Orumamu (hidden in a hut) arbitrated complaints and arguments of the women . . . usually of a financial nature. . . . Orumamu could send his minions to punish children who had gotten in trouble or to supervise the water supply in times of shortage.

The Orumamu mask illustrated is not one of the more beautiful African masks by our standards—or even compared with other masks made by the same tribe—but questions of beauty were secondary to the guardian functions Sieber described.

In many areas of Africa, there are secret societies that are miniature versions of tribal life itself. These societies perform various functions, which range from maintaining the social order to protecting the tribe against unfriendly demons. Both are roles of the Ekpo secret society of the

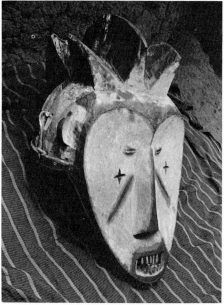

Ibibio in southwestern Nigeria (Fig. 50). In one of the finest Ekpo masks, the face is reconstructed in a menacing form, as a reminder to nonmembers of the hostile character of the spirits with which the society is concerned. If this head is looked at as sculpture, we can see how the artist conceived the various shapes not only as eyes, nose, and mouth but as variations and echoes of one another's form, or of a basic form. Their configuration—protrusion and recession—and vertical alignment guided their proportion and carving and produced an emphatic rhythmic sequence within the compactness of the head. The menacing quality of the mask comes in part from its battery of sharp teeth, which are visible because the jaw portion is hinged to permit movement during rituals.

The most spectacular examples of masks with moving parts were made by the Northwest Coast Indians of North America. The Kwakiutl and other tribes particularly delighted in fashioning masks within masks, which during ceremonial performances and dances were opened by strings pulled by their wearers, thus creating a type of dramatic revelation (Pl. 2, p. 55). In some masks, three or four such revelations were possible, ranging from various animal or bird heads to human representations. These masks were beautifully carved and painted, and exceptional craft went into their hinging. The designs were part of a clan and tribal repertory with motifs often derived from animals and birds. The colors are strong and the color

areas cleanly shaped, changing with each successive revelation within a single movable mask. The Kwakiutl mask illustrated belonged to a *shaman,* the equivalent of a witch doctor, who was believed to possess supernatural powers to heal or to perform feats of magic. By means of the mask, he impersonated a demon or spirit. The non-naturalistic color and drastic reshaping of the facial features were calculated to evoke these supernatural forces. Art for these Northwest Coast tribes was a conscious form of competitive social ostentation, an attitude that accounts for their elaborate design and visual brilliance.

The mask worn by the Northwest Coast Indians differs from the African tribal mask in its relationship to the wearer. When the African actor ceases his role of impersonation, he relinquishes his relationship to the entity of the mask. In societies such as the Kwakiutl, the mask affirms the ancestry of the wearer; it proclaims his inherited rights and privileges and establishes his status in the tribe's social hierarchy. By contrast, African masks have no connection with the tribe's castes or classes. There are thus varying relationships between the social order of the living tribe and the supernatural world. In societies that have a tradition of the multiple mask, the wearer's status is directly tied to the myths, pedigree, and rituals he enacts. He acquires from the god, according to the French anthropologist Claude Lévi-Strauss, "by a continuous process of creation at each moment of social life, his titles, rank, his position in the status hierarchy."

50. Ekpo secret society mask. Ibibio, Nigeria. Wood, height 12″ (31 cm). Lindenmuseum, Stuttgart.

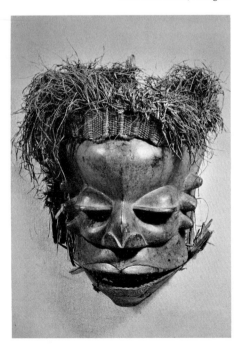

Body Art and Regalia For many tribal people art is as close as their skin. Through body painting and scarification, as prescribed by tribal traditions, men and women achieve permanent social identities, induce fertility, beautify their bodies, and protect themselves from harm (Fig. 51). A pallid Western comparison would be the putting on of makeup and piercing of the ears to make people more physically attractive or socially presentable. When this is done by young women for the first time, it is an attempt at identification with a new group of peers. Tribal societies have their "rites of passage," comparable to sacraments. Tribal art helps to dramatize crucial transitions and occasions in life such as puberty and admission to secret societies. The assumption of social and political offices often leads to polychroming the body. The removal of body paint, a ritual "washing off," in some tribes signifies a rebirth and purification. In many tribes, scarification is both deliberate and artistic, susceptible to aesthetic criticism. Pre–World War II Prussian dueling scars identified their owners as members of an elite cult, one of bravery, skill, and disdain of death. Tribal scarification is a means by which the individual achieves beauty or mystical significance or identification not only with a family or tribe, but with humanity.

The richness of tribal art extends to the regalia of rulers (Fig. 52). The king of the Kuba tribe in Africa literally wears

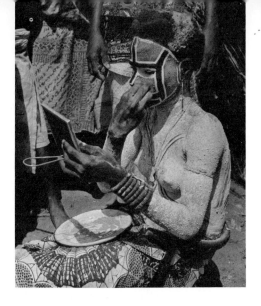

above: 51. Tai girl applying pigments. Ivory Coast.
right: 52. *Nyim* Mbop Mabiinc maMbeky (Bope Mabinshe)
in ceremonial dress. Zaire. 1947.
Museum of African Art, Washington, D.C.
(Eliot Elisofon Archives).

his wealth, for the hundreds of cowry shells he adorns himself with are currency. His ceremonial dress with leopard skin, as much as the weapons, announces the power of his office. The layering of his costume, its density of adornment and richness of patterning enhance his considerable size. Even today in many areas of the world, fatness connotes elite status, beauty, and prosperity.

Some of the most beautifully designed textiles in the world come from the cultures of the Northwest Coast Indians (Fig. 53). Mostly made in the late 19th century, when Indians obtained wool, the famous Chilkat blankets served ceremonial and important social purposes and gave the owner special status. The long fringe recalls the robe's use in dances and how it was often seen in movement. Woven by highly skilled women from designs painted in black on boards by the patron, these black, white, yellow, and blue robes have motifs so densely compacted together so that there is no background. The motifs were often totemic, relating the wearer to, say, the bear and raven and hence to a secret society or clan to which the owner belonged. These

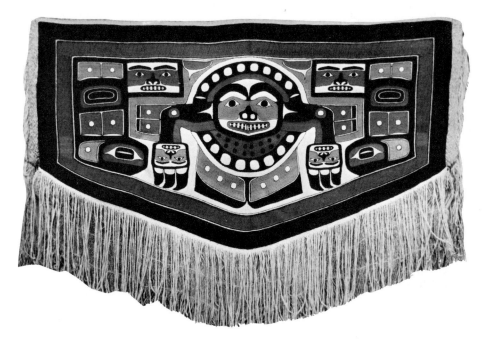

53. Blanket. Chilkat, Alaska.
c. 1875. Mountain goat wool
on cedar-bark fiber,
3 × 6′ (.91 × 1.83 m).
Museum of the American Indian,
Heye Foundation, New York.

uniformly delineated split images, often derived from animal parts so that the weaver could fill in the entire field, are so stylized that only the weaver could fully understand them. This phenomenon was also known among carvers, who along with the weavers were permitted to innovate only within a strict tradition. This discouragement of originality as we know it was generally found in the traditions of all tribal artists.

The Lessons of Tribal Art Since the turn of this century, modern artists have been among the principal beneficiaries of the great legacy of tribal art. They have done much to increase Western society's awareness and tolerance of what we have been looking at. What continues to touch modern artists is the boldness, the forcefulness of tribal art's emphatic allover design, its expressive power and mediation between the known and unknown. The lack of resemblance to a living model impressed painters and sculptors, who saw this as encouragement of feeling and imagination on their part. Modern artists have admired, even envied, the integral relationship of tribal art to communal life and, above all, how seriously tribal societies have taken art.

Much of the finest sculpture belongs to cultures not usually considered "civilized." American blacks seeking their heritage have found that Africa has one of the longest continuous traditions of sculpture, but that this tradition has been jeopardized in recent years by the introduction of "civilization" to that continent. They have not, however, found an art dedicated to the celebration of "blackness," for in common with art throughout the world, the art of black Africa has until recently been without ethnic purpose. African art of both past and present is not nationalistic but tribal, not revolutionary but conservative—one arm of an establishment dedicated not to individuality but to the common good. Tribal art depends for its character upon its own language and hierarchies of social structure and upon religious and political beliefs. Each tribe has traditionally constituted an "in-group" in which everyone knew everyone else. All tribal members possessed considerable information about their own circumscribed society and natural environment, though adjacent tribes might be totally ignorant of each other's customs and art.

Much can be learned about the complexities of humanity and its art from the disinterested study of tribal peoples. The late psychiatrist Paul Schilder, in *Image and Appearance of the Human Body,* described the subtleties of vision and mental imagery in children and primitive peoples: "The process goes from the general to the individual and from complication to simplicity. The thinking of the child and the primitive person is fuller of meaning than the thinking of the adult. They see more relations; everything is connected with everything else. Their thinking is full of symbolizations and condensations. An object means much more than the adult mind sees in it; it is not only animated but connected with all activities in the universe."

Claude Lévi-Strauss, in his essay "The Science of the Concrete," reminds us that one of the great purposes of art shared by all societies is that of *miniaturization.* He points out that most works of art are *miniatures,* being smaller in size or lacking some of the properties of that which they represent. An African ancestor sculpture and Michelangelo's Sistine Ceiling (Fig. 213) have this in common. To his own question about the virtue of such reduction of scale or in the number of properties, Lévi-Strauss responds:

> It seems to result from a sort of reversal in the process of understanding. To understand a real object in its totality we always tend to work from its parts. The resistance it offers us is overcome by dividing it. Reduction in scale reverses this situation. Being smaller, the object as a whole seems less formidable. By being quantitatively diminished it seems to us qualitatively simplified. More exactly, this quantitative transposition extends and diversifies out power over a homologue of the thing, and by means of it the latter can be grasped, assessed and apprehended at a glance. A child's doll is no longer any enemy, a rival or even an interlocutor. In it and through it a person is made into a subject.

Miniaturization is thus a graphic illustration of how art has helped humanity to come to terms with its environment. The work of art in all forms and at all times is in some way an object of knowledge, responding to the timeless impulse to know and to do.

Chapter 3

Images of Gods

The history of religion tells us that gods made men in their own likeness, but the history of art tells us that men have remade the gods into their own image. Art has served no more important purpose than giving a visible presence to gods. For millennia, art provided visual reminders of celestial authority and made more intelligible the nature of deities. The sculptured or painted image of the god was the focus of worship and ritual, and it also gave to the faithful a feeling of reassurance and protection. Ancient Greek cities, for example, placed a statue of their tutelary god on the battlements to ensure their defense. The focusing of the imagination upon great and mysterious objects of worship is one means people have used to liberate themselves from the bondage of mundane facts. Investing the god with material form also satisfied mortal curiosity and the desire for familiarity with and recourse to the god. The act of making a sculpture or painting of a god was both an honorific gesture and a means of coming to terms with the supernatural. The finished work of religious art also provided a visible ethic to guide people in the conduct of their lives. Today we need not believe in the religions that inspired the images of Apollo, Buddha, and Christ to be impressed and moved by them. Their greatness as works of art transcends time and the boundaries of religious belief. Still, unless we can share to some extent the original concepts and emotions that produced this sacred imagery, we cannot fully appreciate the awe, wonder, and gratification with which it was received at the time of its creation. Nor can we appreciate the achieve-ment of the artists who first brought this imagery into being. To content oneself with considering only the visual or aesthetic value of religious art is to miss the equally rewarding experience of learning about significant human attempts to discover and give form to the truth of existence. Sacred imagery shows how elastic is the potential of the human body, which has been represented in so many ways to accommodate such divergent concepts, and how flexible is the human mind that has accepted religious art as real, or at least as convincing and sincere.

Apollo

On the temple of his sacred precinct at Delphi were inscribed the precepts of Apollo:

> Curb thy spirit.
> Observe the limit.
> Hate hybris.
> Keep a reverent tongue.
> Fear authority.
> Bow before the divine.
> Glory not in strength.
> Keep woman under rule.

In his study *The Greeks and Their Gods,* W. K. D. Guthrie has summarized Apollo's value to the Greeks by observing that Apollo is the embodiment of the Hellenic spirit. Everything that distinguishes the outlook of the Greeks from that of other peoples, and in particular from that of the barbari-

ans who surrounded them—beauty of every sort, whether in art, music, or poetry or in the qualities of youth, sanity, and moderation—is summed up in Apollo. Above all, he was the guardian against evil, the god of purification and of prophecy. Any good Greek could see in Apollo the preacher of "Nothing too much" and "Know thyself." Under his most important and influential aspect may be included everything that connects him with principles of law and order. Primarily, he represents the Greek preference for the intelligible, the determinate, and the measurable, as opposed to the fantastic, the vague, and the formless. Apollo was also looked to as a god of nature and was known as "keeper of the flocks." He was the first Olympic victor. He presided over the transition from boyhood to manhood, and he was variously shown as a warlike god who carried a silver bow and as a patron of the arts who played upon a lyre. Concomitantly, he was thought of as the god of both physical and spiritual healing, capable of purifying the guilty. Finally, he was the patron of civilized institutions.

That any sculptor, no matter how skilled, could portray all these attributes in a single human form seems impossible. In fact, the sculptor had to rely on a sympathetic audience who would be inclined to read many of these traits into the sculpture. That such was the case and that the artist's skill was of secondary importance is borne out by stories from ancient Greece such as that of the father who enjoined his son to be like Apollo, but not like the sculptor who made his statue. The image of Apollo in art originates in 7th- and 6th-century B.C. sculptures of standing youths, *Kouroi,* that spread throughout the ancient Greek world. These small or monumental statues of nude youths, frontally posed, arms at the sides and left foot often slightly in advance, have come to be called *Archaic Apollos,* but most were probably commemorative representations of deceased youths or Olympic victors. Thus the god was imaged in terms of his followers. Many of the smaller early Kouroi were votive sculptures, gifts by which the living venerated Apollo. One such, in the Museum of Fine Arts in Boston (Fig. 54), has inscribed on both thighs the words, "Mantiklos dedicated me to the god with the silver bow who strikes from afar." This votive sculpture, a gesture of homage to the god, may strike us as unreal in appearance; however, in the 7th century B.C., the Archaic period in Greek art, the spirit of Apollo was probably thought to be truly present in this sculpture. Art history teaches us that reality has more often been determined by art itself, not by measuring it against actual life. The credibility of a sculpture or painting was most often determined by comparison with other works of art and metaphors. Thus, when the various sculptures of Apollo illustrated here are compared with one another, the reader makes certain judgments about which of them is most lifelike, without necessarily relating the works to his own body. There is no doubt that the Kouroi derived from Egyptian (Fig. 295) and Mesopotamian sculpture. The Greek contribution was athletic nudity and eventually a

more lifelike appearance. A 6th-century B.C. hymn to Apollo helps us to understand the suitability of the Kouros type to the image of that god who was "like to a man, lusty and powerful, in his first bloom, his hair spread over his shoulders." After the 7th century, there is a gradual change not only in the image of Apollo but also in the human image in general. The sculptures slowly but perceptibly assume a more human aspect, an increasingly lifelike quality, as the sculptors mastered new skills with which to respond to and satisfy—and, in turn, to influence—changing tastes and conceptions of the god's nature.

In the *Tenea Apollo* (Fig. 55), done in the style of the mid-6th-century B.C., the god is still represented standing erect, rigidly vertical and frontal. His body forms a perfectly symmetrical composition; the arms hang at his sides, and although one leg is extended forward, the body weight is equally distributed on both legs. The figure has taken on more convincing musculature and proportions. All these characteristics are Egyptian in origin but are appropriate to

below: 54. *Apollo,* from Thebes (Boetia). c. 675 B.C. Bronze, height 8'' (20 cm). Museum of Fine Arts, Boston (Francis Bartlett Collection).

right: 55. *Tenea Apollo.* c. 550 B.C. Marble, height 5' (1.52 m). Glyptothek, Munich.

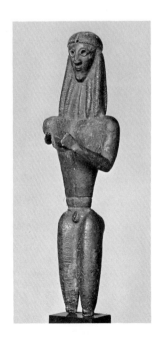

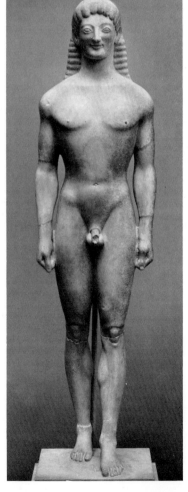

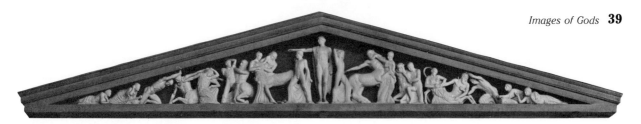

56. Reconstruction of west pediment of the Temple of Zeus, Olympia. 468–460 B.C. Width c. 91′ (27.74 m). Archeological Museum, Olympia.

the interpretation of Apollo as an authoritarian deity, in line with the Greek view of him as the giver of laws. This Apollo is not flat-footed like Egyptian figures, however, and his feet have a more resilient contact with the ground. His complete nudity relates to his role as a supreme athlete. Nudity in early Greek art was generally reserved for commemorative sculptures honoring athletes victorious in the Olympic games. The 6th-century standing sculptures of Apollo are thus almost indistinguishable from the trophy sculptures erected for mortal, contemporary athletes. This ambiguity resulted because it was customary to idealize athletes rather than create portrait likenesses of them. It is often only through the dedicatory inscriptions on the base that the identity of the standing figure can be ascertained. From his first appearance in art, Apollo was interpreted *anthropomorphically,* that is, as having human characteristics, and was depicted in perfect physical form.

The pediment of the Temple of Zeus at Olympia (Fig. 56) shows Apollo at a legendary nuptial ceremony intervening in a disruption caused by drunken centaurs who were trying to abduct the bride. He epitomizes the Greek ideal of "the cool." The idea being developed in this Apollo (Fig. 57) parallels other changes in Greek art. The rigid, frontal symmetry of the earlier statues (Figs. 54, 55) has been broken by the profile position of the head and by the gesture of the right arm, raised to restore order. Made in mid-5th century B.C., this Apollo departs from the Archaic figures in his softer, more sensuously modeled body, which results in a more subtle joining of the body parts and the limbs to the torso. The treatment of the muscular fold of the pelvis, a Greek sculptural convention, affirms the perfect fit of the thighs in the socket of the torso, like the modulated juncture of a column capital with the lintel above. The new full-round conception of the body admits successive and varied silhouettes, instead of merely the front and side views of the other types. The body and the face, relaxed from the stylized expression of the *Tenea Apollo,* are more beautiful in terms of actual human anatomy. Less mystically remote because of their physical perfection, such statues prompted the 5th-century Athenian public to voice the opinion that their best sculptors could portray beautiful *men,* but not beautiful gods. Even the great sculptor Polyclitus

was not immune to this criticism (Fig. 474). Scaled larger than the other figures in the composition and placed in the center—both of which are older devices for establishing hierarchy—the god has been assured his authority. The ideal proportions, physical development, and facial features immediately set the god apart from the mortals and centaurs who surround him. It was, however, the newer qualities of grace and physical self-confidence that endowed this Apollo with dignity and divine identity and with great self-control in a situation of emotional and mental

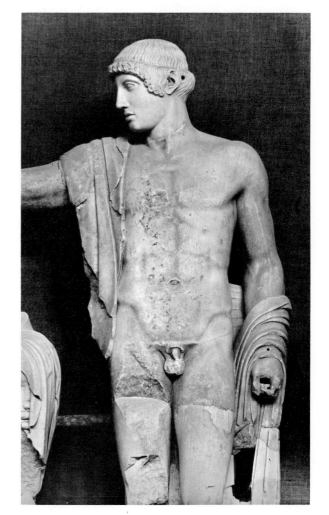

57. *Apollo,* detail of west pediment of the Temple of Zeus. c. 460 B.C. Marble, height 10′4″ (3.15 m). Archeological Museum, Olympia.

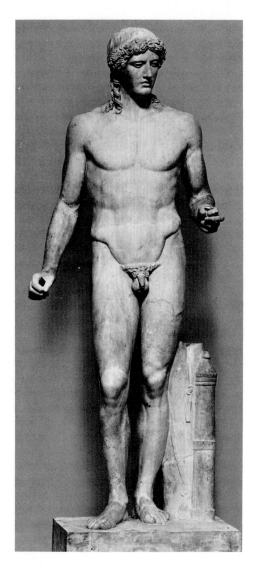

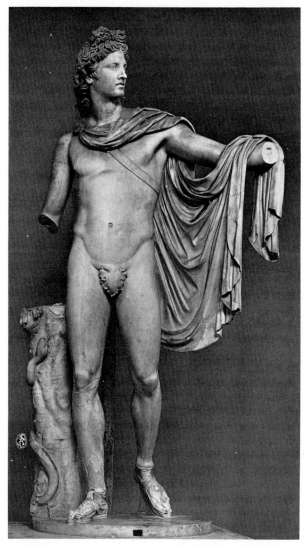

stress. Thus, despite the emphasis on corporeality, the portrayal epitomizes conduct and restraint, as well as law and order, through presence and gesture.

Although close in date to the Olympia *Apollo,* the Classical *Apollo* (Fig. 58) of the sculptor Phidias carries even further the sensual possibilities of the body. The rigid axis through the center of the body has been eliminated, and the weight is placed on the right leg in a hip-shot pose that creates a more active balance of the body—one of the great achievements of Classical Greek sculpture. In this system of *contrapposto* (or "counterpoise"), the movement of each portion of the body is an ideal compositional counterpart to the Apolline tradition of harmony between spirit and body. The strength of the still-idealized visage and the impressive physique, coupled with the resilient pose, assist in conveying a feeling of authority that has now become more hu-

above left: 58. *Apollo.* Roman copy after Phidias' original of c. 460 B.C. Marble, height 6′5½″ (1.97 m). Staatliche Kunstsammlungen Kassel.

above: 59. *Apollo Belvedere.* Roman copy after Greek original of late 4th century B.C. Marble, height 7′4″ (2.24 m). Vatican Museums, Rome.

mane than in the 6th-century model. The perfect proportioning of the torso is a striking lesson in moderation, in avoidance of physical or sensual excess.

At the end of the 4th century, the military conquests of Alexander the Great extended the rule of Greece throughout the Near East and into Egypt. This political domination spread Greek art and civilization to many different peoples and thus produced a heterogeneous culture termed

Hellenistic. In general, the effect of this new internationalism on sculpture was an increasing development toward the more realistic depiction of nature and toward more complex and vigorous compositional mobility.

The Hellenistic *Apollo Belvedere* (Fig. 59) depicts the god in decided movement, with his draped left arm extended. It is believed that originally his left hand held the silver bow, his military attribute. The controlled movement permits illustration of Apollo's supreme physical grace and, by implication, his intellectual discipline. While retaining obvious idealized traits in face and body, the *Apollo Belvedere* is the most lifelike, and hence the most nonsacred, of the Apolline sculpture we have discussed, and this change corresponds to political and sculptural developments in Greece as a whole. This last figure also suggests why the Greek religion declined in power. The gods are almost totally conceived and presented in human terms, an attitude that permits a fatal familiarity and identification between god and worshiper. This congruence of identity is apparent in spite of the fact that many of Apollo's attributes are beautifully incorporated within the sculpture. The handsome figure, with its athletic and dancerlike grace, retains a suggestion of the purity of mind and body and of the faculty of wisdom so cherished by the Greeks. In all these images of Apollo, the Greeks sought to present the beauty of the god's mind and of morality through the medium of a beautiful human body. The mastery of sculptural mobility achieved by the artists, while powerfully evoking the personality or temper of the god, may ultimately have caused the weakening of his divine efficacy.

Buddha

The Buddha is traditionally presumed to have lived between 563 and 483 B.C. in the region of Nepal on the border of India. Born a prince, he became a reformer of the Brahmanist religion and a great ethical teacher whose sermons in many ways paralleled those of Christ. Like Christ, Buddha emphasized meditation and good works and viewed this life as filled with pitfalls. Also like Christ, he did not work toward the establishment of a complex religious order in his own lifetime; the formal religion that evolved from his teaching came long after his death. Buddhism is composed of two main sects. The Mahayana (Great Vehicle) or "pious" sect looks upon the Buddha as a god possessing the power of miracles and protecting the faithful from harm. He is lord of the universe. This sect developed strongly in China and Japan from its origins in India. The Hinayana (Lesser Vehicle) or "rationalist" sect looks upon the Buddha as a great, but human, sage who provided a code of ethics that could deliver humanity from the sources of misery. His image in art was a reminder and not an actual presence, similar to images of Christ in Western art. The Hinayana sect was strongest in Southeast Asia, in Burma, Cambodia, Ceylon, and Thailand.

The history of the images of the Buddha goes back to the first centuries before our era, when he was not shown in human form but was represented by symbols—his footprints, the Wheel of Learning, the tree under which he achieved Enlightenment, an altar, or an honorific parasol recalling his princely origin. The faithful could achieve communion with Buddha by meditating on the symbols that induced his presence. One of the early sculptures that does not show the actual form of the Buddha (Fig. 60) portrays an evil spirit menacing the divine throne. Although the Buddha is physically absent, his attributes, such as the throne and his footprints, as well as the reverent attitude of the court, are indicative of his sacred presence. This initial unwillingness to give tangible form to the Buddha has a parallel in Early Christian art, and there are no images of the Buddha or Christ dating from their own lifetimes. To have given tangible form to either of the gods may have seemed at first a contradiction of their divine being. The incentives

60. Cushioned throne with detail of assault of Mara, from Ghantasala. A.D. c. 350–400. Gray marble, height 5′9¾″ (1.77 m). Musée Guimet, Paris.

for Buddhist artists to change were the growing competition with Hinduism and exposure to Roman and Late Greek art.

Perhaps the earliest freestanding sculpture of Buddha was made in Mathura, India, during the 2nd century A.D. and is termed a Bodhisattva, or potential Buddha. This powerful figure, the Bodhisattva of Friar Bala (Fig. 61), stands about 8 feet (2.4 meters) tall and was originally situated before a tall column. Atop the column was a stone parasol, 10 feet (3 meters) wide, which was carved with symbols of the heavenly mansions and represented the Buddha's royalty. The lion at his feet was also a regal attribute, symbolizing the Buddha as the lion among men. The rigid, frontal, and squarish formation of the body sets it apart from the Mediterranean art of the time and argues that the standing Buddha image was of Indian origin. The symbolism and body type, however, are markedly different from Hindu sculpture of the 1st century, such as the sandstone god Siva (Fig. 62). In this representation, the god is designated both by a human form and by his attribute—a giant phallus that was known as a *lingam.* Though it was accessible only to Hindus, who could enter the sanctuary of the temple where it was housed and daily anointed with oil, this Hindu icon helps us to understand why the Buddhists overcame objections to imaging the focal figure of their worship.

When the Buddha was finally given human form by the Gandhara artists, in the 1st or 2nd centuries of our era—roughly seven centuries after his death—his body was a materialization of concepts similar to those the symbols had conveyed. The tasks facing the early sculptors of the Buddha included the incorporation of 32 mystic signs of his superhuman perfection: among these were the cranial protuberance, symbolic of wisdom; elongated earlobes, indicative of royal birth; a tuft of hair on his forehead, which like the sundial halo signified his emission of light; spoked wheels on the soles of his feet to symbolize the progress of his doctrine and the power of the sun; and a series of ritual hand gestures, or *mudras.* The Buddha's right hand pointed downward meant his calling of the earth to witness his tri-

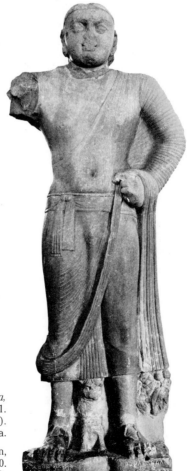

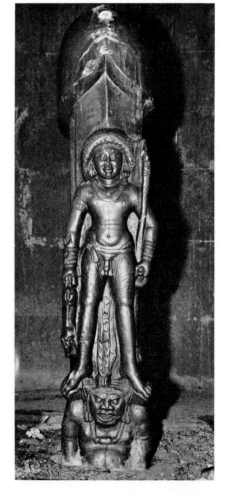

right: 61. *Bodhisattva of Friar Bala,* from Mathura. A.D. c. 131. Red sandstone, height 8′1½″ (2.48 m). Sarnath Museum, India.

far right: 62. Parasurameshvavara Lingham, from Gudimallam Temple. A.D. c. 10–100. Polished sandstone, height 5′ (1.52 m).

umph over evil and his Enlightenment or dispensation of favors; his right hand raised was to dispel fear and give blessings. By joining his thumb and forefinger, the Buddha set the wheel of his doctrine in motion.

Of greater challenge to the artist was the endowment of the Buddha's body with metaphorical significance; according to tradition, the face of the Buddha is likened to an egg, the eyes to lotus buds or petals, the lips to ripe mangoes, the brow to the god Krishna's bow, the shoulders to an elephant's head, the body taper to that of a lion, and the legs to the graceful limbs of a gazelle. The sculpture had to embody the sacred flame or fiery energy of the Buddha and his preterhuman anatomy. Finally, the sculptor had to impart to the statue that ultimate state of serenity, perfect release from pain, and deliverance from desire that the Buddha achieved in *nirvana*. According to his teachings, inward tranquillity was to be gained by first appeasing the senses, for only then could the mind become well balanced and capable of concentrated meditation. The sensuousness of Indian art is partly explained by this attitude that the senses should not be denied but rather should be used as the first stage in a spiritual ascent whereby the faithful would ultimately be purged of attachment to the self and the world's ephemeral delights and achieve a more perfect spiritual union with their gods and ideals. This confidence in the need for and mastery of the sensual explains why Greek art such as the Apolline sculptures would have appealed to the early Buddhists, who used it.

Without question, the seated Buddha statue is indigenous to India and is a native solution to the problem of how to give artistic incarnation to the Great Teacher and god. The seated position was favored, for in the life of the Buddha it is recorded that after six years of penance he at last came to the Tree of Wisdom, where the ground was carpeted with green grass, and there vowed that he would attain his Enlightenment. Taking up the seated, cross-legged position with his limbs brought together, he said, "I will not rise from this position until I have achieved the completion of my task." It seems likely that the model or prototype for the seated Buddha was the earlier Hindu mystical system of *yoga,* which was constantly before the eyes of the early Indian artists and which was recorded as having been the means of the Buddha's achievement of nirvana. The objective of yoga is enlightenment and emancipation, to be attained by concentration of thought upon a single point, carried so far that the duality of subject and object is resolved into a perfect unity. The Hindu philosophical poem the *Bhagavad-Gita,* described the practice of yoga:

> Abiding alone in a secret place, without craving and without possessions, he shall take his seat upon a firm seat, neither over-high nor over-low, and with the working of the mind and of the senses held in check, with body, head, and neck maintained in perfect equilibrium, looking not round about him, so let him meditate, and thereby reach the peace of the Abyss; and the likeness of one such, who knows the boundless joy that lies

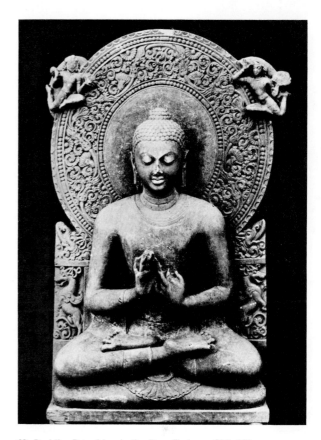

63. *Buddha Preaching in the Deer Park.* A.D. 320–600. Sandstone, height 5'3'' (1.6 m). Sarnath Museum, India.

beyond the senses and is grasped by intuition, and who swerves not from the truth, is that of a lamp in a windless place that does not flicker.

Through yoga one may obtain the highest state of self-oblivion. It involves highly developed discipline in muscular and breath control and the ability to clear one's mind of all superficial sensory preoccupation in order to concentrate upon a single object or idea. The discipline of yoga seeks not only control of the physical body but also a cleansing and rebuilding of the whole living being. The human body transformed by yoga is shown free not only from defects but also from its actual physical nature. The sensation of lightness, or release from the bondage of the body, induced by yoga produces the "subtle body."

It is often difficult to distinguish between the sculpture of the Mahayana and Hinayana sects. One of the most beautiful of the seated Mahayana Buddha sculptures, an example from Sarnath (Fig. 63), was made in the 4th or 5th century of our era. It shows the Buddha seated upon the lotus throne, making the mudra of the wheel-turning as he preaches his first sermon in the Deer Park, where he first

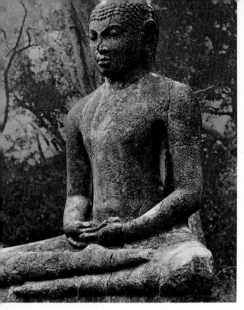

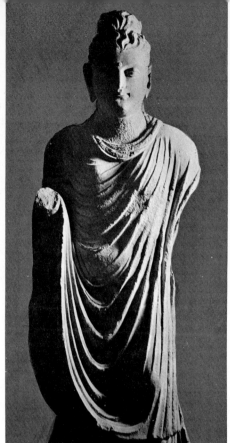

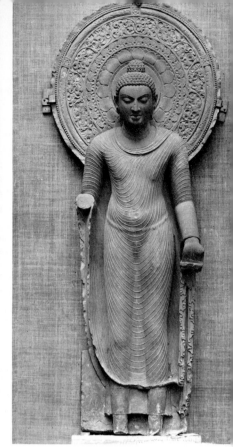

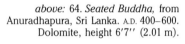

above: 64. *Seated Buddha,* from Anuradhapura, Sri Lanka. A.D. 400–600. Dolomite, height 6′7′′ (2.01 m).

right: 65. *Buddha,* from Gandhara. A.D. 200–300. Stone.

far right: 66. *Buddha,* from Mathura. A.D. 400–500. Red sandstone, height 5′3′′ (1.6 m). National Museum, New Delhi.

achieved his Enlightenment and to which he has returned. Below his throne (in a segment not shown in the illustration) are a group of his followers and the symbolic wheel. The back of the throne is ornamented with the winged lions of royalty and the foliate ornamentation of the sun disk, or halo. This decoration derives from Iran and the cult of Mazda, the god of light, and its use represents an assimilation of earlier fertility and vegetative symbols. Airborne minor deities flank the Buddha in reverent attitudes, not unlike the angels in medieval Christian imagery. The hierarchic formality of the whole composition indicates that the sculptor is no longer dealing with a specific event; the sermon has been solemnized into a more abstract sacred symbol. The earlier, more individualized and human interpretations of the Buddha have been replaced by the idealized figure that was to be the basis of later imagery.

In the Deer Park Buddha, there is no reference to skeletal or even muscular substructure; the body appears to be inflated by breath alone. There is no trace of bodily strain caused by the posture. The seated attitude is firm and easy, indicating the Buddha's mastery of yoga. Unlike the proportions of the Classical Apollo, which were based on the living body, those of the Buddha had become almost canonical by this time and were based on a unit called the *thalam,* equivalent to the distance between the top of the forehead and the chin. The symmetrical arrangement of the body makes of it a triangle, with the head at the apex and the crossed legs as the base. The face, wearing the "subtle

smile," is marked by the symbolic lotus-form eyes and ripe lips. The downcast eyes shut off his thoughts from the visible world. Such compositional devices were employed, for the most part, because the sculpture was meant to be contemplated and viewed metaphorically.

In contrast to the Sarnath Buddha, symbolic of the regal and mystical beliefs of Mahayana Buddhism, is a more austere and unadorned seated Buddha from Ceylon, exemplifying the Hinayana view of the Great Teacher (Fig. 64). Notwithstanding the severe weathering of its stone, the Ceylon Buddha has a less sensual, yet still firm aspect; the hermitlike figure appears to be completely absorbed in meditation, indicative of the Buddha's renunciation of worldly concerns. The Ceylon Buddha lacks the strongly stylized prettiness, even effeminacy, of some later Buddha images in Southeast Asia.

Early standing sculptures of the Buddha (Fig. 65), created in the late 1st through the 3rd centuries at Gandhara, display an obvious relationship to early sculptures of Christ—and both types of imagery were indebted to Hellenistic and Roman freestanding figures. This influence resulted from the invasions of India by Mediterranean cultures and the subsequent occupation of some Indian territory by the Romans. Indian artists, working perhaps from Roman statues of emperors such as Titus in a toga, early produced a standing Buddha whose drapery and balance recall Roman Imperial sculpture. The Buddha is shown here in his capacity as the Great Teacher. The togalike

monastic robe is cut in naturalistic channeled folds, so that we are aware of a counterpoised body structure beneath it. Further Late Greek influence can be seen in the face of the Buddha, which is a variant of the Apolline or Hellenistic ruler portrait type, with the addition of the mystic signs. The freestanding Buddha image also derives from Indian sculptures of royal personages, which again illustrates how the god is imaged in terms of his followers.

In the art of succeeding centuries, notably in a 5th-century standing Buddha from Mathura (Fig. 66), Indian artists departed more radically from Greek and Roman influence and developed a monumental standing Buddha more consistent with their own religious ideals. The Mathura standing Buddha is a sophisticated study in opposites. Against the vertical and immobile frontality of the body, the sculptor has designed an undulating sequence of drapery folds that prevent the eye from fastening on the boneless grace of the torso beneath. The transparency of the monastic robe suggests the shining forth of the Buddha's radiance. The hypnotic sequence of concentric disks leading into the ovoid head culminates in the downcast eyes that intimate the Buddha's withdrawal from earthly vision. The flat disk background, with its ornamental foliate motifs, is a foil for the sensual smooth volume of the head, while the rings of the halo and the outlines of the face and neck area play against the drapery rhythms. There is no abrupt transition or single detail to jar the eye or feelings; the totality of the design holds the eye soothingly within its borders and constantly returns it to the head of Buddha. The image is one of quiet authority that invokes love and respect without fear.

While repetition is frequent in the images of Apollo and Christ, Buddhist art exhibited far greater adherence to a prototype for almost fifteen hundred years. The successive replication in Buddhist imagery stems partly from a belief in the magical efficacy of certain prized statues; copies of these were thought to partake of the original's power. Furthermore, the Buddhist artist was not encouraged to work from a living model or to rely on natural perception. With the help of fixed canons, it was his obligation to study the great older images, meditate on them, and then work from his inspired memory. Because the Buddha's beauty defied apprehension by the senses, the artist worked from a conception nourished by existing images and metaphors.

Christ

Good Shepherd and Teacher The first known paintings of Christ seem to date no earlier than A.D. 200 and are found in the Christian catacombs on the outskirts of ancient Rome. Once believed to be secret refuges from persecution or underground churches where large congregations would assemble, these catacombs were actually burial chambers connected by long passages; they were known to and inspected by the Roman government. Their lack of ventilation and restricted size precluded their use for worship services.

In 1955, there was discovered under the Via Latina a private Roman mausoleum in which both Christian and non-Christians were buried and where coexisted both pagan and Christian art. Done in the same style and presumably by the same artists, one scene depicts what is believed to be Aristotle surrounded by students discussing the existence of the soul in a recumbent body (Fig. 67). In the same chamber is an image of Christ flanked by four figures, possibly the Evangelists, and he, too, resembles a teacher. Here reproduced from another catacomb is a scene of *Christ Teaching Among the Apostles* (Fig. 68), garbed as philosophers. The close relation of Christianity and its art to pagan sources is thus dramatized, and it is not unlikely that the concept of Christ as a respected teacher derived from Greco-Roman prototypes.

below: 67. *Aristotle (?) with His Disciples.* A.D. 200–300. Wall painting, 5'6'' × 6'7'' (1.68 × 2.01 m). Catacomb of the Via Latina, Rome.

bottom: 68. *Christ Teaching among the Apostles.* A.D. c. 300. Wall painting, 1'3'' × 4'3'' (.38 × 1.3 m). Catacomb of Domitilla, Rome.

above: 69. *Raising of Lazarus.* A.D. c. 300. Wall painting. Sacrament Chapel, Catacomb of Saint Callistus, Rome.

above right: 70. *Calf-Bearer.* c. 570 B.C. Marble, height 5'5'' (1.65 m). Acropolis Museum, Athens.

When shown not as a philosopher-teacher, but performing a miracle, such as the *Raising of Lazarus* (Fig. 69), Christ also wears a toga. In this image of around A.D. 200, the stress is upon Christ's hand, not his body or face. In none of these catacomb paintings can one see a portrait likeness of Christ, only a dignified generalized image that links him to his followers. Similarly, the scene of the miracle has a highly synoptic character, as if the artist were painting essentially a reminder of a story known by heart to Christians. Scenes from Christ's life were intended to link him by analogy with pagan gods and heroes and to encourage the hopes of the faithful with a promise of afterlife. Their optimistic message was that if one had faith, resurrection would be achieved.

Among the first images of Christ, found in the catacombs and in funerary sculpture, are those showing him as the "Good Shepherd," which was a familiar image in Greek art (Fig. 70). There is ample evidence to confirm that the Christians recognized and valued the similarity between Christ as the shepherd and Orpheus, the son of Apollo who descended into Hades and sought through the charm of his singing and playing to save his wife Eurydice from the Underworld. The Greek mythological figure had much in common with both Apollo and Christ, since he was associated with salvation, sacrifice, love, and protection. The shepherd image was an ideal expression of the Early Christian community, which was characterized by a close relationship between priest and congregation: the priest was seen as the shepherd, the congregation as the flock. The artistic presentation of the shepherd amid nature was also fitting, for the Early Christian view of paradise was comparable to that of the Roman poet Vergil—a beautiful sylvan paradise where the soul could repose, ruled over by a gentle shepherd. Christ as the shepherd, whose coming Christian theologians saw prophesied in Vergil's writings, thus ruled over a bucolic world as if in a Golden Age (Fig. 71). Second-century Christian saints also used the image of a magnificent garden to describe the paradise in which the soul would find rest.

In a 4th-century sarcophagus (Fig. 72), the shepherd is surrounded by winged angels harvesting grapes. Such small, childlike figures were customarily substituted for representations of adults in Roman art of this type. Both the angels and the vineyard derive directly from pagan sources in which the grape harvest and wine alluded to premature death and regeneration. This explains the choice of theme for the sarcophagus of a deceased Christian who was well-to-do. Christian art that dates from before the 5th century mostly interprets the Jesus of the Gospels, or *the historical Jesus*—Jesus as the Messiah and not as a divinity. In the Lateran Sarcophagus, Jesus as the shepherd stands upon an altar, which suggests his death and sacrifice for mankind. His resurrection provided hope and a spirit of optimism for the Early Christian community and its converts.

left: 71. *Orpheus-Christ with Animals,* detail. A.D. c. 200–300. Wall painting, 19½ × 35½'' (50 × 90 cm). Catacomb of Domitilla, Rome.

below: 72. *Christ as the Good Shepherd.* A.D. c. 350–400. Marble. Vatican Museums, Rome.

bottom: 73. Bust of Christ. A.D. c. 350. Ceiling painting, 23½ × 28½'' (60 × 72 cm). Catacomb of Domitilla, Rome.

There is no stress on Christ's militant or royal nature before the 4th century. The artistic prototype of the historical Jesus seems to have been late Greek and Roman paintings and statues of seated or standing philosophers (Fig. 142), a type associated with the contemplative or passive life. Artists in the late Roman period often worked on pagan figures at the same time they were fulfilling Christian commissions. Sometimes carved sarcophagi were completed except for symbols or faces; thus they could be purchased by either pagan or Christian clients and finished to suit their purpose.

Christ as King Artists of the Early Christian era did not render portraits in the sense of direct likenesses of individuals. Portraits of Christ after the 4th century were based upon Roman Imperial portraits, which in turn depended upon formulas devised to show rank and dignity (Fig. 73). This use of artistic formulas and *types* is termed *typological art.* The Church and public judged the success of Christ's portrait by whether or not he was given appropriately grave and noble features, had majestic bearing, made the correct gestures, and wore the right insignia and garments for the situation in which he was depicted. These standards are exemplified in the *Bust of Christ* shown. His full-bearded face and abundant hair suggest a long life and fullness of power, qualities regularly depicted in images of pagan gods such as Jupiter, Neptune, and Pluto.

In the 4th century, Christianity received Imperial support and was no longer the private religion it had been in its earlier phases. The Church was reorganized along the lines of the Roman Empire, the priesthood became an autocracy,

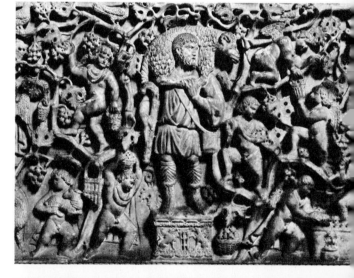

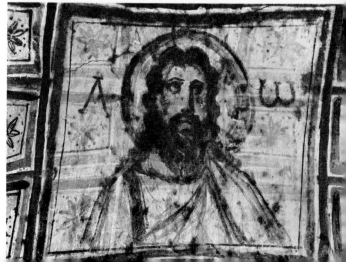

and theology and art were subjected to radical transformation and formalization. The external forms and the cult aspect of religion that had been criticized by the historical Jesus became prominent. One of the earliest manifestations of this momentous change is the famous sarcophagus of Junius Bassus, Prefect of Rome, who like Constantine was baptized on his death bed (Fig. 74). The carving, which is in the pagan style of the time, was finished in 359 by a sculptor who imposed a new and strict order to his reliefs in terms of their architectural framing and symbolic sequence and juxtaposition. Christ occupies the center of both registers, and the flanking images are symmetrical and of a symbolic formality. Innovational were the two central scenes of Christ's royalty: his entry into Jerusalem, equivalent to a monarch's state entry or advent into a city, and his enthronement with the pagan symbol of the cosmos under his feet, indicative of his world sovereignty. The Imperial imagery is thus transferred to Christ, just as Christian and pagan terms for a ruler's greatness were similar. Christ is enthroned between Peter and Paul, to whom he assigns, respectively, the founding of his Church and the spreading of the Gospel. (Roman emperors were similarly shown between consuls.) The youthful beardless Christ may suggest, just as his contemporary catacomb counterpart does, his imperviousness to time. (In later images, Christ is shown with a beard; for theologians, an old head could also signify eternity.)

In the 6th century, the Byzantine Emperor Justinian ordered an ambitious mosaic series for the apse of the Church of San Vitale in the city of Ravenna, which he had just conquered from the Goths. The mosaic of the enthroned Christ flanked by angels and Sts. Vitalis and Ecclesius (Fig. 75; Pl. 3, p. 56) in the half-dome of the apse reflects the transition from the historical Jesus to the *theological Jesus.* The incarnate Messiah has been replaced by the Son of God, the humanity and humility of the shepherd by the impersonality of a celestial ruler over the hierarchy of religious government. The doctrines that lay behind this mosaic were not those that had been taught by Jesus himself; in San Vitale, the theology of the Incarnation and the Second Coming is the essential subject of the mosaic.

Like a Roman or Byzantine emperor (Figs. 305, 308), Christ holds an audience in which he grants and receives honors. Bishop Ecclesius donates the Church of San Vitale to Christ, and Christ gives the crown of mercy and martyrdom to St. Vitalis. This is preeminently sacred art; the more mundane attitudes of earlier Christian imagery have been replaced. The event transpires outside a specific time and place, an intention affirmed by the fact that these saints lived in different centuries. Also, St. Ecclesius presents a replica of the exterior of the church, and at the same time, the mosaic showing the donation is inside this very edifice. Christ sits upon the heavens, yet mystically he is also within the heavens, and beneath his feet flow the four rivers of Paradise. This mosaic demonstrates how theologians had reconciled the divinity and authority of Christ with that of the earthly emperors who acknowledged obedience to him. Christ rules the heavens, while the emperor Justinian, shown in an adjacent but lower mosaic, rules the earth. The relative informality of earlier Christian imagery has been replaced by a complex series of artistic devices conveying

74. Sarcophagus of Junius Bassus. A.D. c. 359.
Marble, 3′10½″ × 8′ (1.17 × 2.44 m). Vatican Grottoes, Rome.

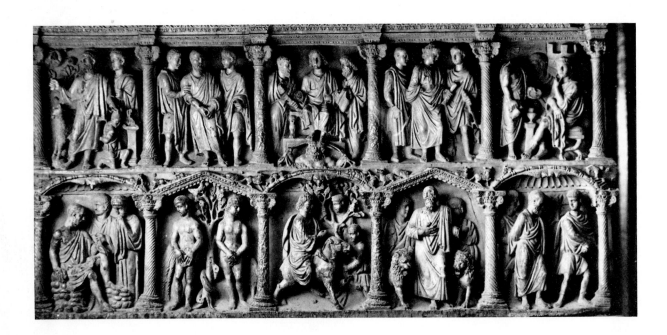

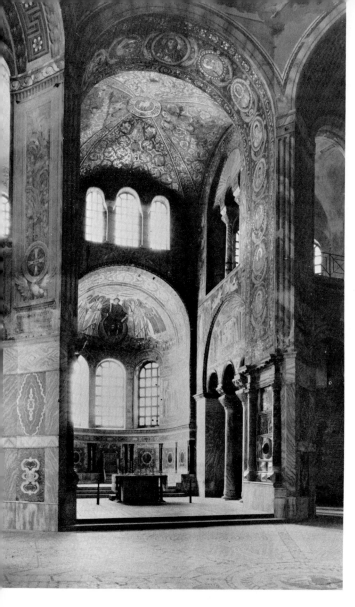

left: 75. Interior, San Vitale, Ravenna. View across inner octagon into apse: A.D. 526–47.

below: 76. *Buddha in Majesty.* A.D. 400–500. Fresco. Cave 9, Ajanta.

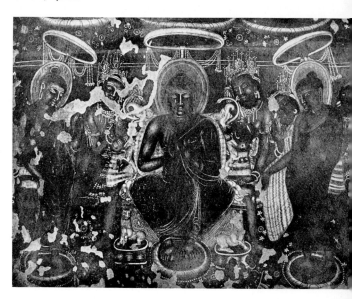

the concept of Christ as the Second Person of the Holy Trinity. This mosaic is a dramatic example of how meaning in art is conveyed. (In Chapter 12, "Images of Authority," Roman Imperial sources of these devices are discussed.) Besides its privileged location and the symbolic shape of the field, the materials are precious and semiprecious stones and glass. Against the gold background of the heavens, symbolizing the ineffable light of God, the youthful, beardless Christ sits attired in the Imperial purple and gold. Certain postures and colors were Imperial prerogatives. Contrasting with the attendant figures who must stand in his presence, Christ is frontal and larger; he appears oblivious of those around him. His ritual gestures of investiture and acceptance make a cross shape of his body, accentuating his centrality in the image and in Christian dogma. Thus scale and gesture may be symbolic, as well as the type of composition. Although the mosaicists may have been inspired by St. John's descriptions of the radiance of Heaven,

like the Evangelist, they based the attributes and qualities of divinity on their experience of the highest form of earthly authority known to them, on the magnificent court ceremonies of the temporal monarchs.

The San Vitale mosaic embodies changed aesthetic forms as well as dogma. Each figure, for example, is sharply outlined, with every detail clearly shown as if the viewer were standing close to each subject. The figures do not overlap, and they are all seen as being near the surface of the mosaic, which accounts for their great size. The scene has only limited depth, and no attempt has been made to re-create atmospheric effects or the light and shadow of earthly perception. Positive identification of the role and status of each figure had to be achieved. The colors are rich and varied, but their use over large areas is governed by symbolism. The composition is closed, or strongly self-contained, so that there is no suggestion that the frame cuts off any significant area or action. The figures display, at most, a limited mobility, for their static quality is meant to reflect a transcendent nature and to induce a meditative state in the reverent viewer. Thus artist and theologian combined to give a physical presence to dogma by creating imagery of an invisible, divine world.

More than a century before the San Vitale mosaics were executed, there was painted on a wall of one of the Ajanta caves of northern India a scene of the Buddha in Majesty (Fig. 76) that bears a striking similarity to these mosaics in its use of formal devices—such as centrality, frontality, and pose and gesture—to show authority. It is possible that

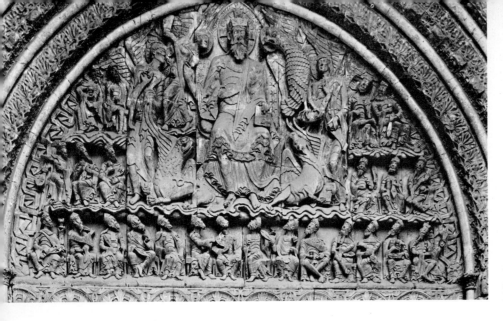

77. *Christ Enthroned,* tympanum of the west portal, St-Pierre, Moissac. 12th century.

both the Ravenna mosaic and the Ajanta fresco were influenced by Eastern sources such as Persian art, which, along with Roman art, provided models for the representation of rank in the late-antique world. The Buddha is enthroned between the sinuous figures of Bodhisattvas (exceptional beings who are capable of reaching nirvana but who renounce the possibility in order to teach others how to attain it) and two of his disciples. Courtiers are shown in the background. Buddha's gesture of teaching and his robe and posture are as ritualistic as those of Christ in the mosaic. Lions guard his throne, and he and the disciples have halos shown under ceremonial parasols, further symbols of roy-

78. *Last Judgment: Separating the Sheep from the Goats.* A.D. c. 493–526. Mosaic. Sant' Apollinare Nuovo, Ravenna.

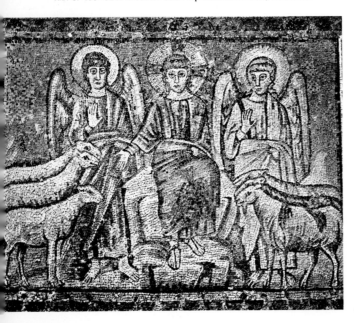

alty. The flower-strewn background and wall suggest the garden of a palace, a special place that only the faithful are privileged to see and comprehend.

The great Byzantine images of Christ and those in the Early Christian basilicas of Italy are found within the churches. By the beginning of the 12th century, however, French Romanesque sculptors had transferred sacred images to the exterior of the edifices, as seen, for instance, in the great relief carved over the doorway of the Church of St-Pierre in Moissac (Fig. 77). This change did not as yet result in a conception of Christ as being of the world of the living. While adopting the ceremonial and sacred traits of the San Vitale image, the Moissac sculptor forcefully added new ideas to the conception of the lordly Christ. Wearing a crown, Christ is a feudal king of kings, surrounded by elders who are his vassals. His remoteness is reinforced by the great difference in scale between his figure and the representatives of humanity. All glances are directed toward Christ as to a magnetic pole. From his immobile frontal figure, the composition moves outward in waves. Angels and evangelical symbols, intermediate in scale between Christ and the elders but more closely proportioned to Christ, serve to impress upon the onlooker the hierarchical nature of the universe and to bridge the figures in motion with the motionless Christ. Here Christ is like the awesome Old Testament God, commanding and completely aloof. He is thus shown as the Redeemer and God of Judgment at the Second Coming. His beauty does not derive from the comely proportions with which Apollo was endowed; rather it is of an entirely impersonal and unsensual nature, appealing to thought and faith.

Christ as Judge There is no analogy in either the Apolline or the Buddhist religion to Christ's Second Coming and the Last Judgment, which are the themes of many of the most dramatic and interesting Christian works of art. The earliest Christian image of a Last Judgment is believed to be a scene

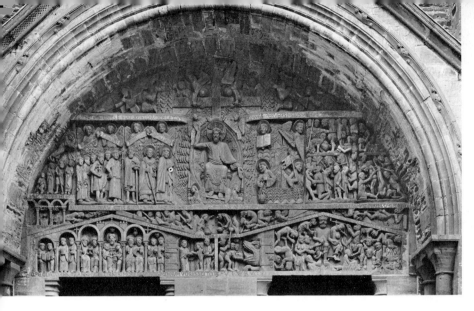

left: 79. *Last Judgment,*
tympanum of the west portal,
Ste-Foy, Conques. 12th century.

below: 80. Detail of Figure 79.

from the 6th-century mosaic cycle in Sant' Apollinare Nuovo in Ravenna (Fig. 78). In this small work, Christ is shown seated in the center and clad in a purple robe; he gestures to his right toward three sheep. Christ is flanked, on his right, by an angel in red and on his left, by one in blue. The angel in blue stands directly behind three goats that, like the sheep, are facing toward the center. The episode is in the Gospel according to Matthew (25:31–34), in which Christ symbolically separates the sheep (the elect) from the goats (the damned). The figure of Christ is almost completely frontal, and he expresses no emotion. It is an extremely simple but formal composition that relies upon a knowledge of the scriptures, color, and gesticular symbolism, as well as the significance of left and right. The artist, in illustrating literally St. Matthew's metaphor, sought to give the event sacramental dignity and transcendence.

After the fall of Rome, there was a break in the continuous tradition of monumental sculpture. The 12th century saw a sudden revival of this art form as the result of heroic intellectual effort and the skill of carvers who had to reinvent what had been lost. An early-12th-century French Last Judgment tympanum on the Church of Ste-Foy in Conques (Fig. 79) represents a tremendous change in the interpretation of the judgment theme. This is one of many exciting apocalyptic sculptures done in southern France during the first half of the 12th century. In the Ste-Foy version, much more of the apocalyptic account has been encompassed by the artist, who relies far less upon metaphor and prefers to give a more tangible realization of the concrete details and mechanics of the Last Judgment. His art was a vivid memento, in its brilliantly modulated carved surfaces and abundance of human, divine, and demonic forms, of that fateful event, the day and hour of which "no man knoweth" (Matt. 24:36).

The large tympanum is set above the main doorway of the church, through which the worshipers must pass every day, and hence serves as an ever-present reminder of their

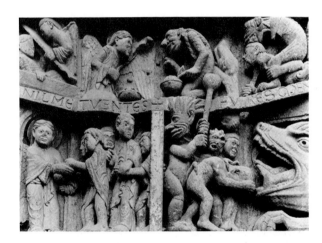

obligations. Moreover, to enrich his subject, the Ste-Foy sculptor and his theological adviser drew upon sources outside the Bible; the writings of such Fathers of the Church as St. Augustine were absorbed into the work. As an example, the weighing of souls (Fig. 80), which is not in the biblical accounts of the Last Judgment, is perhaps borrowed from Augustine, who wrote, "Good and evil actions shall be as if hanging in the scales, and if the evil preponderate, the guilty shall be dragged away to Hell." The motif of the scales may also have come from Near Eastern art and indirectly from Egyptian sources in the Book of the Dead. The Egyptian funerary god Anubis, as watcher of the "weighing in," has been replaced by St. Michael. Contrary to the inviolable conduct of the Egyptian ritual, a devil here seeks to tip the scales in his favor as he sees that a soul on the side of Michael (on Christ's right, our left) has outweighed one on his side. This attempt at judicial corruption by an agent of Satan was amusing in the 12th century, particularly in southern France, where law had become so important as a result of the feudal system and the rise of the Church.

The ordered and legal aspect of the final judgment is stressed by the artist at Conques in both his composition and his disposition of the figures. Each zone and compartment of the scene is strongly separated by a thick stone border on which are written the virtuous phrases, the teachings of the Church, and so on, appropriate to the location. This composition reflects a view of the universe as strongly ordered, so that everyone in it was consigned to a definite area, just as the living at the time had little difficulty in defining their own status in the feudal system. Thus the image of the universe on the last day becomes a projection of the real world as it was involved in the social, economic, and political structures of the time. The authority and absolute dominance of Christ over the scene is achieved by his centrality and great scale. He sits immobile and frontal as a symbol of power; he gestures upward with his right hand toward Heaven on his right side, with his left hand he points downward to Hell.

The upper zone of the scene contains angels carrying the Cross, the symbol of the Passion and the Second Coming on the day of justice. The central position given to the Cross and the downward movement of the angels draw the eye centripetally to the Supreme Judge. On Christ's right, in the largest zone, is a procession of the saved, who proceed in homage toward the ruler of Heaven. They are led by Sts. Peter, Anthony, and Benedict, who symbolize the origins and rule of the Church. The saints lead a royal figure, believed to be Charlemagne, who had been a benefactor of the Abbey of Ste-Foy. The moral implied by this arrangement is that Charlemagne got into Heaven not by force of the crown he carries but through the prayers and efforts of the holy men—an unsubtle admonition to the secular rulers of the time to support the Church. On Christ's left (our right), in another zone, are those consigned to Hell, nude and cramped in awkward poses, experiencing all sorts of painful indignities and punishments inflicted with enthusiasm by demons.

The lowest zone is divided into two large porticoes known as *basilican castrum*. Between these, literally on the roofs at the point where the buildings come together, the weighing of souls take place; this is also the principal axis of the Cross and Christ. Next to the weighing-in on the left, armed angels are rousing the dead from their coffins, and on the right demons are pummeling the resurrected. In the center of the left portico (that on Christ's right) sits Abraham, who receives the souls of the deceased into his bosom. Entrance to Heaven is through a heavy open door, which reveals a fine medieval lock and set of strong metal hinges. The entrance to Hell is through the jaws of the Leviathan, whose head protrudes through the door to Hell (Fig. 80). The Book of Daniel (7:7) describes the terrifying Leviathan that God has created. Hell is ruled over by the seated Devil, surrounded by his squirming subjects. In the treatment of Hell and the Devil, medieval artists had their greatest freedom and could give vent to their fantasies, repres-

sions, and humor. Here as elsewhere, by far the more interesting of the two sides is that dealing with the damned.

The 12th-century Byzantine mosaic of Christ the Pantocrator (Figs. 81, 82) in the dome of the monastery church of Daphnē, outside Athens, focuses attention on the face of Christ, his gesture of benediction, and the Bible he is holding. It is an image calculated to evoke awe, reverence, and fear. The severe expression is climaxed by the hypnotic glance, giving the effect of watchfulness. The celestial countenance is that of an immutable, stern judge who is both giver and enforcer of the law. An impressive face, it is not beautiful in the Classical sense, for it denies the importance of the flesh, of naturalistic rendering, and instead stresses the power of the divine will. There is an un-Classical imbalance in the Byzantine stress upon the eyes and in the intensity of expression. No Greek sculpture of Zeus hurling his thunderbolt conveys the wrath of which the Daphnē Christ seems capable.

The Beau Dieu The judicial and authoritarian aspects of the Byzantine Christ are continued but somewhat relaxed in the 13th-century French sculpture of the Beau Dieu (Fig. 83) from the Cathedral of Amiens. The figure of Christ stands between the main doors of the cathedral and below the scene of the Last Judgment. Beneath Christ's feet are the lion and serpent, symbolic of the evil he conquers. Both in his location and in his appearance, Christ is more accessible to the congregation. He stands before the doors to his house not as a guard but as a host, like a gallant feudal lord. This humanizing of Christ into an aristocratic ideal is reflected in his new familiar name, "the Handsome God," a title in many ways unthinkable at Moissac and Daphnē. This investing of Christ with a more physically attractive, a more tender aspect accompanies his reentrance into the world of the living and the reduction of the sacrosanct nature of the art itself. The transition has been from the Byzantine Pantocrator, Lord of All the Universe, to the more human dignity of the Gothic lord of men.

The *Beau Dieu* has an idealized countenance that bears instructive comparison with the head of the *Apollo* from Olympia (Fig. 84). The Gothic head is noticeable for its sharp features and subdued sensuality, indicating an essentially Christian attitude toward the body. This is particularly marked in the treatment of the mouth. The more pronounced ovoid outline of the Christ image, enhanced by the long tightly massed hair, and the axial alignment of the symmetrical beard, the nose, and the part of the hair give the deity an ascetic and spiritualized mien. Despite the generalized treatment of the forehead, cheeks, and hair, the Amiens Christ possesses a more individualistic character than does the Olympian god, who is totally unblemished by the vicissitudes of mortal existence. The eyes of the Gothic Christ are worked in greater detail in the area of the eyelid, and the upper arch is more pointed than the simplified perfect arc of the *Apollo*'s upper lids. In both sculptures, de-

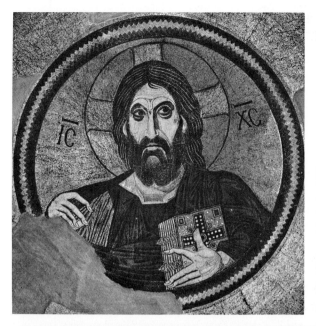

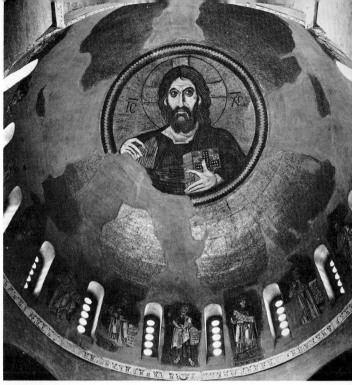

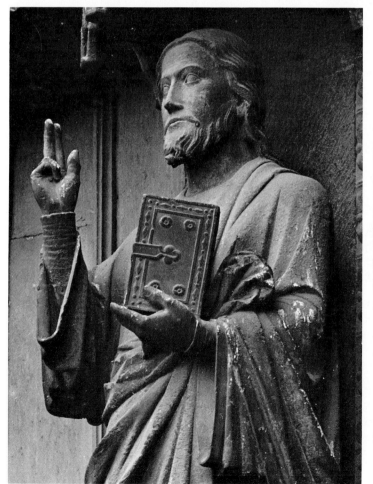

above left: 81. *Christ,* detail of dome mosaic. Monastery Church, Daphnē, Greece. c. 1100.

above: 82. Comprehensive view of the dome at Daphnē.

left: 83. *Beau Dieu,* detail of the west portal, Amiens Cathedral. 13th century.

below: 84. *Apollo,* detail of Figure 57.

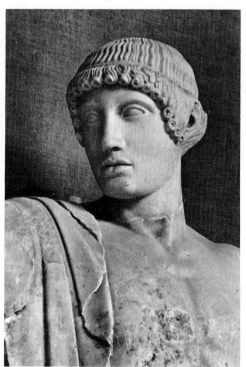

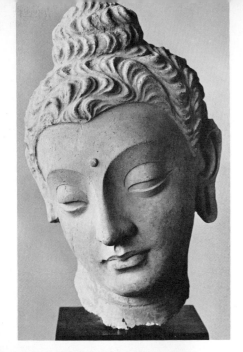

tails of the eyeballs were originally added in paint. The Gothic Christ lacks the calm of the Classical Apollo.

Comparison of a Buddha sculpture with a 13th-century head of Christ from the French Gothic cathedral of Reims provides us with a summation of two radically divergent tendencies in the respective art forms of Buddhism and Christianity (Figs. 85, 86). The Buddhist head reveals the development toward anonymity in the celestial countenance, a refusal to glorify a specific individual. It seeks a pure incarnation of that spirit of Buddhism that conceives of the Buddha as representing the incorporeal essence of a religious attitude. The smile on the Buddha's lips recalls his wisdom and sublimity, which he attains in the *abyss,* or sphere beyond nirvana. The Reims Christ wears the marks of his passionate earthly sojourn in the worn and wrinkled surface of his face, and we sense that this deity has a unique and dramatic biography. There is no intimation of past experience, of trial and pathos, in the images of either Buddha or Apollo. Christ's face, however, speaks to us of a tragic personal drama; it displays or implies a far subtler range of feeling than the faces of the other two deities. The Gothic sculptor wished the viewer to read tenderness, compassion, pain, and wisdom in the lines of the divine face. The Reims sculptor may even have taken a French king— perhaps Louis IX (St. Louis)—for his model, so that Christ was now literally presented in terms of man, or *a* man. The Reims Christ represents the second half of the cycle begun in the catacombs when Christ emerged first as a humble man, then as an emperor and ruler of Heaven. Now the cycle moved in the other direction, to terminate in the images of Christ discussed in the chapter on Rembrandt (Chap. 11).

The Deaths of Christ and Buddha Western Christian art, like its theology, is dominated by the execution of its God. Buddha's death came tranquilly: for three days, he lay on his right side, with his head resting on his hand, until he passed into the final nirvana (Fig. 87), in which he was freed from reincarnation. Buddhist art as a consequence does not know the pathos of Christian images. Christ's

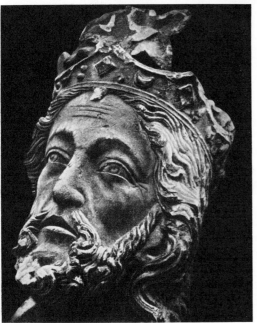

top: 85. *Head of Buddha,* from Gandhara. A.D. 400–500. Victoria & Albert Museum, London (Crown Copyright).

above: 86. *Head of Christ,* detail from *Coronation of the Virgin,* Reims Cathedral. 13th century.

right: 87. *Ananda Attending the Parinirvana of the Buddha.* Gal Vihara, near Polonnaruva. 12th century. Granulite, height 23′ (7.01 m).

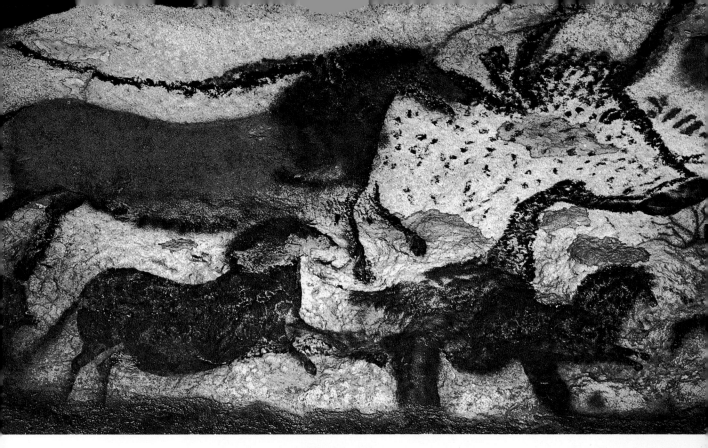

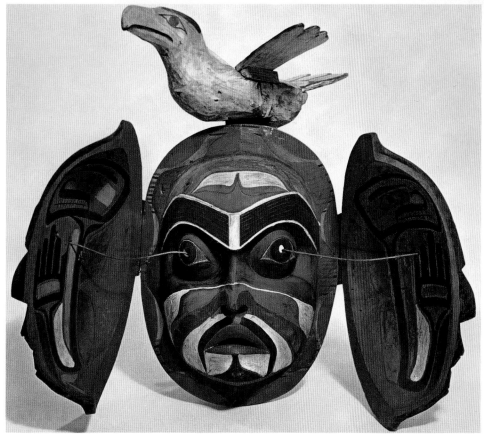

above:
Plate 1. Cave paintings,
Lascaux (Dordogne), France.
c. 15,000–9000 B.C.

right:
Plate 2. Movable mask,
from Cape Mudge,
British Columbia.
Kwakiutl, 1850–75.
Painted wood,
height 21½″ (55 cm).
Museum of the
American Indian,
Heye Foundation,
New York.

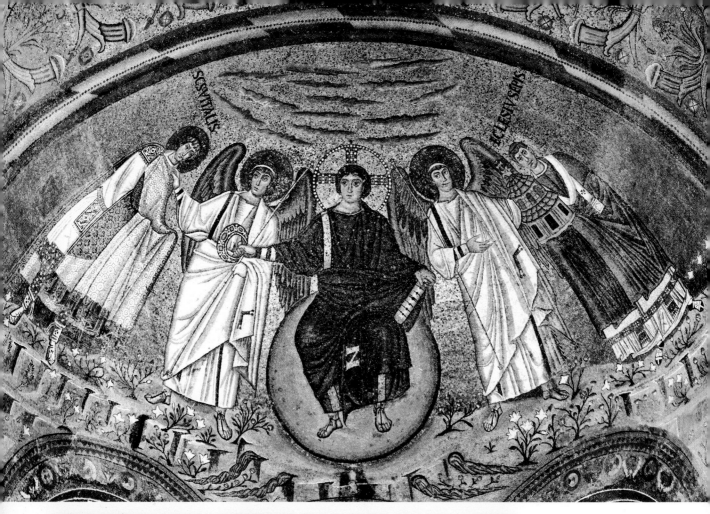

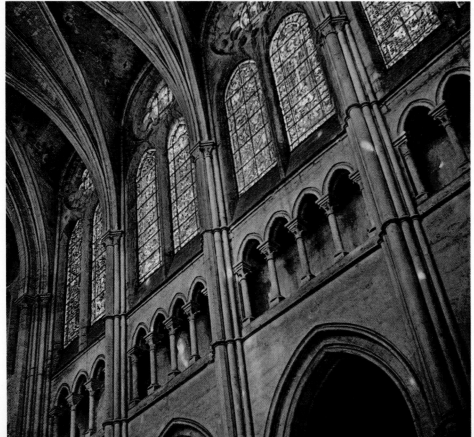

above: Plate 3.
Christ Enthroned
with Sts. Vitalis
and Ecclesius.
c. 530. Mosaic.
San Vitale, Ravenna.

left: Plate 4.
Interior,
Chartres Cathedral.
1194–1220.

A small ivory relief carving from the beginning of the 5th century shows Christ on the Cross, with head erect and eyes open, fastened by four nails (Fig. 88). In this presentation, the sagging head and shoulders and the bent knees common in this type of death were avoided. The absence of any evidence of physical suffering stresses Christ's divinity. At the right, below the crucified figure, is Longinus, the centurion who lanced Christ's side; to the left, St. John and the Virgin, and at the far left, the hanged Judas. It was almost six centuries before artists had the sanction of the Church to begin to show the pathetic tortured form of the crucified Christ and to close his eyes in death. On a *reliquary* (a container to hold relics, usually a bone from the body of a dead saint) made in the Rhineland in the 12th century (Figs. 89, 90), an ivory inset shows the body of the crucified Christ with his head slumped to the right. This pose may have originated in the sculptor's own conception of what this form of death involved, but more likely it derived from the tradition that in the last moment Christ's head bowed to his right. (From medical evidence, it would seem that the head of a crucified man would fall straight downward in death, in a vertical line with the median of his torso.) A more modest covering for the loins has replaced the simple 5th-century breechcloth. Even earlier than this example of 1180, the figures of Mary and St. John had taken up their familiar positions flanking the Cross, with Mary on Christ's right, and for centuries to come this was the fixed format.

physical and spiritual anguish on the Cross has no counterpart in Buddhist or Greek art. It was not until the 5th century, however, that the first Crucifixion scenes appeared, and these were in sculpture. Before that, there had been only symbolic references in the form of an empty cross. One reason for the early absence of this subject, so central to Christianity and its art, is that crucifixion was an undignified punishment meted out by the Romans to criminals, whose bodies were often left to be devoured by wolves.

below: 89. Reliquary in the form of a church with dome. Cologne School, c. 1175. Gilt copper, champlevé enamel, and ivory. Staatliche Museen, West Berlin.

below right: 90. *Crucifixion,* detail of Figure 89.

91. Cimabue. *Crucifixion.*
c. 1268–71.
Painted and gilded wood,
10′11′′ × 8′8⅛′′
(3.36 × 2.67 m).
San Domenico, Arezzo.

The 13th-century Italian large wooden *Crucifixion* by Cimabue is a brilliant example of how the creation of a mysterious object of worship could divert the imagination from the everyday world (Fig. 91). This great painted cross still hangs in its church at Arezzo, and it is still carried in religious processions, thereby bringing Christ's image literally among the people, just as the Franciscans who commissioned it sought to reach the poor with their message of salvation. Flanking the extended arms of Christ are miniaturized mourning figures of St. John and the Virgin. At the top, painted by an assistant, is the image of the blessing Christ. To augment visibility from below and add to its realism, the head of Christ is literally tilted forward by a raised section of the cross. Working from a rigorous tradition of imaging Christ that developed in Byzantium, Cimabue daringly manifested his individuality in interpreting how Christ overcame his death. He showed the power and pathos of Christ's stilled features, but by conceiving a new, expressive swaying posture for the body, Cimabue symbolized the promise of continued existence. The hard, stylized anatomy

imparted to Christ a muscular and, for its time, heroic body, which would assume even greater athletic associations in the 15th century (Pl. 12, p. 124). Unless it is seen in its church, one can only imagine how seven centuries ago worshipers would have been moved upon first seeing this intensely vivid and modern incarnation of Christ's death suspended before their very eyes. Almost three hundred years later a far more pathetic and brutal image of the Saviour would comfort the afflicted.

One of the most impressive and personal interpretations of the theme of the Crucifixion is that by Matthias Grünewald (d. 1528), which occupies one of the main panels of the *Isenheim Altarpiece* (Fig. 92). Painted probably between 1512 and 1515, the altarpiece was intended for the monastery church of the hospital order of St. Anthony in Isenheim, Alsace. The monastery's hospital treated patients with skin diseases such as leprosy and syphilitic lesions. It was thought that skin disease was the outward manifestation of sin and a corrupted soul. New patients were taken before the painting of the Crucifixion while prayers were said at the altar for their healing. They were confronted with this larger-than-life painting of the dead Christ, whose soulless body was host to such horrible afflictions of the flesh. Only the Son of God had the power to heal the sinner, for Christ had borne all the sorrows of the flesh that garbed the Word. The previous regal, authoritarian, and beautiful incarnations of Christ were replaced by the image of the compassionate martyr. The vivid depiction of the eruptions, lacerations, and gangrene of the body were intended to encourage patients' identification with Christ, thereby giving them solace and hope. From the late Middle Ages, partly because of widespread pestilence, there are countless examples in the art and literature of northern Europe of the faithful being enjoined to identify emotionally with the Passion of Christ. Grünewald probably drew upon the vision of the 14th-century Swedish saint Birgitta, who wrote:

The crown of thorns was impressed on His head; it covered one half of the forehead. The blood ran in many rills . . . then the color of death spread. . . .

After He had expired the mouth gaped, so that the spectators could see the tongue, the teeth, and the blood in the mouth. The eyes were cast down. The knees were bent to one side, the feet were twisted around the nails as if they were on hinges . . . the cramped arms and fingers were stretched.

Grünewald's image of Christ goes beyond this description in exteriorizing the body's final inner states of feeling. The extreme distension of the limbs, the contorted extremities, and the convulsive contraction of the torso are grim and eloquent testimony to Grünewald's obsession with the union of suffering and violence in Christ. He focused so convincingly on the final rigidifying death throes that the feet, a single hand, or the overwhelming face alone suffices to convey the expiration of the entire body. The brutal stripping of the living wood of the Cross is symbolically in ac-

cord with the flagellation of Christ. Cedar, used for the vertical member of the Cross, was also employed in the cure for leprosy. The hopeful message of the painting can be seen in the contrast between the light illuminating the foreground and the murky, desolate landscape behind—a device signifying Christ's triumph over death. Miraculously present for this Crucifixion, John the Baptist intones, "I shall decrease so He shall increase." Men and women are enjoined to humble themselves in order to renew their lives in God. The static doctrinal and symbolic right half of the painting contrasts with the extreme human suffering and emotion to the left, seen in the grieving figures of St. John, the Virgin, and Mary Magdalen. Grünewald's painting and religious views seem to have stressed a communal response to tragic but elevating religious experience. Psychologically and aesthetically, each figure, like the composition as a whole, is an asymmetrical, uneasy synthesis of polarities.

Through the images we have seen, it is possible to trace the changing conceptions of Christ, from his depiction as a humble messianic shepherd, through the kinglike God to be revered from afar, to the God-like king who could be

92. Matthias Grünewald. *Crucifixion,* center panel of exterior of Isenheim Altarpiece. Completed 1515. Oil on wood, 8′9⅞″ × 10′7⅞″ (2.69 × 3.07 m). Musee d'Unterlinden, Colmar.

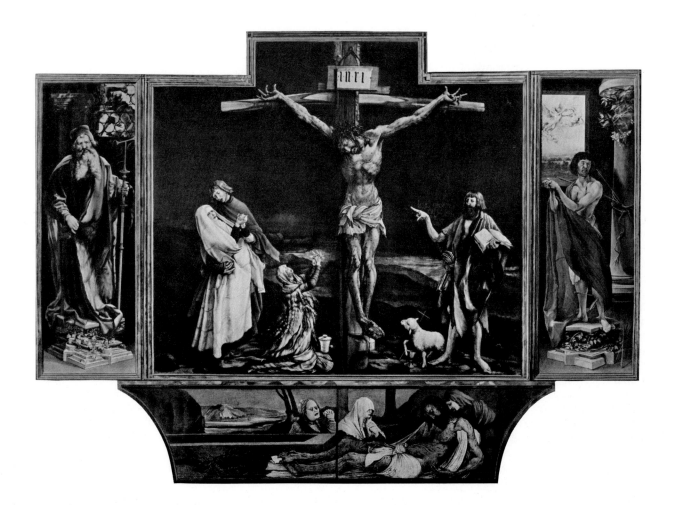

loved as a benevolent ruler, and finally to the Man of Sorrows, whose own compassion evoked the pity of suffering humanity. The transformation of sacred art proceeded differently for Apollo and the Buddha. Apollo's effigy began as sacred art and terminated in the profane imagery of a beautiful youth. The Buddha's early interpretation progressed from a humane individuality toward the sacrosanct impersonality of the 6th and 7th centuries. To comprehend the effectiveness of Greek, Indian, and Christian artists in uniting form and idea, one may exchange in the mind's eye the head of the Reims *Christ* for that of the *Apollo* at Olympia, the Lotus throne of Buddha for Christ's role in the Moissac relief, the nude figure of Apollo for the *Beau Dieu* of Amiens Cathedral—or finally, transfer the San Vitale Christ to the Grünewald altar painting.

The Faceless Christ In subsequent chapters there will be discussed many examples of the ways in which Christ was interpreted during the same century and in the centuries that followed Grünewald's altarpiece. In the 20th century, the finest painting and sculpture are no longer primarily in the service of religion, and the most important art has been secular. Nevertheless, in 1948, two enlightened Catholic priests approached the painter Henri Matisse, a non-Catholic, to decorate a convent chapel at Vence, in south-

ern France. Matisse's previous art had been entirely concerned with subjects that were sensual and that delighted the eye, such as beautiful women and colorful interiors. A richly gifted decorator and draftsman, Matisse accepted this commission. Part of his chapel decoration (Fig. 93) consisted of two linear black-and-white ceramic murals that received soft changing color reflected from adjacent windows of yellow, green, and blue glass. One mural shows the Virgin and the Christ Child, and the other the Stations of the Cross. The first subject is drawn in a soft, lyrical curvilinear style that, with the full blossom designs surrounding it, evokes a joyful mood. What initially astounds visitors to the Rosary Chapel is the absence of facial features for the Virgin and Child, though the brilliantly economical outlines of the figures suffice to identify them. It is as if Matisse had decided that each viewer could project into the mural faces of his or her own creation. In the Stations of the Cross, Matisse consciously changed his style: he avoided the graceful silhouettes and used more harsh, angular drawing—rather than gestures and facial expression—to express the tragic theme. The events are numbered and follow one another abruptly. Each consists of only the most rudimentary indication of the action and shows no concern with background. Realizing that the worshiper knows these episodes by heart, Matisse, like the catacomb artist, chose to render them symbolically or synoptically, but in a personal style possible only in his time. He exemplifies the sincere modern artist who cannot, as the medieval artist willingly did, repeat the conventions and styles of his predecessors.

Religious Art and Earthly Freedom Most of the ancient images in this chapter constituted *sacred art:* art that had a special prescribed style and function, set apart from the secular community, art that was dedicated, consecrated, and a living part of religious ritual. The works were made holy by their association with a god and were treated with reverence and respect. That in later years such works were often razed and defaced—in the English Civil War and the French Revolution, for example—testifies to their potency and to the strong feelings they could arouse. It is in religious art—as the historian of freedom, Herbert Muller, has pointed out—that the artist has contributed to the suppression of the growth of civil freedoms. Many modern artists agree the artist has been the voice of institutional religion, which historically has not championed political or civil rights, but has stressed liturgy, humility, and intolerance. In persuading their audience that the only true freedom was that of the spirit's release from earthly bonds, artists and priests did not inspire people to seek greater earthly freedom or encourage a sense of personal worthiness. Worship of the god through his image was a duty, not a freedom. One can only speculate whether Buddha or Christ would have approved of an art that inspired and restricted, educated and obscured, united and divided, encouraged and discouraged, freed and enslaved the spirit.

93. Henri Matisse. *Ave* (left) and *le Chemin de la Croix.* 1951. Murals. Rosary Chapel, Vence.

Chapter 4

Religious Architecture

In his *Laws* of the 4th century B.C., Plato wrote, "Life must be lived as play, playing certain games, making sacrifices, singing and dancing, and then a man will be able to propitiate the gods, and defend himself against his enemies, and win in the contest." As the historian Johan Huizinga has pointed out (see p. 31), the highest and holiest function of the form and purpose of such play is to make people conscious that they are embedded in a sacred order of things. Play is thus involved in sacred performances or rites, during which something invisible takes a beautiful and holy form. This would include religion and sport as well, for during both the players are convinced that their rituals actualize and bring about an order of things higher than that in which they usually live. And the efficacy of their rites presupposes a hallowed spot, or as Huizinga has described it, "a sacred space, a temporarily real world of its own, expressly hedged off. With the end of the play its effect is not lost; rather it continues to shed its radiance on the ordinary world outside, a wholesome influence working security, order, and prosperity of the whole community until the play season comes again." Thus the temple and the football stadium are in some ways alike.

What elevates a structure, whether it be a stadium, a palace, or a house of god, to a sacred order beyond the limits of its materials—in other words, what distinguishes *architecture* from building—has been beautifully expressed by the modern Swiss-born architect Le Corbusier in *Towards a New Architecture:* "You employ stone, wood and concrete, and with these materials you build houses and pal-

aces; that is construction. Ingenuity is at work. But suddenly you touch my heart, by the use of inert materials and starting from conditions more or less utilitarian you have established certain relationships which have aroused my emotions. This is architecture."

The history of religious architecture is thus more than just a record of styles and engineering achievements. From the beginning of civilization, the construction of a temple or church has been an act of faith and gratitude performed by its builders—a joyful offering to a god from the living in return for manifold gifts. Such architecture is in many ways a collective social endeavor by which architects express or symbolize the most sacred values of their cultures. Religious architecture, like images of gods, is intended to make manifest to the intellect and the emotions a sense of what lies beyond the visible world and this life. Thus far in this century, few sacred buildings of lasting distinction have been created, and these have been the work of gifted individuals who relied less on a consensus of congregational attitudes and conventional symbols than on their own artistic intuition and personal interpretation of the faith for which they were working.

From antiquity to the present, architects have had to meet certain basic demands in designing religious architecture: the structure has to be suitable as a house of God; it must be effective for the performance of the liturgy; it must be conducive to prayer or communion with the god; and it has also to be a meaningful expression of a congregation's beliefs.

The Parthenon

The ancient temple residence of the Greek goddess Athena Parthenos in Athens was the structure named after her, the Parthenon. Considered by many architects and historians to be one of the great works of architecture, the Parthenon was built on the fortified hill, or "city on a height," known as the Acropolis of Athens during the years 448–438 B.C. The brilliant sculptural decoration was finished by 432 B.C. By the time it was completed, the temple's significance included a glorification of Athens from which the devotion to Athena was inseparable. Although the Parthenon's architecture does not literally represent the forms of myth and religion, it is nonetheless an inspired expression of the higher values of Classical Greece. Through analogies and the circumstantial evidence of culture, the Parthenon reflects the world view of Periclean Athens and is an idealized spiritual self-portrait of that city. The reason for its building and for its location on the sacred hill of the Acropolis in the city's center (Fig. 94) are important considerations.

Athena, goddess of the city-state of Athens, was known as the protector of heights and the goddess of fortified places. During the Persian invasion of 480, work ceased on a partially constructed temple dedicated to her. After the Persians were defeated, Pericles, who was the leader of Athens and who sought the support and respect of the people, argued that it was a sacred duty to rebuild the temples in gratitude to the gods for their help in the Persian war. As part of the beautification of Athens and to give employment to workers without jobs, Pericles had Ictinus build a larger and more impressive building with more columns and a slightly changed orientation. This structure made use of the available components of the temple begun earlier, including columns and the metope sculpture. The building of the Parthenon occurred in the flush of Greek confidence in the Athenian gods, Athenian moral values, Athenian mercantile success on the seas, and, above all, in Athenian culture. Ironically, construction of the great temple also coincided with the beginning of the fateful decline of Athens' political power and of what several historians have felt was her moral corruption. Many in Athens protested the great cost of the temple and were offended as well at Pericles' impatient offer to pay for it himself. To prevent Pericles from claiming for himself all the glory, the Senate approved the project at public expense; the expenses were covered by funds taken from the Delian League, comprised of allies of the Athenian city-state, by loot from piracy and military campaigns, and by contributions from free citizens, who along with their slaves donated work on a daily basis. The small size of the Parthenon in comparison to the Egyptian temples (Fig. 324) reflects a marked difference in respective resources and, to some extent, the absence of a powerful priestly caste in Greece. Nevertheless, for a city of 100,000 people, the Parthenon was an ambitious undertaking. The Parthenon was a gift to the goddess of war and wisdom from a free people who willingly submitted to her. Moreover, it was a votive offering in return for past naval and commercial success, for Athena was also the protectress of the navy.

Community participation in honoring Athena is perhaps commemorated in a long frieze (Fig. 95) that runs from west to east above the inner columns at the entrances to the

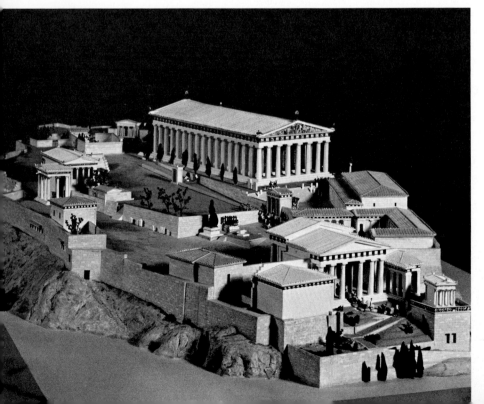

94. Model of the Acropolis,
by G. P. Stevens.
Royal Ontario Museum, Toronto.

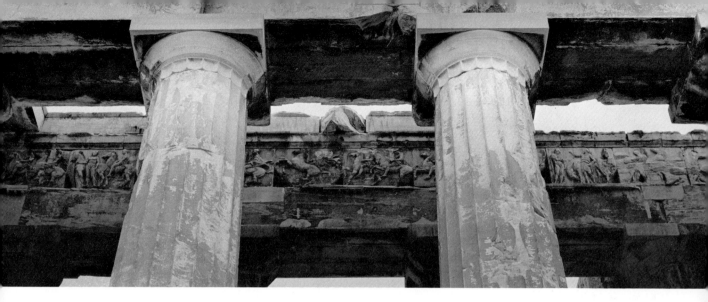

95. The Panathenaic frieze on the Parthenon, above the western entrance to the cella.

sanctuary, or *cella,* the interior room housing the statue of Athena Parthenos. This continuous relief is 525 feet (157.5 meters) long, and its subject is the Panathenaic ceremonies that took place every four years to celebrate Athena's birthday. A procession of representatives of all Athens escorted the wheeled model of a ship, from the mast of which hung a newly woven purple woolen robe, or *peplos;* on this peplos were embroidered in gold mementos of legendary battles in which Athena had triumphed. When the procession reached the Acropolis, the sail was lowered, folded, and turned over to a priest, who draped it on the statue of the goddess in the sanctuary. In the relief, also, the gods are shown, seated, witnessing the procession (Figs. 102, 103). This frieze depicts the sequence and organization of the procession, which began in the city and which included the marshals, magistrates, sacrificial animals, libation-bearing maidens, elderly citizens, youthful musicians, charioteers, and armed cavalry. The location of the relief, about 40 feet (12 meters) above the base, and the consequent indirect illumination as well as its partial obstruction by the outer columns indicate that it was primarily intended for the eyes of Athena. To accommodate the mortal viewers on ground level, the sculpture at the top of the frieze is in higher relief and was originally painted.

The Panathenaic procession recalls the spirit in which the temple was built. Art was interwoven with the civic ceremonies accompanying dramatic performances, athletic games, and religious offerings and rites (Fig. 96). Public expenditure for art was conceded as necessary to enrich the lives of Athenian citizens. The ideal citizen was an active contributor to the affairs of the city. Within half a century, this ideal was realized by, among others, Pericles, Sophocles, Aeschylus, Euripides, Anaxagoras, Socrates, Thucydides, and the sculptor Phidias, overseer of the sculptural decoration of the Parthenon. It may have been Phidias, in conjunction with Pericles, who assigned the architectural design to Ictinus and an assistant named Callicrates. Many artists from all over Greece were recruited for the project, and according to Plutarch, who wrote centuries later, such was the spirited rivalry among the workers and artists to excel in quality and speed that, remarkably, the Parthenon was finished within the lifetime of those who inaugurated it.

The prime purpose of the Parthenon was to provide a worthy house for Athena. The temple form is the descendant of the *megara,* or dwellings of Mycenaean kings, built on the Acropolis long before the time of the Parthenon. This temple was not designed as an interior space in which a congregation could worship; for this purpose an altar was placed outside, in front of the eastern entrance. The cella of the temple housed the gigantic 40-foot (12-meter) effigy of

96. The Parthenon, view from the west.
Reconstruction by G. P. Stevens.
American School of Classical Studies, Athens.

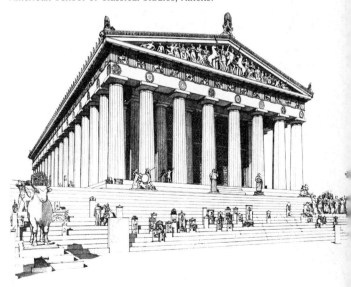

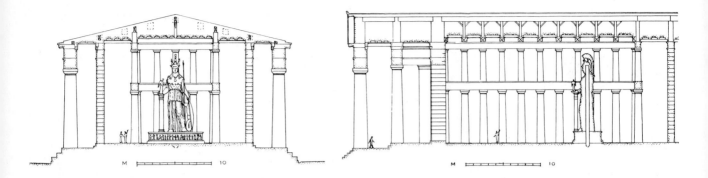

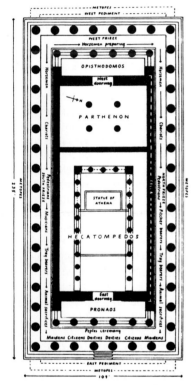

above: 97. The Parthenon. Cross section (left) and detail of longitudinal view of the sanctuary (right), omitting the storage chamber. Reconstruction by G. P. Stevens. American School of Classical Studies, Athens.

left: 98. Plan of the Parthenon and Panathenaic procession, after N. Yalouris.

Athena Parthenos, garbed in military costume. The statue's great size therefore required an unusually wide plan to satisfy the necessary height. Although the original is lost, we know that Phidias made this sculpture using gold for the dress and armor and ivory for the flesh. Appropriately, a ship's mast was used for the interior armature, indicating Athena's role as protectress of the navy. Entrance to the sanctuary was reserved for the priests and for privileged laity on certain occasions. Ordinary laity were permitted to look into the sanctuary through the enormous eastern doors.

The orientation of the temple was worked out with painstaking care, as was true for all ancient sacred architecture. The temple has a roughly east-west orientation. The central axis is slightly south of due east, so that on Athena's birthday the rising sun shone directly through the doors onto her effigy. The location of the temple on the Acropolis was also calculated to permit the widest view from the city below.

Architectural Design The overall form of the Parthenon is basically that of the traditional Greek temple, with its walled interior divided into two parts. The windowless eastern chamber housing the cult statue was known as the *Hecatompedos* ("100 feet"), because of its 100-foot (30-meter) length. As seen in the plan and sectional reconstructions (Figs. 97, 98), there was an inner two-tier open colonnade that continued from the doorway to behind the statue, where it formed an aisle that permitted a view of the image from the rear. Natural illumination was provided by the huge doorway (32 feet, or 9.6 meters, high; 13 feet, or 3.9 meters, wide). Beneath the double-pitched marble-tiled roof was a flat ceiling of wooden beams. The sanctuaries of the Greek temples are of substantial historical interest because they were among the first large enclosed interiors and employed columns, even though the space within was not so expressively shaped as it was in edifices of later periods—of Imperial Rome or Gothic France, for example (Figs. 114, 332, 334). The statue of Athena dominated, if not crowded, the sanctuary. The second, and smaller, western chamber was the storage space for ritual objects, important votive offerings, and the treasury of the Delian League and the state. This room was known as the *Parthenon* ("Chamber of the Virgin"), from which the whole temple took its name.

The Classical Greek architects believed that the splendor of a temple should not be confined to its interior, and in fact the most inspired part of the Parthenon's design is its exterior. This emphasis may be explained by the fact that the public ritual was conducted out of doors, and visually the temple was intended to appear accessible. Worship of the Greek gods did not entail the secretive ceremonial of ancient Egypt. The presence of important sculptural programs outside in the *pediments* (the gables, or triangular areas, formed by the sloping roof of a Classical temple) and *metopes* (panels that, with the *triglyphs*, cover the frieze zone above the architrave in Doric temples) also suggests

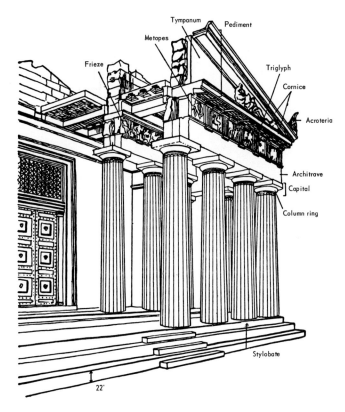

Tympanum

Pediment

Metopes

Frieze

Triglyph

Cornice

Acroteria

Architrave

Capital

Column ring

Stylobate

22′

99. Sectional drawing of the Parthenon, after N. Yalouris.

order." The temple, affirming its makers' belief in a rational unity of reality, is a visual analogy of the Greek idea of the world as ultimately knowable, static, and symmetrical. After its completion, Athena's attributes were extended to include perfect equilibrium. A little over a century before, Greek temple sculpture had expressed the demonic and the common apprehension, if not fear, of the unknown. The Parthenon and its sculptural decoration, instead, express a people's confidence in themselves, in their place in the world, and in the dignity of their gods, who had human as well as divine qualities. To see these religious and philosophical generalities in the specific components of the temple, it is important to visualize the whole architectural ensemble, even though we can only perceive its radiant design from the ruins and appreciate how this accorded with Athenian speculation on the goddess's nature.

The Parthenon, like Classical sculpture, was designed according to the Greek ideal of *eurythmy*—the well-proportioned, harmonious, and pleasing appearance of the whole. It gave the immediate impression of compactness and completeness, and its beauty lay in the impossibility of adding, subtracting, or altering any part without disrupting the whole. Its ideal rhythm consisted of a lucid repetition of similar elements, such as the columns, which within themselves have a harmonious stability. Oswald Spengler has described the *Classical* as that which can be taken in at a single glance. While this seems an oversimplification, the Parthenon's major design does give itself thus readily to the eye. We are immediately aware of certain individual parts, then of their tidy and disciplined relation to other parts and to the whole—not unlike the relationships making up the *polis,* or Greek city-state, of which Athena was the embodiment. Each component has its own identity and designation within the nomenclature of the Doric order; if separated from the totality, the part and its location could be quickly identified. Parts with similar identity have a like measure and proportion to the whole, constituting the Greek ideal of symmetry. If we were presented with only one half of a Greek temple, it would be possible to predict or reconstruct the other half with maximum certainty.

Beauty and nature were interpretable to the Classical Greek in terms of an ideal, or conceptually perfect, human body. Such a body, composed of harmoniously disposed and interrelated parts, was symmetrical and lucidly manifested its weight and support. Much of the architecture, such as the fluted columns, and the sculpture was carved in place, giving them shared qualities of shaping. The temple columns and their capitals are like legs easily supporting a torso. The taste for a round, tapered, and fluted column is indicative of a preference for light and shadow and sensitive proportion found in the best 5th-century figure sculpture. Each groove or *flute* can contain a man's back. As further evidence of the application of human scale, the intervals between the column axes can be expressed in terms of a column diameter and the width of a man's shoulders.

that the temple was more "extroverted" than interiorized in its address to the general community (Fig. 99). The exterior Pentelic marble columns were a shimmering white, and the *triglyphs* were painted blue; the horizontal architrave blocks above the columns were hung with military trophies in Roman times.

The temple was mounted on a three-stepped base that set it apart from the earth and the viewer, much as a pedestal does for sculpture. The height of the individual steps was intended to discourage their being climbed. The sanctuary's outer wall and entrances were surrounded by a handsome range of columns. These columns and the horizontal elements above them belong to the Classical order known as *Doric.* The masculine severity of this order was appropriate to a war goddess.

Mind versus Chaos The Parthenon tells more about the human than the metaphysical nature of the Greeks. Even in its ruined state, a casualty of war, it reminds us of the power of human intellect and of the Greeks' reverence for Athena as both the goddess of wisdom and an inclusive symbol of victory. The words of the 5th-century Athenian philosopher Anaxagoras could well have been inscribed on the Parthenon: "All things were in chaos when mind arose and made

The overall size of the Parthenon is itself more humanly oriented than that of the mammoth Egyptian temple. The Greek temples owed their unusual width to their unprecedented use as housing for a colossal cult statue. Like the perfect idealized human form, the form of the Parthenon is based upon a mathematical module and a consistent set of ratios. There was an Athenian foot unit, and Professor William Dinsmoor's meticulous measuring of the Parthenon has revealed that Ictinus used mathematics rather than impulse to achieve the structure's perfect and unprecedented visual harmony. The ratio of the temple's height to its width on the east and west faces is 4 to 9; that of its width to its length is also 4 to 9; and that of the column diameter to the interval between columns *(intercolumniation)* is 9 to 4. The seventeen columns on the long sides are twice plus one the eight columns on the east and west, which again reduces to a 9 to 4 relation. With but a single module and ratio, the architect could calculate mentally all the proportions and dimensions of his building. It is likely that Pythagoras' work with numbers and his belief that everything could be expressed in terms of them influenced Ictinus. Numbers were believed to be eternal and incorruptible values because they existed outside the senses. Looking patiently at the Parthenon permits both the visualization and the intuition of its proportional system, which induces a strong sense of equanimity and of the structure's rightness.

Optical Refinements Further separating Ictinus' Parthenon from earlier Greek temples are the excellence and thoroughness of its optical refinements. There is not a perfectly straight line in the entire building. The purpose of every subtly curving edge may have been to correct the optical distortion of sagging that one experiences when looking at a long straight line, or it may have been to give a more sculptural appearance or a certain springiness to the temple's relation to the ground, and also that of its supporting columns to their load. Each step is convexly curved (Fig. 100), with this almost imperceptible curvature forming the perimeter of a tremendous circle having a diameter, according to Dinsmoor, of 3½ miles (5.6 kilometers). The entire upper portion of the temple above the column level had a similar curve, and even the great door frames were curved (Fig. 101). The columns near the corners have been placed closer together in order to provide a visual arrest for the eye as it moves along the peripheral colonnades. This placement also serves to align the triglyphs and metopes with the columns in such a fashion that two triglyphs are made to meet at the corner. The columns at each of the four corners have been slightly thickened so as not to appear spindly or thinner than the others since, because of their position, they are seen against the sky. The column shafts have been given a slight swelling, or *entasis,* as they rise from the base, to prevent the impression of sagging in the middle; they are also tilted back slightly to prevent the illusion that the building is falling forward. Use of such optical refine-

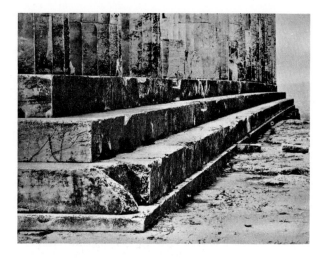

above: 100. View of the Parthenon stylobate, showing curvature.

below: 101. Schematic rendering of the Parthenon exaggerating the curvature and irregularities in the scale.

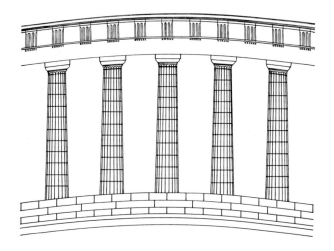

ments, which required a consummate knowledge of mathematics and extremely difficult labor, augmented the beauty of the temple immeasurably. Though these devices are not all, or immediately, apparent to the eye, they impress themselves subtly on the mind and feelings, creating a balance between the seen and known. The brilliant execution of these refinements in the Parthenon surpasses all previous occasional and unsystematic uses and assisted Ictinus in bringing the Greek temple form to perfection.

Sculpture The Parthenon was further enhanced by superb sculpture in the form of the continuous frieze, metopes, two tympana groups on the pediments, and decorative *acroteria,* or roof sculptures (Figs. 102–104). The roof ornament included lion heads and a sculpture group at the apex of the

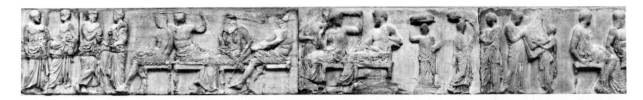

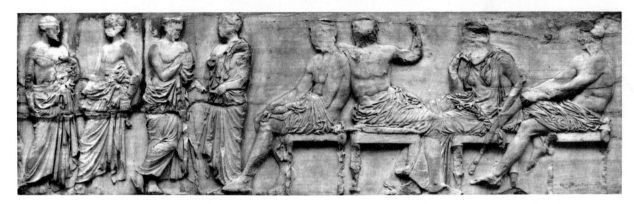

top: 102. *Hermes and Dionysus* (seated right) and
Magistrate with Boy Folding Peplos (extreme right),
from east frieze of the Parthenon.
Marble, height 42'' (107 cm).
British Museum, London
(reproduced by courtesy of the Trustees).

above: 103. *Hermes and Dionysus,* detail of Figure 102.

right: 104. Triglyphs and metope, the Parthenon.
Metope 4'8'' × 4'2'' (1.42 × 1.27 m).

pediment, almost all of which have been lost. The metope
sculptures, which dealt not with the historically recent Per-
sian War but with legendary victories won by the ancestors
of the Athenians over the Amazons, Centaurs, and the
Trojans, lent animation to the horizontal and vertical lines
of the temple. The metope figures are carved in strong relief
and in a wide variety of movements at variance with the
axes of their frames. The tympanums contained sculptural
representations—on the east, of the birth of Athena from
the brow of Zeus, and on the west, of the victory of Athena
over Poseidon. These sculptures were supervised by
Phidias. Many of them were partially painted and were
carved in the round. Isolated, each figure has an autono-
mous beauty, and yet all fit harmoniously into a larger
group. Despite the magnificence of these sculptures, as
decoration they did not overbalance the temple but served
as a crowning religious and aesthetic element.

Just as Parthenon pays tribute to the high civilizing
ideals and the ordering instinct of the Classical Greek mind,
so does it recall some of the limitations of that culture and
its art. Ictinus was respectful of tradition, though not a slave
to it. Within definite limits, he refined and improved what
had come before, but he did not revolutionize Greek temple

architecture. The engineering of the Parthenon is extremely
conservative; its post-and-lintel system was thousands of
years old. The Greeks knew the principles of the arch and
the dome but continued to use more traditional forms in
their sacred buildings. They displayed no structural adven-
turousness like that found later in Rome or during the medi-
eval period of Western Europe. The desire to codify what is
perfect is typical of Classical art, and there is no aesthetic or
engineering advance beyond the Parthenon in Greek archi-

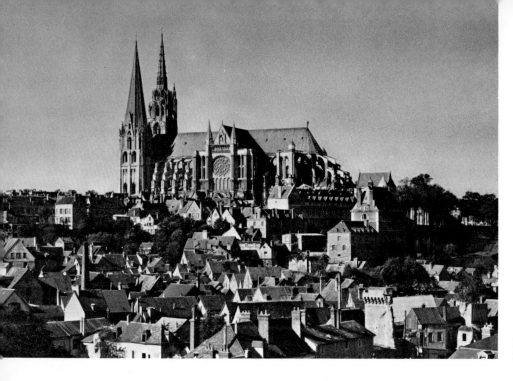

105. Chartres Cathedral, view from the city. c. 1194–1260.

tecture. The Greek impulse to order everything made it hard to adapt to the tensions and changing times that followed the Classical period. The cool aloofness and exquisite closed perfection of the Parthenon, like Classical sculpture, do not partake of the qualities of variety, the unexpected, emotional warmth, and psychological range encountered in ancient daily living. In Classical art, time is suspended; as a result, there are many links missing between the Parthenon and life in 5th-century Athens.

The downfall of Athens can be attributed in part to her inability to sustain successful alliances with the other city-states. Political misfortune and disunity caused the initiators of the Parthenon—Pericles and Phidias—to fall from power, the latter ironically and falsely accused of stealing gold intended for Athena's statue. Longer than the city-state that produced it, the Parthenon and its noble but restricted ideals have endured as a beautiful abstraction. As Spengler has observed, the Greeks' mode of worship was a pious observation of form, not soaring aspiration.

The Gothic Cathedral

Bomb the Cathedral? In wartime, a great Gothic cathedral is being used by an enemy army of occupation as an artillery observation post and for snipers. A liberating army that cannot detour around the city in the haste of its advance is confronted with the dilemma of whether to bomb the cathedral, causing its destruction, or to try to dislodge the enemy with troops, thereby incurring casualties. In the balance are great art and life. Which would you choose? Pro-life and military expediency arguments need no rehearsal here. To understand why the unprovoked German bombardment of Reims Cathedral in 1914 solidified the Allies with France in all-out war against Germany at the cost

of millions of lives and why General Eisenhower ordered the sparing (except in extreme military necessity) of great historical and artistic sites such as Chartres in Allied-occupied countries during World War II, it is necessary to know their importance not just to the French, but to humanity. The best approach to the Gothic cathedral in France is that taken by the medieval pilgrim, who, traveling on foot to a city such as Chartres, first saw the distant cathedral spires across the open fields. Physically, economically, aesthetically, and spiritually, the cathedral still dominates the town of Chartres (Fig. 105). The cathedrals that rose above the medieval houses glorified not only Christ and the Virgin but also the cities that erected them; thus they symbolized man's awareness of the divine as well as his own self-consciousness. The Gothic was basically an urban style, for the very phenomenon of cathedral building presupposed the extensive development of cities in the 11th and 12th centuries. The rise of these cities, in turn, reflected important stages in European socioeconomic growth: the accumulation of wealth, the organization of labor, administrative efficiency, improvements in transportation and communication, the establishment of relative political stability, and specific, mechanical developments and techniques such as horseshoe nails and pulleys. Also important is the emergence at this time of significant intellectual resources and activity outside the monasteries.

Economics Cathedral costs were enormous. Their financing was a stupendous enterprise. The financial histories of the cathedrals, as shown by Henry Kraus, were as varied as their appearance. The Church produced the dynamics for fund raising, and usually much of the money, but impassioned builders among clerics were rare. Orders to allocate one-fourth of church revenue were frequently ignored, and

planning was often injudicious, insufficient, and overtaxed a city's resources. At times, coercive methods (such as confiscation of heretics' property) were used to keep funds flowing, yet burghers were not always courted by bishops who sought to avoid their influence. Amiens and Strasbourg stand out for cooperation between bishop and burghers. The economic foundations of Amiens Cathedral were partly underground in the form of local dyes stored under the city, which brought good prices in trade. Midway in its construction, the citizens of Strasbourg fought a war and took over the building of their cathedral. Helping and hindering funding were the sale of indulgences (the forgiving of sins), treasure from royal conquests, new currency, inflation and taxes, the growing wealth of the middle class, bequests from bishops and laity, and the preoccupation of churchmen with other building projects or worldly pleasures. The financing of cathedrals, without detailed budgets and often with only intermittent funding, now seems as miraculous as their construction.

The Cathedral in Life Although built to satisfy civic pride, the Gothic cathedral was above all a gift to God. The rivalry among French bishops and their cities to outdo one another in the size and magnificence of their cathedrals was undoubtedly motivated in part by secular concerns, such as economic benefits, but the deep and measureless religious faith and optimism of the builders were truly the prime movers. Like their cities, no two Gothic cathedrals are the same. In addition to great variations in size, the sheer variety and complexity of Gothic cathedral architecture prohibits us from writing about a fixed type as we could in discussing the Greek temple. This variety in itself furnishes evidence against the stereotype of the essential unity, conservatism, and lethargy of medieval society. There was only one Church, however, and the cathedral does symbolize a basic spiritual unification. The so-called Gothic period was a time of continuing change; its architectural styles seemed constantly in process, their evolution reminding us of the vitality and discord of the Middle Ages.

The word *cathedral,* derived from the Latin *cathedra,* signifies that the bishop's seat is within. The bishops and their urban dioceses were, in a sense, rivals of the Cistercian monasteries and their ascetic world-denying doctrines. The richly ornamented and elaborately designed exteriors of the cathedrals reflect a more affirmative attitude toward life on earth and a more explicit recognition of the civil community than do the austere, introverted monastic churches such as that at Fontenay. From every prospect within the town, the forcefulness and rich variety of the cathedral's design make themselves felt. There was no prescribed approach, no one sacred way by which the worshiper was to proceed to the front of this house of God. In their original state, the cathedrals were not isolated by the open spaces or plazas that girdle many of them in their present condition (Fig. 106). A cathedral might have had

squares of some sort on the west and north or south, but usually the city's secular buildings encroached directly upon the church walls, on its complex of chapterhouse, cemetery, school, prison, and bishop's residence. This tight proximity of the secular and the sacred parallels the role that the cathedral played in the community.

The Gothic cathedral was more than the religious focus of its society. Its bells regulated the day's secular activities, just as events in the life of Christ, the Virgin, and the saints provided the calendar for fairs, festivals, and the mystery plays. From the 11th century on, the cathedral was a seat of both secular and sacred learning. It satisfied the human need for spectacle, serving as backdrop and stage for its daily religious drama as well as for popular, often irreverent festivities. Churchmen regarded the public explosions on the Feast of Fools as safety valves against the rigorous proscriptions of Christian dogma. This explains why they allowed on specific occasions such outrages as gambling and sausage-eating at the high altar, the worship of donkeys in the sanctuary, and the election of a mock pope by the laity dressed as monks. At times, the Heavenly Father's house served as playground for his children. Merchants used tax-free Church property during the great fairs that brought wealth to the city and funds for the construction of the cathedral.

The silence encountered today in the cathedrals is in great contrast to the clatter of voices about which the priests complained in medieval times. These disruptions led to the building of screens *(rood screens)* in the 13th century to separate the choir and altar from the congregation and to allow the priests to celebrate the Mass in privacy. The cathedral nave served variously as a lecture, hiring, and concert hall, as a repository for important civic

106. Amiens Cathedral, aerial view. c. 1220–88.

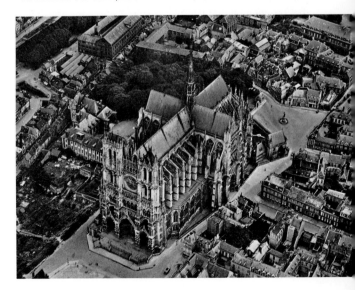

documents and commemorative monuments, as an arsenal, a municipal museum, and a trysting place. In many instances, the bishop or deacons owned only the eastern portion of the church; the nave belonged to the city.

The Cathedral Builders The term *architect* does not become customary until the 15th century. Not until about the middle of the 13th century do master masons, as they were known, seem to have been given lifetime assignments to oversee the building of one cathedral. Before that time, the system, as exemplified by Chartres Cathedral, consisted of mobile crews of 50 to 100 artisans led by masters, skilled in geometry and masonry, who were building contractors. They traveled from site to site, succeeding one another in building campaigns made episodic by sporadic funding and slow-drying mortar. The architect-scholar John James argues that although a client may have seen the first master's intentions, possibly in the form of a general overall model and/or drawings for plan and elevation, at Chartres, the cathedral was the result of additive planning and construction done by as many as *ten* contractors in a 30-year period. When the French building boom ended in 1230, James believes permanent masters and fixed workshops came into being. At Chartres, however, a succession of strong individual designers, respecting the ideas of their predecessors, still imposed their own preferences. A study of styles of some work and masons' marks shows that each contractor's team worked on the building from end to end, rather than in just the nave, transepts, or choir. There were sculptors on these teams, and James believes that all the Chartres sculptures were done in this 30-year period—their variety, like that of the building, reflecting different teams who trained their own members in trade secrets and skills and stayed together for life. Master masons made templates or patterns of existing building parts to allow continuity between teams, but at Chartres, there were changes, confusion, and small misalignments that give the cathedral its interest and un-Classical beauty. Each contractor had his own geometric systems and measures and would modify the layout of his predecessor. There was agreement on the overall design, but each contractor wrestled with problems left by his predecessor and carried out his own ideas. James believes that cathedral building was a "fluid, organic process," not "an act." That Chartres was not constructed under the direction of one or two masters is a view some medieval architectural historians find hard to live with.

In medieval custom, the name of the client was more important than that of the builder, but the names of many medieval architects have survived because of the medieval distaste for anonymity. Jean d'Orbais and Hugh Libergier of Reims and Robert de Luzarches of Amiens are examples. Some builders were given such degrees as a doctorate in stonemasonry, and certain notable architects—Robert de Luzarches and Hugh Libergier, for instance—were entombed in the churches they built (Fig. 107) and their effigies were

107. Tombstone of Hugh Libergier, Reims Cathedral. 1263.

engraved on the burial slab. The master builders of the cathedrals frequently came from distinguished lay families, were trained by their fathers, and had a roughly middle-class and free professional status. They seemed to have been pious men of good moral character and education who were quite well off financially. They had opportunity for travel, since their services were often vied for on an international basis. Their education was in the craft of masonry or carpentry, Euclidean geometry, drafting, Latin and French, and various techniques and secrets of building that were passed on from one generation to the next. Unlike painters and sculptors, they were considered practitioners of the liberal rather than the mechanical arts. The 12th-century translation of Euclid from the Arabic was a great boon to builders. Much of their education was empirical, being based on what worked, and for centuries, Gothic architecture developed by trial and error.

The master builder conceived the plan in consultation with a priest or the cathedral canons, perhaps even the bishop, and then decided how to go about building the edifice. A financial adviser told him the margin for the building's splendor, and thereafter he usually relied on a foreman to oversee the actual construction. Managing the business aspect per se was not the architect's job; his tasks were more specific. Often responsible for selecting materials, he also procured the labor, estimated costs and quanti-

ties, settled labor disputes, and saw to the welfare of his artisans. By the 13th century, the master builder only gave orders and had achieved a social status superior to that of earlier medieval architects.

Because of its prohibitive cost, plans were not drawn on parchment until the 14th century. Earlier, the drafting of details or sections had usually been done on plaster slabs or wood panels, and these were not saved. Not until the 15th century, with the erection of Brunelleschi's Pazzi Chapel, was the whole building meticulously planned in advance. Many of the details of building and ornament were left to experienced and trusted masons, carpenters, and sculptors. When an architect on one of these great projects died, his successor respected what had already been constructed and continued work on unfinished sections according to the original plans; still, he might also choose to introduce new ideas. The Cathedral of Chartres lacks a homogeneous style, for its sponsors did not insist upon any standard of architectural consistency other than excellence. It is a peculiarity, even a distinction, of the Gothic style that it is able to absorb heterogeneous modes.

Although it is the rich symbolism of the Gothic cathedral that impresses the modern viewer the basic problems confronting the master builder were practical, such as how to keep the great roof up. Other considerations were adapting the plan to the demands of the liturgy and the performance of the canonical offices; providing for the proper disposition of relics and subsidiary altars; facilitating the movement of the congregation and of processions; and making provision for delivery of the sermon.

Meaning and Organization As discussed in Chapter 2 (p. 36), Lévi-Strauss has suggested that all art metaphorically miniaturizes that which it represents. Though the Gothic cathedrals are great in physical size, they, too, are imaginative models of the many things they stand for. Within the French medieval city, the cathedral usually meant *unity*—of religion, wealth, and politics. The Church sanctified a political monarchy, and the Gothic cathedral signified the solidarity of urban bishops, and often their cities, with the Capetian kings of France (Fig. 108). This union served the contracting parties by weakening the respective powers of the monastic abbots and the nobility. As the spiritual defender of the realm, the cathedral was thus an official seal upon an alliance of commerce, the Church, and the state. In the 12th and 13th centuries, the cathedral represented a growing French consciousness of cultural as well as religious and political unity.

The extent to which conscious symbolism entered directly into the developing form of the Gothic cathedral is difficult to assess. In the period of great cathedral building, there was a strong interest in symbolic interpretation, allegories, and metaphors. The cathedrals lent themselves to a wealth of allusions, to views that the material form of the church structure, for example, symbolizes the spiritual

Church. Since Early Christian times, the Church was seen as a metaphor of man's soul, and also as a representation of the Kingdom of Heaven and the mystical body of Christ. Both externally and internally, the cathedral served as a kind of sacred theater: its west façade provided a backdrop for mystery plays, and in its altar area, the mysteries of the ritual were performed and the holy objects were displayed. The architects were in contact with the intellectual leaders, both spiritual and lay, of the community. They consulted with canons, bishops, theologians, and priests on the theological program for the sculpture. Great theologians of the past had given much significance to the concepts of *measure* and *light,* but that these abstruse interpretations were consistently and systematically translated into medieval architectural design is conjectural. Of great influence were the already existing religious buildings, as well as the practical problems posed, after 1200, in erecting and supporting enormous vaults more than 100 feet (30 meters) from the floor of the nave. The height of the nave at Chartres is 116 feet (34.8 meters); at Reims, it is 123 feet (36.9 meters); at Amiens, 137 feet (41.1 meters).

Official handbooks of Church symbolism did not exist for the artist to consult. While there were important 12th- and 13th-century writings by such men as Durandus, these were not dogma, and the literary symbols contained within the treatises gave no assistance in matters of style or, in many cases, for evolving the shapes of parts. The cathedrals inspired reverent fantasies in many writers who worshiped

108. *Abraham and Melchizadek.*
Relief sculpture at western end of nave,
Reims Cathedral.

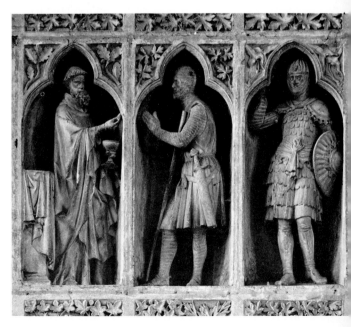

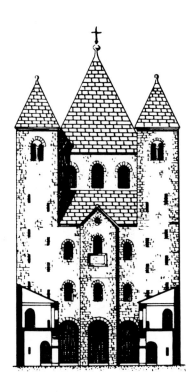

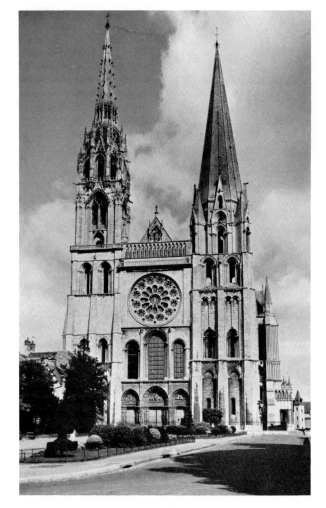

above: 109. Façade, Abbey Church, Corvey, Germany. 873–85. From *Architectural Symbolism of Imperial Rome and the Middle Ages,* by E. Baldwin Smith (copyright © 1956 by Princeton University Press).

right: 110. West façade, Chartres Cathedral. Width 157′ (47.85 m); height of south tower (right) 344′ (104.85 m); height of north tower (left) 377′ (114.91 m). Façade c. 1194–1260 (portals and lancet windows c. 1145); south tower c. 1180; north spire 1507–13.

within them, and their various interpretations of the same architectural features were formulated after the fact and were not consistent. What adds to the wonder of the cathedrals, and to their intellectual greatness in history, is that their architects did give—in one way or another—symbolic form to the highest ideals and much of the spirit of their age. Acquaintance with the Gothic cathedrals makes us aware of their profound and sometimes elusive connection with the societies that produced the Crusades, the feudal system, and universities, and that enriched science and philosophy and contributed significantly to the system of jurisprudence.

By its great size and ornateness alone, the Gothic cathedral was truly acknowledged the house of God, but unlike a temple of Athena, the deity in sculptural form did not dwell within. The cathedral was an ambivalent symbol of the new and greater Temple of Solomon, a symbol of Christ, the heavenly Jerusalem, and the universe. Its magnificence, in terms of the treasure expended on it, was deemed appro-

priate to its function as an offering from the faithful and as the spiritual residence of Christ or the Virgin. At Chartres, the Virgin was more than a remote symbol; she was, as George Henderson has observed, a distinct personality, and like Athena, she was involved in the affairs of the city. When the fire of 1194 ravaged the old cathedral, it did not damage the cherished relic of the Virgin's cloak that was housed there. This was interpreted as a sign of the Virgin's will, a sign that she wanted an even greater residence.

It was through the cathedral that the Christian was made aware of the invisible and infinite, the immanence of the divine. The master builder sought to devise a setting that would so stimulate the thoughts and feelings of worshipers that they would be able to realize the most important event of their lives, the soul's communion with God.

THE WEST FAÇADE All the major parts of the cathedral have a tradition extending back into the early Middle Ages, in some cases, even to antiquity. Their assimilation into the

cathedral structure was a process involving not only formal adaptation and modification but also symbolic meaning. The sources of the *Gateway to Heaven,* as the west façade was called, can be traced to Syrian churches of the 6th and 7th centuries and to certain Roman Imperial palaces fronted with twin-towered portals. As Baldwin Smith has shown in a brilliant study, towered gateways were used as entrances to royal cities and abbeys in Carolingian times (Fig. 109) and were the scenes of impressive ceremonial receptions upon a king's arrival. The transformation of the Early Christian basilica into a twin-towered edifice must be seen in the light of Charlemagne's revival of Roman political symbolism and his desire to show his ascendancy over the Church as well as the state. The emperor's symbolic participation in the religious service and his exalted authority were indicated in the towered façades of Carolingian and certain Romanesque churches. Sun symbolism was in that epoch equated with the authority of the king as well as of Christ. By the late 13th century, however, the symbolism of the west façade alluded entirely to Christ. Nevertheless, the façades of such Gothic cathedrals as Chartres (Fig. 110), with portals that had evolved in Carolingian times, "galleries of kings," circular windows, and double towers, bear the impress of earthly royalty.

THE CIRCULAR WINDOW The origin and significance of the great circular window of the west façace has been explored by Helen Dow, whose research indicates that circular windows go back to Babylonian times and had been known in Europe since Roman times. Unlike the well-known but misnamed Gothic "rose window," the circular window,

with few exceptions, lacked stone tracery until the building of the Abbey Church of St-Denis, about 1140. The basic form of the rose window (Fig. 111), as found at Chartres, may have originated in old schemata of the symbolic wheel. Great Byzantine chandeliers, composed of pierced metal disks, were in use in France by the 12th century, either as hanging or as standing lamps. Lamps lent themselves to expression of the sun and light symbolism which had become associated with Christ in the Middle Ages. The circular form was rich in meaning, for it might signify virtue, eternity, God, or the Church. The great circular window also echoed the form and associations of the wheel of fortune, through which Christian virtue and its reward were contrasted with the vicissitudes and transient nature of earthly existence. Ezekiel's vision of the wheel in the Old Testament made the window form an appropriate allusion to the Scriptures. The prominence of the window as well as its form symbolized the eternal and righteous eye of God. The word *nave* means "ship" in Latin, the window being, thus, the ship's guiding eye. Divine light and justice seem to have been two of the most important meanings of the window. The circular window in combination with the many sculptures of saints surrounding it conveyed the notion of a king surrounded by his armies. The full significance of this interpretation becomes apparent when the sculptural program of the west façade of Chartres is examined.

THE SCULPTURAL PROGRAM OF THE CHARTRES WEST FAÇADE The great main doors of the Gothic cathedral represented the Gates of Paradise. The purpose of the programs worked out with theologians for the sculpture occu-

111. Rose window, west façade,
Chartres Cathedral.

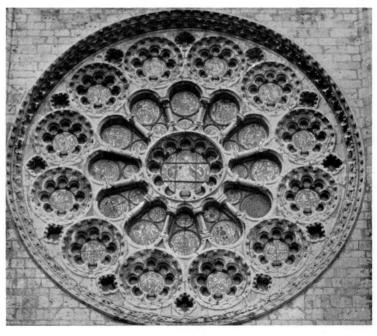

pying the honored positions around and immediately above the doors and for the imagery in the stained-glass windows was to manifest Church doctrine. It is questionable that these sculptures were intelligible to the public without assistance, for it would appear that the faithful relied upon the spoken word for their instruction in dogma and, hence, in the meaning of art. That elaborate theological programs were actually planned and carried out for cathedral imagery has long been known. In this connection, Adolph Katzenellenbogen contributed an outstanding study of the sculptural program of the west façade of Chartres (Fig. 112), which explained that the figures of the three *tympanums,* or semicircular relief panels over the doors, present Christ in his dual nature of God and Man, and as the source of divine wisdom as well.

At the far right, the Christ Child is shown seated on the lap of the enthroned Virgin, indicating her role in his Incarnation. In the pointed vaults bordering the tympanum are representations of the seven liberal arts (grammar, dialectic, rhetoric, arithmetic, music, geometry, and astronomy), the intellectual means by which to attain awareness of divine wisdom. The Virgin, being the vehicle for the incarnation of divine wisdom in Christ, became the inspiration and guide of these arts—an indication of the growth of humanistic studies within the medieval Church. The left tympanum depicts the Ascension of Christ. Its surrounding frame contains symbols of the zodiac and of diverse manual labor. The concepts illustrated here are Christ's transcendence of and rule over time, and the value of active physical labor, which, balanced with the contemplative life of learn-

ing, led the faithful toward knowledge of God. The central tympanum shows the Second Coming of Christ. Immediately below the central tympanum, on the rectangular lintel panel, are arrayed the twelve prophets who foretold Christ's Incarnation. (The Last Judgment was represented in the rose window above the façade.)

Flanking the doors of the Royal Portal are the *jamb figures,* whose purpose it is to proclaim the sympathetic concord between Church and state and between the Old Testament and the New, and to publicize the illustrious lineage of the French monarchy. It was common practice in the Middle Ages to portray past or present kings and queens of France as important personages from the Old and New Testament; this custom emphasized that the royal line was a defender of the Church and enhanced it in the public esteem. The implication was that the monarchs of France had inherited the virtuous qualities of the Old Testament kings. These concepts relate to the medieval preoccupation with searching for parallels between the present and the past, the old and the new, the visible and the invisible. The elongated jamb figures, which date from about the mid-12th century, have a columnar aspect, and their form and purpose suggest that they comprise a second wall by which the Church is strengthened and defended. One must pass between the predecessors of Christ on the jambs before reaching him; this sequence signified the old leading to the new. To pass through the door was to move toward God through Christ, for Christ had said, "I am the door. Whoever enters me will be saved." The gallery above the circular window contains the effigies of French monarchs; hence the famil-

112. West portals, Chartres Cathedral. c. 1145–70.

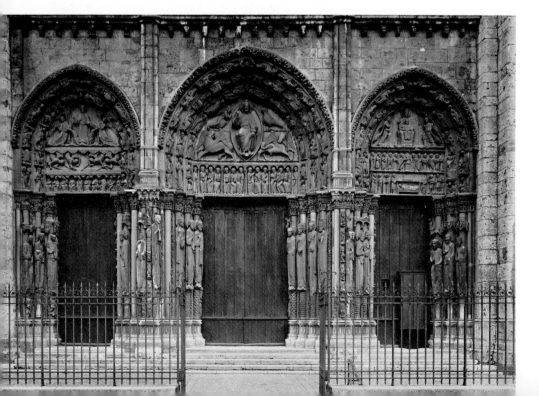

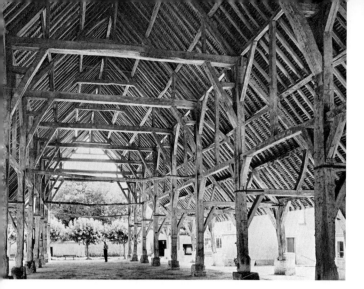

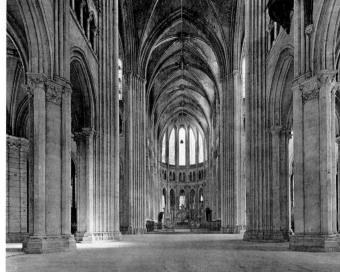

iar name "gallery of kings" (Fig. 110). The gallery itself may have derived from the earlier medieval and ancient palace "window of appearances," from which the ruler presented himself to the public. While the effigies of the kings protected the western front of the church, the bishops' images were presented as defenders of its sides.

THE BAY SYSTEM *Bays* are the rectangular cubelike compartments formed by each vault and its four piers. Professor Walter Horn has traced the origin of the bay system in medieval churches to early medieval secular wooden architecture as used in all-purpose structures, episcopal tithe barns, and houses (Figs. 113, 114). A few timber churches subdivided into bays have survived from the Middle Ages. In many sections of medieval Europe, residences, markets, and barns were structurally interchangeable. Tithe barns, which stored the one-tenth of a crop given to the Church by the faithful, were often of tremendous dimensions, since their construction from regular units permitted structures of great length. The Early Christian basilicas were not composed of bays, and the entrance of this technique into religious architecture, probably during the 9th century, is another important example of drawing upon secular sources for religious architecture. The introduction of the bay into the basilican form allowed the partitioning of the interior into similar units, thereby opening up great possibilities for expressive articulation of the space and for the use of geometrical or arithmetical premises in organizing the interior. The bay system was valued by the cathedral builders because of its familiarity and ease of handling. It met the Gothic need for a multiplicity of parts, and the implications it carried satisfied a feudal and hierarchical intent to express the world of rank. The Scriptures may not have provided sources for specific architectural shapes, but they might be quoted as comfort to the successful architect: "Thou hast ordered all things in measure and number and weight."

THE PLAN AND MEASURE The orientation of the Gothic cathedral was meant to place the building in harmony with

above left: 113. Market Hall, Méréville, France. 1511.

above: 114. Nave, looking east toward the apse, Chartres Cathedral. c. 1194–1221.

below: 115. Plan, Amiens Cathedral.

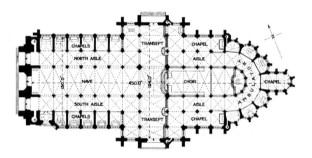

the universe (Fig. 115). The apse, containing the altar that symbolized Christ's tomb, was oriented consistently toward the east, signifying rebirth. The western end was traditionally associated with death and evil; hence it was on this entrance that the Last Judgment was carved. The north was identified with cold and darkness, the world of the old order before Christ. The south signified the new dispensation. In addition to its symbolic value as a form, the long-established cross plan satisfied the demands of the liturgy: it facilitated procession through the nave, provided a large area for the choir east of the transept and ample space for the altar, and made feasible side aisles for accommodating the pilgrims who came to venerate the relics in the chapels. The basic plan of the Gothic cathedral had already emerged in Carolingian times, with the addition to the standard basilican elements (nave aisles, apse, and an occasional transept) of a crypt, choir, and radiating chapels. In medieval times, many private side chapels were added to the apse, indicating the growth in strength of private families, on whom the Church relied for funds and influence. The marked internal divisions of the cathedral's plan signified the hierarchical order and authority of the clergy and its relation to the laity, who were prohibited access to the choir and altar areas.

The plan thereby symbolized the stratification of the Kingdom of God according to rank and responsibility.

Scholars who have taken pains to draw accurate ground plans of medieval churches have found that in certain cases it is possible to discover a kind of scientific organization. One of the trade secrets of the master builder was a module on which he established both the scale and the proportions of a building. Recent surveys have shown that these proportions were often used in the plan and elevation of Gothic cathedrals, bridging what had been thought to be a gap in building practices between antiquity and the Renaissance.

Using any polygon, the master builder worked out the problem of building a tower and effecting the transition from a square base to a round spire. While all builders recognized the use of geometry as an aid to building, there were undoubtedly some who by temperament sought to use it extensively in a way that guaranteed them "true measure" and thereby heightened the cathedral's symbolic analogy to the measure that unified the universe. Otto von Simson argued strongly for the incidence of the latter attitude in his study of Chartres. His findings showed that a basic ratio of 5 to 8 was utilized in the plan and elevation of the cathedral. Von Simson found further support for his argument in the fact that, in the Middle Ages, God was frequently referred to and even depicted as a geometer (Fig. 116). Church literature before and during the time of the cathedrals is rich in religious interpretation of numbers and geometry: to cite but two examples, the triangle symbolized the Trinity, and the square the relation of God the Father to the Son. In mystical numerology, almost any number could be interpreted as revealing some aspect of divinity or dogma. Numbers and geometry were thought to be important means through which the intellect and workings of God could be made intelligible to human understanding. The Gothic designer's taste for enumeration is displayed in sequences of towers, windows, pinnacles, piers, balustrades, arcades, statues, and doors. The parts of the cathedral do lend themselves to counting in numerical sequences, but not to a single grand program of interpretation as numerical symbolism. Selectively, rather than in a literal, quantitative way, the master builder realized and gave form to a vital preoccupation of his time.

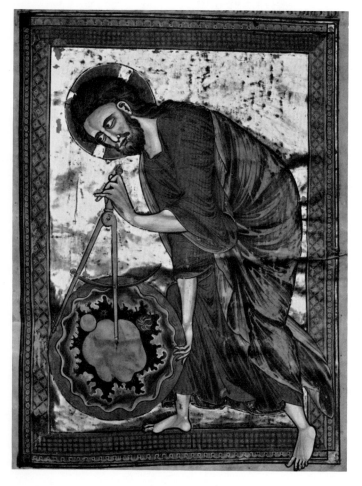

116. *Christ as Geometer, from the Bible Moralisée.* Paris, 13th century. Manuscript illumination, 10 × 7″ (26 × 18 cm). Österreichische Nationalbibliothek, Vienna.

The plan of a Gothic cathedral (Fig. 115) shows the enclosure of the nave and aisles to be a continuous series of points, a regular constellation of piers, which are connected by thin, parallel wall sections. While the medieval architect may not have used the word *space* or even thought of it in modern architectural terms, he had a great sensitivity to the effectiveness of certain distances between walls.

THE INTERIOR AND LIGHT The dedicatory services performed in the sanctuary of the cathedral drew principally upon three biblical sources to link the building to the past. The first was the account of the Temple of Solomon (II Chron. 2–6), the second was the Temple of Ezekiel (Ezekiel 41–43), and the third was the description of the Heavenly Jerusalem by St. John (Revelations 22:10–23). While the Bible does not describe in detail what Solomon's temple looked like, it does record facing of gold and precious gems, and this description may have influenced St. John, who presents the most striking description of the celestial city:

> And the building of the wall of it was of jasper; and the city was pure gold, like unto clear glass. And the foundation of the wall of the city was garnished with all manner of precious stones. . . . And the city had no need of the sun, neither of the moon, to shine in it; for the glory of God did lighten it.

Other biblical sources speak of glass walls, and the increased use of stained glass in the 12th and 13th centuries may have been an attempt to strengthen the analogy between the church structure and the Heavenly Jerusalem. The design of the cathedral's exterior reflected much of the religious and secular history of humanity; the interior was considered the mystical heart of the cathedral, where God's epiphany takes place.

To enter into the initial darkness of the cathedral from the sunlit exterior is to experience the medieval worshiper's sense of proceeding from the material to the celestial world (Pl. 4, p. 56). Perhaps the most exalted efforts of imagination, the most inspired creations, of the Gothic builders are the colored light and the idealized space inside the cathedral. Light and color are both form and symbol, the style and the content of Gothic religious architecture. When the cathedrals had their original complement of windows, the suffused polychrome glow from the stained glass never permitted total revelation of the space and detail, or significantly, of the measure of the interior. There was no comparable spatial or lighting effect in any other type of medieval building. The ranges of windows became luminous walls, and their deep and shifting reddish violet hues dematerialized the interior stonework, as if abstractly signifying spiritual triumph over material things. The space, lighting, and music of the cathedral interior transported worshipers from an environment of familiar sounds, illumination, scale, textures, and dimensions into a world of intricate melodies of sound and color, changing vistas, elusive surfaces, and

heights not determined by their own measure. The quick change from sunlight to darkness impelled visitors to slow their pace in order to penetrate what initially seemed veiled from the eyes. The stained-glass windows were intended to keep out almost all external light and all reminders of the earthly world. Their task was to elevate and enlighten the mind and soul. Seen from the floor of the nave, 60 feet (18 meters) away, the narrative scenes on the windows did not lend themselves to easy reading, and details of the rose window were undecipherable. Within the relative obscurity of the interior, the sonorous reds and blues could be fully apprehended by the eye, and the gold of the altar achieved a finer luminosity.

The brilliance of the original cathedrals, however, was not confined to their stained-glass windows. In the 13th century, Durandus wrote:

> The ornaments of the nave consist of dorsals, tapestry, mattings, and cushions of silk, purple and the like. The ornaments of the choir consist of dorsals, tapestry, carpets and cushions. Dorsals are hangings of cloth at the back of the clergy. Mattings, for their feet. Tapestry is likewise strewed under the feet, particularly under the feet of Bishops, who ought to trample worldly things under their feet. Cushions are placed on the seats or benches of the choir.

It was the light from the windows that inspired the greatest awe and caused theologians to praise the cathedral's "bright" and "lucid" structure. God was perfect light into which no mortal eye could look, and the light the human eye could see was but a pale reflection of God. Light was the source and requirement of beauty, the means by which God manifested His presence and His Creation. Light passing through the windows symbolized the Incarnation of Christ. Light symbolism, inherited from earlier Christian churches, had been known and used in ancient times. The power and uniqueness of its use in the Gothic cathedral inspired the great Abbot Suger, builder of St-Denis, to record his mystical ascension to God by means of meditation on the light of his abbey church:

> Thus when—out of my delight in the beauty of the house of God—the loveliness of the many-colored gems has called me away from external cares, and worthy meditation has induced me to reflect, transferring that which is material to that which is immaterial, on the diversity of sacred virtues; then it seems to me that I see myself dwelling, as it were, in some strange region of the universe which neither exists entirely in the slime of the earth nor entirely in the purity of Heaven; and that, by grace of God, I can be transported from this inferior to that higher world in an anagogical manner.

Gothic Style The Gothic style had its highest expression in cathedrals; by 1400, it had become an international style and had been extended to secular buildings. In addition to the colored light, soaring spaces, and complex perspectives within the cathedral, the distinguishing features of the Gothic cathedral style include the pointed (occasionally

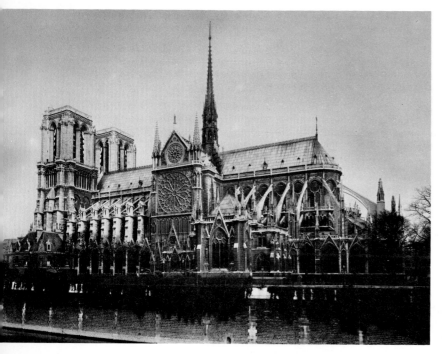

above: 117. View of Notre Dame Cathedral, Paris, showing the eastern or apse end with flying buttresses.

below: 118. Model of Amiens Cathedral showing optical analysis of stress. Reprinted from *Scientific American,* November 1972. Courtesy Fritz Goro.

above right: 119. Vaults at the crossing of the nave and transepts, Chartres Cathedral.

rounded) arch, ribbed vault, and flying buttress, all of which had in some form been known or developed during previous architectural periods. These elements are usually combined in rhythmic numerical sequences. The subordination of components to larger parts and of larger parts to the whole has a strong feudal and hierarchical character. Unlike the organization of the Parthenon, however, no fixed numbers or proportions govern the subordination of all the parts. Like elements and sequences recur in different scales and combinations with other motifs. It is difficult to separate individual parts from their contexts because of their sequential arrangement and the density of the sequential groups; the viewer, nevertheless, is always conscious of looking at the parts of a greater but incomplete whole. Again, unlike the Parthenon, the cathedral's total design cannot be comprehended from any single prospect. Like Gothic sacred music, the composition of a cathedral is polyphonic: it consists in the simultaneous combination of a number of parts, each constituting an individual theme that harmonizes with the others (Fig. 117).

Much of the physical character of the cathedral was undoubtedly determined by the engineering functions of

load and support; the width of the building was probably fixed by what the builder felt he could safely vault and buttress (Fig. 118). It is too limited a judgment, however, to say the architect's sole intent was to raise a structural *tour de force*. Many design decisions—such as the clustering of slender shafts against the main piers, and possibly the ribbing of the vaults (Fig. 119)—were not purely structural but were intended to enhance the whole and increase its visual expressiveness. Much of our experience in entering a Gothic cathedral depends on a rational and an intuitive awareness of the builder's logic, which he went to considerable trouble to make perceptible to the senses. The master builder's rich and complex inventiveness with three-dimensional form, as well as the various adjustments, alterations, additions, and refinements he made beyond a simple concern for the structural imperatives, have occasioned the opinion that in the Gothic cathedral, it is function that follows form.

Why We Didn't Bomb the French Cathedrals The intellectual triumph of the cathedral builders included their insights derived from the analysis of nature, even though they lacked modern scientific procedures for studying structural behavior. The builders used the natural forces of gravity and their understanding of the forces in stone to build the largest space-filled structures in history till then. Master masons recognized that pointed arches would not only make internal spaces soar higher, but they would concentrate the vaults' weight at the corners, where they could be joined to supporting piers. As the vaults grew higher, the stresses they generated were transferred to external half arches, or flying buttresses. Still awesome to engineers is the ingenuity of Gothic builders in countering pressures and stresses of weight and wind loads caused by increased cathedral heights. At Amiens, the dead-weight load of the ceilings is today calculated at 6.1 million pounds (2.7 million kilograms). Seventy-mile-per-hour winds acting on an Amiens bay can generate pressures up to 330,000 pounds (148,500 kilograms). Once thought purely decorative, pinnacles are now known to help stabilize the outside buttresses on which they stand. With the dead weight of the ceilings carried by piers and buttresses, there need be no masonry where there is no stress. The cathedral's walls were thereby voided and opened up to stained glass and marvelous stone tracery. The structure of a Gothic cathedral is thus like that of an arched cage hung from the external structural skeleton.

We didn't bomb the French cathedrals in 1944 because they were crucial to the heritage and identity of France as a nation, and because they stand as one of the great—and irreplaceable—achievements of human intellect. Tragically, the Allies did, however, bomb some of the cathedrals of Germany and Austria, notably those of Cologne and Vienna.

A Secular "Cathedral" of Culture

The cathedral was the cultural center of the medieval city: besides the worship of God, one was exposed to learning, music, theater, and art. Both in purpose and design, the Georges Pompidou Center (Fig. 120), located near the cathedral of Notre Dame in Paris, is the modern secularized "cathedral" of culture. Built between 1972 and 1977 by the architects Renzo Piano and Richard Rodgers (who like medieval architects competed for work outside their own countries), the Center contrasts as dramatically with its surroundings in central Paris as did Notre Dame when it was built. The project was intended as "a live center of information, entertainment and culture," to attract as wide a public as possible. Politically, it was intended to recapture from New York City leadership in the arts. The Center houses a museum of modern art, the first French public library, and centers for acoustical research and industrial design. The forum on the west side is like the parvis or open space before the cathedral, a flexible secular space and playground for the public. Like Notre Dame with its crypt, the Pompidou Center is a multipurpose building underground and above, surrounded by commercial activities, crowded with tourists, and affording spectacular views of the city. As did their medieval predecessors at Notre Dame, Piano and Rodgers "hung" their building from an external steel framework of trusses and braces to allow maximal flexibility in the use of internal space. They described their design as a "giant meccano set" (as such, it is replaceable if destroyed, unlike the cathedral). All sides are visually compelling. The building is "inside-out", with all service elements on the exterior. Piano and Rodgers wanted "scale, transparency

120. Renzo Piano and Richard Rogers. Georges Pompidou National Center for Art and Culture (Beaubourg), Paris. 1977.

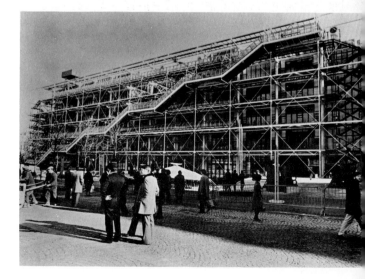

and movement" versus the "static and closed." Not until the 19th-century development of structural steel did architectural engineering progress beyond the Gothic cathedral. In their respective and spectacular ways, Notre Dame and the Pompidou Center articulate humanity's hope for the good life: the former in the hereafter, the latter here and now.

Le Corbusier's Chapel at Ronchamp

The Parthenon and Gothic cathedrals such as Chartres came out of definite established traditions of religious architecture, and their architects sought neither novelty nor original self-expression. In 5th-century Greece and in medieval Europe, the most advanced architecture in terms of design and engineering was in the service of religion. The builders had, in architectural precedent and scriptural sources, a preestablished public basis for attaching symbolic or religious meaning to their architectural forms. In the 19th and 20th centuries, the finest and most advanced buildings in terms of design and structural techniques have been secular enterprises. The problem confronting 20th-century architects has been to evolve, from this generally nonreligious background, an architecture suited to religious purposes, one that would capture the feeling and tone of the sacred. The best modern architects have utilized a personal, empirical approach to each problem rather than depend upon conventional formulas. As a result, they have avoided imitating church architecture—of any period. Those enlightened congregations and clergy who have allowed a gifted architect the freedom to create churches and synagogues appropriate to their time, place, and particular religious beliefs have thus inspired rather than inhibited good architecture. Modern architecture has often proved that a fine religious structure need not presuppose that architect and patron are of the same faith, as was also seen to be the case in the murals of Matisse at Vence (Fig. 93). Common to Phidias, Hugh Libergier, and the modern Swiss-born architect Le Corbusier (Charles-Edouard Jeanneret, 1866–1965) has been their inspiration by noble ideals as communicated in the idiom of their time.

Ironically, Le Corbusier's pilgrimage chapel of Notre-Dame-du-Haut (Fig. 121), located at Ronchamp in the Vosges Mountains of western France, near Switzerland, was inspired many years before when as a young architect he visited the Parthenon. In his notebook, the youthful Le Corbusier set down his thoughts on what constitutes architecture and wherein lay the secret of the Parthenon's power. These ideas were later to have a strong influence on the Ronchamp chapel. Architecture, he felt, is an art of sensation, affecting our visual responses, inciting emotion through the senses, and bringing joy to the mind: "Architecture is the skillful, accurate and magnificent play of masses seen in light." The Chapel of Notre-Dame-du-Haut can be profitably analyzed on this basis.

Le Corbusier's assignment was to crown a hill with a new Catholic chapel intended to replace an undistinguished building destroyed in the war, on a site where, for as long as could be remembered, pagan and Christian places of worship had been located. Surrounded by extensive hills and valleys, the elevated site had no accessible road. A specialist in residences and city planning, the architect had never before designed a place of worship, and he was not a Catholic. He was nevertheless given a free hand in the project by the Archbishop of Besançon—on the premise, one can assume, that architectural genius is nonsectarian. In a letter to the archbishop when the chapel was finished in 1955, after five years of planning and construction, Le Corbusier wrote:

> I wished to create a place of silence, of prayer, of peace, of spiritual joy. A sense of the sacred animated our effort. Our workmen . . . calculators . . . are those who brought this project into being, a difficult project, meticulous, primitive, made strong by the resources brought into play, but sensitive and informed by all-embracing mathematics, which is the creator of that space which cannot be described in words. A few scattered symbols, a few written words telling the praises of the Virgin. The cross—the true cross of suffering—is raised up in this space; the drama of Christianity has taken possession of the place from this time forwards.

In 1910, Le Corbusier had written that "the Parthenon is drama," and this is the special quality that unites the three religious edifices discussed in this chapter, which sets them apart from secular structures in their vicinities. The way in which Le Corbusier achieved his dramatic effect is apparent from the moment the pilgrim or traveler first sights the Ronchamp chapel (Fig. 122). Like the silhouettes of its Greek and Gothic predecessors, the silolike towers and sweeping roof line of the modern chapel reveal their general character from a considerable distance. As one comes closer and mounts the hill, they become partially obscured and are then lost from sight—reminiscent of the ascent along the Sacred Way to the Acropolis or toward the cathedral through the streets of Chartres or Amiens. As one approaches the crest of the hill, the chapel slowly reemer-

121. Le Corbusier. Notre-Dame-du-Haut, view from southeast. Ronchamp, France. 1950–55.

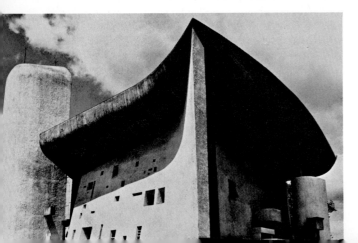

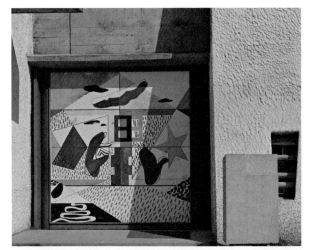

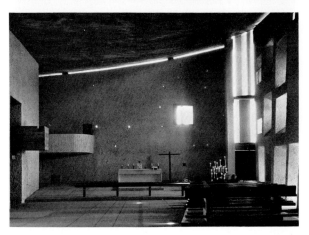

above: 122. Notre-Dame-du-Haut, Ronchamp, distant view.

above right: 123. Notre-Dame-du-Haut, Ronchamp,
view of enameled doors, south wall.

right: 124. Notre-Dame-du-Haut, Ronchamp,
view of interior south and east walls.

ges, like a ship rising above the swelling ground formation the architect had landscaped; and as noted by Le Corbusier himself, its crescent roof echoes a wave. The distant view of Ronchamp, like that of the Acropolis, prepares us for the structure's dramatic exterior, for its brilliant rough white-washed walls with the dark raw-concrete roof fold hovering above. The use of whitewash for the exterior brings to mind the once-brilliant color of the Parthenon, which served to evoke the radiant wisdom and beauty of Athena. Further, it recalls the "snowfall of cathedrals," which were, as Le Corbusier himself noted, originally white. When the summit has been reached, the first view of the chapel is that opposite the huge, brilliantly enameled processional door (Fig. 123) and the nonuniform and randomly placed splayed openings, suggesting the gun ports of a fortress, on the sloping south wall (Fig. 121).

When first seen from the hill's crown, the chapel's form creates a dramatic sensation that evades comparison. Le Corbusier wanted no possible association with any previous architectural style, and although interesting attempts have been made to liken the conjuncture of sloping roof with battered walls to forms found in crude Stone Age architecture, Ronchamp's architectural uniqueness prevails. Its massive and militant aspect, its secretive darkened interior, and the prowlike encounter of the south and east walls evoke quick analogies with fortresses, sacred grottoes, and ships—none of which were consciously sought or intended by the architect as symbolic allusions or design sources. And the soaring, exuberant form seems to combine imaginatively the sweep of the spire, roof, and towers of the Gothic cathedral. Le Corbusier relied on the lucidity of mathematics, not to illustrate theology, but to give form to artistic intuition in creating an indefinable structure molding an indescribable space: "I defy a visitor to give offhand the dimensions of the different parts of the building."

This ingrained resistance to paraphrase and a succession of devices in the structure calculated to astonish the beholder are crucial to the architectural drama. As one instance of this, the massive walls do not bear the load of the roof, which is actually supported by triangularly shaped reinforced-concrete piers imbedded in the rubble-filled walls. Consequently, there is a 4-inch (10-centimeter) space between the roof and the walls, through which light penetrates the interior and which imparts the sense of a floating roof (Fig. 124). Like the Gothic architect, Le Corbusier did not wish to emphasize the engineering aspect of the construction. The dramatic visual and emotional effects devised to induce a meditative and awed mood were most important. The great roof, which seems to be cradled by the towers, bows downward near its center like an enormous trough or

sail catching the rain or wind; this covering is hollow and has external shell layers only about 2 inches (5 centimeters) thick but 7 feet (2.1 meters) apart. Its structure is like that of an airplane wing. The architect attributed the shape and construction to a crab shell picked up on a Long Island beach, which when inverted, gave the idea for the roof.

When first asked to design the chapel, Le Corbusier refused. Only after he had spent several hours on the actual site and felt the impact of the sweeping natural panorama did his first ideas come, and he reversed his decision. He has written of his building "echoing" nature, as if it were some great sounding board for the natural forms around it. The metaphor and the relation to its site are poetical, for the building does not literally illustrate by its formation the architect's comparison.

The pilgrim's spontaneous instinct, after ascending the hill, is to walk around the structure in a counterclockwise direction. As shown in the perspective diagram (Fig. 125), its various curving sides are more unpredictable in character than those of Gothic cathedrals. The great enameled door is used only for processions on special occasions; the north side contains the door for daily ingress, so the newcomer usually walks one and a half times around the building before entering it. On the west, the wall (Fig. 126) is not pierced with apertures, and its curves reflect small interior chapels and the confessionals. From the roof parapet, there issues an omega-shaped waterspout or abstract gargoyle,

from which the rainwater descends and splashes off geometrical shapes imbedded in a concrete pool below. The towers mark the interior chapels, and their vertical concrete louvers, giving texture and rhythmic variety, are permanently fixed. The north wall, though also curved to a degree, has a more markedly squarish character than the south, but its apertures are irregularly disposed in similar fashion, defying Greek and Gothic ideals of alignment and repetition.

The east wall (Fig. 127) is like a large open-air amphitheater or, with its upswept overhanging roof, a great acoustical backdrop for the Word that is given from the external pulpit and for the sounds of the choir and of the Mass performed at the nearby altar. As many as ten thousand pilgrims have assembled for Mass here; in its use for services, this external church is analogous to the Parthenon's west façade and to the medieval cathedral façades used as backdrops for religious plays.

In contrast to the sculptural riches of the Parthenon and the cathedrals, at Ronchamp there is but one piece of sculpture, a 19th-century statue of the Virgin of indifferent artistic quality that survived the bombardment during World War II and is housed in a glass case high up on the eastern wall. The image can pivot so that it can overlook the congregation whether the service is held at the inside altar or in the outdoor amphitheater. Despite the absence of specially executed sculpture, the Ronchamp chapel is in itself the most sculptural or molded of the religious buildings here

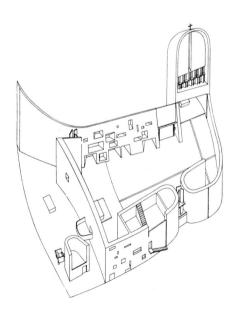

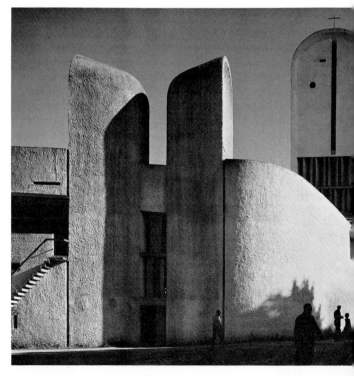

above: 125. Notre-Dame-du-Haut, Ronchamp, perspective diagram.

right: 126. Notre-Dame-du-Haut, Ronchamp, view from northwest.

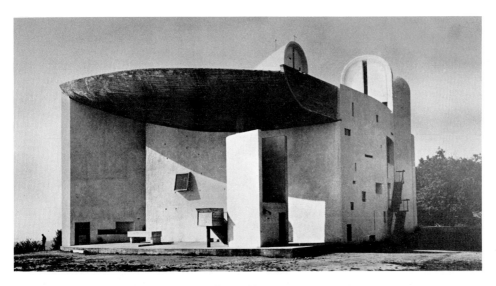

127. Notre-Dame-du-Haut, Ronchamp, view of east side.

considered, and its forms often refute or disguise their structural function. Le Corbusier consciously sought to avoid a building that seemed the product of a technological age, with the rigid rectilinear, repetitive, and invertible forms that have become so familiar in the steel-and-glass boxes of modern commercial architecture. He regarded this chapel as a place of value in a world of fact.

The actual building of Ronchamp was a curious blend of hand labor and modern practice, of traditional and new materials and tools, of intuition and sophisticated scientific calculation. Through the efforts of a small group of versatile laborers of different nationalities under an excellent foreman, the building took shape from materials at hand—such as the ruins of the previous stone church—and from wood, sand, and cement hauled to the hilltop. In the great variety of materials and techniques used in its construction, Ronchamp parallels the cathedrals. Both inside and out, Le Corbusier viewed this work as "sculpture in the round." Pulpits, altars, stairways, and wall recesses and projections were all shaped and proportioned to catch light or to cast striking shadows: "Observe the play of shadows . . . precise shadows, clear cut or dissolving. Projected shadows, precisely delineated, but what enchanting arabesques and frets. Counterpoint and fugue. Great music."

Many modern architects, observing what they feel to be "truth to the medium," refuse to disguise the materials or conceal the structural system employed, thus usually producing a starkly skeletal building. Le Corbusier, however, did not hesitate to cover the rubble and steel reinforcing frames inside the walls with concrete, which in turn was given a rough stucco finish and whitewashed. As he once wrote of the poet, the architect must give us more than "an exercise in grammar."

Within the church there is more to astonish. The chapel does not symbolize a rational, finite world, expressible in numbers or geometry in the way that Greek temples were microcosms of their universe; nor is it an evocation of the Heavenly Jerusalem of medieval society. Neither the north nor the south door is on the axis of the altar, and part of the dramatic effect of the interior scale results from entering on the building's narrow axis. At first, standing in the darkened interior, one has the feeling of being within a fortress or cave, a citadel against death and a secret place for the enactment of religious mystery. Built to accommodate a maximum of three hundred worshipers, the acoustically fine nave brings to mind Le Corbusier's words, "Inside alone with yourself, outside ten thousand pilgrims in front of the altar." Silence and wonder are evoked by the relative darkness, the slope of the concave ceiling and the floor, which diverge upward and downward toward the altar, the absence of familiar right-angle corners or easily recognizable wall designs, and the unfocused illumination that filters in under the roof and down through the deep reveals of the windows, some of which have colored glass.

Outside, the structure is so conceived as to appear to rival the power and grandeur of its natural setting; within, one is struck by its initimate, human scale, so unlike the cathedral's vastness. Le Corbusier and his associates had years before devised a proportional system based on a standing figure with arm upraised, equaling a height of about 7½ feet (2.25 meters). By using this measure and its subdivisions, called the modulor, in his designs, the architect felt he could assure a human scale of reference. Thus he is closer to Ictinus, whose intervals between the Parthenon's columns were a column diameter and the width of a man's shoulders, than to Hugh Libergier.

Despite its massiveness, the south wall of Ronchamp (Fig. 128), one of the great wall surfaces in the history of architecture, does not overwhelm the worshiper by its scale. Its beauty and expressiveness depend upon an inspired and subtle coordination of apertures that all differ in scale, proportion, and angle of their reveals, as well as on the paradox of such a massive wall serving as a kind of sculptural quarry. Within each niche, the windows differ in size, color, or decoration. Often Le Corbusier painted a few words of praise of the Virgin on the glass: "Je vous salue Marie," "pleine de grâce." This wall, like the church as a whole, resists memorization or easy comprehension, which adds to the richness of its design and the appropriateness of its function: to provide an atmosphere for spiritual communion and to enhance the performance of the liturgy, with its attendant mysteries.

Le Corbusier cast off the obvious Euclidean geometric vocabulary and envelope of his earlier work and the symbolic axial symmetry customary in religious structures since the Parthenon and the cathedral. In both its parts and the whole, the chapel at Ronchamp demonstrates a decided asymmetry. Its most dramatic manifestation on the interior is the daring arrangement of the eastern end of the church (Figs. 124, 127). The Virgin's statue is set off to the upper right and balanced to the left by a concentration of perforations in the north wall that looks like a constellation of lights. At first, a great wooden freestanding cross was stationed directly on axis with and behind the main altar. Subsequent transfer of the cross to the right of the altar was a type of stage direction not licensed by tradition or Scripture, but the change was sincerely motivated by a desire to animate and dramatize the otherwise quiescent religious symbols. Perhaps mindful of future criticism aimed at this rearrangement, Le Corbusier wrote, "This focusing is an act of architecture, an act having a real relation to architecture . . . architecture which puts all in order and regulates." The large cross is actually movable and during religious processions can be carried outside to be placed before the second altar. A second cross is located atop the south tower: "Breaking the silence of the walls it proclaims the great tragedy that took place on a hilltop long ago in the East."

Unlike many other modern churches, the chapel at Ronchamp has been well received by pilgrims and by those living in the area. It continues to function successfully as a religious structure. Le Corbusier produced one of the few modern religious structures that have a dignity, power, and beauty that bear comparison with the best of the past. He is a rare reminder that a modern architect, drawing from his own inspired imagination, can meaningfully symbolize the Virgin as well as the dynamo. In Le Corbusier's own words, "I have worked for what men today most need: silence and peace"—and one could add, inspiration.

128. Notre-Dame-du-Haut, Ronchamp, view of interior south wall.

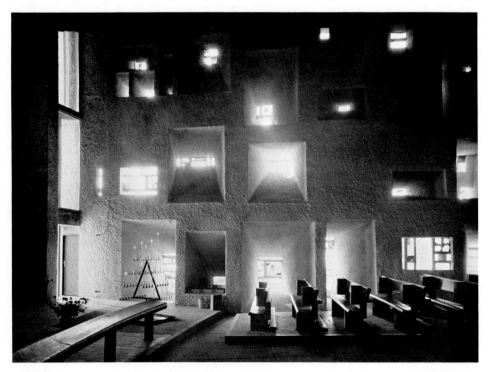

Chapter 5

The Sacred Book

Remote in time, written in a foreign language, difficult to see in the original because of their rarity, medieval manuscripts seem far removed from our life today, but they are the ancestors of *Peanuts*. The modern comic strip has excited people to learn to read, just as medieval religious books did. Both often treat of adventure and violent crime and offer commentaries on life. Both are usually unintelligible unless one can read the accompanying text of "balloon" speech. When, as they lounge under a tree, Peppermint Patty asks Charlie Brown whether he has any "good rules for living" and he advises "Keep the ball low," someone who cannot read English will never know this profound answer to Peppermint Patty's philosophical question. Without a knowledge of baseball vernacular, some historian seven hundred years from now will be as baffled by *Peanuts* as scholars are today regarding certain forms of medieval writing. If one knows Latin and reads the accompanying explanation drawn from the Bible, Revelations 12:1–8, the 13th-century manuscript illustration (Fig. 129) makes sense. It is the ancient prophecy of Mary and Christ, the story before time began of a pregnant woman menaced by a red dragon having seven heads, horns and crowns, who would eat the newborn child destined to rule the world. In the bottom register, St. Michael and his angels fight the war in Heaven that defeats evil. Besides their ties of image to text, manuscript and comic both have writing within the image field; both tell stories in one or successive panels; both avoid illusionistic treatment of space and place and hence are drawn in outline, solidly and brightly colored,

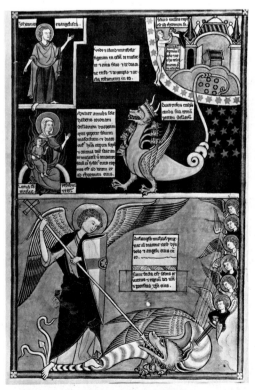

129. *Woman and Child Menaced by a Dragon,*
from the *Liber Florius.* c. 1260. Manuscript illumination.
Bibliothèque Nationale, Paris.

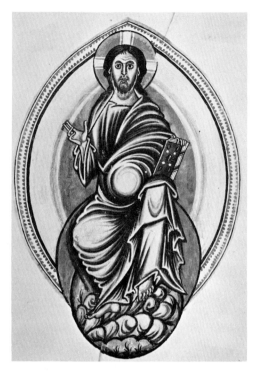

above: 130. *Christ Seated upon the Heavens,* from the gospel book of St. Marien ad Martyres, Trier. Echternach, c. 1000. Manuscript illumination, 11⅛ × 8⅛'' (29 × 21 cm). Landeshauptarchiv Koblenz.

right: 131. *St. Erhard Celebrating the Mass,* from the *Gospel Book of Abbess Uota.* Regensburg, 1002–25. Manuscript illumination, 15¼ × 11'' (39 × 28 cm). Bayerische Staatsbibliothek, Munich.

and relatively flat; both utilize symbolic scale and simple gestures—although those of Peppermint Patty and Charlie Brown are more knowledgeably foreshortened. For clarity and simplicity, Schulz presumably adopted a regressive style that has medieval characteristics. Medieval manuscripts, which bridge the thousand-year interval between ancient writing and the invention of printing, are essential to our knowledge of our culture and its sources.

Significance

Christ is the only god who has the book as one of his principal artistic attributes, and Christianity is a book-oriented religion. Early Christian art includes images of a bejeweled throne on which sacred writings have replaced the figure of Christ. Many medieval Christian images show Christ hold-

ing a gem-encrusted Bible; a late-10th-century manuscript from Trier depicts Christ giving the benediction with his right hand and holding the sacred book with his left (Fig. 130). Christ is shown seated upon the heavens with the earth as his footstool. The extreme formality of the arc alignments and the axial symmetry of Christ comprise for the viewer a mystical and formal manifestation of Christ. Although of great importance, the book is secondary to the conspicuous vortex design in the navel area, possibly a symbolic reference to Christ's divine birth.

Until recent times, many cultures united mineral with artistic wealth. The most skilled artists transformed precious metals into objects for rituals and display. We cast our gold in bars and store them in Fort Knox. The sumptuous type of medieval illuminated manuscript, that used for liturgical purposes, often possessed magnificent book cov-

ers on which were set precious stones, pearls, carved ivory panels, enamels, and elaborate gold and silver work. These covers, treasures in themselves, were often donated by kings or queens. The precious materials were not intended primarily to delight the eyes but rather to create a binding appropriate for the sacred text and to symbolize mystical truths found in the Bible. The color, luminosity, and perfection of precious stones were interpreted as divine attributes or as symbolic of the blood of the martyrs, the Virgin's purity, the radiant presence of God, and so on. In some cases, medieval Christian patrons supplied pagan gems carved in antiquity. The gems were suitably blessed, the pagan spirits exorcised and made Christian.

Medieval artists and patrons did have an aesthetic, or concept of beauty, that was both religious and secular. It was based on skill, and even religious objects could be enjoyed for their own sake; beauty was equated with God. We know from medieval churchmen as well as alchemists that gold was thought to possess magical powers; the color and luster of gold were the most appropriate light symbols of the period. Legends sometimes grew up about the miraculous powers of these richly adorned books, particularly those that had been used by saints.

A superb example of these magnificent book covers is that of the *Lindau Gospels* (Pl. 5, p. 89), which was made about 870, possibly in or near Reims. Within a carefully composed geometrical format, reliefs in bossed gold show Christ on the Cross, grieving angels, and, above Christ's head, the symbols of the sun and moon. Below Christ's arms are the figures of Mary and St. John. The thinness and malleability of gold permitted the working of intricate details on the agitated angels and a handsome relief modeling of the figure volumes.

The key to understanding the reverence accorded the medieval illuminated Bible lies in the meaning of the phrase "the Word." The Gospel of St. John begins thus: "In the beginning was the Word, and the Word was with God, and the Word was God." The words of the Bible were therefore sacred, and it was the task of the artist, when commissioned by royalty, to "clothe" the word in the richest and finest manner of which he was capable. Many manuscripts contained gold or silver writing on purple-dyed parchment. In a German book written at the end of the 10th century are the words, "May the Lord clothe your heart with this book." The precious nature of the materials and the care lavished on the book were in a real sense gifts to God from the faithful.

The profound significance of the word in Christianity helps to explain why illuminated manuscripts made of it a cultural and imaginative object to a much greater extent than had the ancient scrolls and pagan books. No earlier writings demonstrate an ornamentation of letters—specifically, of initials—comparable in calligraphic beauty. While many ancient books were written in handsome script, the manuscripts themselves were not given imaginative treat-

ment. Ancient writing recognized no "privileged" words, except for the names of Roman emperors, and the task of writing was considered to be menial and fit only for slaves. In antiquity, literature was thought of as oral. With Christianity, the practice of writing passed from slaves to the priesthood, and down through the 12th century the development of the book is bound to the history of the monks. Certain words and letters did have special value or emphasis to the medieval monastic scribe, who gloried in the task of transcribing the Gospel that was from and for God and embellishing the text's appearance. For the Christian, the act of writing was in itself sacred. Often a monk was scribe and artist.

Before the 14th century, a medieval Bible was not produced for the private pleasure of a wealthy secular patron. The laity, in fact, did not own hand-illuminated books until the late Middle Ages. Even the royalty who commissioned the most elaborate manuscripts seldom kept possession of the book or appreciated all its intricate beauty. The book was meant not for the eyes of the public but for God and for his servants in the Church.

The sacred book was a privileged object generally owned by a priest, abbot, or bishop, as the representative of the Church of God. The congregation was separated from the book, just as it was remote from the sacred objects on the altar. They submitted to it for their religious instruction, and the Gospels along with the sacraments assumed a central position in medieval Christian life. It is difficult for us to comprehend the dramatic experience of the congregation when the sacred book was revealed during the Mass, at coronations, or for special blessings. The Gothic cathedrals make manifest the complex religious ordering of life and the universe, and the sacred book presents the source and basis of that order. More than a collection of sacred stories, for its medieval public, *the book was Christ.*

In some medieval churches, the Bible was suspended from the ceiling above the altar by gold chains. It was carried in religious processions, and in Eastern churches it was placed upon a throne. Usually the Bible stood on the altar, flanked by candles and incense burners; the candles symbolized the light shed by the Gospels. A sumptuously decorated page of an early-11th-century manuscript made in Regensburg shows St. Erhard with an assistant celebrating the Mass (Fig. 131) under a canopy symbolic of Heaven. The saint is dressed in robes meant to be those of an Old Testament priest; to his right can be seen the sacred book, painted in gold, resting on the altar below a suspended gold crown and next to the Eucharistic objects. When the book was used during the Mass, it was kissed by the bishop; during the reading from it, knights drew their swords as a gesture of their defense of the Scriptures, and the people put down their staffs. During investiture ceremonies, the sacred book was laid on the neck of the candidate, indicating that Christ was the head, the source of authority of the bishop, who was about to assume leadership of the Church.

Production of Manuscripts

Sometime between the 2nd and 4th centuries the book form, or *codex,* evolved; it replaced the papyrus scroll, a single horizontal sheet written in columns and having its ends attached to rods. The ancients had occasionally included text illustrations or technical diagrams in their scrolls; those found in the Egyptian *Book of the Dead* and in Greek and Roman scrolls dealt variously with medicine, science, and mythology (Fig. 132). Roman illustrations were primarily wall or panel paintings reduced to minature size. Between the 1st and 4th centuries, vellum, or calf- or kidskin, gradually replaced the more expensive and less durable papyrus. With the development of the vellum book that, unlike a scroll, opened from the side, the artist was offered an entire page, more or less a framed picture, and the composition could be as elaborate as desired. Painting on papyrus had consisted of ink and watercolor, whereas the qualities of vellum encouraged the use of gouache and richer coloring. Vellum and the book form also permitted painting on both sides of the page without the dangers of flaking experienced with scrolls.

Acquaintance with ancient books was essentially a matter of hearing the text, whereas the Christian book was intended to be appreciated both aurally and visually. The sustained imaginative development of the illuminated book stemmed from decorated initials made by Irish monks in the 7th century and from illustrations made by Byzantine artists of Constantinople and Syria. The earliest West European development of book illumination took place in England during the 7th and 8th centuries, principally in Northumbria, the border region between England and Scotland. During the reign of Charlemagne, at the beginning of the 9th century, illuminated book production accelerated beyond the rate of the preceding two centuries in France and England. Christianity and the book were essential to each other's growth. The Carolingian Renaissance, the efforts of Charlemagne about A.D. 800 to revive aspects of Roman culture, gave the great impetus to illuminated book production in Western Europe. In the 8th, 9th, and even the 10th centuries, there were specific, clearly defined locales and geographical sources for book production—most frequently in monasteries. Thereafter, production became widespread throughout Europe, and during the 11th and 12th centuries, an enormous quantity of manuscripts was produced. After the 13th century, urban centers such as Paris began to rival or surpass the monasteries in the production of decorated books. Many women were involved in book art from the 10th to the 16th centuries, in convents and cities.

A great variety of illuminated books was produced during the Middle Ages. Sacred books consisted not only of the Bible but also of limited excerpts from it—such as the Gospels or the Psalms—calendars of the religious feasts, prayers, blessings, commentaries, sermons, and lives of the saints. Generally these books had ornamented covers, frontispieces, canon tables, or tables of concordances for the Gospels; less frequently they contained a full page devoted to the Cross, portraits of the Evangelists or saints, illuminated initials, and miniatures illustrating the particular text.

The notion of the medieval artist as a self-effacing craftsman resigned to oblivion is a glib one. At the end of many of the books are hundreds of signatures of artists—many accompanied by short prayers, in which the artist asks for praise, avows reverence, and curses the arduous labor that went into the book and the obdurate nature of the tools: "I've come to the end, curse this pen and damn this ink."

Parts of Sacred Books

Dedication Page From a great Bible made during the first half of the 9th century at the Monastery of St-Martin in Tours,

132. Reconstruction of a 3rd century B.C. *Odyssey* roll.

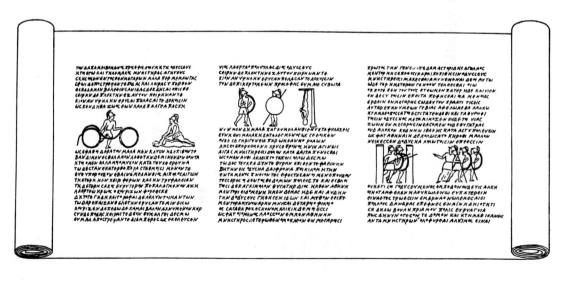

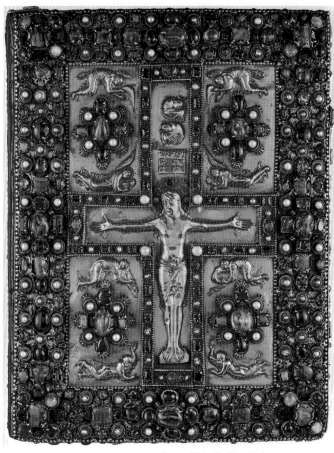

above: Plate 5. *Crucifixion,* upper cover
of the Lindau Gospels. Reims or St-Denis, c. 870.
Gold and jewels, 13¾ × 10½'' (35 × 27 cm).
Pierpont Morgan Library, New York.

right: Plate 6. *Lion of St. Mark,* from the Echternach Gospels.
Anglo-Irish, c. 700. Manuscript illumination.
Bibliothèque Nationale, Paris.

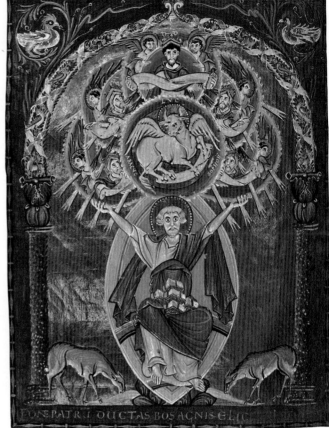

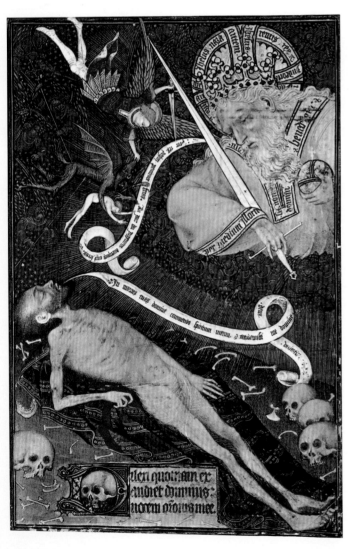

above: Plate 7. *St. Luke,* from the Gospel Book
of Otto III. Reichenau, c. 1000.
Manuscript illumination, 13⅜ × 9⅝″ (34 × 24 cm).
Staatsbibliothek, Munich.

left: Plate 8. The Rohan Master.
Dead Man Confronted by the Lord, from
Les Grandes Heures de la Famille de Rohan.
Early 15th century. Manuscript illumination.
Bibliothèque Nationale, Paris.

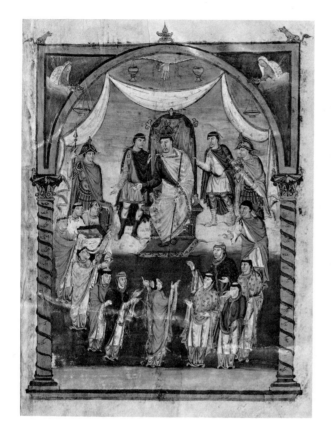

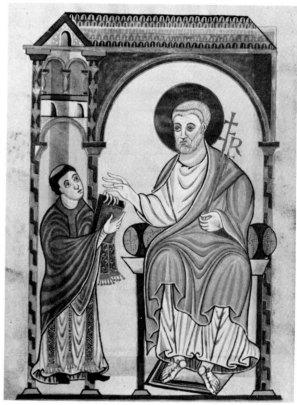

above: 133. *Abbot Vivian Presenting the Bible to Charles the Bold,* from *Count Vivian's Bible.*
Tours, 843–51. Manuscript illumination, 19⅜ × 14⅝''
(24 × 37 cm). Bibliothèque Nationale, Paris.

above right: 134. *Scribe Presenting the Bible to St. Peter,*
from the *Gero Codex.* Reichenau, c. 970.
Manuscript illumination, 9¾ × 7'' (25 × 18 cm).
Hessische Landes- und Hochschulbibliothek, Darmstadt.

France, comes a painting of the Abbot Vivian presenting the finished manuscript to the Carolingian King (Fig. 133). The depiction of an actual historical event is the exception rather than the rule in medieval manuscript painting. The monarch is shown enthroned in a space that suggests the apse of a church. Abbot Vivian and the other monks appear in a semicircle before the King, and the artist ingeniously managed to reveal the faces as well as the backs of some figures. The painting commemorates the King's patronage and the purpose of the Bible as a gift, implying the supremacy of the Emperor over the Church. The artists of the Tours school were deeply imbued with an awareness of rank and protocol and evolved important devices to interpret these themes. Rather than put the spectator on the level with the monks, for instance, and thus obscure part of the Emperor's person, the artist chose an elevated viewpoint that freely

discloses the entire scene. The disposition of the figures and their gestures, as well as the pose of the ruler and his central placement, are governed by the conduct of the ceremony.

Another donation scene is in a German manuscript of the late 10th century known as the *Gero Codex* (Fig. 134). The scribe is seen presenting the Bible he has copied and embellished to his patron saint, the apostle Peter. Peter is shown enthroned, larger in scale than the scribe, and placed exactly beneath an arch of a simple structure symbolizing a church. His greater size is a function of religious value or rank. The separation of the monk's feet from any ground line does not signify that he is "jumping for joy"; in Europe, painting had by this time ceased to attempt any suggestion of spatial depth. The visible world had been reduced to symbols, so there was no need to preserve its three-dimensional qualities. Text and image shaped a common reality. In the absence of a deep spatial setting, the figures acquired a relative flatness and weightlessness. Medieval painting was a symbolic and mystical art whose power did not depend upon duplication of the world of appearances. The fact that the figures overlap the same architecture under which they at first seem to stand or sit is justified on the basis of desirable clarity and avoidance of cutting or segmenting the figure, gesture, or movement.

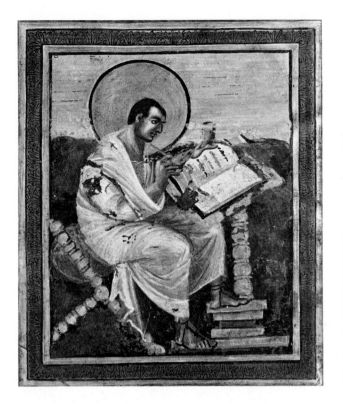

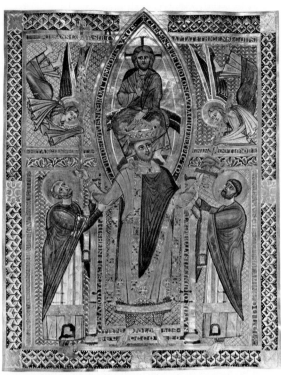

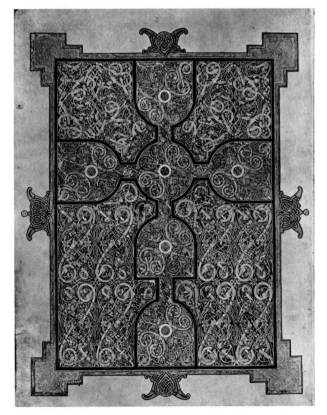

above: 135. *St. Matthew,* from the *Gospel Book of Charlemagne.* c. 800–10. Manuscript illumination, 6¾ × 9″ (17 × 23 cm). Kunsthistorisches Museum, Vienna.

above right: 136. *Christ Crowning King Henry II,* from the *Sacramentary of King Henry II.* Regensburg, 1002–14. Manuscript illumination, 9½ × 11¾″ (24 × 30 cm). Bayerische Staatsbibliothek, Munich.

right: 137. Cross page, from the *Lindisfarne Gospels.* Late 7th century. Manuscript illumination, 13 × 9½″ (33 × 24 cm). British Museum, London (reproduced by courtesy of the Trustees).

Some of the great German manuscripts made for 11th-century Ottonian emperors possess magnificent coronation images for dedication pages, commemorating events in which the book itself played an important part. When Charlemagne's tomb was opened in the 10th century, the body was found seated on a throne, with the coronation Bible (Fig. 135) open on its lap. This Bible was used, in turn, by Ottonian kings at their coronation. A page showing the divine coronation of the German King Henry II, from an early-11th-century sacramentary painted in Regensburg (Fig. 136), depicts the arms of the King being supported by representatives of the Church. In this pose, the King imitates that of Moses during the battle with the Amalekites, when his arms were supported by Aaron and Hur to ensure victory. Seated above the ruler is the figure of Christ, who blesses the new King and places the crown upon his head. The use of gold and brilliantly colored patterns in the background and in the robes, as well as the geometric composition and careful ordering of right and left, upper and lower zones, and center and subsidiary areas, makes this page exciting testimony to the theme of state.

Cross Page During the 7th and 8th centuries, some English and French manuscripts included elaborate pages devoted to the Cross. In the cruciform page of the *Lindisfarne Gospels* (Fig. 137), the form of the Cross is seen against a dense field of interlaces. The conjunction of flowing lines and strict geometry may have been symbolic of the bringing of law to the lawless, for the interlacing has been subordinated to the limits and shapes of each area by strong linear boundaries; the right angles provided by the Cross and its frame are of Roman Christian heritage. This idea is only conjectural, however, for while the monks had converted the Saxons and Celts to the Cross, they themselves had been won to pagan art. Old barbaric notions of magic may have influenced manuscript painting, combined with the artist's desire to make the richest and most powerful presentation of the Cross.

The Cross page died out in the 8th century, but a painting of some two hundred years later (Fig. 138) seems to continue pictorial ideas that were implicit in the earlier works. In a state of mystical trance, St. Valerius makes his gesture of blessing in such a way that his whole body becomes a cross fixed centrally within the frame. Behind the saint, symbolically rendered in dark colors against his light form, are menacing bestial forms. The all-consuming faith and trancelike withdrawal of the saint ensure his survival and final glory in a world of evil. This moving image illustrates the medieval conception of the holy man who must live in a dark and hostile world.

Images of Evangelists In many medieval Gospel books, the Evangelists were portrayed at the beginning of the scrip-

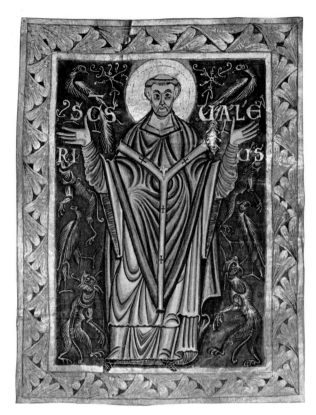

138. *St. Valerian,* from the *Egbert Psalter.* Reichenau, c. 980. Manuscript illumination, 11½ × 7½″ (29 × 19 cm). Museo Archeologico Nazionale, Cividale del Friuli.

tures for which they were responsible. Generally, the Evangelist was shown seated, usually in a side view; his symbol, adapted from the biblical account of Ezekiel's vision—the lion for Mark, the eagle for John, the ox for Luke, and the winged man for Matthew—was often shown above him. In the *Echternach Gospels,* a late-7th-century Irish manuscript, the Evangelist Mark is not shown in person but is represented by his symbol, a lion (Pl. 6, p. 89). Remote from a literal image, this leonine figure presents a strongly imaginative equivalent. The sharpness of the lines that compose the body suggests that the painter may have been influenced by metalwork. The artist may have been unaware of a lion's true anatomy, but he still was able to impart a lively movement and ferocity to the beast. The design of the entire page is one of the most forceful in manuscript art. The geometric frame has an active life of its own, intruding into the central area and playing against the curves of the lion's body. Since the writing partakes of the color and calligraphy of the lion, the whole takes on a powerful consistency and discipline.

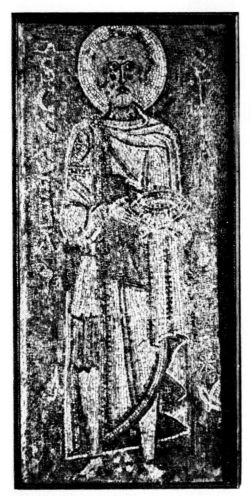

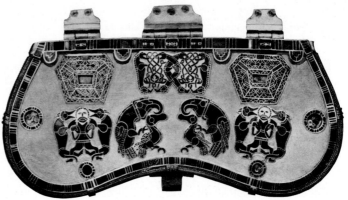

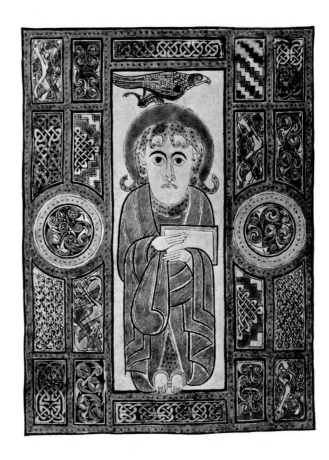

above: 139. *St. Sebastian,* mosaic from San Pietro
in Vincoli, Rome. 7th century.

above right: 140. Purse lid, from the Ship Burial
at Sutton Hoo, England. 7th century.
Gold with garnets and glass. British Museum,
London (reproduced by courtesy of the Trustees).

right: 141. *St. John the Evangelist,*
from Irish Evangeliarium No. 51. 8th century.
Manuscript illumination, 15¾ × 8⅞″ (22 × 29 cm).
Stiftsbibliothek, St. Gall, Switzerland.

Of great importance to Western medieval art was the
convergence in manuscript painting of the figure-oriented
Mediterranean tradition and the nonfigurative style of the
North. A mosaic from Rome and a purse lid from a ship
burial found in southeastern England, both of the 7th cen-
tury, illustrate these divergent traditions (Figs. 139, 140).
The mosaic figure of St. Sebastian, which comes from a
Roman church, shows the robed saint holding a martyr's
crown. His body is largely concealed, but the pattern of

folds suggests the correct location and general proportion
of the limbs beneath, and the position of the feet suggests
that they still carry weight. The face, while lacking in indi-
viduality, is nevertheless convincingly human. The origin of
the purse lid, with its garnet and gold plaques, is not known
for sure, but it came from somewhere in northern Europe,
possibly Scandinavia. Among the plaques are two showing
a figure flanked by two rampant animals, which may or may
not represent Daniel in the lion's den. Figures and animals

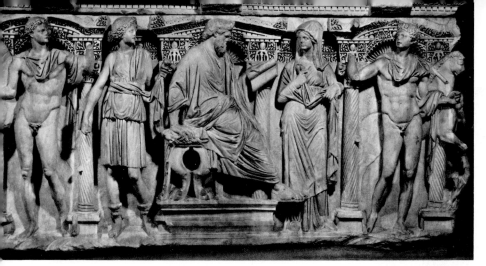

left: 142. *Seated Philosopher,*
detail of sarcophagus from Sidmara,
Turkey. 3rd century.
Marble, length 12′5″ (3.78 m).
Archeological Museums, Istanbul.

below: 143. *St. John,* mosaic
from San Vitale, Ravenna. c. 547.

are greatly schematized into flat, strongly outlined compartments, with no attempt to convince us of the corporeality of the subjects. The beautiful filigree and enamel work and the sureness of the outlining warn us that artistic skill need not presuppose naturalistic anatomical knowledge; these jeweled images were no doubt intensely real to their owner.

The human figure was exceptional in this northern non-Christian art; abstract or animal ornament was far more common. It was in the manuscript art of Irish monks, who had access to illustrated books from Rome and to barbaric art both in England and on the Continent, that these powerful artistic tendencies were joined. The Evangelist portraits provided the initiative for this synthesis in the 7th and 8th centuries. A page of an Irish Gospel book of the 8th century, the *Irish Evangeliarium No. 51* (Fig. 141), gives evidence of the assimilation of the two traditions. In the frame are found the motifs from northern pagan art—knotted forms, spirals, fantastic four-legged animals, geometric shapes, rows of dots. The figure of the saint, still of paramount importance on the page, has had imposed upon it the northern taste for incisive curvilinear outlining, flatness, and arbitrary proportion. There is no impression of a body existing beneath the drapery. Despite the rigid frontality and symmetry of the figure and the lack of flesh color and portrait features, the synthesized saint evokes a powerful presence. Before the end of the 8th century, as a result of the Carolingian Renaissance, the Mediterranean and Classical figure style gained ascendancy.

The artistic origin of the prototypes for the Carolingian Evangelist portraits probably goes back to 3rd- and 4th-century Greek and Roman sculptures and paintings of seated philosophers (Fig. 142). The seated posture had, in antiquity, acquired connotations of the contemplative life, as opposed to the active life. Further sources may have been certain 6th-century Ravenna mosaics (Fig. 143) that depicted the four Evangelists seated and accompanied by their symbols. Unlike the representations of ancient philosophers, who were shown dictating but never actually engaged in the inferior activity of writing, the images created by medieval artists included the inspired, pensive, puzzled,

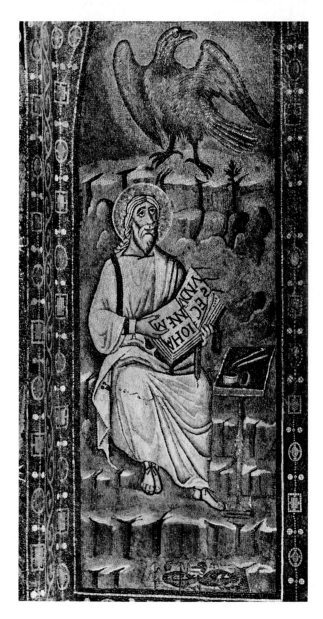

aloof writer, clearly identified with his profession. The artist could associate himself with the Evangelist, since both were involved in conveying the words of God.

One of the most exciting Evangelist portraits in medieval art is from the *Ebbo Gospels* (Fig. 144), produced near the city of Reims in the early 9th century. Nowhere in ancient art does one find so emotional an image. As much by style as by facial expression, St. Matthew is shown as a deeply inspired figure. His inner agitation, as well as the artist's own passionate enthusiasm, can be seen in the energetic drawing and nervous rhythms of the garment—qualities that overflow into the landscape background and the frame. The reserve or detachment of Classical philosopher portraits is unknown to this artist, who charges with excitement his color, composition, and the frame itself.

In contrast, an Evangelist figure (Fig. 145) from an English manuscript of the early 11th century, the *Gospels of Judith of Flanders,* presents a cool and elegant appearance.

below: 144. *St. Matthew,* from the *Gospel Book of Archbishop Ebbo.* Hautvilliers, near Reims, before 823. Manuscript illumination, 10¼ × 7⅞'' (26 × 20 cm). Bibliothèque Nationale, Paris.

right: 145. *St. Matthew,* from the *Gospel Book of Judith of Flanders.* England, early 11th century. Manuscript illumination, 11½ × 7½'' (29 × 19 cm). Pierpont Morgan Library, New York.

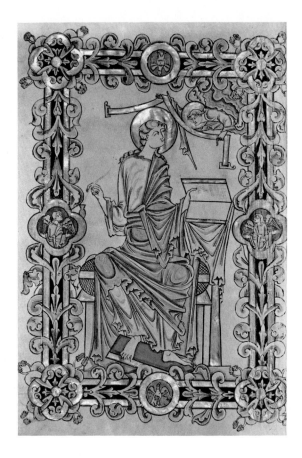

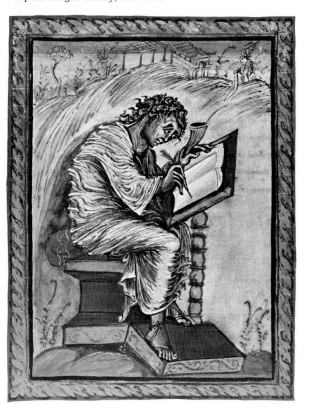

The elongated figure of St. Matthew and his gold-edged garment convey dignity and restrained spirituality. The intricate, active qualities of the garment and frame are more expressive than the man's features or gestures in themselves. Expressiveness in medieval painting was not confined to gestures and facial expressions, for emotional tone was frequently conveyed in the drawing of the entire composition.

An early-11th-century artist working on the island of Reichenau, situated in Lake Constance, Switzerland, produced an image of St. Luke in which the Evangelist is shown in an ecstatic and hypnotic trance (Pl. 7, p. 90). In the Evangelist's lap are five books of the Old Testament, and the prophets of these books are grouped about the Evangelist's symbol. The symbolic meaning of the image lies in the belief that the Old Testament prophesied the coming of Christ and that the Evangelists were the new heralds of his Incarnation. The trancelike state of the saint is appropriate to the time and place in which the image was painted. Monastic reform under the Ottonians called for more intense piety and a renunciation of worldly pleasures. St. Luke is presented as a model of mysticism. The saint and his vision are seen simultaneously, and he appears to be supporting the image, not unlike Atlas holding up the world. The mini-

ature has a mesmerizing effect, with its rigid symmetry extending even to the enormous eyes and fixed gaze of the saint. The arch is a symbol of Heaven, the drinking animals refer to those who are nourished by the Scriptures, and the brilliant gold background transports the scene outside time and place.

Illuminated Initials Writing was a privileged activity in medieval Christianity. The written word came to have great personal value for the scribe, and between the two there evolved an intimate relationship unlike that between the ancient stenographer and his text. St. Augustine, writing of the advantages of the priestly life, spoke of the opportunity to participate in the creation of the Book and the meditation upon the Word. The results of this relationship between scribe and letters can be seen in the great changes in the appearance of writing and the structure of the written page that took place from the 6th through the 9th century. The increased beauty and intricacy of the writing indicates that the scribes did not always worry about easy legibility of the test, which was usually known by heart. The variety of scripts, the scale differences of the lettering on the opening page of a Gospel, the variety of colors, and the addition of elaborate decoration to certain initials created a hierarchi-

above left: 146. Page of the Gospel of Matthew (24:19–24), from the *Book of Kells.* Ireland (?), c. 800. Manuscript illumination, 13 × 9½″ (33 × 24 cm). Trinity College Library, Dublin.

above: 147. Page from the *Lindisfarne Gospels.* Late 7th century. British Library, London (reproduced by permission).

cal structure based on increased valuation of words stressed in prayers, the liturgy, and chants, or stressed because of their location. In contrast to the uniformity of Greek and Roman writing, no two pages of medieval text look the same, as can be seen in illustrations from the *Book of Kells* and the *Lindisfarne Gospels* (Figs. 146, 147). About the end of the 6th century, the initial was separated from the main body of the text; it was enlarged, set out into the margin, and formed with different kinds of lines and colors. The illuminated initial gradually took over the margin of the page and began to intrude upon the text itself, as in the page from the *Lindisfarne Gospels,* until about 800, when the initial began to occupy an entire page. The illuminated initial opened to the artist an entirely new world of meaning. The imagery enhancing the initial is not ordinarily illus-

above: 148. Page with initial *I*, from *Moralia in Job.*
12th century. Bibliothèque Municipale, Dijon.

above right: 149. Page with initial *A*, from Josephus'
Jewish Antiquities. Canterbury, 1100–30.
Manuscript illumination. University Library, Cambridge.

trative of the text, but is the product of pure fantasy. Its justification probably lay in the belief that the magical power of the Word required commensurate visual garb.

During the Romanesque phase of manuscript art, the initial became the outlet for private sentiments of the monk illustrator and for themes that reflected his immediate environment. Scenes of humor, gymnastic movement and aggression, conduct not normally associated with Christianity, often overflow initials and margins of 12th-century French and English manuscripts. One can even find satires on the activity of the monks (Fig. 148), in which the initial I becomes a tree whose upper branches are being pruned by one monk, while below his efforts are being undercut by a brother. Such imagery literally introduced secular activities from the everyday world into the margins of medieval religious art. By the time of Pieter Bruegel in the 16th century, this motif could have served for a painting by itself. Another 12th-century initial (Fig. 149), made in England, is animated by interwoven acts of violence: a knight stabs a lion who claws his assailant's back while swallowing a naked woman holding an imaginary bird; simultaneously a small

dragon bites the knight's leg and claws at the limb of the squire who supports the knight on his back while wrestling with the hind quarters of a lion. The cycle of aggression has nothing to do with the text and exemplifies the artist's freedom to indulge his fancy. The skillful and imaginative nature of this art is shown in the way the letter A is evoked by the placement of the figures whose intertwining is echoed in the vine. The compositional imperative of this and many medieval decorations seems to have been always to connect. Acrobatic figures in these initials may have been inspired by actual performances of jongleurs, the itinerant mimes and singing actors who performed before audiences in courts and towns. The fascination of artists, particularly in England, with oral aggression has been traced to Anglo-Saxon literature and *Beowulf,* with its detailed descriptions of monsters.

The initial had become a kind of safety valve for the artist of a religion that had a strongly prohibitive cast. It gave free play to demonic instincts, tastes for rapacious energy, and the convolutions of labyrinthine forms and processes. This type of art provides an insight into the private torment and uncertainties of medieval religious life, as well as into the delight of the artist in the movement and freedom found in secular life. Comparable license was taken by the medieval sculptors who, in carving the capitals for monasteries and cathedrals, conjured an otherwise proscribed world of monsters and phantoms of irreligious imagination (Fig. 539). It must be remembered that there was no artistic outlet for secular fantasy other than religious

150. Rufillus of Weissenau.
Page with initial *R* and self-portrait. 12th century.
Manuscript illumination. Formerly in Hofbibliothek,
Sigmaringen, West Germany.

nonofficial art, made for the private contemplation of the monks. The most notable medieval manuscript decorated with drawings is the *Utrecht Psalter,* produced in or near Reims about 833 to 835 (Fig. 151). It contains 166 illustrations of the Psalms and thousands of figures and objects, drawn in brown ink on the text pages without the separation of a picture frame. The source of the *Utrecht Psalter* was probably a lost Greek manuscript made centuries earlier. There was great freedom in the copying of the earlier manuscript, and the artists of the *Utrecht Psalter* felt free to infuse their drawings with an energy and impulsiveness not characteristic of the original. The drawings contrast strongly with the uniformity of the script, and the narrative compositions are more loosely structured than are the columns of text. The artists did not interpret the Psalms literally, but often added to them or contrived fanciful metaphors. These drawn figures are much more animated and freely rendered than those found in other painting of the time. The *Utrecht Psalter* comes close to being encyclopedic in its manipulation of figures and groups, and one can perceive the artists' enthusiasm for landscape forms, although a total integration of figure and background is absent. The psalter contains many images of the Mouth of Hell, as seen in the illustration for Psalm 102 (Fig. 151), which were to have a

art. This intimate dialogue between artists and their work, the personal conflicts and choices expressed in it—marginal, to be sure, in medieval art—was to become central in later periods (see Chap. 20). A marvelous self-portrait by the monk Rufillus of Weissenau (Fig. 150) is the most overt expression of these concerns. Rufillus illustrates his tools, his face, his name, and the creatures—both sacred and profane—of his vivid imagination.

Storytelling Miniatures

Beginning in the 9th century, there was a revival of storytelling miniatures, a genre found in late Roman art. Frequently artists had copies of late Roman work from which they worked. Copying, however, did not preclude some display of individuality, and Carolingian copies of now lost Greek and Roman prototypes display important differences from what is known of the original styles.

Not all the decoration of medieval manuscripts was painted; many manuscripts contain outstanding drawings. Such manuscripts were not intended for royalty or for use in great public ceremonies but were what might be called

151. Illustration of Psalm 102, from the *Utrecht Psalter.*
Reims, c. 833–35. Entire page 13 × 9⅞″ (33 × 25 cm).
University Library, Utrecht.

significant influence on later art. The manuscript as a whole was one of the most influential in medieval times because of the quality of its execution and rich variety of subject matter.

Eleventh-century German artists, such as those who produced the *Golden Codex of Echternach* (Fig. 152), rank among the finest storytellers in the history of art. Unlike Roman artists, the Ottonian painters conceived of the entire page as possessing an integral design. The placement of the figures or groups in each zone was carefully thought out in terms of the whole page. The climactic moments of the Adoration of the Magi and the Presentation in the Temple take place on the right side of the page, with the most important figures located beneath symbolic arches. The chronology of the events is rearranged in order to give the most important events privileged locations in the codex. Medieval art permits us to see simultaneously the inside and outside of a building; open doors signify that the action or location of the figures is indoors. The Ottonian artists cre-

ated strong rhythmic designs and broad gestures played off against single-color backgrounds. There is a distinctness and terseness in Ottonian miniatures that recalls the actual narrative style of the Bible.

Versatility and great imagination went into manuscript miniatures such as an 11th-century painting of Christ on the Sea of Galilee (Fig. 153). Through the precarious tilt of the dragonlike ship that seems about to swoop out of the frame, the undulating composition of sail and ship played against the agitated sea, and the anxious looks of the disciples, the painter has realized a spirited image of individuals in distress. The sleeping figure of Christ is the one stable element; even the frame has received impulsively flecked touches of gold.

To the modern viewer, both of the preceding paintings may seem lacking in truthfulness because they do not accord with our views of reality. Medieval painting had its own decided system and logic of conception, which contradicted perception; the visual world was only a reflection of

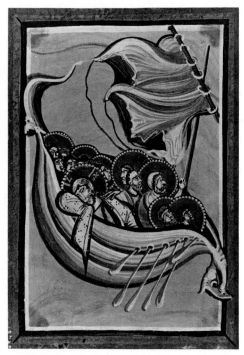

left: 152. *Adoration of the Magi; Divine Warning and Departure;* and *Presentation in the Temple,* from the *Golden Codex of Echternach.* 962–1056. Manuscript illumination, 17⅛ × 12″ (44 × 31 cm). Germanisches Nationalmuseum, Nuremberg.

below: 153. *Christ on the Sea of Galilee,* from the *Gospels of the Abbess Hitda of Meschede.* Cologne, 978–1042. Manuscript illumination, 6⅝ × 5⅝″ (17 × 14 cm). Hessische Landes- und Hochschulbibliothek, Darmstadt.

a higher spiritual reality, and truthfulness in painting was based instead on *fidelity to the Scriptures* or image prototypes in art itself. For example, in such a painting as *Christ on the Sea of Galilee,* the scriptural passage against which it would have been measured reads: "And behold, there arose a great tempest in the sea, in so much that the ship was covered with the waves: but He was asleep." No mention is made of what the ship looked like, so that the artist had license to work from his own idea of an appropriate vessel. There is no horizon line to give depth, and the sea is rendered from above to ensure its identity, just as the boat is presented from the more identifiable side view. The necessity for clear identification, or readability, of forms precluded consistent or convincing perspective at this time. Textual brevity and abrupt changes of events have their visual counterpart in these terse images. The medieval idea of truthful representation of scriptural episodes was to scale the participants large, relative to the picture area, give them simple declarative movements, and establish a minimal

suggestion of surroundings when necessary. There is no shadow in these images because there is no reference to the sun or natural lighting conditions in the Bible, and the brightly colored figures are flat because they move in a two-dimensional world.

Humanity's Fear One of the most dramatic, startling, and visually stunning medieval manuscripts is the *Beatus of St-Sever* (Fig. 154), which was copied in southern France in the 11th century from an older commentary on the *Apocalypse* by an 8th-century Spanish monk, Beatus of Liebana. Without knowledge of the text (Rev. 9:1–11), the viewer will find the imagery horrific but inexplicable. Familiarity with the text explains how the artist synthesized scriptural fact and his imagination. After the fifth angel has sounded his trumpet, the bottomless pit of hell is opened:

> And there came out of the smoke locusts upon the earth. . . . And it was commanded them that they should hurt only those men which have not the seal of God in their foreheads. They should be tormented five months. And the shapes of the locusts were like unto horses prepared unto battle; and on their heads were crowns like gold, and their faces were as the faces of men. And they had hair as the hair of women, and their teeth were as the teeth of lions and the sound of their wings was as the sound of chariots of many horses. And they had tails like unto scorpions, and there were stings in their tails. And they had a king over them, which is the angel of the bottomless pit.

To the medieval person of both the 8th and the 11th centuries, the end of the world was of great concern, and synoptic and powerful images such as these confirmed humanity's fears, and also satisfied its curiosity—one of the great historical purposes of art.

Like the sculpture of the Gothic cathedrals, medieval manuscripts were not entirely devoted to illustrating the Bible. Concern with death and moralizations about human vanity produced many images known as *memento mori* ("Remember that you must die") that were reminders of death. A late-13th-century collection of French poems contains a painting of three living nobles who confront with apprehension their skeletal counterparts (Fig. 155). Although there is some evidence of observation from life and

above: 154. *Satan and His Locusts,* from the *Beatus of St-Sever.* c. 1050. Manuscript illumination, 14¼ × 11″ (36 × 28 cm). Bibliothèque Nationale, Paris.

right: 155. *Three Living Nobles and Their Dead Counterparts,* from the *Recueil de Poésies Françaises.* c. 1285. Manuscript illumination. Bibliothèque de l'Arsenal, Paris.

of death, the figures still straddle the picture frame and exist in a world apart from the viewer. That medieval artists did develop certain devices and skills to make their images more natural can be seen in one of the most powerful and morbid images from the early 15th century in which a dead man is confronted by the Lord (Pl. 8, p. 90). The Rohan Master, as this painter is called today, convincingly depicts the emaciated, naked mortal stretched out on a bone-strewn ground behind the picture frame. From his mouth, in medieval fashion, there issue the words from the Prayer for the Dying: "Into Thy hands I commend my spirit; Thou has redeemed me, oh Lord, the God of Truth." The Lord answers: "For your sins you shall do penance. On Judgment Day you shall be with me." The dead man's soul is fought over by a devil and an angel against a tapestrylike background of blue and gold angels. The Lord's countenance and sword are not comforting, and the painting was intended to evoke awe and fear in the viewer. The simulation of withered flesh and bone through modeling and tinted colors and the receding tilted ground plane encourage an emotional identification with the subject; the spectator is projected into the painting in ways that were not possible in the 13th-century *memento mori*. New demands were being placed on the artist at the end of the medieval period, partially by his acquisition of new artistic devices by which the visible world could more plausibly be rendered, but the break from medieval symbolism and style was slow. The Rohan Master skillfully joins symbol and fact, visible and invisible, mortal and God.

The development of naturalism in medieval art was to bring about the destruction of that which gave conviction to its greatest manuscript art—the visual and textual consistency, the superb coordination of written word and image on a common two-dimensional surface. Changes in patronage and ownership of books were also influential. From the 13th century on, private persons commissioned and collected beautiful books, urban workshops directed by a master painter catered to luxurious secular tastes, and the quality of decorated initials declined as improvisation came to be replaced by repeatable patterns.

A 14th-century page (Fig. 156) painted or supervised by Jean Pucelle (fl. c. 1324), whose workshop was in Paris, attests to the persistence of the medieval coordination of text with decoration. However, in the now receding spatial box where Saul is threatening David with a spear, one sees the beginnings of the breakup of this unity of surface. The rudimentary spatial recession of the architectural setting punches a hole in the flatness of the page, and some of the strongly modeled playful figures in the margins seem to exist in front of the page surface. Pucelle also influenced the development of elegant and amusing margins, including at the left, for example, a dragonfly that was a pun on his name and served as his signature. The marginal byplay between animals and insects is symptomatic of the increasing interest of artist and patron in introducing elements from nature—a development paralleled in the increasing

natural references of the cathedral sculpture of the time. The development of volume and articulation of figures in 14th-century painting derived from imitation of sculpture. The close textual ties of earlier illustrations were gradually being weakened, and a split was developing between the reality of the words and the images.

About a century later, a private prayerbook, the *Turin-Milan Hours* (Fig. 157), decorated probably by the Flemish Jan (d. 1441) and Hubert (d. 1426) van Eyck, reached a point similar to that from which early medieval painting had departed: namely, manuscript illustration based on the style or actual example of panel painting. One of the oldest manuscripts surviving from antiquity with a similar character is the *Vatican Vergil*, dated about A.D. 400 (Fig. 158).

156. Jean Pucelle. *David and Saul,* from the *Belleville Breviary.* c. 1323–26. Manuscript illumination. Bibliothèque Nationale, Paris.

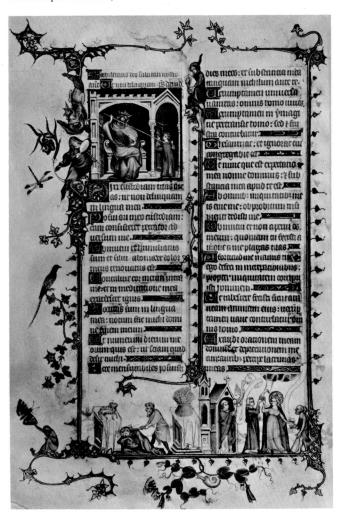

location of the figures, as was appropriate to the sacred eminence and superiority of the subject over the viewer. Part of the democratization of art at the end of the Middle Ages consisted not only of making it increasingly available to more people outside the privileged classes, but also in rendering the world of the painting through the eyes of the living artist and the viewer. Thus medieval painting, once a cross section of the heavenly order, became "a slice of life." The *Turin-Milan Hours* shows the awkward conjunction of the new illusionism and older manuscript decoration. The bedroom scene can be viewed by itself, out of the context of the decorated page, with no loss of interest or completeness. The stylized vines of the margin have a reality that is distinct from that of the flora in the Baptism landscape, just as the highly naturalistic and sculptural seated figure of the Lord differs in style and character from the flat linear outlining of the initial within which he appears. The text paragraph no longer lies on a flat page but seems to intrude into the unframed sky over the Baptism. The calligraphy of the letters is not of the same spirit in which the midwives and objects of the room are outlined.

left: 157. Jan and Hubert van Eyck. *The Birth of St. John the Baptist,* from the *Très Belles Heures de Notre Dame (Turin-Milan Hours).* 1416–20. Manuscript illumination. Museo Civico, Turin.

below: 158. *Seated Philosopher with Figures Paying Homage,* from the *Vatican Vergil.* c. 400. Vatican Library, Rome.

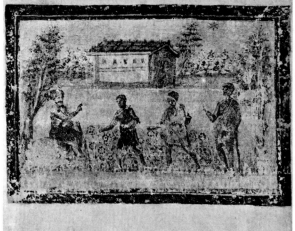

Though of lesser quality, one of its illustrations gives us an idea of how far Roman artists had gone in achieving illusionism—but how short that route seems next to the mastery of Hubert and Jan van Eyck's paintings of a bedroom and landscape. The ancient Romans had never achieved a spatial organization such as that of the Van Eycks, in which the scene is rendered as if from the position of a theoretical observer standing at a fixed point. Contrasting the Flemish and Roman landscapes, one sees that to achieve depth, the earlier artist resorted to a raised viewpoint, whereas the Van Eycks constructed a space from the ground. Eye-level projection would gradually supplant elevation in spatial perspective of the 15th century.

In earlier medieval art, the subject of the painting, not the viewpoint of the onlooker, determined the scale and

These and other developments eventually made the book dispensable to serious painting in the 15th century. A changing conception of reality, new criteria for truth to the natural world, the loss of mystical associations between the Work and the written text, the great demand for more books and the ultimate response of the printing press and movable type, all brought to an end more than a thousand years of great contributions to art by the hand-decorated book. Easel painting and murals were soon to preempt the attention of the best artists and patrons. Van Eyck's rendering of the baptismal scene—a sacrament that means rebirth—prophesies the new life, the new direction, for painting as it began to centralize what had been marginal medieval concerns: the celebration of the time, places, persons, and events of earthly life. The development of the woodcut in the 15th century brought a new and viable synthesis of text and illustration to the printed book toward the end of that century (Fig. 159). The lines of wooden type and the carved wooden block illustration seen against the white page recreated some of the beauty and unity of the earlier painted and calligraphic manuscripts—but not the sumptuous effects, grace, and power that had emanated from the hands that manipulated pen and brush.

From the fall of Rome until the 14th and 15th centuries, the handmade, illuminated, and miniature-filled book was the carrier of much of the most important painting and literary content in Western Christian art. The historical worth and intrinsic beauty of the medieval manuscript are insufficiently recognized by the general public today. We have come to associate great painting with that done on walls and easels, both executed on a fairly large scale; but excellence in art does not depend upon either sheer physical size or the medium the painter chooses. Furthermore, the concept of a literally sacred art—in which the works of art, such as many of the medieval manuscripts, mystically partake of the liturgy—is also alien to present-day thinking and experience. Illuminated medieval manuscripts, precious records of the cultural and civilizing interests of society during the so-called Dark Ages, reveal the varied development in art that prepared the way for Renaissance painting. They give evidence of the imagination and skill with which medieval people came to terms with their religious concerns. Far from being merely a public record of the lives, times, and artistic standards of medieval men and women, this form of painting also furnishes a valuable reflection of their private nature.

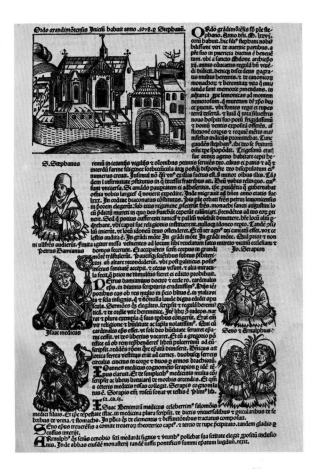

159. Michel Wolgemut. Page from the *Nuremberg Chronicle.* 1493. Woodcut. 14½ × 9¼″ (37 × 23 cm). Private collection.

Chapter 6

15th-Century Flemish Art: The Synthesis of Heaven and Earth

The predominantly secular character of modern Western culture owes much to the 15th century, when art and thought gradually won greater independence from the Church. This struggle influenced the purposes of art and increased the division inherited from the 14th century between the spiritual and secular interests of a broadening patronage and the artists themselves. There was in northern and southern European art a pronounced acceleration of the secularization and democratization of humanity's hope for the good life, which would be irreversible in the centuries to come. God was still to be praised in art, but so were worthy men and women. Continuing concern for the soul's salvation no longer precluded the enjoyment of earthly life, now more perfectly mirrored in art. Both could still be reconciled. The growth of worldly values not only resulted in an increase in secular art, but also infiltrated religious painting and sculpture.

The political freedom, economic prosperity, and intellectual vitality of the great Flemish cities, such as Bruges, Ghent, and Louvain, paralleled that of Florence (Fig. 160). The most gifted artists were drawn to—and were content to remain at—not only such art-minded ducal courts as those of Burgundy, Urbino, and Mantua, but also those cities where patronage came from the nobility, jurists, and finan-

160. *Flemish Town and Gateway,* from the *Chroniques de Charlemagne* by Jean de Tavernier. 1460. Grisaille, entire page 7⅞ × 6⅝″ (20 × 17 cm). Bibliothèque Royale, Brussels.

cial courtiers of powerful dukes, the wealthy clergy, the merchant class, corporations and guilds, rich urban visitors, and the cities themselves. To display their piety or penance, those who gained wealth by fair means or foul commissioned paintings from the finest artists for churches and hospitals, thereby showing peers and public money well spent. For many sponsors the purposes of art were to gain them passports to Heaven and greater earthly status, thereby alleviating their spiritual anxiety and gratifying their vanity. By century's end, these great urban communes would lose their political independence to kings and domestic tyrants. Not until the 17th century in Holland would northern Europe see an art comparably inspired and supported by free citizens and cities.

Religious Art

In Flanders, the development toward a naturalistic style began in book art, as discussed in the previous chapter, but received its greatest impetus from paintings on wooden panels that were to be hung in churches, guild halls, and private homes. Flemish panel painting began to abandon many medieval attitudes and artistic devices for the interpretation of religious subjects. No longer in consistent use were such symbolic attributes as halos and abbreviated settings. Also abandoned was the conventional surface adherence of figures caused by emphasis on strong linear contours and flat, bright colors, which resulted in an absence of depth and of bodily weight and volume. Generic facial types were replaced by strong characterization and individual portraiture. Fifteenth-century northern art rejected depictions of a remote mystical world that viewers could not penetrate or identify themselves or their values with. The celestial sphere of earlier manuscript painting was replaced by what appeared to be a spotless mirror of 15th-century Flemish life. Nonetheless, this art did not abandon religious subject matter but continued to affirm the attachment of artist and patron to Christian beliefs, for the essential objective of the Flemish artists was to garb mystical religious content with the appearance of the visible, material world.

The motives for this shift in northern European art included the desire of artists to present the real world as they saw, touched, and walked through it, as they experienced its beauty with all their senses. The affluent Flemish cities such as Bruges, Tournai, Ypres, and Ghent seemed appropriate incarnations of the Heavenly City, as well as means through which to express sentiments previously excluded from art. Rather than resist the new realism, the Church sought to utilize it for its own purposes. Because of the vivid and familiar aspect that naturalism could lend to invisible holy personages, the new art seemed a strong instrument for the exposition and support of religious dogma, which itself had become more tolerant of the facts of earthly existence. Unforeseen by the Church was the possibility that artists could not negate their private and nonreligious feelings when they painted religious figures and the interiors and landscapes in which these figures moved. Thus the new art of the late Middle Ages was an uneasy synthesis of religious and secular values—with an undertone of conflict that was eventually settled in favor of the latter. This synthesis was the beginning of the disengagement of art and ideas of beauty from religion.

The Use of Symbol The key to the synthesis of this new art was the *symbol*, or the tangible sign of the invisible. Erwin Panofsky, one of the most brilliant scholars to study this period, has pointed out that the artists' and theologians' problem was to disguise religious symbolism under the cloak of real things, thus merging the symbol with empirical probability. Over a thousand years of Christian tradition had to be reconciled with the new naturalism and made into "corporeal metaphors of things spiritual." Use of the symbol was abetted by the fact that all reality came to be thought of as permeated with meaning. The process of looking discerningly at a Flemish painting becomes one of gradual penetration beyond the externals into submerged layers of meaning.

One of the earliest and most important 15th-century Flemish paintings to illustrate the symbolic synthesis of the mundane and theological is the *Merode Altarpiece* (Pl. 9, p. 123), assigned to the Master of Flémalle, who was probably the Tournai painter Robert Campin (c. 1378–1444). In the left panel, the donor, a businessman named Ingelbrecht, and his betrothed kneel in a walled garden. Through the open gate can be glimpsed a street like those of Tournai, where the painting was done. The figure standing behind the open gate has been variously interpreted as the painter himself, a servant, or the marriage broker who arranged the betrothal of the patron and his wife. The garden and its flowers were, simultaneously, traditional symbols of the Virgin and familiar adjuncts of Flemish urban middle-class houses. The partially open door serves to link the left and center panels, but its rendering creates an ambiguous relationship between the donor and the scene to his right. As a result, one does not know if he is intended as an actual eyewitness to the event. The Annunciation scene of the central panel is depicted, for the first time in art, in a fully appointed middle-class parlor. Only the presence of the angel and the small child carrying a cross and hovering overhead on rays of light overtly announce a supernatural event. The child and cross, replacing the customary dove in this Annunciation scene, signify Christ's Incarnation and Passion. In her physical appearance, posture, and surroundings, the Virgin is a middle-class type of the era. Her virtues are those esteemed in both the Virgin and the ideal Flemish housewife. Her sitting on the floor evokes her humility; the immaculate orderliness of the room and its contents alludes to her purity; the reading of the Bible and theological literature signifies her piety and awareness of her role. Meyer Schapiro has observed that what is seen in the

room is a metaphor of what takes place within the Virgin's body. The handsome bronze utensil hanging in the niche above the angel's head refers to the Virgin's body as an immaculate vessel, and the lilies also are associated with her purity. The candle's wax and wick become the flesh and soul of Christ. The absence of flame from the candle and the fireplace is explicable on the basis of the divine light entering the room through the closed window; light had been the mystical metaphor of the Virgin birth for centuries before this painting. In the words of St. Bernard, "Just as the brilliance of the sun fills and penetrates a glass window without damaging it, and pierces its solid form with imperceptible subtlety, neither hurting it when entering nor destroying it when emerging: thus the word of God, the splendor of the Father, entered the virgin chamber and then came forth from the closed womb." If extended, the rays of light would meet the side of the Virgin's head, consonant with the traditional view that she conceived through the ear.

The tiny infant carrying the cross symbolically links the middle panel to the third, in which Joseph is shown (Fig. 161) steadfastly at work in his carpenter's shop. On the table in front of Joseph is a mousetrap, the presence of which is plausible as a household object of cleanliness. Its theological significance, as Schapiro has shown, pertains to Joseph's role as earthly husband of Mary and to Christ's Incarnation. Medieval theologians explained Christ's assumption of the flesh as a plan to redeem humanity from the devil: "The Deity was hidden under the veil of our na-

ture, and so as is done by greedy fish, the hook of Deity might be gulped down along with the bait of the flesh" (Gregory of Nyassa). Joseph was to conceal the birth of Christ from the Devil, and the painter has shown him as neither too old to have fathered a son nor too young to disturb the attitudes of the faithful, but of the right age to deceive the Devil. The mousetrap was a theological symbol explained by St. Augustine: "The devil exulted when Christ died, but by this very death of Christ the devil is vanquished, as if he had swallowed the bait in a mousetrap. He rejoiced in Christ's death like a bailiff of death. What he rejoiced in was his undoing. The Cross of the Lord was the devil's mousetrap; the bait by which he was caught was the Lord's death." The block into which Joseph is boring holes may correspond to a fishing-bait box lid and to spike boards attached to the ankles of Christ in 15th-century Netherlandish paintings of the Carrying of the Cross.

To look at the *Merode Altarpiece* only in terms of its complex symbolism is to neglect Robert Campin's ability as a painter. The panels are marvels of lucidity in the way in which figures and objects impress themselves upon the eye. The composition, like the painting's meaning, is a synthesis of medieval and new devices. The elevated viewpoint and careful alignment of shapes tend to orient them toward the old surface pattern, even while creating the illusion of spaces and objects seen in depth. The objects strewn on Joseph's workbench and the table between the angel and the Virgin manifest this double character. The inconsis-

161. Robert Campin, or the Master of Flémalle. *Joseph,* detail from right wing of the *Merode Altarpiece* (Pl. 9, p. 123).

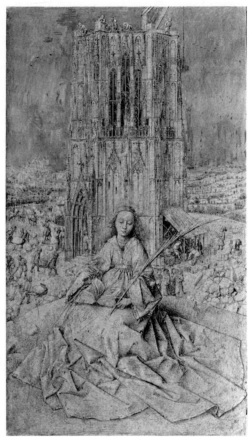

tency of scale permits complete re-creation and visibility of objects shown in depth—for example, the window lattice and shutters and the second trap seen through the window over Joseph's right shoulder. The rightness of the artist's compositional sensibility is understood when we look at the panel as a whole and then mentally move any object slightly out of position. Campin seems to have conceived of the painter's purpose as being both a reconstitution and a more perfect ordering of reality.

Both the Joseph panel of the *Merode Altarpiece* and Jan van Eyck's small painting of *St. Jerome in His Study* (Fig. 162) might easily be taken for secular subjects. It is such painting, in fact, that inaugurated the secular art of genre subjects. Van Eyck, asked by a Roman cardinal to paint St. Jerome, surrounded the translator of the Scriptures with all the accessories that would be found in a scholar's study. The result was a work in which the cardinal could identify himself with the saint as a leader of the Church, while Van Eyck, a man of substantial learning, could pay homage to Jerome's intellectual achievements. Among the objects associated with scholarship are books, writing materials, and the *astrolabe,* an instrument used in astronomy. Van Eyck was a mapmaker and—to judge by the wealth of meaning

in his painting—an avid reader. The painter's craft also necessitated translating the Scriptures into the vernacular of society.

The miniature size of the painting (8⅛ by 5¼ inches, or 21 by 13 centimeters) attests that Flemish panel painting originated in manuscript art. Rarely did Flemish artists paint on the scale attempted by contemporary Italians in their mural art (see Chap. 7). Painting such as Van Eyck's gains much of its effect from its modest scale, which demands close viewing of its microscopic detail. The compositions do not consist of large, easily grasped relations between shapes. The sense of a precious object imparted by the St. Jerome panel resides in its small, concentrated areas of saturate luminous colors and in the hard brilliance of surface stressed in both technique and content.

When Van Eyck placed the human figure against a background of architecture and landscape (Fig. 163), he was able to adapt the medieval habit of showing the principal figure on a large scale, without forsaking his explorations of illusionism. St. Barbara is shown before the tower in which she was to be imprisoned by her pagan father for her Christian beliefs. The plausibility of her size was achieved by seating the saint on a rocky ledge in the foreground, where

she reads from a book in her lap. The middle ground falls away sharply, and to her right and left can be seen workmen bringing materials or shaping them for the churchlike tower under construction. Both the subject matter of the panel and the panel itself demonstrate how artistic projects were carried out in the 15th century. The tower's construction is being supervised by a foreman who stands on a block at the right and is perhaps arguing with a workman atop the edifice standing with arms akimbo near a hoist. The shed near the foreman is where the stonecutters or sculptors worked, protected from sun and rain. The logistics of quarrying, transport, cutting, carving, stonemasonry, and the mechanics of construction are presented in detail against a gently swelling landscape to the right and a distant city to the left. It was a visual reminder of the medieval view that every Christian was a builder.

In this brush drawing, Van Eyck has also given us wonderful evidence of how he prepared his paintings, even though the minute details of the St. Barbara panel would suggest that it was not meant to be carried further. Panel paintings were begun by carefully preparing and joining the wood segments together. Plaster or gesso was then applied to the surface and carefully smoothed. Upon this prepared surface, the artist would then make a drawing, which served as the guide for the later building up of layers of color and glaze. In the St. Barbara panel, color was applied only to the sky area. Desire to re-create the brilliance as well as the detail of the visible world was probably the strongest incentive for Van Eyck's improving on the old medieval technique of superimposing layers of linseed oil over tempera painting; Van Eyck and Robert Campin combined their pigment with oil rather than with egg, as in tempera painting. The glazes intensified the color and, because the medium dried slowly, permitted reworking and admixture of colors. This technique was ideal for the simulation of light and its reflection. The oil-treated surface was semitransparent, and natural light that fell on it was partly repelled and partly absorbed, further adding to the jewellike quality of Flemish art. As is apparent in a painting such as Van Eyck's *Madonna with Chancellor Rolin* (Fig. 164), and also in the St. Barbara panel, all the shapes were first drawn on a plaster ground. Tints of hand-ground mineral or earth color were applied directly to the gesso and then in layer after layer of glazes, so that the color acquired depth and volume as well as luminosity. Color as a property became less separable from the figures, and objects seen in depth tended to

opposite left: 162. Jan van Eyck. *St. Jerome in His Study.* c. 1432–41. Oil on panel, 8⅛ × 5¼″ (21 × 13 cm). Detroit Institute of Arts (purchase, City Appropriation).

opposite: 163. Jan van Eyck. *St. Barbara.* 1437. Brush drawing on panel, 12¾ × 7¼″ (32 × 18 cm). Koninklijk Museum voor Schone Kunsten, Antwerp.

right: 164. Jan van Eyck. *Madonna with Chancellor Rolin.* 1436. Oil on panel, 26 × 24½″ (66 × 62 cm). Louvre, Paris.

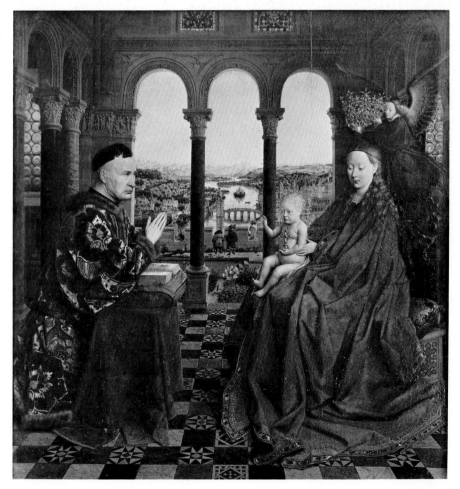

left: 165. Detail of Figure 164.

right: 166. Rogier van der Weyden. *Mary Magdalen*, detail of the *Descent from the Cross* (Pl. 10, p. 123).

below: 167. Hugo van der Goes. *Adoration of the Shepherds*, center panel of the *Portinari Altarpiece*. c. 1476. Oil on panel, 8′ 3½″ × 10′ (2.53 × 3.05 m). Uffizi, Florence.

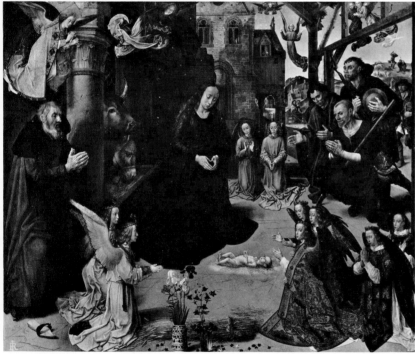

lie less consistently on the painting's surface than in earlier manuscript art. Van Eyck sought the illusion of three-dimensional sculptural roundness to increase his painting's verisimilitude to nature. He had also been a painter of stone and wood sculpture, which at the time was more naturalistic than painting.

Van Eyck's passion for exactitude and the virtuosity of his painted illusions could suggest an unimaginative art. Such criticism would fail to comprehend that more than manual dexterity is required to make on a two-dimensional surface a convincing representation of space, light, and three-dimensional objects. Let us consider, for instance, the subject and composition of the *Madonna with Chancellor Rolin*. Imposing figures inhabit a spacious and luxurious interior, beyond which extends a seemingly infinite panorama. Though empirically verifiable in every detail, the scene in its totality existed wholly in the artist's imagination. To prove his spiritual merit or possibly to fulfill a wish, the Burgundian chancellor commissioned for himself an audience with Christ and the Virgin in the heavenly cha-

teau. Though inspired by archaeological sources that Van Eyck incorrectly associated with Christ's lifetime, the final design of the interior has no definite earthly counterpart. The enclosed flowering garden seen through the colonnade is a metaphor for the Virgin and her purity. Two unknown and fascinating figures look out over a crystalline river that divides an earthly city on the left (identified as Maastricht) from the celestial metropolis on the right. Christ was the divine link between Heaven and earth; thus the benedictional gesture of his hand (Fig. 165) appears tangent to the symbolically seven-pillared bridge between the two cities.

Van Eyck's art was activity in sympathy with God's creation of the world, and the reality created in the painting is at once based on, yet remote from, his own. The painter has established himself as the sole arbiter of this reality—selecting, rejecting, refashioning what is to enter it. All material substance has been painstakingly and lovingly explored, given a heightened surface materiality, and fixed into a complex order. The painting contains a thousand glittering points to be discovered and enjoyed. To be shared with the painter is his wonder at the traits of optical perception: for instance, the fact that small objects near the eye may block out distant objects of far greater magnitude behind them or the fact that the eye cannot take in at once all that exists within the sweep of its gaze. Thus the wealth of a lifetime's accumulated visual and intellectual experience is given a new imaginative cohesion on a rectangular surface measuring but 26 by 24½ inches (66 by 62 centimeters).

To comprehend Van Eyck's re-created world, the viewer is always obliged to commence with the most minute detail. The face of the 76-year-old chancellor, for example, betrays his hard and perhaps questionable career; and Van Eyck has reconstructed the man from his very pores. There is a hint of visual wit in the painter's having made the distant obdurate hill adjacent to the chancellor's brow, while above the head of Christ are placed the spires of the Heavenly Jerusalem, forming a kind of halo. Although Van Eyck was doubtlessly aware of the fallibility of his patron, this painting—like all his art—is a radiant expression of optimism for the order of life, of faith that because of Christ's sacrifice the earth will again know Paradise. Van Eyck respects earthly rank as a counterpart of celestial authority, and his imagery is aristocratic in form and content. Van Eyck and the Master of Flémalle reflect the divergent tastes and conflicting attitudes that existed among the aristocracy and the middle class of their time. The domestic Virgin in the *Merode Altarpiece,* for example, cannot be interchanged with the regal Madonna of Chancellor Rolin.

More man-centered in the expression of his religious sentiments than the Master of Flémalle or Van Eyck was the Flemish painter Rogier van der Weyden (1399/1400–64). He opposed their fairly equal focus on figures and objects, and in particular Van Eyck's pantheism. Van der Weyden's *Descent from the Cross* (Pl. 10, p. 123) is unusual in Flemish painting—it assigns the entire weight of expression and composition to the figures alone. To ensure its powerful and immediate impact upon the viewer, the painter compressed the action within a shallow boxlike space much like the sculptured altarpieces of the period. His intent was to provide an image for pious meditation through which the worshiper could empathize with the suffering of Christ and his anguished followers. The subject is the lowering of Christ's body from the Cross, and the theme is one of passion and compassion. The artist's purpose has been best summarized by Otto von Simson in a fine study of this painting: "The Christian artist must seek to approach God through the affect of compassionate love. He must seek to awaken these affects in others in order to help establish the bond of similitude between God and the contemplator of His image. This is the religious mission of the emotionalism of all Gothic art."

The Van der Weyden painting grows out of the compassionate emphasis on the tragic in Christianity that had arisen at the end of the Middle Ages. The critical response of the worshiper's identification with the grief-stricken followers of Christ hinged upon lifelike rendering. It is not only their outward physical appearance that the painter conveyed with such power, but also the refined range of their emotional states. This range includes varying degrees of active and contemplative participation in the moment—from the deathlike swoon of the Virgin, who mystically shares the death of Christ in her role as intercessor for humanity, through the levels of awakening comprehension of the event seen in the figures supporting Christ, to the full capitulation to grief of the Marys, and finally St. John's calm resignation as he seems to foresee the consequences of Christ's death. The bodies as well as the faces make transparent the protagonists' inner state. At the right, for instance, Mary Magdalen (Fig. 166) is caught in a suspended movement that is clearly the result of a total loss of self-consciousness. The emotional and psychological unity of the participants is marvelously embodied in the composition itself; the placement of and alliteration in the limbs join the whole in forceful rhythms. This complex unity was essential to the intent of Van der Weyden—to induce the whole congregation to share in the mournful experience.

As we have seen in the illustration from the *Gero Codex* (Fig. 134) and in Rogier van der Weyden's portrait of himself as St. Luke drawing the Virgin (Fig. 8), artists in both early and late medieval times were not averse to portraying themselves in religious compositions. The Van der Weyden self-portrait was an affirmation of the esteem in which contemporary Flemish ecclesiastical and secular patrons held the art of painting. While such inclusion could be interpreted as an exercise in pride, the painter actually represented himself in the role of worshipful servant to the Mother of God. Even when the artist did not specifically reproduce his own features, his painting might constitute a self-portrait of his nature. The *Adoration of the Shepherds* (Fig. 167), executed by Hugo van der Goes (1440–82) and commonly

168. Detail of Figure 167.

known as the *Portinari Altarpiece,* is characterized by explosive tensions and alternate strains of serenity and turbulence that are revealing in the light of the artist's withdrawal to a monastery and his depressions and suicidal tendencies. The painting's large scale and ambitious panoramic composition rivaled the greatest works of such predecessors as Jan van Eyck and Rogier van der Weyden. Van Eyck's amplitude of setting and particularization of detail are present in the *Adoration,* as is Van der Weyden's insistence upon strong emotive qualities. Van der Goes' painting is, in fact, a magnificent summation of Flemish achievements, climaxed by the bold intrusion of the painter's personality.

Van der Goes mined the symbolism of his painting from the rich deposits of theological literature. Joseph is given prominence by being placed in the left foreground in front of a large pillar that is part of a ruined stone edifice. Since he represented stability both in the painting and in Christ's earthly family, his connection with the sturdy pillar is appropriate. He kneels and pays homage to the scrawny newborn babe who lies in the center of a circle formed by attendant angels, shepherds, and the Virgin. The pillar may relate to the apocryphal tradition that the Virgin leaned against it during the night when she gave birth to Christ, a description analogous to the birth of Buddha. Van der Goes used the medieval device of scale discrepancies between the figures to set angels and mortals apart.

There is no shed for the Christ child, but the ruined stone setting relates to the decay of the synagogue and the changing of the old order for the new that is signaled by the Nativity. Panofsky has shown that the vacant-looking building in the background bears the insignia of David, indicating that it is his house. The sheaf of wheat in the center foreground alludes to Bethlehem, "the house of bread," and to the words of Christ, "I am the bread which came down from Heaven." The flowers—lily, iris, and columbine—refer to the blood of the Passion, the pain that pierced the Virgin's heart,and her grief and sorrow.

The ox and ass, standing behind the manger in the stone building, had radically different connotations in medieval times, derived in part from a sentence in Isaiah: "The ox knoweth his owner, and the ass his master's crib." This was taken to mean that the ox recognized the Savior, while the ass did not. The ass was often used as an anti-Semitic symbol referring to the synagogue, which was also at times personified as a woman riding an ass, In older images, the ass was shown eating, biting its tail, or tearing at the swaddling clothes, indicating its own stupidity and, by implication, that of the Jews for failing to recognize the Savior. Van der Goes has shown the ass eating the straw of the manger. The ox is sometimes shown as engaged in a tug-of-war with the ass for the swaddling clothes, protecting the babe with its horns, or even reverently down on all fours before the child, identifying the event as a full epiphany.

Van der Goes has given the shepherds (Fig. 168) great importance in his painting, paralleling the magnified roles

169. Hugo van der Goes. *The Death of the Virgin.* c. 1478–80. Oil on panel, 4'10'' × 4' (1.47 × 1.22 m). Musée Communal, Bruges.

they began to play in the mystery plays, in which dialogue was fabricated for them because of their popularity with the audience. Van der Goes treats the annunciation of the Nativity to the shepherds and their appearance at the child's side in synoptic fashion, for the annunciation is represented as taking place simultaneously on a hill in the right-hand corner of the panel. The faces of the shepherds are a striking contrast in excitement and ascending levels of comprehension as they realize what they are witnessing. They are given an intensity of expression that borders on the fanatic. This study in psychological reactions to a situation, while occurring in a religious context and as a more or less marginal concern within the broad composition, anticipates later art, which extracted such moments from biblical incidents and described them in purely secular situations (Pl. 19, p. 176). When the *Adoration* was sent to Italy after its completion, it elicited great interest and proved influential in subsequent Italian art.

In what may have been his last painting before his death in 1482, Van der Goes further developed his characterization of those participating in great moments of emotional stress. In the *Death of the Virgin* (Fig. 169), the assembled disciples are shown in the pathetic attitudes of a shared human grief and yet distinguished in ways appropriate to the nature invested in each of them by the painter. Compressed within the confines of a small room are not only mourners and the deceased but also Christ as he descends with angels to receive the Virgin. A brilliant glow emanates from him and penetrates the darkened interior, and an open space has been left for the viewer at the Virgin's bedside. Van der Goes was among the first to elevate the humble and ugly in art by showing them as possessing true faith and enlightenment. Such dedication to the lowly perhaps accounts in part for his renunciation of early personal success and of the pleasures of secular life for a monastic brotherhood. Deep feelings of guilt concerning the adequacy of his devotion and a conflict between his worldly interests as a painter and his concerns as a strongly ascetic man were thereafter to cause severe mental problems and illness. The

intensity of feeling displayed by his subjects and the rigorous pictorial construction from which we, as onlookers, cannot detach ourselves convey Van der Goes' obsession with overwhelming the beholder's senses and reason with the emotional stress of witnessing the miraculous. Van der Goes' mental condition was a case in which the synthesis of heavenly and earthly values could not be easily or finally achieved—he suffered an affliction by conscience that was known to many at the end of the Middle Ages.

Secular Art

A considerable number of secular paintings, sculptures, and decorative objects were made by Flemish artists at the end of the Middle Ages; regrettably, almost all have been lost. We know that Van Eyck and Van der Weyden executed hunting and bathing scenes and that Van der Goes, before his retreat from public life, had been employed in such commissions as the decoration of the sails of a ship. Just as the great courts and the wealthy city burghers sponsored the development of religious panel painting, so did they fund extravagant secular projects for which the finest artists were expected to contribute their services. Court artists or town-dwelling painters such as Van Eyck lent their skills to the painting of sculpture, furniture, and carriages, and to the designing of costumes, shields, banners, and the costly adornment of private fleets. In 15th-century Europe, art still served mundane purposes, and it was not considered demeaning for an artist to paint utilitarian objects.

In the view of Johan Huizinga, late medieval mentality craved to turn every artistic idea, sacred and secular alike, into a precise image; this "crystallizing tendency" of thought, "which encouraged and supported naturalism in arts," did not anticipate the Renaissance, but rather closed the medieval period. A brilliant demonstration of Huizinga's thesis is seen in two Flemish objects from this period: an aquamanile (Fig. 170), which dispensed either wine or water to wash the hands, and a copper plate (Fig. 171). One of the favorite stories at the end of the Middle Ages con-

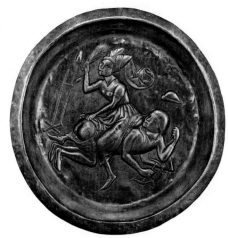

left: 170. *Phyllis Riding Aristotle.* South Netherlandish or French, c. 1400. Bronze aquamanile, height 13¼" (34 cm). Metropolitan Museum of Art, New York (Robert Lehman Collection, 1975).

right: 171. *Aristotle and Phyllis.* Netherlandish, c. 1480. Copper, diameter 20" (51 cm). Metropolitan Museum of Art, New York (Irwin Untermeyer Collection, 1964).

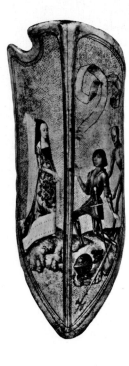

left: 172. Parade shield.
15th century. Paint and gilt,
height 32" (81 cm).
British Museum, London
(reproduced by courtesy
of the Trustees).

below: 173. Petrus Christus.
St. Eligius. 1449. Oil on panel,
38½ × 33⅝" (98 × 85 cm).
Metropolitan Museum of Art,
New York
(Robert Lehman Collection, 1975).

below right: 174. Pierre the Fleming.
The *Burghley Nef.* c. 1482–83.
Nautilus shell mounted in silver,
gilded; 13⅝ × 8" (35 × 20 cm).
Victoria & Albert Museum, London
(Crown Copyright).

cerned Phyllis, the mistress of Alexander the Great, who
subjugated her lover's teacher, Aristotle. In the objects
shown here, the metalsmiths have given visual form to the
idea that woman has the power to overcome the wisest of
men. On the aquamanile, Phyllis accomplishes this by
physical force; on the copper plate, by guile in the saddle.
Both objects were for the nobility's tables and were ances-
tors of the modern "conversation piece." Such themes from
antiquity also remind us that not only the Italians, but edu-
cated people of the North as well, were interested in the
subjects of antiquity.

Another example of this secular art is a hand-painted
shield used on parade occasions and done by an unknown
artist (Fig. 172). On the shield of gilt and paint is depicted a
knight kneeling before a beautiful lady. Behind the knight,
in the position of a second or a benefactor of his profes-
sion, is the figure of Death. The heraldic emblems used in
like contexts in the earlier Middle Ages had by then given
way to chivalrous scene painting.

The Flemish veneration of the craftsman, joined with the
purpose of homage to a saint, is seen in a depiction by
Petrus Christus (d. 1472/73) of St. Eligius, patron saint of

above: 175. Mask. c. 1499. Bronze, lips and throat pierced with holes for a ring now disappeared; $9\frac{7}{8} \times 5\frac{1}{8}''$ (25 × 13 cm). Stadsbiblioteek, Veurne, Belgium.

right: 176. Gérard David. *The Punishment of Sisamnes.* 1498. Oil on panel, $5'11\frac{5}{8}'' \times 5'2\frac{5}{8}''$ (1.82 × 1.59 m). Musée Communal, Bruges.

goldsmiths, in his shop as he waits upon a young couple about to be married (Fig. 173). The materials of his craft are displayed on shelves; and among the other objects, the mirror, which permits us to see the street and passersby, may also have been a device to thwart the Devil, who feared losing his image. In this, one of the earliest significant paintings devoted to the subject of business, Christus ingeniously created a type of marriage and professional portrait and also treated a whole wall as a still life. Moreover, it is a forerunner of the numerous paintings concerned with events enacted at or near a table (see Chap. 10).

Just how important jewelers and metal sculptors were to secular Flemish society is recorded by contemporary chronicles. The finest painters and craftsmen were employed by Charles the Bold for extravagant secular undertakings. One of the most famous spectacles was the wedding of Charles to Marguerite of York, the sister of the English king, in July of 1468, described by Baron van der Elst from chronicles of the event:

A forty-foot tower was set up, painted with heraldic devices and adorned with mechanical boars, wolves, and donkeys, to be operated by puppeteers so that they danced and sang. . . . Inside the hall was lighted by bronze chandeliers shaped like castles. They were surrounded by artificial forests, where wandered extravagant Gothic monsters. . . . A table was set for the bride and groom and for the most important guests under one canopy. Down the center stretched a huge lake framed in silver. In its waters floated thirty ships, each so marked as to represent a territory of the Duke's domain. Some of them were seven feet long and rigged like the galleons that dropped an-

chor . . . before the port of Bruges and Damme. This marvelous fleet of carriers brought food to the guests seated around the table.

Small but magnificent, a silver ship, by the Parisian goldsmith Peter the Fleming, survives to give witness to the dazzling display of late-15th-century banquets (Fig. 174). Known as *nefs,* such ships were set as status symbols next to the host at dinner. The hull of the *Burghley Nef* is a nautilus shell mounted on a recumbent siren. A salt cellar in the poop reveals the work's practical purpose. Though fantastic below the gunwales, the upper part of the ship corresponds to the latest design of the time. A crew of tiny figures mans the silver rigging, sails, and guns, while at the foot of the main mast Tristan and Isolde play chess.

The Flemish concern for law and punishment touched art in many ways. Convicted prisoners in some cities were forced to pay the expense of having bronze sculptures made of hand or head by which to advertise to the public the nature of their guilt (Fig. 175). At the very end of the 15th century, the city of Bruges commissioned the painter Gerard David (c. 1460–1523) to paint two pictures on the theme of justice taken from the writings of Herodotus. In the *Punishment of Sisamnes* (Fig. 176), David shows the corrupt Persian royal judge being punished by flaying; the victim is stretched out on a table before witnesses who watch him being skinned alive. Afterward, Sisamnes' son was made a judge in his father's place and forced to sit on a chair covered with the skin of his father, as is shown in the scene in the right-hand corner. This painting was hung in

the town hall of Bruges as an admonition to that city's justices. The moralizing purpose of medieval art thus continues, but it is treated in mundane terms and deals with civil behavior. While David's Italian counterparts of the Renaissance were most famous for reviving subjects from antiquity and for making studies of dissection (Figs. 197, 203), this painting reveals Flemish interest in both. Curious is the noticeable restraint in the expressions of the witnesses; only a small boy at the right shows any sign of repugnance. Gruesome pictures such as this remind us that the common view of art's purpose as being pleasing to the eye has many historical contradictions.

The Last Judgment

Having briefly noted various changes in painting occurring since the 12th century, we shall turn again to the theme of the Last Judgment, already discussed in terms of cathedral sculpture. The Flemish artist Hans Memling (c. 1440–94)

177. Hans Memling. *Last Judgment Triptych.* 1473. Oil on panel; center 7′4⅜″ × 5′4″ (2.24 × 1.63 m), each wing 7′4″ × 2′4⅝″ (2.23 × .73 m). Pomorskie Museum, Gdansk, Poland.

created a version of this theme (Fig. 177) that provides a valuable illustration of how the conception and execution differed from what was seen earlier—for instance, in the 12th-century tympanum of Ste-Foy (Figs. 79, 80). One of the most obvious developments was the increased naturalism that gave great emphasis to the geographical locale and to the details of the physical action of the resurrected. Through its stark naturalism, the judgement scene has become more familiar, thereby permitting the viewer to identify with the fate of those in the painting. The central figure of St. Michael weighing the souls has assumed an importance equal if not superior to that of Christ, who sits enthroned upon the rainbow described by St. John. The weigher of souls and the divine judge no longer seem uncompromising or inaccessible, as they were in earlier medieval versions of the scene. From the mouth of Christ there radiate the sword and the lily emblematic of his justice and mercy. At the sides of the rainbow kneel John the Baptist and the Virgin, whose prayers intercede on behalf of man. Looking at this work, the spectator has the impression that in Memling's view, man has a greater hope for clemency than he did at Ste-Foy.

The left wing of the triptych shows St. Peter herding the naked elect up a golden staircase where they are robed

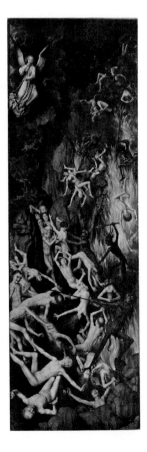

prior to entering the Gothic portals of the heavenly chateau. The right wing shows the infernal cascade of souls plummeting into the bowels of Hell, where they are greeted by demons who exercise their punitive office with enthusiasm. The plausibility of the miraculous second advent of Christ and his judgment is achieved by couching the entire scene in as natural a setting and with accessories as realistic as was possible for the time. Christ and the citizens of Heaven seem suspended just above an earth that resembles a barren Flemish landscape, in a real sky that fades in color to almost white at the horizon.

Rogier van der Weyden's *Last Judgment* at Beaune (Fig. 178), done in 1443, provides an interesting variant on this theme. The scales held by the resplendent St. Michael, who is garbed in a costly Flemish robe of consummate workmanship, are tipped in inverse fashion from the position seen in Memling's and older judgment scenes: the saved soul is lighter than that of the damned. The painter was reverting to older traditions, going back to Greek times, in which the goodness of the hero's spirit was outweighed by the lesser virtues of his adversary or counterpart. This restores to the weighing ceremony the traditional connotations of up and down, right and left, that we see carried out in the organization of Heaven around Christ and in the elevated situation of Heaven as contrasted with Hell. Van der Weyden also deviated from his contemporaries by not having demons inflict corporeal punishment upon the damned (Fig. 179); their punishment is inward, the result of conscience. With masterful skill and insight, the artist transcribed the anguished expressions of figures in varying states of mental distress.

In medieval manuscripts, the Word of God became art. In 15th-century art, the Word became flesh. Fidelity to text was now joined with fidelity to the world of appearances. Flemish and, as we shall see, Italian artists took pride in their prowess as *visualizers of stories.* This form of satisfying humanity's need to know by being shown (for example, the invisible made visible, the past and the dead brought back to life, life after death) had always been important purposes of art and would so remain until this century. What gave Flemish art seemingly unprecedented vividness and memorability was its worldly enrichment of narrative and setting, its depiction of individuals rather than types in situations in which they not only acted, but reacted. This gratified a more sophisticated audience that shared the artist's continuing Pygmalion dream of re-creating life and the self.

The older arbiters of truth and beauty in art (textual accuracy, adherence to prototypical images and an invisible universal hierarchy) gave way to the eye, the window, and the mirror. At century's end, Leonardo da Vinci would express this new secular standard: "That picture is the most praiseworthy which most resembles the thing represented." The visible world was won for art by the brilliant development of a host of artistic devices: oil painting, systematic

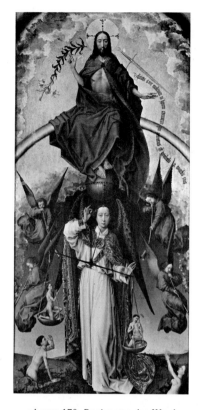

above: 178. Rogier van der Weyden. *Last Judgment Altarpiece* (center panel). 1443. Oil on panel, height 7' (2.13 m). Hôtel-Dieu, Beaune.

right: 179. Rogier van der Weyden. Detail of a side panel from *Last Judgment Altarpiece.* (See Fig. 178.)

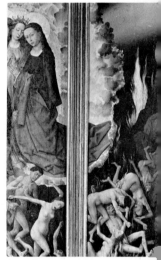

perspective, empirical studies in anatomy, proportion, physical movement, and psychological expression. The old conditions by which art was made were transformed by the drives of aggressive artists and their ambitious patrons to realize an art that refracted sensory experience of the visible world and themselves. By the 1420s, there had come into being a consciousness in many courts and cities of a new age: *Ars Nova* in Flanders and the "good modern manner" in Florence. The only past now regarded as worthy of comparison with the new modern art in Italy came to be that of Greek and Roman antiquity.

Chapter 7

15th-Century Italian Art: The Synthesis of Heaven and Earth

Today, we consider history as continuous, but in the 15th and 16th centuries, there was a strongly held view that a new culture, a new civilization, was born a thousand years after the fall of Rome and that it followed a millennium of cultural darkness. Even in our own times, writers continue to comment on the sudden outbursts of creative energy that occurred in the 15th century. This attitude, as well as the myth of the "Dark Ages," does disservice to the creativity and energy of the medieval period. The renaissance of city building, for example, was not a 15th-century phenomenon but actually took place during the 12th through 14th centuries. Ironically, Renaissance artists and writers traced the "rebirth" of art and the beginnings of a "modern style" to Giotto, who lived in the late 13th and early 14th centuries. This should remind us, as it did not his countrymen, of the vitality and genius that nourished Western art before the events of the 15th century.

Humanity in Giotto's Art The Florentine artist Giotto (c. 1267–c. 1336) exerted great influence on the efforts of 15th-century Italian artists to unite in perfect harmony the divine and earthly aspects of existence. Giotto was able to project biblical subjects into his paintings in ways that made the supernatural plausible and intelligible to all. He divested religious art of its aristocratic aloofness and theological abstraction, and he reduced its reliance upon symbolic accessories and gestures. What his contemporary Dante was to literature, Giotto was to painting—each translated the divine into a new vernacular that facilitated simple

devotion. To his own age, Giotto's great achievement was the more lifelike appearance of his subjects, in contrast to the art of his contemporaries. The criterion was not the direct matching of Giotto's paintings with the real world, but a comparison with the art that had gone before. While it may be difficult today to appreciate this difference, Giotto remains a brilliant interpreter of the Bible, whose mastery of composition was indivisible from his abilities as a narrator. *Raising of Lazarus* (Fig. 180) is one of a great series of mural paintings adorning the Arena Chapel in Padua; it was painted about a thousand years after the catacomb painting of the same theme (Fig. 69). Dead for three days, the putrefying Lazarus was brought to life by Christ. To those who first looked upon this painting, it seemed that Giotto, in a similar way, had miraculously brought new life to art.

To read the story within the painting is to retrace the major compositional movements. At the left, as if having turned from the disciples, Christ effects the miracle through the magnetism of his gaze (Fig. 181) and the gesture of his hand. There is no distracting object behind him. The gold background traditionally used in most art of this time has been replaced by blue sky, which returns the action to earth. So powerful is the eye of Giotto's Christ that it impels the viewer across half the painting to the figure of Lazarus. A second bridge between the Resurrector and the resurrected man is formed by the gestures of two intervening figures. On the center axis the arm movements of the two figures who serve as intermediaries are not symbolic but instinctive, showing Giotto's relaxation of the figure's ad-

herence to stereotype. Even when Giotto's people are motionless, they impress us as sentient beings. Gesture is precious coin for the artist who expends it judiciously, and Giotto never squanders it. It must build the action and forcibly link or pace the composition, never distract by trivial movement or ostentatious detail. Not only the arm movements of the principals lead from Christ to Lazarus, but also the powerful but simple directional arrangements of the draperies, which retain a medieval quasi-independence of the body. Those of the figure behind Lazarus, whose face is veiled to ward off the smell of putrefaction, slow the eye's drive to the right and refocus its attention on Lazarus. The small bending figure of the man who had removed the lid of the tomb is so placed as to guide our attention to the figures of the kneeling women, who return the elliptical movement of the action to Christ. The figures are bonded together by ties that reflect both a deep inward awareness and a simple physical grace.

At all times the viewer's concentration is held within the frame. The painting is like a window through which we look into a clear shallow space, sufficient for the firm sculpturesque volumes that displace it. Giotto has developed a way of constructing a painting that is new. It is as if the viewer's eye were the apex of an imaginary pyramid or cone whose base is the rear plane, or blue sky, in the painting. The painting's surface is like a transparent plane intersecting the pyramid parallel to its apex and base. This form of visual cone allows Giotto to project his figures in depth with fair consistency, on the basis of their distance from the viewer—a way of seeing that was to be systematized mathematically in the next century. The frame works with the figures, serving as a measure and foil for their large scale, erectness, and resulting dignity.

As seen in this painting, Giotto's was a man-centered world in which Christ appeared as a man among men. His art fostered hope both in the humane vision of Christ and in the temperance, humility, and dignity assigned to men and women, who are shown as worthy of redemption. Giotto's rendering of the figure is integral with the spiritual values he assigned to his ideal of humanity. The painter made a historically influential equation between the weighty mass of his figures and their moral worth. The stability of their movements and disposition within the scene convey the impression that humanity has a meaningful part in a larger order.

Landscapes of Ambrogio Lorenzetti In Italy as in northern Europe, the artist's conquest of the visual world was a slow process attended by timid or hesitant efforts as well as by bold advances. After Giotto, the 14th-century artist who struck out in the most venturesome way to open up the space of his fresco and to create a more natural environment—thereby representing the abundance of earthly life—was the Sienese Ambrogio Lorenzetti (act. 1320–48). Commissioned by the city-state of Siena to decorate its town hall, Lorenzetti filled the walls of a room with allegories and commentary on the subject of good and bad government. Visually and historically, the fresco containing the effects of

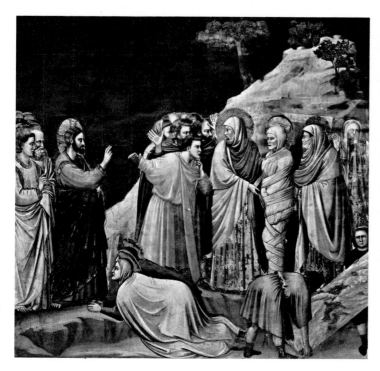

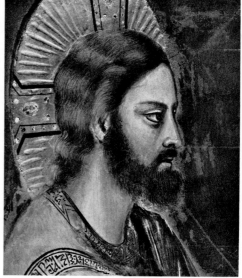

left: 180. Giotto. *Raising of Lazarus.* 1305–06. Fresco. Arena Chapel, Padua.

above: 181. Detail of Figure 180.

182. Ambrogio Lorenzetti. *Effects of Good Government*
(scenes in the city). 1337–39. Fresco. Sala dei Nove,
Palazzo Pubblico, Siena.

good government on the city and the country is the most
exciting (Figs. 182, 183). Both views are original panoramic
vistas, which depend not upon conventions or memory but
on actual visual experience, based on the hill city of Siena
and its natural surroundings. The spatial construction of the
fresco is from the viewpoint of someone near the center
foreground in the city, near the point at which the women
dance as evidence of happiness under just rule. The archi-
tecture, figures, and landscape diminish in scale both in
depth and laterally in relation to this vantage point within
the city itself; the reference is not to the viewer or based on
one's distance from the painting. The entire city is rendered
in focus, as if to accommodate the movement of the eyes as
one searches through the fresco outward from the city's
center. Lorenzetti was not working with scientific perspec-
tive or attempting photographlike naturalism, since his was
an empirical effort based on trial and error. The obliqueness
of the streets, for example, is convincing but not scientific.
There are minor inconsistencies, such as his failure to
make figures in the landscape smaller in proportion to their
setting, but the painter took the artist's license of bending a
rule for purposes of clarity and vividness.

Not since antiquity and the Roman wall paintings (Fig.
393) had a Western artist attempted an embrace of the vis-
ual world as sweeping as Lorenzetti's—or as topographi-
cally specific. The light of the entire scene is strongest in
the area of the principal viewpoint, and it diminishes as it
moves outward. Lorenzetti caught the continuity of light

and natural space and the kind of roving focus of the trav-
eler (not dissimilar to what was happening in Chinese
painting of the time, as will be seen in Chapter 15, "Art and
Nature").

Humanity in Masaccio's Art More than a hundred years
after the creation of Giotto's Arena Chapel frescoes, the
Florentine artist Masaccio (1401–28) contributed to a fresco
cycle of St. Peter in a chapel newly built by a silk merchant
named Brancacci. No artist in the intervening period had
fully grasped or extended the ideas of Giotto as did
Masaccio in his fresco *The Tribute Money* (Fig. 184). The
Brancacci Chapel became a fountainhead of ideas and in-
spiration for many artists who followed, including Michel-
angelo (who supposedly had his nose broken there during
a quarrel). In 1427, the city of Florence imposed an income
tax, which was advocated by Brancacci's party; the theme
of the fresco is perhaps a subtle reference to this support.
The events depicted by Masaccio are those attending the
arrival of Christ and the disciples before the gates of
Capernaum, where a toll was asked of them. In the 5th cen-
tury, St. Augustine interpreted this event as foretelling the
toll that Christ was to pay upon the Cross for humanity. At
this moment, for the first time, Christ singled out a disciple,
Peter, to participate in a miracle—a prophecy perhaps of
Peter's role in founding the Church and his aid in the re-
demption of humanity. Following Christ's instructions to
him (the episode in the center), Peter takes the coin out of a
fish's mouth (far left) and then pays the publican (extreme
right). As in the work of Giotto, the main group is assem-
bled in the center and close to the lower edge of the paint-
ing. Though the fresco was high up on the wall, the view-

point of its construction is about level with the heads of the group. The intense illusion of reality Masaccio achieved is contingent upon the fresco's construction from a fixed viewpoint. As defined by John White, "One of the most significant characteristics of artificial perspective is that it assumes an observer with his eye in one particular position at a fixed distance and direction from the scene before him"; but this viewpoint may not always coincide with the spot in which the beholder finds it possible to stand, as is the case in the Brancacci Chapel.

The setting is new. The scene takes place on a broad plain before an extensive mountain range, seen in atmospheric depth; and though small in relation to the figure scale, the entrance to the city is drawn in correct linear perspective. The vanishing point of its diagonals is coincident with Christ's head, thus uniting the structural with the

theological focus. Dramatic emphasis as well as structural clarity was furthered by the new perspective. While the human form still dominates the painting—a requirement of Florentine art in this century—it has been set into a natural context. As if affirming this relationship, Masaccio's figures cast shadows upon the ground, conveying a marked sense of their relation to the surrounding world and their exposure to natural light. The artist's building blocks were the study of such qualities as the reflection of light and shadow by broadly treated volumes, the relation of solids to voids, and the rhythmic interplay of the human body with the forms of nature and architecture. The figures around Christ belong to an impersonal ordering and do not display spontaneous volitional movement.

Masaccio modernized but did not basically alter Giotto's ideal of a stable world governed by powerful laws. This

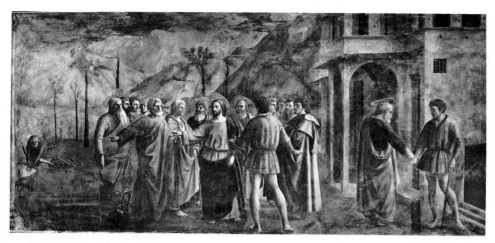

top: 183. Ambrogio Lorenzetti.
Effects of Good Government
(scenes in the countryside).
1337–39. Fresco.
Sala dei Nove,
Palazzo Pubblico, Siena.

left: 184. Masaccio.
The Tribute Money. c. 1427.
Fresco, 8'4'' × 19'8''
(2.54 × 5.9 m).
Brancacci Chapel,
Santa Maria del Carmine,
Florence.

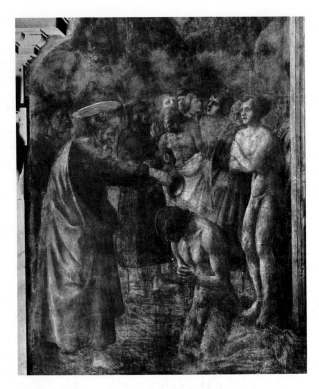

185. Masaccio. *St. Peter Baptizing the Neophyte.*
c. 1427. Fresco. Brancacci Chapel,
Santa Maria del Carmine, Florence.

modernization took the form of a greater awareness of and skill in rendering the anatomical makeup and coordination of the human figure. The corporeal body asserts itself even when sheathed in draped folds. Masaccio utilized newly discovered gestures and postures modestly but tellingly in enriching the human role in religious drama. This release of the human body from inertia was as important for the future secularization of art as was the Flemish celebration of the man-made object.

Masaccio literally and figuratively brought a new shudder to painting. The theme of baptism in which a figure is immersed in water—or, as in Masaccio's *St. Peter Baptizing the Neophyte* (Fig. 185), has it poured over him from a bowl—was an old one; but for the first time, the Florentine painter gives us the reaction of trembling flesh under the touch of cold water, and the instinctive but futile warming gesture of the man who has disrobed while awaiting his own baptism in the icy stream underlines this sensation. What may well have brought a shiver to Masaccio's contemporaries was his power to bring home to them in this performance of a sacrament their all too human and familiar frailty during such an ordeal. With Masaccio, the senses of the subject come alive, and flesh and temperature become tangible elements.

Secular Criteria for Art What imparts excitement to the developments of the 15th century is the artists' pursuit of ways to mirror nature in art, which released tremendous energies and gave rise to a pervasive spirit of free inquiry, which in turn nourished venturesome ideas and produced brilliant individual styles. A galaxy of talents crowned Italian art before the century was half spent. Masaccio and Veneziano, the sculptors Donatello and Ghiberti, and the architects Brunelleschi and Alberti—the latter being primarily a theorist—evolved, both theoretically and empirically, scientific bases for the means of representation. For most of the century, these discoveries did not dogmatically circumscribe the artist. Furthermore, these abstract devices for rendering and ordering—perspective, proportion, anatomy, and the study of light—were not limited to either sculpture or painting. Secular criteria were established for the making and judgment of all art. The rationalization of the means by which the artist could master the representation of the visible world coincided with the aggressive urban middle-class drive to systematize business conduct, explore the earth's surface in successful mercantile enterprises, and exalt man-made goods. Body and mind were to be in felicitous coordination, and this ideal enhanced the attraction of the ancient Roman sculpture known in that century. The supernatural was still respected; however, priority was given in art to the sensorily verifiable experiences, like the clear, measurable shaping of space and vital, energetic bodies, as well as the convincing re-creation of familiar settings of home, city, and landscape. Artists continued to rely upon imagination for their basic conceptions, but they were now armed with new constructive and expressive means to suit their own tastes and those of their time for emulation, but not literal imitation, of all that was material and measurable.

How Do We Know All This? From Michael Baxandall's research, for example, we know more of who the Italian Renaissance art public was and what it brought to the viewing of art in terms of experience and expectations. Most of the art discussed in this chapter was addressed to a patronage class drawn from senior clergy, princes and courtiers, mercantile and professional people, but not the urban poor and peasants. Artists were expected to produce imagery that would accurately and lucidly instruct, be vivid and hence memorable, and incite devotion or move the emotions. All were traditional purposes of art. By evolving more sophisticated visualizations of stories that utilized new artistic devices, artists challenged the greater interpretive skills of an audience that was accustomed to visualizing the places and persons of religious stories for purposes of private meditation. Preachers exhorted the laity to imagine persons they knew acting the biblical roles. Theoretically, the artist was thus to complement the viewer's private vision. Preachers gave public and painters a repertory of religious gestures, a body language to bring biblical stories to

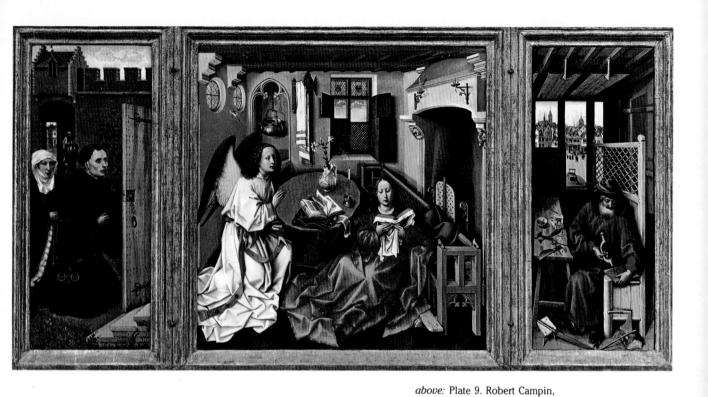

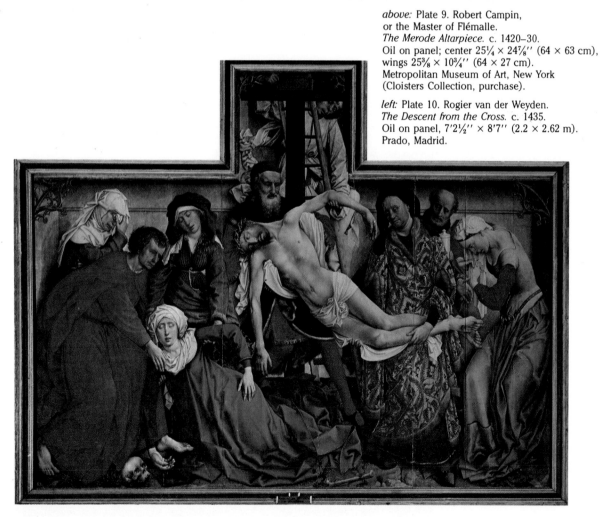

above: Plate 9. Robert Campin,
or the Master of Flémalle.
The Merode Altarpiece. c. 1420–30.
Oil on panel; center 25¼ × 24⅞'' (64 × 63 cm),
wings 25⅜ × 10¾'' (64 × 27 cm).
Metropolitan Museum of Art, New York
(Cloisters Collection, purchase).

left: Plate 10. Rogier van der Weyden.
The Descent from the Cross. c. 1435.
Oil on panel, 7'2½'' × 8'7'' (2.2 × 2.62 m).
Prado, Madrid.

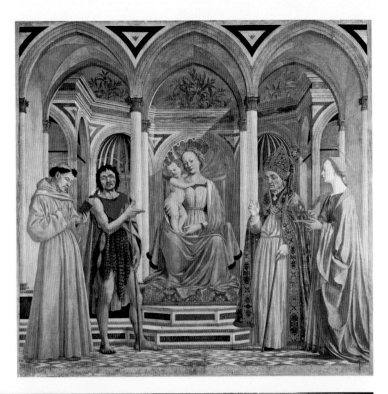

above right: Plate 11.
Domenico Veneziano.
Madonna and Child with Saints,
from the *St. Lucy Altarpiece.*
c. 1445. Oil on panel,
6′7½″ × 6′11⅞″ (2.02 × 2.13 m).
Uffizi, Florence.

right: Plate 12.
Piero della Francesca.
The Resurrection. 1460.
Detached fresco.
Pinacoteca, Borgo San Sepolcro.

life. Artists such as Leonardo studied the sign language of mutes and the gestures of orators and of actors and actresses in religious dramas. Treatises on painting and dancing showed concern that physical movement aptly reflect mental states and graceful groupings. Artistic realism was tempered by color codes based on the theological aptness of certain hues, but also by a prejudice for costly colors such as blue from lapis lazuli and red from silver and sulphur, rather than cheaper pigments such as ochre and umber. Artists employing the new mathematically based perspective and proportion challenged their public's training in and use of commercial mathematics, analytical skills involving gauging distances and volumes, reducing complex forms to simple geometrical shapes like cones and cubes, and calculating ratios. These skills were important to landowners and merchants, who had to survey land and buildings, estimate weights and measures such as the volume of goods, and barter in many currencies.

The Baptistery Competition The promise of the 15th century in Florence was evident during its first years, when, between 1401 and 1403, two artists in their twenties competed for that city's greatest artistic honor: designing and casting in bronze the east doors of the Baptistery, which faced the cathedral. Finalists from among seven competi-

tors, Filippo Brunelleschi, a goldsmith, and Lorenzo Ghiberti, a goldsmith and painter, still ranked as apprentices in the guild system. They presented their bronze relief panels depicting the Sacrifice of Isaac (Figs. 186, 187) as prescribed by the large jury of businessmen, artists, and theologians. The competition, the focus and pride of and the source of argument for the entire city, was carried out despite a recent devastating plague that had wiped out 30,000 inhabitants. Florence had also successfully withstood the military threat of the Duke of Milan, who died suddenly in 1402 as he was besieging the city. The artistic enhancement of a holy building was a gesture of thanks for divine protection as well as one of civic pride. Both entries combined medieval and new ideas and forecast the vigor and creative imagination of Florentine sculpture.

Brunelleschi's seems today the more dramatic of the two interpretations; his every figure (even the animals) was involved in strenuous movement. Cast in the round and then attached to the panel, Brunelleschi's energetic figures lean or twist into the viewer's space, overlapping the medieval frame. Their actions, however, have less synchronized mutual integration than his competitor's design. Ghiberti divided the attendants from those engaged in the sacrifice by a diagonal landscape device rather than by arranging the composition in horizontal layers. Despite its high relief,

186. Filippo Brunelleschi. *The Sacrifice of Isaac.* 1401. Gilt bronze, 21 × 17½'' (53 × 44 cm). Museo Nazionale, Florence.

187. Lorenzo Ghiberti. *The Sacrifice of Isaac.* 1401. Gilt bronze, 21 × 17½'' (53 × 44 cm). Museo Nazionale, Florence.

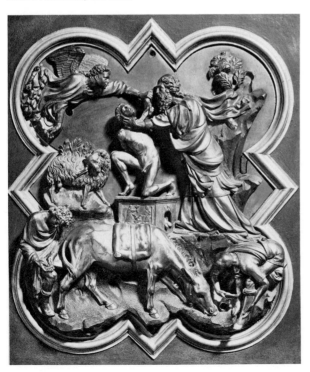

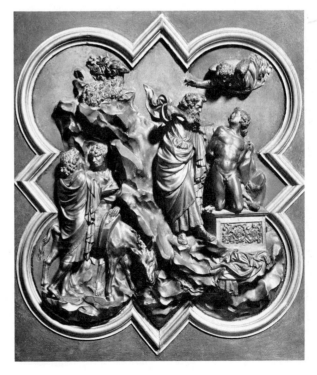

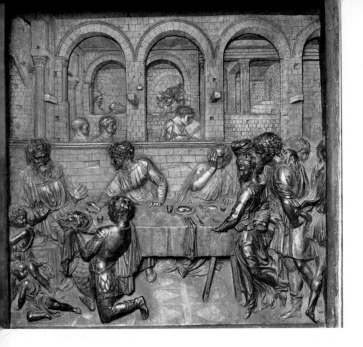

188. Donatello. *The Feast of Herod.* 1425–27. Gilt bronze, 23½'' (60 cm) square. San Giovanni, Sienna.

San Giovanni, Siena. For *The Feast of Herod* (Fig. 188), Donatello drew upon Brunelleschi's newly discovered device of systematic linear perspective to create the appearance of the relief's orderly recession into depth. In the oldest extant example of a composition based on this system for transposing the three-dimensional world onto a flat surface with all distances measurable, the diagonals of the steeply sloping floor converge to a point marked by the elbow of the seated figure who gestures toward the severed head of John the Baptist. The diagonals of the upper part of the relief meet at a point slightly above, on the cornice of the wall behind the banquet table. This area of convergence corresponds roughly to a theoretical viewer's eye level.

No artist of his century surpassed Donatello in the ability to dramatize the workings of the human mind in situations of great excitement. He brought to art a great awareness of crowd psychology that vivified and united his figures with a range and depth of feeling unequaled at the time. These qualities were suited to the subject, which shows not the sacred moment of martyrdom but the animated group response to a sadistic murder. The reactions of the figures to the sudden appearance of John's head are polarized between attraction and repulsion. Donatello bridged the gap between the two foreground groups partially by means of the triple arches and the table but also, and most importantly, by the fanatical stare of Salome suspended in her dance.

Though Donatello is referred to as a Renaissance sculptor, his lifesize painted wooden image of the Magdalen (Fig. 189) remains the expression of an essentially medieval Christian attitude toward the incompatibility of body and soul. Donatello often carved healthful and cosmetically attractive figures in an age that admired physical beauty, but he retained much of the penitential spirit of the late Middle Ages. Intended for the Baptistery of Florence, his sculpture is a merciless study of the body made less than human, first through self-indulgence and then through a self-denying asceticism. He renewed the late medieval dichotomy between inner truth and surface beauty. The Magdalen has become a living corpse, like a medieval reminder of death and the wages of sin. Only the zeal of the convert animates the leathery flesh of this skeletal figure, holding out the same hope as baptism. The spiritual intensity imparted to the sculpture by Donatello transcends its physical repellence and makes the work aesthetically compelling. The slight gap between the hands creates a life-giving tension that complements the psychological force emanating from the head, and essential to this focus is the self-imposed rigidity of the body. No sculpture in Western art is further from the Greek Classical ideal, and yet Donatello did make sculptures of the body that share certain Classical ideals.

Brunelleschi's design still clings to an overall surface disposition of elements. The technical qualities of fine finish, down to the smallest detail of features, hair, and drapery, drew greater admiration for Ghiberti, but he may also have impressed the jury by his ability to achieve a more natural and graceful suggestion of depth. Cast in one piece except for the figure of Isaac, Ghiberti's panel may have seemed to the artists better grounded in conservative standards of craftsmanship. Too, Brunelleschi's impetuous Abraham may well have appealed less to the theologians than did Ghiberti's interpretation of reticence and thoughtfulness. The businessmen, anticipating the costs of 28 such panels on the future door, would have appreciated the lighter weight of Ghiberti's relief. Both artists included paraphrases from Hellenistic-Roman art: Brunelleschi in the attendant pulling a thorn from his foot, and Ghiberti in the torso of the young Isaac and the decoration of the altar. Even before the painters, it was the sculptors and, above all, the architects who saw in ancient Roman forms the basis for a new, beautiful, and expressive art.

Ghiberti won the competition and went on to design two great doors for the Baptistery. Brunelleschi became the greatest and most influential architect of the century, forsaking his great talents as a sculptor. The bitterness between the two that began with the competition never abated, for neither was a modest man. In his autobiography, Ghiberti, the older of the two, wrote, "To me the palm of victory was conceded by all the experts and by all those who competed with me." There is, however, some evidence of a split decision and no evidence that Brunelleschi ever admitted his rival's superiority.

Psychology and Nudity Almost contemporaneous with Masaccio's *Tribute Money* is a relief sculpture made by Donatello (c. 1386–1466) for the font in the Baptistery of

It was Donatello who created, in his *David* (Fig. 190), the first life-size nude since the end of antiquity. The work was probably commissioned by a private patron for his home, for in 1430, the sculptor's society was not yet prepared to see a biblical hero such as David commemorated in an unclothed representation. For unknown reasons, Donatello chose to show the vanquisher of Goliath wearing a hat and boots, accessories unthinkable for Classical statuary. Donatello's figure is a synthesis of postural derivation and personal observation of the body. Although the contraposto pose was borrowed from ancient statuary, the youthful model lacks the fluid contours and joints and the pronounced articulation of body structure, such as the joining of the legs and torso, found in ancient figures (Fig. 58). The *David* nonetheless furnishes an early-15th-century Florentine aristocratic ideal of youthful masculine beauty and intelligence, with the latter faculty triumphant over the brute strength of Goliath.

The Sacred Conversation The Venetian painter Domenico Veneziano (c. 1420–61), who came to Florence in 1439, drew insight and inspiration from Donatello and the insurgent art of his time to produce his masterwork, the *Madonna and Child with Saints* (Pl. 11, p. 124). Flanking the enthroned Madonna and Child at the left are Sts. Francis and John the Baptist, while at the right are Sts. Zenobius and Lucy. This is a devotional and honorific painting of a type frequently found in later Italian art, called the "sacred conversation," implying the possibility of discourse between the figures. The formal symmetry by which divinity is honored is tempered by the forceful individualization of the saints. They belong to a timeless hierarchy, but have acquired personalities and states of feeling that prohibit their total submission to an impersonal order. We may speak of the saints' heads as portraits in an even more exact sense than we use in discussing the work of Masaccio or Giotto. Veneziano's most inspired characterization is that of John the Baptist. Ironically, the saint, who is used as an interlocutor between the viewer and the Mother and Child, is the most magnetic figure in the painting. Much may be read in his face—suffering, compassion, the gift of clairvoyance, and obliviousness to self. Taken as a whole, John has a late medieval head and the firm body of a Hellenistic athlete.

So strong is Veneziano's overall design that it does not disintegrate under the weight of the attention given to the heads. His color lacks the detailed, sumptuous radiance of

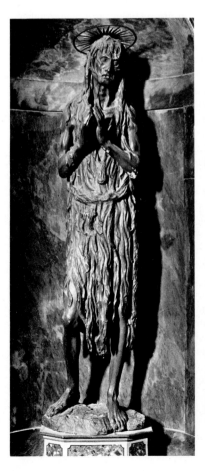

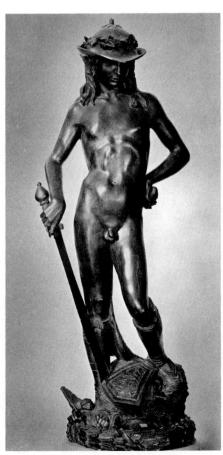

far left: 189. Donatello. *Mary Magdalen.* c. 1454–55. Polychromed wood, height 6'2'' (1.88 m). Baptistery, Florence.

left: 190. Donatello. *David.* c. 1430–32. Bronze, height 5'2¼'' (1.58 m). Museo Nazionale, Florence.

the Flemings, but is more obviously constructive in its broader application, as in the greens and pinks of the loggia. The airiness and clarity of the scene depend upon many light, delicate tones with strong accents, such as yellow and red, discreetly allied to the principal figures. The severe clarity and simplicity of the architecture do not conflict with the gestures of the saints but serve to underscore their slightest movement. Building on Masaccio's work, Veneziano introduced a convincing representation of brilliant sunlight, which shines from a single source on the rear wall just to the right of the Virgin and Christ. The light provides not only warm illumination of the background but a contrast to the cool foreground area.

The Secular Conversation Throughout the 15th century, it was customary to show the "sacred conversation" in the central panel of an altarpiece; narrative and more active images were relegated to side and lower panels. One of the earliest manifestations of a secular conversation that prophesies the further humanizing of art in later times is to be found in Andrea Mantegna's fresco showing the marquis *Ludovico Gonzaga and His Family and Court* (Fig. 191) painted in a tower of his patron's palace in Mantua. The subject concerns the visit of the marquis' thirteen-year-old son, who was a cardinal, and the detail reproduced shows at the left a servant, who has brought news of the boy's arrival, listening to Ludovico's instructions. No previous painting shows comparable informality involving an oral exchange between a ruler and his subject. Commissioned for his own personal pleasure and that of his family and successors, rather than for public display, it manifests the

marquis' desire to have a natural yet vivid depiction of himself and his court, foregoing the tradition of showing a ruler central to or dominating the field in a "theme of state."

"Oh, What a Sweet Thing This Perspective Is" Today it is possible to teach almost anyone in a single lesson simple perspective tricks and how to suggest convincingly three-dimensional space on a flat surface; but in the 15th century, the development of perspective devices was still a challenge and could produce great emotional excitement in the artist who discovered that, through certain techniques, it was possible to explore a new artistic world. Consider for a moment that such artists as Masaccio, Donatello, and Veneziano, faced with the opportunity of depicting stories they had never actually witnessed, could now paint or model these incidents as if they were happening before one's very eyes. At their disposal were the new scientific as well as optical perspectives to achieve this illusion. Artists most concerned with the former had access to Florentine mathematicians interested in Euclidean geometry. One such artist was the energetic and inventive Paolo Uccello (1397–1475), who passionately loved the geometry possible in objects and the unifying space of scientific perspective, but would not submit totally or blindly to its use to dictate the form of an entire painting. As Uccello painted his fresco of *The Flood* (Figs. 192, 193) in the cloister of a Florentine church, he was weighing in his mind the effects of linear perspective against actual optical experience and making adjustments between the two. Thus within a single composition he includes two views of the Ark, its length at the left, its width at the right. Each has its own point toward

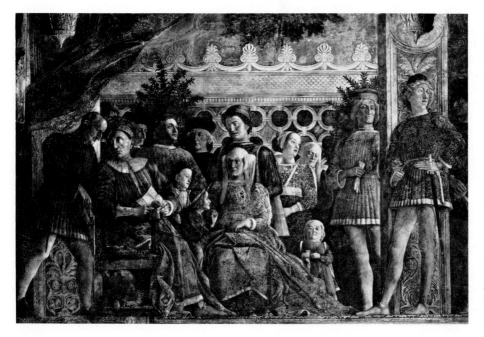

191. Andrea Mantegna. *Ludovico Gonzaga, His Family and Court.* 1476. Fresco. Camera degli Sposi, Palazzo Ducale, Mantua.

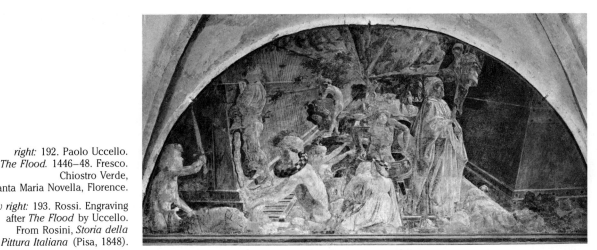

right: 192. Paolo Uccello.
The Flood. 1446–48. Fresco.
Chiostro Verde,
Santa Maria Novella, Florence.

below right: 193. Rossi. Engraving
after *The Flood* by Uccello.
From Rosini, *Storia della
Pittura Italiana* (Pisa, 1848).

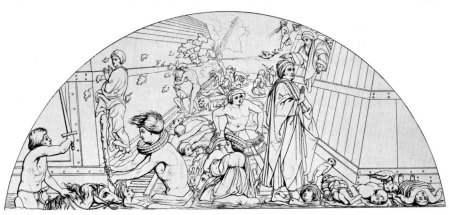

which the diagonal lines of the ship converge; there is no common vanishing point, which would be the case if the entire scene were constructed from a single, frozen viewpoint. As Giotto had done, Uccello was partly accommodating the shifting gaze of actual visual experience and the needs of pictorial organization, which could well differ from those of science and sight. Uccello recognized that linear perspective was not something toward which the beholder is neutral, and he exploited the sensational possibilities of this system through the deep dramatic funneling space created by the sides of the Arks. He then proceeded to populate this deep space, thereby varying the scale and postures of his figures. Shown in the same fresco are the beginning of the Flood (at the left) and Noah's awaiting of the dove and the recession of the waters 40 days later (at the right). The present battered condition of the fresco explains our use of an old engraving to assist the reader. The folly of men and women when faced with disaster is shown by the figures who continue personal quarrels and physical combat in the left foreground, and the futility of resisting the onslaught of the elements is seen in the man who tries to climb into a barrel and in those who try to cling to the sides of the sealed Ark. The arched, bloated body of a drowned child lies in the right foreground. The identity of the tall standing figure who looks to Heaven and whose ankles are clasped by a half-submerged figure is not known. Possibly he is Noah, or perhaps he is a priest who has recognized the truth of Noah's warning from God too late.

Here was a subject in which Uccello could indulge his curiosity and wonder about the appearance of the elements, the naked exposure of the body and human psychology, the shapes of objects such as the checkered collar around the neck of a struggling figure in the left foreground (which was a personal caprice or like a signature)—life and death in their most violent manifestations. His ego as an artist was gratified by proving he could convincingly render clouds, a wind-blown tree, drapery, animals, and the figure in unconventional ways.

Too often called a scientist rather than an artist, Uccello saw geometry and linear perspective as surveying tools for mapping what had in painting been unknown territory. Empirical study and intuition made him believe that there

were certain geometric shapes common to humans and animals that should serve truth and beauty as the artistic substructure of their re-creation.

Uccello's most brilliant demonstration of the power of rationalizing figures as well as space in art took the form of a 34-foot (10.2-meter) long series of three battle paintings for a bedroom in the Medici Palace (Figs. 194–196). The left panel shows the Florentine chief, Niccolò da Tolentino, directing the battle against the Sienese, whose leader is shown just killed in the center panel; at the right, reinforcements attack the enemy's rear guard. Against the backdrop of the San Romano hills and fields, Uccello shows what began as a debacle turn into a victory. The bloodless combat and dazzling pageantry of the event recall the character of battles fought by mercenaries, who were greater threats to the civilians who employed them than to one another. Art, science, and reason were not alien activities to Uccello, who reportedly said, "Oh, what a sweet thing this perspective is." Today artists are using the computer to give them unimaginable perspective views of simple shapes, which can then be enlarged and transposed into illusionistic but abstract painting. Uccello used simple projective geometry to get unfamiliar views and shapes of familiar objects, reveling in the ambivalence he could evoke between pure geometry and the idiosyncratic forms of armor, horses' flanks, and pennants. Uccello disciplined his soldiers so that they fought and fell within his ideal perspective and proportional framework. This artifice is continued in the gold and silver trappings and bright, unnatural colors of the horses which, unlike the receding lines and shapes, hold to the surface plane of the paintings. Uccello has thereby achieved cohesion of surface as well as depth, and he has temporarily synthesized the medieval and Renaissance ideals of picture-making in a magnificent decorative effort.

Synthesis of Present with Biblical Past During the 15th century, the rulers of Florence satisfied their subjects and fellow citizens with frequent and lavish pageantry; for such tournaments and parades, in Florence as in Flanders, the

above left: 194. Paolo Uccello. *The Rout of San Romano: Niccolo da Tolentino Directing the Battle of San Romano.* c. 1455. Tempera on wood, 6′ × 10′6′′ (1.83 × 3.2 m). National Gallery, London (reproduced by courtesy of the Trustees).

above: 195. Paolo Uccello. *The Rout of San Romano: The Unhorsing of Bernardino della Carda.* c. 1455. Tempera on wood, 6′ × 10′7′′ (1.83 × 3.22 m). Uffizi, Florence.

opposite top: 196. Paolo Uccello. *The Rout of San Romano: Micheletto da Cotignola Attacking the Sienese Rear.* c. 1455. Tempera on wood, 6′ × 10′5′′ (1.83 × 3.18 m). Louvre, Paris.

best artists would be called upon to design ornament for their patron's armor. Fortunately preserved is a parade shield bearing the figure of David (Fig. 197) by Andrea del Castagno (c. 1421–57). Instead of decorating the shield with a coat of arms, Castagno has staged David's triumph against a natural backdrop. The vital figure of David is shown as if first confronting Goliath with loaded sling, and at his feet is the grisly evidence of the story's end. David was one of the great heroes of Florence, as well as a symbol of freedom, and on the shield Castagno shows him as vigorous and vigilant, ready to repel his enemy and, by implication, the enemies of Florence. In his figure of David, Castagno joined the posture of an ancient Greek statue with the results of his studies of human anatomy, for he was one of the first artists to study the body by dissection. This practical knowledge of musculature imparted energy, strength, and new expressiveness to his figures but, in the case of David, created an awkward synthesis with the archaic or conventionalized landscape. Castagno's art was more effective when figural studies were complemented by architectural perspective.

Shortly after Veneziano's *Madonna and Child with Saints* (Pl. 11, p. 124) was completed, Castagno painted his fresco *The Last Supper* (Fig. 198), which was the prototype for several later 15th-century versions of the same theme.

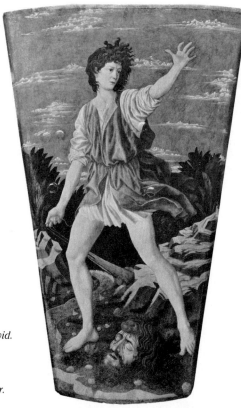

right: 197. Andrea del Castagno. *The Youthful David.*
c. 1450–57. Parade shield, tempera on leather;
height 45½″ (116 cm). National Gallery of Art,
Washington, D.C. (Widener Collection).

below: 198. Andrea del Castagno. *The Last Supper.*
c. 1445–50. Fresco. Sant' Apollonia, Florence.

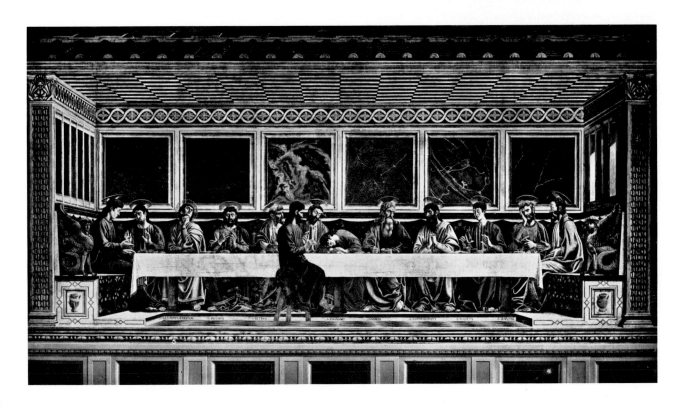

Although the subject is biblical and the fresco's location was in the refectory of a Florentine church, Castagno's interpretation is in human and mundane terms. The disciples and Christ are shown seated at a long table in a severely beautiful pavilion, whose design is based on contemporary architectural tastes.

Marginal evidences of the increased interest in ancient art are the bronze sphinxes at the ends of the bench and certain details of the architecture. As had their Flemish counterparts, Italian painters such as Castagno often reconstructed or designed with the brush their own architecture and furnishings. Through linear perspective, Castagno created the forceful illusion of the pavilion's recession behind the end wall of the refectory. Within the resulting space of the room and seen against its coordinate system of verticals

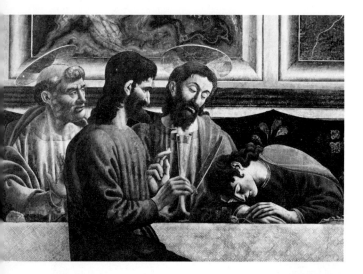

and horizontals are the impressive figures of Christ and the disciples. The initial appearance of the group resembles a social gathering, common to both Castagno's society and that of the ancient Hebrews, whose principal evening meal was an almost public occasion for assembling friends and a speaker. Castagno selected the moment when Christ prophesied his betrayal (Fig. 199). Judas is singled out by his placement across from Christ and by the absence of a halo. Because Castagno adhered to laws of perspective, Judas is actually larger in scale than Christ, who sits farther in depth—a relation of scale never seen in medieval art.

Christ has not, in fact, received the same emphasis as the disciples who flank him and ponder the significance of his announcement. The group of Peter, Judas, and Christ is set off slightly by the accentuation of the marble pattern in the wall above their heads. The natural light entering the room through the windows at the right falls equally on all present. The individualization and humanization of the disciples is accomplished by their rugged countenances, the variety of their rhetorical postures, and the lack of restriction by the architectural framework. Despite the relative passivity of the figures, Castagno's ideals of latent muscular energy and cool hard-edge sculptural surfaces assert themselves. Such painting was thought to bring the dead and the past to life by giving them a vivid physical presence.

Architecture and the Human Form It was the locating of figures in architectural settings in the 14th and 15th centuries that accelerated developments in perspective. These settings acquired a beauty and interest of their own, competitive with the figures, as seen in the Castagno fresco and in the *Flagellation* (Fig. 200) by Piero della Francesca (c. 1420–92). One can conceive of the setting as existing prior to the presence of the figures, which was not possible in

above: 199. Detail of Figure 198.

right: 200. Piero della Francesca. *The Flagellation of Christ.* c. 1456–57. Tempera on panel, 23¼ × 32″ (59 × 81 cm). Galleria Nazionale delle Marche, Urbino.

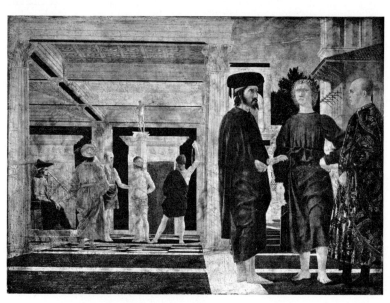

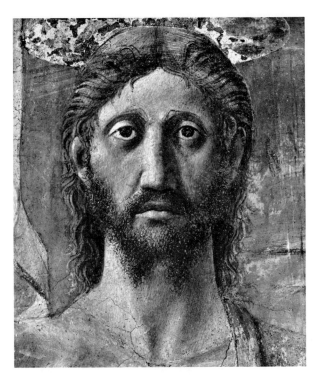

201. Piero della Francesca. Detail of *The Resurrection of Christ* (Pl. 12, p. 124).

medieval painting before the 14th century; indeed, there were drawings and paintings of architectural vistas without humans in 15th-century art. Piero was as devoted to geometry and perspective as Uccello had been, believing that its Euclidean shapes were the purest form of beauty. Pilate's palace invited an elegant conception; using a basic unit of measurement and geometry, the artist carefully constructed a handsome open edifice in which the flagellation takes place. Christ is located against the traditional pillar—here surmounted by a bronze statue symbolizing paganism—and he stands in the center of a strongly foreshortened circle inscribed on the pavement. Conceivably, Piero was symbolically signifying Christ's divinity and central place in the universe. The entire pavement design and the careful measurement of the building's elevation coordinated with it may have had richer esoteric symbolism, known to very few other than the artist. Piero's *Flagellation* has been the subject of much serious inquiry by scholars, who have yet to reveal all its meaning or reach agreement on its content. Why is Christ upstaged by the three large foreground figures at the right? Who are these three men? How may we account for the recession of divinity from the central focus? Dr. Marilyn Lavin has given the most brilliant and persuasive argument, pointing out that the two older men were contemporaries of the artist and that they were fathers grieving over the disease that had felled their respective sons.

The figure at the left, in exotic dress to suggest his interest in astrology and comparison with a wise man, is Ottaviano Ubaldini, who probably commissioned the work around 1466. His companion on the right, who shares the moment of enlightenment, is Lucovico Gonzaga. Ottaviano is shown explaining that, like Christ, their sons have gained eternal glory through their suffering. The handsome youth standing between these two men symbolizes their sons, whose beauty remains unimpaired in memory. The overall message of the painting is thus that of the "triumph of Christian glory over the tribulations of this world." The asymmetric pictorial design was Piero's solution to the problem of synthesizing within a unified space the biblical past and the present, the divine prototype and the contemporary event, Heavenly Jerusalem and 15th-century Italy. By placing the three well-dressed, contemporary Florentine types nearer than Christ to the spectator, the painter humanized the action and encouraged the onlooker to identify with the mortals in the foreground. The ramifications of this recessive focus were later to be more extensively explored.

Rationalizing the Miraculous In view of their preoccupation with reason and physical laws, the most challenging religious subject for Italian artists was the miracle of the Resurrection. *The Resurrection of Christ* painted by Piero demonstrates how faith and reason joined to produce what may be the most profound painting of its age (Pl. 12, p. 124). Under a cool matinal light, Christ is risen, while at his feet lie the soldiers in deep slumber. The supernatural conversion is expressed in such subtle and diverse ways as to reflect the concentrated effort of a superior intelligence. Much of the shock immediately induced by the painting comes from the unexpected appearance of hieratic symmetry in a natural setting. Piero's passion for geometry as form and symbol explains the arrangement of the base of the tomb and the head of Christ into an isosceles triangle; at its apex Piero painted the most powerful head of Christ of the entire 15th century (Fig. 201). In this head, specifically in the hypnotic eyes, is condensed the most crucial mystery of the Christian religion. Through the eyes, Piero conveys the concept of the risen Christ awakening into a world beyond mortal vision. The rigidity of Christ's face and pose and his obliviousness to the surroundings suggest spiritual or psychological rather than physical transformation. True to the account of the Resurrection, Piero shows Christ in human form. His body still has material weight, as seen by the discernible pressure of his leg on the tomb's edge. The dark hollows around the eyes speak of the Passion and the Entombment. Death is treated by Piero as a form of sleep, which gives additional meaning to the dormancy of the pagan guards, as yet unenlightened by the miracle.

Piero suffuses his message throughout the painting by means of contrasts, and all the contrasts involve the figure of Christ. He divides the painting into vertical and horizontal, right and left; but, as in medieval art, these directions

above: 202. Antonio Pollaiuolo. *The Martyrdom of St. Sebastian.* 1475. Oil on panel, 9'6'' × 6'7½'' (2.59 × 2.02 m). National Gallery, London (reproduced by courtesy of the Trustees).

below: 203. Antonio Pollaiuolo. *Hercules Crushing Antaeus.* c. 1475. Bronze, height 18'' (46 cm). Museo Nazionale, Florence.

must be viewed from Christ's standpoint. The landscape to Christ's right is one of winter and, like the wound in his right side, indicative of death. The tree trunk nearest the banner is an alliteration of his body, as the branches of both sets of trees are alliterations of Christ's head. To the Redeemer's left is the springtime of nature, alive and verdant again by his sacrifice. Thus the landscape symbolizes the world before and after his coming. The convergence of the trees on both sides toward the figure of Christ implies his relation to the state of the landscape, while the mound at the viewer's far left serves to balance the head of Christ and hold the focus within the frame. Piero's Christ is the God of all that lives. In Piero's paintings showing him before death, Christ is a gentle, submissive figure. Resurrected, he becomes a masculine and militant being.

The Athlete of Virtue By now the reader must have noticed not only the athletic image of Christ in Piero's *Resurrection* and *Flagellation,* but also the gradual appearance of at least partial nudity and the heroic physiques given to so many Christian saints by artists working in the service of the Church. Did not Christian dogma condemn the body as sinful? Colin Eisler has helped solve this seeming paradox by tracing the meaning and tradition of the "Athlete of Virtue," represented in Piero's paintings, for example, back to ancient Greece and to its glorification of the gymnastic heroes (see Chap. 3). This tradition continued through the Middle Ages in commentaries by theologians, who equated the body of Christ and the Church itself with that of the healthful, clean, or purified body of the athlete. In religious texts known to artists such as Piero and later to Michelangelo, Christ was compared to Hercules and Olympic champions and his Passion analogized to an athletic endurance contest. Christ's Resurrection proclaimed him the Eternal Victor. His virtue comprised physical manliness and mental fortitude, reminding us that medieval saints were equated with athletes of the spirit. The Italian Renaissance interest in antiquity allowed artists such as Piero and Michelangelo not only to examine the form of ancient Greek and Roman statues of heroic male figures, but also to consider these beautifully formed pagan bodies as metaphors for Christian spiritual values. Not surprisingly, the depiction of David and the martyred saints, such as St. Sebastian (Fig. 202), as the "forerunners" of Christ also fitted this image, one already suggested by Veneziano (Pl. 11, p. 124).

Anatomy Until recently, it was customary to look upon art and science as incompatible and to differentiate between artists and scientists on the basis of temperament. Their broader cultural and disciplinary unity is often ignored. In 15th-century Italy, however, many artists contributed to the study of natural science. The development of mathematical perspective, for instance, was carried out by artists, while the study of human anatomy by artists was well in advance of that taught in the medical schools. Beginning probably

with Castagno and assuredly by the time of Antonio Pollaiuolo (c. 1431–98), artists undertook actual dissection of the human body in order to study the relation of its structure to its functioning. One of the appeals of ancient sculpture was that it provided what was thought to be accurate information concerning physiology and musculature and furnished artists with poses and gestures by which to increase the expressiveness and animation of their figures. Religious personages were given more lifelike traits as a result of this study, but artists such as Pollaiuolo celebrated the body as a model of energy, strength, and action.

Pollaiuolo was one of the first Italian artists to join ancient Classical form with Classical subject matter. However, the full enactment and revelation of the human body's considerable strength, rather than implication of its potential force, is what separates Pollaiuolo's small bronze sculpture of *Hercules Crushing Antaeus* (Fig. 203) from the struggling figures in ancient Greek art. The Greeks would temper the full manifestation of muscular tension in order to ensure conformity of the body's design to their ideal of fluid grace (Fig. 486). Pollaiuolo, who had the opportunity to dissect corpses, broke new ground for sculpture and discovered the means to embody convincingly the human energy demanded in gestures of violent pushing and pulling. The more angular and active silhouettes of his figures, in comparison with those of the Greeks, resulted from direct observation of how, for instance, the shoulder bones of the human form (such as that of Hercules) are pushed outward as the arm muscles are stretched and tightened. In Donatello's *David* (Fig. 190), body structures are only faintly articulated, but in Pollaiuolo's statue, the skeletal-

muscular system operates clearly, and its construction can be traced right down to the feet of Hercules.

In his *Martyrdom of St. Sebastian* (Fig. 202), it is clear that Pollaiuolo was fascinated with the expressiveness of the same body and pose seen from multiple perspectives. Forms are carefully arranged around St. Sebastian to overlap as little as possible. Here, the artist made the human figure break completely the old mold of symbolic and rhetorical gesture and achieved a convincing representation of physical strength in muscular action; but he was unable to give graceful resolution to the energies and movements of his figures, who seem overdeveloped and often static. More successful as a sculptor, Pollaiuolo failed in painting to integrate the new conceptions of the body with space. He used a plateau arrangement and an elevated viewpoint for the figures, which tends to flatten the foreground area. The deep landscape backdrop behind the plateau provides no aesthetic or dramatic ties with the foreground. The figure of St. Sebastian has a certain sentimental and soft quality, which does not permit it to dominate the scene by any means other than its elevation and centrality. In sum, Pollaiuolo's painting is more impressive in its parts than as a whole and more notable for its vigorous espousal of secular values than for its religious ideals.

Man and the Earth To appreciate the changed view of nature and art that had evolved from the Middle Ages into what is referred to as the Renaissance, one need only compare the 10th-century manuscript painting of St. Valerian (Fig. 138) with a portrayal of St. Francis (Fig. 204) done five centuries later by Giovanni Bellini (1429–1507). A holy man

204. Giovanni Bellini. *St. Francis in Ecstasy.* c. 1485. Oil on panel, 4'1½'' × 4'7'' (1.23 × 1.4 m). Frick Collection, New York (copyright).

in approximately the same posture is common to both, but where St. Valerian turns his back, figuratively speaking, to a demonic world, St. Francis seems at first to be embracing the earth and the sky and its light. Both men were hermitic personalities who had renounced the material pleasures of the world, but the rural home of St. Francis is populated by harmless animals and a verdant private garden amid the rude rocky retreat. The gestures of both saints are symbolic, those of St. Francis indicating his miraculous reception of the *Stigmata,* the wounds of Christ, on his hands and feet. Unlike earlier painters of the same subject, Bellini includes neither Christ nor a seraph, and, as Millard Meiss has shown, the miracle is accomplished by means of the brilliant golden light of the sky into which the transfixed saint stares open-mouthed. This same scholar argues persuasively that the event took place at night and that what at first seems in the painting to be daylight is in fact the illumination from the radiant apparition. If we are to judge by the direction of the cast shadow of the saint and orientation of his body, the source of light is relatively low and on this side of the laurel tree, which reflects and moves in the supernatural glow emanating from a source out of sight beyond the left limit of the picture. Bellini continues the tradition of the theological significance of light, which goes back even earlier than the St. Valerian painter, but synthesizes it with the results of optical experience. There is a second, and this time natural, light source seen streaming through the clouds at the upper left, and it is explicable on the basis of the St. Francis literature, which speaks of the nocturnal event causing an illumination comparable to the light of day.

This Venetian artist may have derived from Flemish painting the use of some sort of oil medium that gave depth to his color and allowed overpainting. His shadows have a base layer of light blue-green that gives them volume. The meticulous reconstruction of the earth and distant cities is deceptive; while the rocky area resembles the geological formations near the site where St. Francis received the Stigmata, Bellini has synthesized many observations from nature and, like Van Eyck (Figs. 163–165), has used the actual to create an imaginary place that nonetheless belongs on earth. Thus Bellini affirms that by his day people and the earth belonged to each other no matter what their origin or destiny after life.

Synthesis of Religious and Secular Philosophies The interest of painters and sculptors in the art and literature of antiquity, which became most important in the last quarter of the 15th century, was to affect profoundly the pictorial synthesis of religious and secular values. As Erwin Panofsky expressed it, "In the Italian Renaissance the Classical past began to be looked upon from a fixed distance, quite comparable to the 'distance between the eye and the object' in . . . Renaissance focused perspective. This distance pro-

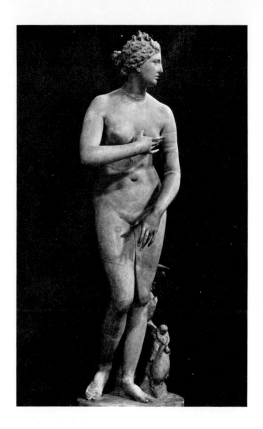

hibited direct contact . . . but permitted a total and rationalized view." Classical culture was approached historically, as an integrated whole, and the ancient world became "the object of a passionate nostalgia." In the second half of the 15th century, there was a union of Classical form and Classical content, most strongly in architecture and mingled with naturalism in sculpture; it was least manifest in painting, which was dominated by fidelity to nature. But there were painters who expressed in individual works the longing of the enlightened of their age for a "rebirth" of ancient culture.

The Birth of Venus (Pl. 13, p. 157), a painting of 1485 by the Florentine artist Sandro Botticelli (1445–1510), celebrates the nude pagan goddess on a large scale for the first time since Roman antiquity. It was executed as a visual sermon in philosophy for a fourteen-year-old boy, Giovanni de Pierofrancesco, whose upbringing was in the hands of the most brilliant Humanist thinkers in Europe. The reconciliation of nudity and pre-Christian philosophy and art with Christianity was restricted to a small group of artists, scholars, writers, and aristocratic patrons such as the Medici family. According to Marsilio Ficino, the outstanding philosopher of the time, truth and beauty knew no distinction between pagan and Christian expression; both pagan literature and the Bible were revelations of the truth, of the same principles. The chaste beauty of Botticelli's Venus was inspired by the view that she symbolized not lust or sensual pleasure but pure intelligence or the highest attainments of the mind. Her role in the education of the young Giovanni

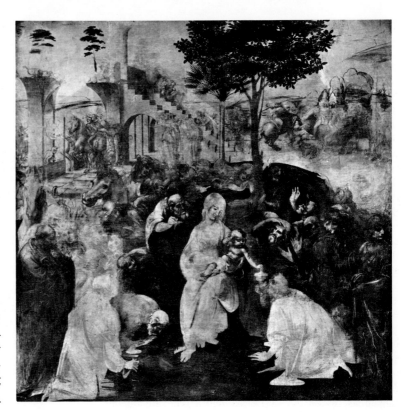

opposite: 205. *Venus de' Medici.*
3rd century B.C. Marble, height 5' (1.52 m).
Uffizi, Florence.

right: 206. Leonardo da Vinci.
The Adoration of the Magi. 1480–82.
Oil on wood, 8'7⅞" × 7'11⅝"
(2.46 × 2.43 m). Uffizi, Florence.

was to inspire him to search for the true reality behind appearances and to discover the world's hidden harmony.

The figure of Venus was patterned after a specific sculpture—a Roman copy of an ancient Greek statue owned by the Medici (Fig. 205). The painting's format and the figure on the shore derived from previous Christian paintings of St. John baptizing Christ. The Humanists drew analogies between the miraculous birth of Venus and Christ, between her emergence from the sea and Christ's rebirth by rising from the water of Jordan. The painting's lesson included the birth of beauty in the human soul. The zephyrs who blow her to the shore are like angels, and the seashell was occasionally used by Renaissance painters and architects as a symbol of Heaven.

Botticelli's style was admirably adapted to rendering Venus in a way that would not arouse physical desire. The delicacy of his drawing and tinting of colors imparts sophisticated grace and strong pleasure to the eye and mind. Drawing was the basis of the work and deemed at the time the most appropriate for the education of the intelligence; strong color was avoided so as not to stir base emotions. (This prejudice would continue even into 19th-century art.) Botticelli was an artist ideally suited to the aristocratic intellectual tastes of his courtly patrons, but he underwent a deep spiritual crisis and reversion to mystical Christianity toward the end of his life, upsetting the pagan-Christian synthesis announced in this famous painting and forecasting a similar and broader cultural change at the beginning of the next century.

Art in the Service of the Mind Though known as a man with universal interests, Leonardo da Vinci (1452–1519) did not share Botticelli's preoccupation with antiquity, philosophy, and literature—in short, the Humanism of his time. The direct experiences of eye and hand, which painting and drawing served best, and the active use of the mind in their support were what Leonardo believed in; and they explain his unprecedented empirical studies from nature accompanied by innumerable drawings and voluminous notebooks. Leonardo's modernity resides in his refusal to take untested assumptions as the basis for his art. Unlike many artists before him, his dedication to representing the visual world was not exclusively in the service of religion. Leonardo's few paintings deal mostly with religious subjects, but this is not the case with his drawings. On the basis of the paintings, one would surmise that Leonardo believed that through knowledge and imagination one should interpret noble themes, but with his drawings the compass of art takes in the entire earthly world for the enjoyment of the eyes. His unfinished painting of *The Adoration of the Magi* (Fig. 206) serves as an excellent example not only of his interests but also of his frequent inability to conclude his ambitious projects. The setting depends upon his observations of what might be called *natural science,* specifically studies of trees and geology. Fascination with geometry led him to introduce at the rear left a perspective rendering of a ruined structure that may relate to the fall of the old religious order. Lifelong interest in equestrian subjects and an inclination toward violent aggression account for the com-

bat of mounted figures in the upper right. The foreground drama was the occasion for demonstrating his experience with psychology and the expressive capacities of the entire body. Against the reverent actions of the Magi, he contrasts the manifold and strong reactions of the onlookers, thereby giving full play to his researches into different age groups regarding facial types, gestures, and the drama of bodies in movement and inspiring future artists to broaden the psychological base of painting. The incomplete state of the painting shows its method of construction: first it was drawn and then the colors were applied in tones from dark to light; the lighter tones have not been filled in. Dark backgrounds often create the lighter shapes, such as some of the heads in the center group, and this was one of the many devices by which Leonardo brought to painting new tonalities and more varied moods evoked by light. His light is never brilliant, but favors that of late afternoon, thereby muting differences among the forms it illuminates. In the *Adoration,* Leonardo makes tangible the elusive existence of light amid darkness.

Leonardo purposely did not employ a single perspective system for this painting, as he was later to do in his *Last Supper* (Fig. 235), but used different perspectives for different areas, giving the whole painting a synthetic quality. Rather than clearly establish at the outset a measurable space for the foreground figures, as Piero would have done, he sketched their movements and volumes. The figures themselves create their own spatial environment, which differs from the more measurable gridlike area at the upper left. The formal arrangement of the centralized Virgin and flanking Magi was, like many of Leonardo's ideas, subsequently frozen into artistic dogma.

Leonardo's drawing of a male nude (Fig. 207), historically one of the first in chalk, is a sign of the mutual self-confidence of the artist and his subject around 1500. The drawing reflects Leonardo's conviction that artists had not yet achieved complete knowledge of the human body and how the surface should smoothly and subtly reflect the complex anatomical structure, unlike the "sack of nuts" treatment of Pollaiuolo, for example. Stripped of clothing, symbols, and rank, the figure is studied and valued for its structure, sensual surface, and graceful potential for action. Above all, Leonardo was making this art for artists to admire and from which to learn. Many values had changed. No longer was a work of art valued for its materials, but rather for the artist's skill. The concept of progress based on the overcoming of obstacles or problem-solving had come into being, and the notion that art was improving as a result of accumulated skills and knowledge was a legacy that lasted until this century. We may reject the qualitative notion of progress in art's history, but in the case of the Renaissance and Leonardo's work, there is no question but that art was being taken into areas where it had not been before.

To the argument of whether individuals make the times or the times make them, one can point to Leonardo and the

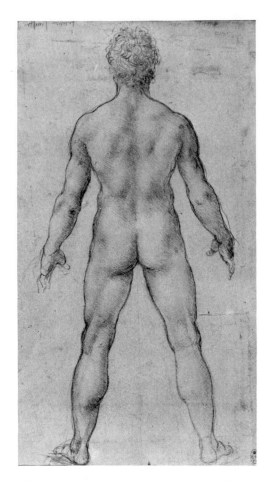

207. Leonardo da Vinci. *Male Nude.* c. 1503–07. Red chalk, 10¾ × 6¼″ (27 × 16 cm). Royal Library, Windsor Castle (copyright reserved).

other leading artists of the 15th century as examples of the interaction of the two. Artists benefited from the civic pride, energy, and enthusiasm for art found in Florence; in turn, men and women gained from art greater understanding of their own humanity. The most lasting and creative contributions of the Italian Renaissance were not social, political, or religious, but artistic. The art that grew out of and away from the Middle Ages was influenced by the rise of science and the worldly interests of Italian tyrants and vigorous merchants who patronized art. Leonardo stands for the artist who by means of art achieved greater self-realization and intellectual freedom than did his medieval and ancient predecessors, but who also served despots and enemies of Florence. As he said, "I serve the one who pays me." Political and social freedom have not historically been prerequisites of great art. The history of intellectual freedom embodied in Leonardo's thinking and inquiry is older than political and social liberty.

Comparison with Flemish Art In both Flanders and Italy of the 15th century, art was given an earthly stage, human scale, and natural location. Truthfulness to the visual world was the desire of northern and southern artists. Both achieved perspective whereby the three-dimensional world was convincingly transposed through a series of corresponding points onto a two-dimensional surface. Art was confirmed as an important means to enrich earthly life. The synthesis of the heavenly and earthly was changing and unstable, and the values of the latter were gathering into a groundswell at century's end. Art still guided people to the meaning of true spirituality, but now it also corroborated their celebration of the secular beauty and pleasures of the mortal environment. The self-confident societies of Bruges, Ghent, Antwerp, and Florence produced artists obviously aware of their own talent, importance, and ambitions; and society's respect for artistic genius, familiar to us today, had its foundations established.

When we consider the differences between Flemish and Italian art, it is apparent that science and ancient art had a stronger influence in the south. Painters in the north achieved verisimilitude to continuous three-dimensional space without recourse to the theories, systems, or geometry so prized by the Italians. Medieval art, which had a more lasting interest and influence in the north, came to be viewed as barbaric in the south—which gave the word *Gothic* unpleasant connotations. Geographically, historically, and ethnically, ancient Roman art seemed right for emulation to Italian artists.

Beginning with Giotto and continuing through Piero della Francesca, Italian style was characterized by a compact and immediately perceivable unity through the large, fluid continuity of the sculpturesque figures dominating their environment. The ideal composition resulted from the smooth interdependent functioning of figures and environment—the easy flow of statuesque figures in measurable space. Flemish style was characterized by a less mobile, if not static, complex additive ordering of the microscopic through the telescopic, in which the setting often rivaled the human being in importance. The Italians delighted in the relation of large, distinct, sensual figures set against one another and in credible space. Their color was important to shaping volume. It clung to the curving surfaces and was not intended to belie its distance from the viewer. The northern artists favored dense groupings of contrasting rich tones of color and light and intricate linkages of the edges of shapes lying at varying depths from one another. The brilliance of their color would at times make it hover in space and not hold to the actual depth of the plane it was painted on. The Flemings valued all that was given to the senses as a sign of divine meaning, and they searched for individuality in nature. Their criterion of realistic painting was largely a quantitative one of measuring and matching the subject against the painting. With the aid of geometry, Italian artists sought what they thought were the abstract principles behind the appearance of nature, the truly harmonious and beautiful form. Flemish art arrived at convincing spatial illusion through the trial and error of observation; their space, though additive, is still expressive. The Italians first developed it empirically and then through theory and preferred the overall lucid appearance of measured order. They favored the good and pleasing appearance of the human form with supple coordination between mind and body. The Flemish accepted the unathletic yet natural movement that often accompanies profound inner feeling.

Later, in the 16th century, Michelangelo illuminated the differences between the art of two areas and revealed his own prejudices:

> Flemish painting will, generally speaking, please the devout better than any painting in Italy, which will never cause him to shed a tear, whereas that of Flanders will cause him to shed many, and that not through the vigor and goodness of the painting but owing to the goodness of the devout person. . . . In Flanders they paint with a view to external exactness of such things as may cheer you and of which you cannot speak ill, as for example saints and prophets. They paint stuffs and masonry, the green grass of the fields, the shadows of the trees, and rivers and bridges which they call landscape, with many figures on this side and many on that. And all this . . . is done without reason or art, without symmetry or proportion, without skillful choice or boldness, and finally without substance and vigor.

Chapter 8

Michelangelo

Imagine that you had the occasion to present the credentials of an experienced artist to a congressional subcommittee whose task was to select someone to design and decorate a new Capitol building. Knowing our government's concern for examining character references and searching for possible undesirable associations, you must address yourself to the following: Your candidate traces his ancestry to an aristocratic family and does not believe in democracy or universal political freedom. He has celebrated in sculpture the assassin of a head of state. He places loyalty to his city of birth above all. He has contributed designs for the expensive defense system of his city, but he deserted that city during war. Tyrants have benefited from his service. While he is working, your candidate can be surly, and on one occasion, his patron, the Pope, is supposed to have threatened to throw him off a high scaffolding. There is speculation that he is a homosexual. Many large projects that he has undertaken have remained incomplete for years. He does not believe that great art is or need be intelligible to the taxpayer. In a contract, he once promised the most beautiful sculpture ever made. In all, the case would be a tough one to support and doomed no doubt to failure. Your consolation would be that you knew the import of official rejection of Michelangelo.

Some of Michelangelo's character "flaws" might receive a more sympathetic response from a younger generation today than they would have before about 1965. His desertion of Florence was not out of cowardice, for he returned during the fighting, and the incompletion of many of his projects was due to changes of mind on the part of such clients as the Medici of Florence and the Pope. While Michelangelo's "candidacy" and rejection are hypothetical, we have to acknowledge that in our time many fine artists have been blacklisted or denied access to government-sponsored exhibitions and commissions for comparable activities. Governments often have settled for what is less than the work of great artists, and the decision for art that is "safe" in every sense is altogether apparent in Washington, where, ironically, some of Michelangelo's architectural ideas were used in debased form.

Michelangelo Buonarroti (1475–1564) was born in the Tuscan town of Caprese. At the age of thirteen, he was sent to Florence to study painting with the brothers Domenico and Davide Ghirlandaio. He had been there but a year when his work attracted the eye of Lorenzo de' Medici, who invited the young artist to join his household. There Michelangelo was introduced to the most brilliant group of intellectuals in Europe, and their acquaintance had a deep influence upon his attitude toward ancient sculpture and the intellectual purpose of art. We do not know how he learned to carve sculpture. During these years in Florence, Michelangelo made drawings of the work of Giotto and Masaccio as well as of Roman and Greek sculpture; in 1492, he did dissections of corpses in a hospital for anatomical study.

In 1494, just before the house of Medici fell from power, Michelangelo made the first of several flights in search of the security and tranquillity he needed for his work, but was

never to find. After a short stay in Venice and more than a year in Bologna, he was able to return to Florence briefly before, in 1496, going on to Rome, where he carved his first *Pietà,* now in St. Peter's. He next returned to Florence and stayed for four years, beginning, in 1501, to work on several civic commissions, including the *David.* In 1505, Michelangleo was called to Rome by Pope Julius II, one of the first great and troublesome sponsors of Michelangelo's art. It was the sculptor's fate to be frustrated and harassed by powerful patrons who linked their fame to his and who encouraged grandiose schemes and then capriciously diverted the artist from completing them. Like many artists of his time, Michelangelo was often at the mercy of his sponsors' eccentricities, but he was also a victim of his own reputation. From 1508 to 1512, somewhat reluctantly, he painted the ceiling of the Sistine Chapel, turning intermittently to his enormous, and preferred, project for the Pope's sepulcher; of this last, only the *Moses* and the series of *Bound Slaves* ultimately saw realization (1513–16). From 1518 to 1534, Michelangelo divided his time between Rome and Florence and also between sculpture and architecture. For Pope Leo X, he worked on the Medici Chapel in Florence. In 1529, he served as a military engineer on the Florentine fortifications.

From 1534 until his death, Michelangelo lived in Rome, painting *The Last Judgment* (1536–41) and the frescoes of the Pauline Chapel (1542–50). In 1546, he became chief architect for the rebuilding of St. Peter's, a project that was to excite his remaining thought and energy. During the 1530s and 1540s, he wrote many religious sonnets dedicated to his friend Vittoria Colonna, who deeply influenced his spiritual direction. In his last two years, Michelangelo undertook a number of architectural projects, such as the redesigning of the Capitoline Hill in Rome, and executed only two uncompleted sculptures, both on the theme of Christ's death. He died in Rome in 1564, was laid in state and then interred in Florence, where he was deified.

The history of art includes many examples of artists who brought major talents to bear upon minor subjects. Vermeer (Pl. 21, p. 209) and Matisse (Pl. 45, p. 333) come quickly to mind as examples of men whose greatness lay in the *way* they interpreted the commonplace, giving to it the quality of the uncommon. Michelangelo brought great art to great ideas. He was the most technically gifted artist as well as one of the great intellects of his time and place. The fact that his surroundings were Florence and Rome and that his time was the Italian Renaissance should give some idea of Michelangelo's measure. The artist was obsessed with the infinite nature and mystery of God and his creation Man. Never did Michelangelo show an interest in rendering the details of objects or landscape; his was a Man- and God-centered art. Nor did he paint and carve in terms of specific living individuals: his aim was to depict the universal fate of humanity, and so far as is known, he made only one pencil sketch of a contemporary. Unwilling to be bound to an earthly material model, he felt impelled to work from divine inspiration in order to spiritualize his experience of reality and to achieve eternal and transcendent truth.

It would be futile to attempt, within a single chapter, a full history and discussion of Michelangelo. Instead, a few examples that represent seminal ideas and will make the reader aware of the scope and depth of the artist's work will be discussed.

Early Sculptures Begun when Michelangelo was 26, the *David* (Fig. 208) was carved between 1501 and 1504 in behalf of the Florentine Republic, partly to commemorate the completion of a new civic constitution and partly to demonstrate the city's artistic leadership and vigor. David was famous not only as the slayer of Goliath but also as a ruler, and his association with justice made him an appropriate figure to celebrate governmental reform. By a committee decision, the 18-foot (5.49-meter) statue was placed before the Palazzo Vecchio, the city hall, where it quickly became an emblem of civic freedom and the virtue of its defense.

208. Michelangelo. *David.* 1501–04.
Marble, height 18′ (5.49 m).
Academy, Florence.

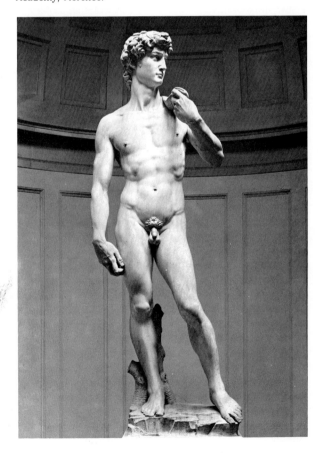

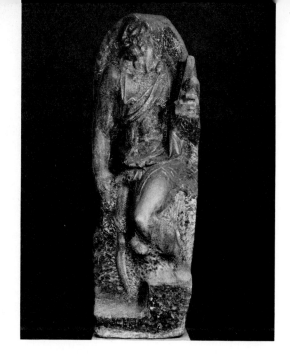

(En route to the site the *David* was stoned, perhaps by Medici adherents or those who objected to its nudity.) In the finely muscled, alert, and somber youth, the citizens could see an embodiment of what they felt were their own virtues. Michelangelo may have shared these ideals, but he also wanted the *David* to affirm his reputation as the greatest living sculptor. In his contract, Michelangelo specified that his sculpture would be of unsurpassed beauty—and this despite the unusually thin block of marble he had been given, which would force him to exercise tremendous virtuosity. Not only did he demonstrate to the satisfaction of all his knowledge of ancient Greek art and the science of anatomy, but he also gave form to a deeply personal vision of a hero. In Michelangelo's view, only a handful of men in the history of the human race qualified as heroes. These were primarily Old Testament prophets or rulers who perfectly embodied a combination of the active and the contemplative life. In his youth, when the *David* was created, Michelangelo equated truth with beauty, and to *David* he gave the body of a Greek Hercules, which enhanced associations with fortitude. By this time, the nude form in art had lost most of its medieval sinful associations, partly because ancient art and thought were now accepted as compatible with Christianity and with the tradition of the "athlete of virtue." Michelangelo believed that the nude male body was divine and that its ideal rendition in art would approximate the prototype conceived by God. He wrote, "And who is so barbarous as not to understand that the foot of a man is nobler than his shoe, and his skin nobler than that of the sheep with which it is clothed."

The quality of repose suggested by a front view of the youth's stance is not sustained, for there is a faint suggestion in the torso muscles of tension, which becomes more obvious in the neck and quite vehement in the angry visage. This climactic psychological element and the contrast in the states of mind and body are alien to Greek Classical ideals. There is a decided asymmetry in the disposition of the right and left sides of the body. The figure's right side is protected by the downward-hanging arm holding the stone; the large right hand signifies strength. The upraised left arm makes that side more open and vulnerable. Significantly, David looks to his left. From the Middle Ages, there had been a tradition that associated divine protection with the right and the origin of evil with the left. It has been suggested that David is "frowning" at the sight of Goliath, assuredly the symbol of evil. Still, it would be a mistake to conceive of this work as illustrating a specific event or moment. David is, above all, a symbol of force and righteous anger, and the stone and sling signify the need for alert and courageous defense of principle and the Republic. Like the pose of the *Colossus of Barletta* (Fig. 300), a late-antique Imperial statue, the militant and defiant attitude of David is a comfort to the good and a warning to their enemies. The angry concentration expressed in the features may also reflect displeasure with human weakness. Michel-

angelo was a Christian sculptor who could satisfy his religious belief with the idea of a Hebraic hero in the body of an uncircumcized Greek god.

Michelangelo considered David his alter ego, and he once wrote, "David with the sling, I with the bow, Michelangelo." The bow was a reference to his sculptor's drill, which like the sling was an attribute and means of serving God. After the *David,* Michelangelo was asked to do statues of the Twelve Apostles, but only the unfinished *St. Matthew* was actually undertaken (Fig. 209). Its unfinished state illustrates Cellini's account of how Michelangelo carved: "After having drawn the principal view on the block, one begins to remove the marble from the sides as if one were working a relief and in this way, step by step, one brings to light the whole figure." Michelangelo devised for the *St. Matthew* a posture that is a tense counteraction of twisting and frontal movements. In the grip of some powerful vision that forces his head to the side, the Apostle is unmindful of his body, which in an un-Classical way reacts by instinct. The strong compactness of limbs, with as little space as possible between the torso and arms, was a self-imposed restriction of the artist, who may have felt that it gave the most concentrated expression of the subject. His figure of Matthew violently twists about an imaginary vertical axis, but is in turn inhibited by the limits of the block, which like mortal flesh is a form of confinement. To contemporaries, this work embodied awesome power. It may also have been a forceful projection of Michelangelo's own personality, a self-image in the throes of divine inspiration.

The incomplete state of sculptures such as this has led to mystical, somewhat romanticized interpretations about the artist's intention to show the birth of the soul, his disinterest once the essential idea had taken form, or his desire to reveal the material source and end of all life. It is a fact that Michelangelo enjoyed working on difficult problems

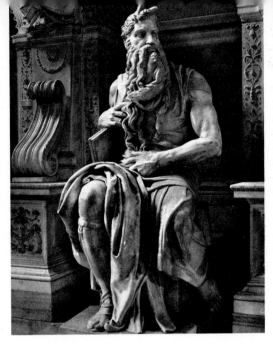

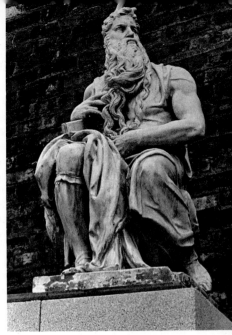

opposite: 209. Michelangelo. *St. Matthew.* 1504–06. Marble, height 8'11" (2.72 m). Academy, Florence.

right: 210. Michelangelo. *Moses.* 1513–16. Marble, height 8'4" (2.54 m). San Pietro in Vincoli, Rome.

far right: 211. Michelangelo. *Moses,* plaster cast, seen from below and 30 degrees to the right.

and had a continuously evolving style or would improvise as he went along; but in the case of this Apostle figure, as often thereafter, demands for the sculptor's talents in Rome simply forced him to stop work. The raw traces of tool marks and vestiges of the original block make the *St. Matthew* a fine illustration of some of the artist's views on sculpture, expressed years later. Michelangelo saw his destiny as being in the chisel and stone. Sometime between 1536 and 1547, he wrote, "The greatest artist has no conception that a single block of marble does not potentially contain within its mass, but only a hand obedient to the mind can penetrate to this image." Elsewhere, Michelangelo defined the art of sculpture as "the taking off that puts into the rough hard stone a living figure grown most great just as the stone had grown most small." This bringing forth of life from base matter was a spiritual act for Michelangelo, one in sympathy with God's creation of life. He once referred to God as the "Divine Hammer." Great art, he believed, depended upon the artist's possessing first within himself a perfect God-given conception (the *Platonic Idea*), whose "first-born" was a simple clay model. The second realization of the Idea was in the "rugged living stone" and possessed "such beauty that none may confine its spirit."

No artist before Michelangelo possessed such complete mastery of the human body and the exceptional ability to render its richness as a material organism as well as its emotional, spiritual, and intellectual range. Possessing natural gifts as a craftsman (he was a prodigious carver), Michelangelo was also a great student of the art of other artists and eras. The sculpture of ancient Greece and Rome and that of his own century all provided ideas and forms that he welded to his personal style. The greatest master for Michelangelo, his greatest influence as attested by the sculptor's own words, was God the Creator. For the Greeks and certain Renaissance sculptors, beauty was achievable

through fixed proportion of mathematical measure, but for Michelangelo, proportion was a qualitative, not a quantitative, value. Proportion meant, for him, the extent to which his image corresponded to the Idea inherent in it. Furthermore, the physical beauty of his figures was not an end in itself; it was intended to reflect spiritual beauty and was meant to elevate the thoughts of the beholder above material things. True beauty could not be obtained by merely copying the visible world. Michelangelo's art proceeds from the mind, through which he believed he could more truly comprehend the perfect form.

Michelangelo despised Raphael's optimistic judgment of the ability of his contemporaries, such as Castiglione, to achieve grace. The sculptor felt that Raphael had a naïve and mistaken faith in simple formulas of human conduct as a means of achieving true earthly happiness and excellence. The differences between their respective attitudes can be seen in Raphael's portrait of Baldassare Castiglione (Fig. 451) and Michelangelo's *Moses* (Fig. 210), intended for the uncompleted tomb of Julius II. To Michelangelo, Moses was a moral and physical giant, a man whose imposing frame was the instrument of heroic physical and spiritual acts—of the leadership of his people in the Exodus. The enormous, vital head of Moses is the locus of divine visions, the fountainhead of law.

The interpretation of *Moses* depends, literally, upon one's point of view. Until recently, although the statue's intended position high on the papal tomb was known, all interpretations of pose and expression were based on an eye-level view (Fig. 211). Thus scholars (including this author) tended to see the portrayal as Moses in righteous anger or seized by an ecstatic vision. The art historian Earl Rosenthal had the good sense to photograph a plaster version of *Moses* raised 9 feet (2.7 meters) above the ground, thereby altering our view both literally and figuratively. The

sculptor carved the figure on its side so as to study it from the proper angle. The view from below modifies the scale of the disproportionately large head and beard and enhances the figure's composed strength. The gaze upward appears appropriate to the wise and contemplative leader of the Jews, and this sculpture gave particular pleasure to the Jews of Rome, even though their religion opposed the graven image. From below, the hornlike forms—the beams of light that apocryphal tradition had spring from Moses' forehead at the moment he saw the Lord—are barely visible. From an angle, nonetheless, the seated prophet is endowed with tremendous vitality and majesty. Here is why Michelangelo's contemporaries found in his style qualities that inspired religious awe and fear.

The spiritual antithesis of *Moses* is Michelangelo's misnamed *Dying Slave* (Fig. 212), also intended for the tomb of Julius II. The sensuously formed dreaming male was inspired by the ancient Greek sculpture of Laocoon's dying

212. Michelangelo. *Bound Slave.* 1514–16. Marble, height 7'6½" (2.3 m). Louvre, Paris.

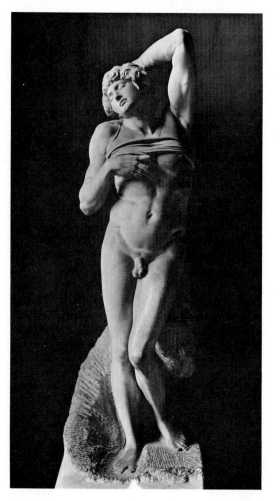

son. The bonds are symbolic, and with the half-formed ape behind the figure may evoke the idea of the sleep of the art of painting after Pope Julius's death. ("Art apes nature.") Detached from the tomb, the figure also evokes Michelangelo's passion for the male figure and personal view of the torment of mortal life away from the Creator. Man's anguish is to have joined in himself a temporal body and an immortal soul, as expressed by the contemporary philosopher Marsilio Ficino in ideas parallel to Michelangelo's:

> Our mind, as long as our sublime soul is doomed to operate in a base body, is thrown up and down with permanent disquietude, and it often slumbers from exhaustion and is always insane; so that our movements, actions, and passions are nothing but the vertigos of ailing people, the dream of sleepers, and ravings of madmen.

To convey an interior state, a pathetic restlessness of soul, Michelangelo drew upon Greek principles of expressive body posturing, which avoided the coincidence in the same plane of parts of the body having a common point or axis. For instance, if the knee is forward, the left shoulder should be back and the right shoulder advanced, balancing forward and backward movements in crisscross fashion. As the eye scans upward, each direction taken by the slave's body is countered by another immediately above, so that the composition is a self-adjusting mechanism in a soft, serpentine formation.

The Meaning of Muscularity Contemporary and subsequent artists selected figure types, postures, and muscular forms from Michelangelo's art without comprehending the essential life attitude in which these properties were rooted. Now it is even harder to understand the conceptualizing that Michelangelo gave to his re-creation of the body from art and life. In Renaissance theology, God was praised as a sculptor, not as a painter. And Michelangelo regarded sculpture, with its sensual physicality, its mass and displacement of space, as the ideal means by which he, a creator second only to God, could surpass nature's own composition. A great dramatist of the human body, Michelangelo makes one sense the full movement and force of skeleton and muscle beneath a taut, leather skin. He greatly enriched the figure's expressive repertory, yet contained its gestures within the cubic block from which they were cut.

Not since ancient Greece had figures been so splendidly endowed to perform superhuman feats. Still, this was not Michelangelo's drama. The true strength was either in latent tension or in tension turned against itself. With few exceptions, his figures do not use force against external obstacles, nor do they take energetic postures of work, love, war, or play. Heroic muscularity was for Michelangelo a prerequisite of God-like beauty, the mortal vestment of his biblical heroes; in addition, it was a fit measure for their momentous personal struggles. In this sense, his message is that great physical strength is futile against God's will. From

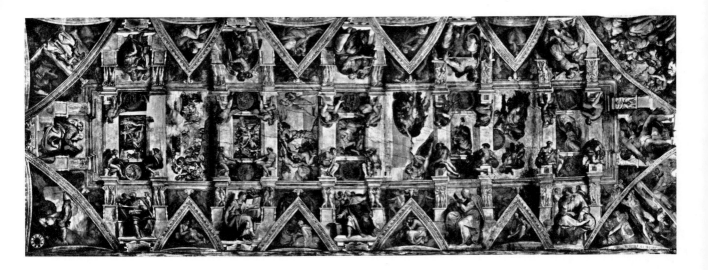

fragments of Greek torsos, he learned to use muscular tension as a means of directing the viewer's thoughts to the figure's spiritual crisis, the conflict of soul and flesh, and toward spiritual exaltation. No living model could serve him, nor could the instinctive and practiced gestures that people make in their daily lives. It was Michelangelo's genius to make the unnatural seem natural. He even invented gestures for death, such as the contorted dangling arm of the dead Christ in the Florence Cathedral *Pietà* (Fig. 221).

The Sistine Ceiling In his painting of the Sistine Chapel ceiling (Fig. 213), Michelangelo executed a humanistic-religious program of unparalleled magnitude. The commission from Julius II was accepted reluctantly by Michelangelo, who longed to devote his energies to sculpture, particularly to the grandiose tomb project. For four years, between 1508 and 1512, Michelangelo covered more than 700 square yards (630 square meters) of ceiling with the great outpourings of a fired imagination. He did a drawing of this painful task (Fig. 214). The strain of working while standing or lying prone on the scaffolding, under the dripping plaster, wrecked his health. At the end of his project, he wrote a poem describing his lamentable condition (*I' ho già fatto un gozzo. . . .*)*:

> I've grown a goiter by dwelling in this den—
> As cats from stagnant streams in Lombardy,
> Or in what other land they hap to be—
> Which drives the belly close beneath the chin;
> My beard turns up to heaven; my nape falls in,
> Fixed on my spine; my breastbone visibly
> Grows like a harp; a rich embroidery
> Bedews my face from brush-drops thick and thin,

above: 213. Michelangelo. Ceiling of the Sistine Chapel. 1508–12. Fresco, 45 × 128' (13.72 × 39 m). Vatican, Rome.

below: 214. Michelangelo. Detail (with caricatural self-portrait) of poem satirizing his painting the Sistine Chapel ceiling. c. 1512. Casa Buonarroti, Florence.

*From *The Sonnets of Michael Angelo Buonarroti,* trans. John Addington Symonds (© 1948 by Crown Publishers, Inc.).

My loins into my paunch like levers grind;
My buttock like a crupper bears my weight;
My feet unguided wander to and fro;
In front my skin grows loose and long; behind
By bending it becomes more taut and strait;
Crosswise I strain me like a Syrian bow. . . .

Despite his plaints and protestations, it seems likely that Michelangelo viewed this onerous task as a penance in which the ardor of his creative labors would expiate his sinful guilt.

The thematic program of the Sistine Chapel ceiling is an amazing fusion of Hebrew and Christian theology with contemporary Neoplatonic ideas. In all likelihood, Michelangelo had papal assistance in formulating the extensive program—though the Pope gave him license thereafter to do as he pleased—and the project undoubtedly satisfied the spiritual and political wishes of the patron. At the time the ceiling was being painted, the papacy was waging war against foreign troops and heretics within the faith. The ceiling's decoration was touched by these contemporary events; through complicated theological metaphors, the Pope had Michelangelo assert the Pontiff's confidence in his ultimate triumph over his enemies.

The subject of the ceiling is ostensibly that of the Old Testament God who created the world and punished man for denying Him. The nine principal scenes are depicted in rectangular frames, and their order does not follow strictly the chronology of Genesis. Above the head of the visitor upon entering the chapel are the Revilement of Noah, the Flood, the Sacrifice of Noah, and the Fall of Man. The common theme of all these episodes is God's punishment by means of the elements—earth, water, fire, and air. They illustrate how God chastises a world that has betrayed Him through false offerings and the partaking of the forbidden fruit.

The fulcrum panel of the ceiling, originally situated directly above the partition that divided the chapel in half, is the scene of God's creation of Eve from the side of Adam. Eve at this time symbolized the Church; thus in the ceiling's sequence, the Church is mediator between humanity and God, furnishing the means of human redemption. The second half of the ceiling is over the sacred area of the chapel, the altar. The overall theme of the remaining four subjects—the Creation of Adam (Pl. 14, p. 157), the Separation of the Waters from the Earth, the Creation of the Sun, Moon, and Planet, and the Separation of Light from Darkness—is the creative power of the Divinity.

In the triangular spandrels are depicted such precursors of Christ as David, who is shown killing Goliath, and Judith, who has beheaded Holofernes. Flanking the central rectangles are the Sibyls and Prophets. The agitated nude figures holding garlands and circular objects that are either large golden Eucharistic wafers or battle shields are altar attendants or human souls. The secondary motives of the ceiling were to assert the theological ancestry of the Pope and to imply that he was a new messiah acting as the earthly agent of God to punish the heretics. The Pope's family name means "oak tree," and there are also references in the ceiling to oaks. The spandrels depict the deliverance of the chosen people, perhaps as a prophecy of the actions of Julius II.

As in Michelangelo's earlier work, the figures are preterhuman in size and action. God is the Old Testament Divinity who roars out of a whirlwind and speaks with a voice of thunder. His visage, as seen in *The Creation of Adam* (Pl. 14, p. 157), is strikingly similar to the bearded profile of Julius II. The purpose of the program was thus to strike fear and awe into the minds of the mortals who looked upon it—awe of the Creator and the Church and of God's earthly representatives.

The Sistine Ceiling is a marvel of skill and endurance; yet the power of Michelangelo's art transcends mere virtuoso effects. There is a philosophical justification for all aspects of his style. He put his knowledge of the forms and the workings of the body into the service of spiritualizing human anguish and exaltation. The agitated, athletic figures of the Sibyls and Prophets mirror the profundity and excitement of visions inaccessible to ordinary mortals. In *The Creation of Adam* (Pl. 14), Michelangelo infused Adam's form with the mingled response of a body awakening with reluctance at the separation of the spirit from its Creator. Adam is not joyful at his emergence into earthly existence; the languid attitude of his arms and torso reveals his melancholy state, and the face has an expression of ineffable longing. With great significance, Michelangelo stressed the hands of Adam and God and the slight interval between them, which represented the measureless gulf that now separated mortals and their Creator. Attention is drawn repeatedly to the contrasts and similarities between the bodies of Adam and God, fittingly reflecting a poem of the sculptor, possibly written during the years of work on the Sistine Ceiling: "He who made the whole made every part; then from the whole chose the most beautiful, to reveal on earth, as he has done here and now in His own sublime perfections. The human figure is the particular form in which beauty is most clearly manifested."

Little indication can be given in this brief space of the intellectual wealth Michelangelo brought to the program of his ceiling. Scholars have, in impressive and often conflicting studies, sought to unravel the many levels of meaning and alternative interpretations of its content. That such searching endeavors are appropriate to a full understanding and appreciation of Michelangelo's art is borne out in the sculptor's own views on painting:

At its best nothing is more noble or devout, since with discreet persons nothing so calls forth and fosters devotion as the difficulty of a perfection which is based upon union with God. For good painting is nothing but a copy of the perfections of God

and a recollection of His painting; it is a music and a melody which only intellect can understand, and that with great difficulty. And that is why painting of this kind is so rare that no man attains it.

The Medici Chapel Like the Sistine Ceiling, the Medici Chapel in San Lorenzo, Florence, on which Michelangelo worked at various times between 1520 and 1534, has been seen by some scholars not only as an artistic interpretation of a Humanistic program but also as a monumental attempt at propaganda (Fig. 215). The official purpose of the designs was commemorative; the creation of a sepulchral chapel to house the bodies of Lorenzo and Giuliano de' Medici, descendants of the 15th-century dukes of the same name. The date of the chapel's commencement is an important one, since it coincided with a decline in the power and aspirations of the house of Medici because of the death of two of its most important members. They, too, were to have been buried in the chapel (a plan subsequently discarded), which may have been intended as a grandiose al-

legory of princely and papal power, the Medici having produced several popes. The chapel was to glorify the deceased occupants by portraying them as ideal rulers and defenders of the Church.

Michelangelo did not himself assemble the sculptures as they are seen today. The four reclining figures, two on each of the sepulchers, were so placed by another sculptor. Below the figure of Duke Giuliano lie the figures of Night and Day; beneath the seated form of Lorenzo are the recumbent figures of Twilight and Dawn. That these sculptures signified time is conjectural, for Michelangelo wrote of them only as mourning figures turned to stone. As times of day, these images may signify the temporal life, which is one of ceaseless grief and restlessness. The suffering of the temporal life is given form in their ample, contorted torsos. On a sketch for the tomb over which are placed the Night and Day, Michelangelo wrote:

> We have with our swift course brought to death Duke Giuliano, and it is just that he take revenge upon us thus: that we have slain him, he thus dead has taken the light from us and with

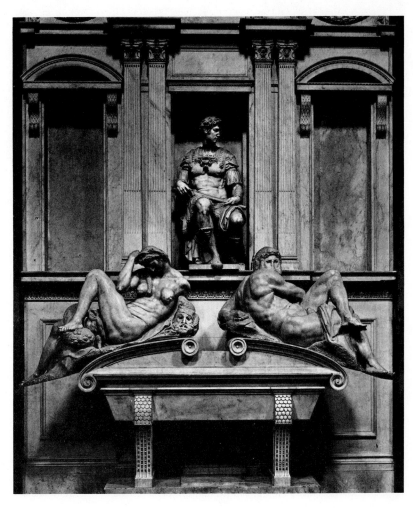

215. Michelangelo. Tomb of Giuliano de' Medici. c. 1524–34. Marble, height of center figure 5'8'' (1.73 m). New Sacristy, San Lorenzo, Florence.

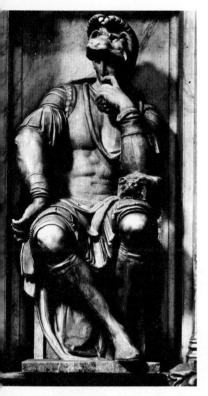

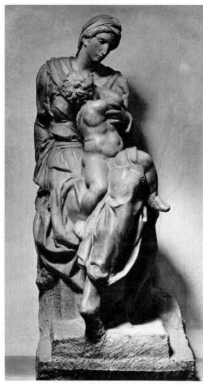

far left: 216. Michelangelo. *Lorenzo de' Medici.* c. 1524–34. Marble, height 5'10'' (1.78 m). New Sacristy, San Lorenzo, Florence.

left: 217. Michelangelo. *The Medici Virgin.* c. 1524–34. Marble, height 7'5⅜'' (2.28 m). New Sacristy, San Lorenzo, Florence.

below: 218. Michelangelo. *Brutus.* c. 1542. Marble, height 29½'' (75 cm). Museo Nazionale, Florence.

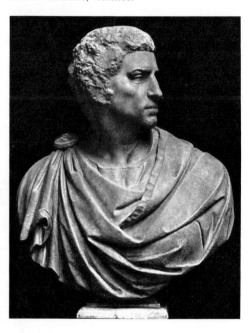

closed eyes has fastened ours so that they may shine forth no more upon this earth. What would he have done with us while he lived?

The moral of this lament may be that in death the duke has vanquished the temporal life, being now outside time. Michelangelo had planned to insert a mouse on the tomb to symbolize the gnawing, destructive action of time on life and fame.

The faces of the two dukes (Figs. 215, 216) show that Michelangelo did not create portrait likenesses of his subjects. He gave them instead a greatness and dignity that seemed to him a fitting commemoration for posterity. These seeming "portraits" are actually personifications of abstract ideals; Giuliano, moreover, did not live up to the principles glorified in his sculptural effigy. The figure of Giuliano may have embodied the Neoplatonic ideal of the active life, one of vigorous physical administration, shown by his open and commanding pose, the marshal's baton, and the coins in his hand, symbolizing a man who expends himself in outward actions. Lorenzo, his finger to his lips and his head partly in shadow, may have epitomized the contemplative life and the saturnine disposition. The fantastic helmet may allude to his insanity at death. In his meditative, introverted pose, he sits with his left elbow on a closed money box, which signified miserliness—in this case, perhaps, of the self. The Medici dukes are clad in Roman armor, recalling

their election by the Pope as militant defenders of the Church. According to Hartt, these sculptured ducal effigies were in a sense a call to the leaders of Italy to rally in defense of the Church in her time of need.

Both lords, who are blind, turn toward the Virgin and suckling Christ placed at the end of the chapel (Fig. 217). She is an incarnation of the Church, which took to its bosom the exiled house of Medici when it was expelled from Florence. She is the prophetic mother who gives herself to the Child, but at the same time draws back with the premonition of his sacrifice. According to an interpretation by Leo Steinberg, she is also the Bride of Christ: the symbolism of the Infant Bridegroom, "all his body, his straddling seat, reveals in the Child the divine lover electing his spouse."

Standing in the Medici Chapel, the visitor has the curious impression of being an intruder. Michelangelo's architecture is scaled to the heroic sculpture, not to the human being. The light entering from high up in the ceiling falls onto cold marble surfaces. The room itself is of exaggerated height and gives the impression of a deep, well-like

space, unearthly and congenial only to the sculptured effies. In 1534, Michelangelo voluntarily exiled himself from his beloved Florence for the rest of his life. Ostensibly, he was working in Rome, and sentimental considerations were involved as well; but it is known that he hated the tyrannical Medici, who had gained absolute rule and were responsible for the destruction of the Florentine Republic. Michelangelo's bust of Brutus (Fig. 218) was commissioned by another political exile from Florence, and this celebration of the slayer of Caesar is explained by the esteem in which men like the sculptor and his patron held the murderers of tyrants. At the time Brutus was a symbol of republicanism. Michelangelo's unfinished portrait of the noble

Roman tyrranicide was based on Roman imperial busts such as that of Caracalla.

The Last Judgment One of history's most awesome expressions of humanity's hope and fear is Michelangelo's *Last Judgment* (Fig. 219), whose painting on the huge end wall of the Sistine Chapel took the aging artist almost five years. Upon first seeing it, the Pope reportedly fell to his

219. Michelangelo. *The Last Judgment.* 1536–41.
Fresco, 48 × 44′ (14.6 × 13.4 m).
Sistine Chapel, Vatican, Rome.

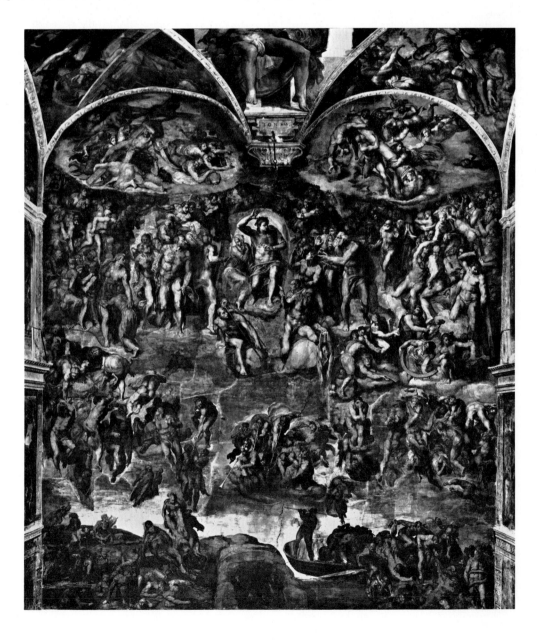

knees in prayer. In the writings of Ascanio Condivi, who wrote a biography of the artist in 1550, we can read the fresco through the eyes of a sympathetic contemporary:

> In this work Michelangelo expressed all that the human figure is capable of in the art of painting, not leaving out any pose or action whatsoever. . . . In the central part, in the air near to the earth, are seven angels, described by St. John in the Apocalypse, with trumpets to their lips, calling the dead to judgment from the four corners of the earth. With them are two others having an open book in their hands in which everyone reads and recognizes his past life, having almost to judge himself. At the sound of these trumpets all graves open and the human race issues from the earth, . . . while in some, according to the prophecy of Ezekiel, the bones only have come together, in some they are half clothed in flesh, and in others entirely covered . . . some who are not fully awakened, and looking up to heaven in doubt as to whether Divine Justice shall call them. . . . Above the angels of the trumpets is the Son of God in majesty, in the form of man, with arm and strong right hand uplifted. He wrathfully curses the wicked, and drives them from before His face into eternal fire. With his left hand stretched out to those on the right, He seems to draw the good gently to Himself. At His sentence are seen the angels between heaven and earth as executors of the Divine commands. On His right they rush to aid the elect . . . and on His left to dash back to earth the damned, who in their audacity attempt to scale the heavens. Evil spirits drag down those wicked ones into the abyss . . . every sinner by the member though which he sinned. Beneath them is seen Charon with his boat, just as Dante described them in his Inferno . . . raising his oar to strike some laggard soul. . . . Afterwards they receive their sentence from Minos, to be dragged by demons to the bottomless pit. . . . In the middle of the composition . . . all the saints of God, each one showing to the tremendous Judge the symbol of the martyrdom by which he glorified God: St. Andrew the cross, St. Bartholomew his skin. . . . Above these on the right and left, on the upper part of the wall, are groups of angels . . . raising in Heaven the Cross, . . . the Sponge, the Crown of Thorns, the Nails, and the Column of the Flagellation.

Michelangelo's originality is also manifest in the composition: a series of roughly horizontal bands starting with the earth and then a flattened oval figure grouping in the sky. The whole is not conceived from one perspective. As if disdaining the rational perspective of the previous century, the figures grow larger toward the top, and each group was conceived as having its own point of view. At the left, figures seem to levitate toward Heaven, perhaps symbolic of Michelangelo's belief that prayer and intense faith would accomplish this ascent rather than the traditional golden staircase. At the right, rather than storming heaven, those who symbolize sin are pushed and pulled downward by angels and demons. One implied diagonal, from upper left to lower right, connects the symbols of Christ's passion, his left and right hands, the pathetic skin of the artist, and the damned below. Such an epic and tumultuous revelation in art was unprecedented, yet it incurred censorship from Counter-Reformation-minded theologians. Christ was not shown enthroned, the angels did not have wings, references to Dante's writings were considered unacceptable,

the resurrected were not all given flesh, and worst of all, so much nudity evoked associations with brothels. Uncommented on, it seems, were the obscenities performed by several sinning figures at the right and, most important of all, Michelangelo's revolutionary view of the Last Judgment.

The most compelling reading of the fresco is by Leo Steinberg, who argues that the *Last Judgment* was a "merciful heresy." He cites the intentional ambiguity of Christ's performance: facial impassivity accompanied by gestures of justice and mercy that seem to cancel each other out, indicating that this is not the final judgment. The Virgin does not recoil in fearful helplessness but gently turns her body toward Christ while looking at the saved, now resurrected in Man's hope of a glorified robust body. Michelangelo's self-portrait in the flayed skin held up to the World Judge by St. Bartholomew signifies both the artist's sense of unworthiness to be among the first resurrected in full body, but also his hope of ultimate reunion with Christ. The saints around the Savior admonish sinners to suffer and be purified before joining them in Heaven. Steinberg argues that Michelangelo did not believe in a static, material, eternal Hell or that Christ would forever preside over the torture of sinners. Hell is not shown, and perhaps Michelangelo has substituted a kind of Purgatory. The tumbling figures at the right are viewed as personifications of Mortal Sin, while those at the lower right, flailed by Charon and awaited by Dante's Minos, are individual sinners tortured by guilt and fear. That there are more elect than damned implies Michelangelo's optimism that punishment will not be everlasting and that all sinners will eventually achieve grace. The final trumpet has, in fact, not blown. If this enlightened but heretical view Michelangelo shared with a group of pious Catholic reformers had been deciphered in the fresco by the Church, the consequences could have been disastrous for the artist. To protect him, Michelangelo's friends, such as Condivi, fostered more orthodox interpretations that have persisted until the present. Nevertheless, the fresco was heavily criticized and censored by painting over some of the nudity with drapery. El Greco even volunteered to repaint the subject on top of Michelangelo's fresco, reminding us that artists have often been their own worst enemies.

Christ's Death During the last 30 years of his life, Michelangelo experienced a deep spiritual and artistic change. He grew dissatisfied with physical beauty, pagan subjects, philosophic truths, with art itself: "Thus I know how fraught with error was the fond imagination which made art my idol and my king." Art now appearing vain, a distraction from thoughts of God, Michelangelo made the dead Christ the theme of his last drawings and sculptures. He came to believe that salvation was dependent upon one's attitude toward Christ's sacrifice—that grace could come only through complete faith in the meaning of the Cross: "No brush, no chisel will quiet the soul once it is turned to the

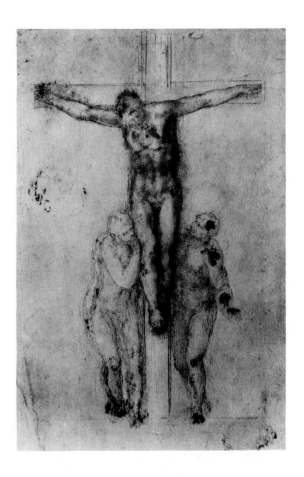

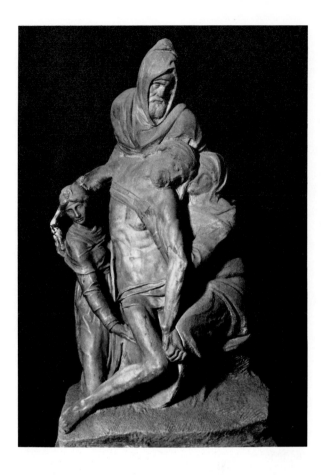

above: 220. Michelangelo. *The Crucifixion with the Virgin and St. John.* 1550–56. Black chalk, 16¼ × 11″ (41 × 28 cm). British Museum, London (reproduced by courtesy of the Trustees).

above right: 221. Michelangelo. *Deposition from the Cross.* 1548–55. Marble, height 7′5″ (2.26 m). Cathedral, Florence.

divine love of Him who upon the cross outstretches His arms to take us to Himself."

In one of his last drawings, Michelangelo showed Christ on the Cross (Fig. 220), the figure's encompassing spread of arms emphasized by the mourning forms of Mary and St. John. The multiple outlines impart a tremulous appearance to the group, due perhaps to an aged, unsteady hand. Light and shadow replaced contorted musculature as the agents of pathos and of Michelangelo's spiritual sentiments. The more deeply he felt the content, the more frugal became his means.

Michelangelo's late life and work seemed, paradoxically, to reject what had taken him a lifetime to gain. Having mastered his craft, the old artist submitted completely to private inspiration, with no self-consciousness about

beauty or his art's appeal for others. Despising his flesh and obsessed with the spirit, whose immortality depended on Christ's broken body, Michelangelo sought a new art that, more directly than anatomical studies, would bring spiritual meaning to the surface.

Two uncompleted *Pietàs* were the only sculptures executed by Michelangelo in the last years of his life. From 1548 to 1555, he worked on the *Pietà* in the Cathedral of Florence (Fig. 221), intended for his own tomb, but after eight years of labor he removed the left leg of Christ. This has been interpreted by historians as a sign of angry dissatisfaction with the form of his work and the artist's desire to achieve greater compositional unity. No one considered other motives until Steinberg argued that in its original position, the left leg of Christ was slung over the Virgin's thigh, forming a connection that was symbolic of sexual union. He has brilliantly traced the motif of the "slung leg" as a sign of sexual or marital union back to antiquity. According to certain theologians and metaphors used by such priests as Savonarola, both Mary and Mary Magdalen were mystically espoused to Christ. Mary Magdalen appears in this work as "lover and penitent," a symbol of the Church Penitent, as the Virgin was of the Church Immaculate. Steinberg

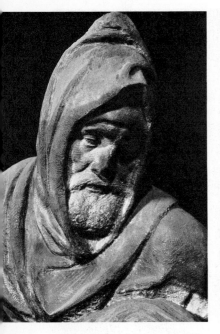

far left: 222. Michelangelo. *Joseph of Arimathea,* detail of Fig. 221.

left: 223. Michelangelo. *Self-Portrait,* detail of *The Last Judgment,* Fig. 219.

below: 224. Michelangelo. *The Rondanini Pietà.* 1550–64. Marble, height 6′4¾″ (1.95 m). Castello Sforzesco, Milan.

believes that the *Pietà* originally employed a direct sexual metaphor on a scale unprecedented in Christian devotional art; in view of the reformist atmosphere in Rome at the time, the aging Michelangelo may have felt that his intent would be misunderstood or that he had said too much in the "body language" of his art. How deeply he identified with this sculpture is shown by his self-portrait in the features of Nicodemus or Joseph of Arimathea (Fig. 222), who tenderly assists in lowering Christ's body into the tomb that Joseph had prepared for himself. By contrast with Michelangelo's agonized expression in *The Last Judgment* (Fig. 223), the visage of Joseph reflects the artist's calm resignation toward death and hope of reunion with Christ.

Until the time of his death in 1564, Michelangelo worked intermittently on *The Rondanini Pietà* (Fig. 224), begun in 1550. Recarved from what may have been an old Roman column and then an earlier *Pietà,* the vertical form of the Virgin supports the sagging body of the dead Christ, just removed from the Cross. Michelangelo apparently knocked off the original head and started another. Incomplete as the work is, the late style of the *Pietà* obviously scorned the supple, muscular, high-finish surface of the early sculpture. In its place were coarse textures and harsh junctures or angular interlocking of the limbs. Michelangelo sought to draw the beholder's attention away from surface qualities and toward a contemplation of the inner meaning of the subject. His vibrant late forms seem built from the inside out, affirming the importance of what the eye cannot see— the life of the soul and the Virgin's final spiritual communion with Christ. The earlier authority of gestures gave way to successive changes during the carving, as if the artist

sought symbolically to fuse the two figures. With his conversion to medieval mysticism, Michelangelo turned away from Renaissance achievements of depicting a vigorous, healthy, and beautiful body in the Classical manner. It was not for lack of inspiration that Michelangelo struggled at the end. Though solemn in form and theme, his last work expresses the spiritual joy he felt in the meaning of his subject. Reputedly, his final words to a friend were, "Remember the death of Christ."

Architecture Not a trained architect, Michelangelo approached the designing of walls as he did painting, like a figure sculptor whose ideas concerned relief compositions, skeletal armatures, systems of muscles and tendons, and tautly stretched skins. In designing the Laurentian Library (Figs. 225, 226) for the Medici, he no more accepted Renaissance conventions of flat wall arrangements than he had the proportional systems of other painters and sculptors. The entrance hall of the library, like the Medici Chapel, is taller than it is wide, a deep well that offers the immediate experience of unfamiliar space and proportions. Into the relatively small space cascades a great stairway, subdivided to separate servants from masters. This was the first monumental interior stairway. Michelangelo's central stair is like a strong current irresistible to both ascent and descent. The gray stone and white stucco walls make one of the most dramatic contrasts in architecture. Doubling the columns in wall niches was not necessary for structural support but,

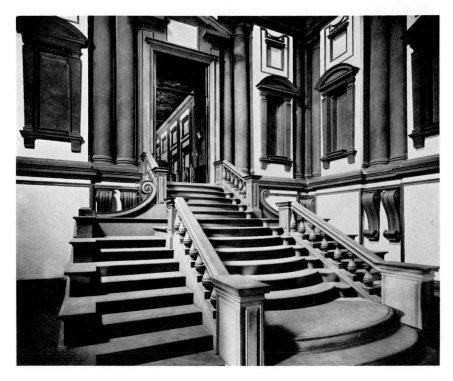

left: 225. Michelangelo. Vestibule of the Laurentian Library, Florence. c. 1524–26 (stairway designed in 1558–59; completed by Ammanati and Vasari, 1559).

above: 226. Michelangelo. Vestibule of the Laurentian Library, looking into the reading room.

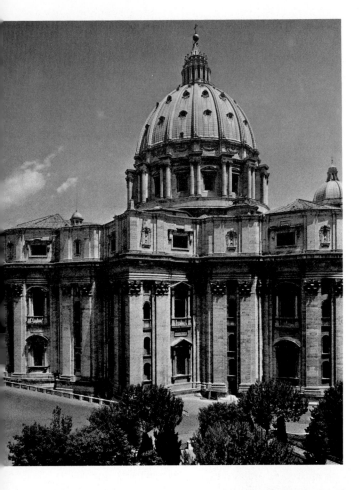

like his constricted figures, imparted a feeling of contained energy. Using the design vocabulary of ancient and 15th-century architecture, Michelangelo devised his own grammar; the scroll brackets, for example, serve a purely expressive purpose. Michelangelo, like no previous architect, could bring a building to life and endow it with expressiveness and power.

Michelangelo's architectural commissions were for structures whose significance equaled that of his elevated subjects in sculpture. For the west exterior wall of St. Peter's (Fig. 227), he used pilasters gigantic enough to rise through two stories and support a massive horizontal entablature. Not since the Gothic cathedrals had the structural elements of a building been given such expressive stress. His vigorous articulation of walls is analogous to the muscular interaction in his sculptured bodies. Instead of neutral openings, windows became emphatic projections with sculptural frames that push aggressively forward and to the sides.

The colossal attracted the artist in architecture as it did in painting and sculpture. In his day, the world was thought to center on the deteriorating Capitoline Hill (the Campidoglio), originally the cite of an ancient temple of Jupiter and then of the medieval city hall of Rome. The Pope approved Michelangelo's plans to redesign the crown of the hill as a great trapezoidal open square approached by a long inclined stairway (Fig. 228). At the end of the square stands the Palazzo dei Senatori; on either side the paired Palazzo dei Conservatori and Palazzo Nuovo. The plaza became an open-air theater for staging such public functions as the reception of chiefs of state. With its sculptural

above: 227. Michelangelo. St. Peter's, apse from the west. 1546–64 (dome completed by Giacomo Della Porta, 1590) Vatican, Rome.

right: 228. Etienne Dupérac. Engraving after Michelangelo's plan for the Capitoline Hill, Rome. 1569. Metropolitan Museum of Art, New York (Harris Brisbane Dick Fund, 1936).

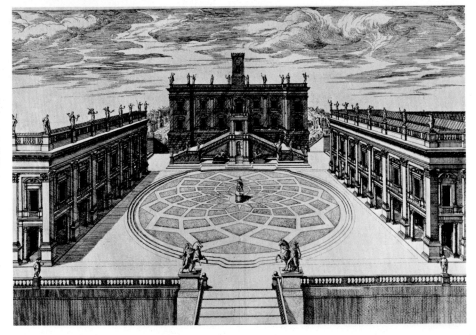

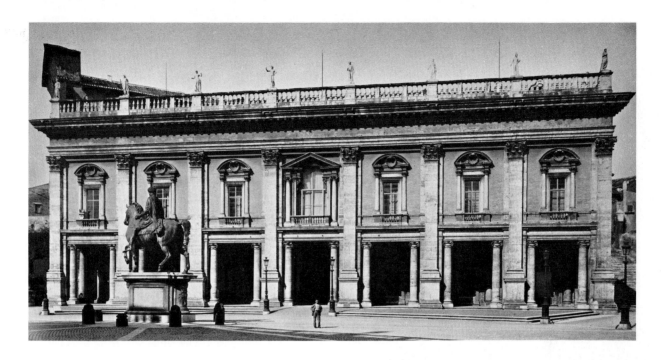

229. Michelangelo. Palazzo dei Conservatori.
Designed c. 1546. Capitoline Hill, Rome.

adornments preserved from antiquity, the plaza linked ancient pagan and contemporary Catholic Rome. Pope Paul III had the statue of Marcus Aurelius brought to the square, because of the aura of Imperial symbolism investing this work. Michelangelo designed the pedestal for the image and placed it on a gentle mound, where converged a curvilinear grid dividing the area into twelve compartments. James Ackerman has shown that the mound and its zodiac design relate to Roman Imperial shields and that the curving lines emanating from the statue's base derive from a sun symbol in Imperial armored portraits.

To the façades of the two flanking palaces (Fig. 229) Michelangelo brought new architectural associations and symbols of authority. Here he joined one-story columns with colossal piers, and the vertical thrusts and continuity of these members balanced the horizontal elements of the low rectangular façade. More than at St. Peter's, Michelangelo has fused the organization of wall surfaces with the functions of load and support so that, as in his figures, high drama comes from powerful countermovements and a continuous adjustment of opposing forces. The pyramidal double stairway before the Palazzo dei Senatori, so influential in later palace design, served simultaneously to frame like a pediment the sculptures of river gods and the goddess Roma, to give access to the main floor (the ground floor was a prison and so marked by heavier masonry), and to provide a platform for the appearance of nobility. Stairways, plazas, and framed vistas excited Michelangelo because they demanded movement rather than the passive inspection permitted by earlier Renaissance architecture.

The patterned oval pavement and the central statue force circulation about the plaza. The trapezoid encouraged movement toward the central palace, or it directed one's view across Rome to the new St. Peter's, where Michelangelo was planning the dome he did not live to see built. Thus Michelangelo gave significant shape to the two great monuments to Church and state in Rome and, in the process, applied the forms of antiquity to the advantage of a new and noble art.

The most gifted artist of his age, Michelangelo was also the most tormented. His writings reveal a man subject to depression, who thought himself mad and sinful. He could be timid, vengeful, and untrusting of those about him, often with good cause. Endlessly fascinated by the mysteries of creation, redemption, and salvation, he was strongly conscious of human frailty and fallibility. In short, Michelangelo was afflicted with magnificent visions that he felt achieved only a pale expression in his art: he sought to grasp the infinite, well knowing his own limitations. His visionary attempt resulted in the brilliant and daring paintings, sculpture, and architecture that still inspire and awe the modern world. In tragic irony, Michelangelo felt himself a failure. By 1550, he had given up painting, and his last sculptures were left unfinished. He turned to architecture, the most abstract of the visual arts, to fulfill his lifetime need for a union with the Creator. Making his art the mirror of his personal growth and change, his ego and moods, Michelangelo seems in some respects a modern personality. In the art are magnificent bursts of inspiration, upheavals of superhuman energy, and the weight of disillusionment. No other artist had ever exhibited so intimate a bond between his personality and his art; none so fiercely insisted on maintaining his individuality.

Chapter 9

16th- and 17th-Century Art: The Synthesis of Heaven and Earth

In our day, it is the mass communications media that convey messages to the public. In the 16th and 17th centuries, painting, sculpture, and architecture were the great transmitters, and their messages were primarily those of the Church. The purpose of religious art then was not only to illustrate or vivify the Bible and theology, as in the past, but also to engage in the war for humanity's spiritual allegiance being fought between religious factions throughout Europe. The word *propaganda* has acquired unpleasant connotations because of the modern history of its political use to distort truth, but in past eras, a crucial purpose of art was the dissemination of information and opinion—or propaganda. The war of ideas that engaged many of Europe's finest artists penetrated to art itself, for, like heretical literature, art that disseminated outdated, incorrect, or contradictory views had to be counteracted. For these reasons, changes in styles as well as in themes during the 16th and 17th centuries must be viewed within a militant context. The art of Leonardo, Michelangelo, and Raphael was highly acceptable to the Church before about 1520, but subsequent changes in Church policy and leadership, the need to respond to the Protestant Reformation, and demands for greater emphasis on piety and mystical faith caused extreme reactions and new alternatives to the work of these three great artists.

In this light, a painting from 16th-century Catholic Spain, *Christ Driving the Money Changers from the Temple* (Pl. 15, p. 158) by El Greco (Domenico Theotokopoulos, 1541–1614), can be meaningfully compared with *The School of Athens* (Pl. 16, p. 158) of Raphael (1483–1520), also painted in the 16th century. Raphael's fresco was located in the Vatican, in a room where the papal signature was affixed to important documents. Despite its position in a place of great importance to Christianity, the fresco portrays the great philosophers of antiquity, with the central focus upon Plato and Aristotle. Raphael was demonstrating the Humanist belief in the compatibility of pre-Christian thought with Church views in his own time. He created a series of imagined but intensely lifelike portraits of many philosophers, situating them in an equally imaginary but dignified architectural structure inspired by the work of Bramante (1444–1514), a contemporary architect who strongly influenced Raphael.

The subject El Greco chose was the single occasion on which Christ used violence. This may have related to the strenuous measures taken by the Church to rid itself of heresy, which by then included acceptance of pagan philosophy and art. Thus El Greco's Christ would drive not only the money changers but also the Humanists from the Church. Through the archway above Christ's head appears a reference to Rome, specifying the target of the artist's commentary. The spaciousness of Raphael's setting, the balance, grace, and vital bearing of his philosophers, so beautifully realized in drawing, color, and composition—all are intentionally counteracted by El Greco. Against the older artist's lucid, metrical space, his fluid composure of groups and orderly alignment of all forms in recessive zones parallel to the picture plane, were now offered congestion, angular,

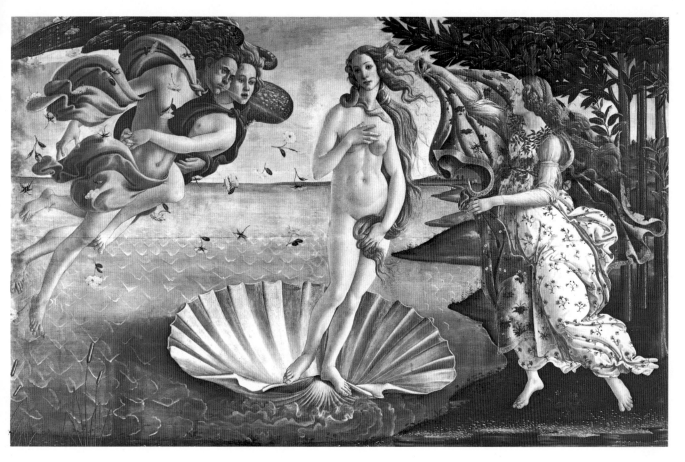

above: Plate 13. Sandro Botticelli. *The Birth of Venus.* c. 1485.
Oil on canvas, 6'7'' × 9'2'' (2.01 × 2.79 m). Uffizi, Florence.

below: Plate 14. Michelangelo. *The Creation of Adam,*
detail of Sistine Chapel ceiling. 1511. Fresco. Vatican, Rome.

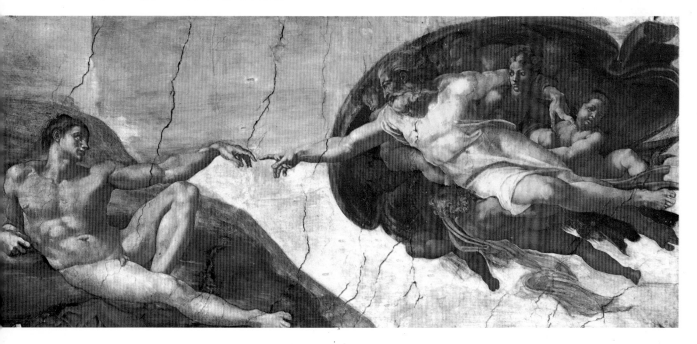

left: Plate 15. El Greco.
*Christ Driving the Moneychangers
from the Temple.*
c. 1570–75. Oil on canvas,
3'10'' × 5'9'' (1.17 × 1.75 m).
Minneapolis Institute of Arts
(Dunwoody Fund).

below: Plate 16. Raphael.
The School of Athens. 1510–11.
Fresco, 26 × 18' (7.92 × 5.49 m).
Stanza della Segnatura, Vatican, Rome.

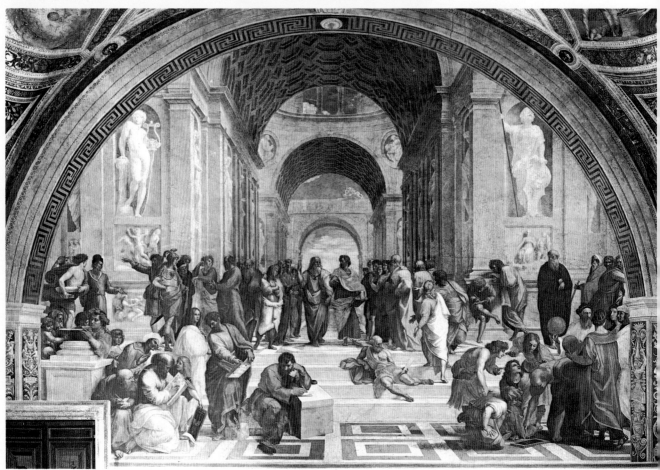

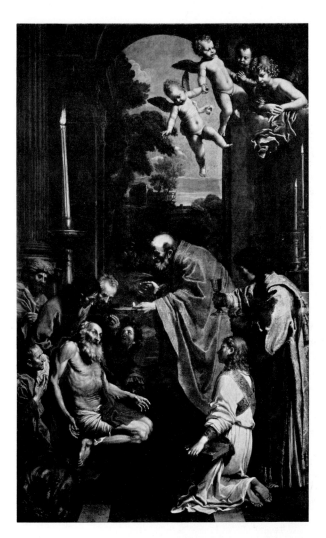

disconnected passages, and dissonant color. El Greco painted not to soothe the eye but to irritate the complacent who took balm from reason.

To combat Protestantism, the Church urged artists to affirm the sacraments, especially the Eucharist. In depicting St. Jerome, the Italian painter Domenichino (1581–1641), unlike Van Eyck (Fig. 162), did not celebrate the saint's scholarship; he eulogized his great will in rising from the deathbed to receive for the last time the wine and wafer (Fig. 230). The struggle to share in the sacred Eucharistic mystery is represented with the full range of expertise developed by the 15th-century painters who brought art down to earth and glorified the marvelous organism of the human body. The task of Domenichino and his generation was to redirect people's thoughts toward Heaven, while working with the devices of earlier Humanistic and secularized art.

Individual License Because 16th-century Protestants viewed as idolatrous the Catholic Church's use of art, no art appeared that explicitly illustrated Lutheranism in the way that the *Spiritual Exercises* of St. Ignatius of Loyola was celebrated in painting. The Flemish painter Pieter Bruegel (1525/30–69), whose religious affiliation is unknown, possessed a mind whose conception of the Bible and religious controversy departed from that of his Catholic contemporaries. His *Blind Leading the Blind* (Fig. 231), based on Matthew (15:12–19), could well have been a commentary on the religious leaders, equated with the Pharisees, then disputing theology throughout Europe. The church fully visible behind the blind men who stumble after each other seems a pointed reference. Since he was painting for a select clientele, Bruegel could count on a sophisticated audience, which included devout churchmen, to recognize certain absurdities in human affairs. For Bruegel, art served the

above: 230. Domenichino. *The Last Communion of St. Jerome.* 1614. Oil on canvas, 13'8" × 8'4" (4.17 × 2.54 m). Vatican Museums, Rome.

right: 231. Pieter Bruegel the Elder. *The Blind Leading the Blind.* Oil on canvas, 2'10" × 5'1½" (.86 × 1.54 m). Museo de Capodimonte, Naples.

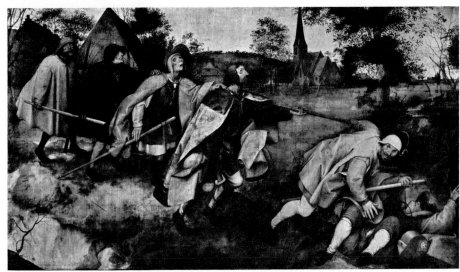

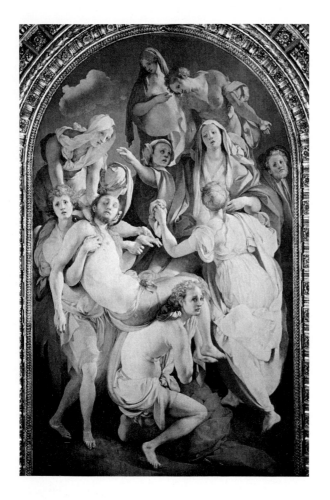

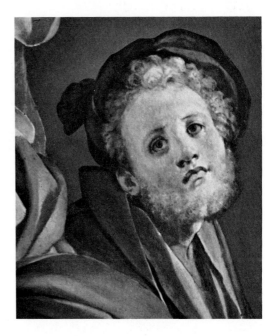

left: 232. Pontormo. *The Deposition.*
1525–28. Oil on panel, 10′3′′ × 6′3½′′
(3.12 × 1.92 m). Santa Felicità, Florence.

above: 233. Pontormo. Self-portrait.
detail of Fig. 232.

opposite: 234. Paolo Veronese. *Christ
in the House of Levi.* 1573. Oil on canvas,
18′2′′ × 42′ (5.54 × 12.8 m).
Academy, Venice.

mind and was the means by which to illustrate knowledge and wisdom detached from the customary partisan causes undertaken by his fellow artists represented in this chapter. Unlike Leonardo, Bruegel was interested in broad, even generic, human relationships, and the viewer's physical remoteness from his figures reflects the kind of intellectual detachment he assumed toward his subject.

To maintain that artists in the 16th century acted and thought only at the bidding of the Church is to overlook the individual initiative and personal feelings and fantasies of many of the greatest painters. Pontormo (Jacopo Carucci, 1494–1556/57), a contemporary of Michelangelo's, was famous in his time for both his art and his eccentricity, which took the form of fanatical isolation and hypochondria; he exemplified the 16th-century concept of the lonely genius, which he was, but he also sought to escape the service of a tyrant. His painting of *The Deposition* (Fig. 232) is a deeply personal and disturbing meditation on the meaning of Christ's death, couched in a language that seems an alien tongue in comparison to the idiom of Raphael and Leonardo. The eye is at first jolted by apple greens, metallic grays, and shrill pinks and yellows—not the ano-

dyne palette of Raphael, with its soft reds, blues, and flesh tones. The distortions of Pontormo's figures ultimately depend upon correct anatomical knowledge, but the demands for an expressive or emotional composition impelled the distention or abbreviation of limbs, dislocation of shoulders, and the elongated, boneless torsos. His figures are of a type, a strange family whose faces betray intense shock. The laws of spatial logic, and hence reason, are decisively put aside: the entwined figures appear to be stacked vertically in some unreal place and moment. This work does not have the rationale of a 15th-century painting; it is impossible to conceive of what the figures will do next or where they will go or to visualize the painting's space without them. It is the unnatural occasioned by mystical attitudes and themes that nurtured Pontormo's style. As was true of Michelangelo, an inner, personal vision, not nature, was his model. It is therefore difficult to determine how accurately his self-portrait (Fig. 233), seen to the right of the Virgin, reveals his actual physical appearance.

The Counter-Reformation Response The Church did not always accept the license taken by artists in the name of

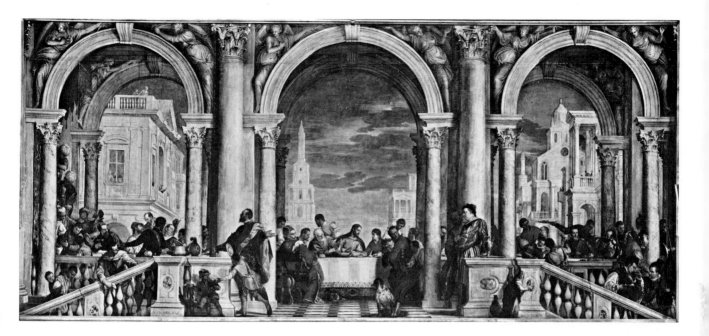

individuality; fearful of a corruption of its message, the Church evolved an official artistic program, concerned with subject matter rather than style, in the second half of the 16th century. This program was intended to counteract the Protestant Reformation and its assaults not only upon the doctrine and practices of the Holy Roman Catholic Church but also on its art. The Council of Trent, which sat in the north Italian town of Trento from 1545 to 1563, was an arm of the Spanish Inquisition instrumental in crystallizing Church policy with regard to internal reform, as well as in plotting strategy against the northern Protestant heretics. In the last year of its meeting, the Council promulgated its views on art. In essence, this program reaffirmed the Church's belief in the importance of art, reiterated the opposition to idolatry, espoused the didactic purpose of art and its provision of an ethical model for the faithful, decried indecency in religious painting and sculpture, and insisted upon decorum, respect, and accuracy in interpreting theological or spiritual matter. The implications of the Council's program included an anti-Humanist attitude, a kind of Counter-Renaissance that favored an appeal to the emotions of the believer in the manner of Loyola's *Spiritual Exercises.* These exercises involved a self-induced ecstatic trance or meditation, comparable to that achieved in yoga, in which the individual lost all self-consciousness and through visions identified himself with the feelings or state of his object of worship. Another implication of the Council's views was a stress on the supernatural, or a suspension of the rational, which gave rise to numerous works of art dealing with miraculous themes. As a result of the Council's promulgations, theological truth and the strengthening of Church doctrines through visual representation became more important than artistic beauty. The implied emphasis was on reaching greater numbers of people as opposed to the earlier focus on the educated classes.

The Trial of Veronese To ensure its decrees would be carried out, the Council instituted a censorship of art by agents of the Inquisition. The most famous case brought before these agents, the Holy Tribunal sitting in Venice on July 18, 1573, was that of the Venetian painter Paolo Veronese (1528–88), who had painted a questionable version of the Last Supper (Fig. 234). The transcript of the trial illustrates, among other things, the uneasy synthesis of the spiritual and the secular in the minds of the judges as well as in that of the painter. When questioned about his profession, Veronese answered as follows*:

A. I paint and compose figures.
Q. Do you know the reason why you have been summoned?
A. No, Sir.
Q. Can you imagine it?
A. I can well imagine.
Q. Say what you think the reason is.
A. According to what the Reverend Father, the Prior of the Convent of SS. Giovanni e Paolo, whose name I do not know, told me, he had been here and Your Lordships had ordered him to have painted [in the picture] a Magdalen in place of a dog. I answered him by saying I would gladly do everything necessary for my honor and for that of my painting, but that I did not understand how a figure of Magdalen would be suitable there for many reasons which I will give at any time, provided I am given an opportunity.

* From *Literary Sources of Art History: An Anthology of Texts from Theophilus to Goethe,* ed. Elizabeth Gilmore Holt (©1947 by Princeton University Press), pp. 245–248. Reprinted by permission of Princeton University Press.

Q. What picture is this of which you have spoken?

A. This is a picture of the Last Supper that Jesus Christ took with His Apostles in the house of Simon. . . .

Q. At this Supper of Our Lord you painted other figures?

A. Yes, milords.

Q. Tell us how many people and describe the gestures of each.

A. There is the owner of the inn, Simon; besides this figure I have made a steward, who, I imagined, had come there for his own pleasure to see how the things were going at the table. There are many figures there which I cannot recall, as I painted the picture some time ago. . . .

Q. In this Supper which you made for SS. Giovanni e Paolo what is the significance of the man whose nose is bleeding?

A. I intended to represent a servant whose nose was bleeding because of some accident.

Q. What is the significance of those armed men, dressed as Germans, each with a halberd in his hand?

A. This requires that I say twenty words!

Q. Say them.

A. We painters take the same license the poets and the jesters take and I have represented these two halberdiers, one drinking and the other eating nearby on the stairs. They are placed there so that they might be of service because it seemed to me fitting, according to what I have been told, that the master of the house, who was great and rich, should have such servants.

Q. And that man dressed as a buffoon with a parrot on his wrist, for what purpose did you paint him on that canvas?

A. For ornament, as is customary. . . .

Q. Did anyone commission you to paint Germans, buffoons, and similar things in that picture?

A. No, milords, but I received the commission to decorate the picture as I saw fit. It is large and, it seemed to me, it could hold many figures.

Q. Are not the decorations which you painters are accustomed to add to paintings or pictures supposed to be suitable and proper to the subject and the principal figures or are they for pleasure—simply what comes to your imagination without any discretion or judiciousness?

A. I paint pictures as I see fit and as well as my talent permits.

Q. Does it seem fitting at the Last Supper of the Lord to paint buffoons, drunkards, Germans, dwarfs, and similar vulgarities?

A. No, milords.

Q. Do you not know that in Germany and in other places infected with heresy it is customary with various pictures full of scurrilousness and similar inventions to mock, vituperate, and scorn the things of the Holy Catholic Church in order to teach bad doctrines to foolish and ignorant people? . . .

A. Illustrious Lords, I do not want to defend it, but I thought I was doing right. I did not consider so many things and I did not intend to confuse anyone, the more so as those figures of buffoons are outside of the place in a picture where Our Lord is represented.

After these things had been said, the judges announced that the above named Paolo would be obliged to improve and change his painting within a period of three months from the day of the admonition and that according to the opinion and decision of the Holy Tribunal all the corrections should be made at the expense of the painter, and that if he did not correct the picture he would be liable to the penalties imposed by the Holy Tribunal.

Despite the Tribunal's injunctions, however, there do not appear to have been any changes made by the artist to the painting itself, but he did change its title to *Christ in the House of Levi.*

Veronese's answers give a 16th-century definition of painting based on the composition of figures which were to be *read,* that is, which were to convey a message and be interpreted. Like a dramatist, the artist had to envision why each figure was present and what it would logically be doing. When it came to filling a large space with ornament and enrichment, Veronese claimed for the painter the same license given to poets—the freedom to include stories and information outside the Bible, in order to bring the biblical event to life in terms of one's own time. Veronese's criteria were his ability and personal judgment of fitness, fortified by what he had seen in great art of the past. The great scale of his painting and the sumptuous setting and elaborate social milieu were reflections of his personal delight in contemporary Venetian customs.

Sacramental versus Psychological Though not insensitive to secular life, Tintoretto (1518–94), another Venetian, painted religious images fully consonant with Counter-Reformation ideals. The Roman Church affirmed that, contrary to Protestant theology, to participate in the Eucharist was to partake mystically of the body and blood of Christ. This belief impelled Tintoretto to emphasize in his *Last Supper* the miraculous meaning and origin of the Eucharistic doctrine.

Tintoretto's art was typical of a Counter-Renaissance attitude that saw the style and content of such painters as Leonardo as too worldly. Comparison of Leonardo's *Last Supper* (Fig. 235) with Tintoretto's of a century later (Fig. 236) reveals the ideological gulf separating the two interpretations. Concerned with interior human motivation, Leonardo portrayed the moment when Christ foretold his betrayal but also proclaimed the sacrament of the Eucharist. This permitted a virtuoso display of the artist's knowledge of facial and gestural expression and of the differences in individuals' reaction to shock. Set in an austere room, the scene has been treated illusionistically as a continuation of the refectory whose wall it adorns; thus Leonardo could display his mastery of spatial organization and of the effects of certain lighting conditions. Tintoretto has suggested a rustic inn, and he makes the meal a less formal occasion. We can identify ourselves with the servants between us and Christ. His placement and greater embedding in the scene creates a "recession of the heroic focus," to use Steinberg's term. Almost melodramatic, the lighting accords with the mystical sacramental moment chosen by Tintoretto. The artist's technique for attaining these effects was to set small sculptural figures in an open-ended box and then move different lights over the model.

Leonardo's composition is "closed," or completely contained within the limits of the picture area. The vanishing points and figural action lie either at the center or within the borders of the painting. Tintoretto's arrangement is "open";

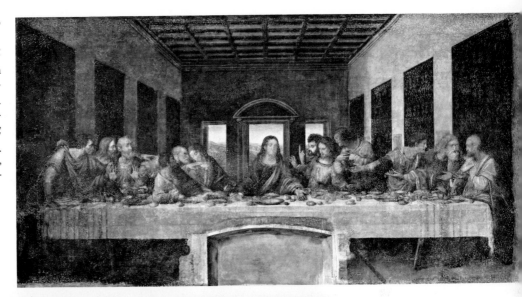

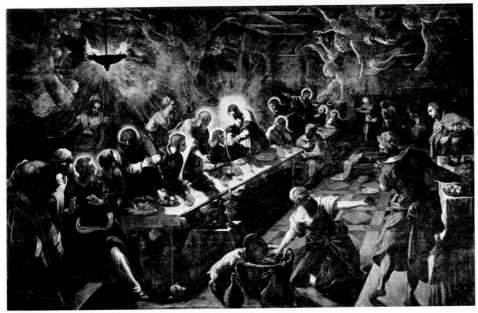

space, light, shadow, and action seem to extend beyond the frame. Leonardo has organized his figures and table on an imaginary plane parallel to the picture surface, holding the viewer off from the action. Tintoretto's forms exist on a strong thrust diagonal to the picture surface, which makes them seem to recess in space. It is easier to isolate individual figures, objects, or units within Leonardo's scheme. The potential of the figures derives from the more distinct edge bounding each and the relative evenness of the light; they are clear in shape and illumination. Tintoretto's figures have a more inextricable relationship resulting from over-

lapped shadows and their construction through color as well as with light and shade. Obscurity and painterliness characterize Tintoretto's composition. Leonardo kept light and dark close to the middle register, avoiding strong contrasts over large areas. Extreme value contrasts in major areas create the dramatic and mystical effects of Tintoretto's composition. Leonardo, a Renaissance painter, eschewed clashing colors placed close together; Tintoretto made visual excitement out of strong disparities between colors. His light sources were multiple and irrational, Leonardo's fewer and more natural. Tintoretto's space pulls the viewer into

the picture with a swift rush, but the eye is drawn back again to the large foreground groups and the angels hovering overhead. The edges and perspective focus of Leonardo's architecture lead the viewer into depth; the head of Christ in the foreground draws one back into an area near the picture plane. Tintoretto set Christ's head in a mystical radiance, the most intense light of the painting; light, therefore, replaced perspective or geometry as the principal instrument of religious significance.

Devotional Paintings It was 16th-century Venetians such as Veronese, Tintoretto, and Titian (c. 1488–1576) who gave new implications to the verb *to paint.* In the 15th century, artists colored areas already described by linear drawing, which gives their work a series of contours that are easy to grasp even when seen in black and white. The monochrome reproduction of the painting in Figure 237 gives the misleading impression of murky indistinctness. The relative coarseness and the fusion of silhouettes with the surrounding space derive from Titian's use of brush drawing in color to build his figures. Color was Titian's prime means of expression and method of construction, color seen not in a vacuum but by natural or artificial light filtered through a palpable atmosphere.

Titian and Tintoretto responded to the physical sensations of brushing color into a surface, savoring the pigment's weight, texture, and pliability, to make each stroke define a shape, degree of light, modeling, and exact color tone. Pressure could spread apart the pigment-filled brush, permitting the underpainting to radiate through and vibrate with the new color. To the elderly Titian came knowledge of the expressive power possible in the judicious selection of a few colored strokes, but his contemporaries, favoring the earlier virtuoso work, thought the style of *Christ Crowned with Thorns* the result of senility, trembling hand, and failing vision. Palma Giovane, a sometime collaborator, has described how the aged Titian worked:

Titian began his pictures with a mass of color which served as a bed or foundation for what he wished to express. I myself have seen such vigorously applied underpainting in pure red ochre, which was meant to give the half-tone, or in white lead. With the same brush, which he dipped in red, black or yellow, he created the modeling effect of the lighter portions. With four strokes he was capable of indicating a magnificent figure. . . . After he had thus applied this important foundation, he turned the pictures to the wall and left them . . . sometimes for months. When he afterwards returned to them, he scanned them with a concentration as severe as if they had been his mortal enemies, in order to find faults in them; and if he found something which was not in accord with his intentions, he went to work like a surgeon. . . . Thus by repeated revision, he brought the skeleton of his figures to the highest degree of perfection and, while one picture was drying, he turned to another. This quintessence of a composition he then covered over with many layers of living flesh, until the figure seemed to lack only breath. He never painted a figure *alla prima* [spontan-

eously], and was wont to say that he who improvises can never fashion a perfect line of poetry. He gave the last touch to his pictures by adjusting with his fingers a spot of black in one corner or heightening with a dab of red, like a drop of blood, the liveliness of the surface. . . . In the last stages of the work, he painted more with his fingers than with the brush.

Just as he reworked a single painting, so did Titian reinterpret certain themes and earlier compositions, not just for his many clients but, in later years, largely for himself. In his *Christ Crowned with Thorns,* he subdued the earlier strong facial reactions, obstructed focus upon hands, and generally suffused the entire scene with a drama of light and strongly textured color. To a certain extent, late works such as this were the painter's private devotional paintings, and in a secular sense, they marked passionate devotion to painting itself.

237. Titian. *Christ Crowned with Thorns.*
c. 1570. Oil on canvas, 9′2″ × 6′ (2.79 × 1.83 m).
Alte Pinakothek, Munich.

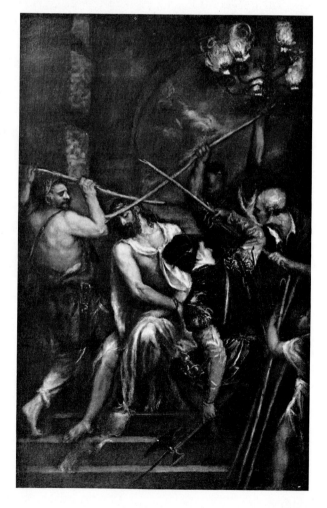

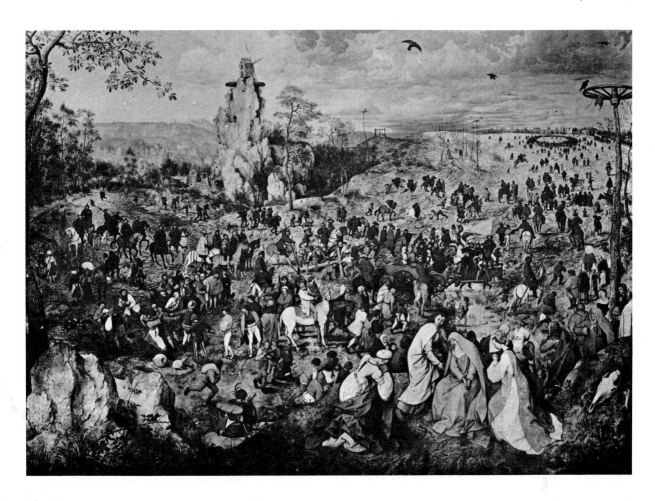

238. Pieter Bruegel the Elder.
The Carrying of the Cross. 1564. Oil on panel,
4′7⅞″ × 5′6⅞″ (1.24 × 1.7 m).
Kunsthistorisches Museum, Vienna.

The Long View of Bruegel In comparison with Titian's painting, Pieter Bruegel's *Carrying of the Cross* (Fig. 238), done a few years earlier, is a radical departure in biblical illustration, yet conservative in terms of the relation of color to drawing. The pathos resulting from Titian's intimate focus upon Christ's ordeal is matched in Bruegel's painting by an equally strong ethos arising from the viewer's remoteness from the figure of Christ, struggling under the weight of his Cross. The Way to Calvary is plotted along a broad curving plane, and Christ is accompanied by a crowd that takes little notice of him but is diverted by all sorts of byplay. In the foreground are the weeping Marys and St. John, and nearby is seen an elevated wheel used for the torture-execution of criminals in Bruegel's time. In a sense, Bruegel gives us the long view of Christ's ordeal: we see the Savior in the broad context of a time and place, as a man among men,

who like many before and after is unjustly put to death, providing the crowd with still another morbid spectacle. It is possible that the curving arc of the plain and the numerous references to circles would have suggested to Bruegel's limited but knowledgeable audience the continual recurrence of injustice. Some historians have seen in this painting the artist's bitter commentary on the brutality of Spanish rule over the Netherlands or an oblique reference to the sadism of the Inquisition; but if this is true, it somehow escaped the notice of the Spanish Catholic royalty, who admired his painting. Bruegel's focus is the reverse of Titian's: it inhibits concentration on the personal and theological implications of Christ's Passion, and it increases the breadth of the artist's statement about history and human nature to a scale then unrivaled.

The Mysticism of El Greco The most mystical of the Counter-Reformation painters was El Greco, who believed in the irrational basis of Christian dogma and the necessity of a uniquely personal style to embody his private visions. The events in his paintings are not depicted in 15th-century

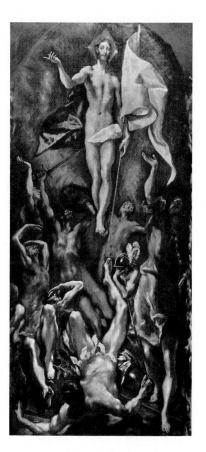

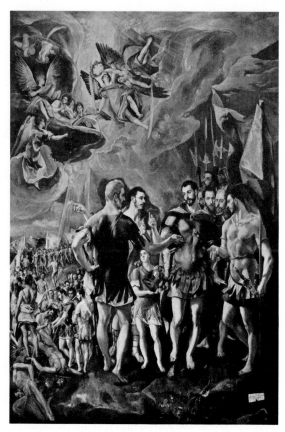

Europe, according to the rational perception of a detached observer, but are emanations of an ecstatic visionary who sought to show in one explosive moment things that defy intellectual comprehension. For this reason, his *Resurrection of Christ* (Fig. 239) seems antidotal to that by Piero della Francesca (Pl. 12, p. 124). El Greco presents the mystical levitation of Christ's body as it rose from the invisible tomb. The position of Christ's feet helps to engender this feeling of ascent and also recalls the posture of his Crucifixion.

El Greco was concerned more with metaphysics than with psychology. The cold, eerie light of the scene originates from Christ's transfigured person. His effortless upward movement contrasts with the forceful effects of the awesome mystical light, which has upset the sleeping tomb guards, dazzled those who have awakened, and exalted those present who comprehend the transformation. Through gestures at once rhetorical and symbolic, El Greco demonstrated the forceful process of spiritual enlightenment and the significance of the Resurrection. The gesture of Christ's right hand is a sign of the completion of what had been ordained, while its counterpart in the large figure at the lower right is one of simultaneous recognition and supplication. The extreme luminosity, the exaggerated elonga-

above left: 239. El Greco. *The Resurrection of Christ.* 1600–05. Oil on canvas, 14′8½″ × 9′10½″ (4.48 × 3 m). Prado, Madrid.

above: 240. El Greco. *The Martyrdom of St. Maurice.* 1580. Oil on canvas, 16′10″ × 9′6″ (5.19 × 2.94 m). El Escorial, Spain (reproduced by permission of the Patrimonio Nacional).

opposite: 241. Stradanus. *The Martyrdom of St. Agatha.* 16th century. Engraving.

tion, and the inconstant silhouette of Christ's body reduce its corporeality and eliminate the suggestion of militancy seen in Piero's God. All that was tangible and substantial in the work of Piero has been made elusive and immaterial by El Greco. The stability of Piero's composition—its implied triangle of verticals resting on solid horizontals, all locked within a square format—has been replaced by an unstable irregular lozenge design in a vertical format. Just as El Greco's mystical Christ was freed from the logic of matter, so is the event abstracted from a specific earthly place and time.

The strength of El Greco's religious message did not weaken his inspired inventiveness as a painter. Great artists of the past and of his own time had early taught him lessons

in drawing, color, and composition. As his art became more introspective, however, it posed unprecedented technical problems, so that the success of his solutions cannot be gauged against the work of others. To a modern viewer, El Greco's *Martyrdom of St. Maurice* (Fig. 240) appears as a beautifully accomplished fact. He has solved the artistic problems so well that he has obscured their original difficulty. Recall that Counter-Reformation art often instructed the faithful in the merits of dying for their beliefs, in response to the Protestants who criticized the Church's veneration of its numerous martyrs. To affirm the sacred act of the martyr and to encourage worldwide missionary work, Roman Catholic artists were enjoined to recount the historical sacrifices of the martyrs. The story chosen by El Greco is that of the wholesale execution of a Roman legion that, with its commander, St. Maurice, had been converted to Christianity. Refusing the Emperor's ultimatum to renounce their faith, every man in the legion was beheaded at the site of what is today St. Moritz, Switzerland. El Greco stressed the moment of decision when the legion officers surrounding St. Maurice considered the Imperial ultimatum. Accordingly, almost a third of the painting's surface is devoted to this small group in the foreground. The upper part discloses angels who descend from Heaven holding the crowns of martyrdom. To the smallest, most restricted area at the left is consigned the execution of the entire contingent.

El Greco boldly juxtaposed the largest and smallest figures in the entire painting. By means of the medium-size angels placed at the upper left and the large standard at the

right, he set the eccentric composition solidly within the frame. The sculptural firmness of the foreground officers is replaced, as the eye moves rapidly into depth, by the diaphanous character of the tiny figures in the distance.

Essential to the style of these paintings by El Greco is the total absence of straight edge, evenly illuminated surfaces, continuous closed silhouettes, repose, and measurable space. Every shape seems in the process of change; rarely is the eye permitted to rest. Figures and clouds swell from tapered points, and rocks and pennants are edged in writhing contours. It is possible to follow the action of the painter's hand in the irregular cloud and flag forms. His thinking was focused on both particular objects and their adjacent areas, so that rarely is a figure or object seen in isolation. No dominant sustained vertical or horizontal axis structures the composition. Unity is finally the result of closely fitted oscillating or irregular parts, often at obtuse angles to each other or else in parallel series.

El Greco has been called insane; more recently, it has been suggested that he suffered from astigmatism. Neither was the case. His unique art was the product of a lifelong development, lucid calculation, and passionate religious conviction. He might have declared that his physical vision was normal but that his "inner eye" was abnormal.

Sadistic License Ironically, the age of the Counter-Reformation, which saw a restoration and increase of the Church's power, was also the lustiest and most perverse in its artistic celebration of sex. Art of the 16th and 17th centuries, ostensibly in the noble service of defending or expounding the true faith, was in fact frequently the outlet for the erotic and sadistic interests of artists, their ecclesiastical patrons, and their audiences. Church scholars chronicled all forms of gruesome martyrdom, and in a Roman college for the training of missionaries, walls were lined with horrifying images of "successful alumni" who had died as martyrs all over the world. Rather than discourage the young, such images fired their zeal. An engraving by Stradanus (Jan van der Straet, 1523–1605) of *The Martyrdom of Saint Agatha* exemplifies the public's fascination with sexual violence enacted upon female martyrs (Fig. 241). Ugliness and beauty are blatantly contrasted as symbols of sin and saintliness. Ironically, it was the Holy Inquisition, with its well-known methods of torture, that fed the public taste for sadism. The synthesis of heavenly and earthly values at the time of the *Merode Altarpiece* (Pl. 9, p. 123) had already begun to incorporate sexual life, and in the period here considered, there was an increasingly frank exposure of sexuality that often tried the credibility of the synthesis.

Synthesis of Flesh and Spirit That there was no homogeneous Counter-Reformation style can be seen by the fact that, along with El Greco's paintings, those of Peter Paul Rubens (1577–1640) were highly acceptable to the Church. El Greco's opposite in temperament and style, the Flemish

Rubens was able to reconcile a vital love of the flesh with a love of the spirit. His mythological pagan types, kings, peasants, and religious personages are interchangeable; all share a robust virility, effulgent health, and an appetite for living. The deeply introverted El Greco distrusted the carnality of the body with medieval fervor, whereas Rubens seems to have been fulfilled through the sensuous painting of the flesh. The energy in El Greco's painting is mystical; that in Rubens' work is muscular.

When Rubens painted his *Descent from the Cross* (Pl. 17, p. 175), he involved his subjects in the arduous mechanics of lowering Christ's heavy body. The figure at the upper right, having both hands engaged, holds the death shroud in his teeth (Fig. 242). Despite the cumbersome process, the mourners are given grace of movement. The tenderness with which the body is received is intended to contrast with the brutality of the execution. Seen at close range, the painting of Christ's blood seems excessively lurid, but it must be remembered that this huge painting was intended for a large church where it would be seen from a distance by the whole congregation. Color helps us to realize how fully Rubens met the Counter-Reformation ideals of encouraging the faithful to identify with Christ's Passion. The flesh of the living has layers of color touched

with the key red, which makes it glow with warmth and vitality. That of Christ has the gray of death and is contrasted with the ruddy-complexioned arms, the whiteness of the shroud, and the brilliant reds of Christ's blood and of the garment of St. John. The strongest and richest contrasts are thus grouped at the center around the broken figure, and the darker tones tend to merge with the deep blue-green of the sky. By focusing the light in the central area, away from the edges, the scene would thus appear to be more illusionistic in the darkened space of the church.

El Greco evokes unshed tears of anguish and disdains the materiality of this earth. Rubens induces the sweat of exertion and rejoices in sensuality. What El Greco shows lying beyond touch, Rubens addresses to our fingertips. While St. Maurice and his captains tread lightly on the earth, Rubens' race of giants grows from it. Rubens' Christ has known heroic physical exertion, that of El Greco only spiritual exercise.

Though comparison with El Greco may mislead the reader into doubting Rubens' religious sincerity, mystical asceticism has not been the only producer of great religious art. Rubens was passionately devoted to the Roman Catholic faith and spent a lifetime enriching the splendor of the altar with his paintings. Like the 15th-century Flemish artists

below: 242. Peter Paul Rubens. Detail of *Descent from the Cross* (Pl. 17, p. 175).

right: 243. Peter Paul Rubens. *St. Ignatius Exorcising Demons from the Church.* 1619. Oil on canvas, 17'6½'' × 12'11¾'' (5.35 × 3.95 m). Kunsthistorisches Museum, Vienna.

244. Peter Paul Rubens.
The Last Judgment. c. 1615.
Oil on wood,
5′11⅝″ × 3′11¼″ (1.82 × 1.2 m).
Alte Pinakothek, Munich.

before him, Rubens saw no contradictions in his attraction to the material world of the mythological past. He had optimistic confidence in himself and in the right and power of the Church. Like the Roman Catholic rulers and ecclesiastical patrons who paid for his secular art, he saw no sin in the healthy enjoyment of what lay outside dogma. When he painted religious subjects such as *St. Ignatius Exorcising Demons from the Church* (Fig. 243), he was attentive to the spirit of his theme. Just as St. Ignatius had recommended projecting oneself into the state of the subject of worship, Rubens' painting draws the viewer into the church to share the excitement of the miracle and the new hope of the sick who have been cleansed of the devil. Such projection is difficult if not impossible in the construction of El Greco's paintings. In Rubens' work, the foreground brilliance and posturing of the nearest figure draw us upward to the saint and back down into depth at the left where the devil quits the church. The diagonal in depth was a consistent stylistic device by which Rubens told a story, achieved dramatic and visual climax, and held his composition together.

The vigorous movement and sensual appearance of Rubens' figures are born in the rhythms of his brush and the creamy substance of his paint. To enjoy El Greco's color is to appreciate rare admixtures of tones, predominantly cool colors under a sometimes shrill light, restraint in the buildup of heavily pigmented areas, and, by comparison with Rubens, a less obtrusive trace of the brush. Showing warm light and lush sequences of opacity and and transparency, Rubens' colors and glazes create the impression of pulse and blood lying just beneath the flesh. Rubens' brush swept with bravura across a form or delicately touched a tiny area demanding a highlight. The viewer looking at a Rubens' painting can sense the physical as well as the aesthetic pleasure the artist enjoyed as he worked. It is not difficult to comprehend Rubens' full involvement in the materiality of the medium that permitted him to re-create the sensuous world he loved.

When Rubens painted *The Last Judgment* (Fig. 244), he depicted the most sensual sinners in history. The damned flood downward from the seat of judgment and overwhelm the picture space, leaving the smaller and more remote upper regions for the elect. How paradoxical it seems that in this painting Rubens would acknowledge the sinfulness of voluptuous flesh and then proceed for the rest of his life

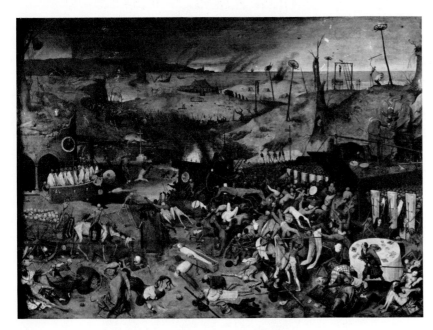

left: 245. Pieter Bruegel the Elder. *The Triumph of Death.* c. 1562. Oil on panel, 3′10″ × 5′3⅞″ (1.17 × 1.62 m). Prado, Madrid.

opposite: 246. Gianlorenzo Bernini. *The Ecstasy of St. Theresa.* 1646. Marble, life-size. Cornaro Chapel, Santa Maria della Vittoria, Rome.

opposite right: 247. Caravaggio. *The Conversion of St. Paul.* 1601–02. Oil on canvas, 7′6½″ × 5′9″ (2.3 × 1.75 m). Cerasi Chapel, Santa Maria del Popolo, Rome.

to glorify the beautiful bodies of mythological heroes alongside similarly endowed saints and royalty. As with so many artists before him, it is the spectacle of Hell rather than Heaven that calls forth Rubens' most inspired painting. Punishment rather than judgment, the provocative contortions and violent intertwining of condemned bodies rather than the composed bliss of the elect, predictably appealed to audiences drawn to depravity. Despite the diminished emphasis upon Heaven and the imbalance between the saved and the damned, Rubens' pessimistic view of the fate of most of humanity would be good Counter-Reformation propaganda.

Pieter Bruegel's *Triumph of Death* (Fig. 245), painted half a century before, seems to take a cynical attitude toward any efforts to buffer humanity from the facts of death. Unlike its medieval *memento mori* prototypes (Fig. 155; Pl. 8, p. 90), Bruegel's version of the encounter of the living and the dead is "catholic" only in its universality. Eyewitness to plagues and wars in the southern Netherlands, Bruegel could draw from personal experience concerning human vanity in the face of such disasters. Rubens championed the theological view of a Last Judgment and life in the hereafter. Bruegel, whose religious convictions are unknown, chose to show life stopping at the entrance to the coffin, with no assurance of an ultimate justice, of Heaven or Hell. There is no indication that the skeletal hordes dispatching the living or herding them into the open end of a gigantic coffin are the emissaries of Christ or the Devil. Instead of the Archangel with his valence, there is a skeleton beating a drum above the coffin, providing the insistent rhythm of death. Churches have been overrun by skeletons who perform irreverent services. The traditional figure of

Death riding a pale horse is seen drawing a wagon load of skulls, while nearby a king and a cardinal are in the grips of skeletons. In the lower right are the cavalier who dares death with his sword, the lovers oblivious to all around them, and the fool who crawls under the table. *The Triumph of Death* is so sweeping in its cataloguing of all forms of destruction that it suggests the end of the world.

The Religious Vision Cataclysmic visions were fewer in the Counter-Reformation period than those of Heaven. So important was the Counter-Reformation concept of the religious vision that an increasing number of Roman churches in the 17th century had their vaults illusionistically painted in grandiose compositions that permitted the faithful to look directly upward into Heaven. One of the largest and most powerful vault paintings was *The Triumph of St. Ignatius Loyola* (Pl. 18, p. 175) of Fra Andrea Pozzo (1642–1709). It celebrated the work and sacrifice of the Jesuit order throughout the world and demonstrated the reception in Heaven of its leader and martyrs. Pozzo transformed the vault to give the impression that the church soars upward an additional two stories and is without any ceiling. Against the illusion of massive stable architectural elements, columns, and arches, Pozzo floated clusters of figures in a remarkable series of foreshortenings, so that from every point of view the scene is in perspective. The entire scene is suffused with radiance, accelerating the eye upward with no prolonged restraint. The message of the painting is that Heaven is directly accessible to the faithful.

The virtuoso 17th-century artists achieved illusions in a wide variety of media and a staggering range of subjects. The most gifted sculptor of the century and the most ardent

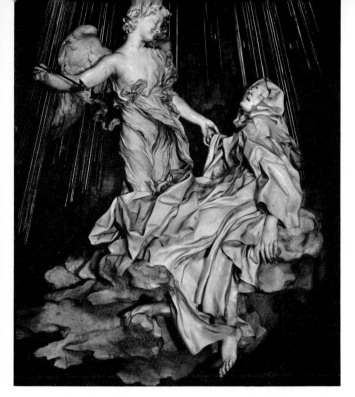

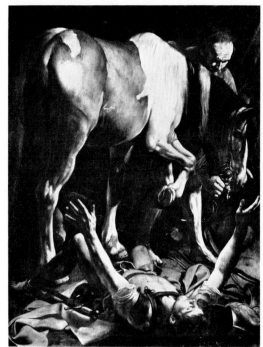

in his devotion to the aims of the Church was the Italian Gianlorenzo Bernini (1598–1680). Among his other talents were playwriting, stage design, painting, caricature, and architecture. His most spectacular production in sculpture is *The Ecstasy of St. Theresa* (Fig. 246). St. Theresa was a 16th-century saint best known for the visions she recorded. One of these, available to Bernini, describes the event portrayed in the sculpture:

> I saw an angel close to me, on my left side, in bodily form. . . . He was not large, but small of stature and most beautiful—his face burning as if he were one of the highest angels who seem to be all of fire. . . . I saw in his hand a long spear of gold and at the iron's point there seemed to be a little fire. He appeared to me to be thrusting it at times into my heart, and to pierce my very entrails: When he drew it out, he seemed to draw them all out also and to leave me all on fire with a great love of God. The pain was so great that I cried out, but at the same time the sweetness which that violent pain gave me was so excessive that I could not wish to be rid of it.

Bernini chose the moment between thrusts of the spear when the saint writhed in paroxysms of pleasure and pain. The erotic nature of both the vision and the sculpture is patent, but in keeping with the religious purpose of making the situation as vivid as possible. Bernini practiced the *Spiritual Exercises* of St. Ignatius of Loyola in order to immerse himself as deeply and accurately as possible into his subject. The nature of the vision excited his interest, particularly the coexistence of conflicting psychological states, which he imaged on the face of the saint with consummate virtuosity. Treating stone as if it were the wax of the models from which he worked, Bernini created the illusion of clouds, cloth, and flesh. The agitated drapery evokes the

saint's internal state. The marble was warmed by light which entered from a concealed yellow glass window. There is no previous sculptural parallel to Bernini's deliberate and controlled use of light as both form and mystic symbol in this composition. The sculptural group is set behind a proscenium arch, and in the background golden shafts serve as radiant backdrops. Sacred sculpture and painted altarpieces, such as that by Rogier van der Weyden (Pl. 10, p. 123), had served as religious theater before. Bernini transformed the small chapel where the sculptural composition was housed into a sphere in which the differences between art and reality were suspended.

Art for the Masses The most influential painter of the 17th century was Michelangelo Merisi (1573–1609), known as Caravaggio after the town from which he came. His history of wild escapades and his attraction to violence contradict the view that only the pious can paint great religious pictures. Caravaggio failed in his intent to make art that would meet the needs of the masses, for the people, conditioned by aristocratic images of insincere piety, distrusted the stark reality of his types and brutal realism with which he interpreted the Bible. It was among connoisseurs and artists that his talent was recognized. When Caravaggio undertook the theme of religious revelation in his *Conversion of St. Paul* (Fig. 247), a painting intended for a darkened chapel, he startled parishioners by showing the rider flat on his back, partially under his horse and with his head toward the viewer. Whether they want to be or not, beholders are vicarious witnesses to Saul's conversion to Paul, for they are made to feel as if the miracle is taking place at arm's length. Cold, brilliant, penetrating light is the only evidence

of God's presence, for Caravaggio could not bring himself to depict the supernatural as Bernini and Pozzo were later to do. Always he sought credibility in terms of the experience available to the uneducated or those of the lowest estate. The action of the attendant who steadies the horse while contemplating the event is completely natural under the circumstances. The usefulness of the old man's gesture contrasts with that of the outflung arms of Paul by which the spiritual drama is revealed. Both gestures are instinctive and good theater. The indelibility of the conception resides in body surfaces made to seem firmer than those in life or than Bernini's later carving in marble and in the pure translucent light polarized against measureless shadows. Later artists such as Rembrandt (see Chap. 11) were to learn from Caravaggio the dramatist that eyes or faces need not be highlighted or made focal points, but that light and shadow could compound, enrich, and dramatize the mystery of crucial events. Still amazing is that Caravaggio worked directly on his paintings without preliminary drawings.

The painting *The Supper at Emmaus* (Pl. 19, p. 176) was intended for the guest room of a convent. It shows the two disciples Cleophas and Peter Simon seated with Christ, whom they had taken for a fellow pilgrim and invited to eat with them. The cockleshell on the disciple's tunic signifies that the men were pilgrims, like those who frequently used the convent's guest rooms. Caravaggio shows the moment when Christ reveals himself by blessing and breaking the bread. Coupled with the revealing gesture of Christ is the clarifying action of the strong light that poetically embodies the illumination of the minds of the disciples. Their reaction is violent, in contrast to the darkened face of the uncomprehending innkeeper. Caravaggio's message was simple, intended for the least sophisticated and humblest viewer: the common people may have direct knowledge of God; the miraculous can occur without angels, halos, or opening of the skies; Christ's epiphany takes place in the heart of the faithful. The modest dress and table fare were obvious means to remind the faithful of Christ's humility. Not unlike the Flemish painters of the 15th century, Caravaggio detailed every surface provided by his subjects, from the constrasting complexions of the figures to the wormholes in the fruit. He attached mystical meaning to the most tangible items. Unlike the Flemings, Caravaggio placed the action against a plain background and spotlighted only the figures and table. He involved the viewer more intimately in the scene through the violent foreshortening of the gestures and precarious balance of the fruit on the near edge of the table. The disciple at the left is so turned as to draw the eye immediately to the hand of Christ and thence to his face, the table, and the figure at the right. The strenuous, extended gesture of this figure, which seems to push into our space, is paralleled by the angle of the table before him, thus harnessing the number of strong movements that otherwise would mitigate one another. Caravaggio has demonstrated the expressiveness the profile is capable of.

Often using models taken into his studio from the street, the painter was at his most forceful in painting rugged or picturesque types and most disconcerting to the public when he attempted the holy subject of Christ's face.

Many Church officials and, it would seem, the general public found Caravaggio's painting lacking in decorum and unnecessarily impoverishing of the holy personages. He was criticized for painting distracting objects, such as the still-life arrangement of the table, which undermined the drama of the moment. Because he avoided elaborate and traditional didacticism, Caravaggio's work was also condemned for not being self-explanatory. To those unacquainted with the biblical story, the supper may have seemed like an ordinary secular event. Caravaggio's paintings of religious subjects had a strong influence on 17th-century secular painting. And, as will be shown in the next chapter, the 17th century was to see a further obscuring of the lines that separated religious from secular painting.

The Classical Humanism of the Renaissance, which centered on the study of ancient culture, did not claim the same allegiance in this period as a more popular humanism based on the study of living men and women in terms of their appearance and manifestation of feeling and psychology. The interest of Baroque artists, for example, in themes of ecstasy and other forms of supernatural religious visions was at a polarity from the individual in quiet meditation. Both made the viewer conscious of the complex internal life, the mixed emotions, of people experiencing moments when the mundane connected with the transcendental. Symbolism kept and varied its disguises as theology constantly butted against worldly experience and the view of artists who agreed with Caravaggio's dictum that art's purpose was "to imitate natural things well." The vicarious sensory reexperiencing through art of ritual, miracles, and martyrdoms was the goal of artists. To that end, they often made more sensual or even sexual the materials with which they evoked their images. That art increasingly called attention to itself—to how it was made—was another manifestation of its secularization. In the 17th century, the viewer was to become conscious of living in a limitless world. Artists' preoccupation with human behavior and the infinite space, light, and time of worldly experience led to the ambitious staging of religious drama that denied even a physical separation between the viewer and the spectacle. Counter-Reformation art produced many sincere and passionately inspired personal statements of faith, but it also laid the foundations for the banal, insincere, commercial religious art that afflicts too many churches today. Side by side with the emergence of many artists of genius, bad religious art came into being on an unprecendented scale. The means for making a convincing representation of a lovely pious Virgin and an adorable Christ Child were easily available to any painter who was willing to trade on the sentiment of an undiscriminating congregation and clergy.

Chapter 10

The Good Life in Baroque Secular Art

The synthesis of spiritual and earthly values continued in paintings having ostensibly secular themes in the 16th and 17th centuries. Both Catholic and Protestant countries derived secular art from a variety of sources that included mythology, folk traditions, business, and domestic and social life. The resulting subjects showed the unethical, irreverent, sexual, vulgar, comic, and passive aspects of human conduct. Painters explored the daily living of the peasant and middle classes. During the Baroque period (the late 16th and 17th centuries), the depiction of vivid emotions and the workings of the mind were not restricted to Christ, the saints, and biblical figures. Everyman makes his appearance, not just as servant or spear carrier in a fateful historical or biblical drama, but now center stage. (Not until the 19th century will the common people be given a heroic role, fighting to better their fate rather than accepting it.) In the Baroque period, commoners were shown at their daily activities and rituals, not in climactic or historic moments that decided the fate of empires and nations. The attitude of the artists and their clientele, drawn mostly from the middle and upper class, toward earthly secular life was mixed: curiosity and amusement usually joined religious awareness of life's transience and the imperative of maintaining a moral stance toward excess, vanity, sin, and corruption. Recent scholarship has shrunk what previously was thought to be a considerable Baroque *genre* art, the depiction of types in typical secular activities in art having no ulterior motive. We now know that many images previously categorized as genre were in fact *disguised symbolism,* moralizing

illustrations of reprehensible conduct. Since artists often showed themselves as participants in this conduct, to the delight of their patrons, the moralizing may not have been taken too seriously. Thus the depiction of secular pleasures may have reflected a growing optimism about earthly existence, though that optimism was usually hedged by at least token observance of communal or church-derived moral values.

Social conscience did not motivate these depictions of peasant life, for the misery, oppression, and tragedies of the lower classes did not find their way into 17th-century art. Favored themes were diversion, local or class customs, and quiet revery, themes that did not threaten the established social order but rather provided the upper classes with vicarious experiences. Thus, far from being democratic, genre art reaffirmed existing class distinctions. The security enjoyed in the 17th century by church and state resulted in a relaxation of the demands made on painters, which enabled them to execute both official commissions and genre painting.

In Holland, specialization began during this century, so that artists painted only landscapes, portraits, still lifes, or genre art, depending upon their success with the market. Genre art, which was rarely commissioned, exemplified the double edge of freedom and material insecurity that accrued to the artist during the Baroque period. The art market was overloaded by midcentury in Holland, and painters were forced to assume additional jobs or give up painting altogether.

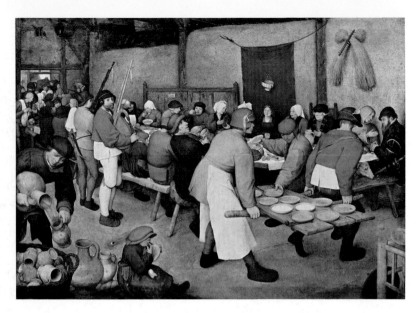

248. Pieter Bruegel the Elder.
Peasant Wedding. c. 1565.
Oil on panel, 3′8⅞″ × 5′4″
(1.14 × 1.63 m). Kunsthistorisches
Museum, Vienna.

While there is much aesthetic value in 17th-century genre painting, the people who bought or speculated in this art—churchmen, aristocrats, and middle class alike—were guided primarily by fidelity to appearance and could hardly be considered connoisseurs. Genre painting was intended for the modest scale of the home and for greater intimacy of viewing, so its format was usually smaller than that of the grandiose paintings done for churches or royal courts. Although not entirely uninfluenced by religious and official painting, genre artists did have great license in making their paintings.

The table frequently appears in Baroque secular painting as a compositional and social catalyst. In religious art, the table was occasionally used to hold books of Church scholars or the devotional objects of a saint, but it was most frequently identified with the sacred drama of the Last Supper (Figs. 235, 236) and Christ at Emmaus (Pl. 19, p. 176). Renaissance painters also utilized it to link the historical past with contemporary social customs, as noted earlier. In genre painting, the table became the natural locus for social occasions or for portraying individual human activity.

Food and Drink The Fleming Pieter Bruegel presented such an occasion—a wedding feast (Fig. 248)—in which the table serves as a meeting place for a segment of the community. Though not the first, Bruegel was the most gifted painter of his century in depicting the daily life of the Flemish peasants. The little we know of his biography indicates that he was not a peasant but a highly educated townsman, whose paintings were bought and admired by kings and intellectuals. Bruegel regarded his art as a means of recording his study of humanity, in the light of advanced contemporary secular theories and his own empirical experience. Bruegel's art reflects his astuteness as an observer and expresses neither criticism nor compassion. He saw peasants as unreasoning creatures who passively submitted

to forces greater than themselves—heredity, customs, and traditions. Bruegel's figures are thus motivated by simple, uncomplicated drives and enact their lives automatically, often with great vigor, if not with great cheer.

Not content with social reporting, Bruegel brought to art a gift of lucid analysis and a genius for storytelling that elevates his *Peasant Wedding* from a prosaic event to good theater. The setting is a grain-filled barn after the harvest, in which an overflow of guests celebrate the personal harvest of the farmer's daughter. She sits coyly and smugly beneath a symbolic crown hung on a green cloth. The full grain stacks and the ripe bride are meaningfully associated, as are the groom and the fertility symbol of the crossed sheaves hanging before his eyes. Art historians were unable to agree on identification of the groom, but the literary historian Gilbert Highet found him in the dark-clad, intoxicated figure in the center, just to the left of the rear figure holding a door used as a serving tray. The ill-mannered groom and his glaring parents seated opposite are wealthy townspeople, and, as Highet points out, Bruegel encourages our speculations on the wedding night and the married life of the bridal couple—though the painting's evidence makes their future quite clear.

A few of the subthemes in the nuptial drama involve the friar's earnest pleas for subsidy from the obdurate landlord at the far right, who seems to be enjoying the occasion less than his dog; the bagpiper's longing gaze at the distant food; and the contrast between the little girl cleaning her plate and the bride's brother filling a jug at the left. The activity of the latter recalls Christ's changing of the water into wine at Cana, and the diagonal composition of the long table and triangular grouping in the left foreground can be found in 16th-century paintings such as those of Tintoretto (Fig. 236). The ample figures are hard-edged in their firm outlines, so that the pile of round jugs in the basket invites an ironic comparison with the peasants who emptied them

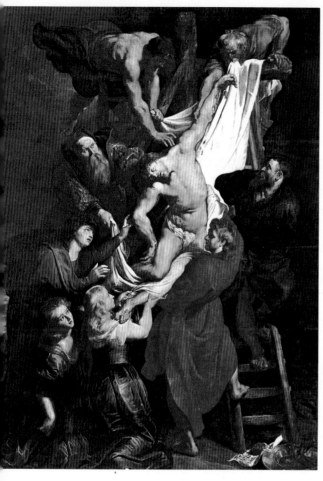

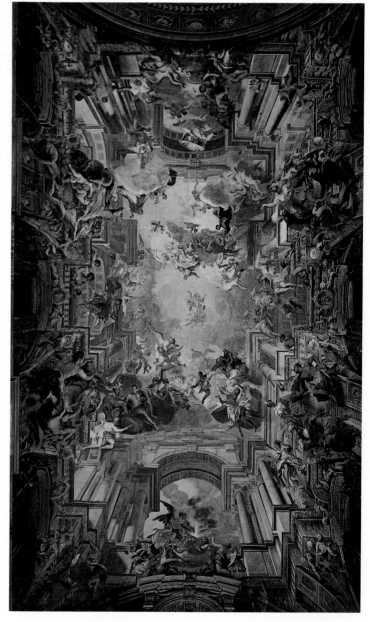

above: Plate 17. Peter Paul Rubens.
The Descent from the Cross. c. 1611–14.
Oil on panel, 13'10'' × 10'1'' (4.22 × 3.07 m).
Cathedral, Antwerp.

right: Plate 18. Andrea Pozzo.
St. Ignatius in Glory. c. 1691.
Fresco, nave ceiling. Sant' Ignazio, Rome.

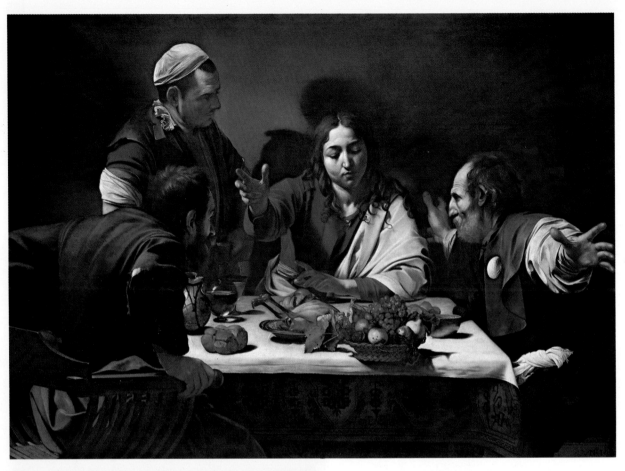

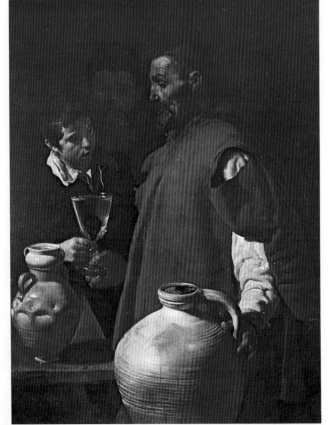

above: Plate 19. Caravaggio. *The Supper at Emmaus.*
c. 1596/98–1602. Oil on canvas,
4'7½'' × 6'5¼'' (1.41 × 1.96 m).
National Gallery, London
(reproduced by courtesy of the Trustees).

left: Plate 20. Diego Velázquez.
The Water Seller of Seville. c. 1619.
Oil on canvas, 41½ × 31½'' (105 × 80 cm).
Wellington Museum, London (Crown copyright reserved).

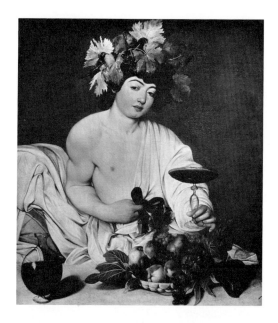

and with the piled-up figures in the doorway who wait their turn to be filled.

The Baroque secularization of painting increased the number of themes involving gratification of the senses and sexual appetites, often simultaneously. The young Caravaggio, for example, painted a well-fed, provocative boy in the guise of the wine god Bacchus (Fig. 249), whose attributes inspired the still life. To contemporary Romans, Caravaggio was obviously depicting a young male prostitute, offering wine with one hand and—by untying his belt with the other—himself. Given the title and costume, Caravaggio escaped censure from the Church, which was satisfied that such paintings showed the decadence of pagans.

In predominantly Calvinist Holland, it is surprising to us today that Jan Steen's *Girl Salting Oysters* (Fig. 250) did not incur official protest or censorship. Far from preparing a family meal in a kitchen, the young girl (estimated to be twelve or thirteen years of age) is preparing what then and now has been considered an aphrodisiac in a bedroom of a brothel for the person looking at her in the painting. Teenage prostitution was not officially condoned in Italian and Dutch societies. Such appetizing depiction of vice was tolerated, if not encouraged, because presumably everyone knew the wages of sin. The beholder of these two paintings is in direct eye contact with those who would be the agents of his or her downfall, and the experience of art became a kind of test of will.

A contemporary of Caravaggio, Annibale Carracci (1560–1609), for the first time in history centered a painting on a man eating (Fig. 251); a rugged anonymous peasant fills his mouth with beans while clutching a roll. The great polarity of Baroque painting is shown in the contrast between Domenichino's depiction of St. Jerome receiving the

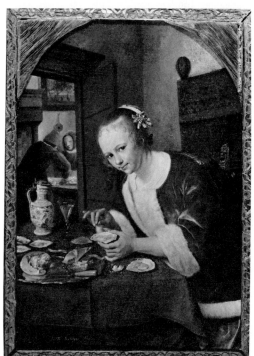

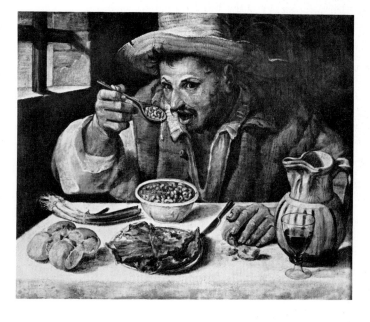

top: 249. Caravaggio. *Bacchus.* c. 1590. Oil on canvas, 38½ × 33½″ (97 × 85 cm). Uffizi, Florence.

above: 250. Jan Steen. *Girl Salting Oysters.* Oil on panel, 8¼ × 5⅞″ (21 × 15 cm). Mauritshuis, The Hague.

right: 251. Annibale Carracci. *The Bean Eater.* c. 1585. Oil on canvas, 22⅜ × 26¾″ (57 × 68 cm). Galleria Colonna, Rome.

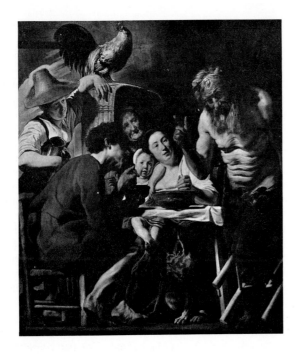

252. Jacob Jordaens. *The Satyr and the Peasant Family.*
c. 1612–18. Oil on canvas, 6′3½″ × 6′8″ (1.92 × 2.03 m).
Musées Royaux des Beaux-Arts, Brussels.

Eucharistic wafer (Fig. 230) and Carracci's *Bean Eater*. The former eats to partake of Christ's body and so ensure his future in Heaven, while the latter is concerned with satisfying his stomach and staying alive. The association of the human mouth with both sacred and secular rituals has an interesting mythological analogy in a painting by the Flemish artist Jacob Jordaens (1593–1678) that shows a satyr at a table with a peasant family (Fig. 252). Jordaens was illustrating a fable of Aesop in which peasants who had given

shelter to a cold and hungry satyr invited him to their table. The satyr saw the man blowing on his hands and was told this was to warm them; then he watched the peasant blow on his soup and was told this was to cool it. The satyr thereupon left the table, for he wisely distrusted those who blow hot and cold with the same breath. Jordaens enjoyed painting the heavy peasant types right down to their bare feet. In this instance, the wisdom of the proverb had to compete with the artist's succulent rendering of the flesh.

Jordaens' *The King Drinks* (Fig. 253) is a Flemish folklore celebration of Epiphany, an occasion for an entire clan to assemble and feast. At Epiphany, "king's tickets" were sold in Antwerp. The old man has become reigning monarch by having drawn the lucky ticket among those at the table. His drinking signals an explosion of festivity. To each relative, he has assigned a mock title for his "court"—the "Singer," the "Cock," the "Doctor," and the "Spinster." Here Baroque art delights in discovering the individual, consciously or not, lost in an abandonment to feeling. Such 17th-century paintings introduced raucous, laughing figures, whereas formerly only angels or the Madonna smiled decorously as a sign of divine grace. The Renaissance and 16th-century theme of mythical satyrs and nymphs rioting at a picnic in an ancient wood has been restaged around the family table as an orgy of the senses.

Both in form and content, this is a painting concerned with the five senses. The figures make or respond to noise, catch the eye with exaggerated or grotesque expressions,

253. Jacob Jordaens. *The King Drinks.*
1638. Oil on canvas,
8′7½″ × 9′4⅝″ (2.63 × 2.86 m).
Musées Royaux des Beaux-Arts, Brussels.

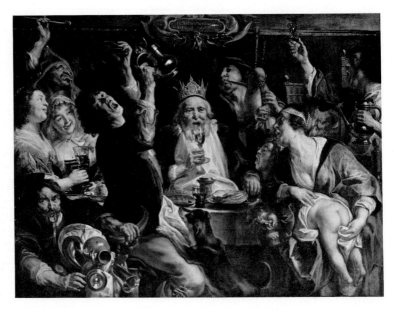

fondle objects sensuously, inhale a variety of odors, and savor a staggering array of food and drink. In a way, this painting is also a study of cycles, distinguishing the flesh of young and old and presenting a broad range of expressions from anticipation to satiation. Jordaens displays great virtuosity in demonstrating the number of ways people may be portrayed with their mouths open. Faces border on caricature. The artist's insight into the ritual rather than spontane-

ous character of the event appears in the forced quality of some of the jeering expressions.

Above the "king" are the words, "It is sweet to be admitted to a friendly table." Such a proverb written above *The Smokers* (Fig. 254) by the Flemish painter Adriaen Brouwer (1605/06–38) would constitute a fine irony. Brouwer was preoccupied with the boisterous life around the tavern table; his small paintings catalogue drinking bouts, brawls, cooking, eating, gossiping, and gambling. His sitters appear to be fellow artists rather than peasants. Daringly, he devoted entire paintings to gross types with bulbous inflamed noses and gaping mouths or to sleeping drunks with deluded notions of exalted status. His self-portraits show a discoloration and deterioration in his own face due to alcohol. Brouwer's *The Smokers,* probably done in the 1630s, is a personal avowal of manliness and the ethic of being oneself: the artist can drink and smoke with the best, take practical jokes, withstand pain, and not give a damn for whoever looks at his painting. Naturally disdainful of contemporary theories on composition and drawing, Brouwer sketched coarsely, but his characters and his painting convey the disorder of a tavern atmosphere, with its stale smells and murky lighting. The paint is applied ruggedly and with gusto, the technique also affirming his distaste for the delicate and precious. His strokes and tones convincingly render the garments and flesh of those poor in purse but rich in their enjoyment of earthly pleasures.

Moralizing and Allegory From Holland in the early 17th century came the morbid association of food with human vanity or life's brevity. In a large painting of an interrupted banquet (Fig. 255) attributed to the Flemish artist Jean Ducamps, a skeleton dramatically intrudes at the right. His

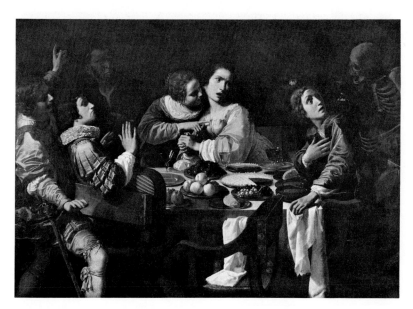

above left: 254. Adriaen Brouwer.
The Smokers. c. 1630. Oil on canvas,
18⅛ × 14⅜'' (46 × 37 cm).
Metropolitan Museum of Art, New York
(Michael Friedsam Collection, 1932).

left: 255. Jean Ducamps. *Momento Mori.*
1615–20. Oil on canvas,
3'11½'' × 5'8½'' (1.21 × 1.74 m).
Isaac Delgado Museum of Art, New Orleans
(gift of Mrs. William Helis, Sr.).

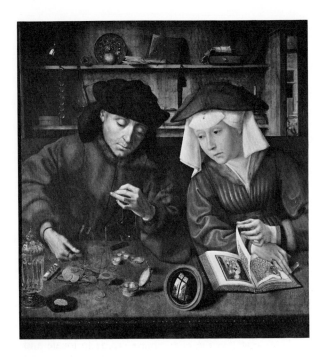

above: 256. Quentin Massys. *A Money Changer and His Wife.*
1514. Oil on panel, 28 × 27'' (71 × 69 cm).
Louvre, Paris.

below: 257. Jan Vermeer (?). *The Procuress.* 1656.
Oil on canvas, 4'8¼'' × 4'3¼'' (1.43 × 1.3 m).
Gemäldegalerie, Dresden.

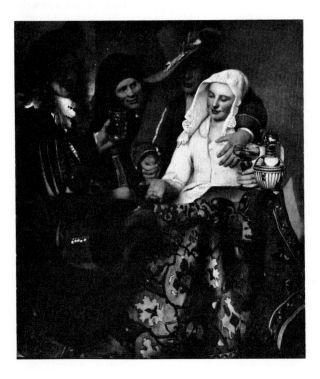

presence warns *memento mori* ("Remember that you must die"), and also evokes the fear of Catholics that sudden death would not permit the last rites. The festive costumes and the highlighting of the man and woman to the right suggest that this may have been a marriage supper and that it is the bridegroom whom Death calls. The painter pulls out all dramatic stops in contrasting the vehement reactions of the revelers to Death's apparition. Rather than terror or awe, the sybaritic guests at the left seem to register dismay and displeasure at the meal's interruption. The broad stagey character of the gestures and the extremes of light and shadow unmistakably place the artist among Caravaggio's following.

Business at the Table Secular paintings of genre subjects involving the table go back to the early 16th century; one of the earliest of these introduces the theme of business. In *A Money Changer and His Wife* (Fig. 256), the Flemish painter Quentin Massys (1465/66–1530) showed the couple receiving a call from a client, who is visible in the small convex mirror on the table. The painting served as a double portrait honoring the husband's profession and his wife's piety. In the painting of St. Eligius by Petrus Christus (Fig. 173), secular objects help identify a holy man, but here a holy book has become the pious attribute of a businessman's spouse. The possible significance of her divided attention between the prayer book and the scales—a touch that might at first glance seem purely sardonic—was to certify the honesty of their business. In a figurative sense, the convex glass reflects the delight of the Flemish painters in mirroring the actual world. Its small curved surface allowed the *tour de force* of simulating greater space than that in which the couple actually sits. Paintings and prints such as this found their way to Rome and were known to Caravaggio, who probably was strongly influenced by their format and crisp, lifelike style.

The table also appears as an adjunct to business in *The Water Seller of Seville* (Pl. 20, p. 176) by the Spanish artist Diego Velázquez (1599–1600). Though a painter of Spanish royalty, Velázquez did not spare his brilliant talent in portraying a street vendor named El Corzo, his young clients, and the modest objects of his trade. The mundane act of selling water has been solemnized by the painter into an almost sacramental event, and it is not improbable that Velázquez had the sacrament of the Eucharist in mind. He may also have intended the scene to comment on the three ages of man, with the oldest passing on the gift of life. There is no intimation of the noise and jostling of the streets. The man drinking is in shadow, while in strong illumination, the vendor and a young boy receiving a glass seem to share silently in a meditative union. Both in content and in form, Velázquez has changed small coin into gold. The strongly individual qualities of El Corzo, of the youth holding a glass that contains a fig to keep the water fresh, and even of the jugs rise above typicality and are impressed on the memory.

The tractable face of the youth contrasts with the lined face of the older man and with the jug upon which his hand rests. There is no overt attempt at pathos. The large objects and three-quarter figures, presented close to the viewer, have a restrained dignity and powerfully assert their worth. Immobility adds to their eloquence. The effect is obtained through a formal closure of shapes, a rough ovular form that holds the eye within the frame. The large jug leads the eye to the shadow of the smaller and to the hand of the man; the small jug is tangent to the boy's wrist, which directs the viewer to the glass, to the boy's head, and to those of the other two figures; finally, the smock's curvature returns the eye to the large jug and anchors the oval to the frame at the right. A few tones—chiefly gray, terra cotta, white, and flesh color—are applied over large areas with deft and subtle nuance; reserved for the glass and droplets of moisture on the jug are the most brilliant highlights. The lucid lighting and the firm drawing of the forms are countered by the virtuoso painterly manner in which the rich pigment has been applied to the canvas.

Although possessing an ancient history as a profession, prostitution was not introduced as a theme for printmaking and painting until the 16th century. Mary Magdalen had been shown much earlier in religious paintings, but always as a penitent (Pl. 10, p. 123) or closed in a convent. A painting known as *The Procuress* (Fig. 257), thought to be by Jan Vermeer (1632–75), is one of many done by Netherlandish artists on the theme of commercial love. Unlike his predecessors, who often dwelled on the ugliness of lechers, whores, and madams, Vermeer shows two well-dressed, handsome young men clearly able to afford their pleasure with an attractive professional. The drinker at the left smiles in our direction as an indication of his mood, but also as a way of welcoming the viewer as an accomplice.

Unusual for Vermeer is the involved range of expressions and the interchange between his subjects. As other Dutch artists had frequently done, he placed a decoratively patterned rug over the table in the foreground for painterly enrichment. Vermeer's later paintings of men and women are quieter and more circumspect, describing encounters and courtships that are restrained and socially acceptable.

Games and Music at Table The pastime of gaming, with its elements of chance and cheating, delighted an age in which high morality was so vigorously championed by the powerful force of the churches. Though not the first card game painted in history—the theme had entered painting from the north earlier in the 16th century—Caravaggio's *Card Sharps* (Fig. 258) was the most influential. Lost during the last century, it survives only in photographs and numerous copies but, like so many of Caravaggio's other works, it was definitely seen by foreign artists visiting Rome. Despite the acute characterization and delineation of the figures, this painting was not simply extracted from some scene in a contemporary Roman tavern. The players, dressed in costumes of a fanciful character, are set against a background that is so bare that it forbids conjecture as to locale and throws the actors into brilliant relief. Within the self-imposed restrictions of depicting a few figures at close range and within a tight space, Caravaggio has told a good story with great vigor. Artful arrangement of the poses allows one to see all phases of the deception and results in movement toward the center from both sides. He has shown the middle figure executing two gestures at once, and this skill at depicting one person doing two things simultaneously deeply impressed his contemporaries. In addition, he challenged future artists by his ability to render the human head three times in close proximity and from different view-

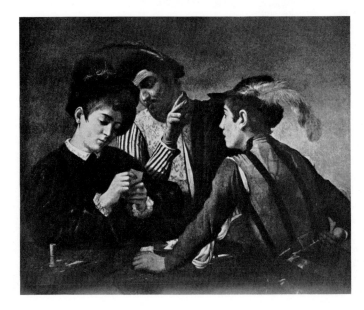

258. Caravaggio. *Card Sharps.* c. 1593.
Oil on canvas, 3'3'' × 4'6'' (.99 × 1.37 m).
Formerly Sciarra Collection, Rome.

points. Ironically, in view of the previous symbolism of light (Fig. 236), the profile of the card sharp at the right is given fullest illumination. Unquestionably, Caravaggio's interest in games was personal; on one occasion, as a result of a violent scoring dispute in a tennis match, he fatally stabbed his partner in the groin. Despite the artist's personal notoriety, *Card Sharps* was purchased by a cardinal—a commentary on the inconsistency of moral conservatism of the Counter-Reformation.

In *The Cheat* (Fig. 259), painted by the French artist Georges de la Tour (1593–1652), the table is again the setting for intrigue, deceit, and downfall. La Tour painted this theme after a stay in Rome, where he may have encountered the pictorial idea. The subject may be related to the biblical parable of the Prodigal Son; this theme, the downfall and return of the errant son, was favored by Roman Catholic authorities in support of the sacrament of penance against the Protestants. Both the painting and the card game are highly contrived. The players are garbed in what for the time were outlandish costumes. The deck is stacked against the young man at the right in such a way that if the aces don't get his money, wine and the courtesan at the table will. The wily cheat has an affected air of nonchalance as he reaches for an ace in his belt. The eyes and hands alone are sufficient to tell the story. All the hand movements have a suave, boneless ease that serves to enact the deception and also to tie the figures together visually. The shadowing of the cheat's face recalls that of Judas in paintings of the Last Supper (Figs. 235, 236). This dark deed, however, is performed in daylight, which coolly illuminates the firm, smooth volumes of the bodies and the sparkle of the shiny accessories. The airless milieu makes possible a meticulous clarity of detail in presenting types who themselves seem all surface and no depth.

Caravaggio's influence was often passed on through Italian followers, who in turn taught painters such as the Frenchmen Valentin de Boullogne (1594–1632). Such genre paintings as his *Soldiers and Bohemians* (Fig. 260) are important historically because they show the growing separation of painting not only from religious symbolism but also from secular allegory or moralizing. Earlier we saw how ancient pagan monuments were used in conjunction with Christian subjects. Here Valentin uses a Roman architectural fragment for an inn table. In the 16th century, musical instruments often symbolized Christian virtues, godlike attributes, or intellectual and poetic gifts, but in this work, they are the natural means of pleasure for low social types. The pocket-picking incident at the left was one of the ordinary hazards of frequenting public inns. In contrast to the powerful concentration of Caravaggio's *Card Sharps,* Valentin has disposed his figures more casually in depth around the table, which is now set on a diagonal. The color is comparably softened, with a simple triad of reds, yellows, and blues played off harmoniously against one another and against the colder grays and the dark browns of the cos-

tumes and setting, in a more painterly style than that used by Caravaggio. Instead of striving to create the illusion of actual textures, Valentin adapts the movement and weight of his brush and pigment to suggest a change of surfaces and stuffs—the hard sheen of metal, for example. The relaxed mood of the entire painting arises from the effortless way that each figure twists in a different direction, turning in and out of the light, free to move in a more generous orbit than that provided by Caravaggio. The common device of an interlocutor between the viewer and the action, first used in the 15th century, is seen here in the soldier at the left who looks over his shoulder in our direction. Less tightly composed than Caravaggio's scenes, Valentin's compositions introduced a relaxed air into French painting.

The Family The table, a natural place for the family to assemble, was often used for a portrait situation. One of the

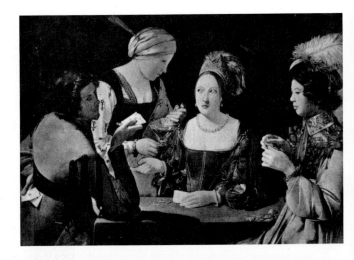

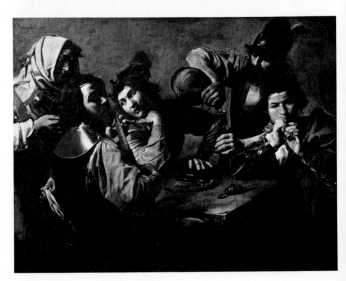

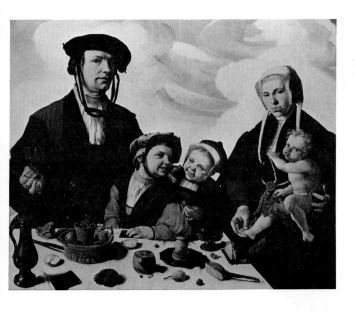

his work with the graceful movement of the Italian art he admired. The result is a rather stilted synthesis, but the painter's rich observation still has a certain compelling attraction for the viewer.

The table as identified with the unity and humility of the family can be seen in *Peasants at Supper* (Fig. 262), painted by the French Louis Le Nain (1593–1648). The table is the means by which the family comes together each day and shares the quiet pleasures of home, hearth, and board. Absent from this painting, however, are the noise, movement, and disorder that one would expect to find during or even after the evening meal. There is no overt rapport between the figures: those in the foreground look toward the viewer, those in the shadows gaze into the fire. Le Nain, perhaps seeking to extol the probity of the peasant, cast him in an artificial mold, and each figure is very consciously posed. The child in the lower right corner, like the objects carefully

opposite: 259. Georges de la Tour. *The Cheat.* c. 1630. Oil on canvas, 3′5¾″ × 4′11½″ (1.06 × 1.51 m). Collection Pierre Landry, Paris.

opposite below: 260. Valentin de Boullogne. *The Concert (Soldiers and Bohemians).* c. 1620–25. Oil on canvas, 3′11″ × 5′2½″ (1.19 × 1.59 m). Indianapolis Museum of Art (William A. Zumpfe Memorial Fund).

above: 261. Maerten van Heemskerck. *Family Portrait.* c. 1530. Oil on panel, 3′10½″ × 4′7″ (1.18 × 1.4 m). Staatliche Kunstsammlungen Kassel.

right: 262. Louis Le Nain. *Peasants at Supper.* 1645–48. Oil on canvas, 3′8½″ × 5′2½″ (1.13 × 1.59 m). Louvre, Paris.

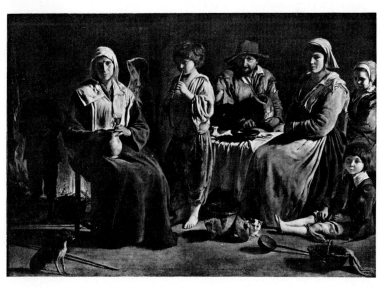

earliest family portraits utilizing still life and the table (Fig. 261) was done by the Flemish artist Maerten van Heemskerck (1498–1574). The prosperous-looking family is rather self-consciously arranged; the figures are posed in clear separation, not unlike the objects on the table, and their silhouettes are sharply delineated against the sky. Outdoor eating was not altogether unusual in the Netherlands, yet Heemskerck's work has the contrived air of having been done in the studio, with a natural backdrop painted in later. The pose of the naked child and its mother may have been intended to recall paintings of the Madonna and Child—an association that would not be impious to the kind of well-to-do and proper family represented. Heemskerck, perhaps aware of the previous lack of easy interrelationships between figures in Flemish art, seems to have tried to infuse

distributed near him, serves as a visual stabilizer for the composition. Each person is carefully turned to counterbalance another figure, eliminating any impression of volition or spontaneity. The general air of decorum in the peasant hut resembles official painting of French royalty. Le Nain chose to stress the peasant's reflective capacity and graceful composure, rather than his life of arduous labor or moments of energetic diversion. The painting's strength lies largely in the realization of the materiality of figures, objects, and setting. The hard reality of the bodies and garments is heightened by soft gradients of shadow and the way the light rebounds from surfaces. Le Nain displays and elicits a certain detachment, a refusal to become deeply and emotionally involved with his subjects; yet he imparts to them obvious respect.

Jan Steen's (1629–79) *Dissolute Household* (Fig. 263) inventories not only the contents of a prosperous Dutch home but also the excesses to which pursuit of the good life can lead when untempered by old-fashioned values. After the family meal, whose leftovers are consigned to the floor, everyone does their own thing. The artist shows himself seated with his long clay pipe, his left leg provocatively slung across the thigh of, presumably, his wife. She offers him the glass of wine that reciprocates his gesture of seduction and possession. Below the figure of a monkey playing with the clock's chimes, one of the children picks the grandmother's pocket. An interested neighbor looks through the window at the noisy dancing couple. Steen's farce shows what happens when gravity and decorum, neatness and manners have been evicted from the home in favor of slovenliness, frivolity, lasciviousness, and disrespect. We can imagine that in a Dutch home, this must have been the source of much amusement, finger pointing, and tireless comparisons with the lives of its owners.

For some Dutch artists, influenced greatly by Caravaggio, the table signified an opportunity for melodramatic enactment of debauchery or perverse conduct, but Pieter de Hooch (1629–c. 1684) satisfied Dutch middle-class taste by showing tables in settings of propriety and quiet sociability. His paintings frequently show tables in arbors, intimate courtyards, or neat interiors around which are gathered well-bred gentlemen who play an honest game of cards, imbibe with discretion, or converse wittily with pleasant hostesses. One of De Hooch's finest paintings is *The Mother at the Cradle* (Fig. 264). Here the table, though set off to the side, is identified with domesticity, with the care and vigilance of the wife for her children and home. This ideal of insulated, constant security is measured out in the relation of the mother to the cradle and in the cool geometrical rightness and sun-warmed atmosphere of the rooms. Everything is in its correct place to compose an ideal home and a beautifully arranged painting. Even the dog has turned his head at a right angle to the floor tiles and is tangent to the door frame, taking the eye both into the vestibule and toward the mother. From the exterior comes not a suggestion of the sounds and sights of Holland's political anguish, but a dreamlike stillness, the reassuring heat of the sun, and the fragrance of well-tended gardens.

The Table and Self-preoccupation In many ways, 16th-and 17th-century art penetrated new areas of life. As taste for the intimate developed, painting invaded the bedroom, which in previous art had been allowed only as the setting for holy events (Fig. 157), such as the Virgin's death (Fig. 169). In the mid-16th century, an unknown artist working at Fontainebleau Palace introduced into painting what might be called *self-preoccupation* (Fig. 265). Titian and the Venetians had depicted such subjects as Venus at her toilette, but the themes were from mythology. Here, the near-naked lady surely was readily identifiable at the French court. Sim-

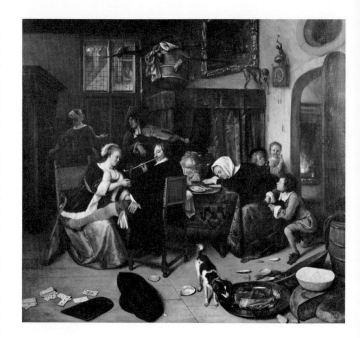

above: 263. Jan Steen. *The Dissolute Household.*
Oil on canvas, 30⅝ × 34½'' (78 × 88 cm).
Victoria & Albert Museum, London (Crown Copyright).

below: 264. Pieter de Hooch.
The Mother at the Cradle. 1659–60.
Oil on canvas,
36⅜ × 39⅜'' (92 × 100 cm).
Staatliche Museen, Berlin.

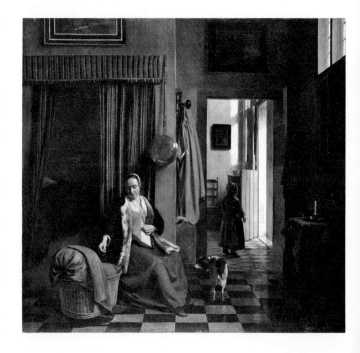

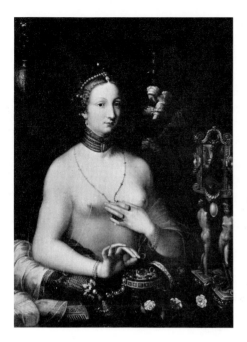

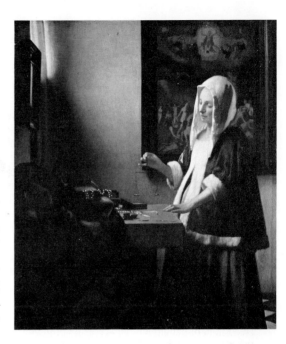

left: 265. School of Fontaine-bleau. *Lady at Her Toilette.* c. 1550. Oil on canvas, 41⅜ × 27⅞″ (105 × 71 cm). Musée des Beaux-Arts, Dijon.

right: 266. Jan Vermeer. *Woman Holding a Balance.* 1664. Oil on canvas, 16¾ × 15″ (43 × 38 cm). National Gallery of Art, Washington, D.C. (Widener Collection).

ilar paintings done of the mistresses of French kings became so popular they were copied. Shown before her dressing table, the young woman touches her necklace with one hand and holds a ring with the other. This double gesture descended from Greek sculpture of Venus and can be seen in Renaissance paintings (Fig. 205; Pl. 13, p. 157). The ring has been interpreted as an erotic sign or as the indication of a desire for marriage. As in Venetian paintings of Venus in her bedroom, a maidservant is shown in the background, where a mirror again reflects the young woman's face. Conceivably, she was being presented as Venus. The various objects and the mirror would have held meaning for contemporary sophisticated society, but today we are not sure of their connotations. For instance, is the painting a veiled reference to vanity? Courtly taste, as much as artistic style, influenced the elegant sensuousness of the torso. This nakedness viewed with cool detachment is unlike the ripe flesh that would later melt under the brush of Rubens. In the focus upon jewels and fine materials, in the attitude toward sex, there is an unmistakable preciosity.

After 1650, in Holland, Vermeer helped restore a quiet decorum to the theme of the table. Constants in his art are sunlit corners of elegant whitewashed rooms, furnished with carefully disposed tables, chairs, and paintings. The calm, handsome young women who inhabit Vermeer's interiors exemplify Dutch culture just before the disastrous wars of the 1670s. Standing near or seated at sturdy tables, they make lace, read, write, converse with military suitors, admire themselves, or sleep—and are comforting images of sedentary feminine diversions. *Woman Holding a Balance* (Fig. 266) juxtaposes a painting of the Last Judgment and a

girl holding a balance. A devout Catholic convert, Vermeer could have intended a symbolic significance—possibly for the religious conscience of the girl, who is faithfully fulfilling her responsibility. Her position is below the figure of Christ, where traditionally the Archangel Michael weighed the souls of the resurrected. The violence and terror of the Judgment Day scene make an ironic contrast to the stilled life of the room. Historically interesting is the fact that the religious painting is in a private room, not over an altar.

The Artist's Table Vermeer's private life belied the tranquillity of his paintings. Before his death in 1675, he suffered financial setbacks, and his widow filed for bankruptcy. With great difficulty, she succeeded in regaining possession of the painting known as *The Artist in His Studio* (Pl. 21, p. 209), which shows what appears to be a frequent genre subject of the time. A seated artist is painting a young model, who plays the role of Clio, the Muse of History. She holds a book and trumpet, symbols of fame. On a table at the left are books and a plaster cast of a face, symbolic of other arts. Vermeer was proclaiming that painting was more than a craft: it was one of the liberal arts. It demanded the skills required of mapmakers.

Scholars have shown that this is not a self-portrait, for the map shows the Netherlands before Holland achieved independence and the artist's costume is also of an earlier era. It may have been a nostalgic evocation of what Vermeer thought were more ideal working conditions for artists in "the good old days." The room itself corresponds to that in which Vermeer actually worked, but its fine furnishings and tiled floor proclaim not a workshop but a studio appropriate

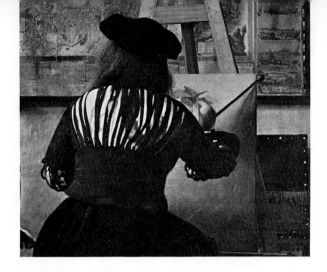

267. Jan Vermeer. Detail of *The Artist in His Studio* (Pl. 21, p. 209).

to the dignity of the artist's status in society as Vermeer wanted it to be.

Vermeer gave the totality of his gifts to this wishful image of an ideal. From this painting, one can begin to comprehend the imagination and inspired effort of the artist, which went much beyond his amazing technical achievement of simulating appearances. The fact that the viewpoint, angle of light, and placement of objects were all minutely calculated before brush met canvas does not detract from Vermeer's creative excellence, for these preliminary decisions were aesthetic judgments in the fullest sense of the word—the room arranged in terms of art. The eye moves into the painting slowly and logically from the large foreground shapes at the left, to the artist at the right, and then to the model, with the distance of each area from other objects and the viewer clearly apparent. The careful, but not obvious, avoidance of simple alignment by means of parallel edges or right angles enriches the visual design and impels us to see each object in relation to another. Contrasts stress the idiosyncrasies of each shape, yet they do not destroy the feeling of inner rapport between everything within the painting. There are several strong rhythmic sequences, such as the ceiling beams, the brass chandelier curves culminating in the Hapsburg eagles, the horizontal vignettes of Dutch cities on the sides of the map, the black-and-white striping of the artist's blouse, and the alternating floor tiles. Against these sequences can be seen the random sparkle of upholstery nails on the chairs and the highlights in the fabric of the drapery. The drape holds all the painting's colors in less concentrated hues, with the exception of a small patch of blue that exactly matches the color of the model's dress; its dense, saturate pattern contrasts with the airy brightness and spaciousness of the room itself. Shadows never obliterate, but rather lead us to new revelations of tones and shapes. The composition is anchored at the left by the half-lighted drape seen against the most brilliant light on the wall behind it and at the right by the judicious alignment of the edge of the map, the chair, the right easel leg, and the segmented black tiles that lead into the painting. Like the seated artist himself, viewers are expected to weigh in their minds the rightness of each stroke in terms of

the stuffs, luminosity, and hue of the object brought into being. The mahlstick held by the artist (Fig. 267) steadies his hand—like Vermeer's art, brilliant wrist painting.

In the manner of Van Eyck, Vermeer reconstructed his world in terms of the smallest ray of light and the fragment upon which it fell. Unlike Van Eyck, however, he freed his subjects and compositions of the hierarchical demands of religious convention, so that he could bring to both arrangement and detail a revelation of his aspirations.

The secularization of culture refracted in the art of the 16th and 17th centuries was like a great thaw. Such robust vitality and evidence of humor had not been given comparable sensual form since ancient Greece. The warming of art meant a fresh candor in conduct. People acted and reacted with new intensity or subtlety. The depiction of the motions of their minds and feelings fulfilled Leonardo's hopes. Secular body language was overwhelming traditional religious gestures. For better and worse, humanity revealed its dualistic nature: piety and perversity, tenderness and cruelty, love and lust, gentility and vulgarity. Thematically, the common was pressing against the limits of the uncommon. How people passed their days might have seemed to many more interesting than saving one's soul. Death was the acknowledged spectator of lusty living, and realism was tempered by a moralistic basis in much secular art. The drive for gratification of the senses and other human appetites suggests a restlessness of mind, body, and spirit. Humanity's fears were not just of Hell, but of starvation and boredom. Humanity's hope included a full belly, and fat was beautiful. Sex was openly sold. Winning at war or cards was at all costs. Stereotypes flourished along with portraits: saints were sensual, soldiers irresponsible, women reliable homemakers and good partners in business and sex. Men were brave, virile, good buddies to each other, but vulnerable to women. Burghers and peasants not only fully tenanted spaces surveyed in the 15th century, but now warmed them with their breath and bodies. The Renaissance's antiseptic stillness was now rent with cries of pain and pleasure, smoke and smells. Even solitude and silence could be made into something tangible. Painters reveled in the substances of their images: flesh and oil paint, the stuffs of clothing and rich glazes. Not the theological but the dramatic potential of light was the great exploratory achievement of this period. With delight in the varied facial expressions and gestures of human interaction went the painter's pleasure in vigorous value contrasts and dialogues between bold or subtle hues. The passionately brushed coexisted with the patiently constructed. Baroque art's purpose was to combat life's dullness, and even though its meanings have dimmed, these images still excite the eye.

Chapter 11

Rembrandt

Rembrandt Harmensz van Rijn was born in Leiden in 1606 and died in Amsterdam in 1669. His father was a prosperous miller who sent his son to a Humanist school from his seventh to his fourteenth year. For a short time, Rembrandt was enrolled at the University of Leiden, and his early contact with great literature was to influence his art. In 1620, he entered the studio of an unimportant Leiden artist and remained there for three years. At eighteen, he went to Amsterdam, where he studied for half a year with a well-known artist, Pieter Lastman. By 1625, Rembrandt was painting on his own. About 1632, he moved permanently to Amsterdam, where he began to have success as a portrait painter. In 1634, he married the wealthy Saskia van Uylenburgh. In quick succession they had four children, all of whom subsequently died; only his son Titus, born in 1641, reached maturity. Saskia died shortly after Titus' birth. By 1649, Hendrickje Stoffels was living with Rembrandt. Her willingness to become the painter's common-law wife brought her social hardship and actual censure at the hands of the Calvinist Reform Church—a fact that makes Rembrandt's repeated interpretations of the theme of Christ and the woman taken in adultery all the more poignant. She stayed with Rembrandt through increasing financial difficulties, brought on by his omnivorous appetite for antiques and other *objets d'art*, many of which he used as props in his paintings. By 1656, Rembrandt was bankrupt and had lost his house and collection. Probably out of jealousy, the Amsterdam painters' guild made the conditions of the auction as disadvantageous as possible. One year later, his

graphic art was dispersed to satisfy his creditors. Contrary to the popular notion that Rembrandt was then reduced to a life of terrible poverty and neglect, he continued to receive good commissions and to devote himself to problems that interested him. He worked for the art firm set up by Hendrickje and Titus in 1658. In 1663, Hendrickje died, and in 1668, Rembrandt lost Titus, one year before his own death.

In his personal and artistic life, Rembrandt defied convention. For much of his life, he recognized none of the accepted canons of social conduct, monetary management, strict adherence to the state Calvinist religion, and flattery of potentially wealthy and influential clients; and he ignored most proscriptions on what and how a Dutch painter should paint. He was an unusual Dutch artist in his refusal to specialize or to show the merrymaking, material comforts, or daily ritual of the middle class who controlled a buyer's art market. He puzzled this buying public by avoiding the art trends then fashionable, favoring more enduring notions of time and subject matter. From documentary evidence, it appears that Rembrandt considered himself a revolutionary in art because he did not acknowledge academic rules and followed only the nature and art of his own choosing. When Rembrandt was at work, legend has it, he would not stop for a king. Late in life he qualified as a "free spirit."

Unlike many painters of his time, he cannot be catalogued as a painter of portraits, genre, or religious subjects. No other artist of his generation was identified simultane-

ously with the different media of painting, etching, and drawing. He drew freely from older art, literature, history, and from the live subjects before his insatiable eye. Rembrandt was a great visualizer of stories. Though he relied heavily upon the written word for inspiration, the vast corpus of his work manifests a displeasure with artistic theory. From varied sources he searched for the ties that bound humanity throughout history. Though compelled to individualize every subject in his art, Rembrandt never lost sight of humanity as a whole and saw life as a historical continuum from cradle to grave. With this view of the continuity of all life, travel was unnecessary, and Amsterdam became for him the microcosm of history. He saw a lot of Italian painting in the Amsterdam art market. Rebel that he was in certain senses, Rembrandt accepted the role formulated by the artist during the Middle Ages—to move, to delight, and to instruct.

Rembrandt's biographers commented on his skill and the secret techniques by which he enriched etching and on the unusual thickness and odor of his oil portraits. He applied his paint in thick lumps—a technique called *impasto*—and built it up so heavily that one critic declared his portraits could be lifted by the sitter's nose. All that went into the making of art absorbed Rembrandt, and for the cookery of painting and printmaking, he concocted his own recipes. The early biographers were impressed by his success as a teacher, for from the age of 22 he had many pupils; their tuition and the income from sales of their work allowed him to live well and to buy art. The students worked in upstairs rooms of his large Amsterdam house, drawing from casts, prints, and drawings and often from naked models. Among Rembrandt's many drawings are several on the subject of the studio (Fig. 268), illustrating his favorite lesson, which was to work not from knowledge of theories but from a visual experience of life. In one sketch, the young apprentices themselves have become the master's model. Such drawings, which the students may have been asked to copy, exemplified his teaching with regard to achieving strong relief by building from dark to light—contrasting shaded, recessive areas with the lightness of figures whose definition resulted from a rapid notation of configurations made by their postures and clothing. To enhance the unity of the whole, which the subject alone could not give, Rembrandt would often impose shadows over his drawing. Their frequent arbitrariness shows that his imaginative intuition was extremely essential; apparently this irrational gift could not be taught, for none of the pupils rivaled the tutor. Although he learned much from his studies of other artists, Rembrandt's development of a highly personal style was founded in the main upon continuous work, which in over 40 years yielded roughly 650 paintings, 280 etchings, and 1,200 drawings.

below: 268. Rembrandt. *Studio of the Artist.* c. 1635.
Pen and wash, 6⅞ × 9¼" (17 × 23 cm).
Louvre, Paris.

right: 269. Rembrandt. *The Presentation in the Temple.*
1631. Oil on panel, 24 × 18⅞" (61 × 48 cm).
Mauritshuis, The Hague.

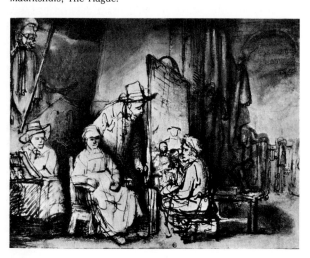

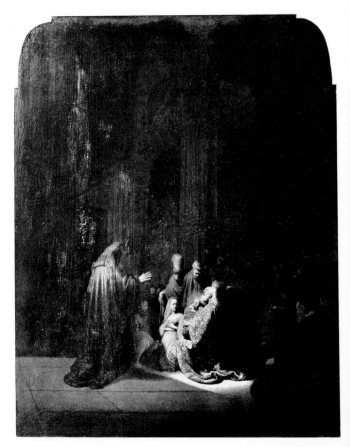

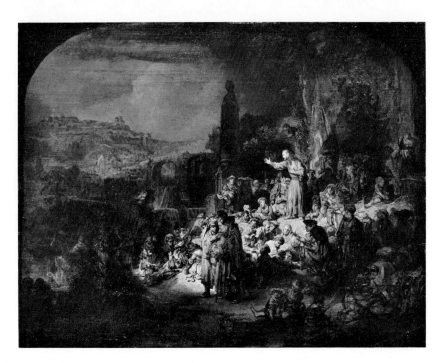

270. Rembrandt.
John the Baptist Preaching.
1636–50. Oil on panel,
24½ × 32″ (62 × 81 cm).
Staatliche Museen, Berlin.

Spiritual Art *The Presentation in the Temple* (Fig. 269) is in many respects typical of Rembrandt's early paintings of religious subjects. This is not, it should be noted, *religious* painting, for it was not intended for use in a church. Rembrandt was a proponent of what might be called private (that is, nonecclesiastic) devotional painting; unlike earlier artists, he did not illustrate dogma or propagandize organized religion. The paintings were small in format and intended for intimate contemplation in the home. Though Rembrandt was a Christian and nominally a member of the Calvinist Church, which looked with disfavor on paintings of religious subjects, his appears to have been a private religion without theology. His paintings, drawings, and prints constituted an individual and spiritual art. From his mother, Rembrandt had derived his love and knowledge of the Bible, and his interpretations of biblical stories have the freshness of personal discovery. The style that produced *The Presentation in the Temple* was doubtless influenced by the Scriptures, particularly by their frequent references to symbolic light. Against the looming backdrop of the impressive synagogue architecture, Simeon kneels with the Christ Child and his parents before Anna, who stands with outstretched arms. The small group is illuminated by a strong shaft of natural light. The faces of the Child and the "just and devout" old Simeon are most strongly lit, recalling the passage from the Psalms, "God is the light of their countenance." Simeon, who knew that he could die in peace since the Messiah had been born, appears to be looking beyond the head of Anna and saying, "O Lord . . . mine eyes have seen Thy salvation, which Thou hast prepared before the face of all peoples; a light of revelations to the gentiles, and a glory for Thy people Israel" (Luke 2:22–34).

Rembrandt knew the chief rabbis in the Jewish quarter of Amsterdam and had visited the synagogues. In his ardor to re-create the true image of the Scriptures, he ignored the archaeological backgrounds popular among the Italians and his Dutch contemporaries and drew inspiration from his immediate surroundings. The small painting is filled with observations of types, costumes, gestures, and poses and contrasts the intense concentration of the central group with the rather indifferent presence of bystanders on the stairs to the right. The figures and architecture are so disposed in depth that the viewer also becomes a bystander off to one side in the shadows. The darkened areas were made luminous by Rembrandt's device of underpainting his canvas with warm bright colors and then scratching through the darker overpainting of the architecture to these high-keyed layers. The whole painting has a theatrical aspect, with the principals dramatically subordinated to the great space and light and dark contrasted stridently. The faces do not reveal Rembrandt's later deep understanding of human motivation. What we see is a drama of place rather than of persons.

Vivifying the Word Rembrandt's development as an individual and as a painter is reflected in a single painting that he began early in his career but felt compelled to rework as he grew older. His oil sketch *John the Baptist Preaching* (Fig. 270), begun about 1636 or 1637, was worked over intermittently until 1650. In this sketch, the ostensible subject is biblical, but the theme is really that of an inspired individual addressing a group. At the time of this sketch's conception, Rembrandt was interested in the Mennonites, a sect that decried a formal organized church and the ritual

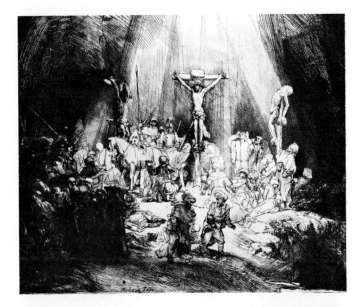

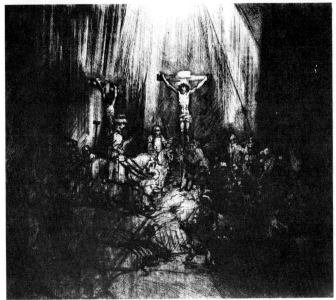

and sacraments of the Roman Catholics. Its ministers were laymen who preached not dogma but the virtues of mercy and charity, humility and obedience. Stress was laid upon the impulses of the heart, deeply felt silent prayer, and simple, warm spirituality. The Mennonites sought to return to the essential truths of the Bible instead of using it as the basis for an elaborate theology. They championed respect for the poor in spirit and love of one's brethren in Christ. Their sentiments may have influenced this painting.

In loose array, all strata of society are gathered to hear John speak, with zeal and from the heart, of salvation. Rembrandt may have portrayed himself in one of those at John's feet. His later reworking of the sketch tended to concentrate the light upon John and those closest to him. As in the painting of Simeon, the illumination is appropriate not only for reasons of style but also for subject: the moment when the ascetic Baptist prophesied the Messiah as light coming into the world. John further spoke of the importance of fellowship, the need for brotherly love. Like the work of Christ, John's word is as a light to the path of the faithful. Rembrandt depicted a crowd divided in its attention, fragmented into those who hear, are moved, and understand, those who daydream or doze, and those who bicker or content themselves with trivial diversions. Rembrandt sought to rival poetry and the theater in eloquence; speaking and listening were important subjects to him for much of his life. (No previous artist was as interested or skilled in showing the impact of a speaker on an audience.) The various ethnic types and exotic costumes suggest the universal scope of John's message. At the center foreground, in line with the obelisk crowned by Caesar's effigy and standing in partial shadow, are three Pharisees, who have turned their backs on John and are disputing among themselves. Rembrandt did not resort to the obvious device of illuminating only those who are enlightened, for signs of vanity and folly can be found in both the light and the dark areas of the crowd. In the bright sections can be seen his earlier style of figure construction, with more opaque faces, a heavy reliance on drawing, and attention to picturesque detail. The later style treated figures and costumes in broader, less precise strokes and with fewer, more somber tones.

Rembrandt never traveled, as did other famous northern European artists of his century; yet his imagination and taste for remote lands and peoples led him to fill his works with archaeological monuments, rugged panoramas unlike those around Amsterdam, and opulent and exotic accessories such as turbans, ornate bridles, monkeys, and camels. This small panel is charged with almost an overabundance of ideas and aesthetic means; the later alterations were in the direction of greater clarity and stability.

Meditations on Death Rembrandt's continual restlessness and relentless self-criticism are also apparent in two states of his dry-point etching *The Three Crosses* (Figs. 271, 272). These etchings also show a great divergence from the early style of *John the Baptist Preaching,* a style that had brought him commercial and critical success. Each paint-

ing, drawing, and print seemed to open up new possibilities for the artist, who set personal goals of artistic inquiry above financial gain.

In itself, the third state of *The Three Crosses* seems to have a moving completeness. It is a readable drama whose religious subject is the Passion of Christ and whose universal theme is the loss of a man. In a centrifugal arrangement, Rembrandt detailed the several reactions to the execution, ranging from the indifference of the mounted troops and the satisfaction of the Pharisees at the lower left to the anguish of Christ's followers and the conversion of the centurion. The harsh barrenness of Golgotha intrudes on the scene in the rocks and scrub vegetation. The tortured bodies of the thieves flank Christ, and the descending light divides its focus among the three crosses. This division of interest and diffuse action impelled Rembrandt to make the fourth state. The successive states are like a chronology of the last hours of Christ on the Cross. The final etching shows the world in near-darkness, except for the torrential shaft of light above Christ's head. As in Genesis, the abrupt separation of light and dark suggests the creation of new life. The solemn centurion is now the principal subordinate figure, stressing comprehension of the meaning of Christ's death and the significance of conversion. The mood is altered by the inaction and rigidification of the few remaining accessory figures, by the rugged, stiff outlines of their bodies and their reduction to almost obscure presences floating in a sea of darkness. Black was felt and savored by Rembrandt as a tangible substance. Etching ink, cross-hatching, and the close striations of the etcher's needle gave him the special qualities of a soft, absorbent black that he could not reproduce in his paintings. The appeal of etching may also have been that it permitted Rembrandt to emphasize the contrast between extremes of light and darkness, with their implications of life and death.

Rembrandt's conception of Christ is personal. Hanging from the Cross is the taut but meager body of an ordinary human being; the artist has made no attempt to achieve sublimity through exceptional musculature. Christ's extraordinary strength and spirit issue from a strikingly erect posture, from the head and the radiance about it. More than Michelangelo, Rembrandt was drawn to the testimony of flesh to affirm Christ's suffering manhood.

Rembrandt had avoided the more obvious evidence of pathetic struggle in the figure of Christ. In *The Slaughtered Ox* (Fig. 273), however, a small secular painting done two years after the Crucifixion series, he evoked the violence of brutal execution. In the early Middle Ages, the ox, symbolic of St. Luke, was thought to prefigure the sacrifice of Christ. It is not impossible that, with the Crucifixion theme so much in his mind during the time of this painting, the emotional associations of the two subjects overlapped. Further, Rembrandt's famous paintings of anatomy dissections, in which dead bodies are cut open and examined, may also have influenced his selection and treatment of the theme.

The painting shows the spread-eagled carcass of the ox hanging from a rude wooden frame. The gutted animal seems self-illuminated with an almost phosphorescent glow. Massing his pigment in viscous patches, Rembrandt created a painterly equivalent of the moist, greasy, rich substance of the animal's muscle, fat, and bone. He showed with wonder the partially hollow interior of the flayed animal, formed of complex substance and color. By allowing it to dominate its gloomy setting and the timid woman peering around the corner, Rembrandt transfigured and heroicized the slaughtered ox and reiterated his fascination with the mystery of life and death.

To juxtapose an etching of the Crucifixion with a scene from an Amsterdam butcher shop is to bring together the poles of Rembrandt's broad interests. The past and present, the imaginary and the real, all of these alternate and interweave throughout his art. Rembrandt was a rebellious Dutchman who could not follow his fellow artists in meticulously documenting and praising their particular time and place. With grandiose projects half-formed in his head, he

273. Rembrandt. *The Slaughtered Ox.* 1655. Oil on panel, 37 × 26⅜'' (94 × 67 cm). Louvre, Paris.

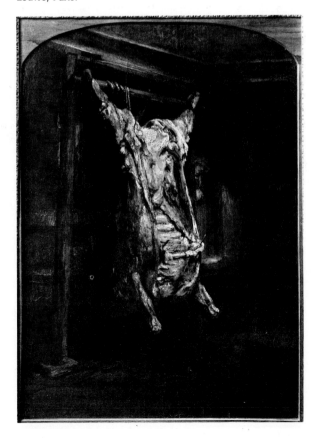

would still take the time to draw whatever immediately attracted his eye in the street or along the canals.

Michelangelo made his art in terms of Man (see Chap. 8), and Rembrandt in terms of men. No two artists in history held more antithetical views of art and humanity. For Michelangelo, Christ had to be shown as endowed with a sublime body to signify his divinity. The Dutch artist could not think or paint in terms of philosophical abstractions; instead, it was the real and veritable that kindled his imagination. Rembrandt's *Male Nude Standing* (Fig. 274) was a life study made from the type of model that drew the criticism that he favored "low types." For him, there was no ugly subject in nature, only endless inquiry into what makes a being human. Beauty would come into his art on his own terms. He disregarded the rules of others and a fixed style with its habits of the hand to satisfy his drive to confront sources freshly. With drawings such as this he shares with us his satisfaction in rediscovering the body. Track the figure's silhouette to see how it is both drawn and provoked from the background shadows. Endlessly inventive, Rembrandt coaxed from the materials unforeseen effects that fuse the man's being and body with the light and space of the place. In this imperfect physical specimen, Rembrandt found the gravity one would expect in a sorrowfully resigned Christ awaiting death. Such encounters with the living may have inspired the artist to paint specific biblical subjects, which, when realized, often retained much of the character of their secular origins.

Tragedy and Joy It is likely that *Bathsheba* (Fig. 275) was created in this way, although none of the preliminary drawings for the painting still exists. Possibly Hendrickje, who was the model for many drawings, posed for Bathsheba. Her pose may have been inspired by Rembrandt's acquaintance, through 17th-century engravings, with Classical Roman sculptures that showed seated women, such as Venus, in profile. Recall Michelangelo's synthesis of *David* (Fig. 208); that of Rembrandt was to take a Protestant Dutch housewife and pose her in the manner of a Roman goddess to re-create the character of a tragic Hebrew woman.

In his later years, during the period when this painting was done, Rembrandt painted fewer crowd scenes and preferred to treat isolated individuals. He tended to immobilize

below left: 274. Rembrandt. *Male Nude Standing.*
c. 1646. Pen and ink with wash and chalk.
British Museum, London
(reproduced by courtesy of the Trustees).

below: 275. Rembrandt. *Bathsheba.* 1654. Oil on canvas,
4'10⅞'' × 4'7⅞'' (1.5 × 1.42 m).
Louvre, Paris.

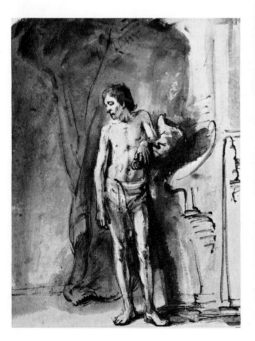

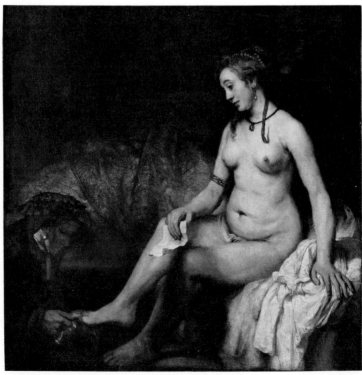

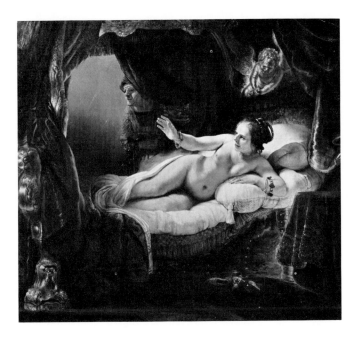

above: 276. Rembrandt. *Danaë.* 1636. Oil on canvas,
6'1½'' × 6'8'' (1.84 × 2.03 m).
Hermitage, Leningrad.

below right: 277. Rembrandt. *Christ at Emmaus.* 1648.
Oil on panel, 26¾ × 25⅝'' (68 × 65 cm).
Louvre, Paris.

his subjects, placing emphasis upon their inner rather than outer reactions to events. The great mysteries for Rembrandt were not those of theology but those of humanity. The theme is typical of Rembrandt, for it reveals the individual's passive submission to fate. He has depicted the moment of recognition, crucial to Classical drama. Bathsheba is attended by a servant or David's messenger, who prepares her for the fateful meeting with the King. In Bathsheba's hand is the note that initiates the tragedy. The expression on her face, the limpness of the arm holding the letter, the unthinking compliance with the actions of the maid—all compose the story of an individual caught in a web of circumstance over which she has no control, though she is aware of the eventual outcome. Moved by the vulnerability of people and their unwitting involvement in tragedy, Rembrandt reconstructed the Bible in human terms. While the painting gives an initial impression of factual account, Rembrandt added an aura of elusive, lyrical revery. Julius Held characterized this type of painting as Rembrandt's formula "of making his models appear both physically present and psychically remote."

Rembrandt's nudes were not in the Italian Renaissance tradition, for they lack Classical proportions, cosmetic perfection, and litheness. More in the northern tradi-

tion (see Chap. 6), they are naked rather than nude, and the revelation of their bodies becomes almost an invasion of their privacy. Rembrandt's intense empiricism would not allow him to submit the naked body to norms imposed by other styles and cultures. His nudes are not generalized types; each body seems shaped by the character of its possessor. His naked bodies seem to retain the impress of clothes and to show the effects of diet and an existence more sedentary than athletic. Gravity of mind and the pressure of conscience are depicted in these heavy bodies.

In an earlier painting, Rembrandt celebrated the beauty of a naked woman in amorous and more joyful circumstances (Fig. 276). On an elaborately ornamented bed, Danaë awaits the coming of the god Zeus, whose presence just beyond the curtain is announced by a golden light. The anguished, constrained cupid above Danaë symbolizes the chastity enforced upon her because her father the king had been warned of his own murder by a future grandson. In paintings of this subject by other artists, Zeus transforms himself into a rain of golden coins to gain access to Danaë's bed. Rembrandt uses the old symbol of divine luminosity and bathes the woman's pliant body in a warm glow. His Danaë is not the statuesque recumbent figure of an Italian Venus, but in her gesture and radiant expression she exhibits a warm-blooded anticipation.

Miracles Few of Rembrandt's paintings deal with miracles. (This was characteristically Dutch.) He saw the Bible in terms of men and women with distinct personalities, problems, and hopes not unlike those daily encountered in Amsterdam. When he painted *Christ at Emmaus* (Fig. 277),

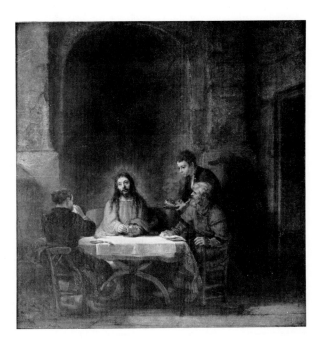

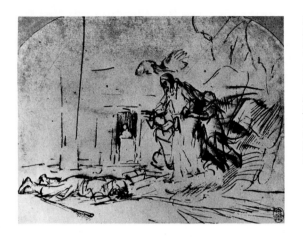

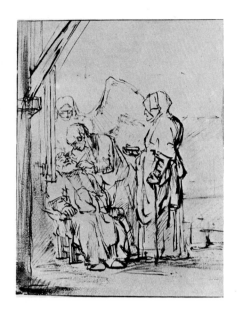

left: 278. Rembrandt. *God Announces His Covenant to Abraham.* c. 1656. Pen and bistre; 7¾ × 10½″ (20 × 27 cm). Kupferstichkabinett, Staatliche Kunstsammlungen, Dresden.

right: 279. Rembrandt. *Tobias Healing Tobit's Blindness.* c. 1649–50. Pen and bistre with wash, 6⅞ × 5¼″ (18 × 13 cm). Kupferstichkabinett, Staatliche Museen, Berlin.

he set the scene in an austere, high-ceilinged stone room that dominates the figures by its scale. Only the radiance emanating from Christ immediately distinguishes the painting from genre art. To evoke the apparition of Christ, Rembrandt set him directly before a sizable hollow niche, which looms like a dark void recalling his miraculous emergence from the tomb. The niche also binds the figures and encloses the area of dramatic, but underplayed, action. Unsympathetic to the formal centrality of Renaissance compositions, Rembrandt shifted the focus of the painting to left of center. Unlike Leonardo (Fig. 235), he bathed the room in a deep but transparent shadow and in a powerful warm light which the figures seem to absorb with varying intensity. He gave Christ an unaristocratic personality, stressing his gentleness, capacity for love, and ability to be at home with the humble. No painter before Rembrandt came as close to fathoming the Jesus of the Gospels or the historic Jesus (see Chap. 3). Rembrandt did portraitlike studies of Christ, probably based on a bearded youth from the Jewish quarter near his home. In the Emmaus scene, the bearded Christ retains the soft, gentle qualities with which Rembrandt endowed him in scenes showing his earthly ministry. Only the sad expression of the eyes suggest the suffering and fatigue of the Passion. Significantly, one of the disciples seems to study Christ's face for signs of the miracle instead of following his gesture of breaking the bread. Deliberately avoiding Caravaggio's rhetoric of gestures and accessory objects (Fig. 249), Rembrandt, as he himself said, sought to convey the greatest inner emotion.

Another subject relating to an epiphany is the drawing of God announcing his convenant to Abraham (Fig. 278), done after *Christ at Emmaus,* in the mid-1650s. As recounted in Genesis (15, 17), God promised to give the 99-year-old Abraham a son and to make him the father of nations. Both themes had a deep attraction for Rembrandt, who was preoccupied with the family all his life and believed that Jews were the chosen people. Rembrandt saw in the community an extension of the family unit; and in ritu-

als such as Christ's presentation in the temple, a linking of the two groups.

In the Bible, it is written that at God's appearance, Abraham fell flat on his face. This was a sign of fear and an indication of his unworthiness to look upon the face of the Lord. Rough as the sketch is, Rembrandt gave enough attention to the face of the Lord to evoke his kindly admonition, "Fear not, Abram, I am thy protector." Unlike Michelangelo, Rembrandt did not view Jehovah as the wrathful force; he gave the Old Testament God the same benevolent aspect as his images of Christ. He flanked the Lord with two angels and above his head drew the dove of the Holy Ghost, thus introducing the trinitarian symbolism that recurs when the three men appear to Abraham and Sarah and the Lord again promises them a son.

The rhythms of Rembrandt's hand as it moved over the grainy white paper, holding the reed pen, presented an intimate revelation. *God and Abraham* was not done from posed models, but the information and shorthand acquired from long study served him when he drew from imagination. The strokes that establish the broad gestures and the limits of movement for the figures of the angels do not form continuous constrictive outlines, but overlap or leave gaps in the silhouette that suggest the fusion of the body with the surrounding atmosphere. In the prostrate figure of Abraham, several of the lines begin or end within the body's outline and have a hooked termination. With a single flourish of the pen, Rembrandt established where a limb was joined to the body and where and to what extent it projected from the body. The body and its clothing were conceived in terms of directional lines and weights. With the paper as a source of light, a few expert touches of dark establish the mood and detail of the Lord's face.

The more that is learned about Rembrandt, the more it is realized how his preoccupation with certain themes satisfied many different personal interests and needs. His drawing of *Tobias Healing Tobit's Blindness* (Fig. 279) is but one of some 55 interpretations the artist made from the Book of Tobit. This Old Testament story of God's compassion toward humanity, with its emphasis on family unity and loyalty, appealed to Rembrandt, who not only had strong feelings of love and concern for his son Titus but also an abiding love for his own father, who had died blind. The drawing shows the subjects near an open window and Tobias examining the sightless eyes of his father before curing them with the gall of a fish held in a bowl by Tobit's wife. The archangel Raphael, who revealed the means of cure to Tobias, stands behind the father and son like a guardian angel or an attending physician. It has been shown that here, and in similar drawings, Rembrandt has accurately delineated the medical procedure for cataract operations as then performed in Amsterdam. Rembrandt depicted many themes in which sight or blindness is an important element—an understandable concern because of the importance of vision to the artist's profession.

Rembrandt's etching of *The Sacrifice of Isaac* (Fig. 280) reverses the roles of Tobias and Tobit, for Abraham tenderly covers the eyes of his beloved son as he is about to deprive him of life. So intense is Abraham's grief in complying with God's command that even the intercession of the angel, who physically stays the sacrifice, does not immediately affect the father's anguished expression. In this last version, Rembrandt compressed the action in the close contact of the three figures, and the ass and servants were relegated to insignificant roles. The black cavities framing the sacrifice suggest the tragic mood of the moments preceding it and the symbolic conversion of darkness to light by the angel's miraculous appearance.

One of Rembrandt's last paintings is the *Return of the Prodigal Son* (Fig. 281). Perhaps because of his close ties to Titus and to his own father, Rembrandt repeatedly interpreted the theme of father and son. In this picture, the wordless but profound reaction of all to the homecoming signifies the indivisible ties of the family. The sons who remained with the father display no jealousy or recrimination but are sympathetic witnesses to a sacred moment. Just as Rembrandt understated the drama, his frugal means

below: 280. Rembrandt. *The Sacrifice of Isaac.* 1655. Etching, 6¼ × 5⅛″ (16 × 13 cm). Albertina, Vienna.

right: 281. Rembrandt. *Return of the Prodigal Son.* After 1660. Oil on canvas, 8′7⅛″ × 6′8¾″ (2.62 × 2.05 m). Hermitage, Leningrad.

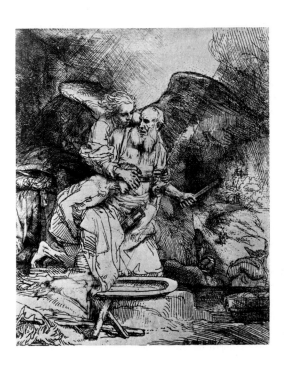

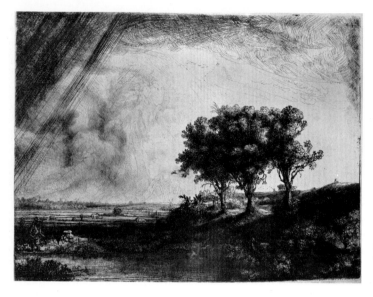

left: 282. Rembrandt. *Three Trees.*
1643. Etching, $9\frac{1}{4} \times 11\frac{3}{8}''$ (23 × 29 cm).
British Museum, London (reproduced
by courtesy of the Trustees).

below: 283. Rembrandt. *The Omval
at the River Amster.* 1645. Etching, $7\frac{1}{4} \times 8\frac{7}{8}''$
(18 × 22 cm). British Museum, London
(reproduced by courtesy of the Trustees).

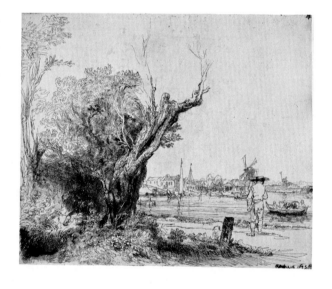

added to the force of the painting. There is no emphatic action or elaborate interweaving of figures and background. The individual forms are somewhat rectangular and block-like. This suggestion of regularity and self-containment is offset by the dissolution of the edges of the forms and their fusion with the luminous ambience. There is a simple scale of emphasis, with the greatest wealth of color lavished on the rags of the son. With the reduction of the figures to a static condition, Rembrandt solemnized the human being and achieved a supreme drama of persons. This image of forgiveness and pity is a form of self-revelation that may reflect the artist's own resolution of conflicts with the world.

Landscapes From about 1640 to 1656, Rembrandt did a number of drawings, prints, and paintings of landscapes, which earlier had appeared in his work solely as a backdrop for figural subjects. Many of his landscapes are of the flat plains, picturesque thatched peasant cottages, and canals in and near Amsterdam. Dutch artists were known to make drawings from nature on the spot, but their paintings were completed in the studio and were often composites of different views. In his etching *Three Trees* (Fig. 282), Rembrandt shows the tiny figure of an artist sketching on a hilltop at the far right. In his more numerous figure compositions, human beings dominate their setting or claim most of our attention, but in his landscapes, Rembrandt was able to contrast their small scale and quiet routine activities with the grand sweep and endless variety of nature. By alternating zones of dark and light, Rembrandt suggested the depth and continuity of the earth's surface and dramatized the rugged trio of trees against the brightness of the clearing sky. A shaft of sunlight illuminates the fisherman and his wife at the left, while above them on the horizon is the silhouette of a city. From the rich sensuous blacks of the foreground shadows emerge the highlighted traces of bushes. Just as he could dignify the rags of a beggar, so could Rembrandt provoke our curiosity and pleasure in even the meanest vegetative scrub in his prints. The etching *The Omval* (Fig. 283) repeats Rembrandt's habit of combining large and small elements, of suggestively detailing the near and far. Secret places in nature such as caves or the shadowed copse seen at the left of the print enhance pictorial interest. To keep his compositions from disintegrating under accumulations of detail, Rembrandt graded the density and definition of areas and left as contrast large untouched spaces. The tangled wooded area at the left is built up from the inside out, whereas the houses and mill across

right: 284. Rembrandt. *The Anatomy Lesson of Dr. Deyman.* 1656. Fragment of oil painting, 3'4'' × 4'4'' (1.02 × 1.32 m). Rijksmuseum, Amsterdam.

below right: 285. Rembrandt. *The Anatomy Lesson of Dr. Deyman.* c. 1656. Ink and wash, 4⅜ × 5¼'' (11 × 13 cm). Rijksmuseum, Amsterdam.

the canal have more pronounced silhouettes and spare linear definition within. At no point does nature seem finite and arrested; it is captured as if in a perpetual, transitory condition of illumination and growth, or of what it reveals and conceals. Rembrandt imposes an emotional character on the nonhuman, for as with his figures, he virtually draws out the biographies of his buildings and trees.

Anatomical Science Rembrandt's insistence on personal discovery parallels developments in western European science and the empirical attitude reflected in the great anatomist Vesalius' opinion that the proper study of mankind is man. In describing the naked body, Rembrandt relied upon the practiced coordination of his eyes and hands; occasionally he even had recourse to the advice of famous Dutch doctors. The discoveries of advanced Dutch science coincide with those of Rembrandt most apparently in his painting *The Anatomy Lesson of Doctor Deyman* (Fig. 284). Only a sketch (Fig. 285) preserves for us the painting's original format; fire destroyed all but a fragment that shows the foreshortened view of the corpse, the chest and hands, presumably, of Dr. Deyman, and an assistant standing to the left and holding the removed top of the skull. Commissioned to make a group portrait of the doctor and his assistants or students, Rembrandt chose to depict a public dissection such as occurred in the Amsterdam medical amphitheater. In an excellent book, William Heckscher has shown that, while saluting the triumph of modern science over superstition and ignorance, the painting also combines the old moralizing ideas of *memento mori* and "the wages of sin are death" (Figs. 155, 156; Pl. 8, p. 90). The corpse was that of a hanged thief, and this was in a sense a punitive dissection comparable to that shown earlier by Gerard David (Fig. 176). Like Doctor Deyman, Rembrandt was heir to the Ren-

aissance admiration of the body as both an object of beauty and the key to understanding life.

Portraits Rembrandt's early prominence, even before his arrival in Amsterdam in 1632, was based on his talents as a portrait painter. Like his fellow Dutch painters, he responded to the demand of the well-to-do middle class for portraits. Personal friends—writers and doctors—and interesting-looking individuals he pulled in from the streets of Amsterdam also sat for their likenesses. In later years, Rembrandt's portraits were in less favor because potential clients preferred the slick, extroverted, and often smug images the fashionable painters achieved. Still, even after his bankruptcy, Rembrandt continued to receive important portrait

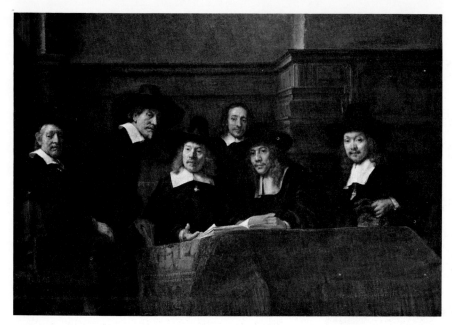

left: 286. Rembrandt. *The Syndics.*
1662. Oil on canvas,
6'7⅞'' × 8'11⅞''
(1.85 × 2.74).
Rijksmuseum, Amsterdam.

below: 287. Rembrandt.
*The Conspiracy
of Claudius Civilis.* 1661–62.
Oil on canvas,
6'5⅛'' × 10'1⅝''
(1.96 × 3.09 m).
Nationalmuseum, Stockholm.

opposite: 288. Rembrandt.
The Polish Rider. c. 1655.
Oil on canvas,
3'10'' × 4'5⅛''
(1.17 × 1.35 m).
Frick Collection, New York
(copyright).

commissions, one of which, from the governing board of the drapers' guild, resulted in the group painting known as *The Syndics* (Fig. 286).

An important contribution of Rembrandt to group portraiture was his successful solution of the problem of achieving an informal, unself-conscious, and convincing union of all the sitters. Since portraits were paid for on the basis of the amount of the figure shown, it was essential that all the faces be clearly in evidence and that priority be given to the guild president. Rembrandt chose a moment during a meeting of the board with its stockholders, immediately after a query had been made from the floor. Within the painting, the figures are subtly united in their relationship to the president, who is rising to respond. The interlocked groupings and the positions of the bodies give a sense of this official relationship. The device of directing all attention outside the picture, toward the viewer, unites the figures on some external focus. The sobriety and similarity of apparel and the warm, heavy atmosphere of the room—suffused with rich tones on the walls and in the near edge of the table covering—further the painting's harmony.

As in the best of Rembrandt's work, there is in *The Syndics* an underlying conflict between the apparent and the real. The subjects were men of status and solid achievement who, on occasion of the board meeting, presented an image of unshakable probity and solidarity. To the far right, however, is set into the wall panel a painting of a burning city, which in Rembrandt's time, as De Tolnay has shown, signified the ephemerality of worldly power. It was a commentary on vanity and a warning against pride to those of wealth. The faces of the men betray their inherent individuality and those human qualities that do not always accord with official roles. As prosaic an event as a business meeting, astutely viewed by Rembrandt, has been transformed

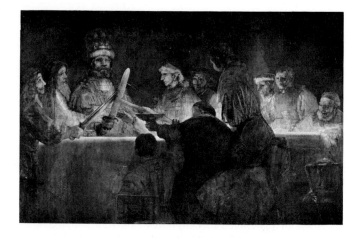

into a work of art and a probing psychological study of the price and nature of power.

In 1662, the same year that he painted *The Syndics,* Rembrandt worked on a painting for the Amsterdam town hall (Fig. 287). Its subject was the ancient conspiracy of the Batavians, ancestors of the Dutch, who rebelled against Roman rule. It is an ambitious example of Rembrandt's ability to create painting from imagination. In its original state, *The Conspiracy of Claudius Civilis* was probably the largest painting Rembrandt ever undertook. When it was rejected, he removed it from the town hall and cut it down to the area he liked most, which made a work of marketable size. The nearly concurrent dates of the two paintings make the contrast between the historical work and the group portrait of *The Syndics* all the more interesting. Rembrandt's visionary inclination was inspired by the midnight meeting of the conspirators, when they swore allegiance until death

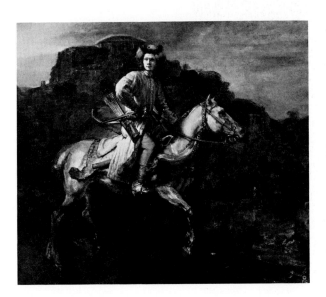

the inspired painting of the horse and military costume, based on a triad of red, white, and gold. A clue to the portrait's meaning lies in the painting itself, in which the warrior rides his gaunt horse through an inhospitable landscape dominated by a massive fortress. The self-assured pose and unnatural radiance enveloping the soldier and his horse are perhaps suggestive of the rider's symbolic role as a Christian knight errant in a world of peril. A descendant of Titian's equestrian portrait of Charles V (Fig. 315), Rembrandt's work makes horse and rider a more unified organism and gives the animal greater character. Rembrandt had, in fact, the opportunity to study the skeleton of a horse in one of the medical amphitheaters. Though he was without royal patronage for his theme, he combined the regal and triumphal associations of the equestrian motif with an idealized portrait and at the same time reflected Europe's concern over the Moslem threat and his own private hopes that resided in youth.

The portrait of *Jan Six* (Pl. 22, p. 209) epitomizes Rembrandt's ideals—dignified masculinity and a certain quality of cool correctness mingled with irrepressible human warmth. Rembrandt endowed Jan Six with traits of the active and the contemplative life, and in reality the living subject of his art was both a successful poet and a politician. Significantly, Rembrandt did not portray great contemporary Dutch political and military heroes. The most compatible subjects in his later life were men such as Jan Six who, like the painter himself, fully indulged both their worldly and intellectual appetites and ambitions. Personal rather than civic accomplishment seems to have impressed Rembrandt most. This admiration for men who lived by strong individual codes was natural in an unconventional painter who resisted the formulas of art. Jan Six stands to the right of center, takes no notice of the viewer, and does not assume a stable pose in the disposition of his limbs. With part of his face concealed in shadow, he is decidedly not the extroverted affable or the prim type favored in the more popular art of the time.

The portrait of *Jan Six,* like Rembrandt's most inspired work of any period, summarizes all that the artist had learned about his craft and human nature. By 1654, when the portrait was done, Rembrandt could produce painting that was both elegant and profound, in which he achieved great expressive power with economical means. The painting of Jan Six is in a sense a double portrait, a blend of studied contrasts that gives simultaneous insight into the public and the private indentity of Jan Six. The automatic gesture of putting on a glove prefaces his going out into the streets; the tan gloves, scarlet cape, green-gray coat, and black hat are part of the gentleman's public identity. The actual public face has not as yet been "put on" or arranged; the subject's features are relaxed in a momentary unawareness of others as his mind is absorbed in gentle reverie. The collar and row of buttons have a firm, tangible appearance that restores to us the external man.

upon the sword of Claudius Civilis. This highly charged incident is an ironic contrast to the mundane discussion in the trustees' meeting. The confident reserve of the fiscally wise guild president makes an equally interesting comparison with the heroic presence of the one-eyed Claudius Civilis, who was to challenge the legions of the Roman Empire. The quiescent sunlight of the board room, with its connotations of security and permanence, gives way to the brilliant, inconsistent, and concealed radiance emanating from the conspirators' table, a strange light that transfigures their varied, rugged features and then fades into the surrounding gloom. The faces of the conspirators belong with their costumes and roles of the moment; the intriguing double life of the syndics is absent. Each figure has freedom of movement within a restricted space, preserving his individuality without weakening his relation to the group. Layers of glazes build up the surface into thick crusts; no color area is composed of pure single tones, and the colors seem suspended within a tangible atmosphere. It is characteristic of Rembrandt's late style that as the paint became richer and more mobile, the outward action of the figures was reduced. Even in this histrionic episode, the participants are submerged within themselves.

Linked in spirit with the *Claudius Civilis,* and likewise an imaginative portrait, is Rembrandt's misnamed *Polish Rider* (Fig. 288). The proud and alert horseman is based upon eastern European light cavalrymen, whose heroic exploits in defending Christian Europe against the Turks were legendary even in Amsterdam. Their service as mercenaries in western Europe would have accounted for Rembrandt's acquaintance with his subject, since he shows the full military equipment of this type of soldier without specifying his nationality or personal identity. The darkened background throws into relief the rider's manly beauty and

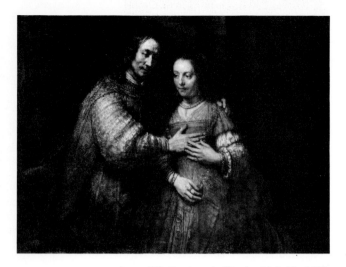

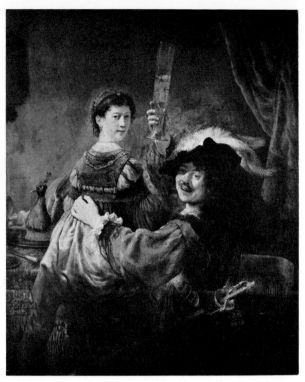

above: 289. Rembrandt. *The Jewish bride.* 1668.
Oil on canvas, 3′10⅜″ × 5′4½″ (1.18 × 1.64 m).
Rijksmuseum, Amsterdam.

right: 290. Rembrandt. *Self-Portrait with Saskia.*
c. 1635. Oil on canvas, 5′4″ × 4′4″ (1.63 × 1.32 m).
Gemäldegalerie, Dresden.

Rembrandt's ability to tell a story and to widen the narrative beyond its literal meaning was not restricted to group scenes, for it can also be seen in a painting with but two figures: *The Jewish Bride* (Fig. 289), which was done in 1668. Though the work was possibly based on the biblical story of Rebecca and Isaac, its essential theme was marital concord, and the models were probably Titus and his wife. Into this painting the artist projected his sentiments of family and erotic love. It proposes a frank, sensual attitude, one of sharing, unlike any found in Renaissance paintings of the family. The story unfolded in delicate, subtle gestures can be compared to marriage portraits by Van Eyck and Kokoschka (Pls. 46, 47, p. 334). The gestures of the man, who has draped a necklace about his bride, suggest love and possession, while the attitude of the bride conveys submission and encouragement. A gamut of affectionate feeling finds expression in this one painting. Its economy and restrained style make the slightest movement count. Colors emerge from shadow, with the strongest tones reserved for the area in most intense light. This highlight, significantly, does not fall on the faces but on the man's sleeve. The lightest parts are most thickly painted, so that in places the pigment actually forms a relief that catches shadow and light from the room where the painting hangs.

Self-Portraits No previous artist made so many self-portraits as Rembrandt. What began from convenience and vanity ended in the search for self-understanding. The 1635 self-portrait with Saskia (Fig. 290) was equatable with the biblical theme of the prodigal son and also recorded Rem-

brandt's transformation from a country miller's son to an urban man of the world, a gentleman virtuoso whose opulent tastes would lead to financial disaster. His contemporaries would have understood the role-playing and even the flouting of morality, for the setting and situation were those of a brothel. At the upper left on the wall is a slate for recording the client's score. (It was left to Picasso to make explicit to modern eyes Rembrandt's association of art with sex. See Figure 535.)

The year of his bankruptcy, Rembrandt etched *The Phoenix,* showing the overthrown statue of a youth replaced by a scrawny bird (Fig. 291). This was, arguably, a self-portrait, conveying defiance of adversity and confidence

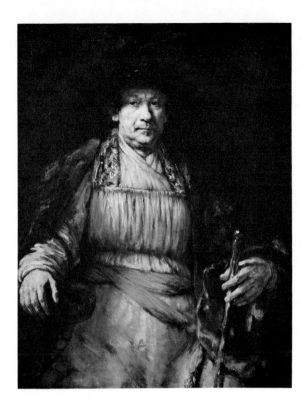

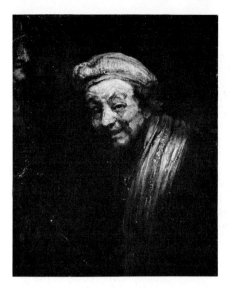

opposite below: 291. Rembrandt. *The Phoenix.*
Etching, 7″ (18 cm) square. British Museum, London
(reproduced by courtesy of the Trustees).

above: 292. Rembrandt. *Self-Portrait.* 1658. Oil on canvas,
4′4⅝″ × 3′4⅞″ (1.34 × 1.04 m). Frick Collection,
New York (copyright).

above right: 293. Rembrandt. *Self-Portrait.* 1669.
Oil on canvas, 32¼ × 24¾″ (82 × 63 cm).
Wallraf-Richartz Museum, Cologne.

that, like the phoenix, he would rise from the ashes of financial ruin. Fame would forever trumpet his triumph over younger competitors. Shortly before or after his art collection and house were auctioned to pay his debts in 1658, Rembrandt also showed himself as what Gerson calls "the old master painter" (Fig. 292). Stripped of all but self-possession, neither bitterness nor self-pity mark his face. The painting is a calm, supremely understood evocation of the artist's ultimate isolation. As age invests the flesh, the world comes to reside in his mind. Here is confirmed Rembrandt's view that wisdom and intellect are unrelated to external beauty. Art is knowledge, and Rembrandt sits among the wise men of history. His toughness and independence of spirit led to the ultimate vanity (Fig. 293). In an extraordinary self-portrait made shortly before he died, Rembrandt showed himself next to the bust of the Roman god Terminus. He laughs not just at the world, but at death! Where his contemporaries Vermeer and Velazquez sought painting's parity with the liberal arts, by his art's power, Rembrandt claimed death's motto, "I yield to none."

His ideas and feelings rank Rembrandt with the finest humanists. His art is one of people whose destiny he saw through the body. In Rembrandt's paintings and graphic works, human beings appear in both historic and private moments, as heroes and victims. To the protagonists of the Bible, legend, myth, and history—remote from the artist's sight—he gave a personality and humanity unprecedented in the history of art. He showed rulers in their fallibility, biblical heroes and businessmen in their frailty, and the King of Kings as a gentle human being. Moral expression, for Rembrandt, took precedence over physical beauty.

The principal means by which Rembrandt expressed his human consciousness was light. Early in his career, he used light as a device to organize his paintings, to achieve melodramatic effects, and to convey a transparent symbolism. As he grew older, he became aware of its more profound potential. The luminosity in his later paintings was no longer the convincing illumination of the room in which the viewer stands; nor was it subject to rational theories of the particular relation of solids to voids. The light in his mature works is a mysterious and enveloping radiance, tangible yet independent of local colors. Its qualities proceed from the nature of the subject. Rembrandt used light to play upon the polarity of inner and outer worlds and a rich incrustation of paint to achieve a materiality previously unknown. By doing so, he created an astonishing range of substances as well as infinite gradations of light and shadow. His art is a profound synthesis of a basic materiality and spiritualization of forms.

Rembrandt has not always been acclaimed as a great artist. He was "rediscovered" in the 19th century, but not until our own century was the magnitude of his achievement realized. Today it is acknowledged that no other painter surpassed him in sensibility to paint and ability to develop its expressive potential. Rembrandt was one of those great artists we now see as humanity's spokesman for its hopes—hopes for love, understanding and compassion, which are essential to the good life at any time.

Chapter 12

Images of Authority

For the last hundred years or more—since the invention of photography and growth of the mass media—the leaders of government have no longer called upon their finest artists for official portraiture. This separation of the best and most advanced art from the uses of political authority and the consequent decline in artistic quality of the official state portrait are historically recent developments. The informality possible in the photograph corresponds to what modern leaders believe to be the tastes of the populace. Great portraits of past rulers, however, gave them more vivid life than did written chronicles; even today these sculptures and paintings satisfy human curiosity about the appearance of famous people. Here, we shall see how art has historically served the ruler in many vital areas, particularly as a means of projecting abstract ideas of authority rather than human personalities.

In antiquity, art was an important means of making concrete the abstract concepts of kingship. Ordinary people usually knew their ruler through art rather than through physical presence. It was the artist who created an embodiment of the ruler's divinity and omnipotence, relying on the subject's likeness as well as on traditional prescriptions for making an interpretation of attributes that would be clearly understood by the people. Such public symbolism of authority extended to the architecture associated with the residence, appearance or epiphany, and ceremonies honoring the ruler. The recurrence in the Mediterranean world of Egyptian and Classical hieratic symbolism during the Middle Ages was owing to more than its design appeal in painting, sculpture, and architecture. Succeeding cultures assimilated age-old devices to enrich art meant to glorify the reign of an earthly or heavenly monarch and to show continuity with the past.

The King as Deity

The Egyptian pharaoh was regarded as divine, for he was the descendant and heir of the sun god, the ruler of the sky. An Old Kingdom statue of Khafre (Fig. 294) seated on a throne includes behind the head of the Pharaoh the carved symbol of the hawk-headed god Horus, lord of the rising sun. The hawk's wings encircle the ruler's headdress, symbolizing his origin and divine protection. The Pharaoh appears rigidly frontal, a timeless pose that was repeated without deviation during more than three thousand years of Egyptian history and that was ancestor to the 12th-century enthroned Christ on the west façade of Chartres (Fig. 112). The transcendence of the Pharaoh over mortality is revealed by his aloof and immutable posture. There is no suggestion of bodily movement or facial expression. The apparent stiffness and immobility of the human body and countenance were the means by which the sculptor, working with human anatomy, distinguished the king from mortals. In short, pharaonic imagery, dealing with a cosmic kingship, sought deliberately to be as unnatural as possible. The only variation in the position of pharaoh statues is from the elbows down; the ruler is sometimes shown holding a staff of office or the crook and flail. The last two were the attributes of

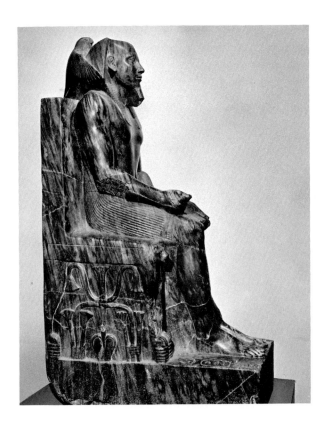

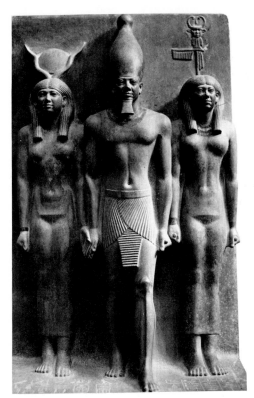

authority held by Osiris, the lord of the underworld and afterlife, who served as shepherd and judge of his people. The sacerdotal nature of pharaonic imagery parallels the ceremonious nature of Egyptian court life and the extreme formality of the kings' public appearances.

One of the oldest and most persistent devices for showing absolute authority and divinity of a ruler is that of *centralized composition*—setting the ruler between two flanking figures whose lesser stature is shown literally in their smaller scale or by their subservient gestures. The pharaoh Mycerinus had himself portrayed erect and rigidly frontal between two goddesses, not only signifying his divine descent but also, for political reasons, demonstrating his acceptance by the local goddess of a province in his kingdom (Fig. 295).

Whether the elements of naturalism, techniques such as bronze casting, and Egyptian symbols of kingship penetrated westward into Negro Africa or were themselves influenced by older Negro cultures is a problem that still occupies anthropologists and archaeologists. The West African civilization of Benin had a highly organized central government and a concept of sacred kingship analogous to that of European countries in the 16th and 17th centuries. A bronze relief plaque, dating perhaps from the 17th century, shows a seated Benin king (or *Oba*) flanked by two kneeling attendants (Fig. 296). His immobile posture and ritual gesture, larger scale, frontality, and possession of a hammer were all symbolic of authority. Both in Egypt and in Benin, certain materials were royal prerogatives for use in art. The

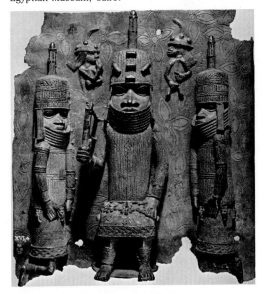

rulers of both regions adorned their palaces with their own effigies and were thought to be descended from dead kings and to be of divine nature. Elaborate ceremonies attended their public appearances. In certain African tribal societies, the ruler and important personages wore clothing (a warrior's surcoat, for instance), and nakedness was a mark of inferior social status. Egyptian pharanoic imagery allowed some facial likeness; that of Benin, however, insisted on a stereotype, representative of an abstract principle.

Warrior Kings

For a period of three thousand years, pharaohs were shown in paintings and relief sculpture that proclaimed their godlike character and protection of the people. Shown in battle, at the hunt, in the company of other deities, and officiating at state ceremonies, the pharaoh's effigy was placed on the walls of tombs, palaces, and temples. One of the greatest of Egypt's rulers, Ramses III, who lived in the 12th century B.C., followed an established tradition by using the pylon of a great temple as a political billboard. In a relief decoration, he had himself shown hunting wild bulls (Fig. 297). This was not meant as a secular scene of frivolous sport, for all activities engaged in by a pharaoh were religious, symbolic of his fight against evil. Wild beasts as well as enemy tribes were viewed as the partisans of Set, an evil underworld deity. While the benevolent hawk god Horus flies above him, the Pharaoh coolly dispatches the fleeing animals with his spear. The reins tied to Ramses' waist seem unnecessary because of the perfect discipline and unison demonstrated by the chariot's horses. The symbolically small-scale troops also seem superfluous, for the divine ruler's victory was inevitable. The raised and extended front legs of the horses were a victory symbol throughout the ancient Near and Far East. The fallen, thrashing animal beneath the horses is interchangeable with bodies of dead warriors in battle reliefs. So effective was this combination of gallop and fallen prey that it persisted in imperial imagery into the 19th century and recurred with new connotations in Picasso's *Guernica* (Fig. 530). This relief of the hunt also demonstrates a fine synthesis of naturalistic observation (in fishes, reeds, and bulls) and the stylized or schematic formula with which Ramses and his retinue are depicted. The intrusion of pictographic writing extolling the Pharaoh demonstrates

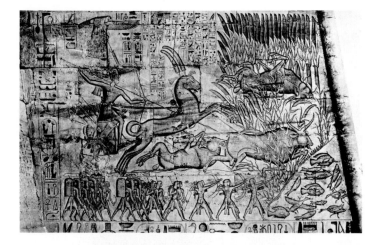

left: 297. *Ramses III Hunting Wild Bulls* (detail of a pylon relief). Medinet Abu, c. 1180 B.C. Sandstone. Oriental Institute, University of Chicago.

below: 298. *Ashurnasirpal II Killing Lions.* Nimrud, c. 850 B.C. Limestone relief, 3'3'' × 8'4'' (.99 × 2.54 m). British Museum, London (reproduced by courtesy of the Trustees).

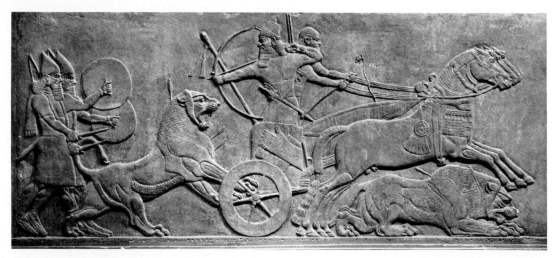

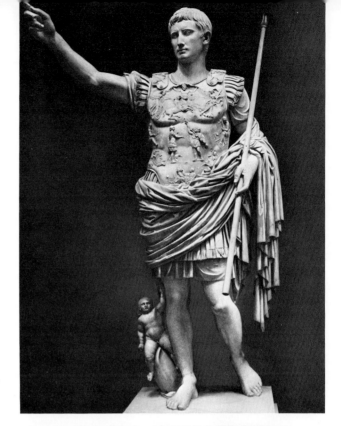

299. *Prima Porta Augustus.* c. 19 B.C.
Marble, height 6′8″ (2.03 m).
Vatican Museums, Rome.

that the event and art transcended unities of time and space
and possessed instead a higher reality.

A hunting relief from a 9th-century B.C. Assyrian palace
shows King Ashurnasirpal II aiming at a lion poised on the
rear of the royal chariot (Fig. 298). Assyrian palaces
abounded in symbolically repetitious reliefs of imperial war-
fare, hunting, and religious ceremonies. The great size and
number of reliefs were intended to impress visiting emissar-
ies with the king's might. Assyrian kings were not deified;
they were mortals who demonstrated their right to rule
through physical prowess, actually jeopardizing their lives
in stalking their prey or in hand-to-hand combat with their
foes. The king's acclaim depended in part upon acknowl-
edging the courage of his opponent, who was given an op-
portunity to attack. The Assyrian relief shown here indicates
the type of hunt the king might conduct, utilizing captured
lions that, if recalcitrant, could be goaded into fighting by
the noise of cymbals and irritating wounds. Deliberate in
his aim despite the beast's proximity, the King is about to
release the fatal arrow. The muscular character of Assyrian
kingship is reflected in the strong relief modeling, in con-
trast to the flatter Egyptian forms, which seem to lack bone
and sinew. The overlapping of figures and objects in depth
and their abundant detail, schematized as it is, show the
more earthbound orientation of Assyrian art.

The richest legacy of imperial imagery derives from
Roman art. The transformation of Republican Rome into an
empire is reflected in two statues of rulers: that of Emperor
Augustus (Fig. 299) was made in the late 1st century B.C.;
the second work (Fig. 300), from the later Imperial era,
probably represents Emperor Marcian, who reigned from
A.D. 450 to 470. The marble statue of Augustus is named for
the site of his wife's villa outside Rome, where it was found;
the bronze cast of Marcian is usually referred to as the *Co-
lossus of Barletta,* for its location in an Italian town on the
Adriatic. Augustus' military uniform befitted the *Imperator.*
In gesture, he is the commander-in-chief exhorting his
troops. On his breastplate is a scene of a Parthian chieftain
voluntarily returning eagle standards captured from Roman
legions, a historic diplomatic feat of Augustus; the scene is
approved by the figure of Jupiter and signifies a peaceful
rule. Also symbolic are the figure of Alma Mater and the
cornucopias, which attest to the prosperity under Augustus.
The dolphin by his leg alludes to belief in the divine origins
of the Emperor's family; the cupid astride it refers to Venus
and fertility. Altogether on the breastplate are represented
an actual event, divinities, and allegories demonstrating the

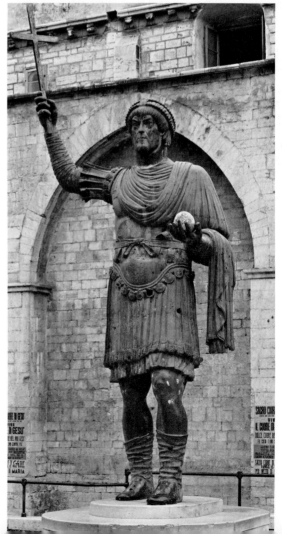

300. *Colossus of Barletta* (Emperor Marcian?).
c. 465. Bronze, height 16′9″ (5.11 m).
Outside Church of Santo Sepolcro, Barletta.

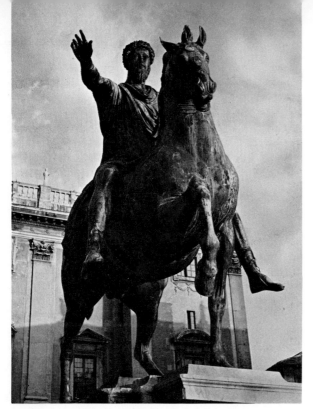

301. *Equestrian Statue of Marcus Aurelius.* A.D. c. 161–80.
Bronze, over life-size. Piazza del Campidolglio, Rome.

Between the Prima Porta and Barletta figures in date are
two other works of Imperial art that reflect political and
artistic changes. The equestrian statue of Marcus Aurelius
(Fig. 301), made between A.D. 161 and 180, survived medie-
val destruction of Roman Imperial statuary because it was
mistakenly believed to depict the first Christian emperor,
Constantine. Originally, a fallen barbarian lay beneath the
horse, and Aurelius' gesture is one of clemency to his foes.
In his left hand he held the orb. Freestanding sculptures of
mounted figures were in that era the prerogative of the em-
peror. So esteemed were Imperial effigies such as this that
laws prohibited certain human conduct in their vicinity; vio-
lation meant severe punishment. Public executions were
performed before the monument, and a prisoner on trial
could touch the statue to claim sanctuary and the right of
appeal to the emperor.

Toward the end of the 2nd century A.D. the gladiator-
trained Emperor Commodus had himself depicted as Her-
cules, the hero who prevailed over obstacles and achieved
eternal fame (Fig. 302). This fusion of Commodus with a
god and the apples that signify deification proclaim the
ruler as immortal. Nero had assumed the role of a living god

302. *Commodus as Hercules.* A.D. c. 185. Marble,
height 43½" (110 cm). Palazzo dei Conservatori, Rome.

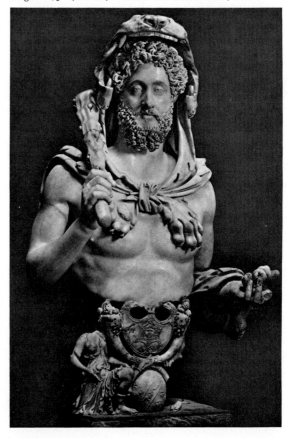

universal Pax Romana for which Augustus was famed.
Though deified by some of the conquered provinces, Au-
gustus chose to remain *Princeps* in Rome, a "first citizen"
nominally subject to the Senate in nonmilitary matters.
Handsome and athletic, dignified but humane, the effigy of
a ruler given to clemency as well as to war, the image re-
calls the grace and balance of the Greek *Spear Carrier* (Fig.
474), of which it is a paraphrase.

Like a second bronze version of the Augustus, the
Barletta statue also stood in a public place. It is a rare survi-
vor among the full-length Imperial statues of the time. Un-
like that of Augustus, which was only slightly larger than
human scale, Marcian's effigy towered impressively over
the crowd, more than two and one-half times life size. No
longer mortal and responsible to an earthly power, this
emperor has a deified aspect and wears a crown. Both em-
perors were military leaders, but Marcian's statue is the
more aggressive. The quality of human mercy exemplified
in Augustus is replaced by the severity of the later divine,
uncompromising guardian of the Empire. In the original
state, Marcian probably held a sword rather than a cross,
his martial spirit giving comfort to his many non-Christian
followers and stirring fear in his enemies. The sword and
the orb, symbols of power and accomplishment, replaced
the complex allegorical program of Augustus' armor. Re-
laxed fluidity of movement gave way to a firmer stance and
rigidity of limbs and body. The sensuous softness of Augus-
tus' form was succeeded by a tough, unyielding surface, as
well as by a stiffer treatment of the drapery.

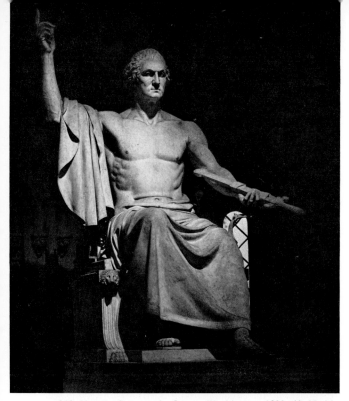

303. Horatio Greenough. *George Washington.* 1832–40. Marble, height 11′4″ (3.45 m). National Museum of American Art, Smithsonian Institution, Washington, D.C. (transfer from the U.S. Capitol).

9 B.C. Built on the Field of Mars, a military parade ground then outside Rome, it was intended to publicize the Emperor's foreign and domestic policy. The Emperor and his family are shown on one of the exterior sides in a procession led by priests, which took place either at the founding or completion of the altar. Only a detail of the relief is shown here (Fig. 304), but it demonstrates the conscious informality of the groupings and the indistinguishability of Augustus (probably the figure at the left, the left half of whose body has been lost) from the others in the procession. Like other members of his family, the Emperor wears a laurel crown, but neither in posture, gesture, nor position is his preeminence stressed. The image Augustus sought to project was that of a ruler eager to restore sincere religious observance and family unity. Lapses in temple attendance and juvenile delinquency were not unknown in Augustus' time.

More than three hundred years later, a great triumphal arch was erected close to the Colosseum and Forum to commemorate the victory of Constantine over Maxentius. It was adorned with new sculpture and with reliefs taken from older monuments. Two of the new reliefs showed Constantine receiving homage from the Senate (Fig. 305) and dis-

in the 1st century, beginning a long tradition that centuries later in America produced Horatio Greenough's sculpture of George Washington in the manner of Jupiter (Fig. 303) and situated Lincoln's enthronement in a Roman temple. The statue of Commodus reflects the vanity that caused this soldier-emperor to shoot five hippopotami with a bow and arrow from his box at the Colosseum before a cheering multitude. It also gives some indication of the caliber of ruler chosen by the army when the Senate acquiesced to its growing power in electing and sustaining an emperor. Commodus' bloody murder after a short and turbulent reign did not diminish the drive to deify the ruling authority of Rome nor that of emperors to use art for their fame.

Imperial Portraits and Reliefs

Like their Assyrian predecessors, Roman emperors were shown in a wide variety of reliefs and paintings of battles, hunts, and ceremonial functions. One of the most beautiful and impressive reliefs of the Augustan age is the Ara Pacis ("Altar of Peace"), constructed and carved between 14 and

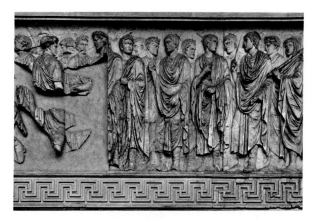

above: 304. *Procession of the Augusti,*
portion of the frieze of the Ara Pacis, Rome.
c. 14–9 B.C. Marble, height 5′3″ (1.6 m).

below: 305. *Constantine Receiving Homage from the Senate,*
frieze on the Arch of Constantine, Rome.
Early 4th century A.D.
Marble, height 41⅜″ (105 cm).

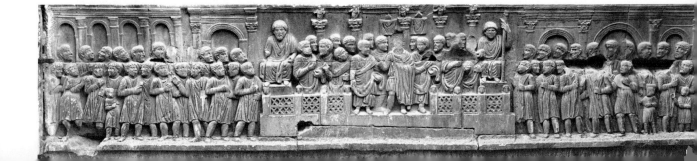

tributing gifts, according to tradition. In strong contrast to the more naturalistic figures of the Augustan relief, those of the Arch of Constantine jar the eye with their stunted bodies, large heads, repetitive gestures, geometric alignment, and total loss of individuality. The figures are flattened out and have lost all sensual appeal. The reliefs were relatively small and were not intended to fulfill the same function as, for example, the more than 60-foot (18-meter) full-length statue of Constantine that was placed in his basilica. Although the best talent available at the time evidently did not work on the relief, it has a certain force and succeeds in conveying the court ideals of the period. In the Emperor's presence, all activity was conducted according to a strict ritual. The importance of these reliefs lies in their culmination of the tendency toward a centripetal mode of composition, with total focus upon the strictly frontal and centralized figure of the Emperor. No previous ancient culture had put artistic devices so completely in the service of authority. The official taste of this epoch was indifferent to the organic qualities of flesh and blood. The expression of ideas superseded emphasis upon outward form, and the sensual life of the body glorified in Greece and early Rome passed into eclipse. A new and positive aesthetic evolved in accord with hieratic and spiritual ideals that would have been out-

raged by an interpretation like that of the Ara Pacis. A sophisticated, predominantly urban taste produced the Arch of Constantine statuary and the Barletta figure, and this taste was the basis for such medieval Christian imagery as the Ravenna apse mosaic of Christ (Pl. 3, p. 56).

The eastern portion of the Roman Empire, known as *Byzantium,* was founded by Constantine in A.D. 330, with its capital city, Constantinople, named for the founder. Earlier Roman Imperial devices for imbuing art with the majesty and deeds of the ruler were continued and refined in the Eastern Empire in the centuries that followed. Art workshops were part of the Great Palace of the emperors in Constantinople, erected during the reign of Theodosius in the second half of the 4th century. The ruler, who held a monopoly on many luxury materials such as purple dyes, sought to ensure that Imperial art would continue to remind the people of perpetual victory and divinely sanctioned rule. Coins, public statues, ivory reliefs on boxes, consular credentials, textiles, paintings, mosaics, army standards, and such precious objects as silver disks bore the Imperial effigy for a thousand years. The emperor was always shown as a majestic authority, whether in battle, hunting, officiating at public ceremonies, or attending the games in the hippodrome. The so-called *Barberini Ivory* (Fig. 306) is an outstanding example of the image of the early Byzantine ruler. A semiprecious medium imported from India and Africa, ivory had the advantage of softness for delicate and detailed carving, combined with durability and the capacity to take paint. Made about the turn of the 6th century, the Barberini panel was probably part of a series commemorating the military and diplomatic triumphs of Emperor Anastasius I. The tripartite organization is a design scheme that can be traced back to Egyptian imperial imagery of the 1st Dynasty, notably in the votive palette of King Narmer (Fig. 307).

above: 306. *Emperor on Horseback* (leaf of the *Barberini Ivory*). c. 500. Ivory, 13⅜ × 10″ (34 × 25 cm). Louvre, Paris.

right: 307. *Narmer Votive Palette.* Hieraconpolis, c. 3000 B.C. Schist, height 25″ (64 cm). Egyptian Museum, Cairo.

above: Plate 21. Jan Vermeer.
The Artist in His Studio. c. 1665–70.
Oil on canvas, 4'4'' × 3'8'' (1.32 × 1.12 m).
Kunsthistorisches Museum, Vienna.

left: Plate 22. Rembrandt. *Jan Six.* 1654.
Oil on canvas, 44 × 40'' (112 × 102 cm).
Six Collection, Amsterdam.

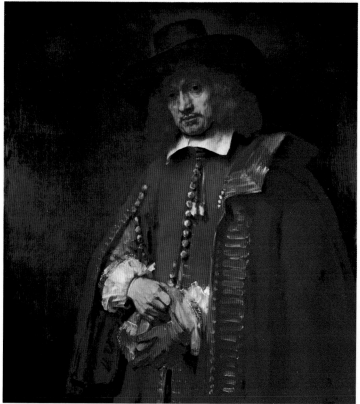

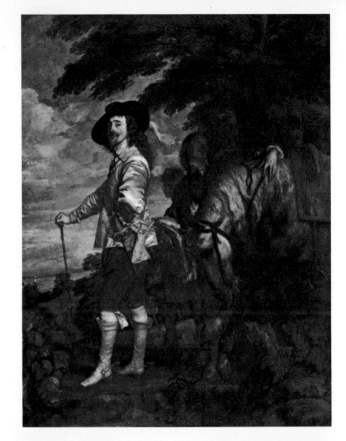

right: Plate 23. Anthony van Dyck.
Charles I. c. 1635. Oil on canvas,
8'11'' × 6'11½'' (2.72 × 2.12 m).
Louvre, Paris.

below: Plate 24. Eugène Delacroix.
Liberty Leading the People. 1830.
Oil on canvas,
8'6'' × 10'10'' (2.59 × 3.3 m).
Louvre, Paris.

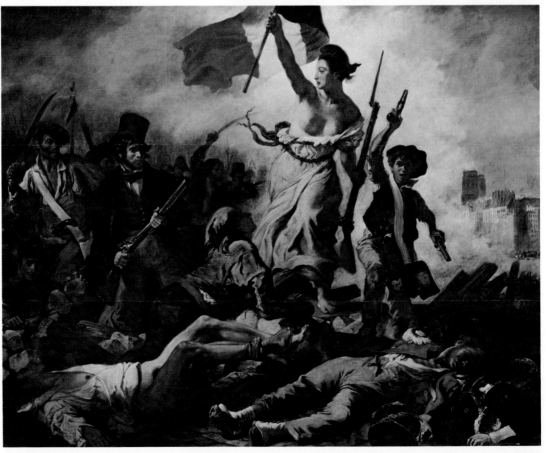

308. *Disk of Theodosius.* A.D. c. 390.
Silver, diameter 29⅛″ (74 cm).
Academy of History, Madrid.

In both objects, the top zone is symmetrical, its uncompromising formality being reserved for images of a supreme deity. The flanking Egyptian gods are represented in the form of bulls (later they would receive anthropomorphic treatment). On the ivory, a frontal bust of Christ appears in a medallion held by angels. The Christians had simply replaced earlier pagan Roman images of the emperor with those of their God and preserved the hieratic format. The second zone of the ivory shows the Byzantine Emperor on horseback, his standard largely obscuring the figure of an Asiatic chieftain. His stirrup is supported by an allegorical figure of Earth, and a flanking official presents him with a statue of Victory. On the palette, King Narmer is shown in a ritualistic gesture, with mace in hand, about to destroy his adversary with a single stroke. By the time of the *Barberini Ivory,* however, Byzantine emperors had reduced the frequency of such violent images, in a reflection of a Christianizing influence. While subordinate to their respective gods, both rulers assert their importance through their great scale within the zones they occupy. Anastasius is shown in not quite frontal pose so that he tactfully does not compete with Christ; he is relatively central within his field, but one flanking official is missing. In the lowest, most inferior register, both pieces have the greatest mobility and, symbolically significant, this is their least ordered portion. The enemies of Narmer flee or are dead, their disarray contrasting with the King's composed solemnity. Below Anastasius, on the left, are barbarians bringing tribute, and on the right, emissaries from India bearing gifts that include ivory. The relief carving in both works is of the highest quality—precise, clear, and adept at shaping compositional demands to political ones.

To someone unfamiliar with Byzantine art, it may appear stiff, repetitious, and unfeeling; there is no display of human warmth in the Imperial images, no dialogue between the figures. Unaccustomed to alternatives, Egyptian, Roman, and Byzantine artists accepted their assigned roles and succeeded in creating inspired art within officially imposed strict limitations. Much of the power of Byzantine art, like that of earlier Roman art, derives from its total realization of political and religious ideals. Like many other works, the *Barberini Ivory* and the silver *Disk of Theodosius* (Fig. 308), made at the end of the 4th century, show the possibilities of excellence in art that is not created in a republican society. Wearing the Imperial diadem, Theodosius is enthroned in the center of a gabled and arcaded structure that may have symbolized the façade of his palace. To the left and right of him are his sons, the princes Honorius and Arcadius, holding orbs symbolic of temporal rule. Flanking the whole are pairs of Imperial guardsmen. An official kneels to receive a gift or investiture of power

from the Emperor. Obeying court ritual, no one looks at the official. His hands are cloaked, showing his unworthiness to touch the divine person of the Emperor. In the area below is the earth goddess with the cornucopia symbolizing abundance under Byzantine rule; at this time, Christian emperors were not averse to using pagan symbolism. The Emperor's omnipotence is shown in hieratic fashion by his great scale, his centrality, and his location beneath an arch symbolic of Heaven. These attributes are more important than the individual personality or features of the ruler; hence the essential impersonality of the image. Again, the artist is depicting an abstract idea. An eyewitness description of an audience held with a Byzantine emperor by Liudprand of Cremona in the 10th century illuminates the environment that the artist was expressing, but not literally describing. Having been led into the audience chamber of the Emperor, Liudprand beheld this scene:

> Before the seat stood a tree made of bronze, gilded over, whose branches were filled with birds, also made of gilded bronze, which uttered different cries, each according to its various species. The throne itself was so marvelously fashioned that at one moment it seemed a low structure and at another it rose into the air. It was of immense size and was guarded by lions, made either of bronze or of wood covered over with gold, who beat the ground with their tails and gave a dreadful roar with open mouth and quivering tongue. Leaning on the shoulders of two eunuchs I was brought into the emperor's presence. At my approach the lions began to roar and the birds cry out. . . . I lifted my head and behold, the man whom I had just before seen sitting on a moderately elevated seat had now changed his position and was sitting on the level of the ceiling.

Unfortunately, no images of this marvelous throne and audience hall have survived the ages. The imaginative genius that contrived the tree and lions lives on only in the verbal record left by Liudprand.

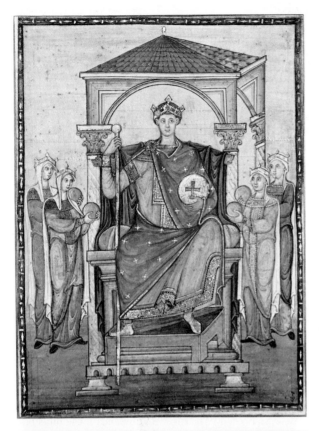

309. *Emperor Otto II,*
from the *Registrum Gregorii,* Trier, c. 985.
Manuscript illumination. Musée Condé, Chantilly.

The influence of Byzantine imperial imagery was felt all through the Middle Ages. One of its strongest manifestations is in 10th- and 11th-century Ottonian manuscript art depicting the Germanic emperors. An Ottonian emperor had married a Byzantine princess, who brought to her husband's court works of art, and possibly artists, which helps to account for Eastern influence in Western Europe. Emperor Otto II had himself portrayed in a manner reminiscent of Theodosius (Fig. 309). Allegorical figures of four nations bring gifts to the impassive ruler, who sits beneath an architectural canopy, itself a celestial symbol. The perspective of the canopy is rudimentary and inconsistent. To preserve the ruler's hieratic centrality within the arc of the canopy, the artist arbitrarily omitted the fourth column. To have rendered the depth of the painting consistently from the viewpoint of a spectator outside the picture would have meant subordinating the ruler to an external system governed by the viewer. Though suitable for thematic purposes, hieratic conventions could not be faithful to natural appearances.

The Ottonian portrait shares certain traits with a Japanese portrait of the great Shogun Minamoto Yoritomo (Fig. 310) by Fujiwara no Takanobu (c. 1142–c. 1205). Both were iconic representations of power. Takanobu, however, combined the impersonal symbols and stiff forms of the commander's ceremonial costume with a noticeable facial likeness of his subject. The Shogun is seated on a cushion throne, as he would be seen in the place of honor during a formal ceremony in the audience hall of his palace. This imposing portrait on silk was painted shortly after 1185, when Yoritomo overthrew the pleasure-loving Fujiwara regents, and the emperor retired from active rule. Yoritomo brought the *samurai,* the warrior caste, into power and created the military regime (Baku-Fu) that lasted in Japan until the 19th century.

Takanobu's painting inaugurated a portrait tradition in Japanese art. The style, a continuation from earlier periods, comprised large crisp silhouettes, clear ornamental surface patterns, a flat-toned, textureless flesh rendering, and an austere, seemingly airless surrounding. The Shogun's individuality resides in the small, immobile shapes of the eyes, nose, and mouth. The position of the head and the hair style are traditional, as are the symbols of his office and power, the sword and scepter. Nevertheless, the injection of some of Yoritomo's distinctive features is evidence of an encroachment of the samurai taste for naturalism, in opposition to the abstract facial types characteristic of previous periods.

310. Fujiwara No Takanobu. *Portrait of Minamoto Yoritomo.*
c. 1185. Painting on silk, 4′6⅜″ × 3′7⅝″ (1.39 × 1.12 m).
Jingo-ji, Japan.

311. Andrea del Verrocchio.
Lorenzo de' Medici. 1485.
Painted terra cotta, life-size.
National Gallery of Art, Washington, D.C.
(Samuel H. Kress Collection).

In Yoritomo's shogunate, the code of Bushido came into ascendance. Yoritomo's portrait is therefore representative of a Japanese feudal ideal of the perfect knight, a code that Takanobu seems to have illustrated in many respects. The samurai was disciplined in the strict course of rational conduct: "Rectitude is the bone that gives firmness and stature . . . without rectitude neither talent nor learning can make of a human frame a samurai." He would at all times exhibit stoic composure and presence of mind: "A truly brave man is ever serene." The absence of animation in the portrait expresses the samurai view that it was unmanly to show emotion in the face and that truly strong character was possessed by him "who shows no sign of joy or anger." An appreciation of culture was also part of his training. The samurai esteemed, and might even spare, an opponent who in the heat of battle maintained the presence of mind to compose or recall an appropriate couplet.

Yoritomo's portrait, which hung in a palace, may have been intended for worship. More likely it was a memorial to his military and administrative genius, to be venerated as an ideal by succeeding samurai. Thus the concept of a ruler's portrait serving as an ethical example was shared by East and West.

State Portraits

The finest sculptural portrait of a 15th-century Italian Renaissance ruler is that of Lorenzo de' Medici, done by Andrea del Verrocchio (1435–88) in 1485 (Fig. 311). This painted terra-cotta bust bears impressive witness to the Duke's power and excellence. The extent to which Floren-

tine style was able to impart ideals of authority is further demonstrated when the bust is studied along with Machiavelli's statements in *The Prince,* written in 1513 and first published in 1532. Although Lorenzo the Magnificent died some twenty years before their writing, these precepts were influenced by Machiavelli's knowledge of his career and the tradition that produced him. Relevant to art is the importance placed upon appearances:

> We . . . encourage such Princes to fortify and guard their own capital city. . . . The Prince ought to go in person and perform the office of a commander . . . have no other aim, nor thought, nor take anything else for his proper art, but war. It is necessary for a Prince, desiring to preserve himself, to be able to make use of that honesty, and to lay it aside again as need shall require. Wherefore a Prince ought not to regard the infamy of cruelty, for to hold his subjects united and faithful . . . a Prince (ought) to serve himself of the conditions of the Fox and the Lion . . . and let him seem to him that sees and hears him, all pity, all faith, all integrity, all humanity, all religion . . . for all men in general judge thereof, rather by sight than touch, for every man may come to the sight of him, few come to the touch and feeling of him. A Prince ought to endeavor in all his actions to spread abroad a name of his magnificence and worthiness. He ought in the fit times of the year entertain people with Feasts and Masks.

Verrocchio's Lorenzo is tough, sober, but contemplative. Once again we see how metaphor was as important as likeness to impart a subject's qualities. Subtle exaggerations make a somewhat leonine face. Like Lorenzo's palace (Fig. 341), the bust—with its firm roundness, simple dress, severe hairdo, and strong, thrusting nose—has a solid, even military appearance. The distinctly separate zones are composed on a frame of verticals and horizontals.

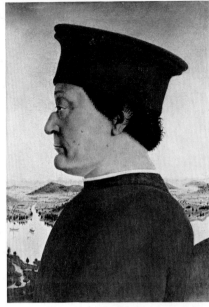

left: 312, 313. Piero della Francesca.
Battista Sforza, Duchess of Urbino
and *Federigo da Montefeltro,*
Duke of Urbino. 1465–72.
Oil on panel,
each 18½ × 13″ (47 × 33 cm).
Uffizi, Florence.

Italian portaits of nobility in the 15th century, like the design of their palace façades, were strongly influenced by the ideas from ancient Rome. In his double portrait of the Duke and Duchess of Urbino, Piero della Francesca (c. 1420–92) posed the subjects in profile (Figs. 312, 313), emulating coin and medallion effigies of Roman emperors. The profile view also served to conceal the Duke's damaged right eye, for while a fair degree of portrait likeness was considered desirable in this period, features that were ugly or deformed, along with conspicuous emotion, were to be concealed. The striking broken bridge of the ducal nose adds to the impressiveness of his birdlike profile. Un-Roman was Piero's use of a landscape backdrop for the portrait. Artful placement of the heads above the horizon line perhaps implies that the Duke is, literally and figuratively, lord over the land he surveys. The couple's elevated viewpoint suggests that they are depicted on a balcony of their palace, and the Roman tradition of the ruler's association with a *loggia* or window of appearances has been seen in Figures 109 and 110 and will be discussed in Chapter 13.

State portraits of the past have little popularity or relevance today because of their extreme formality, their lack of warmth and individuality. These were portraits of ideals as well as of persons, and it is the alien character of absolutist political ideals that contributes to present-day public indifference or dislike. The formulas for the state portrait that originated in exceptional painting of the 16th and 17th centuries encouraged mechanical repetition by uninspired technicians; this continues even today in trustee portraits on our campuses and in corporation board rooms. With the rise of the state in the 16th and 17th centuries, it became the task of the portraitist to give material form to the immaterial entity of the state. The historian Garrett Mattingly, in *The Defeat of the Spanish Armada,* describes the climate in which state portraits emerged:

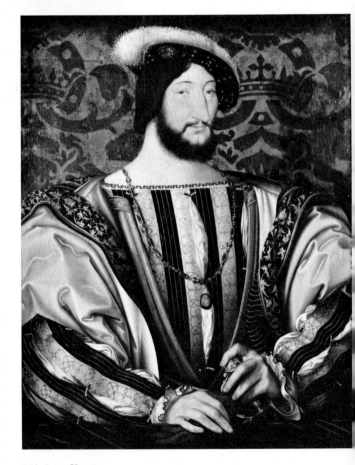

314. Jean Clouet.
Francis I. c. 1525–30.
Oil on panel,
37¾ × 29″ (96 × 74 cm).
Louvre, Paris.

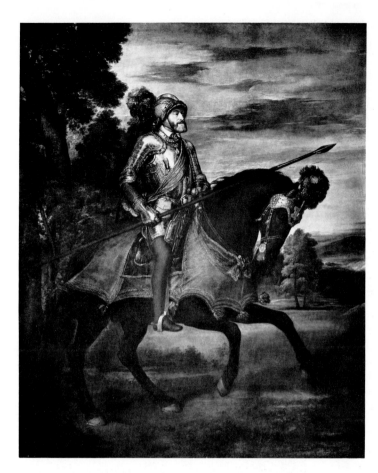

315. Titian.
Charles V on Horseback. 1548.
Oil on canvas,
10'10¾'' × 9'1⅞'' (3.32 × 2.79 m).
Prado, Madrid.

The deepest longing of the troubled and divided sixteenth century was for the unity and peace, and the only effective symbol men could find for the social order they craved was the person of the monarch. So the life of even the wickedest prince, most preachers taught, was sacred, and the duty of obedience was explicit no matter what the character of the ruler. Gradually that ultimate allegiance once given to the universal church was being transferred to secular sovereigns, in preparation for its further transference to an abstraction called the national state when men should think of it. The blasphemous doctrine of the divinity of kings was beginning to be in the air . . . everywhere in Europe. The sixteenth century belonged to the monarchs.

Early in the 16th century, Jean Clouet (c. 1485–c. 1540) painted a half-length portrait of Francis I that is regal in subject and style (Fig. 314). Required to portray grandeur and therefore restricted in the gestures he could use, Clouet depicted the King with one hand symbolically on his sword and the other at rest on a cloth-covered table. Rational composure and power are thus conveyed in the hands alone. The swelling of the costume from the hands up to the shoulders, culminating in the finely shaped neck, was consonant with what were thought to be ideal royal proportions; it was also in accord with the current fashion, which decreed exaggerating the breadth and masculinity of the King. Clouet gave only a subdued relief to the head, which is so disposed as to permit firm but delicate delineation of the long regal nose. The remote stare of the eyes was con-

sidered a fitting expression for a monarch, who was thought to exist and to govern in total isolation. Clouet's design stresses sharp contrasts of brilliant color, such as the red tapestry against the black and cream of the King's attire. Cool, nontactile surfaces add to the aloofness and unsensual character of the subject. State portraits were not supposed to be too literal or lifelike, and Clouet's almost abstract design of color, figure placement, and pose did much to create an aura that was symbolically unnatural. The style of a successful royal portraitist such as Clouet was of necessity identical to that of the ruler. As in antiquity, the state portraitist was enjoined to show the ruler as he should be, not as he was, and Mattingly points out that even from the pulpit people were told to revere and obey the most unscrupulous monarch.

So successful was Titian (c. 1488–1576) in capturing the ideas of monarchy that Charles V ordered that no one else be allowed to paint his portrait. One of many influential state portraits that Titian did of Charles (Fig. 315) shows the Emperor riding on the field of Mühlberg, where he won a great victory over two rival German rulers. In depicting Charles at the zenith of his power, Titian chose to adapt the old equestrian format from sculpture (Fig. 301) to easel painting. This increased the scale and monumentality of the ruler's image and, though he is in a seated pose, revealed him full length. The King's mastery of 16th-century ideas of

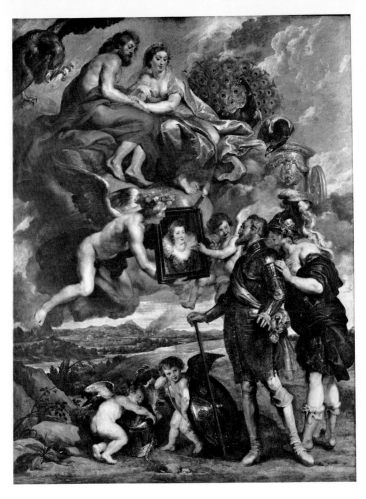

316. Peter Paul Rubens.
*Henry IV Receiving
the Portrait of Marie de' Medici.*
1622. Oil on canvas,
12′11⅛″ × 9′8⅛″ (3.94 × 2.95 m).
Louvre, Paris.

horsemanship was validated in the noble bearing with which Titian endowed him. The gold and black armor, coupled with the aristocratic pose and the isolation of horse and rider, would seem to locate the action not in battle but on parade. The three-quarter pose of horse and rider permitted what Titian felt was the most striking view of Charles' face and displayed the beauty of the rounded, sash-covered breastplate. Many scholars have pointed out that Titian's clients favored his way of working, which was not bound to a strict likeness of the subject. After studying the sitter's features, Titian would then re-create him as he felt he ought to be. Legend has it that the Emperor so respected Titian that he once retrieved the artist's brush, which had fallen to the floor.

During the 17th century, artists of intelligence such as Anthony van Dyck (1599–1641) had discreet freedom to innovate, as long as they suited the taste and ideal of the patron. Rather than begin with an analysis of Van Dyck's finished painting of Charles I (Pl. 23, p. 210), let us consider the problem of representation as it might have been posed in the artist's mind. Charles I saw himself as a cavalier or perfect gentlemen, a patron of the arts as well as the embodiment of the state's power and king by divine right. He prided himself more on his dress than on robust and bloody

physical feats. Van Dyck had available to him precedents for depicting the ruler on horseback or in the midst of a strenuous hunt, but he set these aside. How, then, could he show the regal qualities and sportsmanship of a dismounted monarch in a landscape? Compounding the artist's problem was the King's short stature, just about 5 feet, 5 inches. To have placed him next to his horse, scaled accurately, would have presented an ungainly problem. Van Dyck found a solution to this last problem in a painting by Titian, in which a horse stood with neck bowed, a natural gesture that in the presence of a king would have appropriate connotations. Placing the royal pages behind the horse and farther from the viewer than the King reduced their height and obtrusiveness, yet furnished some evidence of the ruler's authority. Nature also is made to support and suitably frame the King. Van Dyck stations the monarch on a small rise and paints branches of a tree overhead to resemble a royal canopy. The low horizon line and our point of view, which allow the King to look down on us, subtly increase his stature. The restful stance yet inaccessibility of Charles depends largely upon his pose, which is itself a work of art, derived from art, notably that of Rubens (Fig. 316). Its casualness is deceptive; seemingly at rest in an informal moment, the King is every inch the perfect gentle-

man and chief of state. The cane was a royal prerogative in European courts of the time, and its presence along with the sword symbolized the gentleman-king.

Royal esteem sometimes took the form of a monopoly on painting the ruler, like that granted to Titian by Charles V for his portraits. Peter Paul Rubens (1577–1640) even served as a royal ambassador; his life-style was aristocratic. Rubens was the greatest interpreter of Baroque rulers' expectations, for, with his broad education, he was able to synthesize pagan and Christian symbols for interpreting absolute monarchy and the divine right of kings. In 1635, for the triumphal entry of Archduke Ferdinand into Antwerp, Rubens directed a corps of artists in the decoration of the entire city. Earlier, Marie de' Medici had commissioned Rubens to execute a great cycle of paintings dealing with her life as Queen of France and celebrating the reign of her late husband. In *Henry IV Receiving the Portrait of Marie de' Medici* (Fig. 316), Rubens mingled fact and fancy. Royal custom called for an important artist to portray the bride-to-be for the groom, who may never have seen her. Here, in double flattery, Rubens depicted the King as enraptured by the *painting* of his betrothed. The allegorical figure of France shares the King's admiration. Two cupids, who have seized the royal armor, signify that, for love, the monarch has put aside thoughts of war, then being waged in Saxony— perhaps referred to in the burning· city in the distance. Above sit Jupiter and Juno with their attributes, the eagle and the peacock, an ironic approval in pagan heaven of this Catholic union. In one of the most inspired postures in state

portraiture, the King, attired in royal armor and bearing the courtly gentleman's cane, gracefully turns so that we see him in full length while the royal profile is directed toward the smiling visage of Marie. Even in the 17th century, such conceptions demanded willing suspension of disbelief.

The deification of Louis XIV was a full-time project for the army of artists, musicians, writers, and poets gathered at the great court of Versailles in the 17th century. Among this brilliant coterie was the sculptor Gianlorenzo Bernini (1598–1680), who in 1665 carved the magificent bust of King Louis XIV (Fig. 317) in Louis' bedroom at Versailles.

In his memoirs, Louis set down his views of the ideal Christian king:

> As he is of rank superior to all other men, he sees things more perfectly than they do, and he ought to trust rather to the inner light than to information which reaches him from outside. . . . Occupying, so to speak, the place of God, we seem to be sharers of His knowledge as well as of His authority.

The ideals of kingship carved by Bernini accorded perfectly with those of Louis. Verocchio had organized the bust of Lorenzo de' Medici (Fig. 311) geometrically and made it rest solidly on a broad base, with the subject's eyes turned down. Bernini's King seems airborne above a sweep of drapery swirling about a narrow base, the head turned unabashedly in a three-quarter view, its far-off expression suggesting response to some "inner light." The wig billows about the serene countenance, while the gleaming marble recalls that Louis was the Sun King.

The Ruler as Art Collector

By the 17th century, all over Europe a ruler's intellectual sustenance had become his art collection and library. Since the 15th century, great collections increasingly reflected the pride, prestige, strength, and magnificence of their royal owners and signified to their heirs the continuity of the dynasty. After 1600, to favor hunting and gorging over collecting art was deemed unworthy of royalty. To a ruler's virtues were added taste in art, and it became the fashion for the prince to patronize the arts and learning, to maintain great libraries and art galleries. As defenders of the Protestant and Catholic churches, these rulers collected religious as well as secular art. Competition between collectors who were ministers, dukes, princes, and emperors not only fueled international art commerce, but in fact led to wars by which a rival sought to absorb the artistic sustenance of the opponent. In 1648, Queen Christina of Sweden sent her army against Emperor Rudolf II at Prague, admonishing her general to "take good care to send me the library and works of art that are there: for you know that they are the only things for which I care." No question that royal acquisitiveness

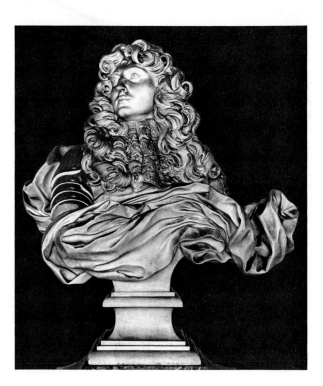

317. Gianlorenzo Bernini. *Louis XIV.* 1665.
Marble, height 31¼″ (79 cm).
Palace of Versailles.

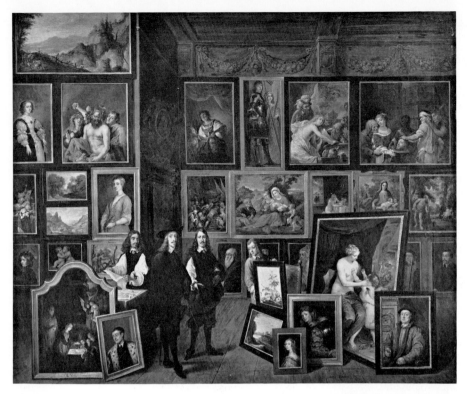

318. David Teniers the Younger.
*Archduke Leopold William
Inspecting Pictures
in His Gallery in Brussels.*
1651–56. Oil on panel,
27½ × 33⅞'' (70 × 86 cm).
Kunsthistorisches Museum, Vienna.

caused many to die for art. Christina's loot from that war matched the earlier cannibalizing of the great Palatine Library belonging to a Protestant prince in Heidelberg by German allies of the Pope, who wanted to see the heretic punished and the Vatican library enriched. His own mania for collecting left Charles I of England short of funds to send a relief army to help the Protestants at La Rochelle, where they were besieged by Cardinal Richelieu, who in turn plundered the city's library. When Charles I was beheaded, much of his great collection was bought by other rulers, but what remained, as well as what was dispersed, eventually went into national museums of England and France. Not until the late 18th and 19th century did people begin to see these royal collections as their national patrimony. European, and ultimately American, art museums benefited from the plunder of the arts in the 17th century. David Teniers II's painting of the Habsburg governor of Flanders, the *Archduke Leopold William Inspecting Pictures* (Fig. 318), gives an idea of what these 17th-century art galleries looked like and how a ruler wished to project his fame by means of art about art. We can also understand why so much art was destroyed in revolutions: it had become the tangible symbol of hated political systems.

Napoleon and Hitler Napoleon was the last of the great rulers of Europe to employ the most important artists of his time. At Napoleon's request, the French artist Jacques Louis David (1748–1825) showed the general leading his troops on a historic march across the Alps in 1800 (Fig. 319). This constitutes the last of the great imperial equestrian paintings, although Napoleon was actually in the office of First

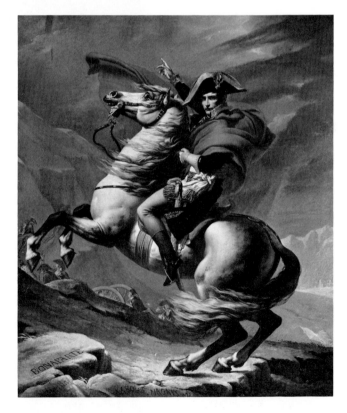

319. Jacques Louis David.
Napoleon Crossing the Alps. 1800. Oil on canvas,
8'10'' × 7'7'' (2.69 × 2.31 m).
Palace of Versailles.

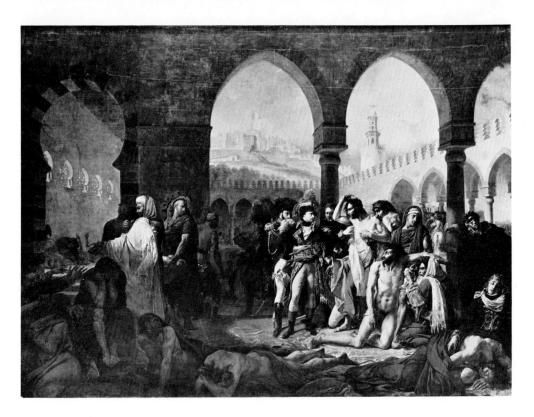

320. Antoine-Jean Gros.
Napoleon Visiting the Pest House at Jaffa.
1804. Oil on canvas,
17′5″ × 23′7″ (5.31 × 7.19 m). Louvre, Paris.

Consul when David painted him. Following the orders of his subject, David showed Napoleon expertly mounted on a wildly rearing horse and pointing upward, as if to the mountain peaks or to Heaven. In reality, it was not this romantic, commanding gesture that inspired forty thousand men to traverse the mountains; rather the feat was accomplished by great staff work and five days of soldierly fortitude. Napoleon posed only briefly for the rendering of his face, telling David that close resemblance was not important: "It is not the exact reflection of features, warts on the nose, that makes a likeness; it's the character and what animates the physiognomy, that needs to be painted. No one inquires if the portraits of great men are likenesses. It's enough that their genius lives in them." By showing the advancing army in the middle ground, seen from under the belly of the horse, David was following tradition and rational perspective, but Napoleon was displeased that his men were shown so small, as if they could be crushed by the horse's hoofs. The painting, with its obviously staged quality, is indeed contradictory to fact, for Napoleon crossed the Alps on an ass, an animal better suited to the terrain. As stand-in for the subject, one of David's students posed atop a ladder, pointing his arm till it dropped. Separate studies were made of Napoleon's white charger, which was shown rearing in the manner of 17th-century equestrian portraits. Despite such contrivances, David was sufficiently inspired to make the painting genuinely impressive. A dark foreground, spot-

lighting, and the pearly gray of the mountain setting and turbulent sky throw the striking figure of Napoleon into dramatic relief. Reviving an ancient symbol of victory, David has the wind at Napoleon's back, and the agitation it creates makes the face seem the serene center of a storm. The statement was that, like Hannibal and Charlemagne, with whose names *Bonaparte* is inscribed on the foreground rock, the soon-to-be Emperor would lead his country to new heights of glory.

Not a hereditary monarch like Charles V and Henry IV, Napoleon used art to help legitimize his claims to power and, in one spectacular instance, to counteract a catastrophe that set his Egyptian army violently against him and threatened his support in France. After the fall of Jaffa, Napoleon's generals violated the terms of surrender and slaughtered the entire garrison. Shortly afterward, bubonic plague nearly decimated Napoleon's army, a tragedy that to many seemed divine retribution. At great personal risk, Napoleon visited his suffering men at the hospital in Jaffa. Though not an eyewitness, Baron Antoine-Jean Gros (1771–1835), at Napoleon's order, utilized written accounts to produce a painting that is a fine example of counterdefamation propaganda (Fig. 320). Shown in the midst of the plague-stricken, Napoleon calmly extends his ungloved hand to touch the bubonic boil in the armpit of a soldier. This gesture derives not from history but from art history, from scenes of Christ and the saints healing the sick and of the king, in 17th-century imperial tradition, touching to effect cures. But no royal image ever made the public so aware of death, which is exhibited in gangrenous bodies at the base of the painting at the viewer's eye level. While he accurately

portrayed the terrible casualties of the Egyptain campaign, Baron Gros also transformed Napoleon into a savior-king. In actuality, Napoleon, when forced to retreat from Acre and Jaffa, ordered poison placed by the wounded to enable them to take their own lives.

Knowing the historic effectiveness of art in political propaganda, Adolf Hitler banned certain art and used compliant, technically proficient mediocrities to revive state portraiture. A formal portrait of Hitler (Fig. 321) inspired the critic Harold Rosenberg to refer to him as an "apocalyptic chauffeur." The placement of the Führer's figure above the viewer's eye level enhances a modest physical stature. Other heroicizing devices are the uniform and the gigantic sculpture of a powerful youth holding an eagle, the latter recalling the hawk god of pharaonic imagery (Fig. 294) and rulers portrayed with deities (Fig. 295). The building instruments and blocks strewn over the foreground refer to the New Order's achievements in construction and to Hitler's obsessive self-image as an architect. The stadium, seen on the horizon, was the incubator of Nazi youth, whom Hitler served as spiritual father. With his upward gaze and three-quarter view, Hitler posed as the visionary contemplating the future. Total frontality would have brought portraiture full circle to pharaonic forms. As in older state portraiture, the painter conveyed the abstract ideas of the regime rather than the personality or mood of his subject. It is skilled propaganda in support of the Hitlerian legend of invincible strength and immortality, admitting neither compromise, humility, nor compassion.

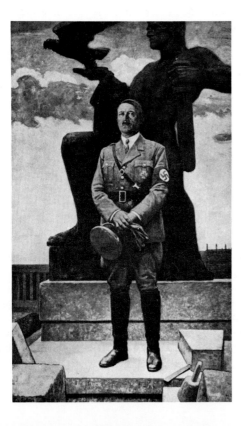

321. Ehrler. *Der Führer.* 1939.
Oil on canvas. Whereabouts unknown.

Personalizing the Presidency

Before this century, the artist's sole purpose was to portray *the office in the man.* The formal state portrait continues, but Elaine de Kooning's vital portrait of John F. Kennedy (Fig. 322) indicates the modern artist may show *the man in the office.* From years of portraying friends, de Kooning had developed a style based on quick execution in a single session, "to get close to the essential gesture of the sitter." Though executed in a few hours, her portrait was built on numerous drawings made from Kennedy's television appearances. "I had to contend with the 'world image' created by the endless newspaper photographs." Her style accommodated the restless, energetic, and informal character of the late President. Where Clouet saw the state in Francis I, Elaine de Kooning saw that:

> He was not the grey, sculptural newspaper image. He was incandescent, golden. And bigger than life, . . . not revealed by the newspaper image were his incredible eyes with large violet irises half-veiled by the jutting bone beneath the eyebrows. . . . I was struck by the curious faceted structure of light over his face and hair—a quality of transparent ruddiness. This play of light contributed to the extraordinary variety of expressions. His smile and frown both seem to be built into the bone. Everyone is familiar with the quick sense of humor revealed in the corners of his mouth and the laugh lines around the eyes, but what impressed me the most was his compassion.

By contrast, Robert Rauschenberg (b. 1925) accepted President Kennedy's popularized image and adapted newspaper photographs to his own complex, personal imagery (Fig. 323). Rauschenberg's eccentric placement of the presidential photo within the composition disregards the world of rank, and its juxtaposition with other photographs neither conjures the attributes of the assassinated chief of state nor attempts to synopsize the Kennedy years. By the 1960s, the image of authority had become susceptible to an artist's playful memory, nostalgia, taste for surprise, and wit; thus *Buffalo II* is an autobiographical assemblage of motifs culled from the artist's studio and from his urban environment. His repertoire of press images permitted an idiosyncratic and unprogrammed conjuction of past and present, common and rare, art and life. Titian's *Venus* is discernible, on its side and reflected in a mirror. (Whether this is an allusion to Kennedy's private life is unknown.) Near the President's head appears a photograph of the American eagle, possibly a pun on the Egyptian hawk god Horus (Fig. 294), even though the dotted line leading from the eagle discourages the allusion. The enlarged hand, photographed during a presidential conference, draws attention to a small bird. The "key" to the work offered by Rauschenberg is the photo of an ignition key silk-screened onto the canvas. In *Buffalo II,* the artist's private meditations fuse the ruler's

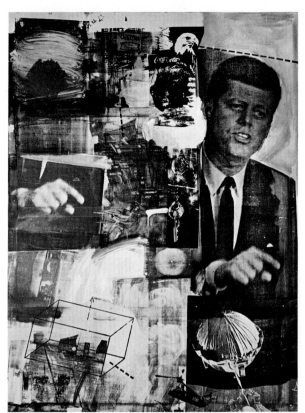

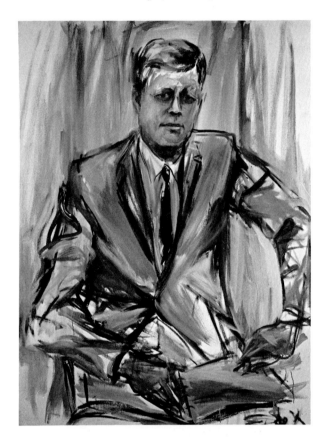

image with art and nonart. The photograph, esteemed by
the public as arbiter of what is true, real, and vivid, is para-
doxically dimmed or made ambiguous by cropping, en-
largement, and superimposition, and then ironically con-
trasted with the tangible evidence of the artist's energetic
presence left by his brush in the upper left. In Rauschen-
berg's view, it is the artist, not the ruler, who today fashions
our vision of the world.

The Persistence of Ritual and Role-Playing Why are
older images of rulers important today? Apart from their
artistic value and their function in expanding our under-
standing of concepts of authority in past cultures, they re-
mind us of art's potency and the persistence of certain ritu-
als and roleplaying by world leaders in our time. Whenever
a government is overthrown, the media show us demonstra-
tors pulling down or decapitating a statue or burning por-
traits of the ousted leader—acts that are a substitute for
tyrannicide. That these images are destroyed with such vio-

lence and enthusiasm reminds us that art is still capable of
strong political investment.

The rituals in which modern leaders participate have a
long history in art. Teddy Roosevelt loved to pose after the
hunt, flanked by gun bearers, one foot on his fallen prey.
The modern military uniform has replaced the cuirass or
armor of the *Prima Porta,* but military leaders still exhort
citizens and soldiers with outstretched arm. In Catholic
countries, military leaders, like the late Francisco Franco,
still enact the ancient ritual of receiving the Eucharist from
a priest, as did Abraham from Melchizadek. A Bible is used
at the swearing-in or investiture of our presidents, as it was
at the coronation of emperors. Like Joshua during the battle
with the Amalekites, our newly nominated presidential can-
didates stand in triumph with unpraised arms before the
assembled convention. When a hero or political figure is
given the key to the city and rides standing in a tickertape
parade, we recall the Roman advent ceremonies. When our
President speaks in public beneath or behind the symbol of
his office, the great seal with its American eagle, there are
echoes of Khafre. When President Carter is photographed
taking his family to church, we are reminded of Augustus
taking his family to the temple as a model for the Roman
Republic. Napoleon was not the last ruler to visit the sick in
a hospital and provide therapy by touching. For those who
saw it, who can forget the photograph of Lyndon Johnson
baring the scar of his operation to the doubting Thomases
of the American press? As the French say, the more things
change, the more they remain the same.

Chapter 13

The Architecture of Authority

Throughout history architecture has given tangible form to humanity's secular hopes for good government, whether or not this was achieved by consent of the governed. When we learn the languages of architecture (they have changed, like those we speak) and understand how meaning is conveyed, we find it possible both to bring past architecture to life mentally and to be more critical of what is being erected in our own time and place. *How* architecture means, rather than *what* it has to say, depends upon many elements. Some meanings come from historical usage, such as the column, dome, and pediment, but others are rooted in less verifiable, more subjective, or more intuitive experiences of our own. A building's *site,* its physical location, can affect us by whether it is on high or level ground, is solitary, peripheral, or central in a community. The building's design may ignore the terrain—turn its back on nature, so to speak—or take advantage of it and seem to rise from the earth. These things may tell us something about how the architect viewed the place of the indweller in the scheme of things. How a building is *oriented* in relation to the compass, prevailing winds, sunrise and sunset, or the stars can tell us about the ruler's attitude toward physical comfort and relation to nature and the universe. Whether the approach is casual or controlled, long or short, straight or curved can set mood long before one enters the building. *Plans* can be formal or informal, dictated by ceremony or geometry, or both; they can have long or short axes, or both; they can show compartmentalized or fluid spaces, static or flexible use—how a court or family lives and enter-

tains. The *size* and *proportions* of a building can make us feel intimidated or welcome. Involuntarily, we measure ourselves against the building's height and width. The more powerful and autocratic the ruler, the more that ruler's building seems to take our measure.

Whether the building's *materials* are durable or ephemeral, rare or common, finely or crudely crafted—all in relation to other structures in the area—conditions our degree of respect for it. The *elevation* of a building can dramatize the formality or informality of its owner and reveal the building's architectural peers and ancestors. Buildings, like people, can be introverted, extroverted, or a mixture of both. Façades are like faces: they can be expressive or deadpan, joyful or solemn, aggressive or friendly. Like painters in certain periods, architects have often assigned hierarchical value to top and bottom, and center, right, and left, whether designing a wall or a whole structure. Symmetry and focus on a central element such as a doorway, which stands out from the flanks, has historically signaled formality. If we have to mount a flight of steps to enter, it is equivalent to the experience of looking at a statue on a pedestal; both are intended to make us feel humble. In the past, architectural, hence royal, dignity was often incurred at the expense of the visitor's self-respect.

Since the Egyptians, columns have signified privileged ownership. From the time of the Greeks, pediments were the prerogative of the elite. The Romans popularized the dome of heaven. The presence, absence, location, number, and size of windows evoke the owner's status in some peri-

ods, and in others, a desire for privacy or openness. The secularization and democratization of these elements today can be seen in their indiscriminate use. Roof lines, like crowns, helmets, or derby hats on people, can give status as well as expression to a structure. How a building meets the sky has always concerned architects. Whether or not a building's exterior prepares us for what is inside in terms of size, arrangement, and possible contrasts or richness or plainness can be very meaningful. Once within a building, we are moved not just by sight, but by smell and sound, as when we hear our footsteps on a marble floor. Good architects treat a structure for a ruler as theater, and they stage not only their patrons' appearance, but how visitors progress to the audience chamber. The character of a room rests not just in its furnishings, but in its proportions and lighting, as well as its size. Interior stairways are a culture unto themselves and tell us much more than how to get from one level to the next. They can be businesslike or designed for leisurely ascent and descent, affording us the chance to see and be seen as on a stage. Finally, the relative care with which details have been carried out or ignored reflects on the art and craft-consciousness of the patron.

Ancient Gateways

In their formal relations with the public, ancient rulers used specially designed architecture as a backdrop for ceremony. But even without such public rituals, the architecture—by its symbolic associations, grandeur, durability, and distinction from the homes of commoners—was, in a sense, a substitute for rulers, a constant reminder of their power whether they were at home or abroad. Ancient coins usually bore the king's image, and often there was also a simple rendering of the entrance to his palace—which was all most people would know of the royal residence.

Ancient Egypt and Mesopotamia cradled much of human civilization and evolved important architectural symbols, notably the imposing gateway to a city or to a palace-temple complex. The great *pylons,* or gateways, to Egyptian temples such as that of Ramses III at Medinet Abu also served to front the palace when it adjoined the sacred precinct (Fig. 324). Upon the huge walls of the pylons, the pharaohs had carved and painted records of their victories and descent from the gods, in whose company they were often shown. Set into rectangular recesses on the face of the pylons were flagstaffs from which flew pennants signifying the god or pharaoh in residence (Fig. 325). The pylon form consists of a central zone for the great doorway, possibly surmounted by a solar disk; both disk and doors were originally covered in lustrous metal. Completed by two taller flanking sections, the pylon ideologically represented the gateway to Heaven, with its hieroglyph denoting the sun setting between two mountains. In all probability, this tripartite division derived its form from that of Mesopotamian fortified gateways (Fig. 326). The great scale of the pylons was intended to overwhelm those who approached them frontally, along a prescribed path that was often flanked by guardian sphinxes. The massiveness of these gateways is explained in the declaration of a pharaoh who announced to his god that he had built him an august house that would endure for a million years. The act of passing through the gate was a symbolic one, for within lay the Egyptian equivalent of Paradise. Although the palaces have been destroyed,

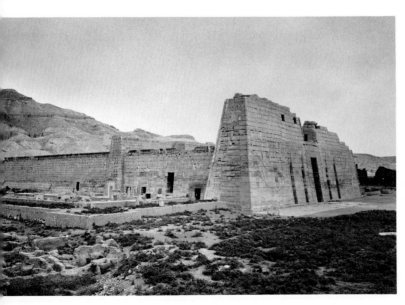

left: 324. Funerary temple of King Ramses III, Medinet Abu (Thebes). 20th Dynasty, 1198–1167 B.C.

above: 325. Drawing of a pylon from the Temple of Khons, Karnak.

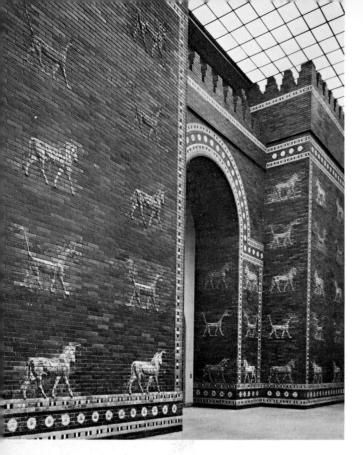

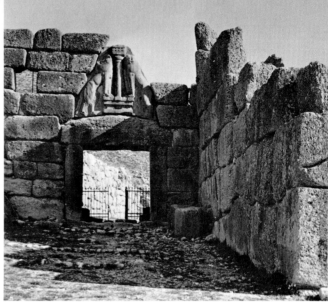

left: 326. The Ishtar Gate of Nebuchadnezzar II,
from the Processional Way, Babylon (modern Iraq).
c. 575 B.C. Reconstructed by Koldewey. Staatliche Museen,
East Berlin.

above: 327. The Lion Gate, entrance to the citadel, Mycenae.
c. 1250 B.C.

it is known that when they adjoined the temples (at right angles to the forecourt and central axis), provision was made for the pharaoh to appear on a balcony or at a window (the *window of appearances*), from which he could look down on his subjects and on the ceremonies in the first open court behind the pylon.

The prevalent mud-brick architecture of Mesopotamia has not survived to as great an extent as the stone structures of Egypt, but the shape and meaning of its great symbolic gateways are known, and one can see the famous Ishtar Gate of Babylon through an archaeological reconstruction (Fig. 326). The simple tripartite design consists of two flanking square towers with an arched portal between. Crenellated battlements for defensive purposes crowned the gateway. The arch was a symbol of Heaven, simulating its apparent curvature; the blue decoration enhanced the comparison. The king would often appear enthroned under the arch of the gateway to his palace or the city and there hold public audience or administer justice. The animals modeled in ceramic tile distributed over the wall surfaces of the Ishtar Gate are spirit guardians, and the king's epiphany to his people was thus staged with tangible evidence of his support by the gods. The persistence of this type of tripartite, arcuate portal can be seen in various examples in this chapter, for not only the Egyptians but the Romans and medieval lords as well found it ideal both for practical defense and for its long-standing associations of kingship (see also Figs. 109, 110).

When Agamemnon marched off to rescue Helen, thus beginning the Trojan War, he passed through the Lion Gate of his citadel Mycenae (Fig. 327), which dates probably from the mid-13th century B.C. The gate is so named because of the heraldic lions carved in relief above the actual opening. The utilization of sculpture and symbolic figures to heighten the appearance and significance of an important entrance had analogies in the Assyrian human-headed winged bulls who guarded royal palace entries. The device of the lions flanking a single column is interpreted as an emblem of the royal house of Mycenae, for the ruler lived in the only structure fronted by columns. The column of the relief rests upon an altar, intended to signify the closeness of the royal house to the city's goddess and the descent of the royal family from Zeus. The association of the house of the ruler with columns has persisted down to the 20th century, and rulers have often had a column included in their portraits. It was the Greeks who first erected isolated columns as victory symbols. While the column may not have had specific symbolism in a building context, early in its history it came to indicate a special place—the royal house—of king or god, and this continuing association was more important than aesthetic considerations of design.

As Rome won dominion over the ancient world and gradually absorbed the cultures of conquered peoples, her emperors adapted the architectural symbols of their enemies to satisfy their lust for fame. The origin of the Roman triumphal arch was probably in certain Etruscan portals

used for temporary displays and as a backdrop for ceremonies celebrating a triumph. As reminders of Roman rule, triumphal arches were built in conquered cities as well as in Rome itself (Fig. 328). Occasionally they were used as actual gateways to cities or forums and for ceremonies celebrating the advent or arrival of an emperor or distinguished person. Most of the great stone arches we know probably replaced wooden and painted arches hastily erected for a specific occasion. As permanent, gigantic billboards, they propagandized the military triumphs or foreign and domestic policies of a ruler. Like sculptural monuments that carried inscriptions on their pedestals attesting to the hero's virtue, triumphal arches bore dedicatory inscriptions of gilded bronze in their upper or attic story, which on a sunny day flashed to all the identity and achievements of the *triumphator.* Many of these arches originally were surmounted by gilded bronze sculptures, such as a horse-drawn chariot bearing the ruler and personifications of victory and of the defeated. By the 3rd and 4th centuries, whether single, double, or triple arched, as in the case of the *Arch of Constantine,* these structures had evolved elaborate architectural and sculptural decoration. Those that survived exerted a considerable influence on the histories of architecture and sculpture down to this century, as New Yorkers who live near the Washington Arch would be able to testify.

Roman Civic Structures

The Arena The single monument that best commemorates the Imperial, and uncivil, playground is the Colosseum (Figs. 329, 330), built between A.D. 70 and 80 by Vespasian and his son Titus on the site of an artificial lake on Nero's palatial estate. The Colosseum was inaugurated in A.D. 80 with the killing of five thousand animals in the arena. Within the three succeeding centuries, this imposing figure paled beside the expenditure of five thousand pairs of gladiators and eleven thousand animals in one day or in comparison with the bill of $2,500,000 for gladiators paid by Marcus Aurelius for a single series of games. The martyrdom of Christians was, numerically, but a minor item on the arena's bill of fare.

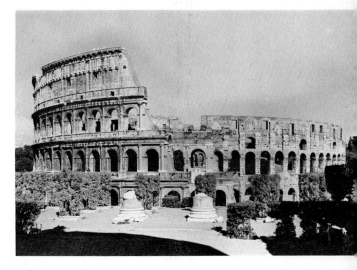

below left: 328. The Arch of Constantine, Rome. A.D. 315.

above: 329. The Colosseum, Rome. A.D. 70–80.

below: 330. The Colosseum, aerial view.

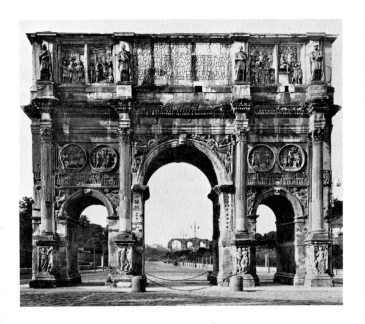

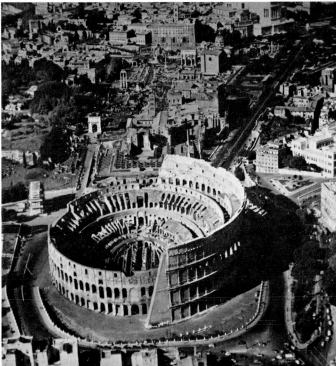

While many of the architectural forms and principles used by the Romans had been known earlier, no previous culture had brought so many ideas and techniques together on such a grandiose scale. Whereas previously the finest styles and most perfect buildings had been reserved for gods and rulers, the Romans also made fine architecture available for public use and Imperial propaganda. The development of the arch, buttress, barrel and groin vaults, and the masonry and concrete dome were Roman contributions utilized for the needs of the living populace, but they also constituted symbols of Imperial benefaction.

The Colosseum rises in several tiers above the ground, covering 6 acres (2.2 hectares) and forming an open-air oval amphitheater with diameters of 615 feet (184.5 meters) and 510 feet (153 meters); the arena itself is 281 by 177 feet (84.3 by 53.1 meters). It probably accommodated fifty thousand spectators. The partially ruined exterior shows its three tiers of arcades, the upper two of which were decorated with sculpture. Above the arcades was a wall punctuated by windows, shields, and supports for the ship's masts to which the ropes for the canvas awning shading the spectators were fastened. Sailors manned catwalks to manipulate the awning, which was at times painted like a billboard of political propaganda. On the exterior, the 160-foot (48-meter) wall gained a muscular and rhythmic emphasis from the columns engaged to the piers of the arcades. Travertine marble attached with metal clamps covered the outer wall. At ground level, 80 archways gave access to the arena. The exterior had a handsome masculine simplicity in the clarity, vigor, and starkly expressive design of its serial openings and horizontal courses.

The open arena was supported on a great brick, stone, and concrete skeleton of piers, arches, vaults, and corri-dors. This network permitted quick entrance and exit of the masses, whose tickets—like those sold by a modern stadium—showed them their entrance arch and seat designation. The concentric, continuous vaulted galleries on the second and third levels permitted shaded strolling during intermissions. Beneath the arena, with its floor of sand (often covered by wooden boards), was a network of rooms, cages, ramps, and elevators run by counterweights and pulleys that brought the beasts directly onto the field. Elaborate sewers served not only for the disposal of blood and waste but also for draining water when the arena had been flooded for mock naval battles. The natural springs that had fed Nero's lake serviced the Colosseum. On a given day, the arena might in the morning contain a miniature fleet in combat and in the afternoon hold artificial mountains and forests through which animals and hunters would stalk each other. The ingenuity, energy, and ambition of the Colosseum stage managers became increasingly taxed and perverted as the centuries went by and the public demanded new and bigger thrills from their rulers.

Imperial Baths The Colosseum and its slaughterhouse function for purposes of public diversion are not the sole keys to understanding Imperial architecture and Roman society. No other government provided its people with such

below: 331. Plan of the Baths of Caracalla, Rome. A.D. 211.

right: 332. Baths of Caracalla (reconstruction).

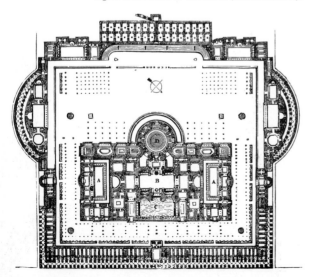

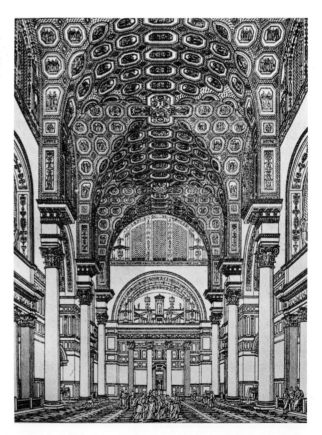

extensive, practical, and handsome architectural facilities for enjoying life. The Roman Imperial bathing establishments, or *thermae,* provided healthier recreation than the Colosseum. While Rome had hundreds of small public baths, there were eventually nine major thermae, which could serve several thousand people at a time. Roman concern with personal hygiene goes back to the city's earliest history. By the time Emperor Caracalla built his enormous bath, there was a long tradition whereby all Romans set aside at least the late afternoon to go to the thermae, there to tend both body and mind. The Imperial baths were, in truth, miniature cities. All are presently in ruins, but those of Caracalla, built in A.D. 211 and appreciably restored in modern times, are typical.

The Baths of Caracalla (Figs. 331, 332) were built upon a great walled platform, which was 1,080 feet (324 meters) on each side and covered 270,000 square feet (81,000 square meters). Outside the thermal complex were shops. Underground were furnaces for heating water and steam to warm the gigantic rooms, great *hypocausts* or ducts, and service corridors large enough for horse-drawn vehicles to pass through. Within the walled area were colonnades, gardens, fountains, sculpture, lecture halls, and libraries (in the east and west semicircular segments of the plan), as well as athletic fields and the great central complex of bathing halls, dressing rooms, and grand concourse. For the first time in antiquity, sports and bathing practices were brought together, permitting both athletic exercise and cleansing of the body in the same place. The cultural facilities permitted audition of new plays and of speeches, examination of art objects, and reading. Juvenal's prayer for "a healthy mind in a healthy body" could thus be realized. Further, the baths were ideal for socializing and the exchange of news and of political views. Personal reputations and politics were, needless to say, both in jeopardy at times of mixed bathing in the nude.

A bathing ritual began with skin-scraping and a "dry bath" of steam; then followed immersion in a domed hot pool *(caldarium)* to the south, passage to the central concourse *(tepidarium)* for cooling off and conversation, and finally a dip into the cold pool in a chamber *(frigidarium)* open to the air on the north side of the complex. The warm central hall contained an estimated 1,600 people at one time. No previous society had provided such extensive *indoor* facilities for civic enjoyment.

This conquest, or creation, of vast internal space was made possible by engineering. Enormous brick and concrete vaults were raised upon huge buttressed piers. The *groin vault,* the intersection at right angles of two barrel vaults of equal diameter, permitted support of the structural load on four piers and in turn freed great wall areas for fenestration. The Romans were masters not only of large-scale spatial organization but also of the use of lighting. This light fell, moreover, not upon rude concrete but on marble and mosaic floors and pools, polychromed marble

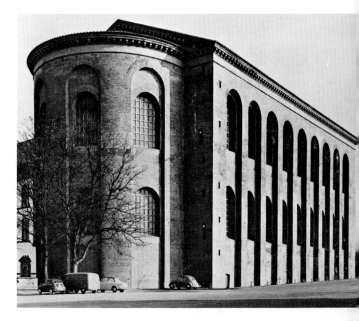

333. Roman basilica, Trier, W. Germany.
A.D. c. 300.

walls, and gilded stucco and coffered ceilings. Exteriors were often stuccoed and painted to simulate marble, for the Romans lavished their art and costlier materials on the interior. Within the baths, Romans found delight and grandeur for the eye, endless gossip for the ear, culture for the mind, and the means of making fit or pampering the body. At the Baths of Caracalla, they could, in addition, satisfy the needs of the soul, for included in the basement was a shrine to the god Mithras.

The emperors built and supported admission to the baths to keep the political allegiance of the public, but it is the formal design and organization of the environment created by these buildings that put the Imperial stamp on the baths as well as on all great Roman public monuments. The shaping and control of a vast impersonal interior space and its vistas, the precise ordering of the sequence of rooms according to function and scale, with the whole garbed in the costliest materials, compose as much an image of Imperial authority as the emperor's own effigy.

The Basilica The most influential Roman Imperial structure for the history of architecture was the *basilica,* or public assembly hall. One of the oldest surviving examples, though much restored, is the basilica at Trier (Fig. 333), here shown from its eastern end. Its layout, with a long central hall terminating in an apse and often with flanking aisles, was a decisive influence on the form of the Early Christian basilica and, ultimately, on the Gothic cathedral (Figs. 114, 115). While Roman basilicas varied, they were generally rectangular and had either double-pitched wooden roofs or masonry barrel and groin vaults, as in the

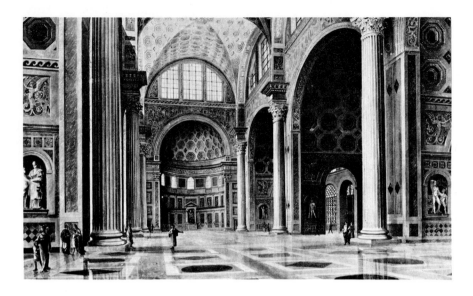

great Basilica of Constantine (Fig. 334). Basilicas served the military as drill halls, were found as separate chambers in the Imperial baths, saw use as stock exchanges, and were host to the administration of justice. What imparted an aura of royalty and divinity to the basilica was the law by which the effigy of a god or, more usually, of the emperor had to be enshrined within its apse. When the Christians adapted the basic plan of the basilica to their liturgy, they substituted the image of Christ for that of the emperor in the apse. Though most edifices of this kind have been destroyed, it is known that their interiors were often sumptuously decorated and also that some basilicas may have had small flanking towers or cupolas above the corners. The entrance

above: 334. Basilica of Constantine, Rome. A.D. 310–320. Reconstruction after G. Gatteschi.

below left: 335. Town hall and square, Bruges. Late 13th century. Belfry height 279′ (83.7 m).

below: 336. Palazzo Comunale, Siena. 1288–1309.

façade, which along with the occasional addition of an arcade on the parapet level would have related to palatial symbolism, indicated that the basilica was the seat of royal power. The Early Christian bishops took over the contrasting plain brick exteriors and luminous colorful interiors as fitting symbols of the house of the Lord. Ancient visions of the Heavenly Jerusalem were conditioned by the most sumptuous of earthly structures, one of which was certainly the basilica.

City Halls During the Middle Ages, not only towns but also the homes of the wealthy and seats of municipal government came to be fortified. More important than castles to the history of later palace design was the architectural development of the town hall in European cities that won political independence. In Bruges, the present-day town hall (Fig. 335) was originally a clothmakers' guild hall as well as a seat of government. The 279-foot (83.7-meter) tower, which contains a belfry and clock, rivaled that of the local cathedral in height, articulation, and expense. Such communal halls served as watchtowers and signaled travelers on the roads that they were coming to a free city. In the absence of a tradition of symbolic architectural designs for city halls, that of Bruges is an interesting mixture of castle and cathedral design elements, which articulate the building's great expanse without causing it to lose scale. Its symmetry and austere elegance make it still an ideal ceremonial backdrop. The expensive stone rebuilding of an originally wooden structure and the employment of skilled architects to interpret the pride and militancy of Bruges are among the most dramatic evidences of civic consciousness in urban history.

In Italy, communes that successfully achieved independence centralized government in a chief magistrate, or *podestà,* whose authority was signified by the town hall. The communes had to have meeting halls and occasionally living quarters for a podestà. The earliest Italian city halls had arcaded ground floors that served as covered market areas. By the end of the medieval period, these had been eliminated. In Florence, the Loggia dei Lanzi was early associated with the dispensation of justice. Medieval architects had to develop a form of building that was nonroyal and that fortified the town hall against rebellions of dissident political factions within the city itself. When communes such as Florence fell to tyrants like the Medici, these structures similarly protected the new ruler. The wealth of many Italian cities encouraged considerable private building, and from the Middle Ages on, ordinances governed the character of houses near the town halls. The halls themselves show the effects of this conscious, rational planning. The Palazzo Comunale of Siena (Fig. 336), with its soaring tower and impressive red-brick façade, dominates a huge fan-shaped square (where the famous horse races, or *Palio,* are still run). The embattled histories of cities such as Florence explain the fortified aspect of the building with its

stepped battlements. The blind arcade that runs below the third story of the two wings flanking the center may be a vestige of the Roman Imperial use of arcades to designate the seat of authority. Characteristically medieval are the pointed arches and predominance of tripartite windows in the upper stories. The entrance to the tower, which served practical as well as symbolic purposes, was enhanced by a portico containing sculpture. The numerous doors remind one of the frequent use made of these town halls in the daily life of the medieval citizenry.

By contrast with their medieval predecessors, modern public buildings housing civil authority can rarely be enjoyed for both their beauty and for the way they embody the particular character of governmental institutions in their overall design. More familiar in our republic are city halls and county, state, and federal buildings that mingle (or mangle) architectural motifs borrowed from the temples, churches, and palaces of ancient Rome and the Renaissance and Baroque periods. Most American governmental buildings are indistinguishable from the products of autocracy and the modern totalitarianism of the Soviet Union, Nazi Germany, and Fascist Italy. All these architectures are characterized by massive bleak walls of heavy masonry, squared and monotonously aligned windows, endless flights of steps, and grandiose cornices. Throughout American history, Democratic and Republican administrations have shared in the bad taste and addiction to architectural timidity and fiscal extravagance.

Boston City Hall The Boston City Hall (Fig. 337), completed in 1969 by the firm of Kallman, McKinnell & Knowles, resulted from the rare and spectacular example of

337. Kallman, McKinnell & Knowles. Boston City Hall, west façade and south side. 1968.

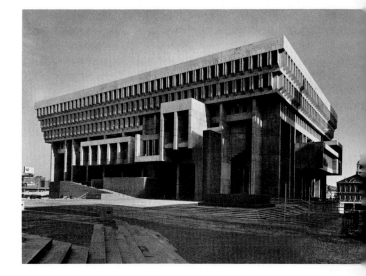

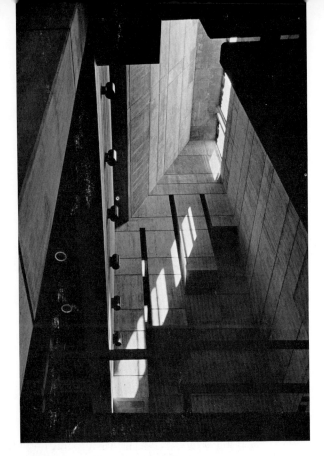

338. Boston City Hall, skylight shaft.

a municipal government, not previously known for its creativity, giving up the stifling claims of "consistency" and tradition, to which civic-planning groups have neurotically clung. By holding its big scale and not attempting to appear larger or smaller than it is, the structure is monumental. By reflecting in its design the interior governmental activities and by mirroring the governing process, it is meaningful. The designers have imaginatively tackled one of the most persistent problems of architecture—how to make the walls of a large building interesting rather than monotonous. Every side of the building is a surprise, because each façade has incorporated the spatial division behind it, without compromising power of shape and without creating illogical sequences or rhythmic discord. The three upper stories, which form a stepped, cornicelike crown, house the offices (the "rabbit warren"), while the meeting rooms of the city's administration are each signaled below. The fortresslike appearance is mitigated by the large entrances inviting visitors into the nine-story lobby, which is like a shopping center of civic services. The building is thus a rectangle around a hollow core, permitting varied and dramatic lighting throughout (Fig. 338) and avoiding the gloom and tedium so often associated with government office buildings. The structure was erected on a sloping site, which the architects accommodated by a daring mixture of materials. The brick plaza and foundation walls, apparent from the southeast, help to link the new complex with the historic red-brick structures nearby; the plaza presents a magnetic attraction for the crowds, who are drawn to the entrances. There are no concessions to conventional symbols of authority, such as columns and domes, and a ramp inside replaces the usually endless flights of stairs. And yet the building's materials and design give an impression of durable dignity and an appealing ruggedness and openness.

Renaissance Palaces

The Meaning and Role of Taste The history of palaces after the Middle Ages is a demonstration of the evolution of taste. Taste presupposes discrimination and judgment as to what is and is not acceptable; in art, it presumes a highly developed society that encourages competition between individuals and groups and a diversity of art forms. Much in the manner of portraiture, palaces are the result of taste exercised by ruling classes for the purpose of affirming their individual merit and their rank as a group. Under the leadership of rulers and influential families, absolute standards of taste have been established in various periods, so that in one country or city, such as Rome, palaces of different eras are markedly different in appearance. Structured by a class-conscious society, tastes are not of equal value, and historically, the socially dominant leisure classes have been the founders, arbiters, and guardians of taste. The rationale behind this phenomenon, as Meyer Schapiro has pointed out, is that, unlike the lower classes whose conduct is influenced by exterior compulsions, an upper class can act freely, from considerations of aesthetic pleasure alone. This process leads to good taste and to palaces that are incarnations of an upper-class taste extended to social as well as political conduct. To those who exercised it, taste was thought to have an evolving history, to progress and improve along with society. Ideas of tact, for example, could determine whether a 15th-century palace was to appear as a fortress or an elegant home, just as the role a monarch or aristocrat wished to play before society could determine the pose and setting he adopted for his portrait (see Chap. 12).

Palace Façades Many of the most beautiful walls in the history of architecture were those designed as palace façades. Particularly from the 15th century on, architects had the opportunity to give greater articulation to palace façades; and as palaces and castles gradually lost their function as fortresses in both the city and the countryside, even greater flexibility of design was possible. Since they no longer posed significant engineering challenges, palaces offered architects the best opportunity to display their talents as designers and decorators. Throughout the history of palace design, there recurs the imperative of announcing the dignity, power, and taste of its owner. For practical as well as symbolic reasons, the formal façades of palaces furnish little notion of what their interiors are like. In com-

parison with a cold, austere exterior, palace interiors might be lavish and brilliant in décor. The public face of aristocrats, according to the Renaissance code of courtiers, should not betray their inner feelings; and a cardinal rule of urban palace façades was to not betray the privacy of the inhabitants or their true natures. The architect had the problem of conforming to current social laws of the aristocracy, which meant achieving the right tone in terms of the amount of formality or sumptuousness; these considerations influenced the degree of freedom permitted to the designer. In practical terms, this conditioned the choice and finish of stone and other materials, the proportional relation of width to height and base to upper stories, the disposition of windows and doorways, the number of openings, the amount and kind of ornamentation, and the scale and character of horizontal dividing elements and the roof line.

How all these parts were interrelated and design focus achieved was a reflection both of taste and of changing symbols of status. To understand certain constant features of palace façade design, it is important to know that the ground floor was not used for entertaining or for living quarters by the owners but was reserved for servants, storage, and stables. Stairways came to be increasingly important after the 15th century, gradually becoming more than an inconspicuous means of moving between levels. The true first floor—what in the United States would be the second story—was the *piano nobile,* where receptions and entertaining were conducted. Its ceilings, which were often the highest in the palace, looked down on large salons and

banqueting halls. Sleeping quarters were usually on the third floor. During the Renaissance, many rulers had self-enclosed small private apartments within their large palaces. Physical comfort was placed second to the prestige inherent in large-scale, elegant structures, which were, for the most part, unheated and lacking such conveniences as plumbing. The conventional proportion of the palace was a greater width than height. Urban palaces like those of Florence and Rome frequently had inner courtyards surrounded by colonnaded loggias; in some instances, there was also a walled garden at the rear. This discussion is concentrated on exteriors because many old palaces underwent drastic changes in interior decor over centuries of continuous use.

The Ca'd'Oro and Palazzo Medici-Riccardi (Figs. 339, 340) were built at about the same time, but their designs mirror the radically different environments of Venice and Florence. The Venetian palace, called the *House of Gold* because of the gilded ornament lavished upon its interior by a French artist, has one of the most delicately beautiful screen arcades in all architecture. The canal-level arcade is broader and simpler than the arcades above, signifying its more prosaic function as a gondola landing from which

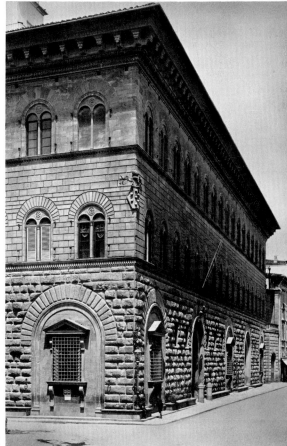

below: 339. Ca'd'Oro, Venice. 1422–40.

right: 340. Michelozzo. Palazzo Medici-Riccardi, Florence. Begun 1444.

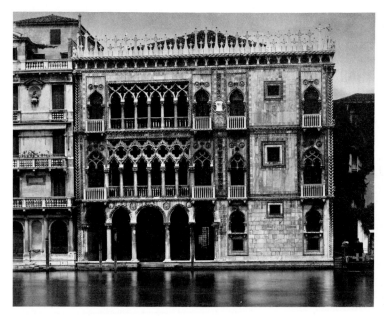

visitors quickly mounted stairways. The entire left half of the façade is dematerialized into a rich pattern of light and dark. Emphasis of the piano nobile is subtly achieved in the open clover-leaf arcade terminating the lower rhythmic sequences established in the railings and colonnades. The Near Eastern and medieval flavor of the Ca'd'Oro design reflects Venice's maritime contacts with Oriental lands and also its remoteness from the significant changes in architecture then evolving in Florence.

The Palazzo Medici-Riccardi, designed by Michelozzo (1396–1427), looks militant and solemn because of the heavy rusticated, or rough-hewn, stonework of the lower story and the barred windows. The turbulent history of the Medici in 15th-century Florence makes such precautions understandable. In keeping with the primarily social function of the piano nobile, the stonework changes at that level to a more finished variety. Double arcaded windows framed by a strong round arch punctuate the wall at regular intervals, maintaining the independence of that story by not aligning with the large windows of the street level. Round-arched windows were medieval carry-overs, and the palace still has a fortress look. Each horizontal level is distinctly marked by a *stringcourse,* or horizontal band between stories, whose slenderness and fine-scaled rhythm contrasts with the powerful overhanging cornice of the roof. The pon-

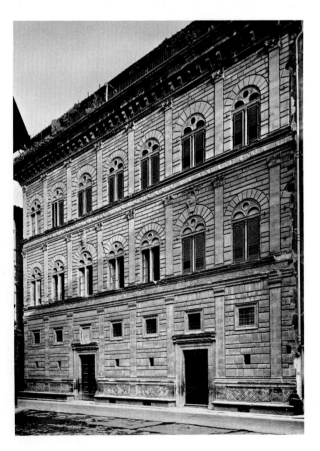

derous base, the clear delineation of the upper zones, which seem to grow progressively lighter, and the dramatic termination of the cornice and roof partake of the same style as Verrocchio's bust of Lorenzo de' Medici (Fig. 311). Both bust and palace have an aspect of solid impenetrability. The façade is quite flat, without embellishment of the doorway, accentuation of a main window, or vertical division into central body and side wings. The preponderant proportion of wall surface to openings assures a massive and compact effect.

If there was an analogy in architecture to the 15th-century secularization of painting, it was in the growing rivalry between churches and ambitious palace design. The architect most responsible for giving secular architecture an importance comparable to Renaissance church design was Leon Battista Alberti (c. 1404–72). His façade for the Palazzo Rucellai (Fig. 341) has a less martial and more Imperial Roman tone than Michelozzo's Palazzo Medici-Riccardi. It was the first Renaissance palace with repeated superimposed orders, like those of the Colosseum (Fig. 329). Alberti sought consciously to re-create the appearance of ancient Roman palaces, and this aim accounts for the finely cut and more or less uniform masonry, the flat vertically aligned pilasters dividing the whole façade into rhythmic rectangular bays, and the substantial cornice, which along with the horizontal stringcourses serves to balance the verticality of the aligned windows and pilasters. The arched windows, however, are still medieval in character. Alberti's ideal of harmony, and hence of beauty, rested on the proper mathematical proportioning of all parts of the structure in relation to other parts and to the whole. For Alberti, Classical beauty meant that nothing could be added or taken away from a perfect, ideally based design. The pronounced flatness and grid arrangement of the entire façade are derived from Alberti's interest in transposing an architectural idea into linear organization on a two-dimensional surface whose own logic could be independent of the building's actual structure. One of many architects without formal architectural training who practiced after the Middle Ages, Alberti was largely responsible for making the architect a wall decorator or arranger, rather than a builder involved with engineering problems and the discovery of new ways to enclose space. With rare exceptions, the great architectural engineers of the Middle Ages do not again have counterparts until the advent of the notable 19th- and 20th-century engineers. Though the right side of the façade remained unfinished, Alberti's design for the Palazzo Rucellai influenced later architects in terms of its fine balance of vertical and horizontal elements and its tendency toward a general harmony and uniformity, with some subtle distinctions in the two upper stories.

341. Leon Battista Alberti. Palazzo Rucellai, Florence. 1446–51.

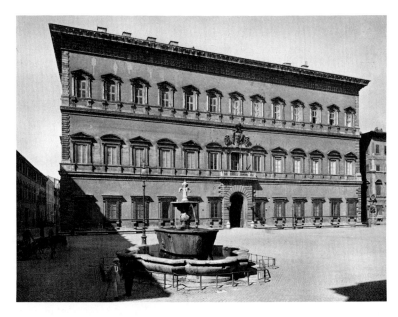

left: 342. Antonio da Sangallo and Michelangelo. Palazzo Farnese, Rome. 1530–89.

below: 343. Carlo Maderno and Gianlorenzo Bernini. Palazzo Barberini, Rome. Begun 1628.

The overall use of heavy stone became outmoded in Roman palace design of the 16th and 17th centuries and was reserved thereafter for country villas. The Palazzo Farnese (Fig. 342), designed largely by Antonio da Sangallo (1483–1546), with the top story facing the interior courtyard and various other details done by Michelangelo, reserves the use of stone for the corners, providing a new framing device for the façade and the main portal. The windows of the two upper stories are surrounded with elaborate tabernaclelike combinations of columns and pediments resting on brackets. Alternation of curved and triangular pediments helps to distinguish the piano nobile, and the tabernacle forms give greater sculptural projection and emphasis against the flat stucco walls. The main portal protrudes somewhat and is enhanced by the ornamented and balconied window directly above. At this window, the Farnese Pope would make his public appearances, not unlike the pharaohs in antiquity or even rulers of our own day; Mussolini, for example, continued this practice in his appearances from a balcony of the Palazzo Venezia in the center of Rome. Michelangelo's addition to the Sangallo façade incorporated into one expressive unit the earlier symbolic devices of the gateway, window of appearances, and coat of arms for the first time in palace architecture. The site was also modified to create a slight rise for the central doorway of the palace.

Although Sangallo and Michelangelo succeeded in making the façade of the Palazzo Farnese more expressive in terms of its strongly framed windows and powerful jutting cornice, the exterior wall was still basically a flat surface and the palace a block in general outlines. In the 17th century, more three-dimensional articulation of the exterior wall occurred with the development of recessive or project-

ing wings for urban palaces and villas. The Palazzo Barberini in Rome (Fig. 343), begun in 1628 by Carlo Maderno (1556–1629) and completed by Bernini, has a façade that is more openly symbolic of centralized power. This was appropriate to a family that gave so many important popes to the Church. Bernini's completed façade has qualities of dignified grandeur, lightness, and openness not seen before in palace design. His extensive use of glass partially accounts for this effect and also reflects the wealth and security enjoyed by its inhabitants. Each story has a distinctiveness, yet the overall design is unified through harmonious scale and proportion, as well as by a rigorous vertical alignment of the bays. The top-floor windows are recessed within their architectural frames, thus animating somewhat the inherent flat-

ness of the façade and also further emphasizing the piano nobile below. The piano nobile is made dominant by the greater size of its windows and its projecting balcony and also through the range of engaged columns flanking its arched windows.

The autocratic rule epitomized by the Barberini is echoed in the way in which windows and columns have lost their independence and are all subordinated to the total effect. The use of projecting wings and the narrow recessed portions flanking the middle section help to focus attention on the central balcony.

Palaces of Kings It was in the French Palace of Versailles that many of the traditional architectural symbols of authority were joined, refined, or elaborated upon. Versailles symbolized the complete centralization of power in one man, Louis XIV (Fig. 317). The palace, which was built on a malaria-infested swamp and cost the lives of thousands of men, became not only the residence of the royal court but also the seat for the entire administration of government. The main building of the palace, over 600 yards (540 meters) wide, was in itself a completely self-contained city. It contained living quarters, business offices, kitchens, banqueting halls, ballrooms, chambers of state, and even its own theater. In size and splendor, there was no other pal-

ace in France or elsewhere in Europe to rival it. For members of the French court or high government officials, not to be able to live at Versailles was tantamount to exile.

Aerial views of Versailles (Fig. 344) illustrate the symbolical relationship of the palace to its environment. On one side lay the city of Versailles, which had been built up as the palace grew. From that direction, great avenues slashed through the city and converged on the main parade ground before the palace. Just as in ancient times, all roads converged upon the capital of the world. The central road came from Paris and, like the palace, shared an axis with the Champs-Elysées and the Louvre, over 9 miles (5.4 kilo-

right: 344. Louis Le Vau and Jules Hardouin-Mansart. Palace of Versailles. 1669–85.

below: 345. Court of Honor, Versailles.

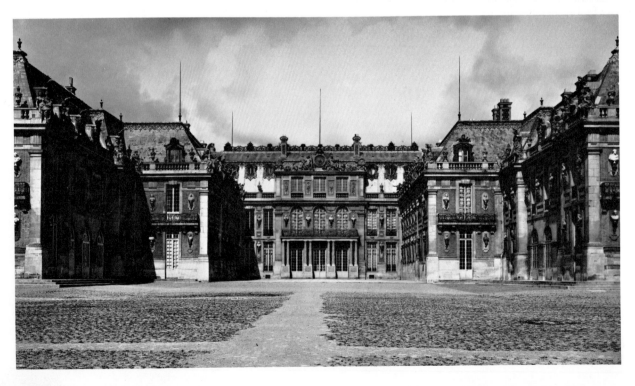

meters) away. The geometry of long straight avenues connecting broad squares and royal buildings was a Baroque authoritarian symbol.

The public side of the palace faced the town and the people, the source of the King's finances and manpower. The funnel shape of the city plan reflects this relationship. The rear façade of the palace was addressed to many square miles of private gardens, an area of private pleasure reserved for the King and his court. Here, Louis' rule over nature was made patent by the rigid but beautiful geometry of the gardens, planted according to the plans of André Le Nôtre (1613–1700). The palace, which significantly stood on the highest ground, was thus the fulcrum between two worlds, the public and private, the focus of humanity and nature.

The approach to the palace was through the traditional Court of Honor (Fig. 345). This gigantic court was recessed toward the center of the palace in a series of stages. Moving toward the main entrance, a visiting ambassador did not enter a fortified, blocklike castle, but was gradually embraced by long elegant palace wings that reached out like hospitable arms to draw him in. In the innermost courtyard, marble busts of Roman emperors were mounted on the walls. Exactly in the center of the palace and above the main doorway, framed by double columns, was the King's bedroom, which opened onto a balcony from which Louis could make public appearances and observe military reviews. The Egyptian window of appearances was here given its most resplendent setting (Figs. 324, 325).

Within the palace, Louis had an army of artists and artisans lavishly decorate the ceilings and walls with murals depicting events in the lives of the gods, with whom he felt a kinship. The famous Gobelin tapestry and ceramic industries were founded as royal monopolies to supply Versailles with miles of tapestries, carpeting, and moldings. Over 140 types of colored marbles were assembled from all over Europe for the wall and stairway decorations. Hundreds of stucco and marble sculptures of gods, nymphs, nudes, and, naturally, of French royalty were carved and set in the rooms and gardens. No expense was spared in making this the artistic center of the Western world; indeed, it became the model for all European royalty. The Palazzo Medici-Riccardi (Fig. 340) would have been as inappropriate to Louis XIV as Versailles would have been to Lorenzo de' Medici. Louis had no need for a fortified residence, since his armies ruled all of France and much of Europe. He did not need rusticated masonry walls to suggest his strength. The huge floor-to-ceiling windows and the great Venetian mirrors in the famous Hall of Mirrors were as expressive of the Sun King as the thick walls and barred windows of the Florentine palace were of the Renaissance rulers. Louis was the "Lord of Light," and his earthly palace became a materialization of this concept.

The gardens were designed to be used by the six or seven thousand people who lived at the court. On the upper

346. Katsura Palace, Kyoto. 17th century.

levels of the gardens, Louis held fabulous banquets, which were often accompanied by brilliant displays of fireworks. Over 1,300 waterspouts were built for the many fountains, each designed around a marine motif. In shaping the water so variously, Louis showed his rule over nature, as was implied in the virtuoso clipping of hedges and trees. Long garden prospects shaped even the natural space. Great open-air stairways, whose design went back to those built by Bramante for the Vatican and by Michelangelo on the Capitoline Hill (Fig. 228), not only carried the promenader from one level of the garden to another but also gave a sensation of leading directly to the clouds. The gardens and palace of Versailles constituted a private city that required the most advanced mathematics and skilled engineering of the time to build.

Contemporaneous with Versailles is the great Japanese princely detached palace of Katsura (Figs. 346–351), built near Kyoto under the direction of Prince Toshihito and his son Prince Toshitada. The palace occupies 16 acres (6.4 hectares), bounded by bamboo thickets and screens and adjoining the Katsura River, the waters of which were diverted into the gardens. As much as by totally different architectural traditions, Versailles and Katsura were formed by different concepts of authority and of man's relationship to nature. At the time of its construction, in the 17th century,

the imperial family was feeling the oppression of the sho-guns, and Prince Toshihito had no effective political power. His palace was thus symptomatic of his retreat from the outside world, whereas the French King used his palace to symbolize the world centered in his person. Except in the temples, the Japanese builders avoided symmetry, and the approach to Katsura was carefully designed to be informal and natural and to provide by its turnings unexpected vistas of the beautiful gardens and ultimately of the palace itself. The accent on artifice and the mastery of the elements demonstrated at Louis XIV's Versailles were altogether alien to the attitudes of the Japanese aristocracy toward nature; the Japanese approach was more passive and romantic.

The main building at Katsura immediately reveals the absence of a strong central focus. There is no formal stair-way or forceful accent on a main door, nor is there the familiar European blockish quality and self-sufficiency with regard to setting. Under the direction of the Prince, Katsura, like its predecessors, was made to appear perfectly adapted to the seemingly unplanned variety of its natural surround-ings. The main building is an *echelon* or zigzag arrange-ment of three large *shoin,* or halls, consisting of some 40 modest-sized rooms, few of which have designated func-tions. The large, slightly convex roof is the dominant design motif, and its weight is crucial for structural stability. The architecture is basically a skeletal post-and-beam construc-tion with paper walls that are not load-bearing, as in Euro-pean palaces. Many of the external and internal walls at Katsura are made to slide open, thereby allowing multiple changes in room layout and vistas into the gardens. The

above left: 347. Katsura Palace, view from the Palace toward the Middle Shoin.

above: 348. Katsura Palace, Middle Shoin seen from the first room of the Old Shoin.

aristocracy stoically accepted the discomforts of climatic conditions, feeling that architecture should serve essen-tially the spirit rather than the body. Unlike European archi-tects, Japanese designers based their work more on aes-thetic preference than on ideal geometry when it came to formulating a proportional system.

The building is raised off the ground by posts (Fig. 347), both because of the sloping site and as protection against floods; the basement is walled to keep animals out. The uniform floor level at Katsura was a break with the tradi-tional aristocratic symbolism of different levels found in earlier imperial palaces. The modern Japanese architect Kenzo Tange, who has written a fine study of Katsura, points out that these deviations from the historical aristocratic norm reflect a new influence of the ideas and energy of the lower classes, who were responsible for the Noh plays, puppet theater, and the tea ceremony so vital to Japanese culture and enjoyed by the aristocracy. Prince Toshihito employed as his director of construction a garden and tea expert named Nakanuma Sakyo, who came from the newly prosperous merchant class, while the chief gardener is known to have been of low birth. Though he no doubt re-ceived advice from fellow noblemen and Zen priests, the Prince seems to have been susceptible to new ideas from outside the court.

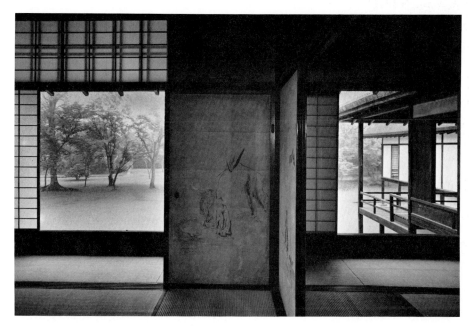

left: 349. Katsura Palace, the New Palace and lawn seen from the Middle Shoin.

below: 350. Katsura Gardens and *Shokintei* (teahouse).

Katsura does continue most of the characteristics of Japanese imperial architecture. Its beauty depends largely upon the utmost restraint in decoration, as seen in the spareness of its rooms and the clean contrasts between vertical and horizontal elements (Figs. 348, 349). Japanese designers thought of space in two-dimensional terms, and the interior of the palace might be described as an additive sequence of flat patterns. Similarly, the symbolic gardens were to be viewed sequentially and with much attention given to contemplating what was underfoot. Neither within nor without the palace does one have the sense of a total integrated form, in contrast to the European palaces with their more static blocklike arrangement, planned and fixed vistas in and from the interior, and predictable overall symmetry. The openness of Katsura becomes in itself an aristocratic symbol, for the houses of the farmers were closed against the elements. Unlike the highly finished decoration of Versailles, that of Katsura is, intentionally, often left rough or incomplete in order to harmonize or suggest analogies with nature. The Japanese brought to a high art the enclosure of space for human enjoyment.

The lesson offered by the garden was that of the underlying harmony of all life in the universe—not, as at Versailles, of one man's self-glorification at the expense of nature. The Katsura garden is the loving creation of gardeners who were fine artists. Mingling ponds, mounds, beaches, and groves, the Katsura gardens are totally unpredictable on the basis of any one part. The ritual tour enjoyed by 17th-century royalty followed prescribed water routes or the discrete paths and stepping stones contrived to appear as integral parts of nature. Constantly changing views were

unfolded to the eye, just as textures subtly changed underfoot. Except for the buildings, the gardens possess no reference to human scale or activity, so that at one moment they are recognized in their normal aspect, and in the next they may appear as endless depths, expanses of sea and mountains. Worn stones and moss and aged trees preserved the viewer's impression of being surrounded by timeless serenity. Impeccably cared for, the garden's correct informality is preserved by the elimination of mud and unsightly collections of leaves. In such an environment, people could cleanse their minds of mundane concerns.

The building most appropriate to such a setting is the teahouse (Fig. 350), where the *chanoyu,* or traditional tea ceremony, is performed. Usually a one-room structure sur-

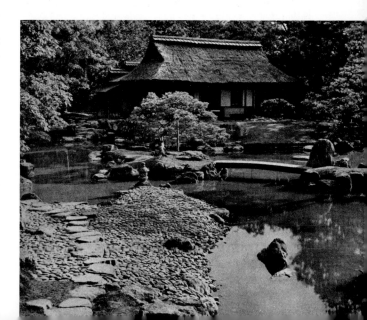

rounded by a small-scale garden, at Katsura the 17th-century tea pavilion, the *Shokintei* (Fig. 351), contains additional rooms. A religious ritual practice by Zen monks before the image of Buddha, *chanoyu* later became secularized into a form of social meditation but preserved the rules and solemnity of its origin. A few invited guests assembled at the garden gate and, in prearranged order, passed leisurely through the garden, cleansing their hands in a rude stone basin and usually entering the teahouse through a low door, as a symbol of humility and the democratic nature of the ceremony. In an alcove of the austere tearoom would be placed a painting, a simple flower display, or a single beautiful object that, after thoughtful inspection by the entering guests, served as a source of discussion. Following strict ritual, the host prepared the tea with intentionally crude but handsome utensils. Simplicity and naturalness were the notes struck by the environment, the tea objects, the gestures, and the subsequent conversation, which ideally never touched on business or politics.

From the Buddhist temple, the tea ceremony passed to a deceptively simple, light, wooden-framed structure topped and stabilized by a heavy thatched roof. Between the exterior wooden supports were rough, mud-covered lath walls and translucent rice-paper screens. Openings in the wall

351. Interior of the Katsura *Shokintei,* with hearth and tree trunk used to support a partition.

were intentionally disposed in an irregular way, both for visual effect and to guide the light properly for the tea ceremony. Painstakingly and at great cost, the owners of the teahouse constructed a building that gave the impression of austere rusticity and natural imperfection. Devoid of interior furniture, with the guests sitting on rice mats arranged over the floor, the tearoom has an air of emptiness and contemplative space.

Arthur Drexler has explained the significance of this quality of "emptiness" according to Zen and Taoist ideas:

> The purest style of tea house architecture . . . claimed to be concerned not with the material of the building itself, but with the emptiness within. . . . It was important to produce a space that would reflect the transiency of things in this world . . . and to this end asymmetrical compositions were preferred: Only what is incomplete is still within the process of life and is therefore imperfect.

This worshipful attitude toward imperfection extended to introducing an untreated tree trunk as a partition support in the room, thus linking those within to the natural world without.

The Country Estate

One of the most influential architects in history, Andrea Palladio, created a series of country houses for northern Italian landed gentry in the 16th century that were later imitated in northern Europe, notably England, and throughout the southern United States by gentlemen-farmers. As exemplified by his Villa Capra, or Villa Rotonda, as it was also called (Figs. 352, 353), Palladio created the type of structure that appealed to people of wealth by flattering their Classical education and desire for grandeur without extravagant cost. (Most of his villas were built of rough brick covered by stucco.) The Villa Rotonda was designed for a retired, well-educated gentleman named Capra, from nearby Vicenza, who wanted a suitable country place to give parties and entertain his intellectual friends and from which to enjoy a beautiful countryside: in short, a place within which he could live life artistically. Accordingly, Palladio gave him what may have been the first rectangular structure in history that had four fronts. Palladio's considerable international influence depended largely upon self-promotion through his *Four Books of Architecture* (1570). In volume two, he recounts the intention for his villas:

> I have made the frontispiece (the pediment of the portico) in the main front of all the villas . . . because such frontispieces show the entrance of the house, and add very much to the grandeur and magnificence of the work, the front being thus made more eminent than the rest; besides they are very commodious for placing the ensigns of arms of the owners which are commonly put in the middle of the front. The ancients also made use of them as is seen in the remains of the temples, and other public edifices and . . . they very probably took the invention and the principle [of them] from private buildings, i.e., from the houses.

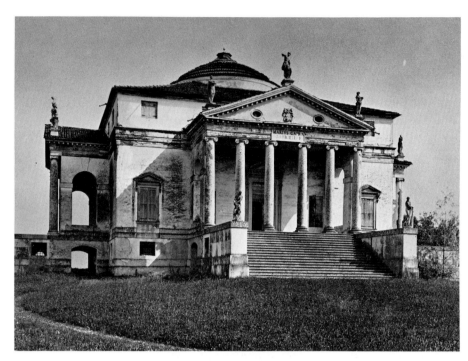

left: 352. Andrea Palladio. Villa Rotonda, Vicenza. Begun 1550.

below: 353. Plan of the Villa Rotonda.

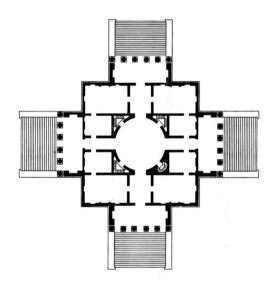

Palladio set his domed cube upon a hill as the visual climax of the site. The slope of the staircases, themselves derived from Roman temples, repeats the hill's incline and leads upward to the entrance as well as to the dome. The centralized colonnaded portico, derived from his earlier study of ancient temples, seemed to Palladio crucial as a symbol of his client's status, if not taste. To patrons like Capra and later architects like Thomas Jefferson, what was so admirable about Palladio's designs besides their reemployment of a Classical architectural vocabulary and essentially planer aspect was their harmony of plan and elevation. No previous Italian architect had so pervasively and consistently controlled the proportional relationships of height to width and to depth, which not only governed the floors, walls, windows, and ceilings, but also connected the interior and exterior. According to Palladio's principles of architectural harmony, which he believed were timeless and universal, geometry and numerical relationships were to govern the design; the plan and elevation were to have axial symmetry, which meant an uneven number of parts horizontally and vertically; ornament was to be kept to a minimum; and there must be a clarity and articulation of loads and supports. In applying the dome to the Villa Rotonda, he not only made reference to a venerable Roman tradition, but secularized the Dome of Heaven concept used in Italian churches since the Renaissance as well. The dome also gave him a unifying feature for his box structure as well as greater visibility from a distance. The graduated sequence from steps through columns to pediment, to pitched roof, and finally to the dome was to be repeated by architects in countless stately homes as well as government buildings, such as our own Capitol building.

Falling Water Frank Lloyd Wright was the first American architect to achieve world fame, and still crucial to that fame is a house he built in 1936–37 for a Pittsburgh department store owner named Kaufmann. "Falling Water," as the Kaufmann house became known, was built out from the

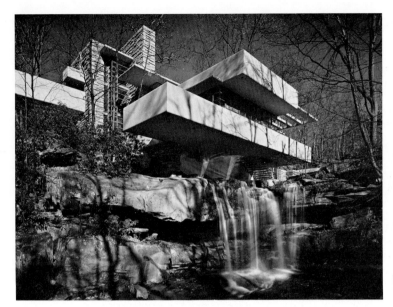

left: 354. Frank Lloyd Wright. "Falling Water" (Kaufman House), Bear Run, Pa. 1936–37.

left: 354. Frank Lloyd Wright. "Falling Water" (Kaufman House), Bear Run, Pa. 1936–37.

bottom: 355. Plan of "Falling Water."

below: 356. "Falling Water," viewed from the entrance bridge.

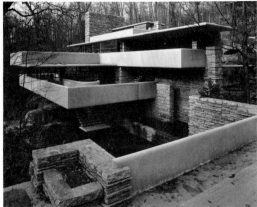

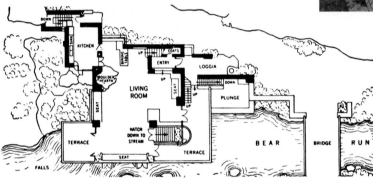

walls of a ravine and over a stream called Bear Run, near Connellsville, Pennsylvania (Figs. 354–356). In our society, which is structured not by birth but mostly by wealth, it is those people who have money, imagination, and daring who have been able to engage the best architects to design houses comparable in quality to Palladio's villas. (This was largely true in Palladio's day as well.) When Palladio wrote about architecture, he had the nobility or wealthy in mind as well as architects. Wright wrote for a broader audience, not just about architecture, but about his view of an ideal society that was classless. His account of Falling Water is more narrowly focused, but makes an interesting contrast to Palladio's statement about his villas:

> For the first time in my practice, where residence work is concerned . . . reinforced concrete was actually used to construct the cantilever system of this extension of the cliff beside a mountain stream, making living space over and above the stream upon several terraces upon which a man who loved the place sincerely, one who liked to listen to the waterfall, might live well. . . . In this design for living down in a glen in a deep forest, shelter took on definite masonry form while still preserving protection overhead for extensive glass surface. These deep overhangs provide the interior . . . with the softened diffused lighting for which the indweller is invariably grateful. . . . This building is . . . the inspiration of a site, the cooperation of an intelligent, appreciative client, and the use of entirely masonry materials. . . . by way of steel in tension this building takes its place and achieves its form. . . . The cantilever slabs here carry parapets and the beams. They may be seen clutching big boulders. . . . This structure might serve to indicate that the sense of shelter—the sense of space where used with sound structural sense—has no limitations as to form except materials used and the methods by which they are employed. (1938)

Even when he used sophisticated engineering, Wright wanted his homes to impart a primitive "sense of shelter," a secure place in nature. He wanted Falling Water to express the ultimate privacy for the individual he felt all should have, even though they are part of society. He believed

there should be as many different kinds of houses as there are persons.

Palladio's architecture was architecture for the aristocracy. Wright believed his principles made his work an architecture of democracy:

> So modern architecture rejects the major axis and the minor axis of classic architecture. It rejects all grandomania, every building that would stand in military fashion, heels together, eyes front, something on the right hand and something on the left hand. Architecture already favors the natural easy attitude. (1939)

Wright had an ideal of "natural" man, living at ease with nature and in a society that he termed "organic," devoid of class structure, wherein the integrity of the individual was preserved and people were mutually supportive. Palladio's model for his design was the human form; that of Wright was the tree. Palladio saw the central core of his structures bound to the wings by proportion, as the head and torso, with the central axis being the spine. When he designed outlying buildings or service units, these related to the lower parts of the body. Wright's paradigm was the tree's adaptability, growth, and change. He wanted his structures to come "out of the ground into the light." The form and character of a building depended upon the architect's responsiveness to terrain, native industrial conditions, and the nature of the materials.

Both clients, Capra and Kaufmann, loved the settings for their future homes. Palladio was very responsive to his site; however, his building can be visualized apart from the ground on which it stands. It is not possible to visualize Falling Water separated from its ravine and waterfall. Palladio believed in revitalizing the ancient vocabulary of architecture, with its fixed relationships and orderly submission of the parts to the whole. (The Ionic order was preferred for the central portico, for example.) Wright rejected older elements, or at least their specialized use, in favor of similar units, like rectangles, ranging in size from small stones to big parapets. For him, the part was to the whole as the whole to the part. Where Palladio's buildings are closed and static, graspable from any view, Wright's seem to grow as well as change and defy total comprehension as one moves about them. As with a tree, there is no one view from which to take in Falling Water; it has no front in a Palladian sense. Spaces in the Villa Capra are compartmentalized and clearly graduated toward the climactic center rotunda. Those in Falling Water impart a greater sense of fluidity, connecting interior with exterior in a more flexible or dynamic way. Palladian architecture sees the human being as the center of the universe, the tamer of nature. Wright's cavelike interiors with their low ceilings, horizontal flow, and interaction with nature—the retention of an untamed site—reflect a more dependent relationship of the human on nature. Falling Water is closer to Katsura than the Villa Rotonda. Where authority is the subject or meaning of

Palladio's designs, in Wright's case, it was the imposition of his will on the lives of those who chose him as their architect that was authoritarian.

Capitol Buildings

The United States Capitol Building Architecture has always been looked upon as the most abstract of the arts, yet its susceptibility to being invested with symbolism runs all through its history. The most dramatic example in this country of the convertibility of invested symbolism and our most important government building is the United States Capitol (Figs. 357, 358). Since the Civil War, no building has so signified the union of the states in a central government as this structure, on which many architects have worked since 1790. For much of the world as well as this country, the Capitol building is a symbol of government by consent of the governed, yet its architectural ancestry can be traced back to temples, cathedrals, palaces, and villas in Europe, all of which represented political systems unlike our own. This European ancestry recalls that of our early population and the Constitution itself. Set upon high ground and approached by long avenues, as were most prominent buildings since the Egyptian temples, the Capitol building is huge and, as befitting its function, is built of the finest and most durable materials (Aquia sandstone and marble) available to its architects. For a long time, the Capitol contrasted with the poorer-quality construction of the rest of Washington. Like certain Italian palaces and Versailles, the Capitol is raised upon a kind of podium; like Roman temples and Palladio's villas, it is approached by flights of steps on the east (Fig. 357). Each flight leads to a colonnade and pediment, or portico, recalling the entrance to the ancient Roman temple of the Pantheon and the Villa Rotonda. The emphasis upon the center, with recessed flanking areas that are transitions to the projecting wings, echoes the articulated façades of Baroque palaces. The strongly framed windows in the transitional area are traceable to Michelangelo's Farnese Palace. The crowning architectural and symbolical element is the dome surmounting a cylindrical drum, a design whose precedents go back to Michelangelo's dome for St. Peter's and Wren's for St. Paul's Cathedral in London, as well as to the domes of certain Baroque churches. How paradoxical that a nation whose laws demanded a separation of church and state should have a dome as its crowning symbol! Ancient associations with Heaven made the dome a fitting cover for Roman temples such as the Pantheon, and for Christian churches. The Capitol's symmetrical plan built around large rotundas was already a stereotype for European palaces and villas by the 18th century.

The historical explanation of these paradoxes lies in the fact that before the building of the Washington Capitol, statehouses of the colonies had begun to use classically inspired architectural features. This was done at the insist-

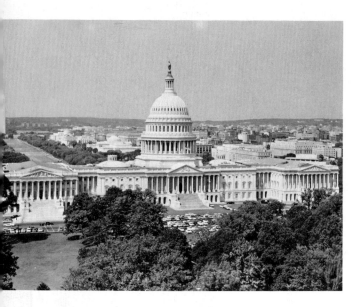

above: 357. The United States Capitol Building, view of the east side. Collection the Architect of the Capitol.

below: 358. The United States Capitol Building, view of the east side in 1846. Daguerrotype by John Plumb, Jr. Library of Congress, Washington, D.C.

ence of state legislatures caught up in the enthusiasm for a democratic form of government and with the encouragement of the British Crown, which wanted dignified, monumental, and permanent statehouses in emulation of the Romans. Virginia's capitol of 1699 was the first building to be so called, and it took its name from the Capitolium, which was the ancient temple of Jupiter overlooking the Roman Forum. Hitchcock has shown that even before the Constitution, the architectural symbols of the republic were in the statehouses: symmetrical plans echoed balanced legislative chambers; towered steeples or domes indicated the rise of colonial assemblies. To express the belief that they had more freedom than anyone else in the world at the time, assemblymen insisted upon such dignified elements as domes and columns. Rather than symbolizing the British triad of King, House of Lords, and Commons, our statehouses symbolized Governor, Council, and Assembly, which were responsible for legislating local government. The U.S. Capitol building's wings, rotunda, dome, balanced chambers, and portico were the architectural symbols borrowed by a young government whose only traditions lay in the individual states.

When first completed in the 1820s from the basic design of an Irish doctor named Thornton, the Capitol seemed uninspiring and had no influence (Fig. 358). It was the additions

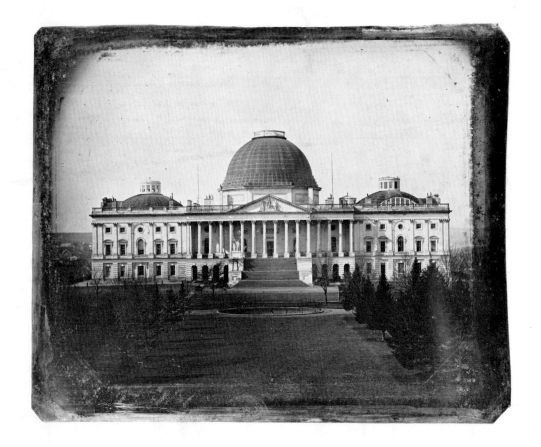

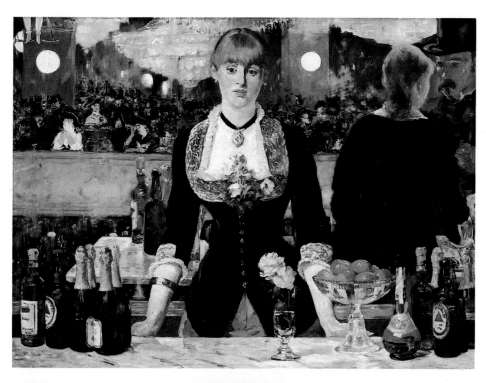

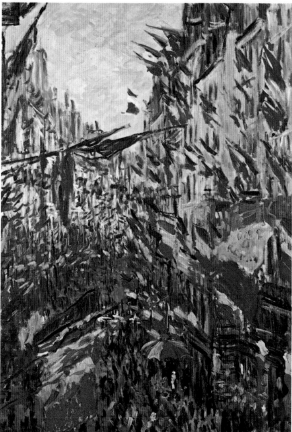

above: Plate 25. Edouard Manet.
Bar at the Folies-Bergère.
1881–82. Oil on canvas,
3'1½'' × 4'3'' (.95 × 1.3 m).
Courtauld Institute Galleries,
London.

left: Plate 26. Claude Monet.
*Rue Montorgueil, Fête Nationale
du 30 juin, 1878.*
1878. Oil on canvas.
24½ × 13'' (62 × 33 cm).
Musée des Beaux-Arts, Rouen.

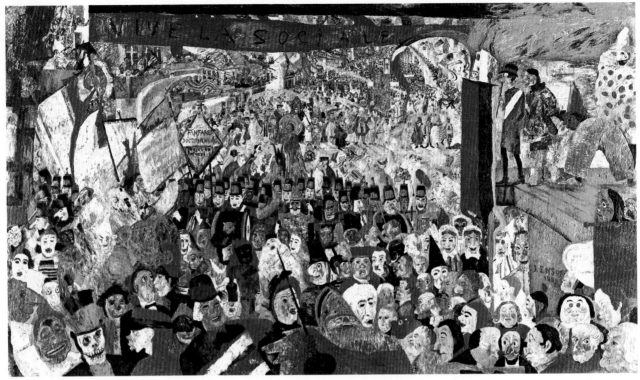

above: Plate 27. James Ensor. *The Entry of Christ into Brussels in 1889.* 1888. Oil on canvas, 8′5½″ × 14′1½″ (2.58 × 4.31 m). Koninklijk Museum, Antwerp.

below: Plate 28. Pierre Auguste Renoir. *The Luncheon of the Boating Party.* 1881. Oil on canvas, 4′3″ × 5′8″ (1.3 × 1.73 m). Phillips Collection, Washington, D.C.

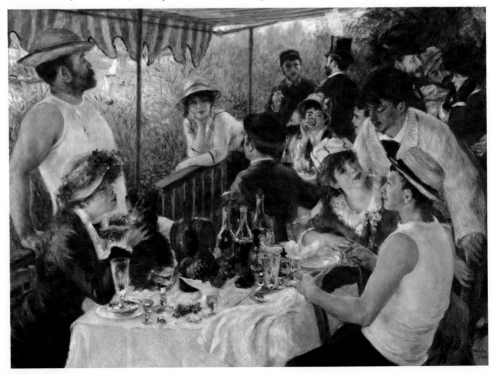

359. Le Corbusier. Final plan
of the capitol complex,
Chandigarh, India. 1951.

after 1850 made by Thomas Walter that conveyed the Congress's increased size, sense of importance, and desire for monumentality, as well as America's prosperity. In 1855, Walter proposed a new dome to climax the old cluster of boxlike structures; this is the monumental dome that crowns the Capitol today. Lincoln ordered work on the Capitol's double iron shell construction during the Civil War to symbolize the continuity of the Union despite the rebellion of the states. After the Civil War, the Capitol won international respect and comparison with Versailles. Domestically, it not only influenced the new state capitols, such as California's, but came to symbolize the faith of many in the Union.

The U.S. Capitol building is largely ignored by architectural historians, perhaps because of its eclecticism and frequent changes. (That tobacco leaves were used instead of the ancient acanthus leaves for cast-iron column capitals has not endeared the building to many purists.) No question but that it is overcrowded and in many functional ways inconvenient for present governmental needs, but the changes made to enlarge it have kept the building alive, and it remains, along with skyscrapers, a distinguished representative of America's contribution to world architecture. Architecturally, the Capitol building reflects the great admiration of our early presidents, notably Washington and Jefferson, as well as the people's representatives, for the architecture of Greece and Rome.

What happened in recent times when a single architect largely ignored the taste and culture of the people he worked for in designing a capitol and imposed his own, we consider next.

Chandigarh When Nehru proclaimed India free from fettering traditions, he selected Le Corbusier to create a city that would instruct young Indian architects, denied experience under the British, in how to build anew an old civilization that had not yet achieved stability. Chandigarh (Figs. 359–366) was thus to symbolize the creative strength of the new republic, so that tribal allegiances would be transferred to the state and country. For Le Corbusier, the toughest technical problems involved the site and the climate: the complex was to be built on a vast plain rising slowly to the Himalayas, against which the buildings would always be seen. The tropical setting meant terrific heat and monsoon rains. The labor force was plentiful but unskilled, the finances were modest, and the technology was crude. In addition, the culture was alien to a European who had planned, but never built, cities for other continents. Leaving the city proper to be designed and supervised by his associates, Le Corbusier made the basic decisions about the placement and design for the capitol complex. He made these decisions by intuition, studying movable flagpoles to determine the locus and height of his buildings against the awesome mountainous backdrop that the complex would have. For the architect, there could be no haphazard or timid solution.

The capitol compound Le Corbusier created (Fig. 359) occupies a large pedestrian plaza, a series of tangent squares with tree-lined avenues, reflecting pools, and mounds and terraces that are still in the process of being landscaped. The east-west axis is marked by the Law Court and Secretariat; adjacent to the latter is the General Assembly. The culmination of the north axis, which was to have been a governor's palace, is now the Museum of Knowledge. The considerable distances between the buildings resulted from Le Corbusier's aesthetic decisions about the relation of architectural forms to one another and to the mountain range and about the space of the plaza. Although they underscore the separate government functions housed within each structure, the distances make pedestrian or bicycle movement (still the principal means of getting about) between the Secretariat and the Law Court an ordeal during monsoons or 115 degree heat. Traffic of different types is accommodated by separate routes that—if Chandigarh grows beyond the planned population of 150,000 to about the size of Los Angeles—should prove adequate and effective. At present, however, the excessive costs of landscaping such a vast space and the small amount of motor traffic make the plaza a barren waste in many areas, a problem that is not unique to it but occurs also throughout much of the rest of the city.

Le Corbusier rejected the symmetry of such urban centers as that around the Place de la Concorde in Paris, but not the scale or open space of that ensemble: his 400- and 800-meter squares do in fact relate to distances along the axis from the Louvre to the Arc de Triomphe. Each building is stamped with his style and symbolic gesture—each ap-

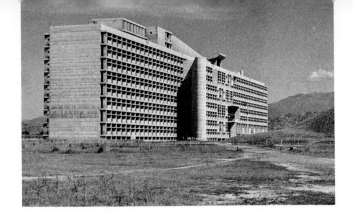

pears as an architectural fist against the onslaught of nature. His concessions to the sociology of his client can be found in the variegated design of the wall-like Secretariat (Fig. 360), which signifies the different levels of administrators, who live in sectors of the city and in homes similarly classified into fourteen levels. The great length of the building anchors the space of the capitol square at one corner, but raises endless problems for the efficiency of the inside. The compact rectangularity of the building serves design but not the need for office expansion.

The General Assembly building (Fig. 361) has a magnificently designed pseudo-portico front (Fig. 362) for its square plan. The detached raw concrete façade answers the powerful challenge flung by the Law Court (Fig. 365) half a mile away. Ceremony, symbol, and visual effects take precedence in the Assembly building over practicality, for the legislators are segregated by design (Fig. 363), and the great cooling tower ceiling of the main chamber is sufficiently compelling to distract those who would engage in parliamentary debate. Inspiration for the tower came from an industrial cooling tower in another Indian city, and its exposure above the roof line answered the challenge of the dramatic mountain peaks in the distance. The 40-foot (12-meter) high forum that circles the main assembly hall (Fig. 364) has a column-supported black ceiling; it is a dramatic assembling area for the legislators. One is constantly moving from narrow to wide, short to tall, dark to light spaces in this building, a situation in which the stage setting upstages the actors but delights the audience. The Assembly governs by consent of the governed, but it must try to operate in a structure created by a single arrogant will. All great archi-

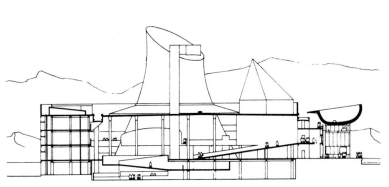

top: 360. Le Corbusier. The Secretariat, Chandigarh, India. 1959.

left: 361. Le Corbusier. The General Assembly, Chandigarh, India. 1959–62.

below: 362. Portico of the General Assembly, Chandigarh.

below left: 363. Section of the General Assembly, Chandigarh.

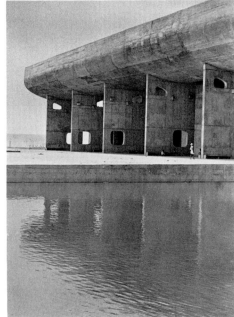

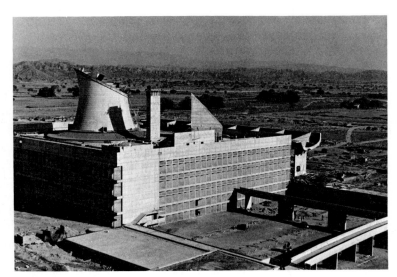

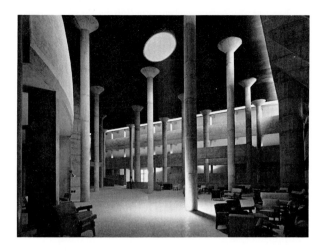

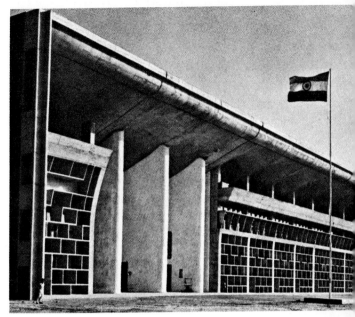

above: 364. Forum of the General Assembly, Chandigarh.

right: 365. Le Corbusier. The Palace of Justice (Law Court), Chandigarh. 1952–56.

below right: 366. Entrance to Palace of Justice, with ramp at the rear, Chandigarh.

tects must be arrogant, appropriating to their conceptions land, sky, materials from the earth, wealth, and labor; but architects must temper brilliance with common sense, else they will produce hardship, if not disaster, for the people compelled to live with grand design.

The great form of the Law Court (Fig. 365) provided no protection for citizens waiting in front of the building in rain or heat to enter the courtrooms; consequently, a covered area has been added. Monsoon downpours funnel into the entrance court, whipping even those ascending the ramps within (Fig. 366). The "air-conditioning" purpose of the double roof and sunbreakers did not work, fixed glass windows generated heat, and judges changed the designs of their courts without regard to the architect's provisions for protection from glare. In her intelligent commentary on Chandigarh, Norma Evanson has suggested that many discomforts could have been avoided without seriously altering the design. Despite the failures of utility, at Chandigarh Le Corbusier kept alive the tradition of monumental architecture at a time when it seemed alien to the course of history and was identified with political dictatorships. Dictatorship by the architect has its flaws, but also its compensations. The capitol buildings at Chandigarh are strong and have an energy that diminishes complaints about them. No modern architect designs with Le Corbusier's authority and sculptural sensitivity; as a model for future Indian cities, however, Chandigarh promises disaster. The vernacular Indian tradition of dense groupings of buildings and covered passageways meets the challenge of heat, wind, and rain far better than do Le Corbusier's solutions; but his ideas, used by imaginative architects, have borne

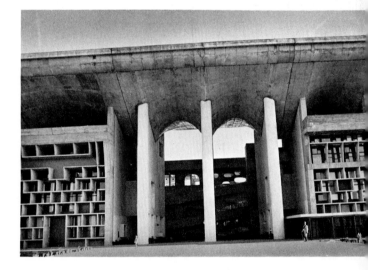

fruit elsewhere, as the Boston City Hall clearly demonstrates. Great as his gifts were, Le Corbusier failed at Chandigarh to prove that a whole city could be shaped externally, rather than being shaped internally by the people themselves.

An American Arch That Is a Triumph

This chapter began with a discussion of ancient gateways that signified the power of a single ruler. It ends with the largest arch ever built, one that celebrates the western expansion of the United States as a result of the Louisiana

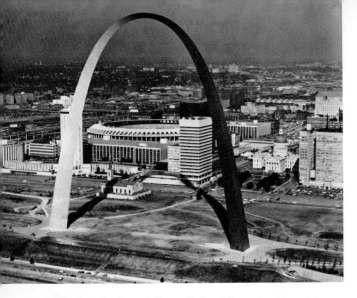

367. Eero Saarinen. Jefferson National Expansion Memorial (The Gateway to the West). St. Louis, Mo. 1966.

Purchase. Known officially as the Jefferson National Expansion Memorial and more popularly as The Gateway to the West (Fig. 367), the 630-foot (189-meter) tall, steel and concrete inverted catenary form that stands in St. Louis was designed by the late Eero Saarinen. It was a federal commission that began under Franklin D. Roosevelt and was conceived to provide "an appropriate national memorial to those persons who made possible the territorial expansion of the United States, including President Thomas Jefferson and his aides, Livingston and Monroe, who negotiated the Louisiana Purchase, the great explorers, Lewis and Clark, and the hardy hunters, trappers, frontiersmen, pioneers and others who contributed to such expansion." The original plans included a museum at the base of the monument illustrating the theme of westward expansion. It was finally realized in 1976. The arch was also to be part of the urban renewal of the St. Louis waterfront, and this plan has also come true. The completion of the design and its precise construction in 40 months were inspired and heroic feats of historical importance.

From a distance, the great arch looks deceptively thin. It is made by an equilateral triangle that rises in a beautifully refined taper. At the base, it is 54 feet (16.2 meters) from corner to corner of its three sides. It is 630 feet (189 meters) between the two legs of the arch. The outer skin is quarter-inch (.6-centimeter) stainless steel plate. Three feet (.9 meter) of concrete are sandwiched between the outer skin and the three-eighths-inch (1.2-centimeter) structural steel plate lining. The whole is tied together by a lattice of rods and bolts. The concrete fill rises for the first 300 feet (90 meters), and thereafter the structure is stiffened by cross bracing. Stairways and elevators are located in each leg of the arch to take visitors to the top, where from inside they have a spectacular view east and west.

Saarinen's achievements were several. His bold and imaginative vision created an arch unlike any freestanding form before it and without the militant connotations of the Roman triumphal arch. The Gateway is at once sculpture and architectural engineering, a graceful soaring form whose size is possible only in our time. Despite its thickness at the base, the form is elevating and not intimidating. It is visible for miles and from all over the city—both a national and a municipal symbol. Like the Egyptian pyramids, it is a richly symbolic but artistically simple form. Also like the pyramids, which were originally sheathed in polished limestone so finely jointed as to resist invasion by a sharp knife, the stainless steel plates of the St. Louis arch are marvelously crafted where they join and give the impression of ribbonlike continuity. The pyramids reflected light as part of their solar symbolism. The Gateway to the West welcomes and is transformed by the ambient light, day and night. On a hot, sunny day, the steel actually ripples due to expansion and contraction, so that the whole form looks ephemeral or like crinkly aluminum foil. The impact of the arch was to shake off the city's dormancy with respect to plans for its own renewal. Saarinen proved that a gifted artist could still rise to the challenge of speaking for his people by giving symbolic form on an epic scale to a part of history in which pride can be taken.

How misleading is the notion that architecture must always be an abstract art form was demonstrated by the discoveries of scholars regarding the symbolism of religious and political buildings. Temples and churches, in turn, derived much of their symbolism or mystical associations from architecture that in ancient times had served kingship. Over a period of centuries, certain architectural features such as gateways and palace façades acquired in the minds of both the masses and the rulers connotations of authority. Since kings acted like gods and gods were interpreted as kings, it is not surprising that the ancient architecture of palace and temple should have acquired both royal and divine associations. The influence of ancient royal architecture descended through the Middle Ages and into the Renaissance and Baroque periods. In modern times, its propagandistic and symbolic values were revived by Mussolini and Adolf Hitler. It is clear, then, that the history of architecture often mingles with the history of ideas and that architecture has been used as a powerful instrument by rulers to strengthen their image in the minds of their subjects. The destruction wreaked on so many palaces is a tribute to how effectively monarchy has been identified with its masonry.

Unlike our own and other present-day governments, those of the past regularly called upon their best architectural talents to construct public buildings. Like religious architecture since the 19th century, the best modern architecture has with but rare exceptions developed independently of the state. For this and other reasons, it is difficult for us to appreciate that what seem to be dead and impersonal ancient ruins once embodied civilization's most important political values.

Chapter 14

To Be of One's Time in 19th-Century Art

Like a river changing in depth and width, receiving new springs, or altering its course and leaving isolated bodies of water to dry up, the history of art is a continual movement unchecked and ungoverned by the calendar. At the beginning of the 19th century, the old synthesis of "heavenly" and "worldly" values was found to be ineffectual and irrelevant; this was not a new discovery, but rather the result of a process of gradual enervation over the two preceding centuries. Like many other fields, art has a dialectical history in which conflicts of opposites have often motivated the artist. The newer synthesis that perplexed and inspired many 19th-century painters centered on the ways in which their art should be influenced by both past and present. Should one's style and subject imitate the past in interpreting the present? Should the artist's themes be of the moment, yet in a style that did justice to the Baroque or Renaissance masterworks in the Louvre? Or should *both* form and theme be grounded in the artist's own time?

Such questions were not raised for the first time after 1800, for they had already been posed and solved at various points in history. Since the 17th century, for example, Dutch as well as French artists had been interested in showing their own time and place without resorting to a paraphrase of the styles of other periods and countries. Portraits, still lifes, and landscapes were modes that permitted artists to interpret aspects of their time, while they also did mythological or historical painting in a style taken from other artists in other countries from other times. Even before the 19th century, there had been excellent alternatives to the

view that the purpose of art should be to educate and ennoble its public. Genre and the foregoing types of painting of people, objects, and nature allowed artists to sidestep these noble aims, and the high value given these works by private collectors had established a base for a nonintellectual painting, esteemed for how it was made rather than for its subject matter.

In the 19th century, principally in France, a number of conditions conspired to change the answers to these questions about the influence of the past and present and to produce viable new syntheses in terms of what was to happen at the beginning of the present century. Many of the leading independent artists were separated from the patronage and ideals of both church and state, as well as from formal art-school training. Progressive artists after 1850 could hope for support from an increasingly large middle-class, art-buying public and from art dealers, who had emerged in increasing numbers. For many important artists, personal study in the Louvre or other art museums came to replace training in academic art schools. Artists relied upon other artists and sympathetic critics and dealers for criticism and encouragement. Independence involved substantial risks, but the ideal of contributing to culture while gaining personal fulfillment from artistic activity was a strong incentive. The heroic focus in advanced painting shifted away from saints, statesmen, and warriors to the masses, to the private citizen, and to the artist himself.

Some of the dramatic changes that occurred in art in the course of the 19th century are apparent when a large canvas

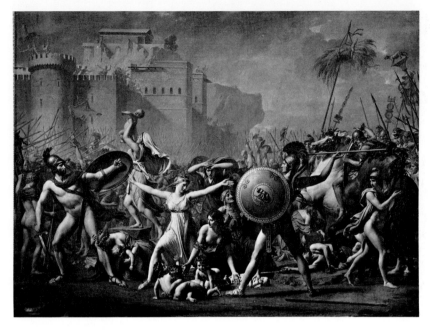

left: 368. Jacques-Louis David.
*The Battle of the Romans
and Sabines.* 1799.
Oil on canvas, 12′8″ × 17′3¾″
(3.86 × 5.2 m). Louvre, Paris.

below: 369. Henri de Toulouse-Lautrec.
Moulin Rouge, La Goulue. 1891.
Color lithograph poster,
5′5″ × 3′10″ (1.65 × 1.17 m).
Philadelphia Museum of Art
(gift of Mr. and Mrs. R. Sturgis Ingersoll).

of Jacques-Louis David (1748–1825), *The Battle of the Romans and Sabines* (Fig. 368), is juxtaposed with *Moulin Rouge* (Fig. 369), a lithographic poster by Henri de Toulouse-Lautrec (1864–1901). Purposes, sources, and styles are separated by much more than merely 90 years of time. David's painting was intended to hang in the great palace of the Louvre, which in 1800, though still serving in part as a residence, had been converted into a museum for the nation. Toulouse-Lautrec's posters were pasted on walls and kiosks around Paris as advertisements for a Montmartre dance hall. David attempted to unify his society by bringing together an aristocracy and a middle class that had come to distrust each other as a result of the French Revolution. Toulouse-Lautrec's message was spelled out literally; his job was to bring together the general public and the virtuoso performers in a nightclub for purposes of business and pleasure. True to tradition at the beginning of the century, David drew upon a historical episode—that is, borrowed from the past—to make a moral point for the present. His source for the painting was literary, Petrarch's *History of Romulus*. The incident chosen was the moment when the wife of the Roman leader interceded to stop his personal combat with Tatius, chief of the Sabines and her kinsman. David assumed an educated audience that would comprehend how women could mediate in class conflict through intermarriage. Toulouse-Lautrec derived the subject of his poster from frequent visits to the Montmartre cabaret Moulin Rouge and direct observation of such stars as La Goulue ("The Glutton") and Valentin le Désossé ("The Boneless One").

David based his style on ancient Greek and Roman art. The past thus provided him with models of pose and composition, as well as confirmation of the archaeological accuracy of details. To assure anatomical exactitude, he first

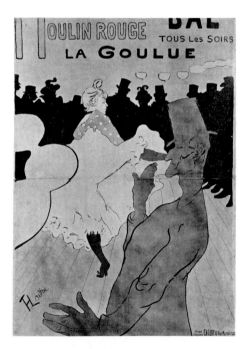

drew from skeletons posed in the manner of the final painting and then from live models similarly posed in imitation of ancient works of art. It was not David's opinion that the artist should be original, that he should innovate; rather, he believed that he should take from the past and perfect his choices. Toulouse-Lautrec's style, though to some extent indebted to contemporaries such as Edgar Degas (Figs. 380–382), was largely formed by personal taste, visual perceptiveness, and the idiosyncrasies of his hand. Just as the dancers in his poster prided themselves on their ability to

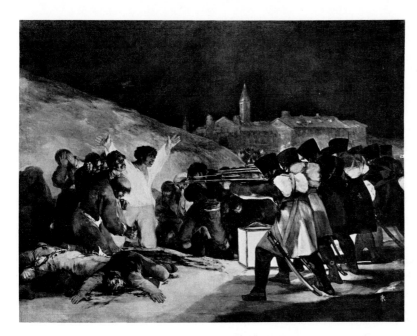

370. Francisco Goya.
Execution of the Madrileños on May 3, 1808.
1814. Oil on canvas,
8'8¾'' × 11'3¾'' (2.66 × 3.45 m).
Prado, Madrid.

improvise and to create highly stylized, even grotesque and surprising movements, so did the artist value his talent for direct observation and spontaneous translation of their movements in a style that was equally exaggerated and individualistic. Both David and Toulouse-Lautrec were affirming the superiority of art over nature—the former by homage to the exalted impersonal styles of the past, the latter by expressing his own temperament.

For David, as for many artists since the 15th century, the model for the rhetoric and arrangement of pictorial presentation was the theater and its performers on a stage. Toulouse-Lautrec's figures were inimitable in a double sense: not only were their postures uniquely unstable, but the artist's conception negated measurable three-dimensional stage space and illusionistic devices that permitted the audience physically to identify with his personages. His poster has a decided surface emphasis, whereby all the shapes and colors are flattened out, and it is the silhouettes rather than the facial expressions and modeling, as in David's work, that impart character and expressiveness. The segmented treatment of Valentin and the ambiguity of the yellow globular shapes at the left (probably a lamp) presuppose changes in the value of the human figure, compositional balance, and clarity from those that had obtained in David's day. Toulouse-Lautrec's art is symptomatic of the turn-of-the-century interest on the part of independent artists in capturing and developing those properties and experiences that are to be found only in the graphic medium of painting and prints—that is, which do not readily lend themselves to paraphrase in other media. David's work is *discursive* painting; one could read and talk about its subject without reference to how it was made. The poster reflects 19th-century changing attitudes toward history and constitutes a form of popular social history of the moment.

This democratization of history was accompanied by changing attitudes toward the artistic suitability of subjects drawn from daily life.

Death and New Heroes At the beginning of the last century, historians and painters began to show that history involved masses of people, and accordingly the reactions of the common man and woman to their fate gradually replaced those of the epic leader. In Chapter 12, "Images of Authority," we saw how David (Fig. 319) and Baron Gros (Fig. 320) interpreted history through the feats of a great military hero. Since the Romans, war had been shown in terms of kings and generals, the victors and their generosity toward the vanquished. During and after Napoleon's reign, war and the concept of the hero underwent a change in European painting. When Francisco Goya (1746–1828) painted *The Execution of the Madrileños on May 3, 1808* (Fig. 370), he did not choose to record a battlefield scene. The French occupation general Murat, who ordered the killing of hostages in reprisal for the civilian uprising in Madrid, was not even shown. Goya had originally been sympathetic to the Napoleonic invasion of Spain, in the hope that it would bring modern ideas to his country. His painting is a manifestation of partisanship, not as an oppressed Spaniard but as a human being protesting brutality and injustice. He does not glorify war, as artists before him had, but instead shows the slaughter of defenseless civilians by a firing squad. The anonymous, doomed yet defiant Madrileños are the real protagonists and heroes, though pathetic ones; the conquerors are machinelike in the cold precision with which they carry out the execution at brutally close range. To impress his audience with the true horror of the moment, Goya brilliantly illuminates those about to die before the volley of the shadowy troops and shows lifeless figures

sprawled in the foreground in the unnatural contortions of violent death. Rather than histrionic pose, the hostages manifest instinctive grief, resignation, and outright defiance at the last moment, and Goya contrasts their disarray and shapeless grouping with the close formation of the soldiers, the unfeeling single-mindedness of those disciplined to carry out any order. Goya may or may not have actually witnessed the firing squads in action on the night of May 3, 1808, but it is certain that he did not require the intermediary of a writer to furnish his strongly felt subject matter.

One of the great 19th-century paintings (Fig. 371), which deals with a mass catastrophe having political implications, was based not on a history book but on contemporaneous newspaper reports and interviews by the artist with the survivors. The French painter Théodore Géricault (1791–1824) had ambitions of doing a monumental painting on a noble theme that would rival great works of the past such as Rubens' *Last Judgement* (Fig. 244) and Michelangelo's awesome fresco of the same theme (Fig. 219). Géricault wanted the subject to be contemporary, however, in order to prove that he could paint modern history on an equally heroic scale. In 1816, when more than a hundred persons were cast adrift on a raft, after the tragic wreck of the government ship *Medusa* off North Africa, Géricault was provided with a sensational and topical subject for his painting. Shipwrecks had often been depicted in the past, but this overworked theme had never before been treated with the stark immediacy and intense focus upon human suffering that Géricault brought to his huge canvas, with its emotional sincerity and imaginative staging. He had the ship's carpenter reconstruct a model of the actual raft, which he then set afloat; he

studied not only the faces and bodies of those hospitalized after their ordeal but also the heads of dead criminals and putrefying limbs from the Paris morgue. He made numerous drawings and painted sketches of various incidents of the shipwreck, but finally passed over such dramatic moments as the mutiny in favor of showing the handful of survivors rising like a human pyramid to signal a ship in the distance.

The eye level of the viewer is at the lower part of the painting, so that one is confronted with a jumble of corpses and the old man's grief over his dead son. This device of engaging the viewer in a direct confrontation with death was learned from Baron Gros. Though Géricault worked from over a hundred preliminary drawings and studies, the final composition evolved slowly by trial and continual change. Its roughly triangular design had precedents in Renaissance painting with hieratic implications of social and political authority; but here the compositional pyramid formed of suffering bodies rests on an unstable base, and the climactic figure is a Negro slave, who has his back to us. Professor Lorenz Eitner had demonstrated in many studies on this work and its period that the figures adrift on the wind- and sea-tossed raft were a contemporary metaphor for the tragic condition of the modern soul.

The scandal of the *Medusa* episode arose over what was interpreted as the negligence or calculated cruelty of the ship's captain and officers toward the crew and passengers in cutting the lines connecting the overloaded raft with the lifeboats. This act provided ammunition for political foes of the Bourbon monarchy. Stories of mutiny and cannibalism persisted long after the event, which resulted in the death of

371. Théodore Géricault. *The Raft of the Medusa.* 1818–19.
Oil on canvas, 16′1⅜″ × 23′9″ (4.91 × 7.24 m). Louvre, Paris.

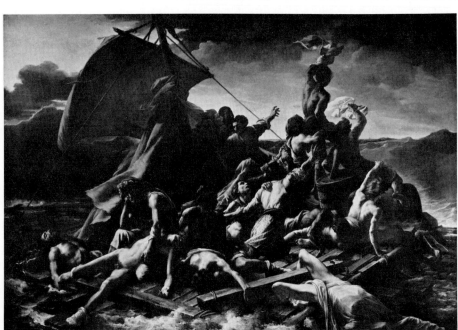

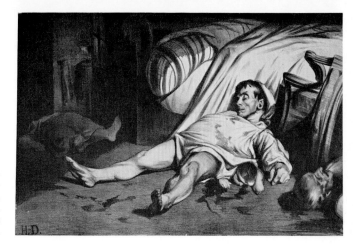

372. Honoré Daumier.
Rue Transnonain, April 15, 1834.
1834. Lithograph,
$11\frac{7}{8} \times 17\frac{1}{2}''$ (30 × 44 cm).
Metropolitan Museum of Art, New York
(Rogers Fund, 1920).

most of the unfortunates on the raft. While Géricault's motives for the painting may have been in part political and humanitarian, it afforded him the opportunity to prove his great gifts as an artist.

In the first half of the 19th century, the most significant change in art was in subject matter, and artists such as Géricault drew liberally upon the ideas and styles of older artists such as Michelangelo and Rubens. With the decline and fall of Napoleon, artists were confronted with the absence of an inspiring leader to celebrate in painting, and their shift of focus to humanity and its suffering and joys produced a new, humane art.

Synthesis of Symbol and Event Such vicarious reliving of romanticized past history did not always content Delacroix, who like certain others had strong egalitarian political views that did not accord with those of the rulers of France, and on occasion he used painting to express them. As a young artist, Delacroix had posed for one of the dead figures on Géricault's celebrated raft. From the slightly older man, he received the impetus to make a monumental history painting that would rival great Baroque compositions and yet do justice to the concerns of his day. His opportunity came during the Revolution of 1830, which led to the overthrow of Charles X and his replacement by Louis-Philippe. Originally titled by the artist *The Events of July,* the painting known as *Liberty Leading the People* (Pl. 24, p. 210) was meant to express Delacroix's hopes for a more enlightened government as well as to gain the ruler's favor. Though he was in Paris at the time of the uprising, Delacroix, like Géricault, relied on newspaper accounts, journalistic prints, and other visual sources, as well as on memory, for his painting of a skirmish that took place at a bridge connecting the Ile de la Cité with the Right Bank of Paris, with the insurgents successfully fighting off the government troops. Included was the Parisian boy of the streets who, while under gunfire, bravely retrieved needed ammunition from the dead troops and planted their flag. Delacroix's stirring painting, with its swirling smoke, vigorous movement, and strident red, white, and blue tones, synthesized the old and new while capturing the momentary nature of the event. From past traditions came the allegorical half-nude feminine figure symbolizing France and liberty; from the specific moment came the excitement of the place and participants, among whom Delacroix may have placed himself as a figure in a top hat. From Géricault came the pathetic motif of the naked corpses and the dense pictorial triangle, here climaxed by the heroic Amazon. The motif of the dying revolutionary looking up to the symbolic flag-bearing woman is a translation from a Napoleonic battle-field scene by Gros, in which a wounded enemy soldier gazes upward at Napoleon as if to a savior; similar expressions of this motif can be seen in Gros' *Napoleon Visiting the Pest House at Jaffa* (Fig. 320). Thus Delacroix was showing the transfer of allegiance from an individual leader to a principle or an abstract concept. This is very likely the last great painting in which an important artist frankly confessed his political activism and optimism in support of a government. Subsequent disillusionment with Louis-Philippe also made this Delacroix's last partisan painting.

The Artist as Political Critic At the cost of personal imprisonment and the official prohibition of his political caricatures, Honoré Daumier (1808–79) was the most outspoken critic of the French state. His thousands of drawings and prints taken from daily life make Daumier the first modern artist for whom the attitude "one must be of one's time" became a lifelong ideal. His lithograph *Rue Transnonain, April 15, 1834* (Fig. 372) is a stark disclosure of the murder of a worker and his family by government troops in retaliation for labor's defiance of the state. The print's title is taken from a tenement in Paris in which all the working-class occupants had been systematically slaughtered. Daumier grimly but subtly depicted the death of three generations.

As in the work of Géricault and Delacroix, Daumier's superb draftsmanship and style were predicated upon older art. The foreshortened corpse of the father is a reworking of past images of the dead Christ, and the artist must have known that this antecedent would not be lost upon a public that still read art in terms of art. The 19th century saw an increase in the practice of artists' adapting pictorial designs previously reserved for religious themes to the service of

more mundane values. This is a manifestation of the secularization of religion that had begun at the end of the Middle Ages, yet it produced a new and viable spiritual art. Whereas modern art has not celebrated directly the Bible and the Church, it has dealt sincerely with the life of the human spirit. Historically, the religion of humanity comes closest to explicit realization in the art of the last century.

Courbet and the Burial of Historical Painting It is ironic that the birth of modern art should be found in connection with themes of death. One of the most crucial paintings for the emergence of modern art, *Burial at Ornans* (Fig. 373) by Gustave Courbet (1819–77), deals ostensibly with a funeral ceremony near French provincial town. Gathered at the graveside are relatives and friends of the deceased, the priest and his assistants, and just entering the scene at the left are the pallbearers with the draped coffin. In the foreground, the grave digger kneels by the open grave. A leaden gray sky looms over the event. Such a routine daily ceremony would hardly seem to provide the basis for a painting that shocked its first Parisian audiences. In retrospect, one might say that more than just a coffin went into the open grave at Ornans. Earlier funeral paintings of religious (Fig. 169), historical, or literary figures had answered the implicit question of who died, as well as why and how. Painting some 50 life-size portraits of his neighbors, Courbet composed a huge canvas whose subject is the burial of an unidentified person dead of an unknown cause. Courbet provided most of the answer to the significant question of *what* died and was buried at Ornans:

> The art of painting can consist only in the representation of objects visible and tangible to the painter. An epoch can be reproduced only by its own artists. I mean by the artists who have lived in it. I hold that artists of one century are fundamentally incompetent to represent the things of a past or future century It is in this sense that I deny the existence of an historical art applied to the past. Historical art is by its very nature contemporary. (1861)

Figuratively speaking, one might say that Courbet cast into the grave the previous history of art, in so far as imitation was concerned. To be of one's time meant for Courbet that anything he had not seen for himself was ethically impossible as a subject. It was therefore the death of everyman that he painted. There is no suggestion of a life beyond the grave, no intimation of a soul or promise of ultimate ascent to Heaven. The one who died survives only in the memory of those left behind. The hero or protagonist is the enduring community. Ordinary men and women are the actors and actresses of history, and their costumes signify its change. Judged by the prevalent critical standards of art, which glowingly praised Ingres, Courbet's painting was a failure because nothing of consequence was being recorded, and there seemed to be no subject in the traditional sense and no moral. The figures seemed wooden, there was no carefully organized composition, and the thickly painted surfaces offended the eye of the contemporary public.

Courbet's style rejected any overt use of older pictorial compositional devices such as the pyramid, harmonious reciprocal physical movement, neatly drawn contours, and smoothly finished surfaces. The basic color range stresses the blacks and grays of the clothing and sky, against which are set the ruddy coloring of the grieved faces and various accessories of the clergy. The absence of conventional methods of ordering the figures resulted from Courbet's conscious desire to preserve the look of the unarranged. His subjects were not athletes, and he caught them in their unimpressive natural postures or movements. Color and an allover dispersal of strong accents were relied upon to hold the painting together. It is incorrect to say that Courbet cut himself off completely from the previous history of art (Fig. 24), for it is precisely the way he used the past that helps us to understand the attitude of so many modern artists:

> I have studied the art of masters and the art of the moderns, avoiding any preconceived system and without prejudice. I have no more wanted to imitate the former than to copy the

373. Gustave Courbet. *Burial at Ornans.* 1849.
Oil on canvas, 10'3⅞'' × 21'8¾'' (3.15 × 6.62 m). Louvre, Paris.

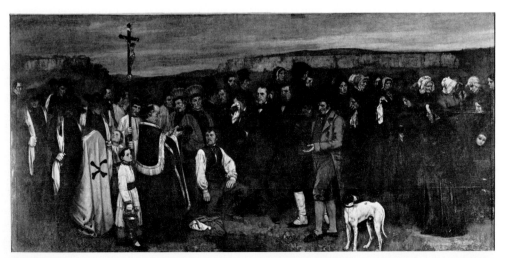

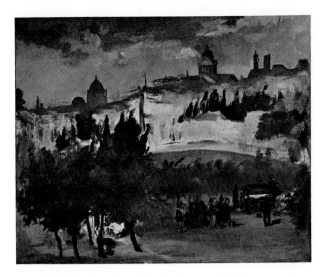

374. Edouard Manet. *Funeral in Montmartre.* 1870.
Oil on canvas, 28⅝ × 35⅝″ (73 × 91 cm).
Metropolitan Museum of Art, New York (Wolfe Fund, 1910).

latter; nor have I thought of achieving the idle aim of art for art's sake. No! I have simply wanted to draw from a thorough knowledge of tradition the reasoned and free sense of my own individuality. To know in order to do: such has been my thought. To be able to translate the customs, ideas and appearance of my time as I see them—in a word, to create a living art—this has been my aim. (1855)

The Modernity of Manet Edouard Manet (1832–83) manifested his respect for museum art as a means of discovering his individuality by drawing and painting copies of such artists as Titian (Fig. 237), Hals (Pl. 43, p. 316), and Velázquez (Fig. 17); yet in the 1860s and 1870s, he became the foremost painter of modern urban life. Like Courbet's, his style was distinctly personal, but inconceivable without the previous history of art. From the old masters he learned how colors worked together and the culture of the brush by which they were to be applied. His painting *Funeral in Montmartre* (Fig. 374) rejects the opportunity for sentiment

in favor of a remote viewpoint, treating the scene of a burial on a cloudy day as a pure painterly problem of matching tones of grays, blacks, and creams under given lighting conditions. As a result of this approach, it is impossible to focus for any length of time on the actual funeral procession, since our attention is pulled toward the deceptively shapeless areas of color, their stroking and nuances. In no painting that we have considered so far has the actual painting process rather than the theme dominated our awareness to a comparable degree.

Manet's generation—which included Degas (Figs. 380–382), Monet (Pl. 26, p. 243), Pissarro (Fig. 383), and Renoir (Fig. 384; Pl. 28, p. 244)—was disenchanted with artistic manifestations of political partisanship, piety, and strong emotional involvement. Their ideal was a detached confrontation of the world, with alert observation and wit. The act of painting alone was approached with passion by Manet. In comparison with the historical or literary compositions of Ingres or Delacroix, which were intended to be read as much as viewed, those of Manet were largely independent of literature and were grounded in his immediate environment. His painting had its validity in artistic rightness, in the handling of color and shape, and in their similitude to the world of aesthetic sensations.

The present-day fame of an artist such as Manet may mislead one into believing that he enjoyed similar repute in his own time or that he was representative of the art then being produced. Both by their numbers and according to the gauge of public approval, it was artists such as Thomas Couture (1815–79), Manet's teacher, whose work best represented the preferences of the public of that time. In the 19th century, academic and conservative rather than forward-looking art was the true mirror of social tastes. Couture's *Romans of the Decadence* (Fig. 375) was a commentary on the moral decline of modern Paris veiled in terms of antiquity. As long as Couture and other artists like him couched sex in a dead language, they were safe from

375. Thomas Couture. *Romans of the Decadence.* 1847.
Oil on canvas, 15′1″ × 25′4″ (4.6 × 7.72 m). Louvre, Paris.

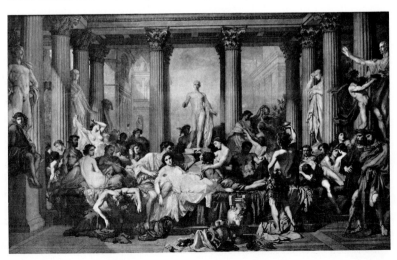

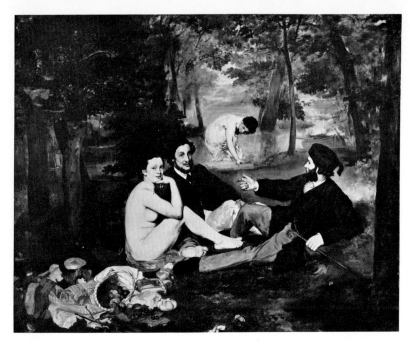

left: 376. Edouard Manet.
Luncheon on the Grass. 1862–63.
Oil on canvas,
7'3¾'' × 8'10⅜'' (2.15 × 2.7 m).
Louvre, Paris.

below: 377. Marcantonio Raimondi.
Judgment of Paris. c. 1520.
Engraving, 11⅝ × 17¼'' (30 × 44 cm).
Metropolitan Museum of Art,
New York (Rogers Fund, 1919).

critical and public censure. By contrast, Manet's *Luncheon on the Grass* (Fig. 376) created a scandal largely because it represented a contemporary scene. Relative to the animated goings-on of Couture's painting, nothing was happening between the sexes. Merely to have shown a naked woman in the woods might have been acceptable, but Manet had the effrontery to add two gentlemen dressed in contemporary fashion and to show his nude unreservedly eyeing the viewer. In one of his many witty inversions of the prevailing public taste, Manet clothed the woman bathing in the background and stripped the woman seated with her male companions, depositing her clothing in the foreground. In this vein, the painting was originally entitled *The Bather.*

Manet's painting forms an important bridge between the past and present. It is essentially a studio problem in which the artist synthesized landscape, still life, genre, portraiture, and the nude—at the same time making the painting appear a spontaneous encounter. He borrowed the basic compositional structure from a 16th-century engraving by Marcantonio Raimondi (Fig. 377), after a lost cartoon by Raphael, adapting from it poses and the triangular arrangement of figures. Notwithstanding this impressive legacy of different types of painting, Manet brought his eyes and aesthetic judgment to bear on his visual allusions in welding the whole together. The richest painting is in the still life, not in the faces. His desire for a more immediate visual impact and convincing optical effect led him to reduce modeling, sharpen silhouettes, and force us to discern his fine nuances of closely matched tones.

The absence of any dialogue or interaction among the figures removed a basic compositional prop, but it also enhanced the sophisticated character of the subject. With Manet, we begin to see the breakdown of psychological

reciprocation, the mutual awareness or exchange between figures in close proximity that, from the time of Giotto (Fig. 180), artists had developed into a high form of pictorial rhetoric. The detached air of his figures may have seemed socially appropriate to Manet, but it was also a reflection of his own attitude toward life. It was Emile Zola who said, in writing about Manet, that when looking at his work in order to appreciate what he was doing "one had to forget a thousand things about art." Since Manet, this has been the case with most of the leading painters and new art movements, for again and again the public has had to set aside or widen its notions of what art should be in order to understand what the artist has done.

Shortly before his death, the ailing Manet brought together in one great painting a number of refractory motifs that summed up what had been the source of his pleasures

378. Jean Auguste Dominique Ingres.
La Source. 1856.
Oil on canvas, 5′4½″ × 2′8¼″ (1.64 × .82 m).
Louvre, Paris.

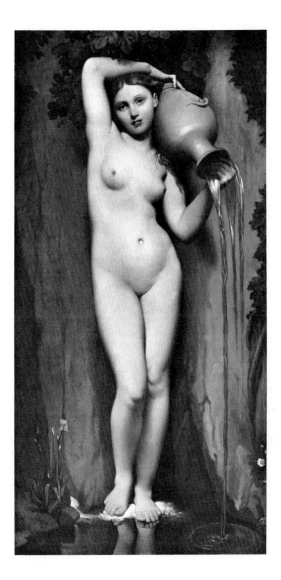

as a painter. *A Bar at the Folies-Bergère* (Pl. 25, p. 243) brings together a beautiful young girl, still-life objects on the bar, and the mirrored reflection of a world of sociability and diversion. For the first time in art, a mirror occupies the entire background of a painting. When the crowd is encountered in Manet, it is engaged in social pleasure rather than the enactment of fateful events. Manet's world is one in which no claims are made on the viewer; it is there to delight the eye, like the barmaid and her wares. The poetic depths of his painting lie not in psychological insights but in a subtle visual counterplay, in the contrast between the world seen directly and its mirrored reflection. The head of the daydreaming barmaid is the intermediary between the tangible objects of the foreground and the elusive optical effects of the mirror behind. What is behind the viewer, that is, what appears in the reflecting surface, tends to mingle with what is before the viewer's eyes, confounding the separation of the two spheres. Enigmatically, the reflection of a top-hatted man is caught in the mirror at the right—like a phantom image, for it is not meant to be the artist or anyone visible on our side of the counter, and the barmaid takes no notice of him. Her reflection is of another pose.

Further, the scene reflected in the mirror requires a viewer on our side of the counter, but there is no indication of any such person. Undoubtedly aware of these visual paradoxes, Manet quite likely preserved them intentionally to spice his painting.

The unheroic, undramatic nature of his paintings has led to the mistaken view that Manet had no real interest in subject matter. For the discriminating and aristocratic sensibilities of Manet, Paris was essential to his art—a city whose provision of worldly pleasure caused Balzac to describe it as a "great consuming eye." Manet's brush needed such an inspiring motif. Without disguising its traces, his brush re-created the handsome wine bottles, the ripe orange color of the fruit, and the elegant cut and softness of the woman's costume. These subtle effects of color and light and texture could not be captured in a drawing, for, like Courbet, Manet sought what was only possible in painting. The problem of distinguishing so many reflecting surfaces was one for a master painter. Concern for actual perception induced Manet to cut off the trapeze artist and leave only her legs at the upper left. Here is the mirror image of the visible world, perceived by the human eye to be blurred and obscure. It was in the 19th century that painting as a whole most faithfully approximated the true experience of vision.

New Candor toward the Body For conservative artists such as Ingres, the worth of any painting other than a por-

trait depended in large part on its choice of subject and its affinity with approved styles of the past; but for Manet, as for his Dutch predecessors in the 17th century, it resided in *how* any subject was painted. Ingres could not content himself with frankly painting an anonymous naked model in the studio, for by training he was compelled to add accessories and a title from literature or mythology to appeal to the beholder's intellect and good taste. For many, Manet's painting of a barmaid seen with wine bottles lacked the intellectual value and dignity of an Ingres nude, such as that posed holding an antique vase and titled by her creator *La Source* or *The Spring* (Fig. 378). Ingres' passion was to purify the silhouette of the female body, which accounted for his adaptation of an antique pose identified with beauty. Omitting the prop of the Classical urn would have lowered or even vulgarized the final painting in his eyes. To be of

one's time meant, for Ingres, to accept the timeless beauty of ancient and Renaissance art, as acknowledged by the public and most of his fellow painters. Thus one might say that his ideal was, in essence, to be of another time.

When Ingres wanted to show the naked bodies of women bathing, he garbed them with remote identities; he depicted them in the manner of *La Source* or as nymphs or harem girls in the exotic Near East or North Africa. With Daumier, instead, the act of bathing was divested of its exotic and erotic associations to become a mundane act of hygiene and even of comedy. Daumier's *The Hot Bath* (Fig. 379) was inspired by the Parisian ritual of hauling boiling water up flights of stairs to one's flat, pouring it into a tub, and then immediately immersing oneself in the scalding depths to obtain the maximum thermal benefit. He shows the prudent but agonizing bourgeois stoically lowering himself into the boiling water and elevating his nose in an expression of his divided instincts and notions of Heaven and

Hell. The dramatic agony of the Christian martyr was thus humorously supplanted by the discomfort of the anonymous modern Parisian apartment dweller.

When Edgar Degas (1834–1917) shows us a woman bathing, it is like a glimpse through a keyhole, for unlike the perspective of Ingres and Daumier, which is that of the Renaissance, his viewpoint is close to and above the bather (Fig. 380). This Degas pastel drawing is but one example of his disenchanted view of women. Our closeness to the figure, which Renaissance theorists such as Alberti warned against, tends to produce curious foreshortenings, emphasizes the body's awkwardness and angularity, and in general defeats the ideal of feminine beauty that Ingres strove to draw and paint. Degas saw washing as a hygienic act that an animal could perform; thus he dwelt on the woman's struggle to contort herself into the meager basin.

Degas gave up formal art-school training after two years and, like many other independent painters, continued his education on a personal basis, by making copies in the Louvre. His desire was to honor the lessons learned from Giotto and other great artists of the past while painting the contemporary Parisian scene. Art was for him a personal fusion or resolution of contradictions, the intellectual and the sensual, and a love for drawing and color. It was in his pastels that these last two found perfect union. While he admired fixity of pose in certain aspects of traditional art, he could not bring himself to render static postures. If Manet has preserved for us the tones of his time, Degas has captured its movement. Rejecting the academic repertory of approved body movements, he drew from both the practiced and the unthinking, routine gestures of his subjects as performed in their day-to-day existence. These gestures tended, as in his bather, to stress the purely physical activity rather than the intellectual and emotional life of his subjects, who were often chosen from the lower classes.

Degas and a Modern Viewpoint *The Cotton Broker's Office in New Orleans* (Fig. 381), with its institutional green walls and customary business gestures of men in black suits or shirt sleeves, exemplifies what being of one's time meant for Degas. Many of the figures are members of the New Orleans branch of the Degas family, whom he visited in 1872, so that the painting is a modern group portrait or genre scene whose daring informality is a 19th-century counterpart of Rembrandt's innovations in *The Syndics* (Fig. 286). The spatial construction is from the viewpoint of someone actually in the brokerage office and standing in a

above left: 379. Honoré Daumier. *The Hot Bath.* 1839.
Lithograph, 8½ × 10⅞'' (22 × 28 cm).
Minneapolis Institute of Arts
(gift of Mrs. C. C. Bovey, 1924).

left: 380. Edgar Degas. *The Tub.*
Pastel on cardboard, 23⅞ × 32⅞'' (61 × 84 cm).
Louvre, Paris.

left: 381. Edgar Degas.
The Cotton Broker's Office in New Orleans.
Oil on canvas, 28⅜ × 35⅜'' (72 × 90 cm).
Musée des Beaux-Arts, Pau, France.

below: 382. Edgar Degas.
Absinthe Drinkers. 1876.
Oil on canvas, 36¼ × 27'' (92 × 69 cm).
Louvre, Paris.

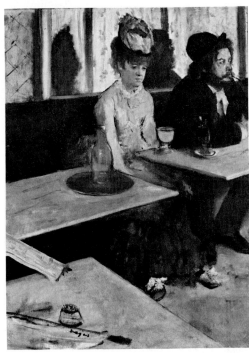

corner, so that the room moves diagonally away from us into depth. Degas would not compromise the conditions of actual vision for the artificial frontal perspective of the Renaissance, with its location of the viewer at a greater distance from the foreground figures. Faithfulness to the idiosyncrasies of his vision led Degas to overlap his figures, and disdain of the formal caused him to pose his relatives and their business associates in suitable and unselfconscious poses. Because of its fidelity to an American business office, Degas had hopes (unfulfilled) that the painting would be purchased by some English or American industrialist.

In the prodigious output of Degas there is an unmatched visual record of contemporary theater and ballet, rehearsal halls, café life, horse racing, modish shops, brothels, and laundries—in sum, the world of diversion and artifice, its places of performance and of preparation, and those whose professional talents made the Parisian spectacle possible. Paradoxically, though professionals of the lower classes fascinated Degas, who memorized their specialized gestures, he showed no sympathy or feeling toward them. Some expression of warmth occurs only in his print of prostitutes celebrating the birthday of the madam. The psychological isolation of people in public has been captured in Degas' *Absinthe Drinkers* (Fig. 382), which was mistakenly interpreted in Victorian England as an indictment of the debilitating effects of alcohol. Degas was not a social critic, but rather a sharp sociological observer of his time. For *Absinthe Drinkers* he posed an artist friend, Marcel Desboutin, and his wife. Their divergent and distracted expressions convey the boredom that afflicts café-goers who consistently rely for enjoyment upon chance public encounters. This fidelity to visual experience meant that new compositional forms had to be evolved, and in 19th-century art such as that of Degas, the viewpoint from which the picture was made became the most specific in the history of art. The spectator functions as a definite part of the scene, and the remoteness of the stage construction seen in David and Ingres has disappeared. The second phase of the modern revolution, occurring roughly between 1850 and 1885, was the radical change in form that accompanied the changes in subject matter. Degas did not place the figures at the painting's center, or even to left or right of center, as a Renaissance or Baroque portrait painter would have; he located them eccentrically to the upper right, as if toward the periphery of our field of vision. Degas thus contributed to the devaluation of the painting's center as the prime location for a subject and, consequently, to the upgrading in visual importance of the peripheral field.

The Spectacle of Paris For Degas and Manet, painting continued to be figure-dominated. Degas did few landscapes and no still lifes or panoramic city views, but preferred instead indoor subjects under artificial light. It was Monet, Pissarro, and Renoir, the open-air painters, who interpreted the great outdoor spectacle of Paris itself. Under Louis Napoleon, numerous boulevards were built in Paris

after 1850 to let in "light, air, and infantry." When Claude Monet (1840–1926) painted *Rue Montorgueil, June 30, 1878* (Pl. 26, p. 243), he did so out of a love for flags and not to evoke the historical source of the holiday. Rather than depict the barricades of the past, he reveled in a contemporary flag-bedecked Paris boulevard seen from a window. Unlike Delacroix (Pl. 24, p. 210), Monet did not deal with historical painting in terms of violent heroic military action, but rather as the thrilling aesthetic experience of sunlight playing over a city street transformed by red-white-and-blue decoration. To the public of his day, it appeared that Monet suffered from an eye disorder, for they were not accustomed to seeing in painting what they saw ordinarily from their own windows. From Monet's elevated and remote viewpoint, the street and flags dissolved into countless individual sensations of light and color. Each touch of his brush gave their equivalent, and the purpose of his discontinous touches was to reproduce the scene's brilliant shimmer. Figures observed in the street were reduced to disconnected spots of dark color, which were captured on the canvas by masterly single strokes. The depersonalization of the urban crowd is explicable on the basis of the remote physical perspective of the artist. In disengaging his strokes from a uniform fused mass, Monet was being visually honest—that is, seeking to convey true empirical perception—but he was also calling attention to the independent existence of the touch of color applied *on* the canvas. Paradoxically, he created both an overall illusionistic image and its opposite effect, a random disposition of colors over a flat surface. It is this allover pattern and roughly equal density of the strokes that weaves the compositional fabric. The new intensity of Monet's color, born of a desire for consistency with visual appearance, was to impress later artists such as Seurat (Pl. 29, p. 261) and Gauguin (Pl. 30, p. 261) with its emotional, symbolic, and decorative possibilities.

The later boulevard views of Camille Pissarro (1830–1903) capture the free and unpredictable ebb and flow of city traffic (Fig. 383). Mobility was for the Impressionists a satisfying sign of modernity, and the physical transformations that did much to beautify and mobilize Paris after 1850 were joyfully celebrated rather than criticized in their paintings. The Impressionists, unlike Degas and Manet, painted directly from their subject on the spot and relied upon their thorough artistic training to compose with great rapidity a perfect painting. Pissarro makes no attempt to contain precisely or to centralize the subject, and like our field of vision, the painting's borders trim the scene on all sides, so that we are made strongly aware of seeing only a segment of a larger fluctuating world. Because there is no horizon line, the street appears to parallel the painted surface, thus accentuating the ambivalence between spatial depth and the picture plane.

Pierre Auguste Renoir (1841–1919), who was more committed to the figure because of his academic training, tended to personalize his street scenes more than Monet and Pissarro did, so that some figures retain their identity. His paintings are sometimes treated as if focused on one spot, such as a woman standing next to him, and the rest of the image slips into a blur that is analogous to peripheral vision. This change in social and optical focus can be appreciated by comparing Renoir's *Place Clichy* (Fig. 384)

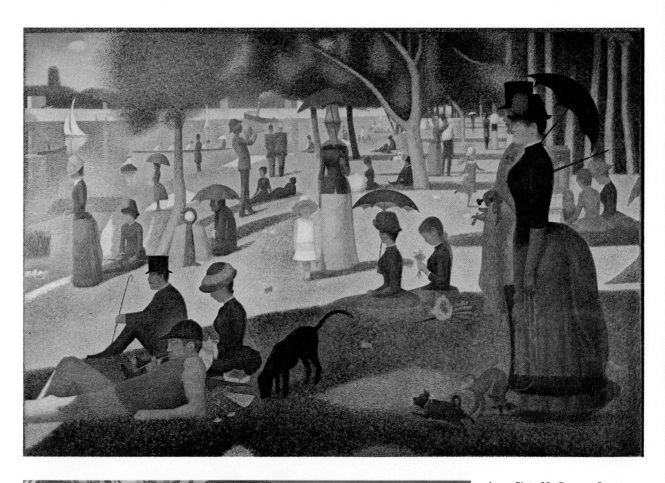

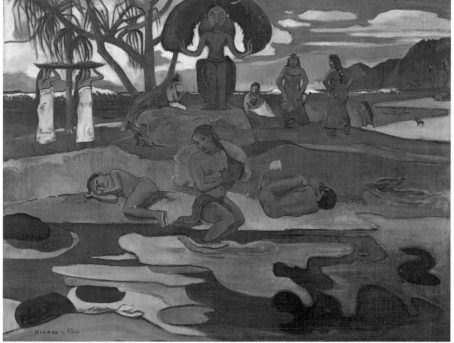

above: Plate 29. Georges Seurat.
*Sunday Afternoon on the Island
of La Grande Jatte.*
1884–86. Oil on canvas,
6'9¼'' × 10'¼'' (2.06 × 3.05 m).
Art Institute of Chicago
(Helen Birch Bartlett
Memorial Collection).

left: Plate 30. Paul Gauguin.
*The Day of the God
(Mahana no Atua).* 1894.
Oil on canvas,
27⅜ × 35⅝'' (69 × 90 cm).
Art Institute of Chicago
(Helen Birch Bartlett
Memorial Collection).

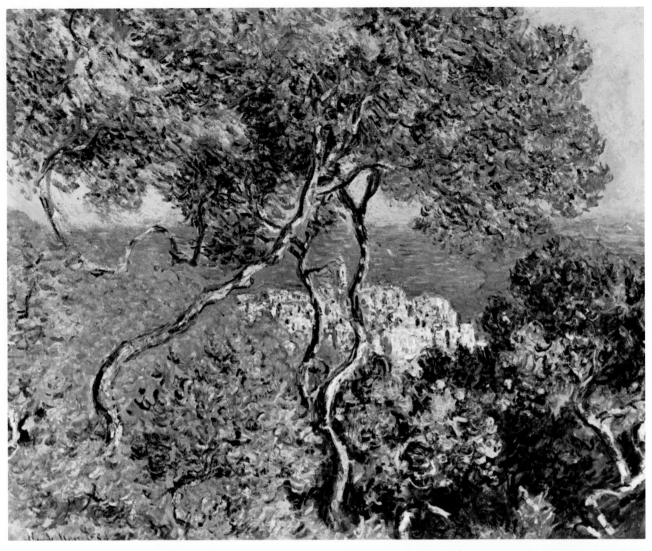

above: Plate 31. Claude Monet. *Bordighera Trees.* 1884.
Oil on canvas, 25½ × 31¾″ (65 × 81 cm).
Art Institute of Chicago (Potter Palmer Collection).

opposite above: Plate 32. Nicolas Poussin.
The Funeral of Phocion. 1648.
Oil on canvas, 3′8½″ × 5′8¼″ (1.13 × 1.73 m).
Private collection, Oakly Park, England.

opposite below: Plate 33. Paul Cézanne. *Mont Sainte-Victoire.*
1885–87. Oil on canvas, 26⅜ × 36¼″ (67 × 92 cm).
Courtauld Institute Galleries, London.

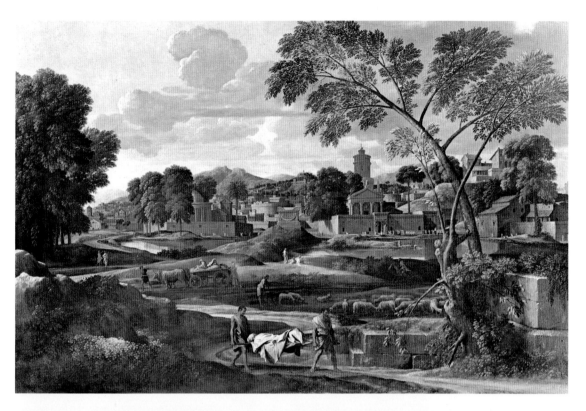

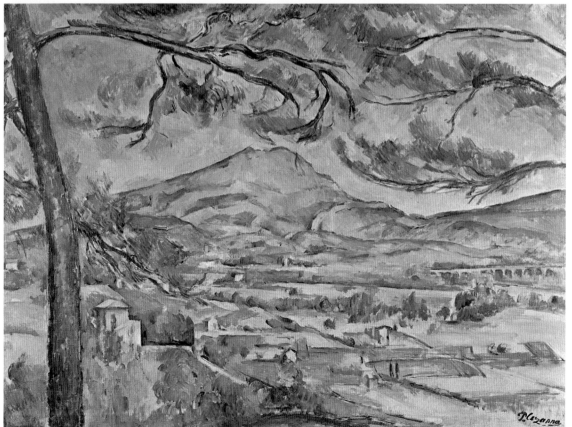

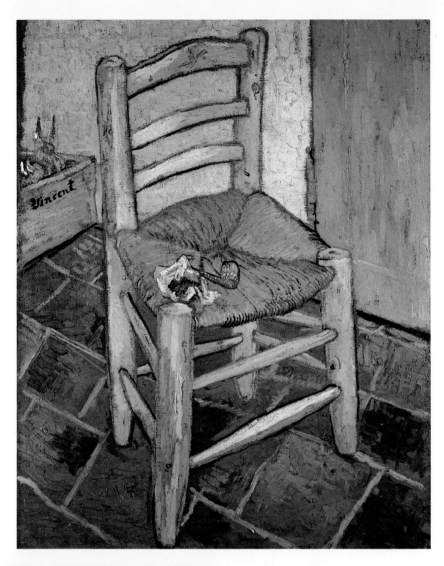

above: Plate 34. Vincent van Gogh.
The Chair and the Pipe. 1888.
Oil on canvas, 36⅛ × 28¾'' (92 × 73 cm).
National Gallery, London
(reproduced by courtesy of the Trustees).

left: Plate 35. Paul Klee.
Botanical Theater. 1934.
Oil and watercolor,
19⅝ × 26⅜'' (50 × 67 cm).
Collection Mrs. K. Bürgi,
Belp, Switzerland.

with Daumier's *The Uprising* (Fig. 385), which is dated about twenty years earlier and shows rioting figures on a Paris street. The Impressionists had political convictions but kept them out of their paintings. Daumier continued the militant partisanship that characterized advanced painting of the first half of the century, and he translated the crowd at least in part into individuals—in fact a family. Though the work is unfinished, the drawing of the heads shows that Daumier intended all to be in focus. For the Impressionists,

the new boulevards constructed between 1850 and 1870 were not to be shown as battlegrounds or parade sites, but as the loci of the truly Impressionist experience; they were to be places where one walked casually and without destination, responding to aesthetic perceptions such as the sight of beautiful women, sunlit trees, and elegant shops. From Impressionist painting such as that of Renoir, one could never glean Honoré de Balzac's famous lines about Paris: "Paradise for women, Purgatory for men, Hell for horses." Moreover, Impressionist painting, unlike large-scale historical painting, was intended primarily for middle-class homes.

At the end of the century, Pierre Bonnard (1867–1947) printed a beautiful screen, patterned as an object and partly in style after Japanese art, whose subject was a Paris square (Fig. 386). Influenced by the late-19th-century Paris Shadow Theater performances, in which silhouettes were illuminated on a screen, as much as by Japanese prints, Bonnard presents the flattened cut-out shapes of a row of horse-drawn cabs and three cloaked women at the top of the screen and below the figures of a woman and child seen

left: 385. Honoré Daumier. *The Uprising.* c. 1860.
Oil on canvas, 39¾ × 42⅞″ (100 × 109 cm).
Phillips Collection, Washington, D.C.

below: 386. Pierre Bonnard. *Paris Square.* 1897.
Four colored lithograph screen panels, 4′6″ × 1′7″
(1.37 × .48 m) each. Museum of Modern Art,
New York (Abby Aldrich Rockefeller Fund).

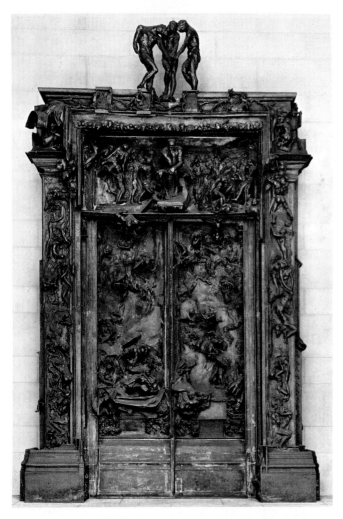

387. Auguste Rodin. *Gates of Hell.* 1880–1917.
Bronze, 18 × 12′ (5.49 × 3.66 m).
Rodin Museum, Philadelphia.

tion, natural illumination and shadows, as they were tradi-
tionally used to achieve illusion, all began to be ejected
from progressive art. The stress was now upon artifice, on
the treated surface itself. Both at the beginning and at the
end of the 19th century, artists believed style was every-
thing, that is, the essence of art; but for David and Ingres,
this implied an imitation of Classical and Renaissance
styles, whereas for Bonnard and Toulouse-Lautrec, it meant
the expression of a highly personal style.

The Gates of Hell The single most important work of
sculpture in the 19th century was the *Gates of Hell* (Fig.
387) by Auguste Rodin (1840–1917). Rodin is repeatedly
referred to as an Impressionist sculptor, though such a
statement is highly inaccurate. In this gigantic portal, he
shows a view of society and a manner of realizing form that
directly oppose the goals of the Impressionists. Mounted on
an architectural frame inspired by great Gothic portals (Fig.
112) and Renaissance doorways are almost two hundred
naked figures who enact the artist's tragic vision of human-
ity disillusioned and frustrated but relentlessly driven by
passion. Rodin sought to rival medieval sculptors (Fig. 79)
and also Michelangelo (Fig. 213) by presenting an epic
image of the spirit in distress, past and present. The three
naked figures atop the *Gates* were deprived of hands to
suggest the futility of resistance to death. The tombs at the
base of the doors announce that the drama above them
takes place in the afterlife. Presiding over the dismal scenes
of fruitless striving sits, not Christ, but *The Thinker*—Rodin's
symbol of the artist as both judge and prisoner of his own
time, as one gifted with intelligence but cursed with pas-
sion. Thus man has replaced his god on the cross of suffer-
ing, and death brings neither celestial solace nor the fires of
Hades—only eternal movement. Bereft of ideals, the aim-
less mobs and the individuals of the portal know unity only
through despair and loneliness. Man carries within him the
eternal divergent goals of longing and dissatisfaction, so that
Hell for Rodin is not a drama of place, but one of people.
The lack of apparent order or composition contrasts with
medieval Last Judgments (Fig. 79), and it reflects Rodin's
disbelief in the theological view of the world, as supported
in thought and composition by such predecessors as Mi-
chelangelo. Rodin sought also a decorative ideal that abol-
ished traditional boundaries between sculpture and archi-
tecture. He made the naked human form respond to a host
of feelings through gesture and movements that had no pre-
cedent in the history of sculpture. These derived from ob-
servations of the living model, and as a psychologist of the
body, an observer of instinctive gesture, and an interpreter
of flesh, Rodin had no peer.

Rodin's *Gates of Hell* is a great work of art despite its
being unfinished in terms of Rodin's dissatisfaction with its
architecture. Rodin likened the state of *Gates of Hell* to the
incompleteness of cathedrals. He worked on the project
from 1880 until 1900, which implies that its imperfections

against a great empty space. The shimmering Impressionist
colored mosaic had given way to large monochromatic
shapes and the consequent emphasis on flat surface pat-
tern. The third phase of the modern revolution continued
with subjects already established, but these were now given
new meaning through new formal ideas. Art began to shift
away from imitation of nature and to stress the unnatural.
By inventiveness of personal style, the artist made the famil-
iar seem unfamiliar. The rightness or veracity of the work of
art was not determined by matching it against a specific
place and moment, but by its internal coherence of color
and shape and their emotive appeal. The imperative of in-
dependent artists after 1885 was to explore deliberately the
expressive possiblities of the materials of art themselves,
such as line, shape, color, and surface organization. The
Impressionist fleck of color had been expanded to a larger,
firmly bounded flat color area; illusionism was abandoned,
but representation remained. Modeling of forms, rational
perspective, nuances of light and dark or of value construc-

related to the protracted, living process of its origin. This epic could no more assume the appearance of fixed order than Rodin's sculptures of individual human forms (Figs. 473, 475, 479) could betray conscious stylization. His aim was to achieve the natural in form and meaning; the closer he came to this goal, the less obtrusive could be his system of work. It might be argued that his *Gates* are not art, but life itself—a vast collection of beautiful parts that nevertheless are valued as a single incomparable whole.

Painters of Personal and Social Crises From the works of the second half of the 19th century that we have looked at, one might derive the notion that advanced painting was entirely devoted to depicting a second Eden on earth. While this was true of Impressionism in France, there were prophetic developments of a different, grimmer nature in other countries. The ugly, hostile aspect of city life, never as-

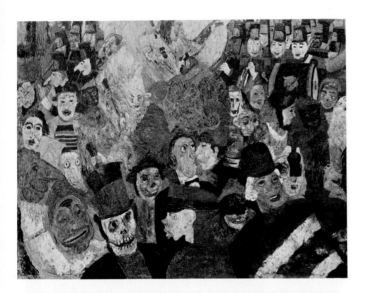

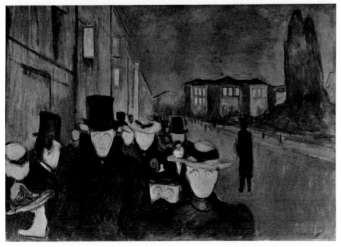

sessed by painters such as Monet, was measured out by the Belgian James Ensor (1860–1949) and the Norwegian Edvard Munch (1863–1944). Ensor's *Entry of Christ into Brussels* in 1889 (Pl. 27, p. 244) is a bitter commentary on society's perversion of a religious event into a vulgar carnival; the painting reflects the artist's personal disillusion and feeling of alienation from society. Ensor identified with Christ and felt that he himself had been unjustly evaluated and persecuted by the public and critics after his youthful acclaim as the savior of modern Belgian painting. The actual events that Ensor witnessed in the streets of Ostend and Brussels, in which political factions assailed one another verbally and physically, became the basis of this personal metaphor. The inconspicuous figure of Christ at the painting's center is drowned in waves of grimacing masks (Fig. 388) and commercial slogans. Ensor was probably influenced by the vernacular art of the contemporary Belgian marionette theater—by its sets, masks, and aggressive action, which included caricatures of religious themes. He had also seen Seurat's painting of the *Grande Jatte* (Pl. 29, p. 261), and he may have been inspired to redo such French paintings of communal sociability. The airy openness of Monet's boulevard has been replaced by a claustrophobic crowding of the street. The subtly inflected touch of Monet's brush contrasts with Ensor's assaults on the painting surface, his violent twisting and streaking of thick pigments. Ensor brought to his paintings sharp insights into the psychology of crowd behavior under conditions of extreme stimulation and the resulting loss of inhibition. The masks become initmate revelations of the depravity inherent in their wearers. Ensor compulsively jammed every inch of the painting with distasteful, hostile figures, thereby weakening the total composition. The painting is important mostly for the arresting qualities and expressive power of its details, as the means by which Ensor brought to art a frank self-realization in his harsh themes and brushwork.

In Munch's painting *Evening on Karl Johan Street* (Fig. 389), the crowd is divested of its individual identity and given no attributes of human warmth. Through magnification of psychological overtones, the faces have become dehumanized, presenting less expression than the blank windows, which are given an exaggerated treatment that makes them seem to pulsate. While the street pulls the eye strongly into depth, physical passage is actually blocked by the phalanx of the crowd. This is a painting whose true subject is anxiety over one's place in a menacing world. Munch imparted to his paintings psychotic distortions of

above left: 388. James Ensor.
Detail of *Entry of Christ into Brussels*
(Pl. 27, p. 244).

left: 389. Edvard Munch.
Evening on Karl Johan Street. c. 1892.
Oil on canvas, 33¼ × 47⅝″ (.84 × 1.21 m).
Rasmus Meyers Samlinger, Bergen, Norway.

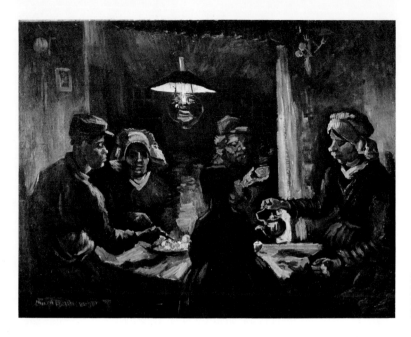

390. Vincent van Gogh.
The Potato Eaters. 1885.
Oil on canvas, $32\frac{1}{4} \times 44\frac{7}{8}''$ (82 × 121 cm).
National Museum Vincent van Gogh, Amsterdam.

the color and shape of familiar objects—faces, trees, the rooftops, the sharp recession of the street. In previous art, the distressed individual was seen within the painting as if perceived by a rational onlooker; with Munch, however, the total environment of the painting is colored and shaped by the subjective state of the artist. Though influenced by Scandinavian writers of the time such as Strindberg, Munch's insights, like those of Ensor, derived in large part from personal crises. In no previous period had the artist's personal uneasiness in society been so frankly painted.

The End of Conversation Painting The themes of sociability so prevalent in 19th-century painting were not new to the history of art, as was evidenced in the discussion of the table in art of the 16th and 17th centuries (Chap. 10). Common and crucial to Baroque table paintings was the demonstration by the subjects of their awareness of others, and pictorial composition was supported by connecting figures through their gestures and facial expressions. Renoir's *Luncheon of the Boating Party* (Pl. 28, p. 244) continues, and brings to a glorious culmination, this theme and its sophisticated rhetorical devices. The last of the great conversation paintings, its subject and form strongly depend upon people clearly manifesting their mutual awareness. In subsequent paintings by other artists, people reveal a diminishing (or nonexistent) sense of mutuality or personal interaction. Renoir, who was cognizant of older art, once again brought the table to life and depicted his friends enjoying the delights of good food and drink, the countryside, and one another's company. The painter's bride-to-be is seen at the lower left, playfully occupied with her dog. Across the table is the artist Gustave Caillebotte, whose posture of sitting on a chair that is turned backward and whose sportsman's shirt did not accord with conservative

notions of decorum either in public or in art. As in 17th-century Dutch and French paintings, Renoir gives us a history of the commonplace. The moral of his painting, which was that of Impressionism on the whole, was to be yourself. The painting's colors are mostly red, white, and blue for festive rather than for patriotic reasons. It is worth the viewer's attention to examine how each color is varied throughout the composition, thereby tying objects, figures, and setting into a radiant, harmonious whole. Just as the subjects manifest complete relaxation, so is the beholder enjoined to savor at leisure such beautiful passages of the painting as the still life on the table or, as Renoir had learned from Rubens (Pl. 44, p. 333), the delights of contrasting colors and textures in a beautiful woman's dress, hat, and flesh. Renoir would soon abandon such themes of informal diversion and the Impressionist style in favor of conventional subjects involving nudes. He treated these with a tighter surface finish and firmer modeling, so as to align his work with the more disciplined masterpieces of the past.

The Family in Life and Death When Vincent van Gogh (1853–90) painted his *Potato Eaters* (Fig. 390), he was living in one of the poorest areas in Europe, where he found his subjects in Dutch peasants. His dark tones matched the character and mood of his grim environment. In this painting, he showed his reverence for those who lived by what they could retrieve from the reluctant soil of Brabant. The solemnity of the figures around the simple table and its humble fare evoke memories of religious paintings of Christ and the disciples (Fig. 277; Pl. 19, p. 176) or the partaking of Communion, and this analogy may well have been in Van Gogh's mind. The cheap religious print hanging on the wall is an attribute of the peasants' piety. Living more poorly than his parish during this missionary period in his life, Van

Gogh had failed to win their respect as a preacher, and it was only with difficulty that his subjects were persuaded to pose individually for him. Self-trained as an artist, he had not learned how to interweave gracefully the glances and movements of his figures in the manner of even the most mediocre academic student, let alone with the skill of Renoir. Van Gogh fiercely asserted the individual identity of each peasant in his portraiture and captured that sense of angular movement conditioned by hard physical labor, but he also achieved a feeling of their sharing in the fruits of common toil. The glow of the oil lamp served to illuminate their faces, but also to endow them with a sympathetic radiance. Van Gogh had become disillusioned with the orthodox church, and he came to believe that those deserving of reverence were not the saints of the past but the humble plowmen, "all those who wear the stigmata of a whole life of struggle, borne without ever flinching." Distrustful of his memory and of painting pictures of unseen subjects, he believed that the Bible could best be illustrated in the guise of the men and women of his own time and place. Once again, the secular subject of figures at a table acquired religious overtones.

Munch was in some ways a Norwegian Van Gogh, and he created a *Frieze of Life* that dealt, in paintings and prints, with ordinary men and women and the crises with which they were continually confronted in life. It was patterned after the great painting cycles of the past that recorded the life of Christ, the Virgin, or saints. Like Van Gogh, Munch endured great personal suffering and sought to transform himself through art. The anguish of others became a metaphor of his own. In his *Death in the Sickroom* (Fig. 391), the theme of tragedy and death that was so prevalent at the century's beginning returns, but now it strikes nameless victims and is presented in a homely setting. Based on his own

sister's death, the print is like a modern version of the medieval *memento mori* (Fig. 155), except that Munch's focus is now upon the great grief that each of the living must bear. The stark use of black and white and the strong outlining of silhouettes sharpen the sense of sorrow's containment and the unbridgeable isolation of the individual in such moments of crisis. For Munch, Impressionism was too superficial an art to deal meaningfully with feeling and suffering in life. Like Van Gogh, he desired to endow men and women with that quality of holiness formerly imparted by the halo and to induce the viewer to remove his hat before such paintings as if he were in church. Both artists continued, and carried further, a tradition of more than four hundred years standing of humanizing the sacred and saintly. Unlike more financially successful conservative artists who repetitiously exploited the formats and devices of older religious art, Munch and Van Gogh created inspired paintings and prints out of their strong, genuine feelings for their fellow human beings, hoping thereby to unify people as they had been unified by the organized Church.

The Good Life of the Past and Present The abstract, idealized art of the 19th century was not provided by progressive painters but by artists such as Pierre-Puvis de Chavannes (1824–98) who championed conservative values of history and culture. Admired as the most important painter of his time by artists of widely differing convictions and tastes, Puvis continued the tradition of making paintings intended as symbols of an entire cultural epoch and civilization. He did not consider 19th-century society worthy of or appropriate for such treatment in painting. When he was commissioned to decorate the museum in Lyon, Puvis chose to interpret abstract concepts of what Lyon meant in antiquity, for him the golden age in that city's

391. Edvard Munch.
Death in the Sickroom. 1896.
Lithograph, 15½ × 21½″ (39 × 55 cm).
Munch Museum, Oslo.

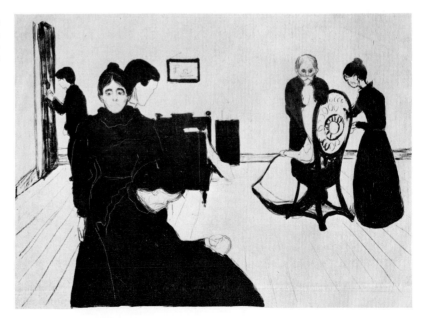

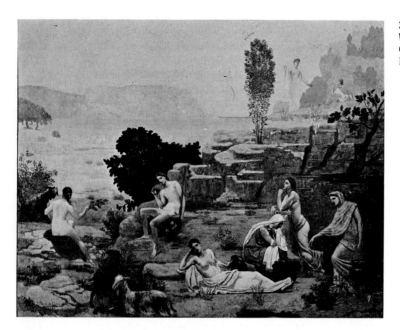

392. Pierre Puvis de Chavannes.
Vision Antique. 1885.
Oil on canvas, wall size.
Musée de Lyon.

history. His *Vision Antique* (Fig. 392) was to decorate a museum room filled with ancient Greek and Roman works of art. The painting was not based on actual history, and unlike David (Fig. 368), Puvis was unconcerned with action. Instead, it is his imaginative evocation of the beauty and serenity of the region's countryside and population. In effect, he was painting life as it ought to have been and should be. The viewer was expected to ponder the intellectual premises of the painting. Each figure is distinctly isolated and shown in a reflective mood in a landscape setting that itself encourages meditation. A dominant tone of cool gray establishes the remoteness of the scene and reflects the painter's disdain for the strong color and taste for outdoor immediacy found in Impressionism. Puvis' painting illustrates art governed by rational notions of what art ought to be. Such was the artist's divided personality that he produced the most gruesome and sadistic private drawings in French 19th-century caricatural art.

When Georges Seurat (1859–91) undertook a large painting in the same years that Puvis was working on his mural, he too dealt with an eternal, idyllic life, but it was that of the weekly holiday outing enjoyed by the working classes, not as portrayed in an imagined Greek setting but on an island in the Seine in northern Paris. In his *Sunday Afternoon on the Grande Jatte* (Pl. 29, p. 261), Seurat's personal vision transformed a prosaic event into a poetic occasion. What seems at first to be a gathering of familiar persons in a mundane setting becomes the source of a haunting paradox. While outwardly appearing to share in the enjoyment of the place and moment, the figures do not communicate. The gaiety of the moment derives essentially from the warmth and brightness of the colors, not from ex-

pressive traits of the figures themselves. Ignoring the potential for movement, Seurat chose to present what might be termed still*ed* life. Seurat believed that monumental painting such as that of Piero della Francesca (Fig. 200; Pl. 12, p. 124) required keeping gesture and movement to a minimum and, moreover, that a valid composition could be achieved without conventional psychological and emotional rhetoric.

The landscape is painted from a single viewpoint, but each figure within it is rendered from an individual perspective, as if the artist were directly opposite each of his subjects. Seurat restored to advanced painting the monumental size and impressive volume of the figure that Impressionist painting had gradually destroyed. The shadows cast by the sun do not accord with a single light source. Convincing as the intensity of sunlight is, the painting was done in the studio by artificial light, for unlike the Impressionists, Seurat had an explicit theoretical basis of working. He distrusted the intuitive and spontaneous. Despite the apparently informal dispersal of the figures, none can be shifted from its position. A taut compositional scheme is contrived by the relation of silhouettes and aligned shapes that link foreground, middle distance, and background. The whole painting has the fresh appearance of instantaneous execution, but each silhouette was meditated upon in extensive preliminary studies and purged of the superfluous. For his purposes, Seurat's edges are more expressive than his faces. The large, solemnly static figures are, ironically, constituted of minute, volatile touches of color. A strict systemization of Impressionist color style, Seurat's aesthetic of meticulously divided strokes of color ensured each color's brilliance by adjoining it with its optical complement—

yellow with violet, red with green, and so on. His stroke varied in size and direction, depending on the shape he was painting and the scale of his canvas. By contrast with the work of Munch, Seurat's distortions were objective and were grounded in consciously formulated aesthetic theory. Seurat achieved an air of the casual through minute calculation. From the recurrent, uneventful moments in the life of mundane city dwellers, he created an impression of the eternalized and heroic.

Primitivism and the Good Life The most famous independent artist of his day, who found that he could better be of his time in Polynesia than in Paris, was Paul Gauguin (1848–1903). In previous centuries, artists frequently left their own countries and traveled for purposes of study (often to Rome, as has been pointed out), but in most cases, they eventually returned to their home country. Gauguin left Paris for the South Pacific for the first time in 1890 for various reasons, one of which was economic. Also, Paris seemed to him to suffer from an excess of civilization— and from an inadequate appreciation of his gifts. Among the Polynesian natives he sought the simple evidence of the true meaning of life and religion, but nonetheless he looked at his subjects through the eyes of a sophisticated and Christian European artist who sought to sell his works in France. Much of what he painted was dependent upon visual encounters, on remembrances of Parisian painting such as that of Seurat or Puvis, and on his own amateur studies in religion and in ancient and primitive art. He was critical of Impressionism as being too imitative and as lacking in imagination, qualities of the mysterious and spiritual, and the capacity to arouse strong feeling. Yet his painting *Day of the God* (Pl. 30, p. 261) is unthinkable without the work of the Impressionists that Gauguin had emulated in the early 1880s and without the innovations of Seurat's *Grande Jatte*. In place of Parisians enjoying the pleasures of the open air and the beach, Gauguin painted South Sea natives in their vaguely distinguished secular and sacred rituals, ranged about his own version of a Polynesian deity. Their postures are in part paraphrases of Egyptian art, in part natural movements. The positioning of the foreground figures is of his own invention, perhaps to symbolize the powers of creation possessed by the idol behind them.

Gauguin's form of Symbolism was unsystematic and largely intuitive. His imagination led him to gestures, shapes, and colors that be believed would have an instinctive universal meaning. Gauguin is the prototype of the modern artist who, while discrediting the form, premises, and values of conservative or academic art, strives to continue its unifying social function and utopian imagery on his or her own terms. By personalizing past influences and means of conveying meaning, unlike conservative artists who drew from an official public iconography, Gauguin helped to open a gulf between artist and public with respect to understanding art that has not since been closed. Even

more influential for later art than his symbolic programs and treatment of the figure, however, are the brightly colored amorphous shapes in the water in the foreground, which resist definition but create a strong visual and emotional experience.

Unlike Monet, Gauguin did not paint directly the source of his feeling in nature; rather, he sought equivalents in shape and color for conveying the feeling itself—to define an object precisely to eliminate its mystery. Thus he alone could judge the rightness of what he painted—a premise that introduces the dilemma and risks of the modern critic and audience. Whereas the Impressionist might argue in defense of his painting, "This is how I see it," Gauguin would very likely argue that he was painting the look of emotion, or "This is how I feel it." Gauguin epitomizes the problems and possibilities of the modern artist at the end of the 19th century. As already noted, he yearned for the universal role that art had played in the days of the great allegorical and religious paintings, when artists could subscribe to public values or symbols and interpret a theology in which they believed and by which they could be genuinely inspired. But Gauguin was also heir to new ideas of personal expression that militated against public painting such as illustrative or dogmatic art. Like his progressive contemporaries, he had a horror of using literature as the basis for art. The expressive power of his means, drawing and color, which he had learned in France from fellow artists, musicians, and poets, defied translation. The artist was obliged to communicate feeling in terms that were possible only in painting.

The Ethic of Modern Art Much of advanced 19th-century art was based on ordinary worldly encounters, which did not need interpretation in the sense that the involved subject matter of previous centuries did; instead it surrendered its meaning to direct experience of the painting. The public was slow to comprehend this attitude or approve it, believing such art was without imagination and culture. Gauguin vacillated in his conviction of purpose and sometimes wrote out programs for his work, or he compromised his flat abstract surface patterns with modeled figures. It remained for 20th-century artists to develop Gauguin's legacy further and more consistently. In the choice between serving public or self, Gauguin and a few others opted for the latter. The 19th century witnessed the logical culmination of a tendency that had existed in art since the end of the Middle Ages: the simulation of the world of appearances. At century's end came the beginnings of a deliberate fidelity to the world of feeling, the artist's feeling, and of making art itself the subject of art and the basis for abstraction. One of the great ethical bases of modern art had been established— that of working directly from private empirical experience in an individual style, personally acquired, as a more direct means of realizing true self-expression. To the imperative of being of one's time was added that of fidelity to one's self.

Chapter 15

Art and Nature

Whether or not painters or sculptors choose to make art *about* nature, they are always creating art out of the things of nature. Whether artists work with ink on silk or rice paper, with animal-hair brushes on wood or canvas, in mineral pigments, clay, marble, or in bronze, the earth is the prime source of their art supplies. Science and technology may permit artists to refine their tools and natural materials, but they are still working with matter in order to interpret matter. In some respects, this relationship explains the deep attachment many artists have to their materials and the special kinship between the stuffs and the subject matter of art that treats of the land. The earth is the source, sustenance, and future of their lives, and as with their gods, countless artists have sought to make nature into their own image. Nature has given man his form, but through art man has given new forms to nature; art is, in other words, nature having passed through man. The Swiss artist Paul Klee has captured the essence of this process:

> He is like the trunk of the tree. Afflicted and moved by the forces of the stream he conveys what he has perceived into his work. The treetop expands in all directions and becomes visible in time and space and all the same things happen with his work. . . . It would never occur to anyone to demand of the tree that its top be shaped just like the roots. Everyone knows that what is above ground cannot be just a reflection of what is below. . . . The artist, like the trunk of the tree, is really doing nothing else than accumulating what comes from the depth and passes it on. He neither serves nor commands; he is an intermediary. . . . Beauty has merely passed through him.

There is no continuous history of landscape painting from ancient times down to the present. The first true landscapes did not appear until Roman art of the last century B.C., and subsequently in Western art there was a thousand-year interruption of this theme from the end of antiquity to the 14th century. Landscapes reappeared first in the margins and backgrounds of medieval art, and not until the 17th century did they become a central concern in the European artist's focus. The absence of landscape painting in past periods of history does not imply that people were totally unaware of or uninterested in nature. It is better accounted for in the lack of incentives and the artistic means by which to render nature in art.

The painting of nature has seldom been done by those who lived closest to the land. It was not peasants but educated and inquisitive town dwellers who evolved the sophisticated coding systems by which mountains, trees, earth, and water found their equivalents on the painted surface. Topographical recording and the literal imitation of specific natural locations have a shorter art history than do many other purposes of landscape art. Indeed, at various times in the past, accurate surface imitation would have been inimical to prevailing artistic ideals.

The Beginning of Landscape Painting In the 1st century B.C., the Romans developed the first true landscapes in painting. These are to be found on the walls of private houses, notably at Pompeii, which was preserved in the

volcanic ashes erupted by Mount Vesuvius in A.D. 79. There, artists had been commissioned to disguise the walls of urban villas with frescoes painted illusionistically to simulate deep space, architecture, and the countryside. These landscapes did not re-create specific locales but were imaginative, mysterious places that could have had sacred and idyllic connotations. The shrine next to the tree in Figure 393 suggests such ties with religion. The Romans looked upon the Egyptian goddess Isis as a nature deity, and the shrine may relate to her worship. The dominant bluish tone adds to the fresco's unreal or enchanted mood. Such a painting gave its owner the prestige of being both educated and a Roman of good taste. Much Roman painting derived from Greek art, and the elaborate architectural elements painted on some Roman walls may have originated in lost Greek painting done as scenery for stage plays. It was the Romans, however, who developed the illusion of natural prospects extending laterally and to a horizon line deep beyond the borders of the painting. The Romans managed to create an art convincingly close to empirical visual experience without the unified geometric perspective system of the Renaissance, which no ancient peoples attained. Though Roman artists did not make all receding lines converge on a single vanishing point (which would have sug-

gested a fixed point for observing the scene), they were alert to the appearance of objects, trees, hills, and the land and realized depth through atmospheric coloring, overlapped shapes, and the diminution of figures and objects relative to their distance from the viewer. The prime Roman device for representing depth in nature was the elevated viewpoint, a technique used in early Renaissance painting before the use of systematic perspective was known (Pl. 9, p. 123).

For Roman urban dwellers, these landscapes afforded spiritual comfort and escape from the annoyances of their everyday environment. They were brought into contact with the beauties of the countryside by painting, just as the reading of Vergil removed their thoughts to the idyllic pastoral life. Today the travel poster is the most familiar means by which we indulge in such imaginative displacement.

The emergence of landscape art in China a few centuries after its appearance in Rome is similarly based on religious purposes, literary analogies, and the escapist desires

393. *Sacred Landscape,* from Pompeii. Before A.D. 79. Fresco. Museo Nazionale, Naples.

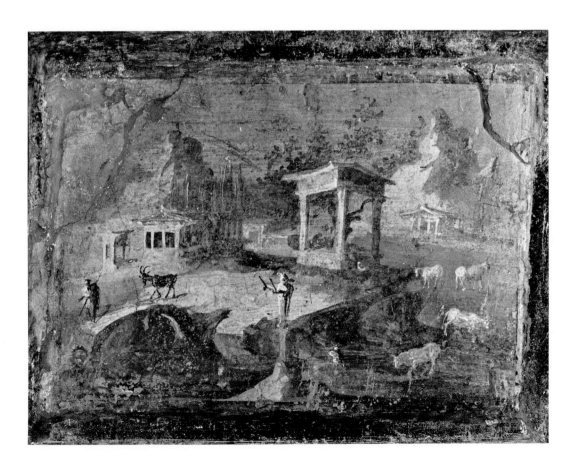

of its collectors. A landscape painting (Fig. 394) by Hsu Tao-ning (late 10th–early 11th cent.) indicates that by the year A.D. 1000, Chinese art possessed a consistent, integrated world view with a focus on nature, not human beings. Landscape painting had its beginnings in about the 4th century A.D. in magical funerary functions and animistic beliefs and afterward passed into the service of Confucianism and then Taoism. Chinese pictorial writing was the source of painting, and all artists were first trained in calligraphic brushwork. Artists were frequently scholars, poets, and philosophers, and their painting was intended for an audience of these groups, constituting, therefore, an elite or aristocratic rather than a public art. Though its aesthetic values were appreciated, landscape painting remained closely tied to mysticism and functioned to facilitate the beholder's communion with the reality of the universe. It demonstrated the belief that all things in nature, no matter what their size, were of worth.

Though Hsu Tao-ning's painting is not the literal recording of a specific mountain site, it shares many qualities with the mist-shrouded, jagged, soaring peaks of northern China. Its subject, fishing in a mountain stream, is an activity as timeless as it is universal in that country. Never in Chinese and Japanese painting was the artist enjoined to imitate surface appearance; literal imitation was thought to be vulgar, an impediment to true insight and the genuine spiritual and aesthetic experience of nature through art. Great painters were recognized by their ability first to fathom the meaning of what they were painting and then to impart this wisdom to their art. For this reason, Chinese and Japanese painting was in great part based on copying the works of

venerable masters. Nature was shaped according to conventional types, signs, and symbols in order to convey thought and feeling. The painter learned by heart the various ways to render mountains, water, and trees, the principal ingredients of landscape art. Despite typification that extended to every stroke an artist might make, sublime artists—as they were regarded by those who followed—were able to transmit their unique personal reactions to a given subject. The ideal mode of painting was one that gave the appearance of being effortless (made possible in part by mastery of types and strokes), as if, figuratively, the artist had allowed the landscape to paint itself. To do this, the artist had to be able to identify with the subject and become a part of the vital movement, the resilience or resistance of the water, trees, and mountains. Painting became a form of deep and serious communion with nature, permitting the artist and the compatible beholder to realize a sense of oneness with the perfect unity, creative energy, and essence of the natural world—from its infinite space, to the mountain range, and down to the smallest pebble. The great purpose of painting was to bring joy to the soul. A city dweller who possessed a landscape painting was supplied with a source of religious experience and a release from urban cares. These paintings were to be approached with reverence, humility, and intense concentration.

Scroll painting, developed by such 10th- and 11th-century masters as Hsu Tao-ning and probably executed at tables, is one of the great vehicles of Oriental painting and the finest format for Oriental landscape. These paintings were not meant to be viewed in their entirety, and rarely were they intended to be savored by more than one or two people at a time. The scroll was to be unrolled gradually, from right to left, in reflection of the temporal progress of a traveler through a landscape. Thus a succession of motifs customarily is revealed in an area about 2 feet (.6 meters) wide. The classic format of scroll painting initiates the scroll with

394. Hsu Tao-ning. *Fishing in a Mountain Stream.* c. 1000. Scroll painting on silk, 1'7'' × 6'10½'' (.48 × 2.1 m). Nelson Gallery-Atkins Museum, Kansas City, Mo. (Nelson Fund).

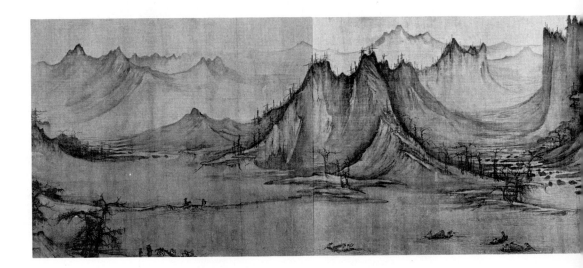

a depiction of the ground near the bottom of the silk, or paper, as if inviting the viewer to enter. In the next passage, the viewer is led into the middle distance by a path or stream, and subsequently to the distant peaks, and finally back again. This sequence is repeated, with variations, throughout the whole. At any point, the viewer can look to the right, the area already passed through, or to the left, the area still to be traveled. Some scrolls trace the course of a river from its source to its termination in the sea, a subject ideally suited to this format. There are no dramatic episodes, no climactic events. Human beings are not the measure of the universe in this art; they play an important but small role in the unfolding of time.

The construction of a Chinese or Japanese landscape painting does not assume a fixed position of a spectator outside the painting. Oriental painting never used the Western window-frame device, which tends to separate the viewer from the scene and suggest a single viewing point. The Eastern paintings were constructed from many viewpoints. Usually the artist began at the top with the most distant forms, such as the faint outlines of mountain peaks, and then, in the manner of Chinese writing, worked downward and forward to the bottom. The total spatial construction depends upon the moving focus of the traveler within the scene. The painter wanted the effect of an infinite and unmeasurable space extending beyond the limits of the frame and the eye, a space in which all things in nature lived. This space could be suggested by pale washes of ink or by entirely blank (that is, unpainted) silk or paper. The space was illuminated by no strong single source of light but rather by an overall diffused light that was concentrated more in certain areas than in others. Shadows were rarely shown.

Color was seldom used in Oriental landscape painting; ink and wash were preferred. Free of descriptive purpose and seeking to infuse their paintings with qualities not given directly to the senses, artists found an ideal instrument in the gradients achievable with ink.

In China and Japan, Zen Buddhist painters developed a technique of splashed-ink painting. During long meditation, the artist conjured up the vision of a painting and waited for the moment of perfect unity with it—in Zen terms, the *moment of enlightenment.* When he achieved this instantaneous revelation, his task was to set it down as rapidly as possible in order to sustain the ecstatic vision. The ink was then literally splashed onto the surface, in conjunction with controlled brushstrokes. A Japanese master at this type of painting was the 15th-century artist Sesshū (1420–1506). In his painting *Fisherman and Woodcutter* (Fig. 395), a dozen

395. Sesshū. *Fisherman and Woodcutter.* Late 15th century. Brush painting.

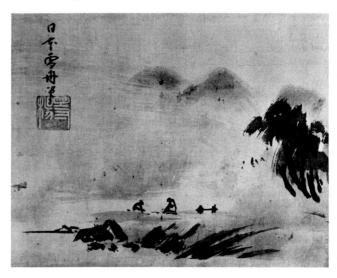

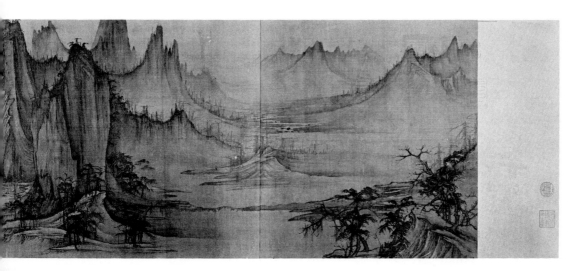

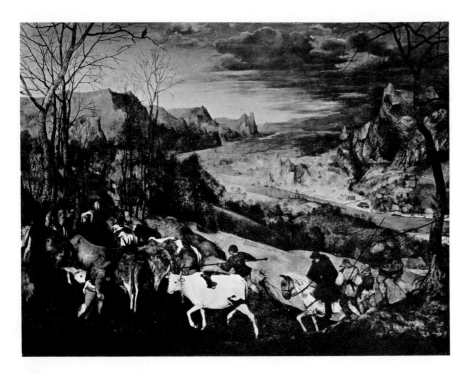

396. Pieter Bruegel the Elder.
The Return of the Herds.
c. 1560. Oil on panel,
3'10¼'' × 5'2⅝''
(1.17 × 1.59 m).
Kunsthistorisches Museum, Vienna.

quick strokes establish, or rather, insinuate, the environment. There are varying degrees of form definition. The relative concentration of the ink establishes what is near and far, and the traceable movements of the brush create forceful directions for the eye as well as suggest the substance of the landscape. This type of painting was not for amateurs, for it demanded firm, disciplined control of the brush, a sure sense of tonal values, and great sensitivity to solid-void relationships, with particular care in the use of empty space. Only what was caught in the web of the artist's consciousness emerges, and once the idea was fixed on paper, the brush was spared. The artist signed his name with a wood block, and often a priest or poet might inscribe a message or line of poetry directly on the painting. Moreover, the paintings were frequently inspired by poetic passages. The placement and weight of the dark ink was with an emphasis on total composition. The writing and the position of the figures testify to the sureness required of the artist in locating his forms within the space of the painting, for he had no systematic network of edges or ground lines to guide him.

There are important similarities as well as differences between the painting of nature in East and West. The Flemish painter Pieter Bruegel (1525/30–69), like his Oriental counterparts, was a cultured man who lived in close association with geographers, philosophers, and writers who shared many of his views and appreciated his paintings (Figs. 14, 231, 238, 245, 248). The development of Western landscape art in the 16th century was related to geographical exploration. There is a thesis that Chinese landscape

painting also had its roots in geography. Like many of the Chinese painters, Bruegel traveled widely, storing in his memory and sketches a vast repertory of motifs. His finished paintings were not of specific locales but were attempts to present a cosmic view of the infinite extension, depth, height, timelessness, change, and order of nature. The purpose of Bruegel's art was to demonstrate his comprehension of nature and humanity's relation to it. Like Hsu Tao-ning, Bruegel thought the world was governed by laws over which people have no control and to which they must passively submit. In *The Return of the Herds* (Fig. 396), men as well as animals bow before the impending storm; they lose their individuality against the overwhelming backdrop of the world in which they live. It is the face of nature, not the human countenance, that acquires expressive power and individuality in this painting. Bruegel, again in the manner of Oriental painters, had an animistic view of the earth, which he conceived of as a great organic body, as described in the words of the 15th-century philosopher Nicholas of Cusa: "The earth is a great animal, the rocks are his bones, the rivers his veins, the trees his hair."

The towering mountain to the right in *The Return of the Herds* has a gaping cavern in its side, like a great wound. Bruegel often sketched cracks and fissures in rocks and the evidences of erosion and decay in nature. He was also attracted to signs of regeneration, however, and this painting was one of a cycle devoted to the seasons, which pictures the death and rebirth of the land. Before Bruegel, Oriental artists had done cyclical paintings of the same subject, but in Bruegel's painting, important formal differences ap-

peared. He painted a continuous earth surface and sky and gave a greater sense of tangibility to space. His viewpoint was more consistently that of an external observer in a fixed position. He sustained a complex integration of the many parts of the scene and covered the entire picture surface with paint, drawn forms, and particularized textures. Like Hsu Tao-ning and Sesshū, Bruegel wished viewers to lose themselves within the painting as they searched out its smallest parts—the village at the mountain's base, the harvested fields, the gallows—and to realize it was not the human beings who imparted drama to the scene, to recognize that human efforts to change the face of nature have produced little more than flyspecks.

Storm, Cataclysm, and Inscape One of the most dramatic manifestations of humanity's fear is the encounter with storms in nature. Even in an atomic age, there is nothing so frightening or awesome as the experiencing of nature's power to destroy and the futility of human resistance. There have been relatively few artists who have succeeded in evoking such dreaded experiences. Weather and water were interpreted with great effect in the Japanese painting *Wind and Waves* (Fig. 397) by Sesson Shokei (c. 1504–89). The absence of any horizontal line and the cumulative curved forms aligned in one direction instill a feeling of the wind's presence. The precarious tilt of the boat and the backward curving thrust of the foreground tree imply the unseen force. A few stylized strokes coalesce into wave

below: 397. Sesson Shokei. *Wind and Waves.* Ashikaga Period, 16th century. Hanging scroll, ink and slight color on paper; height 8¾″ (22 cm). Formerly Nomura Collection, Kyoto.

below right: 398. Leonardo da Vinci. *Cataclysm.* c. 1516. Chalk and ink on paper, 6⅜ × 8″ (16 × 20 cm). Reproduced by gracious permission of Her Majesty Queen Elizabeth II.

forms, but it is the broad undefined area of the painting that strongly suggests the magnitude of nature's power. Sesson did not attempt to emphasize the human drama by placing the boat and its tiny figures in the foreground. Chinese and Japanese artists saw in the bamboo and pine that bowed before the wind a model of ideal human conduct. They emphasized less the danger of the moment than the habitual means by which people and trees accommodate to the adversity of wind and waves and submit to cosmic forces.

Nothing in Chinese or Japanese painting is comparable, in form or subject, with a series of drawings made by Leonardo da Vinci (1452–1519) to depict cataclysms. Where Sesson showed a convincing natural tempest, Leonardo created a vision of the world's destruction in a roaring convulsion (Fig. 398). Leonardo's religious paintings reflect his admiration of order and the harmonious existence of humanity with nature; but his notebooks and drawings reveal a preoccupation with disorder and a belief that the world was a precarious balance of powerful forces. Were these forces unleashed, he believed, the obliteration of all life would be accomplished with greater violence than had occurred in the Deluge.

Leonardo made scientific studies of a wide variety of phenomena, such as the flow of water and rock formation, in order to comprehend all of nature. He used theory and empirical observation to interpret his experience. The scope of Leonardo's interest was so broad that there were no complete models of drawing for him to imitate even if he had so desired. The cataclysm drawing reproduced here shows Leonardo's own devices for tracing the movements of water, wind, and dust clouds. A mountain undermined by the action of water is disintegrating, and its surface, scoured by powerful winds, reveals the ancient marks of earthquakes on its sides. As the mountain peels away and collapses, clouds of dust-filled air and waves move outward in a centrifugal pattern. Accompanying the sketch are long,

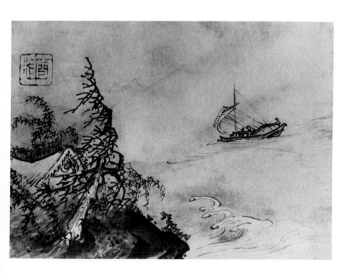

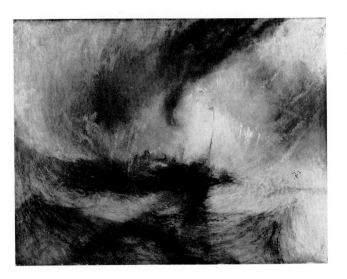

above: 399. J. M. W. Turner. *Snow Storm: Steamboat off a Harbor's Mouth.* 1842. Oil on canvas, 3 × 4′ (.92 × 1.22 m). Tate Gallery, London.

above right: 400. Matta Echaurren. *The Earth Is a Man.* 1942. Oil on canvas, 6′11⅝″ × 7′11⅝″ (2.12 × 2.43 m). Collection Mr. and Mrs. Joseph Shapiro, Oak Park, Ill.

vivid, and precisely written statements detailing the sequence of destruction, the violent psychological and physical reactions of people and animals to disaster, and the "pitiless slaughter made of the human race by the wrath of God." These statements and drawings show that Leonardo was haunted by visions that may have been induced by widespread prophecies that the world would be destroyed at the end of the century. Into these visions entered the artist's misanthropy, pessimism about a natural harmonious order, and deep personal disquiet.

Three hundred years after Leonardo's drawings of an imagined cataclysm, the English painter J. M. W. Turner depicted from memory a violent storm at sea: *Snowstorm: steam-boat off a harbour's mouth making signals in shallow water, and going by the lead* (Fig. 399). Turner was obsessed by nature's power and human impotence when matched against it. No previous painter surpassed him in evoking nature's awesome force as manifested in storms at sea. One night in 1842, while on board a ship, Turner encountered the storm of his painting: "I wish to show what such a scene was like: I got the sailors to lash me to the mast to observe it; I was lashed for four hours, and I did not expect to escape, but I felt bound to record it, if I did." From years of painting land- and seascapes, Turner had come to evolve artistic devices that imparted the driving continuity and elusiveness of what he saw. He characterized his art, "Indistinctness is my specialty." Rather than description, Turner achieved the quality of the whole by indirection: a

vortex-like design fuses sea and sky—frightening in its capacity to disorient the beholder. Colors fuse and thick passages of paint seem to have been layered like veils to provoke a sense of the sea's liquid depths. At no point is the eye invited to rest, and what is at one moment all surface next becomes all depth. Turner's heroic painterly achievement is generally better understood today; in his own time, such paintings brought the criticism that he had painted "soap suds and white wash."

A modern painter who responded to inner sensations and created private images to some extent related to nature is the Chilean-born artist Matta Echaurren (b. 1912). His large work *The Earth Is a Man* (Fig. 400) is an *inscape,* or a landscape of the mind, a psychedelic transformation of his experience of the volcanic landscape of Mexico. Matta's tropical palette of yellows, reds, and blues and his vague retention of a horizon line, with its contingent major divisions of sky and earth, preserve some of the qualities of the Mexican landscape and suggest a vivid experience from certain hallucinogenic drugs native to that country. The painter's transformations are elaborated into a visionary fusion of genesis and apocalypse, of coalescence and dissolution. Unlike Leonardo's visionary cataclysms, those of Matta are not susceptible to literary programming, nor are they based on scientific geological and climatic studies. Matta's turbulent imagery may reflect the anxiety of the times around World War II, as Leonardo's drawings reflected the disturbing apprehensions of his countrymen about the end of the world.

In his painting, Matta created an untraversable and uninhabitable world in constant flux, with fantasized flora, primeval birds, molten eruptive geology, and a solar eclipse. In the upper area is the eclipse, which surprisingly intensifies the light permeating the entire painting. Every shape and area is in the process of changing, and outlines are smooth, undulant, and unstable. Matta gave his shapes an

insubstantial and elusive quality by wiping the paint on with a cloth at certain points, thereby dissolving one color area into another and obliterating sustained reference to the pigment and its materiality. The poetic ambiguity of his space comes from soft transparencies of shapes, avoidance of logical recession, and unpredictable areas of phosphorescent brilliance or absorbent darkness. There is an ambivalence of direction in the composition, so that lateral and vertical movements are reversible, which enhances the cyclical nature of the theme. Putting Matta's work into historical perspective, William Rubin wrote that "Whereas the rationalist Greeks had used the external image of man (microcosm) to represent the order, logic, and finite mechanical perfection of the universe (macrocosm), Matta invokes a vision of galaxies to suggest the infinity and mystery within man."

The Fugitive in Nature A distinguishing talent of Oriental painters was the ability to evoke the elusive qualities of a landscape seen in a mist. One of the most beautiful examples of this type of painting is a depiction of a pine wood (Fig. 401) on a folding screen by Hasegawa Tōhaku (1539–1610). His inspiration came from the early morning view of pines around Kyoto. With but three or four ink tones and leaving broad areas of the paper untouched, he suggested the appearance of a pine forest suspended in a soft vaporous atmosphere. The one tree represented in distinct focus is a stable base for contemplation and serves compositional purposes as well. The strokes are not intended to imitate the surface aspect of the tree but to convey a more subjective impression of the sharp, compact, vertical clusters of needles and the asymmetrical, individual character of every tree. Each screen panel is complete in itself and yet adds to the scope and depth of the whole composition. Fugitive as thought, the painting offers something tangible and solid at one point, then lets shapes melt into the measureless void. Mingled here are delight in an everyday scene, perhaps an esteem for the pines as analogues of human dignity and endurance, and an awareness of spiritual immanence in nature.

The technique that underlies Tōhaku's painting is but one of many basic differences between his work and that of the French Impressionist Monet. Too often Oriental painting such as Tōhaku's is incorrectly termed "impressionistic," implying both similarities to and influences on French Impressionism. In *Bordighera Trees* (Pl. 31, p. 262), for example, Monet did not select from nature properties that could be transcribed into lines or set down with clear, firm boundaries. When Monet confronted the trees, he was not concerned with hidden essence, philosophical symbols, or memory images; rather, he was concerned with sensations of sunlight and color directly experienced at the moment and place he painted. Chinese and Japanese landscapes are without—and did not seek to achieve—the brilliance of Monet's sunlight.

Tactile sense, volume, solidity, continuity, and sometimes even identity of objects are generally absent from Monet's art. The painting's fabric is composed of an overall accumulation of short divided strokes of bright color. The work reveals a discontinuous edge, but a continuous touch (Fig. 563; Pl. 26, p. 243). The spectrum of color and the mixture of tones in a square inch of *Bordighera Trees* (Pl. 31) have no counterpart in Eastern painting. A square inch taken from the bushes at the lower right contains in dispersal many touches of green; a few flecks of red, the complementary color induced in the eye by exposure to green; yellows and whites from the sun and reflected light; violet induced by the yellow; and some oranges and blues from areas either seen through the bushes or adjacent to them. The strokes do not follow lines established in nature itself, and each seems different from the others. This technique was not acquired from a tradition, but developed from Monet's earlier painting and from his immediate encounter with the landscape as he worked quickly to fix with the

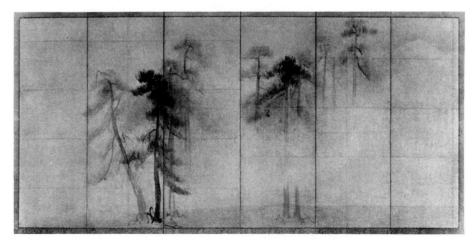

401. Hasegawa Tōhaku. *Pine Wood.* Early 17th century. Folding screen, ink on paper; height 5′1″ (1.52 m). Tokyo National Museum.

brush what was fleeting before his eyes. The inventiveness and energy of his painting is clear at every point on the canvas. The tree trunks, from root to branch, show no formularized pattern but express continuous discovery of the action of light upon color and form. No part of the surface is unpainted. The ground is covered with the thick tangled web of Monet's strokes, heavy-laden with oil pigment. Monet did not compose his painting by arranging his landscape like furniture; he made the whole work together through the equivalence of visual weights or densities of color in each area. In his personal study of the effects of mixed color on the eye of the beholder, Monet learned which tones expand and which contract, which advance and which recede, and how a few high-keyed areas serve to counterbalance deeper tones. It was not color in the abstract, but nature's color, that excited Monet. The landscape was not an excuse but, in fact, the reason for him to paint.

In contrast to Sesshū's landscape (Fig. 395), *Bordighera Trees* shows finite space that does not swallow up those who live within it. It is a personal space that is directly relatable to the location, viewpoint, and feelings of the man who painted near the Bordighera trees. His excitement, betrayed in his brushwork, comes from direct confrontation of the scene in nature. In the 15th century, Jan van Eyck often included within his paintings minute, paradisaical landscapes, seeming wonders of light and color (Fig. 165). One might say that not until four hundred years later, in the secular Eden of Monet's luminescent, sun-soaked landscapes, was a comparable optimism expressed.

Piety and Pride before Nature In Oriental landscape painting, artists took an appreciative and humble stance before the vastness of their physical surroundings. Fre-

quently a scholar or monk was shown seated beneath a tree or standing on a hill, contemplating nature and meditating upon the source of his art and faith. In Western painting, we can see an echo of this interest in solitary communion with nature in *Capuchin Friar by the Sea* (Fig. 402), by the early-19th-century German artist Caspar David Friedrich (1774–1840). Against the bleak, stratified expanses of land, sea, and sky, the single vertical form of the monk, his back toward us, confronts infinity. To his contemporaries, Friedrich painted "the tragedy of landscape"—nature steeped in sadness and the human yearning to embrace the universe. The drama for contemporary German audiences was that of the individual soul, symbolized by the reverent friar, striving to achieve harmony with the soul of the world. Unlike the medieval image of St. Valerian (Fig. 138), Friedrich represented the view that the holy man must not turn his back upon the world, but must assume the enormous task of penetrating its mysteries by his thought. Perhaps symbolically, the painting lightens in its upper reaches, suggesting the elusive object of human thoughts and desires, a theme on which Paul Klee was also to comment in his *Limits of Reason* (Fig. 560).

Almost half a century after Friedrich's painting, Gustave Courbet commemorated his first encounter with the sea in his *Seaside at Palavas* (Fig. 403). One can imagine no Chinese or Japanese painter who would similarly depict himself saluting nature as an equal. In a letter to a friend, Courbet commented on his discovery of the sea and added this thought, which reads like a caption to the painting: "O sea! Your voice is tremendous, but it will never succeed in drowning out the voice of Fame as it shouts my name to the whole world." Courbet was not the first immodest artist in history, but none had so brazenly portrayed his self-confi-

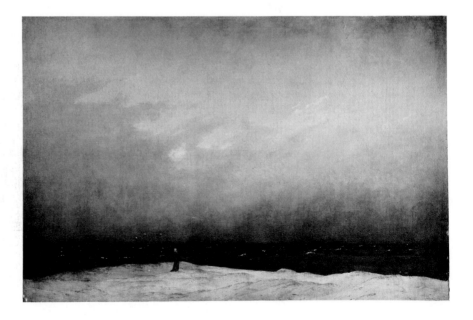

dence before his "competition," before the challenge of making infinity tangible (Figs. 24, 373).

Courbet was one of the painters who influenced Monet to focus directly upon nature itself, rather than merely utilizing landscape as a backdrop for human action or for purposes of moralizing. Courbet's life view was that of a materialist in the most positive and dignified sense of the word. No artist in history loved more deeply the physical substance of nature, its closed, secret places and its vast openness. These last two polarities in his art are beautifully demonstrated in his *Source of the Loue* (Fig. 404). From his oil pigments, using a brush and palette knife, Courbet wrested those properties that permitted re-creation of the material

substances of water and rock. Beyond such technical accomplishment, moreover, Courbet's response to nature was meditative and not confined to its surfaces, for in the grotto painting, the deep cavities from which the river issues lead our thoughts toward contemplation of nature's invisible depths. The grandeur of the cave painting depends upon the absence of humans, which concentrates the drama on the weathered rock and the relentless action of the river. Courbet painted out of doors, directly from nature, and often in the space of a few hours. For subjects such as this grotto, he would first prepare his canvas with a dark color. To friends watching him paint such a subject, he once said, "It surprises you that my canvas is so dark. Nature without the sun is dark and obscure. I do as the sun does. I clarify the salient points and the picture is made."

Nature and Artistic Order The 17th-century French landscape artist Nicolas Poussin (1594–1665) regarded nature as a noble and orderly setting for the enactment of grandiose classical tragedies. Moreover, its mood is directly determined by the human drama enacted within it. The subject of *The Funeral of Phocion* (Pl. 32, p. 263) is drawn from Plutarch and concerns the Athenian general Phocion, unjustly executed by the state he had loyally served. At his request, Phocion's body was carried from Athens to his native city to be cremated, and his ashes were scattered on the earth. The solemnity of the return of Phocion's body is to be read in the mien of the litter bearers and in the gravity of the landscape itself. Basing his ideas on principles of Greek and Roman rhetoric and of music, Poussin conceived of painting in terms of "modes" by which one could interpret happy, calm, or sad events. To control the effect of his art, he did not allow his own emotions to influence the act of

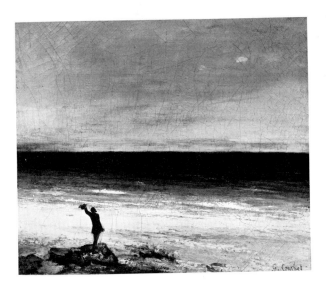

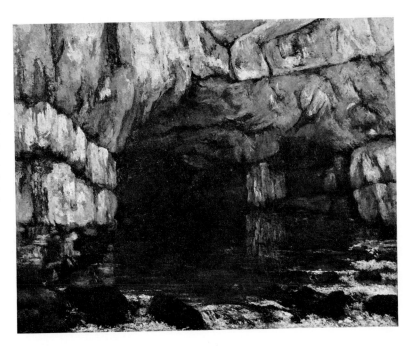

opposite: 402. Caspar David Friedrich. *Capuchin Friar by the Sea.* 1808–09. Oil on canvas, 3'6⅞" × 5'6⅝" (1.09 × 1.69 m). Staatliche Museen Preussischer Kulturbesitz, Berlin, on loan to Schloss Charlottenburg, Berlin.

above: 403. Gustave Courbet. *Seaside at Palavas.* 1854. Oil on canvas, 15¼ × 18" (39 × 46 cm). Musée Fabre, Montpellier.

right: 404. Gustave Courbet. *The Source of the Loue.* c. 1864. Oil on canvas, 3'3½" × 4'4" (1 × 1.32 m). Albright-Knox Art Gallery, Buffalo.

painting, which was to be governed only by a rational adherence to these modes. Nature and art were thus constrained by Poussin's intellect. He thought that painters should impose their will on nature and art, study carefully everything within the painting, avoid the spontaneous and the trivial, and make each stroke a controlled expression of their will. He believed, as did the philosopher René Descartes, that the faculty of reason could determine the true nature of physical order. Nature appears in Poussin's painting as an unopposed harmony, not unlike an aspect of a mechanistic universe. Nature's order was the model upon which Poussin based his painting, showing ancient Classical architecture juxtaposed with precisely formed trees and mountains. The calm stability of the landscape is further stressed and perfected in the walls, columns, and pediments of the city.

Much of the scene's tranquil atmosphere comes from the soft late-afternoon light falling over the landscape from the left. This lighting, which was partially a device to suggest that the event took place in the remote past, illuminates the critical passages of the story and creates successive light zones that gently alternate with soft shadows and lead the eye into depth. Poussin insisted that extreme values of light and dark be smoothly modulated by intermediate ones; thus he provided a measurable and logical transition from the darkened foreground to the most brilliantly illuminated area on the distant horizon. The dark foreground areas hold the viewer apart from the scene, in order to elicit a detached, sustained awareness of the action and the painting's well-thought-out structure. Furthermore, the painter avoided rough edges, jarring angles, and disturbing color combinations to effect an easy, graceful flow from one area to another. His colors were mostly dark brown, greens, and grays, with the strongest colors, the reds and whites, reserved for small areas in which they were essential to identifying the figures. The large trees at the right and left and the clouds were used as subtle coordinates of and containment for the action, providing within the picture frame a second, natural framework for the scene. In the right foreground are stone ruins, which provide visual anchorage for that portion of the canvas; but they also serve to remind us that Poussin meticulously constructed his entire painting as if using building blocks, with each shape and shadow and tone having an unalterable position in the whole.

Poussin's definition of art was "an imitation made on a surface with lines and colors of everything that one sees under the sun. Its end is to please." His work did not truly embody this definition, however, for his painting is based on literature and is a *conceit,* or a conception of the mind, not a scene as directly encountered. He did not reveal colors as they actually appear under sunlight, and he favored drawing over color in the construction of form. His vision was highly selective, and his painting was strongly addressed to the intellect.

Poussin's definition of art was more closely realized in the 19th century by Paul Cézanne (1839–1906), who admired the older painter. This admiration was directed principally toward Poussin's logical method, his systematic means of setting down his thoughts; but unlike Poussin, Cézanne was firmly committed to reproducing strong sensations of color, light, and air, the lessons he had learned from the Impressionists. He felt that the old masters had "replaced reality by imagination and the other abstractions that accompany it. . . . They created pictures, we are attempting a piece of nature." In *Mont Sainte-Victoire* (Pl. 33, p. 263), Cézanne painted what he saw; he emphasized consistently the lines and colors of surfaces; and he directed the whole toward delighting the senses. He made no demands upon literary erudition. By the 1880s, he had given up somber, figural dramas in landscape settings, and the mountain became a personal obsession and the climactic focus of his paintings from nature. Meyer Schapiro defines this attraction on the basis that the mountain externalized Cézanne's "striving and exaltation and desire for repose." No single form, but an idealized nature as a whole, may have held somewhat the same appeal for Poussin. The mountain in the *Funeral of Phocion* was for Poussin, as it was for the Chinese, the dwelling place of public gods.

Cézanne's painting exacted a greater struggle than that of Poussin in putting nature in order, for Cézanne's harmony involves a difficult and arduous balancing of unlike forces—stability and instability, energy and repose (Fig. 457; Pl. 41, p. 315). Poussin made careful plans for a painting and could foretell precisely how it would look upon completion. Each shape such as a tree or a building was probably carried to its completed state before the overall composition was finished. Cézanne's method was more empirical and relied upon momentary intuitions and judgments. He repeatedly worked over the whole painting and would alter what he had already painted or what he saw if it did not fit into the total aesthetic organization. Unlike a composition of Poussin, Cézanne's landscape cannot be separated into definable parts or tidy zones. Cézanne's building blocks are simultaneously color and drawing, and these means constantly fuse, overlap, or grow out of each other. In the fields, for example, he used a line segment to give firmness to a section that would otherwise have been spatially ambiguous or without some sense of direction. He was at once intentionally concerned with presenting a stabilized view of nature in depth and with achieving a coherent surface pattern. The left-hand area between the pine trunk and the frame shows this concern. In isolation, lacking any specific object reference, the section appears to be a succession of colored patches that alternately move forward and backward, but with consistent reference to the surface. Put back into its original context, it falls in place and contributes to the valley's recession. Cézanne coordinated the foreground shape of the tree trunk in its edge, color, and axis with the adjacent areas. Just above the hori-

zon line, he painted sections of pine branches whose agitation heightens the mountain's massive immobility. Appropriately, the mountain is the only object seen in its entirety. The branches also bring the viewer's eye back to the foreground plane.

Unlike Poussin, Cézanne tolerated sharp juxtapositions of warm and cool colors, saturate and dilute tones, such as those found in the area of the sky. The directions of Cézanne's brushstrokes are in actuality as essential to the painting's structure as they are to the imitation of textures in the landscape. They indicate the direction in which a solid moves into depth (as in the foothills of the mountain, which vitalize the large area of the sky) and accelerate or decelerate the eye's movement through the painting (as in the zone of the field). Cézanne sought an equilibrium between emotional and intellectual response to nature and painting, but never did the modern master domesticate the natural world to the extent that Poussin did. Cézanne preserved the irregularity, energy, and contradictions he saw, wishing to claim by his brush nature in all its fullness. As he expressed it, "The landscape thinks itself in me and I am its conscience."

The Dutch Landscape During the 17th century, the great period of Dutch landscape, artists of that region delighted in expressing hearty enjoyment in the external appearance of earthly matter, instead of evoking nostalgia for the ideal past depicted by their French and Italian contemporaries. While figures were usually present, to establish the scale of the scene and to suggest the harmonious relationship of humanity and nature, there was no storytelling. Nature did not serve merely as a backdrop for significant human events, nor was topographical exactness usually a requirement. Dutch artists were now free from older formulas for composition and color. They would make drawings directly from a motif and complete their paintings in the studio; they reserved the right to synthesize and rearrange their notes and experiences in a selective naturalism.

Another innovation of these Dutch artists was the discovery of and fondness for uncultivated nature, often juxtaposed with evidences of human work with the earth. This synthesizing and selectivity, coupled with the modest formats of their commercially viable easel paintings, continued the process of miniaturization, by which the artists and their audience could cope with a natural world greater than themselves. In the landscapes of the 17th-century painter Jacob van Ruisdael (1628–82) and those of the 19th-century painter Vincent van Gogh, we can perceive the dramatic and poignant enactment of the miniaturizing purpose of art.

In Ruisdael's *Wheatfields* (Fig. 405), the only importance assigned to literary subject matter and the human figure is the contrast between their insignificance and the immensity of nature. The landscape is not conceived as the projection of the moods of the people within the painting; indeed, nature's indifference to mankind seems somehow a comfort to the Dutch painter. He shows wheatfields, human attempts to cultivate nature, but he accentuates the wild

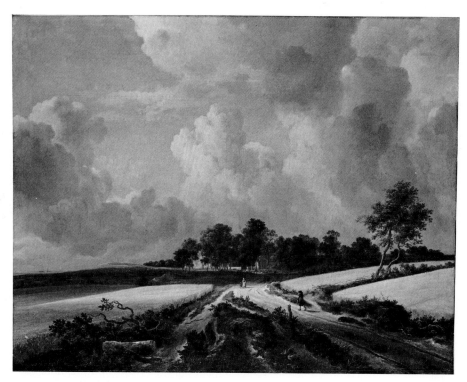

405. Jacob van Ruisdael. *Wheatfields*. c. 1650. Oil on canvas, 3′4½″ × 4′3½″ (1.03 × 1.31 m). Metropolitan Museum of Art, New York (bequest of Benjamin Altman, 1914).

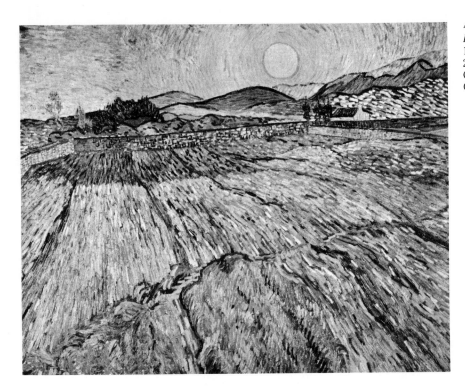

406. Vincent van Gogh.
Landscape with Sun Rising.
1889. Oil on canvas,
28 × 35⅝″ (71 × 91 cm).
Collection Mrs. Robert
Oppenheimer, Princeton, N.J.

scrub along the road, the eccentric positions of the trees, and the shifting shapes of enormous cloud formations that defy any attempt at human alteration. The rough silhouette and tangled mass of vegetation are characteristic of Ruisdael's style.

In *Wheatfields,* the road is brought almost to the viewer's feet to lead the eye more directly and quickly into the landscape. Poussin avoided the emotional involvement that Ruisdael felt was so essential. By alternating zones of shadow and golden light, Ruisdael controlled the pace at which the eye moves through the landscape. The forward roll of the clouds seems to counter the inward thrust of the earth, so that the composition assumes a foreshortened wedge shape in depth as opposed to Poussin's arrangement of successive zones that are largely parallel to the picture surface.

Ruisdael gave to his painting a vivid sense of nature in movement—its processes of growth and decay, the shifting light as the sky changes, and the violent force of winds that propel the clouds and contort the trees. He was stirred by the wars within nature, between the natural forces of life and death and ultimately feeble human attempts to conquer land and sea. A solitary individual, Ruisdael sought in his painting to come to terms with a great impersonal, indomitable force outside himself.

The painting of nature was an even more deeply personal instrument for Vincent van Gogh—so much so that his *Landscape with Sun Rising* (Fig. 406) may belie the painter's stated intent. Writing from St-Remy to the painter Emile Bernard in December 1889, Van Gogh described a painting that is probably the one reproduced here:

> The sun rising over a field of young wheat, lines fleeting away, furrows running up high into the picture toward a wall and a row of lilac hills. The field is violet and yellow green. The white sun is surrounded by a great yellow halo. Here . . . I have tried to express calmness, a great peace.

What a shock is the last sentence! The viewer is pulled immediately and violently by the arrowlike flight of the fields into the painting's depth, but not to another and prime focus of the scene—the sun. Compounding the painting's tension between perspective and spiritual focus is the leftward tilt of the land, which also competes with the pull of the sun. The sun is the only stable form in the entire work, but it is placed at the right and the very top of the painting, the most difficult point of access. No previous landscape painter had looked at and painted the actual sun so directly. This act of Van Gogh was as startling as that of the medieval artist at Daphnē (Fig. 81) who portrayed the powerful face of his god. For Van Gogh, it was from the sun's force and brilliance that nature, art, and he himself gathered vigor and life. In his last years, the basis of his being lay in attaching himself, through the hard work of his art, to humanity, the soil, and the heavens. He wrote of "plowing on my canvases as they do in their fields." The striving for impossible goals of perfection and possession

and the accompanying purge of great feeling perhaps explain why Van Gogh could write of the finished work as being calm.

Van Gogh wrote to his brother and friends that his paintings should be framed in white and hung in white kitchens or against plain backgrounds. This was both a sign of his humility and a realization of how his paintings could be shown to best advantage. They can be seen in the strongest sunlight, unlike those of Ruisdael or Poussin, and still surpass the intensity of the actual scene. Van Gogh wanted not an equivalent of nature, but a more intense re-creation of it. He wanted his drawing and color to smell of the earth. The fields that Van Gogh painted are in a sense disappointing. He made them exciting by coding their forms in his strong pure tones, boldly set against one another in a torrent of staccato touches. We are always conscious of the life of the painter's hand, its obvious power, trained responsiveness, yet inexplicable individuality (Fig. 390; Pl. 34, p. 264). Van Gogh wrote, "What a queer thing *touch* is, the stroke of the brush." Perhaps his wonder and uncertainty stemmed from his use of the brush as a direct and spontaneous extension of his internal state of being. He used the touch to decipher the inner character of what he felt was the true soil of Provence. Wherever he went, Van Gogh absorbed through painting the sights and effects that alone could give him peace.

407. Albrecht Dürer. *The Great Piece of Turf.* 1503. Watercolor, 16¼ × 12⅜" (41 × 31 cm). Albertina, Vienna.

Nature Seen Close Up A common theme from nature is the close-up of a small cluster of plant life in which the artist searches for the individuality of the part. With botanical accuracy, the German artist Albrecht Dürer (1471–1528) in his *Great Piece of Turf* (Fig. 407) depicted the flora in a tiny area of marsh. This was more than a purely secular scientific investigation, for Dürer sought the minute and multiform evidence of God's creativity in his natural subject. His quantitative surface reproduction would have been anathema to Chinese and Japanese artists, who felt that optical fidelity concealed rather than disclosed the essential quality of nature. Dürer, however, found challenge and meaning in the multitude of shapes, colors, textures, and in the precise proportions and inclinations that described each plant form. The clustered natural forms demanded different and less strict compositional solutions than his large religious and figural paintings had involved. He did not impose an obvious stilted ordering on the plants but carefully preserved the appearance of a casual, overlapping disarray, while unobtrusively contrasting and harmonizing the stalks and leaves with one another. In his own words, "Art, however, is in nature, and whoever can draw it out, he possesses it."

To enact his fantasies of nature in such paintings as *Botanical Theater* (Pl. 35, p. 264), the modern Swiss painter Paul Klee (1879–1940) staked out a small uncontested territory of his own, one inaccessible to such optical aids as

Dürer's perspective or the modern microscope. Klee searched for a totally new and poetical approach to make familiar the obscure and minute aspects of nature, such as the intimacy of the night world of plants. His viewpoint is not that of a detached scientific investigator, but a conception that evolves in the mind when the eyes are closed. Through his meditations, Klee's art became a fusion of the interior and exterior world in a way never previously seen in Oriental or Western art. His oil and watercolor *Botanical Theater* seems disarmingly familiar at first. There is no horizon line or sky, no definable light source or measurable distance between the viewer and the plants. No means exist to compare the space and the scale of the painting with oneself or a real landscape. There is no botanical guide to catalogue the plant life. Klee's world seemingly has its own laws of size, light, growth, and species. He believed in the interrelation of all phenomena, and his objects have a dual character, being part vegetal and part animal. The pungent color that floats over and permeates the shapes and the prickly textures in and around the plants recall experiences of sight, smell, taste, hearing, and touch. It is as if Klee were able to project himself into the subhuman night world and perceive the scene through the senses of its occupants.

Klee's drawing method was to some degree automatic; he let his pen and brush explore the surface as if guided by impulse and the feel of the materials. The creative act

sprang from inner watchfulness and listening and from an uninhibited response to the free associations induced by imagination as he worked. When a spiral was begun, for instance, it might emerge as a snail, or two leaves might change into a pair of eyes:

> Art is a simile of the Creation. . . . Today we reveal the reality that is behind visible things, thus expressing the belief that the visible world is merely an isolated case in relation to the universe and that there are many more other, latent realities.

Klee felt that his art would give comfort to his viewers by reminding them that the human mind itself is not confined to earthly potentialities.

Klee strove for union with the "heart of creation . . . in the womb of nature . . . where the secret key to the universe is safely kept." His paintings are small—done, one might say, within the radius of the artist's elbow and the action of his wrist. This modest size encourages intimate and prolonged discourse between viewer and subject. The miniature scale was essential to Klee's style, for, in his words, "style is the ego."

The art of Paul Klee may be termed *imagistic,* for it took form from his imagination, and the root of the word imagination is "image." Imagistic painting gives form to that which is unattainable through the outward senses. Klee felt

that artists had a moral imperative to search their inner being for inspiration and "to render visible those impressions and conceptions not in themselves visible."

Nature and Abstract Painting

At the beginning of this century, the artist's decision to move away from illusionistic painting of nature frequently entailed important concerns and commitments that extended beyond the world of the studio. The implications of the way someone paints reach into that person's psychological and emotional makeup, and style is part of the artist's world view ("style is the ego"). Furthermore, artists will often preserve in their nonillusionistic work a certain residue of their earlier imagery based upon their perception of nature. This can be seen by juxtaposing works from both styles accomplished by a single painter.

As a young painter in Holland at the turn of the century, Piet Mondrian (1872–1944) was inclined toward passive depictions of the Dutch countryside without action or figures. As in his painting of a windmill (Fig. 408), Mondrian searched for solitary prospects, small segments within the vast panorama of nature that reflected an inherently stable and tranquil world. He selected a viewpoint that allowed him to align principal axes within the scene, those of the bridge and windmill, with those of the picture frame, thus permitting stable pictorial construction. The reflections in the placid water echo and reinforce the directions of the mill and bridge, and a grid pattern is recurrent. Many brushstrokes, such as those at the left and in the pond, are unrelated to literal observation of nature but serve to strengthen the design armature of the whole composition. The artist's viewpoint, with the large foreground area given over to the reflecting surface of the water, has contributed to a percep-

below: 408. Piet Mondrian. *Mill by the Water.* c. 1905. Oil on canvas, mounted on cardboard; 11⅞ × 15″ (30 × 38 cm). Museum of Modern Art, New York (purchase).

below right: 409. Piet Mondrian. *Composition in White, Black, and Red.* 1936. Oil on canvas, 40¼ × 41″ (102 × 104 cm). Museum of Modern Art, New York (gift of the Advisory Committee).

tible flattening of the space, which, coupled with the pronounced use of repeated motifs, gives a strong surface rhythm and pattern to the painting. During Mondrian's subsequent growth as an artist, as well as in his writings, his obsession with the possibilities of rhythm became patent. Rhythm was a critical link by which Mondrian hoped to unite "the individual with the universal."

Hundreds of paintings intervened in Mondrian's career from *Mill by the Water* to *Composition in White, Black, and Red* (Fig. 409) of 1936, but in mood and design, the latter work is a condensation of the former. Though it gave up representation of the specific in nature, Mondrian's later art preserved the ideal of manifesting the underlying harmonious order of nature in its broadest sense. The structural components of the later work, straight lines meeting in a rectilinear grid, were present in the mill painting. Junctures now become crisp right angles, and all the rectangular shapes and pure colors lie completely at the surface. Irregularities traceable to the hand of the artist are absent. Crucial to the continuity of form and meaning between the two paintings is the relation of the asymmetrical composition to the frame, treated as if what is within its borders were an incomplete, fragmented view of a greater order. The irregular quadrature of the later painting is controlled not by directly perceived shapes in nature but by the artist's intuition of balance between black lines and small red and large white rectangles. Mondrian's compositional reflexes had been conditioned by his paintings of land, sky, water, and trees. The painting's title accurately describes what is *on,* not *in,* the picture plane. Mondrian believed this type of painting was important for humanity because it presented in purified artistic form a model of equilibrium, a condition imperfectly experienced in nature but eternally sought in all forms of life. Seeing as the painter's task the expression of a vision of reality, Mondrian desired the purest expression of life through the freeing of color, rhythm, and form from their particularized appearance in nature. In the varying dimensions of the rectangular areas, with their impeccable arrangement and perfect balance of tension, he felt such artistic liberation could be accomplished: "Space becomes white, black or gray; form becomes red, blue or yellow."

Another pioneer of abstraction after 1900 was the Russian painter Wassily Kandinsky (1866–1944). His early art shows a strong attraction to the countryside. By 1910, when he painted his *Landscape with Factory Chimney* (Fig. 410), Kandinsky had proceeded to a point where it was increasingly difficult to match his painting with an actual landscape. He had reduced distinctions between land and sky, trees, hills, and buildings, between space near and far; his paintings coalesced into strong arbitrary color harmonies that were less and less governed by perceived sequences of hues. Kandinsky did not seek a stable viewpoint or a geometrically based order, but instead presented a turbulent, heaving earth. Against the broad, sweeping curves of the hills are ragged and diffuse color patches, which produce

410. Wassily Kandinsky. *Landscape with Factory Chimney.* 1910. Oil on canvas, 26 × 31½″ (66 × 80 cm). Solomon R. Guggenheim Museum, New York.

intense color sensations and contribute greatly to the excited mood of the whole. Unlike the Impressionist painters, Kandinsky did not paint the mood induced in him by contact with nature, but rather superimposed upon the landscape an already existing emotional state. Kandinsky's predilection was for wild, hilly terrain laced with precipitous diagonals—the kind of landscape that might provide an adequate carrier of his feelings. These qualities flood over into a later painting, *Picture with White Edge, No. 173* (Pl. 36, p. 297). Though not intended as a landscape, it shows that his mind and the movements of his hand could not expunge earlier experience, for within this seeming abstraction there remains a pictorial sign language of wavelike hills and jagged peaks and trees.

Taken as a whole, *White Edge* has an apocalyptic mood. Dating from the eve of World War I, it may have been indirectly inspired by Kandinsky's response to the tense atmosphere in Germany, where he was working. Its brilliant color evokes a sensation of clashing sounds. Kandinsky believed that sensory experiences overlapped and that each color had its equivalent in sound, so that painting became an orchestration of elements having inherent expressive associations with which the painter could strike chords in the soul of the viewer. Framing the dense and saturate color mass in the painting is an irregular white edge, a color that Kandinsky wrote of as a "pregnant stillness." Like Frenhofer, Balzac's fictional painter (see p. 368), Kandinsky sought a perfect fusion of drawing and color and achieved an exquisite but nonetheless controlled chaos.

Kandinsky's departure from illusionism was gradual, hesitant, backsliding, and rarely complete in the years be-

tween 1910 and 1914. His writings show a deep awareness of and misgivings about a possible important loss to art in abandoning nature and the familiar as a frame of reference. What impelled him in the direction of *White Edge* was a growing distrust of modern materialism, science, organized religion, and illusionistic art—all of which he came to regard as impediments to free expression of the human spirit. Inner freedom was for Kandinsky the sole criterion for both ethics and aesthetics. The creative process ideally meant a suspension of consciousness and a purely spontaneous and intuitive activity, though Kandinsky did in fact impose some critical judgment:

> I have painted rather subconsciously in a state of strong inner tension. so intensely do I feel the necessity of some of the forms that I remember having given loud-voiced directions to myself, for instance, "But the corners must be heavy." The observer must learn to look at the picture as a graphic representation of a mood and not as a representation of objects.

Seascape (Fig. 411), an early painting by the American Jackson Pollock (1912–56), projects the moody image of a storm-tossed boat seen against a disquieting sky. The canvas is filled with dense pigmentation, rough shapes, and strong movement. The subject was appropriate to the strong and aggressive temperament of the young artist. From his first works, Pollock asserted his rebellious nature and the need to impose his will and muscular energies on both nature and art. The small format and the limits of the canvas are strained to contain the violence of his painting.

Created sixteen years and hundreds of paintings and drawings later, Pollock's *Autumn Rhythm* (Pl. 37, p. 297)

continues, refines, adds to, and subtracts from the seminal qualities of *Seascape.* From the scale of the conventional easel painting, Pollock had gravitated toward what might be called a "portable canvas mural," a huge work roughly 8½ by 17 feet (2.55 by 5.1 meters). In 1947, the painter wrote:

> I prefer to tack the unstretched canvas to the hard wall or floor. I need the resistance of a hard surface. On the floor I am more at ease. I feel nearer, more a part of the painting, since this way I can walk around it, working from the four sides and literally be *in* the painting.

Vermeer's painting of the artist in his studio (Pl. 21, p. 209) demonstrated a system ideal for wrist painting; the artist's subject was reduced to the scale of a traditional easel format. In Pollock's work of the late 1940s, scale was not strongly predetermined but resulted from the interaction of the artist and his evolving image, which established the size of the painting. Further, Pollock was impelled to arm as well as wrist painting; the rhythm and energy of his whole body found outlet in the creative act. For both technical and aesthetic reasons, he gave up oil for enamel paints. In this way, he was freed of oil paint's historical associations, and the more viscous enamel medium also permitted a continuous spinning out of the linear fabric—the heart of Pollock's mature style. The dripping and spattering of paint as Pollock walked around and over the horizontal canvas was a technique thoughtfully and deliberately arrived at as the inevitable means by which to impose his visions and feelings on the painting's surface and the viewer's eye.

Accidents and chance were encouraged, but controlled and corrected. "I *can* control the flow of paint: there is no

411. Jackson Pollock. *Seascape.* 1934. Oil on canvas, 12 × 16″ (30 × 41 cm). Collection Lee Krasner Pollock, New York.

accident, just as there is no beginning and no end." The automatism of Kandinsky continued in Pollock's colored drawing, but with less disposition to repeat obvious landscape and object forms. Pollock literally wished to be *in* his painting, more deeply involved in its creation than had ever been physically or psychologically possible.

> When I am *in* my painting, I'm not aware of what I'm doing. It is only after a sort of "get acquainted" period that I see what I have been about. I have no fears about making changes, destroying the image, etc., because the painting has a life of its own. . . . It is only when I lose contact with the painting that the result is a mess. Otherwise it is pure harmony, an easy give and take, and the painting comes out well. . . . I want to express my feelings rather than illustrate them.

The expression rather than illustration of feeling is therefore the content-form of *Autumn Rhythm* (Pl. 37, p. 297).

Just as Pollock felt that he must not lose contact with the painting, so must the beholder give it full and sustained attention, and not look for an image of leaves and clouds. Seen in its own terms, *Autumn Rhythm* constitutes a new, physically impenetrable, and unstable environment. Its tangled web or netlike configuration possesses inconstant densities, suspended in ambiguous relation to the surface. The eye is permitted to look through the web as if into a tinted void that is given atmospheric properties by the spattered color. This web is woven by the intimate calligraphy of the artist into a composition punctuated by nodes of coagulated color, congested tangles, and open and airy passages. There is neither beginning nor end, but at the four sides the configuration tends to turn back in upon itself as if signifying the limits of the nucleus. The parts and their relation are unpredictable, and no segment is duplicated. The key to the color harmony of the painting is the predominance of black, against which are browns and whites in lesser quantity, and the pervasive color of the canvas itself, which has become a positive element in the artist's conception. The title was supplied after the painting was done, perhaps when Pollock found some correspondence of qualities or mood between the two. He placed his finished worked works outside his barn in a field, not to appraise their similarity to nature but to decide whether they held their own as autonomous objects.

Sculpture and Nature

Until the 20th century, sculptural themes from nature focused largely upon animals. Flora were represented in decorative foliate motifs for architecture, and landscape was often symbolically represented in the backgrounds in reliefs. The human form personified many aspects of nature, such as the seasons, mountains, rivers, and fertility, all of which reflected the view that man, the noblest subject, was the measure of all things. For most sculptors historically, nature meant the human figure fortified with a title and props.

412. Raymond Duchamp-Villon. *The Horse.* 1914. Plaster, height 17″ (43 cm).

The nude, it was believed, could symbolize just about anything. After World War I, a number of circumstances made it possible for sculptors to treat with themes from nature that were previously *unimaginable.* What made this possible and desirable, in part, were the movement of sculptors away from descriptive art in search of more profound expressions about life; the shift from man to a world-centered view; changes in modern science that proclaimed the relativity of knowledge and the existence of worlds within worlds; the development of a modern sculptural metaphor that permitted the intuitive fusing of disparate entities to create previously unknown beings; and finally, the conviction of sculptors that truth could be poetic—that what one imagined and made into art was real! The results of these developments were to expand the intellectual and imaginative reach of many artists and to take sculpture into areas it had never entered before. Not only the appearance but the very means of making sculpture were altered in some cases in order to realize the unique qualities of the creators' visions.

A work that was historically crucial in the emergence of the modern sculptural metaphor was Raymond Duchamp-Villon's *The Horse* of 1914 (Fig. 412). Although first mod-

eled in clay and cast in plaster (traditional materials and means for making sculpture) before the artist's death in 1917, the resulting somewhat coiled form was revolutionary in concept, for it fused the equine and the mechanical in a way that does not permit their clear separation. By contrast, in older art, the centaur was part man and part horse, and there was no doubt of where one entity began and ended. By an imaginative leap, Duchamp-Villon conceived a totally new entity, perhaps as an evocation of modern horsepower, for he was fascinated by the impact of the machine on modern life. This talisman of the modern sculptural metaphor inaugurated the unhinging of logic and the entrance of a new poetry into that medium. In 1912, Duchamp-Villon had prophesied this extraordinary work when he wrote, "The sole pupose of the arts is neither description nor imitation, but the creation of unknown beings from elements which are always present but not apparent."

By contrast with Michelangelo's thunderous Jehovah separating the light from the dark on the Sistine Ceiling, the Rumanian sculptor Constantin Brancusi poetically evoked the silent *Beginning of the World* in his highly polished bronze egglike form of 1924 (Fig. 413). As a young artist in Budapest, Brancusi had been recognized for the anatomical accuracy of his figural forms, but his evolution after coming to Paris in 1904 was toward a purifying simplicity that gave him revelations of the sense of things. Derived from previous studies of a sleeping head, *Beginning of the World* marks the fulfillment of Brancusi's search for an art of joy based on the intellectual and sensual experience of the simple but suggestive form found in nature. He challenged the tradition of beauty as dependent upon the harmonious relationship of parts to one another and to the whole by creating a sculpture with but one part achieved by a continuous unbroken surface. The fertility of Brancusi's egglike form was both aesthetic and poetic, for it influenced this century's taste for the uncomplicated, terse, and perfected in design, while at the same time conjuring in the mind fanciful associations with various forms in nature having peaceful connotations. Brancusi's imperative was to unify: light and space with form, form with theme, humanity with art and nature. His radiant surface, paradoxically achieved by hand rather than machine polishing, brings into the closed form of the sculpture the world around it, thereby achieving a provocative ambiguity of where the sculpture begins and ends in terms of its environment. To assist in getting his sculpture up in the air to an exact height for ideal

below: 413. Constantin Brancusi. *The Beginning of the World.* 1924 (?). Polished bronze, length 11″ (28 cm). Musée National de l'Art Moderne, Paris.

right: 414. Alexander Calder. *A Universe.* 1934. Motor-driven mobile of painted iron pipe, wire, and wood with string; height 40½″ (97 cm). Museum of Modern Art, New York (gift of Abby Aldrich Rockefeller).

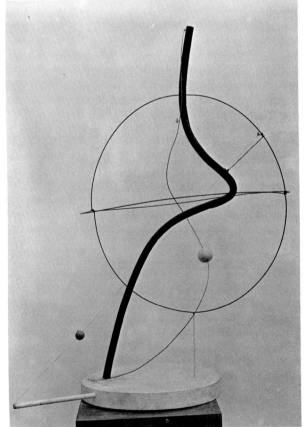

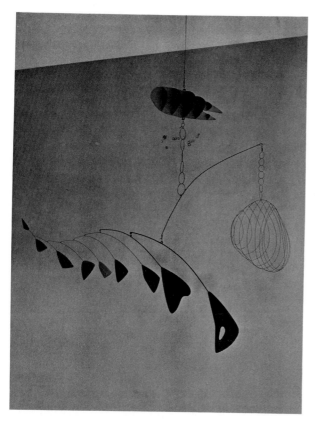

415. Alexander Calder. *Lobster Trap and Fish Tail.* 1939.
Mobile of steel wire and sheet aluminum; height 8'6'' (2.59),
diameter 9'6'' (2.9 m). Museum of Modern Art, New York
(gift of the Advisory Committee).

and enjoyed the full circuit of these orbiting spheres.)
Calder had been inspired by science to engage in a "play of
images," and he liked to look upon scientific models meant
to explain the universe as works of art. His own universe
series permitted him to express experiences such as seeing
from shipboard the sun and moon simultaneously in the
heavens in a way that imparted a sense of "bodies floating
in space, of different sizes and densities, perhaps of differ-
ent colors and temperatures . . . and some at rest, while
others move in peculiar manners." With his wire and
wooden spheres, Calder made sculpture by carving out
spaces within a surrounding space, using lines as vectors
representing motion and energy, and creating different
types of masses, light and heavy, all to show what the artist
termed "a physical law of variation among the events of
life."

The *mobiles,* or moving constructions, of Sandy Calder
involve the artist and sculpture with nature in a revolution-
ary way. Calder was the first sculptor to build an art upon
the premise that a construction could move. In the early
thirties, he experimented with a variety of mechanical
power sources, but then abandoned them as being too re-
stricted in rhythms and too difficult to integrate with the
entire sculpture. He had found a simpler, more appropriate
power source: nature with its wind and gravity. Calder's
mobiles, such as *Lobster Trap and Fish Tail* (Fig. 415), are
based mechanically upon a counterbalance of linear ele-
ments, which may be suspended from a ceiling or poised
upon a fixed point. His colored flat metal shapes sus-
pended from catenary wire arms have an ancestor in the
pure bright colors and biomorphic contours seen in the
paintings of Mondrian (Fig. 409) and Miró (Pl. 51, p. 385).
Calder was largely responsible for bringing color back to
sculpture. He enjoyed the ambivalent references of his
shapes and configurations, which can be viewed as ab-
stractions or as processes in nature such as the movement
of leaves, snow, or clouds. Calder's genius lay in making
sculpture that either in movement or at rest is a harmony of
satisfying configurations and their shadowed reflections.
His use of flat forms and movement contributed to the
larger process of sculpture's gradual dematerialization in
this century.

From the end of the Middle Ages to the early 20th cen-
tury, one of the dominant incentives of sculptors was to
discriminate differences: between various parts of the body,
one person and another, the human and other forms of life.
In modern sculpture after about 1918, there are artists who
reverse this trend, as we have seen in Brancusi's monoform
sculpture. Jean Arp (1887–1966) was one of the most elo-
quent sculptors in expressing a modern view of the ideal
harmonious relation of the human to nature, in short, a
benevolent ecological vision. Arp's *Growth* of 1938 discour-
ages the making of comfortable distinctions between plant
and human form, for he created a poetic form that evokes
both simultaneously, as well as the biological process of

viewing while establishing a rapport between it and the
supports, Brancusi carved his own bases, which he even
used at times as complete sculptures in themselves. No
modern sculptor has been more eloquent than Brancusi in
showing sculpture's power to move us and to induce the
contemplative person to meditate on sculpture, such as *The
Beginning of the World.*

In the early 1930s, the American artist, Alexander Calder
(1898–1976), made crucial new assumptions about sculp-
ture: that the model for his art would be the universe and
that sculpture should move as well as be stationary. These
decisions, and Calder's training in engineering and expo-
sure to the most venturesome art in Paris, art that was orien-
ted to the cosmic, led to such sculptures as *A Universe* (Fig.
414). A motor separate from the sculpture itself activates
the two spheres, which traverse the curving paths assigned
to them within the open sphere. The two spheres of differ-
ent colors move at different speeds like two stars. Calder's
interests were stimulated by advanced ideas in astronomy
and 18th-century scientific instruments, such as model
planetaria. (Einstein is supposed to have patiently watched

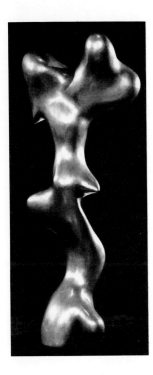

416. Jean (Hans) Arp. *Growth.* 1938. Bronze, height 31½″ (80 cm). Philadelphia Museum of Art (gift of Curt Valentin).

evolution. Arp's *Growth* (Fig. 416) is but a single example of a lifetime of work dealing with the unseen forces and processes shaping life. In this small bronze sculpture, he evoked the internal fluid pressure of life's force in the soft serpentine ascension of the form and its multiple protuberances. Although the theme is generic, the form suggests associations with various plant and human shapes. Movement is achieved through the flowing surface continuity, the absence of clearly delimited parts, and the smooth finish that permits the unobstructed play of light and shadow. The sculpture seems to pulsate, enlarge, and strive upward. Arp has treated the lower area in a way that suggests it continues below the level of sight into a root.

To his abstract sculpture Arp gave a sensuality and grace equal to that bestowed upon the antique figures of Apollo (Figs. 54, 55, 57–59). Like Klee's, Arp's purpose was to show the importance and relatedness of common, recurrent phenomena in nature and to recompense for the vanity that viewed the world as man-centered. A witness to wars and revolutions, Arp wanted an art that countered both human bestiality and society's adulation of the rational and technological. In affirming the peaceful, the handmade, and the irrationally conceived, he longed for man's return to a more simple existence and "an elemental, natural healthy art" that would bring release from material cares and self-consciousness. "Works of art should remain as anonymous in the great workshop of nature as the clouds, the mountains, the seas, the animals and man himself. Yes! Man should once again become part of nature."

Barbara Hepworth's *Pendour* (Fig. 417) is the affirmative answer to Arp's imperative. In fact, it was Arp's example that made it possible for this admirable artist to resolve the problem of harmonizing the figure in the landscape, a problem that had obsessed her for years. Her solution was to evoke poetically the landscape in the figure. *Pendour* takes its name from a cove on the Cornish coast of England where Hepworth spent many hours experiencing the rocks and caves, the tides and the rhythms of nature. Her carving expresses these sensations as felt within her own body, as when one lies on a beach daydreaming or loses self-consciousness by surrendering to the sensations of the time and place. In her own words, "I was the figure in the landscape and every sculpture contained . . . the ever changing forms and contours embodying my own response to a given position in that landscape." Besides the "ideal unity" she felt with nature, Hepworth's carved sculpture reflects the winning of a sense of identity with the textures and growth patterns of the wood. They inspired a form by which to build her own sculptural anatomy, "dictated only by my poetic demands from the material." Both the white paint and the carved holes were used to evoke the experiences of the depths of water, caves, and shadows.

The American sculptor David Smith (1906–65) forged, twisted, and welded steel into his *Hudson River Landscape* (Fig. 418). While riding on a train back and forth between Albany and New York, he drew several ink sketches of impressions the moving landscape made upon him. In actuality, Smith's sculpture has more projection and recession than can be seen in a photograph; nonetheless, it possesses a unique quality of drawing in space, and its steel configuration appears to have been lifted from a flat surface. Smith was not representing a specific locale or particular landscape feature, for as he himself said, this could be any landscape; but he found the flow, contrast, and rhythm of the Hudson River Valley appropriate to his way of making sculpture. The sculptor liked to view his work outdoors, with the countryside seen through it, particularly in winter, the snow forming additional and complementary shapes on the twisted steel form. The use of steel was not anachronistic, for its tensile properties made possible the personal style that conveys Smith's private vision of nature.

Snelson's *Atom* During the last ten years or so, there have been many artists whose work has refuted the idea that art and science are mutually exclusive. One of the most gifted is Kenneth Snelson (b. 1927), an artist whose scientific background has long interested him in the relationship between tension and compression in discontinuous structures. Unlike Arp, David Smith, or Calder, Snelson does not make metaphorical sculpture, the understanding of which depends upon recognition of such clues as fragments of familiar shapes in nature. His sculpture *Atom* (Fig. 419) resulted from the desire to create in art an analogy with other

kinds of structures, notably those that "stay together because there are forces involved in them." Sculpture for Snelson means creating things in space, and these "things" may derive from what is invisible to the naked eye. After reviewing the theories of scientists on atomic structure, Snelson came to the conclusion that their picture of the atom was "garbled" and "inconsistent" from one field of science to the next. He saw these differences as stemming from *aesthetic* judgments as well as from scientific "convenience." Snelson feels that his sculpture gives a fairly consistent picture or reasonable model of an atom. It is based on the structure of the element and on the way he imagines electrons in motion, their orbits occupying a spherical field around the atomic nucleus. "What I am de-

scribing is the spatial and structural meaning of what are called electron shells. . . . My belief is that the electron in motion is the basic element of space occupancy. . . . This model shows how electrons can occupy a shell simultaneously without interfering with each other." Snelson has relied upon technology for the material—steel—and the means to depict a "frozen statement of an orbit." Snelson's *Atom* is not a scientific model; it does not give scientists more satisfactory statistical data than they had. Rather the artist has drawn upon the invisible in nature to obtain ideas for sculptural forms that satisfy his artistic-scientific desire for knowledge and beauty.

Earth Works A number of contemporary artists during the last few years have become physically rather than figuratively involved with nature. They have exchanged the studio for a place or site in nature—a wheat field or meadow, quarry or land-fill area, desert or ocean floor. They have replaced the conventional artist's tools—brush, chisel, and welding torch—with the pick and shovel, lawn mower and harvesting machine, rental equipment such as bulldozers, and aqua lungs, all of which belong to systems of construction, farming, and exploration. Finally, they have ignored

below: 417. Barbara Hepworth. *Pendour.* 1947. Painted wood, 10⅜ × 27¼ × 9″ (26 × 69 × 23 cm). Hirshhorn Museum and Sculpture Garden, Smithsonian Institution, Washington, D.C.

bottom: 418. David Smith. *Hudson River Landscape.* 1951. Steel, length 6′3″ (1.9 m). Whitney Museum of American Art, New York.

below right: 419. Kenneth Snelson. *Atom.* 1964. Stainless steel, 27 × 12 × 12″ (69 × 30 × 30 cm). Collection Alfonso A. Ossorio, East Hampton, N.Y.

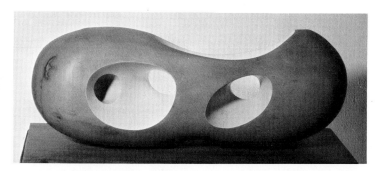

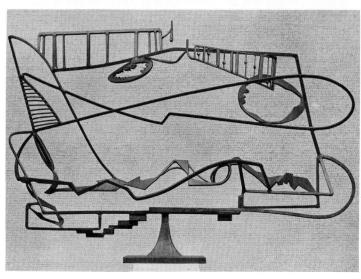

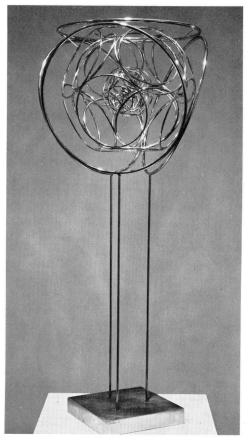

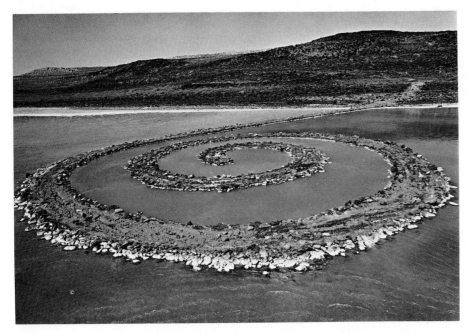

left: 420. Robert Smithson.
Spiral Jetty. 1970. Black rock,
salt crystals, earth, and
red water (algae); coil 1500′
(457.2 m) long, 15′ (4.57 m) wide.
Great Salt Lake, Utah.
© Gianfranco Gorgoni/Contact,
New York.

opposite: 421. Christo.
Running Fence. 1972–76.
Installed in Sonoma and Marin
Counties, California, 1976,
for two weeks.

the traditional artist's materials—oil pigment, stone, and bronze—which, though they derive from nature, are processed or refined by the time the modern artist uses them. Instead, these workers of the earth are putting themselves directly in contact with the raw materials of nature itself, utilizing ecological systems as others have modeled clay. They are not landscape architects who satisfy the pretentious tastes of wealthy clients, nor do they resemble ancient artists who built earth mounds for religious and communal purposes. Their lack of interest in symbolizing links their thought with the widespread literalism of American art of the 1960s. They seek to intervene in nature only temporarily and for no further purpose than the enactment of their own ideas of art. It would appear that this attitude interrupts, if it does not conclude, the age-old purpose of miniaturization in art.

Such art has been variously called *earth work, ecological art,* and *abstract geology.* It has found advocates in those who feel that art should belong to everyone, rather than just to the rich, and who wish to become part of their natural environment by conceiving and executing projects that work within the systems of nature. Implicit in these projects is their ultimate disintegration or reintegration with the earth. Like human beings, all that will remain of them are photographic records, which may or may not be exhibited and sold. The aim of earth workers has not generally been to focus upon the neglected beauty of nature, nor to make us examine a dry riverbed or slag heap with appreciative eyes. Sites may be chosen to stress wild disorder, brutal ruptures, or placidity; often they are selected at random or with aesthetic indifference.

In 1970, attracted by descriptions of its unusual red color, Robert Smithson (1928–73) journeyed to the Great Salt Lake. His fascination with matter and desolate sites drew him to what others called a wasteland. The sight of abandoned and decaying oil rigs, piers, and machinery evoked in Smithson the image of a "modern prehistory," a premonition of the death of civilization in which rusted machines substituted for dinosaur bones. Smithson found pleasure in this evidence of "a succession of man-made systems mired in abandoned hopes." Near this technological graveyard, he found and leased for twenty years a site on which he built with the help of earth movers his 1500-foot (457-meter) long *Spiral Jetty* (Fig. 420). Its form was generated by his first encounter with the site. "It reverberated out to the horizons only to suggest an immobile cyclone while flickering light made the entire landscape appear to quake. A dormant earthquake spread into the fluttering stillness, into a spinning sensation without movement. From that gyrating space emerged the possibility of the *Spiral Jetty*." Recalling his almost hallucinatory vision, the artist continued, "The shore of the lake became the edge of the sun, a boiling curve, an explosion rising into a fiery prominence. Matter collapsing into the lake mirrored in the shape of a spiral."

Using basalt and earth scooped from the shore, Smithson's construction workers built the jetty into the lake. It gradually became covered with salt crystals, which in turn evolved into screwlike structures. Smithson's work of art was thus not an object but a rearrangement of matter that was susceptible to alteration as well as to periodic submergence. This change of state seems to have symbolized the artist's reflections on the coexistence of prehistory and the

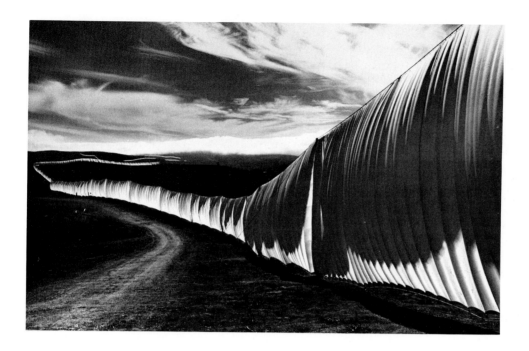

present, his morbid forebodings of the future of this planet, and his own will to be absorbed into nature (to return to his "primordial origins"). He cherished the ambiguities of his visionary sculpture; the instability of its form and uncertainty of its scale when seen from different viewpoints and when the reflecting surface of the lake made it seem that the sun was caught in the spiral. *Spiral Jetty* was Smithson's way of passing into the stream of time.

Running Fence In September of 1976, the Bulgarian-born artist Christo erected for two weeks in northern California a 24½-mile (39.2-kilometer) long *Running Fence* (Fig. 421), consisting of 165,000 yards (148,500 meters) of nylon material attached to steel poles 18 feet (5.4 meters) high. It was the culmination of 42 months of planning, arranging land-use agreements with 59 ranchers, attending 17 public hearings, being involved in three court hearings, preparing a 450-page environmental impact report, and raising over $3 million from the sale of his own work to pay for the project. Christo's work of art included all of these logistics and many more. He once said, "My work is complex, ambiguous. What I learn here—the American system, society, the way the whole big machine works—I find perfect for my use for my projects. To grab American social structure and make it work, this is what I learn in America. . . . I think all the power and force of art comes from real life, that the work must be so much part of everyday life that it cannot be separated. It is because my *Running Fence* is rooted in everyday life that it gains so much force."

Running Fence grew from a vision of the artist in which he sought to "celebrate nature," to call attention to its beauty and to challenge conventional notions of what was art. The fence was his way of temporarily intervening in nature in a civilized manner so that those who saw it could experience art more intensely than in a museum. He conceived of the nylon fabric as a "light conductor for the sunlight," which would also "describe the wind," and its emergence from or entrance into the sea as being a "ribbon of light." Unlike the Great Wall of China or the notorious barrier in Berlin, Christo's fence was never intended to divide, to keep life in or out, but rather to bring people together, and this he did for hundreds of students and hard hats who built it and thousands who drove or hiked its length from sunup to moonrise. This silvery ribbon took on the color and shadows of natural light, clouds, barns, corrals, and animals. It was as if nature had taken on a spine.

A characteristic of genius is that categories are not compelling. Christo's *Running Fence* is not comfortably assigned to painting, sculpture, architecture, or theater. Christo deals in realities; things he dreams of he makes so that they can be seen, touched, photographed, and thought about. Like life, his projects are temporary, the results of great self-confidence and humility. *Running Fence* was one of the most dramatic contemporary expressions of humanity's hope for the good life through communion with nature and one another. What individual in our society has provided a better model of working with nature and others for the common purpose of creating beauty? Unlike so many of his fellow artists and architects who make earth crushers of iron and steel, Christo gave a work that sat lightly upon the land, touched the heart, and forever will weigh in the minds of those who experienced it.

left: 422. Hieronymus Bosch. *The Creation of the World,* closed wings of the triptych *Garden of Earthly Delights.* c. 1505–10. Oil on panel, each wing 7'2'' × 3'2¼'' (2.18 × .97 m). Prado, Madrid.

above: 423. Hans Haacke. *Condensation Box.* 1965–67. Plexiglas and water, 30'' (76 cm) square.

The Articulation of Nature Today's artists are not totally removed from the past. Consider a painting of the earth by Hieronymus Bosch (Fig. 422) in comparison with *Condensation Box* (Fig. 423), by the German-born Hans Haacke (b. 1937). Bosch had the vision, uncanny for his time, that the earth existed within a closed system, symbolized by a transparent sphere. Haacke accepts the same premise, and thanks to technology can build his model, but without Bosch's global symbolism.

To understand the thinking of a gifted and articulate younger artist who is no longer interested in making sculptural objects—fixed, isolated works to be interpreted by a viewer—consider the problems Haacke posed in making his highly individual "weather box." He assigned to himself the task of creating something that "experiences, reacts to its environment, changes, is non-stable . . . that cannot 'perform' without the assistance of its environment . . . [that is] sensitive to light and temperature changes . . . that lives in time and makes the 'spectator' experience time . . . [that] articulates something natural." Using Plexiglas, a product of technology, he fashioned a series of carefully proportioned boxes into which distilled water could be introduced and then sealed. Potentially, these could be mass produced and cheaply sold. When exposed to sunlight and temperature change, hydrodynamic changes resulted. Thus the product and precision of technology have been put in the service of creating a work characterized by random behavior, by organic movement feeding on natural forces. Haacke feels that human beings are at home with natural rather than mechanical motion, natural rather than clockwork time. Aesthetically and intellectually, he favors the mutual enhancement of the geometrically shaped container and the organic happening on the inside. He uses the laws of nature and science as tools, not as ends; thus he is not a science illustrator. The viewer can enjoy the prismatic light

reflections as the light and bubble patterns change over a long period of time. Haacke would have deplored artificially colored glass or liquid; what he has done is to isolate and articulate a natural phenomenon, whose appreciation he feels requires exceptional sensibility. His work is tied to *systems* thought and art in that it involves transfers of energy, matter, or information without the viewer's participation or empathy. The viewer is a witness, not, as in the past history of painting and sculpture, an interpreter.

Art, like science, is a record of humanity's interaction with nature, of meditation on matter. Landscape art is of importance to culture not because it gives us geographical information about China, Holland, or southern France; it has value because of the way these places were seen, felt, remembered, or thought of, and then given new form by artists. Inherent in all the art discussed in this chapter is the artist's curiosity to know about creation, the gods, and the nature of reality—where humanity has stood in relation to the universe. The processes of making art as much as the finished work have brought countless artists the welcome sense of being in communion with nature, thereby realizing one of humanity's oldest hopes. By means of art, gifted individuals have put nature into a more personal or perfect order, offered poetic hopes for an ideal ecology, or realized intuitions of a great disorder. As a theme, nature has served those who would use it for edification and moral or philosophical instruction and those who would passively submit to its beauty. The depiction and interpretation of nature has offered escape from the here and now or penetration into the secrets of existence. Religious or spiritual awe at nature's vastness, power, and incomprehensibility has cohabited with the drive to domesticate a small plot of earth by means of art. Two of many aspects artists have reacted to in nature are the sublime and the mundane.

above: Plate 36. Wassily Kandinsky. *Painting with White Border.* 1913. Oil on canvas, 4′7½″ × 6′6⅞″ (1.4 × 2 m). Solomon R. Guggenheim Museum, New York.

below: Plate 37. Jackson Pollock. *Autumn Rhythm.* 1950. Oil on canvas, 8′9″ × 17′3″ (2.67 × 5.26 m). Metropolitan Museum of Art, New York (George A. Hearn Fund, 1957).

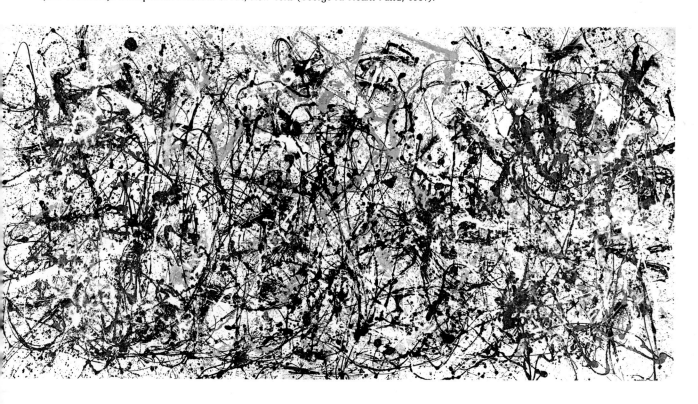

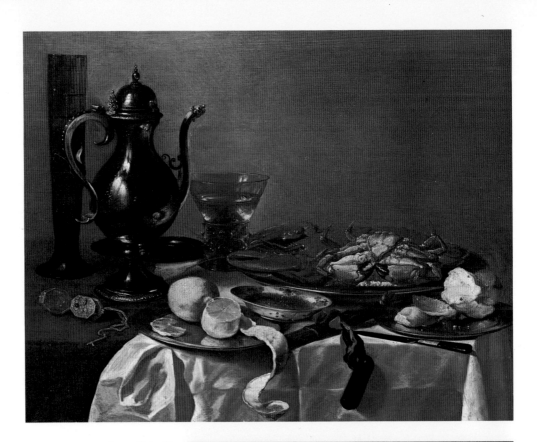

above: Plate 38.
Pieter Claesz. *Still Life.*
1643. Oil on panel,
29½ × 35'' (75 × 89 cm).
Minneapolis Institute of Arts.

right: Plate 39.
Jean Baptiste Siméon Chardin.
Still Life. c. 1732.
Oil on canvas,
15⅞ × 12⅜'' (40 × 31 cm).
Norton Simon Foundation,
Pasadena.

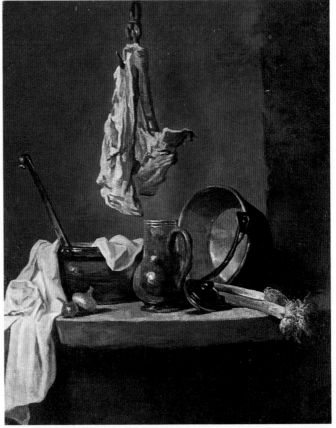

Chapter 16

Art, Objects, and the Object of Art

To understand the fascination that objects have had for the painter, it helps to examine a few of our own fundamental attitudes. No one is neutral toward objects. Aside from the specific function for which an object has been made, its continued use and the mind's tendency to make analogies have often invested it with multiple associations or symbolic purposes. In the Middle Ages, for example, the relics of saints and kings or objects used by them had great value, as if some of the holiness or power of these revered figures had rubbed off on what they had handled. Even today the personal effects of a dead person or of a celebrated figure can have special meaning. People still invest inanimate objects with irrational meaning and value.

We also tend to forget that paintings themselves are objects. They begin as wood panels or canvases that are stretched over rectangular wooden frames and on which pigment has been applied. Throughout most of art's history, this fundamentally static character has been disguised by illusions of naturalism and movement. As will be shown in this chapter, artists have long had the ability to look searchingly at objects and to invent many possible relations with the framed surface. They can create an unfamiliar context by using the frame like a camera lens, forcing the spectator to focus upon objects within a severely limited environment. The small size of most objects chosen for painting allows an artist to preserve their exact scale, a condition that can vivify a painting. Since the objects are painted imitations, they cannot be touched or used; we are obliged to appreciate them solely with our eyes, thus experiencing

them in a new way. Probably for the first time, we become aware of an object's color, shape, volume, texture, and surface reflection of light—the aesthetic properties that commonly unite the interest of artist and viewer.

Like the physical circumstance of the painting itself, objects lack movement, and many artists have been fascinated with their fixity, their quality of *just being there.* The combination of picture and objects has often been used to produce a restful visual experience satisfying the need of artist and viewer to see things put in order. Placing two or more objects next to one another can establish a *dialogue* for the painter, stressing various forms of interchange or reciprocation between objects, creating types of order or harmony that have metaphorically been models for human existence. Changes in composition as well as in the choice of objects often parallel important shifts not just in styles but in broad developments outside the sphere of art. The type of painting in which the subject is an object is important in the sociology and psychology of art. It is the one form of painting in which artists have generally been superior to their subject and could dispose of it when they were finished. Beginning in the 17th century, it was the one form of painting in which the subject was not considered superior to the painting itself. Many beautiful paintings have been created from the most modest or unlikely subject objects. Before the 17th century, it was perhaps still-life painting that most readily allowed the discriminating viewer to contemplate and appraise the judgment and coordination of the artist's eye and hand. Even the most illusionistic ren-

dering of objects does not require total self-effacement on the part of the artist, for we can come to recognize many still-life painters by their choice of objects, by their arrangement and lighting. There are endless ways in which a round wine bottle can be convincingly transposed to the flat surface of a painting. Throughout the history of art, artists have delighted in the challenge of reworking the same subject and even repainting the same picture. Meyer Schapiro has given an illuminating summary of the unique importance of the still life:

> Without a fixed place in nature and submitted to arbitrary and often accidental manipulation, the still life on the table is an objective example of the formed but constantly re-arranged, the freely disposable in reality, and therefore connate with an idea of artistic liberty. The still-life picture, to a greater degree than the landscape or historical painting, owes its composition to the painter, yet more than these seems to represent a piece of everyday reality.

Objects in Antiquity The largest surviving pre-Roman body of painting concerning itself with objects is that found in Egyptian tombs (Figs. 28, 29). The pictures of foodstuffs and vessels in Egyptian reliefs and wall paintings do not constitute pure still-life painting, or rendering of inanimate objects for their aesthetic value alone. They are accompanied by representations of the deceased whom these objects were to serve in the afterlife, of workers who were to make and gather the objects in the service of the deceased, or of the gods who were to receive the objects as offerings. Their purpose in Egyptian art was thus utilitarian. As long as ancient art was god-centered and deeply rooted in magic and religion, no legitimate tradition of still-life painting could develop. But ancient literary sources recount that by the 4th century B.C., urban Greek artists had achieved highly illusionistic techniques of representing objects in stage sets and on portable panel paintings and frescoes for homes and shops. Though none of this Hellenistic art has survived, its emergence in the 5th and 4th centuries B.C. accompanied an increasing secularization of artistic subject matter in both painting and sculpture. It was part of a public taste for enjoying and capturing the immediate material existence, as well as of a growing religious and political relativism. Much of the still-life art produced by Greek artists dealt with food and the vessels and plates with which meals were served, reflecting the tastes and social customs of the artists' patrons and their guests and the delight of city dwellers in the products of the country. The Greek imitation of the fruits of nature, with its connotations of sociability and connoisseurship, had later parallels and influence in Roman painting and mosaic, many examples of which have survived to our time.

One such mosaic, representing the floor of a Roman dining room, is known as *The Unswept Room* (Fig. 424). Dating from the 2nd century, it is probably a copy by Hera-

clitus of a lost work from the Greek city of Pergamon. It was not uncommon for guests at a fashionable banquet to litter the floor with bits of food. The scattered objects in *The Unswept Room* mosaic are table discards, the refuse of a discriminating, ritually ordered banquet such as would be held in the *triclinium,* or dining room. The mosaic consists of small, roughly squared cubes of white and colored stone set into a cement base. The color range and intensity of the stones, or *tesserae,* used by Roman mosaicists surpassed the palettes of fresco and panel painters in antiquity. The minute size in which the stones could be cut permitted subtle tonal gradations and intricate curves, so that the medium did not inhibit the artist's choice of objects or illusionistic intent. Not only the shape and color of the objects but also the relief effect from cast shadows and the naturalistic mouse in the lower left corner would cause an unsuspecting guest to tread carefully in the rooms and would doubtless provide conversational diversion between the courses. Study of this seemingly random composition reveals the brilliant calculation and sensitivity to complex balance exercised by the artist. Objects do not overlap or touch; nor are shadows tangent at any point. There is no single organizing axis or consistent light source. The mosaic is rendered in perspective, so to speak, from any point in the dining room. The careful spacing between shapes and shadows and the overall density established in each large quarter of the floor results in a harmonious ordering of a highly sophisticated type. Comparison of this mosaic with

424. Heraclitus. *The Unswept Room,* copy of a Hellenistic mosaic by Sosus. Rome, 2nd century A.D. Vatican Museums, Rome.

425. *Throne with Scroll and Symbols of the Evangelists Luke and John.* Early 5th century. Mosaic. Santa Maria Capua, Vetere, Italy.

Egyptian paintings of objects illuminates the changes that had taken place in the relationship between people and their environment—from a sense of fear and a deep need for security in the next world to an attitude of relaxed pleasure and confidence.

Objects That Symbolize Persons From the 4th through the 14th and 15th centuries in Western art, the achievements of the Romans in the naturalistic rendering of secular objects and their making of them the complete subjects of works of art were apparently forgotten or ignored. The life of the object in art underwent significant transformation. For about a thousand years in painting, mosaic, and sculpture, objects served in the main as attributes, symbols, or accessories for Christian heroes. The throne, for instance, occupies an important place in Early Christian imagery. The presence of the throne as a venerated object and symbol had various origins; it derived from religious sources such as the biblical description of the throne of Solomon, from pagan traditions, and from the artists' familiarity with the thrones of Roman emperors (Fig. 308). During the important Council of Ephesus in the 4th century, a throne, empty except for the Gospels placed upon it, had the place of honor as a sign that Christ chaired the conclave.

A 5th-century mosaic (Fig. 425) from a church in Rome illustrates how an object could thus replace the image of Christ himself. We saw a similar symbolic use of the throne in our discussion of early portrayals of the Buddha (Fig. 60). The regal, authoritarian tone of the mosaic is attributable not only to the sumptuousness of the throne, with its inlaid precious stones, elegant drapery, and brilliantly colored cushion beneath the scroll of sacred Scripture, but also to the formality of the object's placement. Not unlike the arrangement in mosaic images showing Christ in Glory (Pl. 3, p. 56), the throne is frontal, placed centrally between sym-

bols of the Evangelists John and Luke, and dominates the whole ensemble by its size. The central axis of the throne is shared by the Scriptures and the dove representing the Holy Ghost, which reveals to the eyes of the enlightened beholder the source and omnipotence of Christian law.

Whereas the Christian mosaic of the throne was valued in its time for the exalted nature of its subject and the preciousness of the medium, Van Gogh's late-19th-century painting of his own chair (Pl. 34, p. 264) has come to be valued for its artistic merit and powerful revelation of the artist's feeling about himself and his relation to others. It is questionable whether Van Gogh was conscious of the earlier tradition of the subject as symbol of a human presence or of a god. Largely through instinct and an urgent need to attach himself to others, he came to endow objects—his shoes, pipe and tobacco, books, gloves, and flowers—with human associations. The objects that moved him were modest, and their appearance was shaped by use.

Although the subject is inanimate, Van Gogh's painting of his empty chair can nonetheless induce disquiet in the viewer. The heavy dark outline of the chair aggressively asserts its object character, as does the substance of the thick, strong yellow pigment re-creating the wood and straw. Unlike the impressive frontal throne of Christ, seen from slightly below and eternally stabilized against the backdrop of Heaven, Van Gogh's chair is painted from above and turned as a severe angle to the floor tiles and the corner of the room. No attempt was made to align the objects into a simple deliberate pattern.

Each part of the whole vigorously appeals to the eye, prohibiting tranquil inspection, and in this way the chair's magnetism as an object and as a visual form is brought home to us—for it is to it that we must constantly return our gaze. Whereas the throne in Christian art helped to relate man to his god, to orient him to the universe, Van Gogh's chair was the artist's link with sanity and human love.

above: 426. Domingo Crespi (?). *Instruments of the Passion,* from the *Breviary of King Martin of Aragon.* 1395–1410. Bibliothèque Nationale, Paris.

right: 427. *Cupboard with Bottles and Books.* German, 1470–80. Oil on wood, 41¾ × 31⅞″ (106 × 81 cm). Geib Collection, Rochester, N.Y.

Objects and Narrative The storytelling capacity of objects was recognized more than five and a half centuries ago by a Spanish artist, possibly Domingo Crespi (fl. c. 1409), who decorated a private book of religious lessons and prayers for King Martin of Aragon. The section dealing with the events leading up to Easter includes a large painting filled with an assortment of objects whose conjunction would be incomprehensible to anyone unfamiliar with the details of Christ's Passion (Fig. 426) as recounted in the Bible and the apocryphal gospels. The devout reader of the royal breviary can single out an object and put it in the context of the events leading to Christ's death. But this ability to reconstruct the religious drama owes much to previous painting. Even in the Middle Ages, with its emphasis on textual interpretation, artists took the license of filling in details omitted by Scripture (for instance, the insertion of medieval tongs or pliers, by which the nails were removed from Christ's hands and feet). Purposes of clarity and ready identification influenced the even dispersal of the objects, each of which carried poignant associations. The mystical nature of the painting allows the painter to suspend objects and fragmentary heads and hands in space.

Objects as Attributes It was from the medieval tradition of objects as attributes of Christ, the Virgin, and the saints

that their independent secular painting emerged in the 15th century. A German painting, *Cupboard with Bottles and Books* (Fig. 427), was executed by an unknown artist during the years 1470–80; it has been interpreted as a pharmacy sign, perhaps from a hospital, because the tag on the flask reads, "For toothaches." The lower half of the composition is a neatly distributed but static display of objects hanging on a wall or standing upon a shelf. Within this recessed niche, the objects are susceptible to a varying intensity of light and shadow. The cupboard above is shown with one of its doors partly open, as if it had pivoted into the viewer's space. Paintings that astonish the eye by illusionistically moving away from or toward us have a tradition that goes back to ancient times (Fig. 393), and their reappearance in the 15th century, both in northern Europe and in Italy, is thought to be a conscious revival of this ancient practice.

There is a strong possibility that this German advertisement may have been inspired by compositions of polychrome inlaid wood, called *intarsia,* which were developed in Italy before the middle of the 15th century and for which such major artists as Piero della Francesca and Uccello willingly supplied drawings. Because of the intarsia's associations with Roman nobility, Italian rulers such as the Duke of Urbino commissioned *intarsiatori* or inlay artists to decorate entire rooms of their palaces with this type of illusionistic art. Fra Vincenzo de Verona was active about 1480

in designing optically deceptive inlaid decoration for a church in Modena. Showing this mastery of complex perspective problems, in the panel illustrated (Fig. 428), Fra Vincenzo simulated a partially opened cupboard, whose latticed shutters angle toward the viewer with such convincing effect that they arouse the impulse to open them further or close them. Piled on the lower shelf are liturgical objects such as a cross and a censer, which symbolize God's truth, while the hourglass and skull above symbolize, as they had since antiquity, mortality and human vanity. Instead of depicting living and dead figures, the artist employed objects for his *memento mori.* The French art historian Charles Sterling, in his excellent history of still life, points out that inlay artists utilized the most advanced techniques of perspective developed by 15th-century painters and geometers and that, ironically, their inlaid work in turn influenced 16th-century painters to attempt illusionistic compositions that seem to advance toward the viewer.

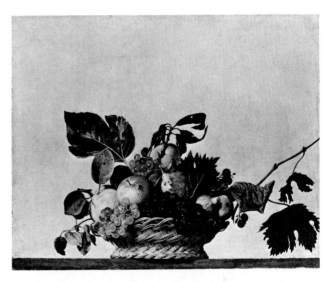

left: 428. Fra Vincenzo da Verona. *Cupboard and Niche with Objects.* c. 1480. Wood inlay. Louvre, Paris.

above: 429. Caravaggio. *Basket of Fruit.* c. 1596. Oil on canvas, $18\frac{1}{8} \times 25\frac{3}{8}''$ (46 × 65 cm). Pinacoteca Ambrosiana, Milan.

Worldly and Pious Objects Heir to the illusionistic tradition and subject matter that went back to ancient Roman mosaics, Caravaggio (1573–1609) painted a solitary basket of fruit (Fig. 429) that, like the vivid relief of his figure paintings (Pl. 19, p. 176), was to have a substantial impact on 17th-century art. This lowliest of subject matter, by artistic standards of the time, was boldly centered in the painting, preempting the customary place of a noble figure. Within this strong formal emphasis, the artist preserved the informal disarray of the fruit spilling over the basket and out of the picture. Rather than perfectly formed and fresh clean fruit, he showed fruit that was dust-covered and deteriorating from worms and the long interval required by the painting. Caravaggio was not appealing to the sensation of taste. Perhaps he was moralizing by using the fruit to signify the transiency of life. Certainly he was giving a lesson in seeing, compelling his audience to look long and hard at what they ordinarily took for granted. That he found the basket of fruit worthy of comparison with figure subjects may be supported not only by the time that he must have spent in the patient detailing of its properties but also by the fact that he illuminated it with the same kind of hard lucid light.

Caravaggio and the Spanish Carthusian friar Juan Sanchez Cotán (1561–1637) furnish persuasive evidence that the serious painting of fruits and vegetables can satisfy both worldly and pious temperaments. Shortly before taking monastic vows, when he was about 40 years of age, Cotán did a series of still-life paintings, and their sober profundity far exceeds in quality his sentimental religious figure paint-

ings (Fig. 430). Like a second frame, he employs a stone window casement in which a quince and cabbage are hung near a melon and cucumber resting on the ledge. The carefully staggeréd disposition of the objects suggests musical notation, but whether or not this was his inspiration, Cotán hit upon an ingeniously simple device to separate and dramatize the individual objects and their relationship. It is known that Cotán was interested in geometry, and this painting may have resulted from personal meditations on contrasts between shapes found in nature and those conceived in the human mind. By cutting open the melon and using a niche that interrupts the strong cold light, he expands the variety of ways in which we can know his subject.

The gradual advance of the objects from left to right culminates in the cucumber precariously balanced on the edge of the sill, so that the artist counteracts the impression of a monotonous horizontal alignment and seems to make a partial loan of one of the objects to the viewer's space. Caravaggio's testimony to the worth of such a theme and the intriguing potential of emphatic side lighting may have encouraged Cotán to digress from his usual pious subjects.

The 17th-century Spanish artist Francisco de Zurbarán (1598–1664), a contemporary of Cotán's, exhibited a duality of interests that produced official religious and royal imagery as well as meditative still lifes. His art on the whole reflects the painter's existence at court and in the cloister, and it captures the domestic environment of objects. That Zurbarán carried over attitudes from one mode of life to another can be seen in his *Still Life with Four Vessels* (Fig. 431). Four beautifully made, variously shaped, but relatively modest objects are disposed along a stone ledge, like a litany, in a line parallel to the picture plane. This arrangement suggests offerings placed before the altar in a Spanish cathedral of the time. The mood of the whole echoes, in inanimate fashion, that of Zurbarán's images of humble monks. Unlike Dutch paintings involving objects, this picture gives no suggestion of casual use or sociable situations. The objects are presented for serious contemplation,

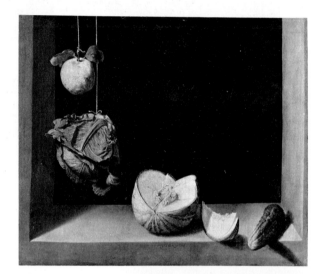

left: 430. Juan Sanchez Cotán. *Bodegon.* c. 1603.
Oil on canvas, 25¾ × 32″ (65 × 81 cm).
Fine Arts Society of San Diego, Calif.

below: 431. Francisco de Zurbarán. *Still Life with Four Vessels.*
1633–40. Oil on canvas, 18⅛ × 33″ (46 × 84 cm).
Prado, Madrid.

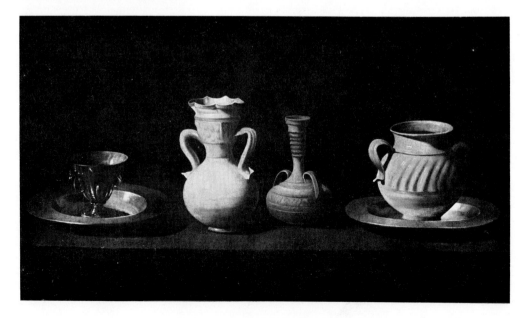

left: 432. Mu-Ch'i. *Six Persimmons.* Southern Sung Dynasty, late 13th century. Ink on paper, width 14½″ (37 cm). Daitoku-ji, Kyoto.

below: 433. Bauguin. *The Five Senses.* c. 1630. Oil on panel, 21⅝ × 28¾″ (55 × 98 cm). Louvre, Paris.

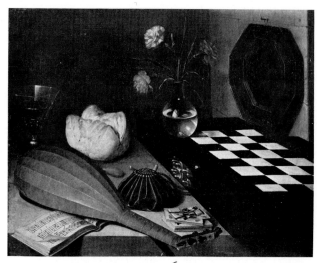

not unlike the monks' practice of meditating at length upon a passage of Scripture. Their symmetrical placement is deceptive, for Zurbarán was deeply aware of the individuality and worth of each vessel and elicited a range of contrasts far beyond the objects' number and superficial appearance.

Objects of Meditation Oriental painting does not include the Western category of still life. Despite the fact that Chinese artists produced magnificent objects with a history of important religious and aesthetic use in temple, tomb, and home, they never created entire paintings devoted to inanimate objects. Closest to Western still lifes of fruit detached from the tree is *Six Persimmons* (Fig. 432), by the Chinese artist Mu-Ch'i (fl. c. 1269). Mu-Ch'i's six pieces of fruit, painted in ink on paper, are divorced from any setting or support; they hover in an undefined space as if suspended in the viewer's consciousness. It is only their proximity to the lower edge of the hanging that suggests a normal relation to a table or the ground, or at least an acknowledgment of the pull of gravity. Because the painting has been cut, however, it is impossible to comment on the relation of the objects to the total field.

The spiritual speculations of the artist are suggested by the fact that the persimmons are rendered in various stages of their life cycle. For this reason alone, the French term for still life, *nature morte,* or "dead nature," would seem inappropriate. The Chinese painter dealt only with living things, and he found the life cycle of the persimmon as important

as that of man. Each fruit has a singular shape, tone, weight, density, and relation to the adjacent fruit. Unlike Zurbarán's regular spacing, the deployment of Mu-Ch'i's persimmons seems naturally informal. They are related by overlap, tangency, and discrete intervals, yet these objects do not share even an invisible ground line. No two stems are the same, nor are their proportions and direction predictable. The many aesthetic judgments made by Mu-Ch'i resulted from sustained concentration and final revelation. Zurbarán's vessels and Mu-Ch'i's persimmons remind us that an artist's attitudes toward life may be manifested through the smallest, most modest subjects.

Objects and the Senses In the 17th century, painters of objects began to depart from the rigorous "inventory" style of alignment and to dispose them in more informal ways and with a greater sense of depth. A French painter named Bauguin (fl. 1620–40), who derived much from Caravaggio, constructed a painting of objects that evoked in his contemporary audience the pleasures of the table, the gratifications of all the senses, and the shortness of life (Fig. 433). Their seemingly casual disarray implied recent use and perhaps interruption by death. In a continuance of the illusionistic tradition of visual tricks, the mandolin seems to jut toward the viewer's reach. In painting such as this, it is not the meaning or purpose of the objects that dictates their locations. Not trusting to gambler's luck, Bauguin invites us to discover his reasoned decisions for pairing and juxtapos-

ing different objects, such as the repetition of fluted edges in the mandolin and purse, the geometric order of the gaming board and the disorder of the adjoining table area, the shape of a flower against the octagon of the mirror, the pure geometry of the glass versus the natural irregularity of the melon. Sophisticated audiences in the 17th century shared the artist's enthusiasm for visual perception and the exercise of intellect. They appreciated the correct shadings of the mandolin calculated on the basis of the light source and varying surface angles and admired the mental scheming that produced musical and pictorial harmonies.

Objects to Satisfy Sociability, Vanity, and Morality

The object became central to painting in the 16th century. In 17th-century Holland, still lifes were an art form of aesthetic as well as symbolic significance. In contrast to the situation in Roman Catholic countries, the Dutch Protestant Church was not an important sponsor of art, and still-life paintings were developed to satisfy the needs and taste of a secular, largely middle-class, prosperous clientele. These paintings were modest-size objects, intended for hanging in the home among other prized domestic possessions. Still lifes were also purchased for financial speculation, so that Dutch artists, anticipating their modern counterparts, did not always know their future buyer. The aesthetic subject matter and passive quality of the Dutch still lifes, in accord with the insulated atmosphere of the middle-class Dutch home (Fig. 264), recall the tranquilizing effect of the pleasant scenes painted inside urban dwellings of ancient Rome (Fig. 393). It was from Dutch paintings after 1620 that described partially eaten meals, with the consequent suggestion of physical deterioration, that still another evocation of the themes of *vanitas* and death emerged. The message was that the good *moral* life meant temperate living. The Dutch love of finely painted objects testifies to a distaste for the passions of epic and dramatic images, which did not suitably reflect the secure and complacent character of Dutch culture and prosperity in the 17th century. The still-life paintings record Holland's acquisition of material wealth and an extensive overseas trade that returned to the home country exotic objects, foods, and wines. The fact that most Dutch still life refers to meals also makes of these paintings emblems of the Dutch pride in hospitality. They are fit companions to portraits of affable Dutchmen who invite us to share their wine and company (Fig. 261). There was a wide range of still-life painting, involving different types of meals and degrees of opulence or modesty, depending upon such factors as their city of origin and their date. Toward the end of the 17th century, the still lifes were composed of more precious, exotic objects and began to display more complex arrangements and a more feminine air.

The Dutch enjoyed seeing inanimate objects organized in stable compositions. Objects were placed close to the viewer, as if soliciting us to share intimately the knowledge and experience of the artist. Both the painstaking creation and the appreciative seeing of the art were best accomplished while seated. Absorbing the satisfactions of a Dutch still-life painting demands the same kind of savoring as is required to do justice to a delicious meal. As illustrated in a work (Pl. 38, p. 298) by Pieter Claesz (1596–1661), Dutch artists and their patrons delighted in a calculated chaos that was very unlike the pristine neatness of Cotán and Zubarán. The objects are represented in disarray, as they might be seen after a meal by someone who had just pushed back from the table. A suggestion of the meal's original order and the timepiece at the left impart a slightly morbid touch of temporality. Before undertaking the painting, the artist spent a great deal of time arranging the objects in search of shapes that "rhymed," means of linking disparate forms and easing the eye's course through the painting, and an angle of illumination that offered a maximal range of values to set off both the materials and the shapes of the objects. It now appears that many of these compositions were invented and not copied directly and as a totality: all the more a tribute to the artists' skill, apparent also in the depiction of light, which illuminates and unites.

Inelegant Objects In an 18th-century still life, a superior work of art was made of "inferior" objects. The French painter Jean Baptist Siméon Chardin (1699–1779) found in simple household utensils a source of wonder and matter for lifelong exploration (Pl. 39, p. 298). The objects chosen by Chardin reveal even more than specifically religious or political accessories could have, the strong morality of the painter. The sturdy basin or pitcher, worn and discolored from daily use, was for Chardin silent evidence of frugality, temperance, and constancy. It served his passionate interest in depicting the mysterious effects of light upon material substance—in other words, reality as it is given to the eyes.

Like Zurbarán, Chardin aligned his objects on a shelf beyond reach and set out for visual research. Unlike the cool, dry, and hard surfaces of Zurbarán, Caravaggio, and Cotán, Chardin's warm and elusive equivalences of his subjects took shape not from firm outlines but from manipulation of light values and the viscous properties of paint. The durable was created by the inconstant. With the exception of the works of Rembrandt (see Chap. 11), nowhere in the Dutch still-life painting that Chardin admired are we as conscious of the physical nature of the oil medium, the touches of the brush, and the sheer material substance of the painting's surface. From a few pigments, Chardin coaxed a rich gamut of tones such as those in the copper basin. When closely studied, these variegated tones contradict the initial impression of the basin's solidity and simplicity, for Chardin established each tone in response to minute sensations of light and dark given directly to the eye.

Picture-Makers and Painters Bauguin and Chardin exemplify the distinction between *picture-makers* and *painters.* Picture-makers, such as Bauguin, wish us to experience the object in a literal manner, to observe their success in closely matching the distinctive properties of objects in a seemingly airless space. It is as if one might reach out and pluck a flower from within the picture frame and thereby perfume the air. Neither the oil medium nor the hand of the artist intrudes upon our awareness of the illusion before our eyes. Rembrandt and Chardin, while they create plausible illusions of objects, also impart to them visible evidence of artifice, the traces of oil and brush, and make it impossible to separate the object from its unique painterly environment.

Edouard Manet was such a painter (Figs. 374, 376; Pl. 25, p. 243). To enjoy his painting is to savor nuances of color and the subtle matching of tones, the tasteful dispersal of color accents over the field of the canvas, the bold application of shapes to the painting's surface. His paintings of objects were not intended as inventories or as incentives to philosophizing. Manet's constructions of broad, strongly edged, and relatively flat areas of closely linked tones appeal more quickly to the eye than do any of the previously considered paintings. The painted fabric of Manet's objects and background is more apparent and more loosely woven than that of Chardin and the Dutch still-life masters. There is a more consistent awareness of the painting process; breadth, direction, and twists of his brushwork call attention to the surface as well as to the object. Manet reserved the most brilliant tone for the small patch of the lemon off to one side. Less brilliant hues such as coppery brown and pinks occur more frequently than the yellow, but less frequently than the grays. Manet gave to the grays and whites, which fill the largest part of his painting, the greatest range of nuance. *Still Life with Carp* (Pl. 40, p. 315) was painted for the cultured vision of a sophisticated, and at the time limited, audience. The objects included were important not only because they set up challenging tonal problems, but also because in themselves their qualities created a discriminating and pleasurable aesthetic experience for the viewer.

Whereas Manet could accept the generally perceived shape, if not the tone, of objects, Cézanne insisted upon reexamining all properties of his subject as if he were seeing it for the first time (Fig. 457; Pl. 33, p. 263). Cézanne could not unquestioningly repeat anything that was given to the senses, but instead was impelled to re-form, recolor, and reorganize whatever entered within the boundaries of his canvas. Zurbarán and the Dutch could admire the craftman's art in making handsome objects, but Cézanne felt no allegiance to the glassmaker, the ceramicist, or even to the farmer whose apples he painted (Pl. 41, p. 315). His reconstruction of objects was motivated by a desire to search out their fullness, to increase their visual interest, and to meet the particular compositional and expressive demands of

the painting. Neither perversity nor ignorance of perspective techniques led him to reshape the compote in Plate 41 into an asymmetrical, flattened oval; rather, his main consideration was the pictorial need of added coordination with the frame to increase the stability and visual weight of the composition. High-keyed tones at the upper left balanced the cloth at the lower right, and the dislocation of the base of the compote was necessary to harmonize with the assembled apples and glass. This meant stretching the basin of the compote.

Each successive decision made in the painting solved some aesthetic or compositional problem raised during a preceding stage of the canvas, instead of satisfying a concern for fidelity to the appearance of the object. Previous painters had allowed the objects to compose their paintings; Cézanne relied upon the painting to compose the objects. The apples illustrate this point, for Cézanne *realized* them in paint both from the outside edge inward and from the inside out. The direction of their stroke-faceted surfaces was coordinated with, and must be seen against, the directions of the knife, the cloth, and the pile of fruit itself, and ultimately the directions of all other movements in the painting. Each daub of the brush on an apple was calculated to fix the light value, hue, curve or flatness, warmth or coolness of a particular area of *sensation.* Every part of Cézanne's painting yields to the pull of adjacent areas because of the thoroughness with which all have been fitted together. On a personal level, these paintings of fruit may have had private sexual associations, and they as well as the act of composing perhaps allowed Cézanne to symbolically put his life and past into order. The importance of Cézanne's contribution and the value of his art has been discussed by Meyer Schapiro:

> At the threshold of our century stands the art of Cézanne, which imposes on us the conviction that in rendering the simplest objects, bare of ideal meanings, a series of colored patches can be a summit of perfection showing the concentrated qualities and powers of a great mind.

Independence from Imitation Fortified by Cézanne's assertion of the artist's obligation to restructure the visual world, the Cubist break with the imitation of the object as seen in nature was a relatively quiet revolution. Picasso (see Chap. 19), Braque (Fig. 436), Léger (Pl. 55, p. 403), and Gris (Fig. 435) did not select radically new subject matter or issue violent manifestoes attacking those who represented the literal form of the object as perceived in three-dimensional space. At no time during Cubism's most important years (1909–14) did these artists completely renounce the object. Their objects, however, were derived from the restricted area of their immediate environment. More specifically, the objects were associatéd with a favored café, the studio, and the artist's home, the latter two frequently being

one and the same. An old photograph of Braque in his studio (Fig. 434), made between 1910 and 1916, shows walls, tables, and floor covered with randomly juxtaposed objects; further, the object character of Braque's paintings themselves is stressed by the inclusion of several of them leaning against a table in the middle ground. The objects found in Cubist paintings are not costly or rare possessions, but were prized for aesthetic or personal reasons and were utilized in daily activities, so they often convey an intimate sense of conviviality. Death, moralizing, personal crises, world events, and so on were all excluded in favor of themes of simple, mostly domestic pleasure. Although the objects conveyed human sentiments, they were rendered in a way that showed the artists' unsentimental attitude toward the older tradition of still lifes. Nor did the Cubists ever arrange objects in the prosaic sequence of their original setting.

If we compare Bauguin's still life, *The Five Senses* (Fig. 433), with *Guitar and Flowers* (Fig. 435) by Juan Gris (1887–

1927), the significance of the Cubist revolution in form may become clearer. Bauguin follows the shapes, textures, and colors of the objects quite literally, whereas Gris asserts his right to rework all the objects in his painting. Gris has destroyed the closure and autonomy of objects, so that they fuse with other shapes or are joined in complex patterns on the painting's surface that have no natural counterpart. Color is not confined within distinctly bounded areas but is disposed in broader zones. The artist's brushstrokes are similarly independent of the objects and are used to create decided directions, textures, and visual patterns that are essential to the painting's structure. There is no manipulation of light and dark according to a fixed light source, as found in Bauguin's work, but an effect of flickering light and shadow is maintained within new rules laid down by the artist. It is difficult to look beyond (that is, to ignore) the surface of Gris' painting into a spatial volume, as is possible with the 17th-century work. With the modern painting, one is very conscious of the artist's inventiveness in imposing a

below: 434. Georges Braque in his studio. c. 1910–16. Courtesy Galerie Maeght, Paris.

right: 435. Juan Gris. *Guitar and Flowers.* 1912. Oil on canvas, 44⅛ × 27⅝" (1.12 × .7 m). Museum of Modern Art, New York (bequest of Anna Erickson Levene in memory of her husband, Dr. Phoebus Aaron Theodor Levene).

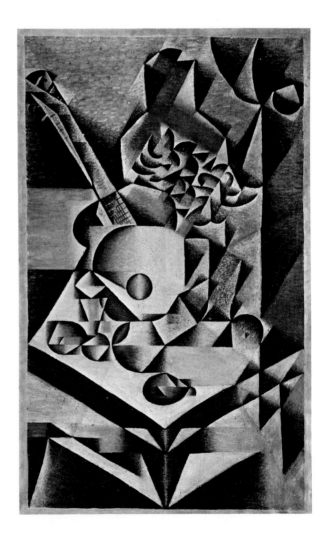

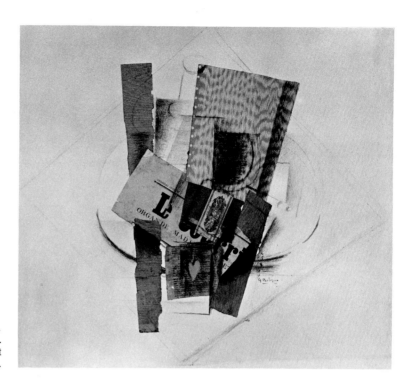

436. Georges Braque. *Le Courrier.*
1913. Collage, 20 × 22½'' (51 × 57 cm).
Philadelphia Museum of Art
(A. E. Gallatin Collection).

new structure upon objects (such as the guitar) that otherwise had remained unchanged for hundreds of years. Gris wants the viewer to be very aware of the constructed aspect of his work, in which no area is neutral or merely "fill." Space and object both become part of an intricate pictorial scaffolding that holds the composition tautly suspended within the frame. Bauguin could conceivably have finished the painting of each object separately, always keeping in mind its final appearance and arrangement. Juan Gris and other Cubists began without such assurance, without a fixed conception of the finished work, and, while improvising, moved back and forth over the whole picture surface at all stages of the painting's development. They continuously adjusted every element to its adjacent areas and the overall design. It is an approach that requires that the spectator judge for *aesthetic rightness* rather than for fidelity to the appearance of objects arrayed under light on a studio table.

By drawing our attention to the physical aspect of artistic creation, to the painting's pigment and strokes, Gris is also affirming the object character of the painting. Although he simulates some movement into depth and forward, we are conscious primarily of the painting's surface. The tangency of compositional elements with the edges of the canvas at various points and the many vertical and horizontal accents reiterate the physical dimensions of the painting. Gris does not depend upon the intrinsic or preexisting beauty of objects, but wrests aesthetic value from each touch and from the firm and lucid total design he has invented. To appreciate his achievement demands not that we try to reconstruct each object from seemingly scattered components in the painting, as if it were a jigsaw puzzle,

but that we savor the pleasures of the work in its painted parts and in the harmony of the whole. Gris' discipline and method may be compared to those of the musician whose improvisations are governed by a profound knowledge of musical structure.

Georges Braque (1882–1963) assembled pieces of a newspaper *(Le Courrier),* a cigarette package with its government seal, and simulated wood-textured paper and pasted them to one another and the paper surface, over which he drew with charcoal (Fig. 436). Thus he chose not to simulate in paint materials that were flat in nature and susceptible of incorporation in his compositions. This *collage* technique (from *papiers collés,* meaning "pasted papers") frequently appears in Cubist art, often with wit and playfulness; here, for instance, Braque cut out a heart from a newspaper article about Italy and alliances. Use of daily newspapers helps to date these compositions and makes them quite literally of their time. The assembled objects were common and readily identifiable, linking the composite artistic image to the world of familiar activities. Unlike older illusionistic painters, Braque actually built his composition outward from the surface toward the spectator. With charcoal drawing, he integrated the pasted paper segments with one another and with the white background, introducing shading for purposes of compositional accent without reference to a consistent light source, as in the Bauguin. Thus even light and shade were now made subject to the artist's will. It was the Cubists such as Braque, Picasso, and Gris who declared modern art independent of the imitation of nature and assumed the freedom to choose the materials of art and to decide how they may be used

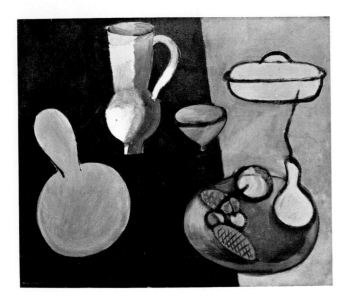

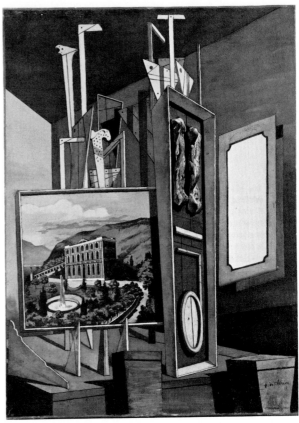

above: 437. Henri Matisse. *Gourds.* 1916. Oil on canvas,
25⅝ × 31⅞″ (65 × 81 cm). Museum of Modern Art, New York
(Mrs. Simon Guggenheim Fund).

right: 438. Giorgio de Chirico. *Grand Metaphysical Interior.*
1917. Oil on canvas, 37¾ × 28⅜″ (96 × 72 cm).
Museum of Modern Art, New York
(fractional gift of James Thrall Soby).

without adherence to conventions about what was noble or faithful to the world of appearances—in short, to be creative in new ways.

New Ideas on Expression It is unnecessary to refer to the original objects in order to evaluate and enjoy *Gourds* (Fig. 437), a painting by Henri Matisse (1869–1954). Line, color, and composition, though influenced to a degree by his contact with the visual world, became primarily personal inventions. The standards of control and quality in his art were supplied by Matisse's exceptionally good taste and reliance on artistic intuition. *Gourds* gives itself immediately and fully to the eye as a fresh sensory experience, the viewer being affected before any reasoning process occurs. The choice, limited number, and forceful rendering of objects eliminates questions about their meaning. Their clarity of contour and careful dispersal without overlap emphasize their familiarity and durability. The objects' internal coherence within the frame and the broad, flat areas of pure bright color quickly establish for the eye the rightness and importance of the total harmony.

Matisse "dreamed" of an art having "balance, purity, and serenity." His imagery endures because of the range and provocativeness of his contrasts. His shapes and colors possess a tenuous tie with the visual world. Painting from

memory rather than from direct perception, Matisse liberated drawing and color from the specific properties of objects so that they in turn could release his feelings of joy and serve his views of expression in art (Fig. 93; Pl. 58, p. 404).

> What I am after, above all, is expressiveness. Expression to my way of thinking does not consist of the passion mirrored upon a human face or betrayed by violent gesture. The whole arrangement of my pictures is expressive. The place occupied by figures or objects, the empty spaces around them, the proportions, everything plays a part. (1908)

As with the term *espressivo* in music, we do not ask "expressive of what?" Matisse's drawing is expressive because it clearly derives not only from skill and taste but also from strong will.

The irregularity of objects in *Gourds,* though also occasioned by the subtle demands of the painting's surface structure, does not extend to the extremes of the Cubists' manipulations. Matisse delighted in the formal completeness of objects as well as in the entire painting. Instead of the linear framework of the Cubists, he set up a seemingly loose dispersal of shapes on a strong asymmetrically divided blue-black background, achieving a daring balance of his few objects against their ground. He made effective use of intervals as well as of linear correspondences and played

upon the visual weight of a color when seen in areas of varying size and in different contexts. In *Gourds* were sounded new color chords, such as blue-black-reddish brown, which did not originate in established sequences before Matisse's eyes but came to him instinctively as he responded with pleasure to a particular tone he had set down. "I cannot copy nature in a servile way; I must interpret nature and submit it to the spirit of the picture. When I have found the relationship of all the tones, the result must be a living harmony of tones."

Objects as Private Symbols The Italian painter Giorgio de Chirico (1888–1978) could not, in another sense, accept the visual world as a basis for expressing his views of reality. In De Chirico's *Grand Metaphysical Interior* (Fig. 438), the painting of objects involved fanciful images that were not imitated from what is given directly to the senses. The stimulus of external sensations was replaced by the artist's inner attentiveness to "strange sensations." The objects of De Chirico's painting can for the most part be inventoried and identified, but their context and connection elude definition. Indeed, what is crucial for the painter is that they *are* enigmatic. The objects are set in an interior that is not a room in the sense that it knows human presence. It is an interior because behind a window shade suspended at the right is not a blue sky, but a green exterior. Within this interior is a naturalistic painting of an Italian villa; the familiar exterior world is thus displaced, consigned to a picture frame to become one more inexplicable object. Painted with equal illusionistic precision in an adjacent framed panel are various normally unrelated objects. The framed panels are supported by a network of drafting instruments, ordinarily to be associated with rational design. De Chirico endowed these tools with obscure meanings that we can perhaps sense but cannot fix in precise terms. They have been used as part of a calculated irrationality. The light and shadow in the room and its spatial construction are also independent of traditional usage or the position of the viewer. The shadows, shapes, space, and the pervasive stillness are an uncanny ambient made compelling by the exactness of its rendering.

The word *metaphysical* in the title refers to De Chirico's belief that the artist should paint a higher reality than that of the senses. He therefore sought to restore mystery to art and to paint the obsessive hallucinatory images that he felt mirrored the state of his soul. He became alienated from the empiricism and pictorial rationale of previous artists. De Chirico's world is that seen when the eyes are closed—a cool, dry, inert, and uninhabitable environment meant to be traversed only by the eye. The intimate personal nature of his choice of objects is in contrast to the social and hedonistic connotations of those used in Cubism or in Matisse's work: "I fill up the empty spaces in my canvas as the structure of the picture requires with a body or an object according to my humor." Objects in older still lifes exhibited some

unity of origin and use, involved some shared frame of reference. Perhaps influenced by Cubism and its collage technique, De Chirico's irrational dislocation and juxtaposition of objects from the everyday world he distrusted were important in loosing the inhibitions and fantasy of later artists who felt that "to be true to oneself" in art demanded response to the fringes of consciousness and the deepest recesses of the self.

The New Literalism The art of De Chirico transposed familiar objects into unfamiliar situations. Duchamp invented objects that insolently parodied objects, human situations, and the body itself. *Target* (Fig. 439), a work by the American artist Jasper Johns (b. 1930), is *itself* the painted object. There is no illusionism, and the painting has no reference to anything outside itself. The subject is a two-dimensional target coincident with the painted papered surface on which it exists. When the artist wished to introduce three-dimensional objects, he made plaster casts and closeted them in a row of boxes with movable lids set above the principal motif. He presents us with no riddle and asks only that his work be taken at its face value. Johns

439. Jasper Johns. *Target with Plaster Casts.* 1955.
Encaustic and collage on canvas with plaster casts,
$4'3'' \times 3'8'' \times 3\frac{1}{2}''$ (1.3 × 1.12 × .9 m).
Collection Mr. and Mrs. Leo Castelli.

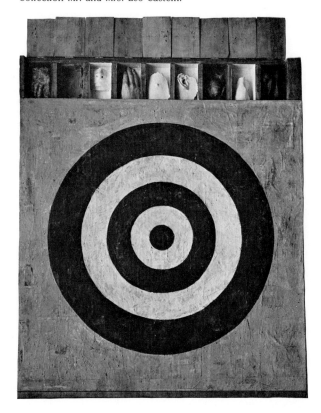

removed two-dimensional objects—in this case, a target, elsewhere the American flag or stenciled numbers—from their accustomed surroundings and connotations. He did not, however, put them into De Chirico's uncanny and enigmatic settings. Johns exaggerated the vividness of the object through increased or intensified size, color, and texture. In short, he wished the viewer to have "a direct painting experience." Johns' position reflects the current view of art as an empirical experience for the viewer, with the work of art regarded as an independent object of entirely surface importance and brought into being by any means the artist may choose.

This permissive notion of means is illustrated in *Broadcast* (Fig. 440), a work from 1959 by Robert Rauschenberg (b. 1925). The artist's premise was that any material, if employed literally, could be used in art, and from his New York environment he culled a host of objects that he brought together into *combines.* The objects have a general character of personal souvenirs, like entries in a diary of the artist and the city. There is no illusionism of objects involved. As such, they have been used before in their everyday existence and are used directly again in the combines. According to Rauschenberg, "A pair of socks is no less suitable to make a painting with than wood, nails, turpentine, oil and fabric." He has combined a stuffed angora goat with an auto tire, a stepladder with a thermometer, scraps from billboards with photographs of celebrities, mirrors, baseball bats, Coca-Cola bottles, and, in one instance, live grass. His selection of objects was not indiscriminate but involved

careful judgments of the eye. In *Broadcast,* he mounted two working radios and adjusted them so that each can be tuned to only one station. One transmits news and sports, the other music. Near the radios are appropriate photographs of racing, police beating a rioter, and the word *Help.* The improvisation of parts and the overall structural effect of the paint produce a jazz quality of harmony with the sounds transmitted by the second radio. *Broadcast* is thus environment painting in a broader sense than we have heretofore encountered. Rauschenberg's combines are like fanciful time capsules, bearing witness for the future to his life and times. Rauschenberg has included smells and sounds along with sights and the pathetic, comic, vulgar, and exuberant means by which modern society has expressed itself as brashly as the artist.

Art, as we saw at the opening of this chapter (Fig. 424), can be made from discards—from the table, from the life of a city, and from a supermarket. Both Heraclitus and Rauschenberg have given society's leavings a second, more durable life through art. When the American painter Andy Warhol (b. 1925) exhibited *Campbell Soup Can* (Fig. 441), it infuriated not only the public but many critics and artists as well. Traditionally, artists have been their own worst critics. One is reminded of what Emile Zola said about Manet—that to appreciate what he was doing "one had to forget a thousand things about art"—and if one is to enjoy Warhol's work, to be sure, it is necessary to forget a thousand things about painting. At the same time, however, there are some things from the past worth remembering on his behalf. The

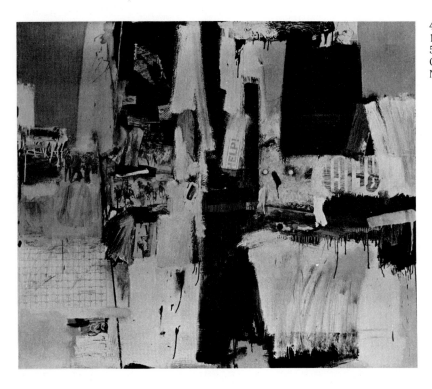

440. Robert Rauschenberg. *Broadcast.* 1959. Combine painting, 5'2'' × 6'4'' × 5'' (1.57 × 1.93 × .13 m). Collection Mr. and Mrs. John Powers, New York.

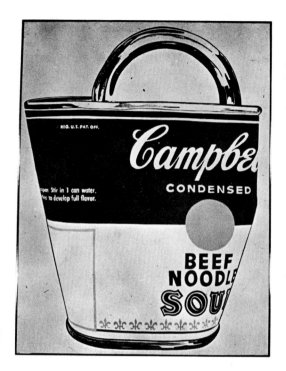

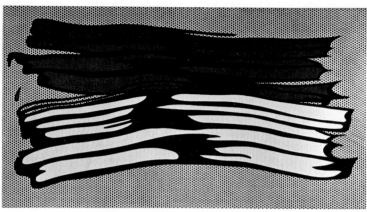

left: 441. Andy Warhol. *Campbell Soup Can.* 1962. Magna on canvas, 5'10" × 4'6" (1.52 × 1.37 m). Courtesy Leo Castelli Gallery, New York.

above: 442. Roy Lichtenstein. *Yellow and Green Brushstrokes.* 1966. Oil and magna on canvas, 3' × 5'8" (.91 × 1.73 m). Collection Robert Fraser.

strongest criticism leveled against the work is that, aside from its magnified scale, the painting presents no imaginative transformation of the subject, no apparent exercise of artistic judgment. Such fidelity to the object has already been seen in 17th-century still life, however. And, while perhaps not of a high order, imagination was involved in both cases.

Warhol flattens out the can (which appears bent as is often the case when it has been opened), but in this respect, his flatness of style belongs to this century and is characteristic of commercial as well as noncommercial art. (One might indeed argue that *any* painting put up for sale is an object of commerce.) The beautiful handmade objects of German and Dutch painting were of their time, and by selecting a mass-produced product and its container, Warhol continues such expression into his own era.

> I adore America and these are some comments on it. My image is a statement of the symbols of the harsh, impersonal products and brash materialistic objects on which America is built today. It is a projection of every thing that can be bought and sold, the practical but impermanent symbols that sustain us. (1962)

Furthermore, Warhol does not believe in individuality of style, and his calculated self-effacement before his subject is as old as the most naturalistic still-life picture-making. The great irony is that for much of this century, the public has cried out for art that it can understand and that clearly relates to its experience; yet when artists such as Warhol deliver what the public seems to have been clamoring for,

this same public is outraged. Fortunately for Warhol, he has had more success than the Ford Motor Company has with its Edsel model, which was designed exclusively from exhaustive market research of the public's wants.

Since 1961, Roy Lichtenstein (b. 1923) has been making paintings that relate to those of Johns and Warhol by their vernacular motifs and by their calculated avoidance of a number of characteristics that the public of the sixties had come to expect of American artists. Lichtenstein's choice of imagery—including comic strips, household objects, stamps, currency, paintings by artists such as Picasso, Monet, and Mondrian, Greek temples, hot dogs, guns, and gun-slingers—at first outraged his audiences because it seemed unworthy of art, mechanical or too imitative in execution, and tasteless. His series of *Brushstrokes,* of which one is reproduced here (Fig. 442), continues the tradition of making art from art. In addition, it represents Lichtenstein's positive objective to seek alternatives to the legacy of past art—alternatives to the Renaissance integration of objects and the ground they are seen against, and to the Cubist reformation of the motif and integration of it into the weblike structure of the field. Lichtenstein draws an image thrown onto the canvas by an opaque projector and then uses the commercial printer's device of benday dots, achieved with a uniformly perforated screen. The brushstroke, before Lichtenstein, had been identified with manual virtuosity, with the expression of feeling, and with a guarantee of aesthetic effect as well as an individuality of "handwriting" (Pl. 43, p. 316; Pl. 53, p. 386). Lichtenstein makes his "Brushstrokes" into *things,* detached from descriptive or passion-

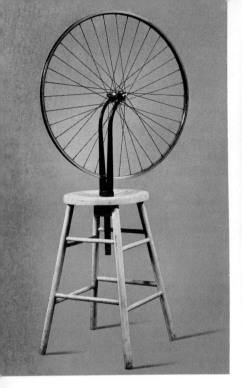

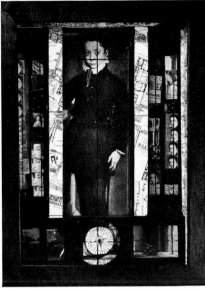

ate function and formally isolated within the limits of his canvas. There is a mock insensitivity in the artists's self-restriction to a few commercial colors. He does have formal values in terms of the aesthetics of his paintings and enjoys the paradox between how real the image seems to the public and how unreal the contrast between its physical nature and the final rendering.

The Use and Making of Objects Throughout history, sculptors and artisans have made objects for a variety of practical purposes, utility and decoration included, to gratify the desires of their patrons. Traditionally artists were responsible for the invention and execution of their objects, although assistants might have carried out some of the tedious craftsmanship. In this century, artists have entered into new relationships with objects, either employing objects not of their own design and manufacture, hence made by others, or else creating things useless or impractical beyond their aesthetic or personally expressive content. The break with tradition came partly with the Cubists' collage: the introduction of a variety of materials, and sometimes objects, foreign to art media countered existing notions of purity (or homogeneity) of means and consistency of illusionism. Another determinant of this break occurred in 1913, when Duchamp mounted on a stool a bicycle wheel turned upside down (Fig. 443). For Duchamp, this was a logical step after centuries of illusionistic painting of objects, which had led, he felt, to a senseless glorification of the artist's hand. Art was not to be found in manual execution. Duchamp developed expressive activity beyond existing artistic means by using *ready-made* objects of commercial production, such as the bicycle wheel; he chose these on the basis of chance and indifference, not because of their aesthetic appeal, and then displaced them from their normal environment or context. To the artist, these ready-mades had a mystique and were a metaphysical projection of invisible reality. Later artists did not always understand or share Duchamp's metaphysics, but they appreciated his new premise that art was made in the minds of artists and not by their hands. Selection replaced execution for many artists after 1913, and today some have extended Duchamp's premise to include the notion that art need not be visible but can exist on the level of ideas, communicated by words.

Perhaps the most sensitive manipulator of objects for the poetic associations they inspire was the American Joseph Cornell (1903–73), who from the late thirties on staged private dramas in small glass-covered boxes. Their smallness of scale and undecipherable plots are constant, ensuring a feeling of intimacy and meditation in the beholder. His sets and actors are sometimes repertorial, since he occasionally worked in series, but more often they change with the mood of the piece. *Medici Slot Machine* (Fig. 444) conjoins in title and form reveries on a long-dead young prince and on the childish delight in the box of chance from an amusement parlor. Gunsight, compass, and map are used to deceive our sense of orientation, while strips of pictures of a painted portrait evoke the film medium and its now unfamiliar fairy-tale potential. Jacks and marbles and the numbers attached to the outside of the box also relate to play; they are appropriate to the aristocratic child, to the associations of the slot machine, and to Cornell's own gentle solicitation to suspend disbelief and the rules of reason as the admission price to his theater. The Surrealism of the thirties encouraged Cornell to collapse the difference between near and far, past and present, painting and sculpture, art and nonart, linear logic and absurdity. His soft-voiced modesty of expression and reluctance to talk about his work countered the public's image of the modern artist as clamoring for public attention.

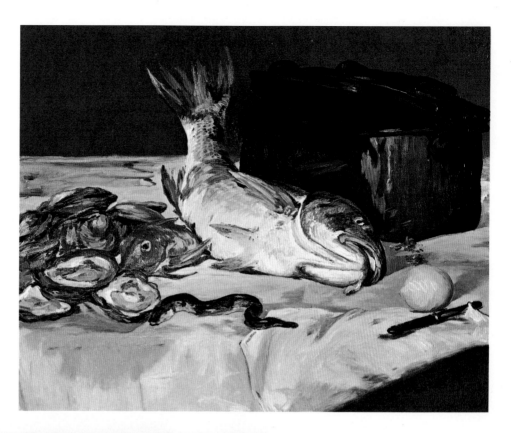

above: Plate 40. Edouard Manet.
Still Life with Carp. 1864.
Oil on canvas,
28⅞ × 36¼'' (73 × 92 cm).
Art Institute of Chicago.

left: Plate 41. Paul Cézanne.
Still Life with Compote. 1879–82.
Oil on canvas,
18⅛ × 21⅝'' (46 × 55 cm).
Louvre, Paris.

left: Plate 42. Agnolo Bronzino. *Portrait of a Young Man.*
c. 1535–40. Oil on canvas, 37⅝ × 29½'' (96 × 75 cm).
Metropolitan Museum of Art, New York
(H. O. Havemeyer Collection).

below: Plate 43. Frans Hals. *Portrait of a Man.* c. 1661–64.
Oil on canvas, 31⅛ × 25⅝'' (79 × 65 cm).
Staatliche Kunstsammlungen Kassel.

Similar in spirit to Duchamp, the Swiss artist Jean Tinguely (b. 1925) has created *assemblages* from metal scrap heaps, which are parodies of machines and witty commentaries on art and social values. They are usually designed to break down, be nonproductive, and underscore the "dumb" movement of the machine, thereby providing comic relief for a public accustomed to standing in awe of things mechanical. His Swiss nationality has led to jokes that Tinguely is personally doing penance for the legendary dependability and precision of his country's timepieces. His scorn for all forms of virtuosity and the handmade led to his "meta-matics" (Fig. 445), mechanical contraptions that contrive to turn out thousands of abstract drawings, rebutting the notion of the inviolability of art by the machine.

Further undermining the public's expectation that sculpture be serious as well as durable (hard) are the soft constructions (Fig. 446) of the Swedish-born artist Claes Oldenburg (b. 1929). Gravity is his collaborator, sewing his means of joining, canvas and kapok his materials, so that bathroom fixtures slump, electric fans wilt, typewriters slouch, auto engines melt, and telephones sag. Bigger than life, but often like their counterparts in commercial advertising, Oldenburg's objects shock or amuse. The blatant familiarity of his subjects obscures his intentions, which are to involve himself in the relation of hardness to softness, conditions of antithesis that express his experience of the world around him:

> I think the objects are more or less chosen as excuses that I can hang my expression of what it feels like to be alive on. Thus I would take a hard object like a telephone and make a soft version of it which would remind you of the hard version and kind of set you thinking or feeling about the contrast between hard and soft in nature.

The Object as Monument During the sixties, Claes Oldenburg dreamed of and drew objects as ironic monuments to their time and place (an ironing board for Manhattan, an electric fan to replace the Statue of Liberty, and so forth). In

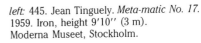

left: 445. Jean Tinguely. *Meta-matic No. 17.* 1959. Iron, height 9'10'' (3 m). Moderna Museet, Stockholm.

below: 446. Claes Oldenburg. *Soft Pay Telephone.* 1963. Vinyl filled with kapok, mounted on painted wood panel; 46½ × 19 × 12'' (118 × 48 × 30 cm). Private collection.

the seventies, he realized his dreams in a 45-foot (13.5-meter) high steel *Clothespin* for Philadelphia and a 101-foot (31-meter) tall, 20-ton *Batcolumn* for Chicago (Fig. 447). Rather than commemorating politicians, Oldenburg chooses to make objects that distill urban experiences. Chicago, a city with two Major League baseball teams, wanted a monument to a former ball player, Ernie Banks; Oldenburg decided a monumental baseball bat was appropriate. Always an artist, Oldenburg knows that his conception must be more than a joke and hold up as artistic form over time. He is aware that simple mundane forms can be rich in symbolic associations and that their means of construction can be relevant to a monument. *Batcolumn* consists of 1,608 pieces of welded steel, and the sculptor says his work "could be called a monument both to baseball and to the construction industry and to the ambition and vigor Chicago likes to see in itself." The sculpture's unsheathed form, like a tube of latticework horizontals and verticals diagonally trussed, is relatable to recent skyscrapers such as Chicago's Hancock Building or the Eiffel Tower. Symptomatic of the respectability and public acceptance that modern art has finally achieved, *Batcolumn* was government-funded as part of an art-in-architecture program and received enthusiastic popular response.

The banality "we are what we make" still tells much about why humanity's hopes for the good life were realized by artists' re-creation of objects. Enjoying their own skill, artists have simulated objects for such purposes as magic, mystery, metaphor, moralizing, meditation, and monuments. Depicted objects for the dead calmed Egyptian fears of a second death by magically providing nourishment. Paintings and mosaics of objects effected the change from Egyptian dread to Roman delight in this life. Christianity brought religious mystery and metaphor to the representation of objects identified with Christ and the saints. With the rise of still-life painting in the 17th century, Christian moralizing about life's brevity coexisted with prideful enjoyment of the well-made and the mundane. Overlapping the moralizing function were the meditative purposes by which artists shared their reflections on the mystery of the motionless object, its materialistic beauty, analogies with architecture, and the provocative mutuality of inanimate forms thoughtfully joined. From the Middle Ages to the present, the rendition of objects has often been a form of disguised symbol-

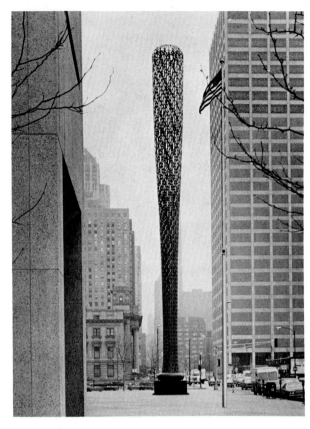

447. Claes Oldenburg. *Batcolumn.* 1977.
Painted Cor-Ten steel, height 101′ (30.78 m).
Social Security Administration Building, Chicago.

ism; before the 19th century, their meaning was drawn from collective values, and thereafter until recent years, their significance was based in the artist's private associations or obsessions. Many modern artists have manipulated objects to unhinge customary definitions of reality. For both 17th-century Dutch painters and American artists since the 1950s, objects have been emblems testifying to their cultures' tastes and technology. Today, as undoubtedly in the past, painters and sculptors enjoy the use of objects because it allows them to start a painting or sculpture that, when finished, they may view as "abstract" art. As much as portaits, objects in art certify human self-love and the need to come to terms with an environment of humanity's own making.

Chapter 17

The Portrait in Painting, Sculpture, and Photography

For centuries, the artist was enjoined "to hold a mirror up to nature," and the mirror itself was a favored metaphor of truth and art. Every morning, the mirror identifies who and where we are. The disquieting image created by René Magritte (1898–1967), *Portrait of Edward James Seen from the Back* (Fig. 448), betrays the role of the mirror and shocks us into remembering the importance of the face. Our language has many clichés that by now unconsciously project the importance of this feature: "to face the future," "to face up," "face to face," "face value," "on the face of it," "to put a good face on," "to lose" or "to save face," and so on. Courage, honesty, trust, deception, and dishonor are some of the connotations of these clichés, implying that character and judgment reside in the face. Before Magritte, the artist's task was to save the subject's face for posterity, thereby gratifying the ego that resided behind it. The face is still our identity badge and insurance against anonymity, our calling card in social life, and the politician's passport to success or failure. If one studies it closely enough, the back view of Edward James reveals his identity or individuality, as would his fingerprints or dentures. A man with no face, however, confronts as bleak a prospect as the featureless environment mirrored in Magritte's portrait. Only in this century would an artist either desire or be able to execute Magritte's enigmatic or dislocated portrait, for reasons that will be considered in relation to imaginative art (Fig. 555).

Problems and Possibilities for Portraitists The face has presented the artist, whether chronicler or commenta-

448. René Magritte. *La Reproduction Interdite (Portrait of Edward James Seen from the Back).* Oil on canvas, 37 × 25½″ (94 × 65 cm). Museum Boymans-van Beuningen, Rotterdam.

right: 449.
Portrait of a Roman.
Republican,
1st century B.C. Marble,
height 14½'' (37 cm).
Vatican Museums, Rome.

far right: 450.
Théodore Géricault.
Portrait of a Kleptomaniac.
1821–24. Oil on canvas,
23¼ × 19⅝'' (59 × 50 cm).
Musée des Beaux-Arts, Ghent.

opposite: 451. Raphael.
Baldassare Castiglione.
1510. Oil on canvas,
32⅜ × 26½'' (82 × 67 cm).
Louvre, Paris.

tor, with an unusual challenge. In the words of the German philosopher and sociologist Georg Simmel, "Within the perceptible world, there is no other structure like the human face which merges such a great variety of shapes and surfaces into an absolute unity of meaning." For the chronicler, or narrative artist, the problem was to unite a multiplicity of disparate elements. For the commentator, or interpretive artist—who could, in Leonardo's words, "mirror the motions" of the subject's mind—there was both the added difficulty of producing a lively interaction between these elements and the revelation that the smallest change in any feature altered the expression of the whole. Artists who worked from death masks in ancient Rome and in 15th-century Italy recognized that they had the materials for individuality, but not for facial liveliness; they could not achieve the expressiveness that separates the animated from the dead. Unless they desired an idealized face, artists had to search for those irrational irregularities—the asymmetry of the right and left halves of the face—that they could use as protagonists in their facial drama, playing them against the general symmetry of the head. Beginning in the late 15th century, artists became concerned with facial animation and with the depiction of personality as well as individuality. As Simmel points out, Christianity in the West prescribed that the human body be shown clothed, and consequently the face alone could project personality. For almost 500 years, artists have developed techniques based upon the acute observation and study of one another's work to catch the potential as well as actual mobility of the face as it responds to the spirit. Portraiture demonstrates how in Western society since the Renaissance the face has been the surrogate for the whole person.

It should surprise no one that artists know the face in subtle ways beyond our usual knowledge of it. They must be conscious of how a face is made: how its cranial and muscular substructures press against the flesh; how features taper, swell, and merge; and how colors work up through the skin's surface. They must think in terms of distances and proportions. The eye affords artists a "window to the soul"; how they shape and focus it or otherwise support the gaze will influence the mood, personality, and character of the subject, the subject's relation to the viewer and surroundings, and will divide or determine the space within the painting.

Roman Portraits Although modern psychology has taught us to be wary of physiognomic analysis in determining a person's character, the study of how an individual's features reflect the soul, spirit, or personality behind them is an old concern of artists. Adherents of this "science" assume that the habitual set of the features, the angle at which the head is usually held, bodily posture, formation and gestures of the hands, and even clothing can be meaningful. The way someone sits or wears a coat has been an important consideration in artists' studies of personality or social status. In this century, photography has preempted the portrait function, and many modern artists avoid portraiture because demands for likeness conflict with their personal aesthetic. Nonetheless, imitation has had an honorable history and inspired many powerful portraits without weakening individuality of style.

The sculpture portraiture surviving from ancient Rome constitutes a significant record of that civilization, for no other people portrayed themselves so extensively in carved and painted works. The countless death masks and portraits made for Roman homes, tombs, palaces, and forums reflect ancestor worship and a healthy strain of egotism. The Republican portrait in Figure 449 displays the sunken

cheeks and mouth of a dead man, and this marble image could well have been copied from a death mask. Except for official effigies of their leaders (Fig. 299), the Romans of the Republican period avoided self-flattery, preferring to portray the stark, harsh evidence that living left upon the face. Such is the candor of this art that the testimony of the many surviving portraits can be balanced against the weight the Romans placed on their values. These, in theory, were honesty and frugality, self-reliance, simplicity, firmness of purpose, gravity, and a sense of what was important. The Romans believed in toughness and discipline, organization and a pragmatic approach to daily life. Their literature reveals many and spectacular exceptions, but the Roman conquest of the ancient world and the Pax Romana (see p. 206) furnish much evidence that elevated standards did in fact prevail during the Republic and early Empire. This portrait shows an honest and tough-minded desire to represent the subject's individuality, from the dented skull to the sagging jowls. The natural discrepancies between the two sides of the face have been retained, and, even without the original paint, the shrewd gaze is consistent with the experience-worn features of the inner and outer man.

Psychological Portraits Throughout the Middle Ages, for almost a thousand years, the realistic likeness of a specific individual did not appear in European art (see Chap. 5). Its return in the 14th and 15th centuries coincided with the naturalism sponsored in secular art by royalty and a prosperous commercial class. No surviving antique paintings equal in anatomical exactness the faces painted in 15th-century Flanders (see Chap. 6). Eric Ambler has written:

A man's features, the bone structure and the tissue which covers it, are the product of a biological process; but his face he

creates for himself. It is a statement of his habitual emotional attitude; the attitude which his desires need for their fulfillment and which his fears demand for their protection from prying eyes. He wears it like a devil mask; a device to evoke in others the emotions complementary to his own. If he is afraid, then he must be feared; if he desires, then he must be desired. It is a screen to his mind's nakedness. Only a few men, painters, have been able to see the mind through the face.

Four centuries after Jan van Eyck brought such coincidence of virtuosity and powerful observation to his portrait of Giovanni Arnolfini and his bride (Pl. 46, p. 334), the French artist Théodore Géricault painted in oil a number of insane patients of his friend Doctor Georget, who believed that insanity proceeded from physiological rather than psychological causes and that a close study of the face would produce pathological evidence. For clinical purposes, therefore, Géricault approached his deranged sitters (Fig. 450) with the same discerning scrutiny that Van Eyck had employed for his aristocratic subjects. With the patients' knowledge he was painting them but making no reference—in background, dress, or general pose—to their hospital environment, Géricault set about to study and record the mask into which each face had set and also to mirror the grinding impulses behind it. In the portrait of a man afflicted with a monomania for theft, Géricault brought to bear all his sensibility for subtle color and surface inflections, thereby attaining considerable aesthetic as well as psychological value. The most obvious symptoms of the man's malady lie in his eyes and in the tension of the facial muscles.

Géricault's style, temperament, and interests were suited for this project. Often he focused on subjects without external anchorage, figures who by force of circumstance were thrown back upon their own resources (Fig. 371)—men portrayed in action or in a state of tense inaction, an oscillation mirroring the severe sociopolitical changes occurring after Napoleon's fall.

Ethical Portraits Géricault painted portraits of those who were, in a sense, victims of modern society; the Renaissance artist Raphael painted portraits of those fortunates composing the elite society that flourished in the early 16th century. Raphael was himself admitted into this society, an interesting commentary on the artist's increased social stature at that time. The portrait that best epitomizes the Renaissance social ideal both in style and subject is that of Baldassare Castiglione (Fig. 451). In a manner of speaking, the picture was made before Raphael took up his brush. The pose, which largely determined the composition, was probably a joint decision of the sitter and the painter. Castiglione's treatise *The Courtier* set forth the requirements for the ideal Renaissance man—his skills, conduct, and objectives. Castiglione could have served as a model for his own book, since he was a poet, a brilliant scholar,

and an outstanding ambassador and courtier. He commented thus on his ideal: "Besides nobleness of birth, I would that he have not only a wit, and a comely shape of person and countenance, but also a certain grace which shall make him at first sight acceptable and loving unto whosoever beholdeth him." The perfect courtier was also expected to be capable in arms and hardihood, to have ingenuity and loyalty, to be pleasant to all, forever witty and discreet, and to accomplish everything with grace. On clothing, Castiglione wrote:

> A black color has a better grace in garment than any other color . . . and this I mean for his ordinary apparel. . . . He ought to determine with himself what he will appear to be and so to apparel himself, and make his garments help him to be counted such a one, even of them that hear him not speak, nor see him do any manner of thing. . . . Our Courtier ought not to profess to be a glutton nor drunkard, nor riotous and inordinate in any ill condition, nor filthy and unclean in his living.

Not only did Raphael faithfully record Castiglione's appearance and manner, but he also enhanced the man's grace and bearing by subtle plays of shadow and light. The pyramidal shape formed by the figure and locked within the frame ensures its stability. The figure's advancing left arm forms a gentle barrier between him and the viewer, while the more frontal face promotes a certain impression of cordiality without undue intimacy. The careful yet easy and unostentatious placement of the hands further exteriorizes the inner grace of the man—a matter of mind as well as of physique.

One of the great painters of 16th-century courtly life was Agnolo Bronzino (1503–72), whose style, like that of Jean Clouet in France (Fig. 314), was perfectly attuned to the tastes of his aristocratic Florentine clientele. His *Portrait of a Young Man* (Pl. 42, p. 316) is the refined embodiment of Castiglione's ideal courtier, a comely man, discreetly elegant in dress, superbly in control of his body and feelings, and a gentleman of letters whose learning included art and architecture. In comparison with Castiglione's portrait, Bronzino's youth has a decidedly cool and more detached air, which seems to indicate the premium placed upon the social remoteness and exalted self-imagery of his elite group. Full comprehension of this portrait at the time of its creation presupposed a beholder as sophisticated as the subject himself.

The three-quarter format allowed more ample display of a manly figure and at the same time established the viewer at a greater distance than would have a bust-length portrait. It also permitted Bronzino to contrive a striking design involving the body, accessories, and architecture. The architectural backdrop underscores the youth's erectness, and its olive tones complement those of the flesh and costume. The purple tones of the table and chair, like those of the wall behind, are unnatural accents that reflect a taste for artifice. The entire painting is an ultrarefined study in con-

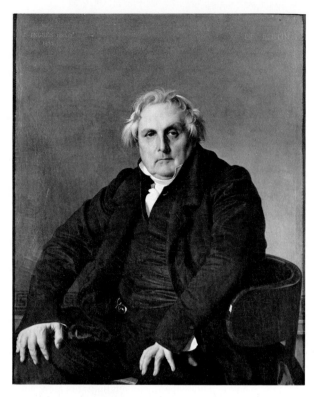

452. Jean Auguste Dominique Ingres. *Louis-François Bertin.* 1832. Oil on canvas, 46 × 35½″ (117 × 90 cm). Louvre, Paris.

trasts, indicative of the fact that there is more than meets the untrained eye. The youth's body is treated like an abstraction, its contours alternately smooth and irregular, the spine rigid and the wrists supple. The aristocratic attitude of the elbow posture has had added to it an affected spread of the fingers against the hip. The complex, even perverse interests of this society are suggested by the contrasts between the perfectly formed beauty of the subject's face and the grotesque carved heads of the table and chair arm. In Florentine courts, an austere or ascetic appearance often masked highly sophisticated erotic imagination and indulgence. The youth's costume, for example, has a tight-fitting, constricting cut to the coat and an exaggerated codpiece.

A totally different ethic of manliness and painting produced the 17th-century Dutch *Portrait of a Man* (Pl. 43, p. 316) by Frans Hals (c. 1581–1666). Quiet reserve is superseded by frank affability and a shared intimacy between viewer and subject, calculated composure by the appearance of good-natured spontaneity. The Dutchman's unkempt state, casual pose, and drinker's ruddiness make him the ideal male companion of his time and place, if not the ideal courtier.

Raphael's and Bronzino's smooth, immaculate picture surfaces, so in keeping with their subjects, have analogies

only in the underpainting of Hals' portrait style. After pains-takingly detailing his subject in a relatively tight surface treatment, Hals rapidly painted over the entire work in slashing strokes and ragged patches of color. It is possible, moreover, that by this late stage in his career, Hals had dispensed with the underpainting. Raphael may be judged a superb picture-maker, Hals a consummate painter. In contributing to the total effect, the material substance of Hals' pigment is as vivid as the man's physical qualities. The painter's gusto is apparent in the way he has avoided the formal, contained posture used by Raphael and has instead twisted the hat, face, and body into angles opposed to those of the frame. Raphael's composition directly relates Castiglione to an impersonal ethical coordinate system; Hals' sitter has his own moral and aesthetic axis.

Modern Informal Portraits In the 19th century, portraitists loosened the conventions of the genre and permitted their subjects to assume more personal poses. The portraits of Jean Auguste Dominique Ingres demonstrate how a seated pose can be made to distinguish the complex of characteristics in a fully mature, highly individual personality (Fig. 452). Ingres had struggled unsuccessfully through many sittings to find the right pose to manifest the strong character of Louis-François Bertin, a newspaper owner. During a conversation with a friend, Bertin unconsciously assumed an attitude that caught the painter's eye, and even before a single stroke had been painted, Ingres informed his client that the portrait "was done." The resulting portrait has the suggestion of a great predatory bird. The disarrayed hair, the attenuated nose, and the talonlike hands are not

disguised but, rather, are accentuated. The man's ample girth is stressed—Bertin quite overwhelms his chair. Even the wrinkled suit magnifies his energy. Ingres was at his painterly best not in the mythological or narrative scenes favored at the time (Fig. 378), but in portraits inspired by a unique and strong-willed human being.

Private Portraiture in a Public Place Ostensibly, *Place de la Concorde* (Fig. 453) by Edgar Degas depicts a small group of strollers, strangers to one another but united in their location on the pedestrian island of that great Paris square. Although not the first to employ this idea, Degas set up a portrait situation in which the Vicomte Lepic, his daughters Janine and Eylau, and their dog are shown not in the familiar intimacy of their home but in the most public place in Paris. This relocation of the portrait enabled Degas to portray the momentary mental estrangement of a family, perhaps while they were pacing and waiting for public transport; he thus avoided the sentimental gestures and poses of mutuality expected in family portraits. All the familiar devices for pictorial coherence, such as reciprocal gesture and gaze, are ignored or pulled apart. The psychological fragmentation of the main figures, as well as the fragmentation of their forms and that of the bystander, is compounded by the picture's borders, which equate the field of vision with that of the viewer. Rare in the history of art are paintings in which the center is empty and the principal figures are about to walk out of the scene. Degas' view of his subjects' expression is extended to the way a hat is worn, the angle of a cigar clenched in the teeth, an umbrella gripped beneath the arm, and a hand tucked in the

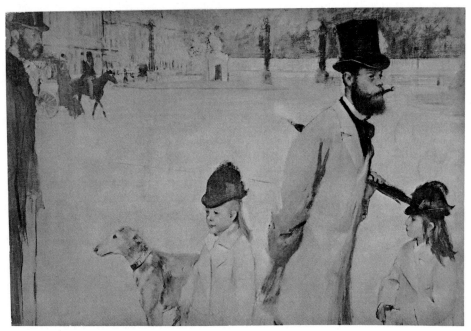

453. Edgar Degas.
Place de la Concorde, Paris.
1873–74. Oil on canvas,
31¾ × 47⅜″ (81 × 121 cm).
Formerly Gerstenberg
Collection, Berlin.

tail of a coat. Degas reminds us that portraits may be of momentary existence and not necessarily of a figure posed as if for eternity (Figs. 380, 382).

Fixing the Fugitive in Sculpture For the great French sculptor Auguste Rodin, the making of a portrait demanded an all-encompassing knowledge of his subject. Every inflection of the head had to be searched out, felt as well as seen. He began his work by making an exhaustive study of every view of the head, even as seen from above. When these successive views were joined, he had an accurate physical resemblance. What gives Rodin's superb modeling its final power, however, is the revelation of character. In his head of the poet Baudelaire (Fig. 454), there is more than just a precise rendition of skin and skull; there is an unbearable intensity of expression in the taut mouth and transfixed eyes. The unformed lumps on the forehead were a final, sculptural touch, unrelated to real anatomy, yet crucial in bringing the effigy to life. Unusual in the history of portraiture is the deliberate severance of the head from both the neck and the chest; in so doing, Rodin sought to create a portrait of a poet who lived completely the life of the intellect. The head is tilted upward, as if the poet's gaze were directed toward some invisible horizon of his own thought. Paradoxically, Rodin, who could model only from living examples (Figs. 473, 475, 479, 481, 484, 504), made a compelling portrait of a man he had never seen and who had been dead for some 30 years. He had found a young artist who resembled Baudelaire and had resorted to photographs of the poet for guidance. That Rodin also knew the poet's life and work by heart gave him insight into his subject's complex personality. His description of the portrait reflects a strongly psychological interpretation of facial features:

> It is not Baudelaire . . . but it is a head that resembles Baudelaire. There are a series of characteristics that . . . preserve the cerebral conformation that one calls the type; this bust is of a draftsman named Malteste who shows all the characteristics of the Baudelairean mask. See the enormous forehead, swollen at the temples, dented, tormented, handsome nevertheless, the face described at length by Claudel; the eyes have the look of disdain; the mouth is sarcastic, bitter in its sinuous line, but the swelling of the muscles, a little fat, announces the voluptuous appetites. In short, it is Baudelaire.

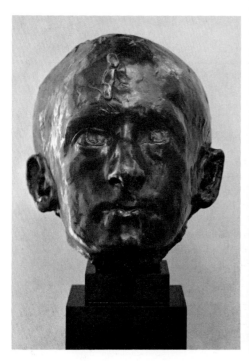
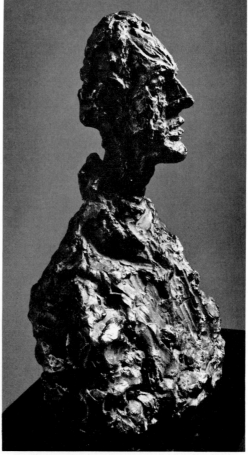

below: 454. Auguste Rodin. *Head of Baudelaire.* 1892. Bronze, height 8″ (20 cm). Indiana University and Museum, Bloomington (gift of Mrs. Julian Bobbs.)

right: 455. Albert Giacometti. *Diego.* 1955. Bronze, 15½ × 13 × 7″ (39 × 33 × 18 cm). Walker Art Center, Minneapolis (gift of T. B. Walker Foundation).

The rare fine portraiture in 20th-century art has typically been intimate, probing studies of unstable individuals. Offended by the demands of fidelity in portraiture, modern artists have preferred subjects and areas closer to their personal notions of what art should be. An exception was the Swiss-born artist Alberto Giacometti (1901–66), who found in portraiture the realization of his particular artistic goals. From his earliest works, he carefully studied the human face, almost exclusively that of his younger brother Diego (Fig. 455):

> Sculpture, painting, and drawing have always been for me the means by which I render to myself an account of my vision of the outer world and particularly of the face. . . . It is utterly impossible for me to model, paint, or draw a head . . . as I see it, and still, this is the only thing I am attempting to do. All that I will be able to make will be only a pale image of what I see.

From this statement, we learn that his art was meant to satisfy Giacometti alone (Figs. 496, 497, 505). His dilemma and inspiration lay in a fascination with his elusive vision of the external. He was not trying to penetrate the surface to reveal his subject's character. For Giacometti, the problem was that when he focused on a detail, he tended to lose sight of the whole, and when he looked away from the live model to the clay he was shaping, he struggled to remember what he had seen. Given his portrait of Diego, the complexity and precariousness of Giacometti's art is manifest. *Diego* has an almost Egyptian remoteness, like an order of being unto itself. The fixity of this state is paradoxically achieved through an inconstant surface; the more closely we examine the head, the more remote it seems to become, for no part is a literal match for the surface or features of the actual face portrayed. For Giacometti, each face has a dual existence: the first is the face he observes; the second is the face which he sees in his imagination and which constantly eludes him. To him, therefore, the finished sculpture is invariably an unhappy compromise.

Portraits of Women

Until the last quarter of the 15th century, Italian portraits of men and women tended to be in profile, because the nobility of that era preferred to have only half the face committed to posterity. This preference was influenced by ancient coins and medallions that bore profile effigies of rulers. The significance of antiquity's attraction for Renaissance society is shrewdly put by Johan Huizinga in his book *Homo Ludens: A Study of the Play Element in Culture* (see p. 31):

> If ever an elite, fully conscious of its own merits, sought to segregate itself from the vulgar herd and live as a game of artistic perfection, that elite was the circle of choice Renaissance spirits. . . . The game of living in imitation of Antiquity was pursued in holy earnest. . . .The whole mental attitude of the Renaissance was one of play. . . . This striving . . . for beauty

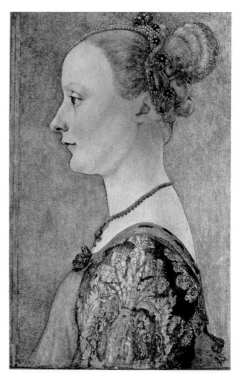

456. Piero Pollaiuolo. *Portrait of a Young Lady.* c. 1475. Tempera on panel, 19¼ × 13⅞″ (49 × 34 cm). Metropolitan Museum of Art, New York (bequest of Edward S. Harkness, 1950).

and nobility of form is an instance of culture at play. The splendours of the Renaissance are nothing but a gorgeous and solemn masquerade in the accoutrements of an idealized past.

This elite segregation and search for beauty and nobility of form is manifest in the design of 15th-century Florentine palaces, which were inaccurate attempts to revive the principles of ancient Roman palaces, as well as in profile portraits. In both instances, the art forms may be conceived of as the public, social façades of their owners. Neither encourages a feeling of intimacy with the viewer. The relevance of such a comparison is apparent in Alberti's Palazzo Rucellai (Fig. 341) and the *Portrait of a Young Lady* by Piero Pollaiuolo (Fig. 456). In the profile portrait, the sitter is caught in an attitude that is permanently aloof. A background of blue sky serves to elevate the figure beyond earthly reference. The careful setting of the head within the picture area and the broad-based tapering form created by the pose add to the stability and dignity desired by the patron. While the profile pose eliminates the possibilities of a searching psychological study of the face, it encourages a stress on the aesthetic grace of the subject. Renaissance costumes and tastes share a certain cool surface elegance. The woman's tight-fitting bodice, upswept hairdo, and plucked eyebrows create a pronounced rhythmic sequence

and a continuous graceful silhouette. There is no strong accent, modeling, or coloring of the face within its contours, so that emphasis remains upon the edges. The fashion favored an artificiality that disguised the natural potential of the flesh. In her grooming and costume, the woman has herself altered nature, and it might be said that the artist continues in this spirit.

The ideal woman of Peter Paul Rubens, as seen in Plate 44 (p. 333), the portrait of Susanna Fourment, enhanced her natural endowments with graceful and revealing clothes whose sensual textures flattered those of her flesh. She neither affected an imitative role nor held herself aloof, but was desirable in personality and body. To give fullest expression to the charms that delighted his eye, Rubens used a three-quarter frontal pose, which was at once modest and alluring. The vitality of the woman and her outgoing personality are set off by a turbulent sky and a splendid hat, which was perhaps a flattering recollection of the umbrellas or canopies under which royalty was accustomed to stand (Figs. 309, 316; Pl. 23, p. 210). It is possible for the viewer to enter into a private dialogue with Rubens' sitter. This, unlike Pollaiuolo's portrait, was a very personal painting, portraying a close friend whose younger sister Rubens was later to marry.

Rubens formed his subject of rich color, tempered or heightened by soft shadows and brilliant highlights. The astonishing range of his brushwork is revealed in the broad treatment of the sky and large areas of the sleeves, the more tightly executed forms of the feathers and hair, the subtly graded strokes in the flesh, and the deft touches that created highlights in the earrings and eyes. Both the outpouring and restraint of feeling in the completed painting would seem to reflect the mood of the woman portrayed.

Paul Cézanne executed a portrait of his wife (Fig. 457) which seems at first to lack the outgoing qualities and warmth of Rubens' portrayal of Susanna Fourment. Many have compared, unfavorably, Cézanne's depiction of women to his painting of bottles (Pl. 41, p. 315), saying that he displayed no more feeling for the one than for the other. Cézanne was not without feeling toward his human subjects, however. In portraits, he presents them as introverted, passive types, seemingly with infinite patience, for the endless hours they were required to sit for the artist would have required great forbearance. Accurate or flattering likeness was not enough for the painter; he struggled to adjust his figure to her surroundings. The tilt of the head and broad directions of Madame Cézanne's body are picked up in the tree and wall behind her, thus effecting a total harmony of the woman and her place. In this unfinished painting, the stages of construction are still evident; the artist proceeded from a sketchy outlining and thin filling of color areas to a deepening of color as seen in the shoulders. Even the angles of the brushstrokes reiterate the major axes of the body.

The joyous hedonism of Rubens was shared by Henri Matisse, as attested in a portrait of Madame Matisse, com-

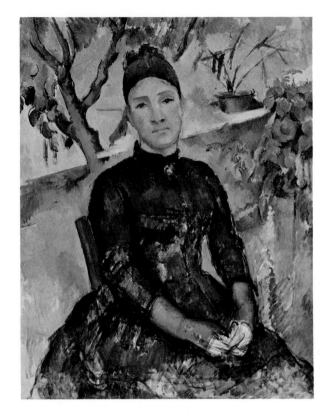

monly known as *Woman with the Hat* (Pl. 45, p. 333). Like Susanna Fourment, Madame Matisse wears a glorious hat piled high with flowers. Matisse did not insist upon a climactic facial focus, as did Rubens. It is not the flesh or a mood of enticement that Matisse celebrates in this painting of his wife. He has painted her as a warm aesthetic delight. Her face is handsome and sympathetic, a strong, quiet foil for the riot of color and movement around her. Matisse painted ecstatically and unfettered color from its previous obligations to modeling and texture (Pl. 58, p. 404). Rubens accentuated and modulated his bright colors by placing them next to subdued hues or by setting them in partial shadow. The flat areas of bright color in *Woman with the Hat* are modulated only by degrees of saturation; they range from pastel greens and pinks to full-bodied orange-reds and purples. The large color patches of the background complement others within the figure and serve as blocks to stabilize the form within the frame. Setting aside the finesse of brushwork of which he was capable, Matisse applied his paint with a raw haste, scrubbing and striping to effect the immediate release of his exuberant feelings. He dispersed his color accents according to the needs of aesthetic structure—thus making the painting, like Madame Matisse's hat, a beautiful bouquet of color sensations.

Sculpture has also recorded many faces of women, with some of the finest examples dating from Egyptian times. A

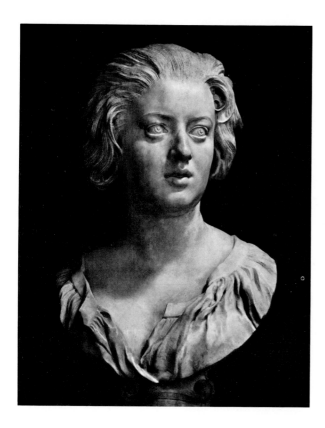

opposite: 457. Paul Cézanne. *Madame Cézanne in the Conservatory.* c. 1890. Oil on canvas, 36¼ × 28¾'' (92 × 73 cm). Metropolitan Museum of Art, New York (bequest of Stephen C. Clark, 1960).

left: 458. Gianlorenzo Bernini. *Costanza Buonarelli.* 1636–39. Marble, life-size. Museo Nazionale, Florence.

below: 459. Constantin Brancusi. *Mademoiselle Pogany.* 1913. Bronze, height 17¼'' (44 cm). Museum of Modern Art, New York (Lillie P. Bliss bequest).

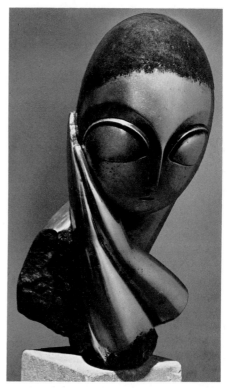

sculptural portrait of striking immediacy is that made in the 17th century by Gianloranzo Bernini of his mistress Costanza Buonarelli (Fig. 458). She is rendered in movement, as if on the verge of speaking. Bernini re-created her as an impressionable, vital person. In removing the extraneous stone, he also lifted off all that masks the private, unguarded, and impulsive facets of the woman's conduct. The intimate emotional nature of the relationship between the sculptor and the woman is hinted in her rather disheveled garment and hair, which seem to be extensions of an internal excitement. As a sculptural form, the bust knows no symmetrical blocklike confines but boldly twists into the space about it. The silhouette is irregular and agitated, yet carefully controlled to return the eye to what lies within it. The iris of the eye is incised to complete the surface reception of light. Bernini's figures presuppose a presence outside themselves to receive the outpouring of their feeling and action.

Constantin Brancusi worked through what he considered layers of superficial appearance in order to find essential, seminal forms, such as the ovoid of the egg, by which to prove his private belief in the underlying unity of living forms and to realize an absolute beauty characterized by simplicity, purity, and equity of existence (Fig. 483). He used reduction in facial detail and arbitrary redesigning of the features in his bronze portrait of Mlle. Pogany (Fig. 459). He stripped away those very characteristics and idiosyncra-

sies of the woman's face that so delighted Bernini; and by rearranging his subject, he created an impeccable clarity and continuity of rhythm and shape. The head has been contracted into a simple egg shape. Although he was trained in a Budapest art academy, Brancusi abjured the academic surface virtuosity and naturalistic fidelity that produced what he called "beefsteak" art. He insisted upon the hard, smooth, closed, reflective surface inherent in metal, a concept alienating to the Baroque ideal of intermingling art and visible reality.

The expressiveness of the head lies not in animation of the features and flesh but in its total gesture, in the constantly changing reflections on the polished bronze surface, and in the evocative power of the design. The self-containment of the composition accords with the woman's introspective withdrawal. The sculpture retains a quality of "likeness," but its measure has become that of the work of art

against the spirit of the woman and Brancusi's personal ideal of beauty.

Marriage Portraits

The double portrait, already known in Egyptian and Roman times, has occurred quite often since the 14th century. A type of double portrait has marriage as its subject.

Giovanni Arnolfini and His Bride (Pl. 46, p. 334) was painted in 1434 by Jan van Eyck. The painting depicts a private wedding ceremony that took place in the bedroom of the bride of a wealthy Italian banker living in Flanders. Inferred is the presence of witnesses, one of whom was the painter himself, indicated by the inscription above the mirror, "Jan van Eyck was here." Until the 16th century, two people by mutual consent could contract a legitimate marriage outside the rites of the Church. Van Eyck's painting is more than a superficial document of the occasion; quite literally, there is more than meets the eye in this portrait. It exteriorizes all the implications of the union of man and woman; in order to accomplish this, Van Eyck used a setting filled with objects whose symbolic connotations were well known to members of his society.

The bride and groom are shown full-length, standing in the center of the room with hands joined. To show the entire figure in a portrait requires a greater interval between viewer and subject; consequently, less area is devoted to the face. Despite this diminished area, the facial characterizations are strong. It is as if Van Eyck believed that the accumulation of an infinite number of details would provide the circumstantial evidence to identify the character as well as the physical aspect of his subject (Figs. 162–164). He did not attempt to flatter the groom, whose morbid sensuality and equine resemblance come through forcefully. The man is shown as the dominating figure by his frontal pose and solemnity, while the bride turns toward him in deference. Some have mistaken the proportions of the bride for signs of pregnancy, but in actuality she is holding the folds of her voluminous long skirt up to her waist.

The choice of the bedroom as the setting for the event and the painting was symbolic, for it was sanctioned by a long religious tradition as a nuptial chamber. Northern medieval painting usually showed the Annunciation to Mary as occurring in her bedroom. The lighted candle in the chandelier relates not only to a masculine symbol but also to its use in marriage rites and its implications of divine light. The dog is a sign of fidelity and, possibly, of passion; its inclusion might also relate to medieval tombs, on which a dog was placed at the feet of its master to serve him in death. The light filtering through the window may have alluded to the purity of the bride. The mirror directly above the joined hands of the newlyweds was a symbol of the all-seeing eye of God, its presence like a celestial notary seal, reflecting in miniature more of the contents of the room than are evident in the rest of the painting. Its spotless image of reality made the mirror a symbol of truth. This use of the reflected objects permitted a second wedding, that of the visible to the invisible. Poetic extensions of the figures themselves, the objects serve to identify the locale and to symbolize the hidden spiritual and sexual relationships.

Early in this century, Oskar Kokoschka (1886–1980) painted a portrait of the newly wed Hans Tietze and his bride Erica (Pl. 47, p. 334); it does not, however, depend upon elaborate symbols, setting, witnesses, or prescribed gestures to show the bond that exists between husband and wife. The picture is given no specific locale; the figures are seen as if in terms of their self-awareness. The painter's intuitive interpretation of their feelings resulted in the absorbent, measureless space around them, the warm ephemeral colors, and the wiry lines etched into the paint surface about the figures by the hard end of his brush.

The hand gestures suggest a bridge between the man and woman, but it is an incomplete span, since, significantly, the hands do not touch. Kokoschka seems to have sensed an unbreachable gulf between the two, their essential isolation. In contrast to Giovanni Arnolfini, Hans Tietze is the more dependent member of the couple. His profile pose, slightly shorter height, lack of his wife's relative self-containment, all seem to bring to the surface certain private weaknesses. This was not a posed portrait; Kokoschka studied the movements and character of his subjects as he searched for the moment that permitted him to pierce the social veneer. He valued the awkward gestures impelled by inner forces as tangible surface evidence of the existence and power of the subconscious. What he presents is even more private and less decipherable than what would find outlet in his subjects' diaries. Kokoschka suggested, but never circumscribed, the ultimate complex depths within individuals in their relation to themselves and to others. Working in Vienna while Freud was teaching there, Kokoschka expressed his findings in his own visual terms in another instance of modern artists' attainments in the study of humanity, independent of contemporary science.

The Portrait in Photography

In one important area, scientific invention was indispensable to the creation of a modern art form. Photography has culminated the long evolution of secularization and democratization of art. To the questions of what could be art's subject and who could make it, photography answered, anything and anyone! By the 1840s, photography was sufficiently cheap and technically available so that it was easy. It could be made anywhere by the self-trained. All over the world people rushed to sit for their portraits. It was estimated in 1853 by a New York newspaper that more than three million photographs had been made the year before. There were still no schools to teach photography, no aesthetic rules to unlearn, and no barriers beyond the acquisition of technical knowledge to prevent women as well as

men from working with "the mirror with a memory." Invented simultaneously by several scientists and artists in the 1820s and 1830s, photography destroyed class distinctions with regard to who could be the subject of art. With the first pictures made in 1827 by Niepce by the interaction of the sun with chemicals on a plate, the monopoly of the painter and sculptor on the rendering of the visible world was broken. The realization of humanity's hope for immortality through art had arrived. Before 1900, everyone, even the poor, could have images of their ancestors (Fig. 460). Photographs helped millions answer the question, "How will we know it is us?" by providing them with a past as well as eternal youth. The visible world never looked the same after photography nor did humanity's image of itself.

The Art of Photography Although officially admitted as art to the French government salons in 1859 and assigned to the print section, photographers to the present time have always felt their claim to being artists challenged. The camera continues to be seen as doing all the work. The art in photography, however, depends upon skill, knowledge, and sensibility when it comes to *decisions.* Photography is a way of seeing, of looking at the world, and some have argued, a way of life. Far from being neutral or impersonal, the photographer's relationship to the machine can produce images of astounding variety. The work of one professional photographer seen as a whole can produce evidence of a style and attitude toward life. Not necessarily in order of importance, the decisions that produce individuality among photographers who make portraits, for example, depend upon the artist's rapport with the subject, whether formal or

informal; the physical and psychological distance between sitter and photographer; the selection of pose and facial set or movement; the choice of viewing angles and the use of light and shadow to model form and describe or interpret character; the presence or absence of a physical context or accessories; and the sitter's relationship to the field achieved by framing. The type of camera, its lens, and the printing process, as well as the quality of the paper, have an important effect on the overall quality of the print. The 19th-century photographs in this book, for example, lose quality by their printing.

The great photographers have brought to their art a sense of photography's possibilities, an ability to see the world in terms of a rectangular photograph and know what it will leave out. Despite the fact that most of the photographers who are discussed here were self-taught, the world of photographic images and the other arts have informed their sensibilities. Rather than claiming photography as the arbiter of truth, as was often done by many earlier observers and the public, the great artists see it as self-expression through others. While for some, the camera has become an extension of thought, feeling, and sight, for others, it is sometimes frustrating in its failure to produce the desired image.

Homage to Heroes Photography was invented when there were still heroes to be celebrated and the public wanted accurate likenesses of doers against all odds. Robert Howlett did a series of Crimean War heroes for Queen Victoria, but his most memorable portrait is of a British civil engineer who built the biggest steamship of the 19th cen-

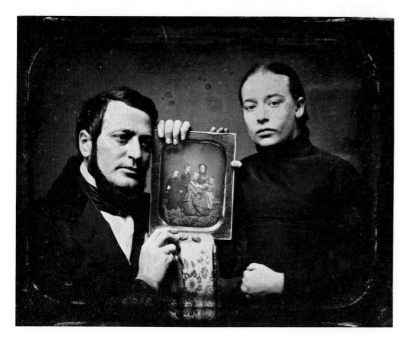

460. Unknown photographer.
Couple with Daguerreotype.
c. 1850. Daguerreotype.
Museum of Modern Art, New York
(Virginia Cuthbert Elliott, Buffalo, N.Y.).

tury, the *Great Eastern.* This engineer had a wonderful Victorian name that combined piety with power: Isambard Kingdom Brunel (Fig. 461). Today it still has the ring of an Old Testament conqueror. The brilliance of Howlett's portrait lies in the choice of background and the contrast between the huge chains tightly wound and the relaxed stance of the cigar-smoking man for whom all things were possible. Brunel epitomized the drive, intelligence, and self-confidence of those who brought about the Industrial Revolution in England. Artistically, it is Brunel's centralized location and large scale within the field rather than the pose that evokes achievement. The graduated lighting and focus of the chains make them like an apparition against the fully illuminated stance of the man who brought them into being. The curved top of the print recalls that of paintings used for the portraits of saints in the past. Formally, it echoes the shapes of the links and tightens our focus on the juxtaposition of man and metal. Today no single individual in business may have Brunel's power, and no present-day corporation president whose picture appears in the business magazines projects an image comparable in terms of drama, success, and mastery of what he puts his mind to.

"A Speaking Likeness" Howlett's secularization of the saints was matched by the hero worship of the first major woman photographer, Julia Margaret Cameron. She came to photography at age 49, when a member of her family presented her with a camera, knowing of this formidable woman's past history of paying photographers to photograph friends under her direction. Self-taught in the considerable complexities and dangers of the chemistry of making and developing photographic plates, Cameron disdained the impeccable technique of less talented but more acclaimed male photographers. Their immaculate prints and sharp focus drew the admiration of critics who admired these properties in academic painting. From the moment she began to exhibit her work, first in England and then internationally, Cameron's critics and admirers commented on the out-of-focus or soft focus of her prints, such as the stunning portrayal of the great English historian Thomas Carlyle (Fig. 462). Of her photograph, Cameron wrote, "Carlyle like a rough block of Michelangelo's sculpture." The long exposures required in the 1860s at times caused the subjects to blink or move slightly, and Cameron sometimes stopped adjusting her lens before it reached sharp focus because she liked the effect. Above all, she detested the static, cardboard images of other portraitists and determined to win for her subjects a "speaking likeness." To bring greater warmth and animation to her prints, she opted for dramatic contrasts in lighting, which caused the subject's head to seem suspended in darkness. In the last century, the sun's lighting of human features was seen by many

left: 461. Robert Howlett. *Isambard Kingdom Brunel.* 1857. Photograph. International Museum of Photography, George Eastman House, Rochester, N.Y.

above: 462. Julia Margaret Cameron. *Carlyle Like a Rough Block.* 1867. Photograph. National Portrait Gallery, London.

463. Edward Steichen.
Rodin—Le Penseur. 1902. Photograph.
Reprinted with the permission
of Joanna T. Steichen.

as a guarantee of truth. In order to achieve further intimacy with her subjects, Cameron was the first to use the close-up in photography.

Beginning as an artist in middle age, Cameron joyfully adopted photography as a "wonderful art that makes something out of nothing." She wrote how photographic theory could be learned in one hour and how to go about making prints in a day. "What can't be learnt . . . is the feeling for light, the artistic appreciation of effects produced by different or combined sources; it's the understanding of this or that effect following the lines of the features which requires your artistic perception. What is taught even less, is the instinctive understanding of your subject, which . . . helps you to sum them up."

Myth Making When the young American photographer Edward Steichen made his portrait of Rodin in 1902 (Fig. 463), he also was openly engaged in hero worship. Rodin was already a great mythical figure in the mind of the young photographer, who came to Paris after seeing the sculptor's *Monument to Balzac* reproduced in a Milwaukee newspaper. Steichen's image with its provocative title, *"Rodin—Le Penseur,"* did much to solidify Rodin's worldwide reputation as the greatest living artist. To achieve this illustration of his awe, Steichen had to manipulate photography and take it beyond selection into synthesis, which had been the painter's domain. The size of the sculptures he wanted as context and the range of his lens at the distance he desired prompted him to make two negatives. He printed the re-

versed image of that which showed Rodin and the white plaster figure of *Victor Hugo.* Thus, through a composite image, Rodin, *The Thinker,* and *Hugo* could be shown in thoughtful confrontation, a heroic pantheon. So well known through photography was Rodin's head that the young artist could daringly use a silhouetted profile. By showing the sculptor brooding alone among his creations, Steichen achieved the model image of the solitary introverted genius, a giant among giants, an immortal. The predominance of the dark tones and the soft focus not only imparted the sense of nocturnal atmosphere—the artist awake while the world sleeps—but also induced a decidedly painterly or artistic look that Steichen felt solidified photography's claim to being an art form. By the time of the First World War, however, more and more artists were interested in "straight" photography, which avoided manipulation for deliberate aesthetic effects.

A Society's Faces One of the most ambitious projects ever undertaken by a single photographer was August Sander's program to make from five to six hundred photographs of his countrymen. It was not the number of subjects that made the program difficult, for he had photographed that many in a couple of days after World War I, when Germans needed photographs on their identity cards. Sander set out to find those who personified all the professions and occupations of his society. When Hitler rose to power, Sander was forced to stop the project and turn to landscapes, but what he did achieve remains remarkable. It was always his

intent, in photographs like his classic of *The Pastry Chef* (Fig. 464), to be perfectly neutral toward the subject. "It is not my intention either to criticize or describe these people." Sander did in fact describe these people, and he did show class consciousness in his style by using different settings for people from different social strata. There is, however, a wonderful contrast between Howlett's engineer and the symbol of his achievement and the relationship of the pastry cook's shape to the tools of his trade. It is hard to believe that Sander did not see this connection before he tripped the shutter. Sander's subjects appear at ease with the man holding the camera; they seem fully in possession of their spaces and selves. The cool clarity of the lighting on the confident cook serves to summarize the subject physically as well as to reflect the artist's warranty of scientific objectivity. When we see these archetypal portraits as a whole, the largely unsmiling and often smug social mask of the German people has a chilling impact. For reasons not clear, the Nazis impounded Sander's publication, *The Face of Our Time,* as "antisocial."

Making Visible the Socially Invisible Even more ambitious than Sander's typographic portraits of the Weimar Republic and very much his life's work was Lewis Hine's dedication to photographing the working people who built America. He worked in the sweatshops, immigration halls, and on the skyscrapers in the first third of this century. More than their counterparts in Europe, American photographers used the camera as a powerful instrument for social change. The best photographer of this group of political reformers may have been Hine, who saw no separation between sociology and art. It was crucial for Hine that his pictures be "straight," never faked or retouched, and steadfastly true to his social and aesthetic vision. This vision, despite hundreds of grim photographs, was optimistic about America. While photographers like Steichen photographed the beautiful women of high society and the tycoons of finance, Hine drew from his childhood work experiences and photographed the "sweat and service" of thousands of human beings that went into the products of the machines and made fortunes for the few. Hine wanted to make "invisible" America visible to the public. His *Factory Boy, Glassworks, 1909* (Fig. 465) is haunting in its pathos and artistic beauty, achieved by the framing of the scene, the distance between us and the boy, and the lighting. Hine makes us aware we are looking at a detail of an actual workplace that is only one part of something vast. In this and hundreds of other photographs, he confronted the skeptics with evidence of child exploitation in the factories throughout the country. His eight hundred such photo-

left: 464. August Sander. *The Pastry Chef.* Photograph. Courtesy Sander Gallery, Washington, D.C.

below: 465. Lewis Hine. *Factory Boy, Glassworks, 1909.* Photograph. International Museum of Photography, George Eastman House, Rochester, N.Y.

above: Plate 44. Peter Paul Rubens. *Susanna Fourment.*
c. 1622–25. Oil on panel, 31⅛ × 21½″ (79 × 54 cm).
National Gallery, London (reproduced by courtesy
of the Trustees).

right: Plate 45. Henri Matisse. *Woman with the Hat.*
1905. Oil on canvas, 32 × 23½″ (81 × 60 cm).
Private collection.

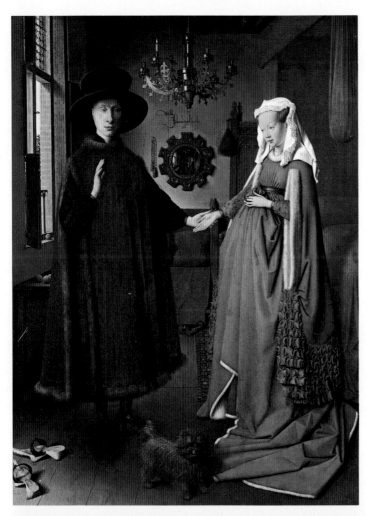

left: Plate 46. Jan van Eyck.
Giovanni Arnolfini and His Bride.
1434. Oil on panel,
32¼ × 23½'' (82 × 60 cm).
National Gallery, London
(reproduced by courtesy
of the Trustees).

below: Plate 47. Oskar Kokoschka.
*Hans Tietze and
Erica Tietze-Conrat.* 1909.
Oil on canvas,
2'6⅛'' × 4'5⅝'' (.77 × 1.36 m).
Museum of Modern Art, New York
(Abby Aldrich Rockefeller Fund).

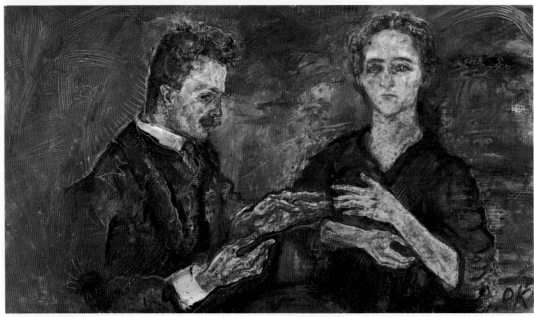

466. Russell Lee. *Farm Security Administration Clients at Home, Hidalgo, Texas, 1939.* Farm Security Administration photograph. Library of Congress, Washington, D.C.

graphs in 1908 alone helped enact laws against such abuse. Within the photograph of the boy in the glassworks, we can see Hine's cyclical theory of poverty and the worst aspects of American capitalism as the century began: child labor and illiteracy lead to inefficient and underpaid adult labor, which in turn produces more child labor. Hine, who himself died in poverty, saw legislative victories, but his artistic gifts were played down as if they detracted from his social message. Though his photography has helped form our image of America's past, we can also see how richly he contributed to the art of photography.

Hard Times in America How photography could give a country a sense of identity, an awareness of its variety and complexity, was shown by the activities of teams of photographers working for the Farm Security Administration between 1935 and 1943. They took over 270,000 photographs, mostly of rural America during the Depression. The charge to the photographers was to provide the government and public with documentary evidence of hard times. The photographers were encouraged to treat people with dignity and show their self-respect, while implying that under the New Deal things would get better. Lewis Hine's humane attitude toward his subjects had a strong influence on the director of the program, Roy Stryker, who had earlier started a photographic history of American agriculture. Armed with

new small film cameras having faster lenses, the 35mm Leica and Contax from Germany, Stryker's photographers were able to work more rapidly and less obtrusively than those who used the old view cameras. They drastically changed documentary photography. Stryker provided his colleagues with detailed scripts about things to look for to fill out this unique American record. One of these shooting scripts called for recording "Home in the evening: photographs showing the various ways that different income groups spend their evenings, for example: Informal clothes, listening to the radio, etc." Russell Lee's *Farm Security Administration Clients at Home: Hidalgo County, Texas, 1939* (Fig. 466), fulfills the script with a double portrait of a married couple that is far from the paintings of Van Eyck and Kokoschka. It is one of those rare pictures that does stand by itself and for a way of life and does not depend upon a caption. The formal symmetry of the composition, the immaculately kept interior, and the relaxed postures of hard-working people who do not have "informal clothes" get across the message of respectable living. Altarlike, the big radio anchors the center, suggesting a secular communal union between the couple and their link with the invisible outside world. On its top sit the inevitable photographs of their children, while above—a nice touch of irony—hangs a cheap textile image of an 18th-century aristocratic family listening to their daughter playing a harpsichord.

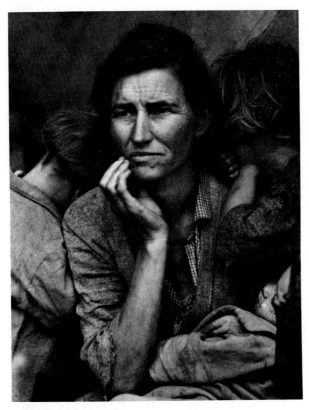

above: 467. Dorothea Lange. *Migrant Mother, Nipomo, California, 1936.* Farm Security Administration photograph. Oakland Museum, Calif.

below: 468. Diane Arbus. *Pro-War Parade.* 1967. Silver print, 14¾ × 14½″ (37 × 36 cm). Museum of Modern Art, New York (Ben Schultz Memorial Collection, gift of the artist).

The Magnet of Despair From Stryker's viewpoint, the single photograph that best summed up the intention of the FSA program was Dorothea Lange's *Migrant Mother, Nipomo, California, 1936* (Fig. 467). One of the paradoxes of this and other photographs such as Lee's is that the names of the subjects are never given, as if to protect their privacy while at the same time exposing them to the world. Lange's own notes on her much reproduced photograph say:

> I saw and approached the hungry and desperate mother, as if drawn by a magnet. I do not remember how I explained my presence or my camera to her, but I do remember she asked me no questions. I made five exposures, working closer and closer and closer from the same direction. I did not ask her name or her history. She told me her age, that she was thirty-two. She said that they had been living on frozen vegetables from the surrounding fields and birds that the children killed. She had just sold the tires from her car to buy food. There she sat in that lean-to tent with her children huddled around her, and she thought that my pictures might help her, and so she helped me.

(Ironically, the mother in the photograph is very much alive today and angry that the photograph that immortalized her darkest moment and received so much publicity, bringing fame to Lange, has not helped her financially. The negative and all rights to its reproduction are owned by the United States government, and prints from it are available to the public for a few dollars. No royalties went to Lange.) Rare in situations where the subject knows she is being photographed is the mother's attitude, unposed and uninvolved with the camera. The intensity of the woman's concern for the future scores the face and impels the absent gesture of the hand. The children, out of shyness or despair, close the form of this powerful composition. Lange's instinct to keep cutting down the field, to get closer to the truth, was shared by certain war photographers who knew that photographs in themselves are not always credible to the public, but a closeup forces involvement on the viewer.

"A Little Bit Cold, a Little Bit Harsh" More than traditional portraiture in painting and sculpture, the camera permits those photographers who do not require intimacy with the subject to make portraits of strangers. Documentary photographers like Lange know that to do this successfully requires, as someone put it, being in a state of grace with chance, forever waiting for appointments that have not been made. The late Diane Arbus, who did not see herself as a documentary photographer, preferred to photograph people she did not know, but usually made appointments to take their pictures. Her *Pro-War Parade* (Fig. 468) was partly a chance encounter, for by 1966 she had determined to photograph "the considerable ceremonies of our present" that, she believed, are "our symptoms and monuments." Unlike Sander, in her project to capture certain aspects of society Arbus did not consciously seek out social stereotypes. From her teacher, Lisette Model, she had

469. Brassai. *Matisse Drawing a Nude Model.* 1939. Photograph. Courtesy Marlborough Gallery, New York.

learned that in a photograph "the more specific you are, the more general it will be." Arbus' patriotic boy fulfilled her intention of making the "ceremonious" and "commonplace" into the "legendary." The antithesis of Julia Cameron, Arbus could not idolize public heroes. She was interested in the ordinary and the socially marginal or the strange. With Lange she could agree that the subject was more important than the picture and that a value of her art was that there were things that nobody would see unless she photographed them.

Arbus' picture of the youth needs no caption, and its analysis would be redundant. The work reminds us that she detested the self-consciously composed picture. "I work from awkwardness. . . . I don't like to arrange things. If I stand in front of something, instead of arranging it, I arrange myself." She was fixed on clarity, and occasionally, as in this photograph, she used a strobe light. A sixteen-year career made her extremely thoughtful about how the camera intervenes between us and other people and how photographs can be mean. On this intervention Arbus once commented, "It's a little bit cold, a little bit harsh." Contrary to the myth of the photographer's mastery of a predictable

machine, Arbus wrote of the "recalcitrant nature" of her instrument. "It's determined to do one thing and you may want to do something else. You have to fuse what you want and what the camera wants."

Search for the Permanent Brassai is one of those photographers whose prints betray their maker's identity, no matter who is portrayed. Brassai did not obviously impose himself on Matisse (Fig. 469) by dictating the pose, for the painter is shown totally absorbed in a study of the model. It was Matisse's comfortable feeling in the presence of a distinguished fellow artist that led to this memorable image, one that captures the stillness and luminous beauty of the artist's studio. The result is totally unlike Steichen's awed view of Rodin. Brassai saw Matisse on equal terms. For thousands of artists, this print is the model of the good life.

Deeply concerned with composition, unlike Arbus, who often opted for simple frontality in her subject, Brassai nevertheless arranged himself, as did she, in order to make us aware that he did "compose beautiful photographs." He had no patience with accident or in capturing the subject

470. Bill Brandt. *Jean Dubuffet's Right Eye.*
1960. Silver print, 13½ × 11½" (34 × 29 cm).
Copyright © 1960 by Bill Brandt.

surprise is the image of the old modern master: neatly trimmed beard, vest, shirt, and tie, a white smock like a doctor's examining the model almost clinically, making notations. For Matisse, art was a serious profession, and he dressed accordingly.

Recalling Matisse's own view of painting, Brassai once wrote of the photograph as "the daughter of the rectangle . . . which requires one to fill up the space agreeably or harmoniously with black and white spots of color." Like Matisse, who spent a lifetime working with brushes, oil paints, and canvas, Brassai showed no interest in technical innovations or dark-room trickery. As he put it, "I invent nothing. I imagine everything."

The Portrait of the Part There are several professions that are symbolized by hands, but that of the artist is also, and particularly, identified with the eye. Monet was once described by a contemporary as being "an eye, but what a magnificent eye." In the early 1960s, the British-born photographer Bill Brandt (b. 1904) did a series of photographic portraits of artists, in each of which he focused on only one eye. Brandt's earlier contact with the Surrealists may have alerted him to the provocative ambiguity of a single, isolated anatomical feature seen close up (Fig. 470). Because of the dry, wrinkled skin around it and the suggestive silhouette at the left, the eye of Jean Dubuffet might also pass for an elephant's. A photographer who had spent much of his career doing documentary work, Brandt showed in this photograph the thin line between the banal and the bizarre. Within the print's limited field, the eye looms uncommonly large and luminous, perhaps as it might in the artist's own consciousness. Otherwise the photograph seems to tell us that at least in its external appearance the artist's eye is no different from those of others. The history of close-up portrait photography, begun by Julia Cameron to achieve a speaking likeness, thus evolved to the eloquent silent portrait of the part.

off guard. For Brassai, the taking of a photograph was akin to a religious ritual, and he wanted the subject to appreciate it. He had no ambition to analyze his sitter, but looked instead "for what is permanent," and one might add, a graceful and relaxed permanence. His ideal was to let the subject "interpret himself." "I like to render the immobility of the face of the person thrown back on his inner solitude." Taking light as he found it, he was more interested in angles and distances that showed its modeling of form than in psychological disclosure. Brassai has the gift of knowing what moment to fix. This comes from patient observation of the subject rather than dozens of shots taken at random. He used the same old camera, claiming that "after twenty years you can begin to be sure of what a camera will do."

This one image was informed by thousands of previous pictures Brassai had taken, but also by the art of others, such as Matisse himself. They shared a common objective: a serious art that would bring joy to thoughtful people. The tangencies and juxtapositions of objects and figures in the print, the connections in depth between persons and things, and the overall radiance of the image, but not its clutter, recall Matisse's own hedonistic imagery. And what a

Portraits continue to fulfill the need for human ego gratification and curiosity about others. They link the living and the dead and now can confer immortality on all. Whereas in the past, the subject of a painted, carved, or modeled portrait had special social status, the photograph became the great eraser of class distinctions. Portraits remain the means of celebrating heroes and heroines, of perpetuating ideals of ethical conduct and concepts of manliness and femininity. By portraying the victims of life and society, the photographic portrait contributed to heightened social awareness and political reform. Portraits put a face on a society and help give it a sense of identity. Faces are there to describe, flatter, and interpret. By the portrait, the artist could fix the fugitive or show permanence in a life of change. No matter how repressive or liberal the society, portraiture has been the means by which the artist expresses the self in terms of others.

Chapter 18

The Figure
in Modern Sculpture

The persistence of the human form in sculpture from pre-historic to present times argues for man's need to re-create himself. Fidelity to ideology rather than to biology helps to account for the fact that throughout its history sculpture has granted to the human body an infinite variety of interpreta-tions. Until recently, man not as he *is* but as he *should be* has been the sculptor's model—along with statues made by predecessors. The human form in sculpture has been as flexible as human imagination and taste, and history does not support absolute and eternal standards of the good, the true, and the beautiful.

In Western art, the great tradition of monumental sculp-ture—sponsored by rulers and institutions, destined for public display, and made by sculptors willing to interpret the values of their patrons—came to an end in the last cen-tury. We can recognize the success of this tradition by the fact that no modern sculpture has been so widely influential or become such a national symbol as Bartholdi's Statue of Liberty, completed less than a century ago. (In recent times, it has been used as a symbol for women's liberation.) This chapter considers the dream and the dilemma of modern sculptors who have chosen to make their own art and to create the need for it. Not only did they choose to make art from values private to themselves; they also had to per-suade the public to believe in their achievement.

The Pathetic Hero Auguste Rodin (1840–1917) is the link between the grand tradition of public statuary and the mod-ern period in which the most important sculpture develops

independently of official support and a sympathetic public. Rodin knew governmental rejection and acceptance in his attempts to make sculptures with the power and appeal of Rude's *Departure of the Volunteers of 1792* on the Arc de Triomphe (Fig. 471). Rude's sculpture epitomized Rodin's conservative view that public art should first educate, then elevate, and finally delight his fellow citizens. Rude created heroic art at a time when France still believed in heroism, when robust civilian volunteers marched off to war with the roll of drums at the call of Marianne, the symbol of France. Like "La Marseillaise," the national anthem, Rude's sculp-ture spoke to Frenchmen in stirring tones of duty, honor, and self-sacrifice for one's country. It educated men by ex-horting them to train and develop their bodies; it elevated their minds and spirits by the example of unflinching patri-otic allegiance to France. Rude's relief narrative delighted the French taste for strong, clear form and the logic of story-telling with an exalted purpose. Rodin read this sculpture as theater, the relief as a play in three acts. So compelling were Rude's design and interpretation of Marianne leading the people that Rodin eagerly paraphrased the winged fig-ure in his own project for a national monument, *La Défense* (Fig. 472), which his government rejected in 1878. Incom-prehensible as it may seem to us today, France encouraged her best sculptors to create monuments celebrating that nation's glory and heroism for more than 30 years after the most humiliating defeat in its history at the hands of Ger-many in 1870. Rodin's wounded warrior, roused almost from the grave by an angrily defiant Marianne, may reflect

left: 471. François Rude. *Departure of the Volunteers of 1792 (La Marseillaise).* 1833–36.
About 42 × 26′ (12.8 × 7.92 m).
Right stone relief, Arc de Triomphe de l'Etoile, Paris.

the sculptor's idea that the battered nation must rally to the call of duty, and he was probably also expressing his country's sentiments that Germany must be fought again! His own government may have rejected *La Défense* because of Rodin's too vivid characterization of the powerfully muscled but grievously wounded male figure. With Rodin, the pathetic hero entered sculpture.

A year earlier, in 1877, Rodin exhibited *The Vanquished,* later retitled *The Age of Bronze* (Fig. 473). Young French artists were delighted with the freshness and honesty of Rodin's re-creation of the human body; critics were dismayed by the ambiguity of its meaning and its unsuitability as a model of physical culture or as an exemplar of a sound

below left: 472. Auguste Rodin.
Study for *The Call to Arms (La Défense).* 1878.
Bronze, height 45″ (1.14 m).
Courtesy Paul Rosenberg & Co., New York.

below center: 473. Auguste Rodin.
Age of Bronze (originally *The Vanquished*). 1876.
Bronze, height 6′ (1.83 m).
Minneapolis Institute of Arts (John R. Van Derlip Fund).

below right: 474. Polyclitus. *Doryphorus (The Spear Carrier).*
Roman copy of Greek original of c. 450–440 B.C.
Marble, height 6′6″ (1.98 m). National Museum, Naples.

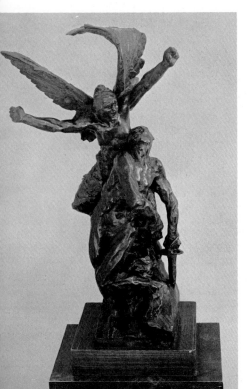

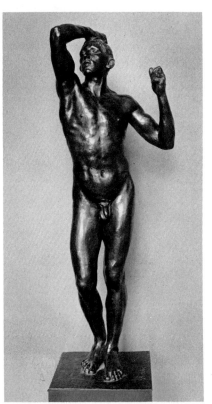

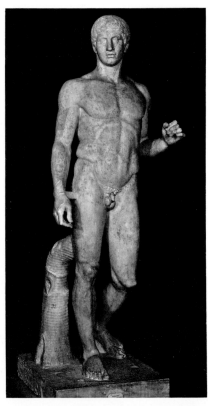

mind in a healthy body. The critical ideal Rodin was contradicting had been largely built upon ancient Greek Classical statuary, exemplified by *The Spear Carrier* (Fig. 474) of Polyclitus. Comparing *The Spear Carrier* and *The Age of Bronze,* we can see the beginning and the end, not of artistic quality, but of the concept of the ideal in public statuary. A messenger of the gods, a soldier, a hero of the gymnasium—the specific identity of the Greek sculptor's subject is lost to us. Probably he was a politican, a man who, as an ideal citizen educated in the democratic tradition of the Athenian city-state or *polis,* could have been elected a general for one war and served as a spear carrier in the next. He represents the cultured 5th-century B.C. Athenian, competent to function alternately as judge and legislator, an athlete whose musical and gymnastic training prepared him for both war and worship of the gods—in short, the Classical Greek ideal of the whole man in whom *virtue* was achieved. Here can be found the commencement of the tradition of the "Athlete of Virtue," the all-around individual of grace and strength, living, like the later medieval knight or churchman, a life of continence and fortitude, always exhibiting moral courage. *The Spear Carrier's* step is confident. It speaks to us of the Greeks' self-image, of their desire to overcome the duality between man and the world, to affirm self-mastery, to civilize nature. The un-self-conscious attitude of the man who displays a body given him by nature but perfected by culture exemplies the bold extension of the human ego into art, the affirmation of the here and now, unconcerned with death.

The Classical nude reflects a world in which the human being is the focus and measure of all things. Who, then, is *The Vanquished*? What ideal does he stand for? What does he offer for emulation? Rodin never said, and we cannot as easily reconstruct *The Vanquished*'s identity and symbolism from the artist's culture as we can in the case of *The Spear Carrier.* Originally Rodin had his figure holding, for support, the tip of a spear with his left hand, but he later removed the weapon and presumably its role as an identifying attribute because of its interference with an all-around view of the sculpture. Literally and figuratively, he knocked the props out from under traditional meaning and purpose in statuary. No doubt Rodin was symbolizing the disillusioned youth of his age, groping in a world without certainty, thrown back upon themselves. The step is hesitant, the gestures despairing. All that is sure in the sculpture is Rodin's modeling. He admired Greek art but not its mathematical formulas for proportion, standards that began with Polyclitus (Fig. 474). He loved the Greeks' penchant for modeling from all the profiles of the figure, but he could not bring himself to idealize by improving on the physique of his model. Rodin was an empiricist, a passionate reporter

of the language of living bodies, not a mimic of rules and counterfeit attitudes. Polyclitus' nude was "clothed" in cultural attributes, philosophical ideals, and scientific discoveries in the field of anatomy. Rodin had begun to strip his figure of centuries of conventions and literary associations, habits of the hand and mind. The hipshot stance of *The Vanquished* still pays homage to the Greek "beauty pose," with its balance of perfect energy and perfect repose, the countering of movements in different directions, and the expressive pathetic gesture of Michelangelo's *Bound Slave* (Fig. 212). What Rodin had discovered and displayed in his sculpture was "pure modeling," the joy of observing and creating a beautifully made surface that at once could express body and spirit. Rodin brought to European sculpture an admiration for the beauty and expressiveness of the body, a compassion for the anguish of the spirit, and a passion for modeling more after nature than art.

Rodin's Sculptural Alchemy The heroes who inspired Rodin's most convincing but officially unacceptable sculptures were not abstractions but modern-day athletes of virtue, gymnasts of the mind and spirit, such as Honoré de Balzac, whose *Comédie Humaine* was an earlier literary counterpart to the *Gates of Hell* (Fig. 387). But when Rodin showed his model for a Balzac monument (Fig. 475) to a sponsoring committee in 1893, it was rejected as blasphemous. The problem Rodin had tackled was that of bringing to life in a heroic public statue a national hero idolized for

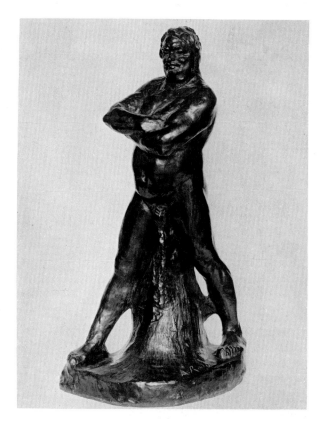

475. Auguste Rodin. *Naked Balzac.* 1875.
Bronze, height 30″ (76 cm).
Courtesy Galerie Claude Bernard, Paris.

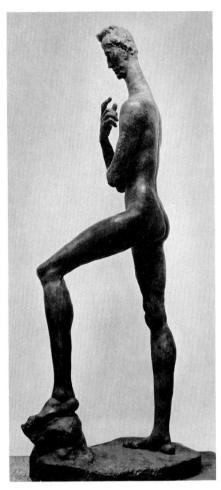

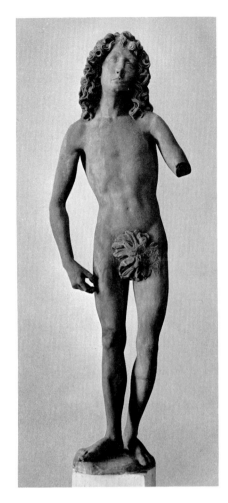

right: 476. Wilhelm Lehmbruck. *Standing Youth.* 1913. Cast stone, height 7′8″ (2.34 m). Museum of Modern Art, New York (gift of Abby Aldrich Rockefeller).

far right: 477. Tilman Riemenschneider. *Adam.* 1493. Sandstone, height 6′2″ (1.88 m). Mainfränkisches Museum, Würzburg.

feats of the pen, who was at the same time physically short, fat, and ugly. In life, Balzac's voice could transform his image among his listeners, so that he could claim conquest of the most beautiful women of his time. Using different models for the body and head of the long-dead author, Rodin's sculpture of body language faithfully re-created not only the hedonistic self-indulgence that corrupted an originally imperfect body, but also the defiant pride and genius that caused Balzac to speak of carrying a world in his head. Disguising nothing and employing an inspired idea for the pose, Rodin turned the short-legged, swollen-paunched, flabby-chested figure into a fork-stanced battering ram. The result was a citadellike monument to Balzac's ego. For Rodin, there was no ugly subject, only bad sculpture. He could transform anatomical lead into artistic gold.

The Exemplary Figure before World War I: In Praise of Youth

Between 1900 and World War I, many of the most venturesome young sculptors, with no hope or desire for official patronage, made exemplary figure sculptures invested with their views of modern humanity expressed without recourse to the revival of past styles. The German sculptor Wilhelm Lehmbruck (1881–1919) wrote, "Sculpture like all art is the highest expression of the age." He was optimistic that he and others would achieve a great monumental art in a contemporary heroic style. Lehmbruck's *Standing Youth* (Fig. 476), made on the eve of a war disastrous to all combatants—which led to his own suicide—is an inspired homage to an entire generation and to the powers of the self. By his sculpture, Lehmbruck tells us that it is the artist who is the measure of man. Through the language of the inclined head, self-directed gestures, and stationary but not static body, he optimistically evokes the inner moral and intellectual strength to overcome life's obstacles. Here again is the "Athlete of Virtue," expressed not through a Classically proportioned, gymnasium-honed body, but through the suggestion of spiritual striving. The lean attenuation and angularity of the sparse frame and the avoidance of lithesome coordination are reminiscent of medieval German sculpture, of the *Adam* (Fig. 477) by Tilman Riemenschneider

478. *Isaiah,*
on the west portal
of the Benedictine Abbey of Souillac.
c. 1110–30.

(c. 1460–1531), for example, who takes no pride in his sinful body. Lehmbruck, unlike his forebear, knew the Classical tradition of body culture, but he suppressed this inheritance in favor of a more northern legacy that favored expressive rather than beautiful movements. From Rodin, Lehmbruck learned the pathos of posture, of finding instinctive self-revealing movements of the limbs, as well as the power of proportion and silhouette. Proportion is meticulously measured not from Polyclitus or an actual model but from the artist's ascetic vision of youth's virtue. The rugged silhouette is like the coarse track of the life youth must inevitably run.

We can see how personal yet how modern Lehmbruck's vision was by comparing it with a paradigmatic sculpture from the past, made about two centuries after the revival of large-scale stone sculpture in Europe. Carved in relief on the portal of the southern French abbey church of Souillac is the Old Testament prophet *Isaiah* (Fig. 478). It was probably inspired as much from manuscript painting as from relief sculpture, but not by a living model. Isaiah is presented in what appears to be a kind of ecstatic dance, but at the time the crossed legs may have been a posture reserved for dignitaries, a kind of status sign, or else the artist may have been suggesting the walking entailed in his ministry. The extended proportions related not to the sculptor's taste but to the prophet's exalted rank. The angular movements betray the sculptor's unawareness of muscular coordination and Greek anatomical science and also the fact that he used an abstract linear armature in organizing his figures. This early medieval Christian hero testifies to the existence and superiority of a spiritual world transcending that of the mundane viewer. The gesture and proportion of the *Isaiah* were not intended to be confirmed by what the human eye could match it against, but were directed to the Church-educated mind. Although the face is serene, the pose has been endowed with energy and excitement, and the total gesture of the figure mirrors the prophet's spiritual intensity. Descended theologically from the virtuous Greek athlete, the medieval *Isaiah,* by his exemplary dedication to Christian virtue, is the remote ancestor of Lehmbruck's modern hero. Unlike the latter, however, *Isaiah* holds an identifying attribute, the scroll of his prophecy, which suggests his relatedness to elements outside himself and his existence within a stratified universal hierarchy.

The Demise of Sculptural Rhetoric The rapidity of changing values and popular skepticism about the worthiness of individuals for celebration in monuments may help,

as a broad generalization, to explain the decline of public statuary made by society's greatest artists in this century. But sculpture itself was changing long before World War I. Rodin, and then Lehmbruck, broke with the self-evident, declamatory gesture, theretofore vital to public art, in favor of expressive gestures, movements of the body that were instinctive, credible, and touching but unparaphrasable. Their gestures were not conducive to inspiring the contemplation of eternal verities. Still another change that irrevocably damaged the tradition of public didactic art was the renunciation of gesture and facial expression altogether as being too literary and contrary to the growing ideal of making sculpture more psychologically and formally self-sufficient. The stress was shifted from what the figure does to what the artist did. In 1908, Henri Matisse wrote, "What I am after, above all, is expression . . . [which] does not consist of the passion mirrored upon a human face or betrayed by a violent gesture. The whole arrangement of my picture is expressive." Matisse, who was a sculptor as well as a painter (Pl. 45, p. 333), could have substituted the word *sculpture* for *picture.*

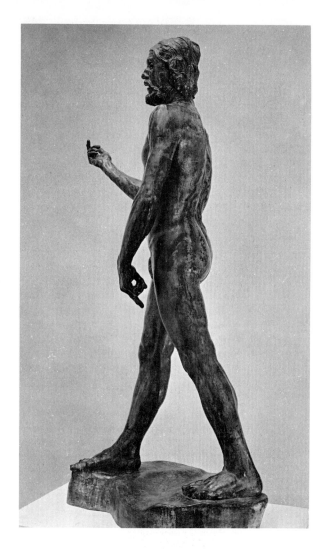

the changing disposition of bodily weight as the figure moves into stride and brings the weight down upon the front foot. Matisse felt that sculpture was static and should not contravene its nature by simulating movement in a free-standing figure, and so he planted the body firmly. One reads Rodin's surfaces as marvels of finesse and observation in the contour mapping of the dense elevations and depressions offered by the flesh. Matisse did not want explanatory details but rather an expressive surface, one whose cutting and modeling would go further than Rodin's facture in richness, controlled response to light, and emphasis upon the body's directions. Thus the muted expression of the serf's face is intentional and unclimactic. Overall, Matisse wanted the effect of stolid durability as well as a figure that seemed more perfectly and interestingly put together than the actual human form. Rodin sought a work larger than life, not just in size but in vitality. Matisse wanted us to be aware of the intervention of art, of the imposition of his own intelligence, feelings, and sensibility on nature. Matisse's work superseded Pignatelli to become a distillation of the artist's own sensation inspired by the repeated sight of the model and the emerging sculpture.

left: 479. Auguste Rodin. *St. John the Baptist.* 1878. Bronze, height 6'6¾'' (2 m). Museum of Modern Art, New York (Mrs. Simon R. Guggenheim Fund).

below: 480. Henri Matisse. *Le Serf.* 1900–03. Bronze, height 36¼'' (92 cm). Mary Sisler Collection, Palm Beach, Fla.

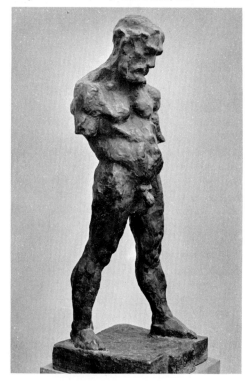

Twenty years apart, the same model, Pignatelli, posed for Rodin's *St. John the Baptist* (Fig. 479) and Matisse's *Le Serf* (Fig. 480). Matisse created this work to stake out his views on sculpture and his differences from Rodin, about whose method of work their common model had informed him. Rodin loved the freshness and vitality of the unprofessional model and saw in the young Pignatelli's animallike energy and bodily eloquence the means of completing a sculpture that would interpret the biblical prophet, for which he had previously made only a torso. Matisse preferred experienced studio models and stock academic poses. He was not interested in building sculptures from previously made parts or in finishing details. He sought to achieve the overall effect of the figure from the outset, by its total arrangement. Rodin incorporated the traditional gestures of the saint pointing to Heaven and earth and then added his own ideas about how sculpture could be truer than photography in showing successive movements of the body. One is to read his *St. John* as a continuous flow, starting with the back foot and working forward, following

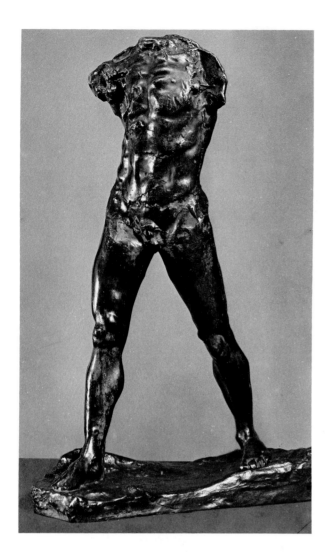

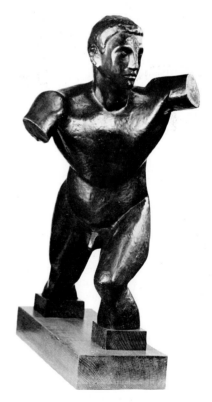

481. Auguste Rodin. *The Walking Man.* 1878–80.
Bronze, height 33⅛'' (84 cm).
National Gallery of Art, Washington, D.C.
(gift of Mrs. John W. Simpson).

body the expressiveness of the human face. His *Walking Man* celebrates not a historical or biblical personage or event, but the human spirit that drives and animates biological man.

The Certainty of Sculpture in a Time of Flux Many young sculptors at the turn of the century disliked Rodin for one reason or another, but they were nonetheless influenced by his ideas at crucial phases of their careers, and most contemporary figure sculptors have used the partial figure concept. Raymond Duchamp-Villion (1876–1918), the first self-trained professional sculptor of our time, objected to Rodin's modeling, which he felt was too emotional, anecdotal, and prey to accidental lighting effects. However, his *Torso of a Youth* of 1910 (Fig. 482) was cut down from a full figure of Adam, quite probably under the influence of the *Walking Man,* when the arms and legs

The Partial Figure *The Serf* lacks arms because Matisse removed them before casting, perhaps because he felt that their rhetorical presence was distracting, or, like Rodin in *The Vanquished,* because he wanted to liberate an expressive silhouette. The arms were also irrelevant to his ideas of expression. But Matisse's action was made possible by Rodin's own pioneering of the *partial figure,* dramatized for the art world in 1900 by his exhibition of the headless and armless *Walking Man* (Fig. 481), which had originally served him in the building of his *St. John.* With this partial figure, Rodin proclaimed that a finished sculpture need not presuppose the body intact. He was the first sculptor in history to make the partial figure important and consistent in his art, not as an imitation of a ruin, symbol of a god, or decorative figure, but as a self-sufficient artistic entity. Cutting off arms and heads severed Rodin's partial figures from the great rhetorical traditions of sculpture and the ideals of proportion based on the whole body, as well as from ideas about what constituted a complete work of art. He wanted to draw greater attention to his modeling and to give the

482. Raymond Duchamp-Villon.
Torso of a Youth. 1910.
Bronze, height 21⅜'' (44 cm).
Stanford University Museum of Art, Calif.
(gift of the Committee for Art at Stanford).

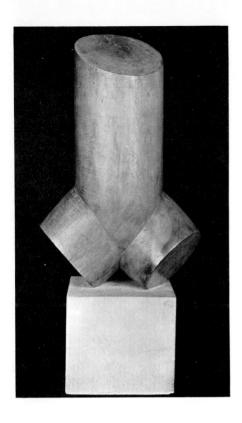

seemed to inhibit the figure's force and clarity. Duchamp-Villon consciously sought a modern aesthetic to counter that of business (as he said) by "clothing" his sculptures in the "virtues of simplicity and austerity." To achieve this aim, he felt that the body had to be remade so that it would present a harmony of "lines, planes and volumes seen at a distance." Guiding this reformation was Duchamp-Villon's interest in mathematics and his fascination with the survey-or's plumb line, which he felt makes "tangible for man a point in the infinite." His *Torso of a Youth* links thematically with Lehmbruck's optimism, although Duchamp-Villon's figure has a life more active than contemplative. The stripped down, hard, cool surfaces of the striding figure enact the sculptural ideal of *certitude,* providing modern man in a time of flux with an image of something sure and unshakable, like an absolute truth.

Figural Sculpture and the Art of Simple Forms For Duchamp-Villon and Constantin Brancusi (1876–1957), modern figural sculptural had been afflicted by the disease of emotional insincerity, trivial detail, and excessive facility of the hand. Their antidotes were to use the intellect to uncomplicate art and to rebuild it with an art of simple forms. Brancusi's *Torso of a Youth* (Fig. 483) and his later *Beginning of the World* (Fig. 413) exemplified his quest for "the sense of things," the essential in life and art, through purification of form. Compared with Rodin's *Torso* (Fig. 484), which was the starting point of both *The Walking Man* and *St. John the Baptist,* Brancusi's image seems to be a

schematic, geometric rendering of the lower torso or a con-junction of tubes in a configuration that appears, but is not, invertible. Brancusi had earlier renounced anatomical fidel-ity and fleshy paraphrase in favor of a deeply personal and mystical vision of life and art (Fig. 459), a vision that had been influenced by African sculpture. Rodin's partial fig-ures may have helped Brancusi evolve his focus on bodily fragments, but his own reduction of detail led him to dis-cover that the purified human form has analogies in nature—such as the fork of a tree from which the sculpture was finally cut—and that one simplified part of the body reaches a point where it can be compared with another. The total configuration of *Torso* (Fig. 483), which lacks gen-itals, suggests the missing male sexual member. As we shall see, the partial figure was important in the develop-ment of a new sexual candor in modern sculpture.

The Future Superman Brancusi's meditations on sculp-ture resulted in quiet, beautiful forms whose effect depends on a reduced illusionism and concomitant physical asser-tiveness, discrete symbolic suggestion, and effacement of the hand in favor of individuality of vision. More militant and more obviously an exemplary figure—entering modern sculpture as a surrogate heroic public image—was the *Unique Forms of Continuity in Space* (Fig. 485) of Umberto Boccioni (1882–1916). It was a 20th-century answer to his Italian countrymen's worship of the past and such ancient works as the *Victory of Samothrace* (Fig. 486), whose spread-legged stance, braced against a ship's prow, he may

485. Umberto Boccioni.
Unique Forms of Continuity in Space. 1913.
Bronze, height 43½'' (101 cm).
Museum of Modern Art, New York
(acquired through the Lillie P. Bliss Bequest).

have paraphrased along with the interaction of figure and wind. Boccioni's aggressively striding figure was also in competition with Rodin's *Walking Man,* to which it owed its armless state:

> We proclaim that the visible world must fall in upon us, merging with us and creating a harmony measurable only by the creative imagination; that a leg, an arm . . . having no importance except as elements of plastic [sculptural] rhythm, can be abolished, not in order to imitate a Greek or Roman fragment, but to conform to the harmony the artist wishes to create. A sculptural entity . . . can only resemble itself, for in art the human figure . . . must exist apart from the logic of physiognomy.

What Boccioni celebrated in his sculpture was the superman of the future. Previous artists, such as Gianlorenzo Bernini (1598–1680), had memorialized biblical supermen like *David* (Fig. 487). Bernini's coiled, muscular figure shows movement with a purpose underscored by the

right: 486.
Victory of Samothrace.
c. 200–190 B.C. Marble,
height 8' (2.44 m).
Louvre, Paris.

far right: 487.
Gianlorenzo Bernini.
David. 1622–24.
Marble, life-size.
Galleria Borghese, Rome.

tensed lips and rock-filled sling. Boccioni's figure symbolizes his evolutionary vision of how modern man's body will be reshaped by his dynamic, high-speed interaction with his environment. Accordingly, he began to rip open the body's closure while aggravating the body's outward thrust against space. Unlike Bernini's form, the solid portions of the body that interact with space are not shown as taut muscles in a fixed position; to indicate the path of their motion through space, they acquire an undulating, molten flow that also serves effectively to fuse the silhouette with its environment.

A Modern Dandy For all his bravado in rejecting ancient art, its gods, and all previous sculpture, Boccioni's art was still informed by muscle power and figural syntax. The Polish-born sculptor Elie Nadelman (1885–1946) was more candid about his indebtedness to the ancient Greeks; in fact, he openly modernized the Classical ideal. His *Man in the Open Air* (Fig. 488), made in New York City, was a transparent paraphrase of Praxiteles' *Apollo Sauroktonos* (Fig. 489). Nadelman gave us neither a superman nor a classless symbol of an age group, but instead the very model of a modern gentleman in bowler and bow-tied elegance. Apollo's posture of repose became Nadelman's gesture of nonchalance. Seurat's expressive purified silhouettes (Pl. 29, p. 261) intervened between the profiles of Praxiteles and Nadelman. In Nadelman's earlier art, the stylized nude had

served as a paragon of feminine beauty; in his 1915 image of the modern dandy, he effected a skintight fusion of body and contemporary fashion.

Evoking the Figure The exemplary figures of the artists previously discussed conveyed ideals, admittedly personal ones, that in different ways related to human conduct. The Cubist sculpture *Man with a Guitar* (Fig. 490) by Jacques Lipchitz (1891–1973) may be construed thematically as the enjoyment of art, but Lipchitz' important message concerned the new rights of the sculptor, which moved him even farther from traditional public statuary. Rodin had demonstrated the dispensability of parts of the body for fin-

below left: 488. Elie Nadelman.
Man in the Open Air. c. 1915.
Bronze, height 4′6½″ (1.38 m).
Museum of Modern Art, New York
(gift of William S. Paley).

below center. 489. Praxiteles.
Apollo Sauroktonos (Lizard Slayer).
Roman copy of Greek original of c. 340 B.C.
Marble, height 4′10¾″ (1.49 m). Louvre, Paris.

below right: 490. Jacques Lipchitz.
Man with a Guitar. 1915.
Stone, height 38¼″ (97 cm).
Museum of Modern Art, New York
(Mrs. Simon Guggenheim Fund).

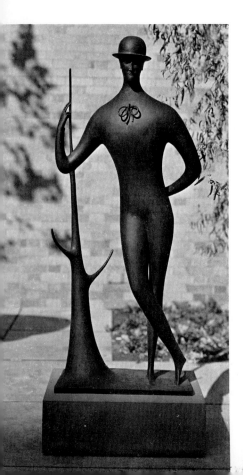

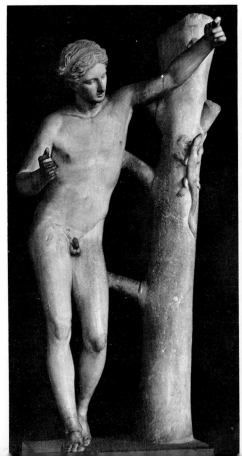

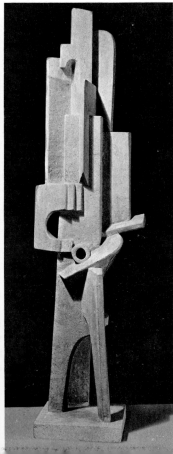

491. Aristide Maillol.
Young Girl Walking in Water (torso of *L'Ile-de-France*).
1921. Bronze, 47½ × 20" (1.21 × .51 m).
Courtesy Paul Rosenberg & Co., New York.

The Credibility Gap By 1914, the beginning of World War I, the most important figural sculptures of the most daring artists could not be considered calls to patriotism, duty, and honor. They were injunctions to self-contemplation, pure action, aesthetic distraction, and good grooming. A Europe bent on self-destruction and an America determined on isolation could not rally behind these ideals. Sculptors not committed to past styles and to seeking government favor disowned the roles of illustrator, biographer, guardian of the public taste, and image-maker for a nation. The war did not inspire the best sculptors to memorialize generals, politicians, or victory. Lehmbruck did produce some moving sculptures of disillusion and dying, one of which found a home in a German military cemetery. Ironically, it was Rodin's *La Défense* (Fig. 472), enlarged and paid for by the Belgian nation in gratitude to France, that was set up near the terrible battlefield at Verdun after the artist's death. Modern sculptors and public values had encountered mutual disbelief. When important sculpture would again take its place in public, it would be on the artist's terms.

The Sensuous Woman and Passionate Sculptors

A New Calm The thematic revolution in modern sculpture took place between the two world wars, and its outlines can be traced in sculptures of women, who preoccupied the leading sculptors far more than men. Before 1914, Aristide Maillol (1861–1944) had determined that he preferred the beauty of women to the dramatic possibilities of men. His *Young Girl Walking in Water* (Fig. 491) illustrates the new calm he brought to sculpture after Rodin's psychological and emotional excitement. The walking torso may have been his response to Rodin's *Walking Man* (Fig. 481). Capable of modeling impressive full figures, Maillol preferred the torso, for he hated the making of arms and legs. ("Arms are my Calvary," he complained.) Rodin's introduction of the partial figure liberated sculptors from private difficulties about making certain parts of the body. The arched, erect torso exemplifies Maillol's personal preference for a healthy, generously proportioned body whose surface has the still beauty of sunlight falling on a Mediterranean whitewashed wall. The resemblance of his sculpture to ancient Classical art is fortuitous, not derivative. Maillol dreamed of making sculpture as if it had never been made before, and his purpose was to give joy.

The New Sexual Candor Gaston Lachaise (1882–1935) produced in the late twenties and thirties some of the most candidly erotic fantasies (based on his wife's body) in mod-

ished sculpture; Lipchitz dispensed with sculpture's resemblance to the body's external appearance, thereby reducing its legibility. Lipchitz' model was not Rodin's imitation of nature, but rather sculptural invention. "We Cubists chose a man-made language rather than a naturalistic one, for we wanted to find a new language to adequately fit our feeling. Cubism is less attached to Mother Nature, it is more a pure invention of the human imagination." The human body has not been *de*formed but *re*-formed by the artist's intellect and aesthetic intuition. Anatomy and body language have given way to a new artistic sign language that *evokes* rather than imitates the human form. Although not working directly from a living model, Lipchitz held a mental image of the body as he assembled his flat, angular planes. That this internal body image of the artist had been influenced by Rodin's partial figure the artist acknowledged. He did not need to find sculptural equivalents for all parts of the body. In arriving at this type of crystalline art, Lipchitz did no violence to hallowed subjects, such as saints and statesmen, for his figures are anonymous. The revolution in early modern sculpture was not in subject but in form and in the concept of what sculpture could be.

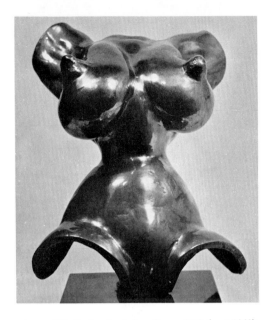

above: 492. Gaston Lachaise. *Torso.* 1932 (cast 1963).
Bronze, height 9½″ (24 cm).
Estate of Isabel Lachaise
(courtesy Felix Landau Gallery, Los Angeles,
and Robert Schoelkopf Gallery, New York).

below: 493. *Yakshi* (Indian tree goddess),
from the East Gate of the Great Stūpa, Sānchi.
Early Andhra Period, 1st century B.C. Bracket figure.

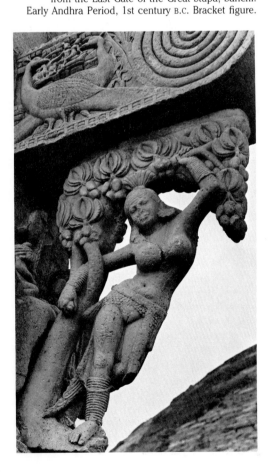

ern sculpture (Fig. 492). The partial figure allowed this sexual focus, which in turn engendered the amazing reproportioning and contrasting of the reproductive areas of the body. Lachaise's private fertility images recall those of prehistoric sculpture (Fig. 40) and the collective ideal of Indian art, which produced the ripe tree goddess on a gate of the Great Stūpa at Sānchi (Fig. 493). Unlike Lachaise's motionless figures, the sexuality of the Indian figure depends upon her subtle and provocative movement. No apparent internal skeleton inhibits the suggestive torsion of her inflated "subtle body." The Indian sculpture had its foundation or symbolic function in both Buddhism and Hinduism, which in their teachings and art convert the human erotic instinct from an end in itself to higher purposes (see pp. 41–45). The exaggeration of the Yakshi's sexual parts had a religious motivation and was intended to arouse those who looked upon her to initiate spiritual communion with the gods.

The Search for Strange Meaning Before the 20th century, many cultures saw nature in terms of the human form. More recently, sculptors such as Jean Arp (Fig. 416) and Henry Moore (b. 1898) have interpreted the human form in terms of nature. A reclining human form signified a sea god to the Greeks, a river god to the Romans, times of day to Michelangelo (Fig. 215), a rain god to the ancient Mexicans (Fig. 494). Henry Moore's long series of reclining figures, begun in the 1930s, has no comparable culturally based and verifiable symbolism. The figures contain structures congruent with what Moore sees in the landscape, in rocks, caves, and mountains. Sculpture is Moore's personal mediation between the mystery and power of nature and his own being. The reclining female form (Fig. 495) is the motif that has most frequently been the occasion for giving form to his reflections on the analogies between hills and breasts, caves and body cavities, stone and bone. The parentage of his art is a mixture of Mediterranean and Mexican sculpture, Classical reclining figures from the Parthenon (Figs. 102, 103), Michelangelo's Medici Tomb figures (Fig. 215), the Mayan-Toltec Chac-mool (Fig. 494), and modern sources in Picasso, Brancusi, and Arp. From stone- and wood-carving cultures came the paradigm of sculpture as a world language, predicated on a few elementary postures, formal hardness, and simplicity. Out of his own time Moore took the incentive to work from direct and strong personal feeling and intuition, and not, above all, "for harmony and beauty but rather for strange meaning." Moore's passion for art has conditioned his vision of nature. His recumbent women are not available, seductive sirens, even though their re-formation leads to sensual surfaces curled about openings in the block. They have dignity and energy even in repose. Their surfaces seem at once eroded by natural forces and also built up from internal pressure like the knuckle pushing against the flesh of a clenched fist. Moore's sculpture is a metaphor for our awareness of the

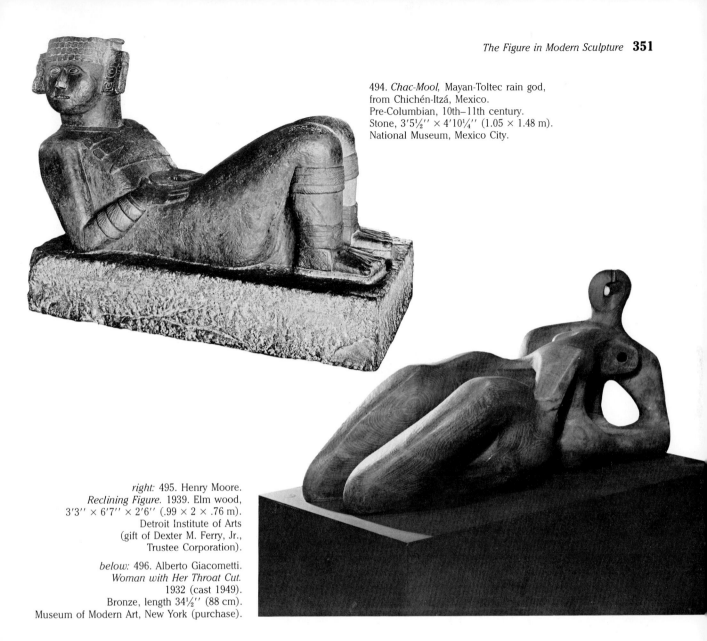

494. *Chac-Mool,* Mayan-Toltec rain god,
from Chichén-Itzá, Mexico.
Pre-Columbian, 10th–11th century.
Stone, 3′5½″ × 4′10¼″ (1.05 × 1.48 m).
National Museum, Mexico City.

right: 495. Henry Moore.
Reclining Figure. 1939. Elm wood,
3′3″ × 6′7″ × 2′6″ (.99 × 2 × .76 m).
Detroit Institute of Arts
(gift of Dexter M. Ferry, Jr.,
Trustee Corporation).

below: 496. Alberto Giacometti.
Woman with Her Throat Cut.
1932 (cast 1949).
Bronze, length 34½″ (88 cm).
Museum of Modern Art, New York (purchase).

inside and outside of man and nature and our intimate relatedness to the earth. Moore reminds us that art is nature added to man.

The Sculptor as Murderer and Visionary Cubism had been an important breach in the historical tradition of making figural sculpture from a norm of the body's external appearance. Alberto Giacometti (1901–66) literally and figuratively took woman off the pedestal and internalized sculptural body imagery in *Woman with Her Throat Cut* (Fig. 496). For the first time in a partial figure, mutilation was a motif rather than a means. By his own account, Giacometti's sculpture, which was intended to be set on the floor, was a private vision of how a woman he met would look if brutally murdered. The fantasy incorporated elements of the skeletal armature, and the missing equivalent

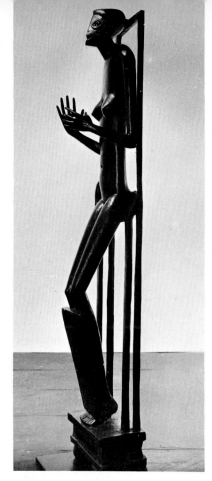

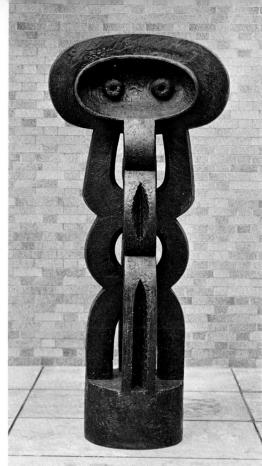

right: 497.
Alberto Giacometti.
*The Invisible Object
(Hands Holding the Void).*
1934–35. Bronze,
height 5'1'' (1.55 m).
Courtesy Marlborough
Gallery, New York.

far right: 498.
Jacques Lipchitz.
Figure, 1926–31. Bronze,
height 7'1¼'' (2.17 m).
Museum of Modern Art,
New York
(Van Gogh Purchase Fund).

of the head was part of the imagined assault. The sculpture was worked out in the artist's imagination and then quickly executed, by contrast with Henry Moore's slow and loving dialogue with his materials and tools. For personal reasons, during the years 1925 to 1935, Giacometti found he could not work directly from the figure, but only in a visionary way. His enigmatic sculptures also included *The Invisible Object* (Fig. 497), another offspring of the artist's self. Framed and supported by a curious high-backed chair, her legs blocked by an upturned panel, the idollike woman whose eyes resemble bullet-pierced windows, cradles or caresses or circumscribes the "invisible object." She is like the imagined priestess of a legendary mystical sect, and perhaps Giacometti's art was responding to the fascination with myth and the subconscious among avant-garde artists in Paris at the time. The immobility, symmetry, fixed gaze, and simple, tubular forms also suggest the influence of tribal and ancient art, both in form and in magical purpose. Modern organized religion and rationalism did not satisfy many artists between and after the two world wars. They sought to find the secret history and to take the mystical temperature of their times. Their search of the subconscious and the religious art of early and tribal cultures often led to surrogate idols for invisible congregations, ambiguous but provocative figural evocations that emanated powerful presences.

The Disturbing Presence Important in this evolution was Lipchitz' *Figure* (Fig. 498), on which he worked for five years. The sculpture was initially inspired by encounters with stones on a beach and then nurtured by recollection of African masks having transfixed gazes. The resulting work is in part chainlike (at one point Lipchitz thought of it as two entwined figures) and is surmounted by a concave oval bearing two protruding cylinders. The vertical creases in the frontal links are references to female sexual organs. The immobility of the figure is paradoxically the result of the irresolvable antagonistic pulls of the chain, suggesting a metaphor of internal human tension, just as the inverted area of the head evokes its interior life. The woman who commissioned the sculpture for her home returned it to the artist as being "unbearable" to live with. Lipchitz had succeeded in making a disturbing, poetic, but almost inhuman presence, an inspired intuition about life, one of what Robert Goldwater called "the crucial symbols of human experience." But it could not and did not serve the modern public's ideal of exemplary sculpture.

The Medium Is Not the Message Just as damaging to the understanding of what serious modern sculptors like Giacometti and Lipchitz have done is the sympathetic writing on modern sculpture by those who stress only formal contributions and insist upon emphasizing the artist's

methods and materials. The sculptors here discussed have had something to say. Matisse wanted his work to appear effortless, like a bird's song. Lipchitz never wanted to be a slave to his materials any more than Moore thinks only of sensual physical pleasures in cutting stone. Materials and methods are means to a more important end—art. What counted and still is paramount for these sculptors is the fusion of form and meaning in the finished work. Craft is at the service of artistic vision. As for the public's resistance to what these sculptors had to offer, Julio González (1876–1942) had the answer: "Why demand everything of the artist? Why not also demand of the spectators that each one, according to his capabilities, try and elevate himself to the work of art? If they don't succeed at the first try, let them persist, even several times. I have often done this."

Private Fantasy and Public Memorial The sculpture of González in the 1930s and his work with Picasso in the late 1920s established iron, welding, the joining of disparate shapes in unorthodox balance, and "drawing in space" as valid and viable for modern sculpture. González had been an ironworker as well as a painter and sculptor, and what separated him as an artist from being an artisan, his art from craft, is, in the admiring words of David Smith, that his "art lies in the concept, not the technique." González' technique was at the service of a concept that started with the premise that, while iron had been used for centuries, "It is time this metal ceased to be a murderer." This was said in the thirties, when plowshares were being beaten into swords all over Europe. The paradigms for González' new art were cathedral spires, "a point in the sky where our soul is suspended . . . points in the infinite which are precursors of the new art: *To draw in space* . . . by the marriage of material and space, a union of real forms with imaginary forms, obtained and suggested by established points, or by perforation . . . to mingle them and make them inseparable . . . as are the body and spirit." González' *Woman Combing Her Hair* (Fig. 499) exemplifies his thrust to restore to sculpture "a mysterious, fantastic, indeed diabolical aspect." This is no armature for a sculpture, no predictable paraphrase of any of the body's systems. Rather, it is an inspired configuration whose gestures and shapes eventually conjure in the viewer what the title meant to the sculptor. But González also felt a deep obligation to the Spanish people beset by a civil war, and while continuing his art of fantasy, he made a more intelligible memorial to the Spanish resistance to fascism. It was named after the sacred mountain in the Basque country, Montserrat (Fig. 500), for Lachaise,

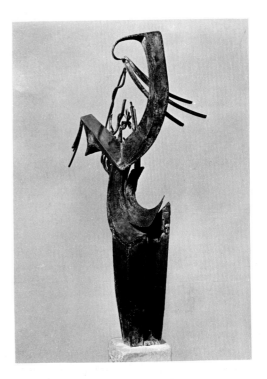

above right: 499. Julio González. *Woman Combing Her Hair.* 1936. Wrought iron, height 4′4″ (1.32 m). Museum of Modern Art, New York (Mrs. Simon Guggenheim Fund).

right: 500. Julio González. *Montserrat.* 1936–37. Iron, height 5′4½″ (1.64 m). Stedelijk Museum, Amsterdam.

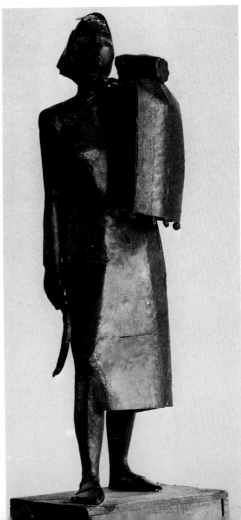

Arp, Moore, and González all thought of mountains in feminine terms. González used the most sophisticated metalworking technique to arrive at two human forms of the utmost formal simplicity, thereby to celebrate the earthiness and spirit of the people. If the Loyalists and not Franco had won, González' *Montserrat* might perhaps have been given a place of honor in Spain instead of permanent residence in the Stedelijk Museum in Amsterdam.

Post–World War II Figural Sculpture

Metaphors of the Hero During the post–World War II period, the human form has been moved further into metaphorical imagery at the same time that it has been brought closer to the artist's actual perception, so it has achieved simultaneously a new literalness and an alliance with its physical environment. Although a few sculptors continue to enact visions of the heroic, many have rejected the ideal of man as he might be in favor of what he is, and some have been moved by the image of man made less than human by society's indifference.

Sentinel (Fig. 501) by Seymour Lipton (b. 1903) remains one of the most powerful sculptures based on the human form made anywhere since 1945, and it merits comparison with Donatello's sculpture of *St. George* (Fig. 502), carved for the armorers' guild in Florence early in the 15th century. Donatello's figure is descended from medieval sculptures of knights, Christian Athletes of Virtue; it serves as both a

serious advertisement of the products of his patrons (originally it was capped with a bronze helmit and the right hand held a bronze sword) and as an exemplar of courage in adversity, which was well known to Florentines of that violent age. *Sentinel* was made in New York City at the artist's initiative and took its form from Lipton's admiration for medieval armor and his desire to make sculpture that articulated the mysterious and heroic elements in the individual's private nature that have allowed the human race to survive. It is an unintentional but ironic model for a New Yorker whose dangers lie within the city. Sentinel's almost calligraphic metaphor fuses ideas about spears, helmets, battlements, battering rams, and vertical coffins split open with a feeling for the human form. Donatello's sculpture relies for its force upon his understanding of body language—the alternately relaxed and tensed hands, the facial expression of alertness and concerned concentration, and the gravity-defying erect stance and pressure of the body against the ground. It is a posture that enforces privacy, not approachability. Lipton draws upon the language of our inherited and accumulated associations with shapes derived from objects and anatomy, signs, emblems, and surfaces identified with violence. The figure in sculpture, like the human body, can have its special psychological space. Both sculptures emanate a convincing, even intimidating presence, such that the beholder has no immediate inclination to invade the sculpture's personal space any more than if these were living personages. To his contemporaries, Donatello's great-

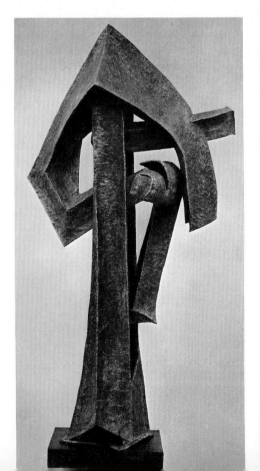

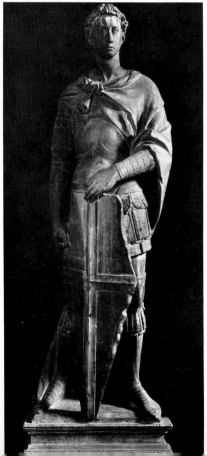

far left: 501.
Seymour Lipton. *Sentinel.*
1959. Monel metal,
height 8'6'' (2.59 m).
Yale University Art Gallery,
New Haven, Conn.

left: 502.
Donatello. *St. George.*
c. 1417. Marble,
height 6'8¼'' (2.04 m).
Museo Nazionale, Florence.

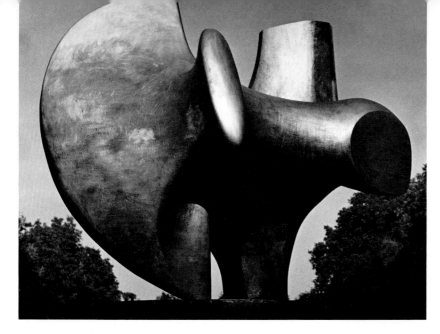

left: 503. Henry Moore.
Three-Way Piece No. 2 (Archer).
1964 (large version).
Bronze, 10'8'' × 11'2''
(3.25 × 3.4 m).
Nathan Philips Square, Toronto,
and Nationalgalerie, West Berlin.

below: 504. Auguste Rodin.
The Burghers of Calais. 1884–86.
Bronze, 7'1'' × 8'2⅛'' × 6'6''
(2.16 × 2.49 × 1.98 m).
Hirshhorn Museum and Sculpture Garden,
Smithsonian Institution,
Washington, D.C.

ness was that he brought new credibility and dignity to the human figure by rejecting medieval formulas in favor of merging fresh observations from life with a strong sense of design to support nobility of theme. More than five centuries later, Lipton's view was that once modern artists had departed from the ideal of imitating the external appearance of the body, they should begin to explore man's inner life and develop imaginative metaphors to suggest his heretofore unvoiced links with his environment. Unfortunately for Lipton, he does not live in a culture that, like 15th-century Florence, has looked to sculptors for its civic self-image. That role has been diffused among souvenir postcards, sporting teams, newspapers, and architecture, to name but a few image makers.

Public Art on the Artist's Terms Thematically, Henry Moore's *Archer* (Fig. 503) is related to such a metaphorical statement and has even been proposed as a national emblem for Canada, as well as for the city of West Berlin. Moore did not begin the piece with either a political emblem or the title in mind. The latter came to him as he worked and saw in the emerging form the archer motif. Moore's sculpture is found today in public places all over the world, but it has been made on the artist's own terms. For many years, Moore has refused to interpret someone else's idea, whether an institution's or a country's. He prefers to make sculptures that, first of all, satisfy himself and that have many possible interpretations.

> I like the incentive to work for myself. I can't work for communication If it gives me a deep satisfaction, I am confident that others now or later will have a similar sympathy or conditioning towards it It is important that there be continued interpretations. . . . People have an intrinsic interest in shapes. . . . It should have relevance in the public's opinion. If it has an immediate explanation as to why it is there, the average person will see this, go away and lose interest. It is better if the sculpture should be of some challenge or of a mystery.

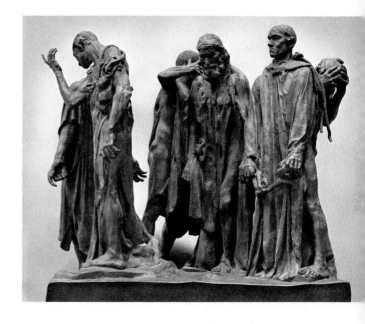

In Moore's more recent sculpture (Fig. 503), unlike his reclining figures of the thirties (Fig. 495), "the human and animal are more fully mixed I now make sculpture that doesn't have any one basic plot." *Archer* still presupposes the partial figure: "A torso fragment has a condensed meaning. It can stand for an entire figure." From certain angles, it suggests an arm thrust outward with a bow. Moore rejoices in the condition of art today that allows him to carry the form as far as possible without having to define its significance. He sees the purpose of his sculpture as comparable to that of older religious art in lifting its audience above the ordinary and the commonplace.

Figures in the City In 1895, Rodin's *Burghers of Calais* (Fig. 504) was a great disappointment to that city, because

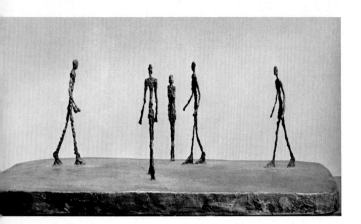

505. Alberto Giacometti. *City Square.* 1948–49.
Bronze; base 25 × 17″ (64 × 43 cm),
height of tallest figure 8″ (20 cm).
Courtesy Pierre Matisse Gallery, New York.

the six medieval citizens who offered themselves as hostages to the King of England in order to spare their city were re-created by the sculptor as men with mortal feelings. Rodin had failed to fulfill the function of sculpture and religious art that Moore speaks of. For Rodin, the heroism of the six depended upon their demonstration of the anger, resignation, sorrow, despair, anguish, and incredulity that people have felt in the presence of death. Calais wanted saints, not pathetic heroes to rub elbows with in the marketplace, where Rodin would have sited the sculpture on the paving stones. Instead, it was placed on a pedestal and fenced off in an area closer to the sea. Ironically, the English honored the heroes and the artist by erecting the sculpture next to the Houses of Parliament. It is no distortion to say that, in terms of recognition, Rodin became a great artist in spite of France.

Rodin intended his modern monument to medieval heroism as a reminder to the middle class of the virtue they had lost through prosperity and self-satisfaction. The commission gave him the greatest opportunity of his life to work with body language, to search out gestures that conveyed the whole attitude of the figure, to link by formal rhyme figures isolated by grief, to depict how sackcloth hangs from a forlorn frame, even the way a man walks at the end of his life and the way his feet grip the ground as he resists the grave's authority. The almost dancelike semicircular composition may have been a half-recollected medieval Dance of Death; perhaps it symbolized eternal sacrifice. Because of its public location, Rodin treated his figures like actors on a stage, whose gestures and expressions must be exaggerated in order to be credible as well as readable. He orchestrated his surfaces so that all lighting conditions, deep shadows as well as shimmering light, would evoke the polarities of life and death. This was the last great monument in which sculpture rivaled theater and literature.

Giacometti's *City Square* (Fig. 505) had none of these ambitions and reflects a more contemporary distrust of emotional display by sculptural figures or the reenactment of historical drama. Giacometti shows us anonymous figures conjoined for a fleeting instant on an urban street, as seen by himself from a distance. From the 1940s, Giacometti renounced his visionary art (Fig. 496, 497) in favor of vision. Previous figural art presupposed an ideal viewer anywhere from 6 to 12 feet (1.8 to 3.6 meters) away, and, as in Rodin's case, the details of the figure remained in focus as one came closer. Giacometti was fascinated by the problem of seeing the figure in part or as a whole and then remembering it as he turned to note his observations in clay. Memory intervenes between seeing and making. Giacometti realized that from certain distances figures lose volume and detail. Their size is reduced to inches. Sex and clothing become blurred. The point at which they separate from the surrounding space becomes ambiguous. His sculptures are residues of this vision, distillations from memory, thought, and the action of his fingers (Fig. 455). Giacometti gave new meaning to the idea of the artist as the measure of man. When asked if he was interested in the psychology of his subjects, Giacometti replied that he had enough trouble capturing their outer form. Although his art was eagerly adopted by existentialists in the 1950s as illustrative of their life attitude, Giacometti insisted that the nature of the perceptual problem was his motivation.

The Sculptural Tableau as Cultural Mirror Turning the products of culture back on themselves can result in a very different effect from that of sleek, chrome-plated mannequins in a science-fiction environment. Edward Kienholz (b. 1927) puts together what he calls *tableaus,* life-size environments made from discarded furniture and objects of bygone eras that somehow are still relevant, allowing us to live with more understanding of the present by means of the recent past. Kienholz' written intentions for *The State Hospital* (Fig. 506) best describe what he has done:

This is a tableau about an old man who is a patient in a state mental hospital. He is in an arm restraint on a bed in a bare room. (The piece will have to include an actual room consisting of walls, ceiling, floor, barred door, etc.) There will be only a bedpan and a hospital table (just out of reach). The man is naked. He hurts. He has been beaten on the stomach with a bar of soap wrapped in a towel (to hide tell-tale bruises). His head is a lighted fish bowl with water that contains two live black fish. He lies very still on his side. There is no sound in the room. Above the old man in the bed is his exact duplicate, including the bed (beds will be stacked like bunks). The upper figure will also have the fish bowl head, two black fish, etc. But, additionally, it will be encased in some kind of lucite or plastic bubble (perhaps similar to a cartoon balloon), representing the old man's thoughts. His mind can't think for him past the present moment. He is committed there for the rest of his life. (From the descriptive portion of the "Concept Tableau" entitled "The State Hospital," 1964–67, reprinted in *American Sculpture of the Sixties,* edited by Maurice Tuchman.)

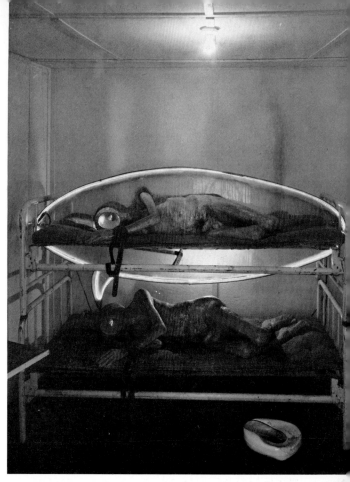

506. Edward Kienholz.
The State Hospital, detail. 1966.
Mixed media, 8 × 12 × 10′ (2.44 × 3.66 × 3.05 m).
Moderna Museet, Stockholm (© Edward Kienholz).

Kienholz' talents as an artist include not only his abilities as a carpenter, electrician, and scavenger of provocative junk ("all the little tragedies are evident in junk"), but also his inventiveness in upsetting the expectations established by his literal contexts, as in the treatment of the heads of his figures. His tableaus are set apart from those in wax museums by rich inventiveness and by the fact that the artist is not dealing with villains and heroes, pathetic or otherwise, but with victims of cities like Los Angeles, which he feels lack the dimension of time, where there is no past and future, "only an eternal dizzying present." Like Rodin, Kienholz challenges theater and the novel as the image makers of his time. His bodies are those of any man and the setting could be any state.

The tableaus of George Segal (b. 1924) lack the bitterness, tragedy, and biting wit of Kienholz. They generally convey a more gentle commentary on human isolation in banal situations—a woman shaving her leg, sitting in a bus, emerging from a shower, or standing in a doorway. Segal's art results from "the everchanging aspects of three-dimensional encounters," and he sees his problem as lying in

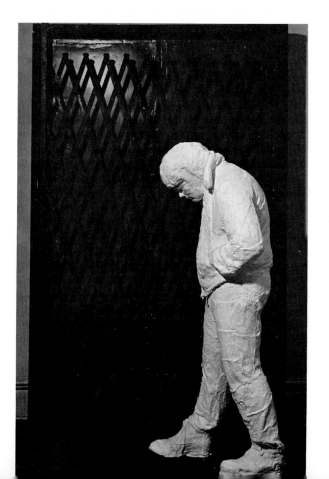

"the emotional choice of the most moving or the most revelatory series of experiences." His peculiar gift is comparable to Rodin's—that of seeing and seizing his subject's self-revealing gestures, gestures that include the whole body: "People have attitudes locked up in their bodies, and you have to catch them." Segal literally takes plaster casts from his figures once he has decided on a revealing pose that the subject can hold for the twenty minutes required to reproduce one section of the body. His *Man Walking* (Fig. 507) was cast in sections, and the truest impression of the model is inside the sculpture. The outside is rough, every square inch has been reworked, details added and subtracted, and creases and angles help create a flow or break up an area. Segal's plaster figures are set among or against actual objects, such as an elevator gate, and remain unpainted. "The whiteness intrigues me for all its special connotations of disembodied spirit, inseparable from the fleshy corporeal details of the figure." His thinking includes what is around the sculpture. "The peculiar shape and qualities of the empty air surrounding the volumes become an important part of the expressiveness of the whole piece. The

507. George Segal. *Man Walking*. 1966.
Plaster, painted metal, and wood;
7′1″ × 4′10″ (2.16 × 1.47 m).
Collection Norman B. Champ, St. Louis.

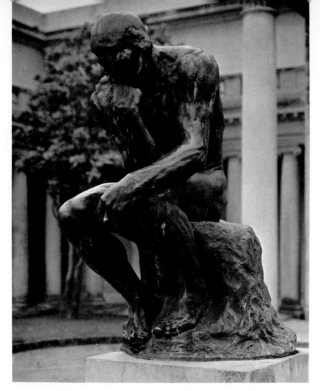 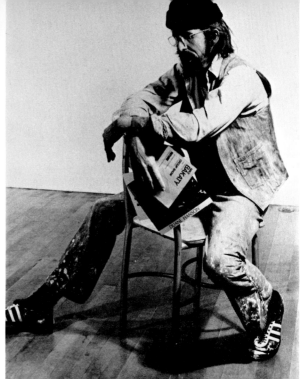

above left: 508. Auguste Rodin. *The Thinker.* 1880–85. Bronze, 6'6'' × 4'3'' × 4'4¾'' (1.98 × 1.3 × 1.34 m). Fine Arts Museum of San Francisco (gift of Mrs. Alma de Bretteville Spreckles).

above right: 509. Duane Hanson. *Artist Seated.* 1971. Polyester resin and fiberglass, polychromed in oil; life-size. Private collection.

distance between figure and another object becomes crucial. My pieces don't end at their physical boundaries."

Rodin made *The Walking Man* (Fig. 481) to refute the charge that, like unscrupulous artists of his time, he took casts from life. Segal openly uses the life cast for his *Man Walking,* but this is merely a point of departure, and its final form is far less literal than the objects of the setting. Rodin wanted to bring art closer to life through the expression of genuine feeling and authentic gestures. Segal's goals are the same but extended into the tableau format that Rodin approached only when he dreamed of placing his *Burghers* in Calais' medieval square near the site of the gate through which the hostages had been forced to walk. By taking sculpture off the pedestal, Rodin contributed to Segal's placement of sculpture in our own environment. Rodin's contribution of the partial figure, only recently employed by Segal, has realized its most spectacular culmination in the fantasy of another artist, who uses it to revitalize the discredited idea of the monument.

The Artist as the Model Rodin's *Thinker* (Fig. 508) and Duane Hanson's *Artist Seated* (Fig. 509) both knew controversy when first exhibited. Critics condemned them for being dehumanized: *The Thinker* for its brutish "executioner" type and Hanson's effigy for its absence of spirit. Rodin had suffered the false accusation of life-casting his *Age of Bronze* and bringing art too close to life. Hanson, who did make a life cast, has been faulted for not bringing

enough life to art. Both were audacious in feeling that sculpture suffered from too much self-conscious application of art to the figure. Both sought, achieved, and were criticized for art without style. *The Thinker* was enlarged from its smaller version in *The Gates of Hell,* Rodin's imagined fate of humanity. Hanson's figure came from a customary pose struck by an artist friend. In his model's pose and muscular figure type, Rodin paraphrased Michelangelo's art to dramatize the internal action of his thinker. Hanson, who may have subconsciously had *The Thinker* in mind to work against, wanted credibility through the habitual or natural posture. The nudity of the heroic physique of Rodin's cogitator detaches him from time and place. Hanson wanted to depict an artist friend as he appeared at that time. Once titled *The Poet,* Rodin's romantic image was of the creator in general, as he believed that a fraternity of artists, writers, and poets by vigorous effort of thought could re-create their time. Hanson likewise did not stress the artist as a doer, but as a quiet, self-reflecting individual. Thought is undramatic. Hanson also produced comparable pensiveness in sculptures of his contemporaries, young and old, from all walks of life. The American wanted no pedestal or nudity, but rather desired that his work literally stand on its own, "something that people could be confronted with as something in their daily existence."

The true antecedent of Hanson's realistic figure is not Rodin's art but a work that stands at the beginning of modern sculpture, Degas' *Little Dancer of 14 Years* (Fig. 510),

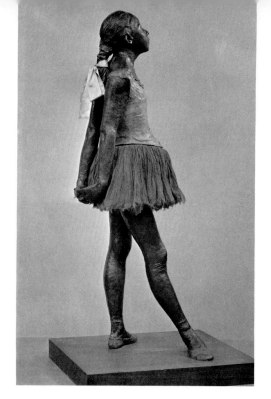

510. Edgar Degas. *Little Dancer of Fourteen Years.*
1880–81. Bronze with cloth accessories,
height 39'' (99 cm). Metropolitan Museum of Art,
New York (bequest of Mrs. H. O. Havemeyer, 1929,
H. O. Havemeyer Collection).

sonality that allowed Degas and Rodin to build their sculptures and then animate them with their own vitality. He trusts to his conception, his selection of a revealing moment "to confront people with themselves more than to his fabrication." Degas' figure now seems prophetic both in its illusionistic form and its celebration of the unheroic.

The End? Saul Steinberg (b. 1914) has wittily summarized the history of Western civilization and its monuments from medieval times to the present (Fig. 511). The hero of one period is overthrown in the next, until finally, in our own time, the common man stands with one foot on his own head. Appropriately enough to the history of sculpture, Steinberg has ended with a partial figure that suggests man mastering himself but losing his head in the process.

Abstract sculpture has replaced the figure in the urban outdoor art of our time. Beginning with Rodin, modern sculptors strove to image the hero in their own terms, but gradually they came to disbelieve in the heroic, even to favoring the victim and the antihero. Where the public statue once symbolized cities and nations, as well as abstract ideals such as liberty, the figure is now often held up as a realistic, unromantic image of ourselves to be confronted indoors in museums, art galleries, and private collections. Abstract sculpture has often been enlarged to gigantic size, whereas modern sculptors, thinking of the colossal statuary in Communist countries, have rejected the larger-than-life-size image of the human form as false and intimidating. (The biggest figures seen in public today may be the balloons in the Macy's Thanksgiving Day parade.) What figure sculpture has lost in terms of public symbolism it has gained in a new poetic range of expression concerning the form of the body and what makes a being human, further manifestations of the secularization and democratization of art. The Pygmalion dream of rivaling the gods by re-creating life and the self has not died. By their audacities in remaking and reinventing the figure in sculpture according to personal rather than public norms, the heroic was no longer depicted, but enacted, by the artists themselves.

modeled in painted wax, with real hair, and clothed in an actual ballet costume when shown in 1881 in Paris. Less than life-size, this statuette was deeply disturbing to its first audiences because of its realism, unusual technique, unfamiliar materials, and the provocative expression on a face all agreed was frighteningly "ugly." Disdaining norms of beauty, Degas had sought a truly modern sculpture, drawn and modeled from life, more real than the effigies in the new Paris wax museum. Unlike the dancer's costume, which is deteriorating on bronze casts, the brilliance of Degas' observation and modeling has not faded, and this is what makes his figure a work of art rather than craft. Hanson does not have the imitative modeling skills or the per-

511. Saul Steinberg. *Monuments.* Drawing © 1958 in *The Labyrinth,* Harper & Row. Originally in *The New Yorker.*

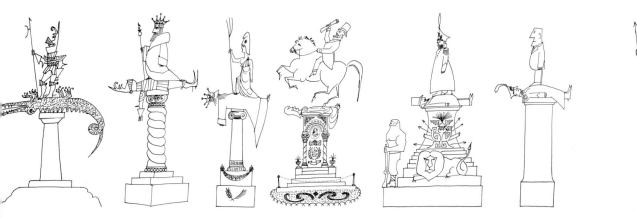

Chapter 19

Picasso

When Picasso died in 1973 at age 92, he had been not only one of history's most famous artists, but also the most prolific and wealthiest. (He may turn out to have been the only self-made Communist billionaire.) For the first half of this century, Picasso was the single most important force in modern art. Worldwide publicity made his private life the most public of any artist, but his art was in some ways the most private, as recent scholarship has shown. While his vast art made him a model of the modern revolutionary and still defies total comprehension, a census of his subjects reveals that in many respects his themes conform to those of older art: portraits, still lifes, animals, landscapes, the studio, the mother and child, interpretations of literature, myth, and old master paints, pleasure and suffering, love and death. No major artist had ever worked in so many media or styles at the same time nor seen his art undergo so many and such radical changes over so long a period. When faced with charges that he lacked consistency, Picasso displayed his self-knowledge as well as wit and confidence by turning to God for creative precedents.

> Every man is a colony. . . . One is constantly changing. . . . I have a curious restless quality that does not reflect self-doubt . . . but the creative spirit of a man sure of himself. . . . I have no preestablished aesthetic basis on which to make a choice. . . . God is really only another artist. He invented the giraffe, elephant, cat. He has no real style. He keeps on trying other things. The same with the sculptor. . . . I am fundamentally an original artist in tune with the cultural discontents and attitudes of our age, but I often show a decided tendency to break away from the proved mold of modern society.

Despite Picasso's seemingly encyclopedic interests, with but few exceptions he has not concerned himself with religious problems and biblical themes. Picasso is close to Rembrandt (see Chap. 11) in his spiritual concern with humanity existing outside the organized church and its laws. Unlike Rembrandt, however, Picasso does not attach a deep philosophical importance to flesh, light, and pigment, though his strength lies in the way he has been able to interpret the human body.

Accompanying the variety of Picasso's subject matter is an equally diversified series of styles, sometimes utilized in the same period. Again the artist's own words are relevant:

> If the subjects I have wanted to express have suggested different ways of expression, I have never hesitated to adopt them. . . . This does not imply either evolution or progress, but an adaptation of the idea one wants to express and the means to express that idea. (1923)

There is an ethical basis, then, for Picasso's modal system and his recourse to such diversified media as painting, graphics, drawing, and sculpture.

Throughout his life, Picasso returned to certain basic themes and problems, feeling that as he grew older he could bring new insights to bear, as well as superior means of realization. With his pride in craft and concern with its problems and potential there coexisted a humanistic sense of inquiry and sympathy.

Merely outlining the statistics of Picasso's personal history, his travels, outstanding projects, and the people who influenced him would take up an entire chapter. It should

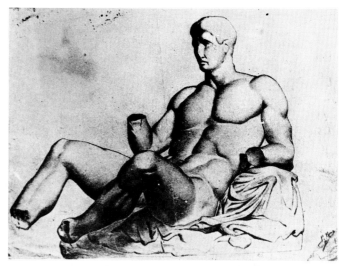

right: 512. Pablo Picasso.
*Drawing from a Cast
of the Figure of Dionysus*
(east pediment of the Parthenon).
1893–94. Conté crayon.
Private collection.

below: 513. Pablo Picasso.
The Frugal Repast. 1904.
Etching, 18¼ × 14¾'' (46 × 37 cm).
Metropolitan Museum of Art, New York
(Harris Brisbane Dick Fund, 1923).

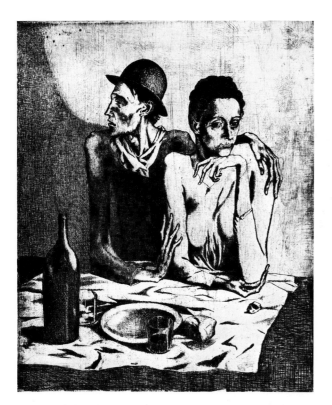

The uneasiness that much of the public still has about Picasso's ability to draw accurately from a subject stems from an unfamiliarity with his naturalistic student drawings, such as a conté crayon rendering made from a plaster cast of a reclining figure from the Parthenon, which was given as a problem to the Barcelona art students (Fig. 512). This early exposure to making art from art deeply influenced Picasso, and years later he was to continue making drawings and paintings in which his version of ancient sculpture and its fragments would be the subject or basis of his style. What the exercise demonstrates is the precocious control the young Picasso had over drawing as an instrument and the acuteness of his vision in preserving the proportions as well as the profile of the motif before his eyes. Picasso felt that as a child he could draw like Raphael; as an adult, he consciously tried on occasion to recapture the open, naïve vision of the child. In Barcelona, he came into contact with an important group of artists and intellectuals and with the advanced European art of the day. By the time of his third trip to Paris in 1904, he had decided to settle in that city, where his work was beginning to achieve critical success after initial neglect.

Picasso's art before 1905 was filled with images of poverty, which were a sincere expression of his own economic plight and that of his Spanish and Parisian friends. His subjects were bohemians, artists, personal acquaintances, the part of society forced to live a difficult marginal existence. *The Frugal Repast* (Fig. 513) is one of Picasso's first prints, a virtuoso performance both in its technique and in its demonstration of the artist's ability to wed modes of drawing to the mood of his subjects. The seated figures, one of whom may be a self-portrait, reflect Picasso's early search for pathos in postures. Joined by the arrangement of their limbs, the bodies make a stable, closed composition that contrasts with the apparent instability and divergence of their attention and personalities. Their bony attenuation is an expressive device that permits extreme and elegant figure distortion at the same time that it conveys privation. The

be noted, however, that there were no important and famous teachers in his youth, no sponsors of Renaissance stature—a fact that casts light on the conditions under which many modern artists work. A prodigious number of books on Picasso make his fascinating biography easily accessible. Let it suffice here to say that Picasso was born in 1881 in Málaga, Spain, the son of an art teacher, whose assistance enabled him to pass with distinction and amazing speed the entrance examinations for two Barcelona academies in 1895 and 1897.

grays and blacks of the etching are appropriate to the morbid subject. At this time, Picasso was exploring the overall use of single tonalities (such as blue or green), with wide latitude of nuance, to set the mood of an entire work.

Two years after *The Frugal Repast,* Picasso painted a vigorous self-portrait (Fig. 514) that reveals his changed attitude toward the human body and art. The elimination of pathos and social consciousness from his work seems to have coincided with Picasso's improved financial status and artistic success. Throughout his work, the painter's life and his art intermingle in confessional, playful, or boastful tones. In this portrait, Picasso avowed a new willfulness, which joined altered conceptions of what was manly and what was art. There is no melodrama or plea for sympathy. Instead, the portrait exudes frank self-confidence; Picasso keeps no secrets. His power comes from his will, eye, and hand and from the colors of the palette. Years later, Picasso was to remark that it was above all the hand that determined the painting. In this self-portrait, Picasso stripped away those details that might mitigate or be extraneous to the concentrated and immediate effect he desired. He had become aware that expression resides in the way the means of art are used, means reflecting the urgent feelings and the intelligence of the artist.

514. Pablo Picasso. *Self-Portrait.* 1906.
Oil on canvas, 36¼ × 28¾″ (92 × 73 cm).
Philadelphia Museum of Art (A. E. Gallatin Collection).

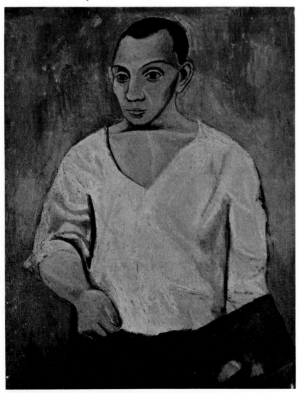

Picasso admired the intensity of expression in primitive masks, but he respected more the asymmetrical constructions of symmetrical human features and objects in Cézanne's art (Fig. 457; Pl. 41, p. 315). Also from Cézanne, Picasso received the idea of creating continuities in art where in nature there were discontinuities, and vice versa. The palette, for instance, is locked into place in the self-portrait by its close coincidence with the sleeve and bottom of the shirt. Cézanne's reduction of myriad shapes to multiples of one another found comprehension in Picasso's conjugation of ovoid forms in the head and the neckline of the shirt and the multiplicity of arcs within the same area. The young artist was learning to recognize and manipulate the emotive power of certain shapes in varied combinations, and in his self-portrait, he made himself more an object of aesthetic than of psychological study.

For some reason, Picasso removed the brush from his hand in the painting, and the heaviness of the pigment's application suggests that he might well have worked the paint with his fingers. In these years, Picasso was searching for a new feeling of what the primal nature of art was and could be. Preserving a certain rawness of means, he gave the completed work a rugged, handmade look. He had even eliminated the customary use of a mirror, as shown by the placement of his right arm on the left side of the painting.

Les Demoiselles d'Avignon (Pl. 48, p. 367) is one of Picasso's most notorious, but by no means most aesthetically successful, paintings. It is the ideas and energies unleashed in its creation, as well as its failures, that make it important in the history of Picasso's art. The largest painting undertaken by Picasso until that time, it was destined to incompletion and inconsistency because of the rapidity and excitement with which his art was changing from month to month and from painting to painting. Thus, in 1906 and 1907, both emotionally and aesthetically, Picasso was incapable of producing a large, complex, homogeneous canvas. In a single year of this phase, his production of drawings and paintings equaled or exceeded the lifetime output of many artists of the past. Here was not only energy but also Picasso's compulsion to work out every idea and impulse in a flood of drawings and paintings, all interrelated and not to be viewed in isolation at their point of entry into his artistic development.

Les Demoiselles d'Avignon was both a battleground and a nursery for Picasso's art. On its surface, he seemed to wage war with the accumulated traditions of Western painting, accepting solely the demands of pictorial order. The tearing down accomplished in this work was partially balanced by what it presented as new and fruitful alternatives, for it was to take Picasso additional thousands of drawings, canvases, and sculptures—in fact, a lifetime—to realize and fulfill all that was begun or hinted at in this one painting. The painting's theme began in sketches as an allegory: "The wages of sin are death." Prostitutes in a brothel paraded before a sailor and, in one instance, a death's head.

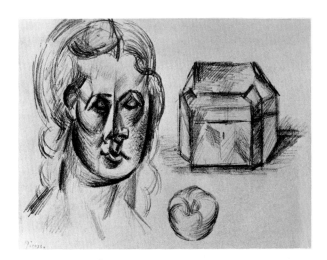

515. Pablo Picasso.
Head, Apple, and Box. c. 1907. Drawing.
Private collection.

The moralizing intent departed along with the skull and sailor from the successive designs. The painting passed through numerous stages until it lost all programmatic meaning and fit only awkwardly into the traditional category of genre. Brutal in conception and execution, *Les Demoiselles d'Avignon* descends nonetheless from a long line of robust paintings of nudes. In retrospect, it seems almost a parody of sensuous nude studies by such Baroque painters as Rubens (Fig. 244). Picasso's nude females elbow against the nymphs, goddesses, and innocent bathers who for generations symbolized concord with nature and sinless fertility.

Picasso seemed undecided whether to stage the women indoors or out; the figure at the left seems to have a farm woman's tan, unlike the pink complexion of the woman next to her. Picasso's women are objects of display transformed by the instincts of the artist, which enter freely into the work. The prostitutes are given a mixed ethnological background, reflecting Picasso's newfound excitement with ancient art (the central two figures) and African tribal art (those on the sides). Picasso's primitivizing tendency adopted certain models of distortion, and what he may have felt was the sexual intensity of African sculpture. These models were grafted onto the Greek Classical beauty pose in the center, the rigid vertical Egyptian stance at the left, and the seated studio model at the right. The profile figure at the left has the Egyptian frontal eye, while in the two adjacent figures, a profile nose appears on a frontal face.

The green-striped face of the woman at the upper right may have derived from primitive masks showing scarification, a process echoed in Picasso's brushwork. Each figure is either an ethnic or an aesthetic hybrid, and only the still life is finished and consistent. Left with too many fragments and ideas, the artist suspended his growth to complete the whole.

Within the frame of the painting, traces of Picasso's struggles to destroy and reconstruct are plainly visible; there are even notations such as the rough blue outline superimposed on the leg at the lower left. Picasso had set aside traditional means of uniting a group of figures: common focus, activity, moods, viewpoint, setting, light and shade, or coordinated limb arrangement no longer met his needs. For his canvas to have its own autonomy, the figures and setting had to relinquish theirs. The body contours were broken into, and parts were made almost interchangeable by reducing them to such basic shapes as the V repeated in crotch, breast, elbow, and jagged background forms. Cohesion and expressiveness of surface demanded making flat rather than voluminous bodies, obscuring the figure's means of support, making space relationships in-

consistent, and assigning accents and visual importance to intervals between the figures that rivaled the bodies themselves. The rhythms and force set by the restructuring of the bodies spill over into the indeterminate background.

The painting's pinks, blues, whites, browns, and blacks are a tonal recapitulation of all Picasso's previous periods. The blue between the central and right figures is glacial and sharply attractive to the eye. Picasso's conflicting impulses led him to mix outline and edge, modeled and flat surfaces, and black, white, and blue silhouettes. He could not resolve so much color and so many modes into a single dominant harmony of contrasts; yet ironically, much of the painting's initial appeal derives from this very freshness of color and raw juxtapositions.

For Picasso himself, the *Desmoiselles* may have been a talisman, even though he rolled it up in 1907 and did not show it for many years. In it he went beyond his previous works in his discoveries of art's power. With taste and tact abandoned, the viewer seems assaulted by the subject. There is no sense of decorum on the part of the ladies. The sexuality of the motif is overt. Picasso ignored tact and beauty for a tough-minded expressiveness. As ruthless as his handling of the figures were his attacks on conventional norms of perspective and clarity of pose. He was fighting for a stricter unity of theme and form, of figures to spaces and to one another. Ambiguities coexist, not only in elements, for example deep and flat space, but also in modes of style. It was as if Picasso were seizing art by the throat and shaking it.

Picasso's development was rapid and extremely varied. There was no simple continuous progression toward his completely Cubist paintings, but we shall try, briefly, to illustrate this latter direction. *Head, Apple, and Box* (Fig. 515) shows more consistency in style than does *Les Demoiselles d'Avignon* and illustrates the artist's extension of the Cubist mode to objects. The head's anatomical structure and the shapes of the objects do not predict the premises of Picas-

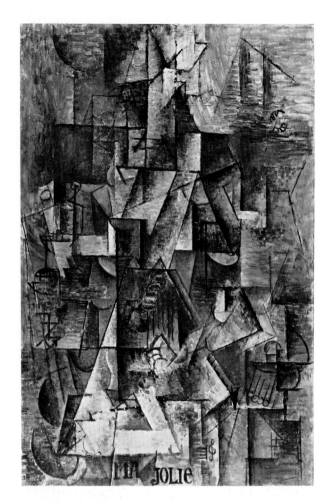

516. Pablo Picasso. *Ma Jolie.* 1911–12.
Oil on canvas, 39⅜ × 25¾'' (100 × 65 cm).
Museum of Modern Art, New York
(Lillie P. Bliss Bequest).

so's drawing. His design does not follow, say, the muscula-ture of the face, the natural curves of the features, or the proportions and planes of the box as generally perceived. He increased the complexity and expressiveness of the face through new angles and facets. Though passive in mood, the woman's face is activated by the energized drawing in such inventions as the peaked eyes and the arbitrary place-ment and increased degree of shadow. There is no domi-nant symmetrical vertical axis in any of the forms; the artist clearly preferred disconnected sequences. The box, with its inverted perspective and multiplication of planes, becomes a crystal form of increased weight and stability. At this stage of Cubism, Picasso was still interested in light and shadow, mass and volume, and the sensual swelling of flesh.

Ma Jolie (Fig. 516) was a painting of Marcelle Humbert, with whom Picasso was deeply in love and who died during World War I. "Ma Jolie" was both the epithet he gave to her and the title of a popular song. In line with his ideas of the years 1911 to 1912, Picasso could not paint her in the tradi-tional portrait manner. In part he "inscribed" his love, as he

put it, on the canvases devoted to her with the words "J'aime Eva" and "Ma Jolie." Such sentiments had never before been so literally a part of the work of art. The fact that Picasso accomplished this without disrupting the integrity or logic of the painting is in itself a sign of Cubism's radical break with the past. From the Renaissance through the 19th century, art consisted in imitating the physical appearance of nature. With the development of Cubism, empirical veri-fication was to be found only in the terms of the painting itself. The similitude to be appreciated became that of the final painting to the emotions of the artist who produced it. Expressed in another way, Picasso in *Ma Jolie* did not deal directly with the world of appearances, with respect for its distinctions and logic. His drawing and color were meant as visual equivalences of his love for Eva in the same way that the words "Ma Jolie" could be equivalences of a song and a woman without really looking or sounding like either. In a sense, the pulse of warm and cool color alternation and the shimmer of countless touches of thin brush give a pal-pable presence to the "vibrations" of Eva's life as Picasso felt them. The diagonals and vertical massing of the planes are vestiges of the seated human figure. Still, Picasso wanted the literal appearance not of a woman but of a painting, a unified, moving, and beautiful object. On the wooden stretcher of the canvas, Picasso wrote, "Woman with a Zither," probably the original title. Part of a hand seen at the lower right is properly in position to hold the instrument. The zither's design has analogies to the paint-ing's vocabulary of forms. While music did not supply the theory or model for Cubist painting, it was a bond by which artist and subject—in this case, the woman Picasso loved—were joined. Though the resulting order of the painting re-flects intellectual precision, the whole was done with genu-ine passion. The drawing and painting of *Ma Jolie* are disci-plined and of great beauty.

Some of Picasso's own statements about Cubism, made in 1923, are important in understanding the artist's concep-tion of its nature and its relation to the past:

> Cubism is . . . an art dealing primarily with forms, and when a form is realized, it is there to live its own life. . . . Drawing, design and color are understood and practiced in Cubism in the same spirit and manner that they are understood and prac-ticed in all other schools. . . . We have kept our eyes open to our surroundings and also our brains. We give to form and color all their individual significance. . . . The fact that for a long time Cubism has not been understood . . . means noth-ing. I do not read an English book that is a blank book to me. This does not mean that the English language does not exist, and why should I blame anybody else but myself if I cannot understand what I know nothing about.

left: 517. Pablo Picasso. *Guitar.* 1912. Sheet metal and wire, 30½ × 13⅛ × 7⅝'' (77 × 33 × 19 cm). Museum of Modern Art, New York (gift of the artist).

below: 518. Pablo Picasso. *Guitar.* 1913. Pasted papers and charcoal on blue paper, 26⅛ × 19½'' (66 × 50 cm). Museum of Modern Art, New York (Nelson A. Rockefeller bequest).

Picasso's *Guitar* (Fig. 517) of 1912 quite simply began a new history for sculpture. Instead of the traditional human subject, carved or modeled in stone or clay, Picasso proposed an object evoked by the cutting, bending, and twisting of sheet metal and wire. Previously, objects had a marginal history in sculpture as symbols or attributes of figures. Picasso's method of assembling or constructing and use of vernacular materials provided future sculptors with ways and means that had no previous art historical or cultural memory. A friend of Picasso's asked him in 1913 if the work was a painting, and the artist said, "No, it is El Guitar." The friend then asked if it was a sculpture. Picasso answered, "No, it is El Guitar. It is just El Guitar." Picasso loved to create the unclassifiable. The piece, made of nondescriptive flat and curving planes, could either be hung on a wall or propped against the corner of the studio. On its flangelike base, *Guitar,* unlike architectural reliefs, has no rectangular frame and advances into our space. It had been made from the inside out rather than by first drawing a descriptive silhouette. Picasso, who owned but could not play a guitar, had intervened in its traditional unchanged shape and created an unprecedented work whose inside and outside were continuous, whose parts by themselves seem abstract and do not predict the whole. Evocation rather than description, fooling the mind rather than the eye, were the artist's intentions. He made the *Guitar* in 1912, at a time when his Cubist painting verged on abstraction and he felt the need for a more tangible relation between his art and the world outside it. *Guitar,* which was to inspire many sculptors to work differently and painters to become sculptors, inspired Picasso to invent collage.

With pasted paper, he unhinged logic and opened art to new mystery and wit. His collage *Guitar* (Fig. 518) evokes the motif by means antithetical to it, such as painted floral paper and newsprint. Cubism broke down the distinctions between figures and objects; in *Guitar,* certain shapes simultaneously suggest a woman's torso and a guitar (to some, the white form at the upper left suggests a rigid male torso), while the Spanish newspaper ads proclaim the services of certain doctors for venereal disease and eye problems. Picasso loved to establish provocative situations whose interpretation or resolution challenged the viewer.

The Artist and Model Series Like Rembrandt, Picasso returned repeatedly to the theme of the making of art, or the artist and model in the studio. Different versions of this

left: 519. Pablo Picasso.
Painter with Model Knitting.
1928. Etching, $7\frac{5}{8} \times 11\frac{3}{8}''$ (19×29 cm).
Museum of Modern Art, New York
(gift of Henri Church).

below: 520. Pablo Picasso.
The Painter and His Model. 1927.
Oil on canvas, $7'1\frac{1}{4}'' \times 6'6\frac{3}{4}''$ (2.14×2 m).
Private collection.

below: 521. Pablo Picasso. *The Painter and His Model.* 1928. Oil on canvas, $4'3\frac{5}{8}'' \times 5'3\frac{7}{8}''$ (1.31×1.62 m). Sidney and Harriet Janis Collection, gift to Museum of Modern Art, New York.

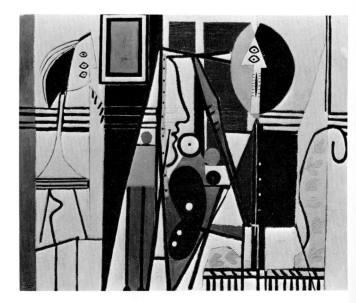

theme reveal Picasso's ability to work in different modes. The etching *Painter with Model Knitting* (Fig. 519), an illustration for Balzac's *The Unknown Masterpiece,* has a subject that reveals the way Picasso worked. The short story is concerned with one Frenhofer, a 17th-century painter who devoted his life to achieving a perfect balance, within a single painting, of drawing and color. Poussin (Pl. 32, p. 263) and Rubens (Pl. 17, p. 175) were considered rivals championing, respectively, drawing and color. The artist's final masterpiece is a chaos of the two principles, producing a small but superb woman's foot. The old artist, recognizing his failure, destroys himself and his art.

In the etching, the artist's design bears no resemblance to the external appearance of the woman, but it does catch the spirit of Frenhofer's dictum that in drawing a hand it is not enough to show its attachment to the body; it must also be shown as a continuation or extension of thought and feeling. The drawing on the canvas is a form of knitting in which the woman is translated into a series of interwoven rhythmic configurations. Unlike the painting in progress in Vermeer's *The Artist in His Studio* (Pl. 21, p. 209), the outcome of the drawing is unforeseeable on the basis of the model. In 1935, Picasso said, "A picture is not thought out and settled beforehand. While it is being done, it changes as one's thoughts change. And when it is finished it still goes on changing according to the state of mind of whoever is looking at it."

It is unwise to try to label Picasso's modes or to call the drawing of the model in his illustration "abstract." On the use of this word, Picasso said in 1935:

There is no abstract art. You must always start with something. Afterward you can remove all traces of reality. There's no danger, then, anyway, because the idea of the object will have left an indelible mark. It is what started the artist off, excited his ideas, and stirred up his emotions [that] will in the end be prisoners in his work.

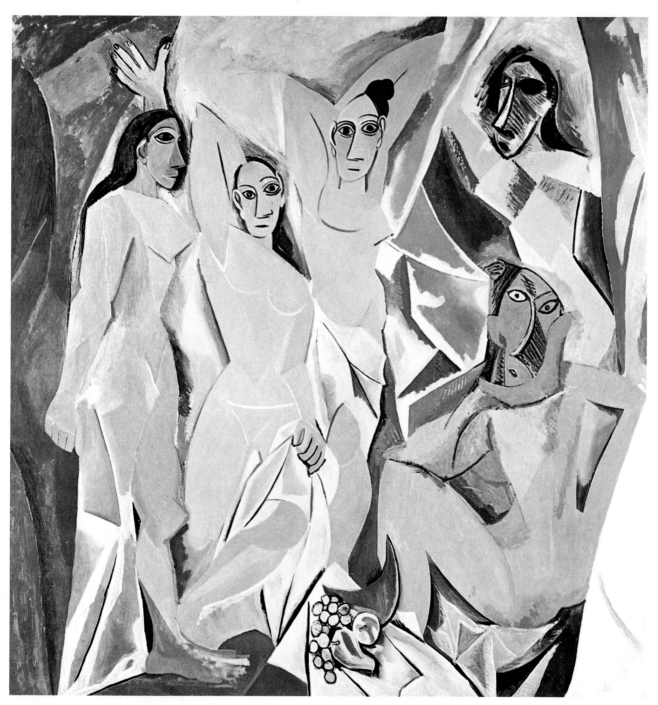

Plate 48. Pablo Picasso. *Les Demoiselles d'Avignon.* 1907.
Oil on canvas, 8' × 7'8'' (2.44 × 2.34 m).
Museum of Modern Art, New York (Lillie P. Bliss Bequest).

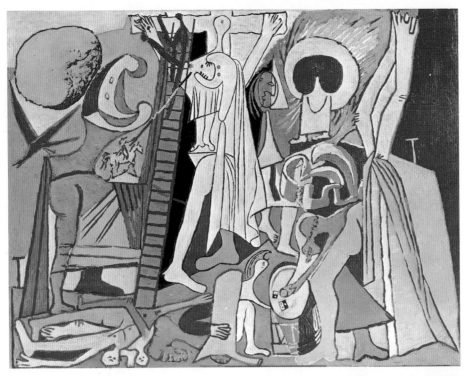

above: Plate 49. Pablo Picasso. *Crucifixion.*
1930. Oil on panel, 20 × 26'' (51 × 66 cm).
Musée Picasso, Paris.

right: Plate 50. Marc Chagall.
I and the Village. 1911. Oil on canvas,
6'3½'' × 4'11½'' (1.92 × 1.51 m).
Museum of Modern Art, New York
(Mrs. Simon Guggenheim Fund).

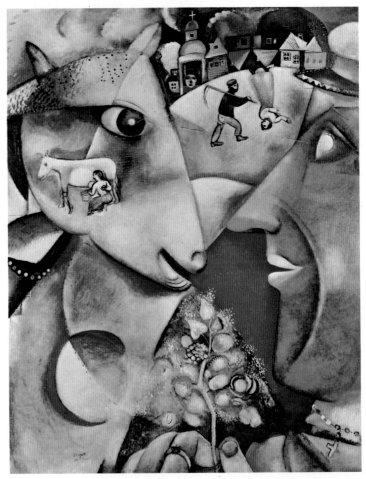

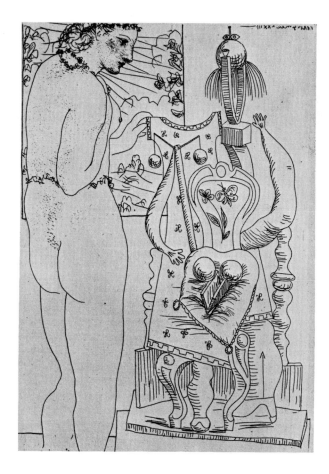

522. Pablo Picasso.
Model and Surrealist Figure. 1933.
Etching in black, plate 10⅝ × 7⅝″ (27 × 19 cm).
Museum of Modern Art, New York (purchase).

In 1928, when Picasso again took up the theme of *The Painter and His Model* (Fig. 521), he was further developing his new artistic sign language and reflections on the way that art could poetically collapse customary definitions of reality. Seated at the right on an upholstered chair whose fringes hang vertically at the bottom right, the artist is concluding the drawing of a human profile. In semaphoric fashion, his right arm projects, phalluslike, upward from the waist to hold the drawing instrument, while the other arm holds a kidneylike palette. At the left is the bust of a triple-eyed woman mounted on a sculpture stand, and while she may replace a living model and be a witness or muse, she is not the subject of the painting in progress, which is the most naturalistic passage in the work: the profile is probably Picasso's own with a displaced breast juxtaposed. The whole is an inversion of the etching of the *Model Knitting,* for in the painting, the most lifelike element is the picture within the picture, while the studio environment we have previously seen and assumed was an extension of our own space and existence has been claimed by the abstract. To further confuse the distinctions, Picasso locks the depicted picture into the scaffolding of the whole painting; the palette coexists with the surface of the picture in process, and the upper edge of the depicted canvas continues into the sky area. On the wall between the bust of the woman and the canvas is a mirror, which, like the window framing the blue area, was traditionally the arbiter of the real. Picasso's mirror, however, is a blank gray, reflecting nothing the artist doesn't want seen, and the blue sky is just as flat as the wall of the studio. Within the domain of painting, Picasso seems to be telling us, it is the artist who determines or constructs reality.

Picasso's belief that the artist should confront what does exist with what could exist is seen in the 1933 etching, *Model and Surrealist Figure* (Fig. 522). A beautiful statuesque nude wearing garlands touches and thoughtfully contemplates a grotesque hybrid personnage. A chair is a surrogate figure, and Picasso's fantasy takes off from that equation, but not to make the relationship more literal. He invents an unknown female being, whose gender is signified by the open book flanked by spheres. The remaining components of the hybrid resist explication, as they are the product of Picasso's free associations. The print further reminds us of Picasso's consciousness of the coexistence of past and present. He conjoins the classical tradition of the rational and the beautiful with the modern absorption with the irrational and the grotesque. Both modes are linked by sexuality. The dreamlike attitude of the beautiful woman, who does not actually look at the hybrid, suggests

In 1927, Picasso also did a painting, *The Painter and His Model* (Fig. 520), in which the artist was remade into an angular linear frame and the woman became a hybrid entity, with drastic relocation of bodily features. The period of the late 1920s was one of Picasso's most fertile in terms of body imagery and imaginative nourishment of his art. Fantasies on the body took diverse forms, and in this particular painting, the model has been brutally reduced to an animal-like and precariously balanced shape. Strong sexual feeling freely entered Picasso's work at all times and inspired new inventions such as those used here for distinguishing the man and woman. What liberated Picasso's imagination still further after Cubism was the conviction that external appearances could be dispensed with in painting and that there were alternative means originating in strong feeling by which to preserve reference to human subjects. Such independence from likeness and conventional modeling of the figure in painting was accompanied in this work by Picasso's separation of color from the limits of drawn contours, so that it is disposed in amorphous areas cutting across several of the drawn motifs.

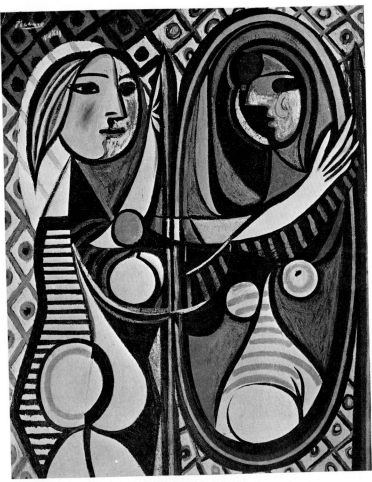

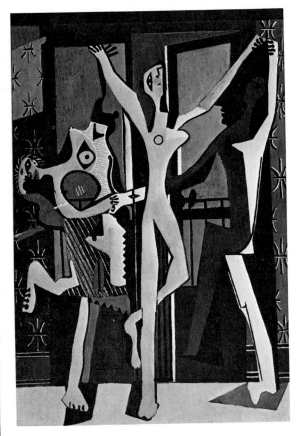

523. Pablo Picasso.
Girl Before a Mirror. 1932.
5'3¾" × 4'3½" (1.62 × 1.31 m).
Museum of Modern Art, New York
(gift of Mrs. Simon Guggenheim).

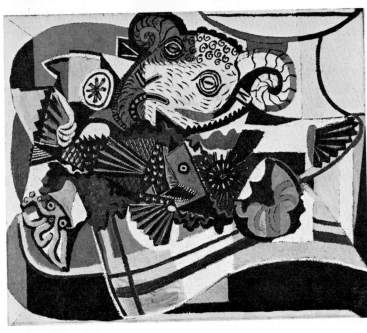

left: 524. Pablo Picasso.
Ram's Head. 1924.
Oil on canvas, 32⅛ × 39½" (82 × 100 cm).
Norton Simon Museum of Art, Pasadena, Calif.

above: 525. Pablo Picasso.
The Three Dancers. 1925.
Oil on canvas, 7'3¾" × 4'8" (2.15 × 1.43 m).
Tate Gallery, London.

that each is the alter image of the other, an idea Picasso had earlier imaged in his *Girl Before a Mirror* (Fig. 523).

Work Leading to *Guernica* Although Picasso's painting of the bombing of Guernica was not accomplished until 1937, its sources within his own art go back many years and can be found among such seemingly unrelated subjects of the 1920s as still lifes, dancing figures, bathers, and, during the 1930s, his interpretation of the Crucifixion themes, bullfights, and Greek mythology.

The still life of the *Ram's Head* (Fig. 524) testifies to the viability of the Cubist style and to Picasso's alertness to new subject matter. There is far less decomposition of objects than in *Ma Jolie* (Fig. 516), and familiar textures and shapes facilitate reading the contents. What is new and unfamiliar in Picasso's art is the range of unpleasant sensations the objects inspire. The objects are foods in a raw, inedible state, unlike the more ingratiating contents of earlier Cubist still lifes (Fig. 435), with their sociable connotations and appeal to the senses. Picasso contrasted the horn and hair of the ram, fish scales, and shells with sharp edges against moist, pulpy substances like the squid at the lower left. The violence in the subjects themselves—the severed head of the ram and the arsenal of teeth in the gaping fish mouth—is consonant with the abrupt conjunctions of textures. The yellow of the blue-veined lemon to the left of the ram's head, a rectangular patch cut by the circular lemon, adds a conspicuous note of color to the dominant blues, whites, and browns. The black linear scaffolding of *Ma Jolie* has disappeared; the composition includes large free-swinging curved lines and planes that alternate and join with rectilinear passages in tight cohesion. The colors and textures lie flat upon the surface, affirming its two-dimensionality. The objects are tautly grouped and held within the frame by such inventive drawing as the free repeat of the serrated edge under the ram's head and in the spine of the fish.

Another area into which Picasso's sensibilities forcefully expanded in the mid-1920s was internal body imagery, seen in *Three Dancers* (Fig. 525). Traditionally, naked figures in an interior signified that the artist was studying anatomy and poses. By 1925, Picasso had become interested in the art of fantasy as exhibited by Miró (Pl. 51, p. 385) and Arp. He was fascinated by their bold incursions into the irrational and their unlocking of inhibitions with respect to form and content. Instead of creating a studio study of how three naked models might look to someone else, Picasso seems to have imagined the models' own inner sensations as their bodies are given over to the abandon of a frenzied dance. Each dancer possesses a phantom, a second and even a third self. This is made apparent in the black areas, which are not literal projected shadows but poetic extensions of each figure's consciousness of the body area in which the strongest feelings are localized. The figure at the left is given an extra breast. The dark silhouette at the right is that of Picasso's friend, Ramon Pichot, who died while

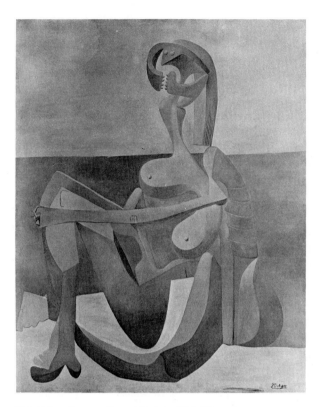

526. Pablo Picasso. *Seated Bather*. 1930. Oil on canvas, 5'4½'' × 4'3'' (1.64 × 1.3 m). Museum of Modern Art, New York (Mrs. Simon Guggenheim Fund).

the painting was being done. Picasso thereupon changed it into a dance of frenzied grief. In an unclinical, intuitive way, Picasso showed how, in moments of great physical exertion and erotic stimulation, a new self-consciousness may come into being. Affected by these conditions may be the emphasis, size, weight, color, shape, location, and even orientation of the body parts. All the figures seem to be boneless, for example, and much of the distortion occurs in the most fleshy areas. Cubism's breakdown of the body conceived as a continuous closed vessel was the foundation for this new imagery in Picasso's art. Picasso and other artists could now express their most intimate sentiments in a complete internal as well as external reconstruction of the body in art. Picasso gave his figures a fictive transparency, so that we see simultaneously the pink of the flesh and the suggestions of internal organs.

In *Seated Bather* (Fig. 526), painted in 1930, Picasso was making a reconnaissance of an idea for a huge sculpture to be located on the Mediterranean coast. The solidity of the body was broken up, and there is an intriguing fusion of bone and flesh forms. The head of the "bather" has an astonishing and ominous viselike substitution for the jaws. The transparency of the later sculpture derives from Picasso's transparent-metal sculpture-constructions of two years before, which themselves grew out of his pictorial arma-

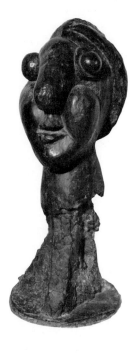

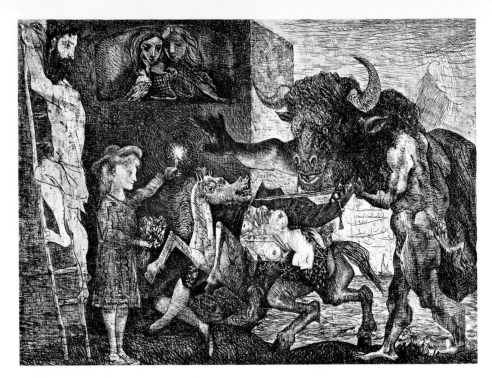

left: 527. Pablo Picasso. *Woman's Head.* 1932. Bronze, 33½ × 14½ × 17⅞″ (85 × 37 × 45 cm). Courtesy Galerie Louise Leiris, Paris.

above: 528. Pablo Picasso. *Minotauromachia.* 1935. Etching, 19½ × 27⅜″ (50 × 70 cm). Philadelphia Museum of Art (gift of Henry P. McIlhenny).

tures. The "cross-pollinating" of Picasso's work in different media was always strong, and this tendency augmented his seemingly inexhaustible ideas for metamorphosing the body. The artist had the impulse to make heroically scaled sculptures, feeling that there were certain artistic traditions that should not die and to which his art could give life.

Thematically, some of Picasso's most personal images are his passionate portrayals of his mistress of the early 1930s, Marie-Thérèse Walter. She so inspired Picasso with sexual fantasies that they flowed equally into painting and sculpture. In the boldest and most imaginative artistic homage of a lover to his mistress, Picasso modeled a large woman's head whose features resembled male and female genitalia (Fig. 527). Picasso's aggressive procreative desires, coupled with his instinct for analogizing forms, were thus candidly transformed into a work that was both a portrait and an image of sexual union. He transferred to the human head activities of the male and female body. His strong carnal feeling, tempered with amazing insight into human body imagery, likewise produced the *Girl Before a Mirror* (Fig. 523), in which the young woman, inspired by Marie-Thérèse, contemplates herself in different ways. Picasso has shown, by the three views of the same woman's face and by the contrasting configurations of her body and its reflection, multiple modes of experience. Meyer Schapiro reads this work as Picasso painting "the body contemplated, loved and self-contemplating." It is a poetic evocation of the way a girl imagines she appears to others and is aroused by the sight of her naked body. Here again, the

artist has made use of analogies with the procreative portions of the human body; the brilliant color echoes the vitality of the woman and of the artist.

Crucifixion and Guernica The impulse to revitalize artistic traditions even when they seemed to run counter to his own work is illustrated by Picasso's investigation of secular and religious themes that had been overworked and degraded by insincere and uninspired handling.

The first painting in which he treated a theme of explicit violence, as contrasted to his own artistic violence in painting passive subjects, is a small picture done in 1930, after many drawings, entitled *Crucifixion* (Pl. 49, p. 368). This is an unusual painting for Picasso in many ways. It was the first time he had interpreted a subject drawn from literature—the Bible—and it was a work not intended for a church or the public. We do not know what caused him to take up this theme. Its relation to his personal life or his possible reaction to a painting on the subject can only be conjectured. What seems to have initially attracted him to the subject of the Crucifixion, to judge from the preliminary drawings, was not Christ's agonies on the Cross but rather the passionate sufferings of Mary Magdalen and the complex and expressive interweaving of limbs and faces. Owing to his own breakthrough in body imagery of the late 1920s, whereby the emotional state of the subject could be exteriorized by drastic changes in the appearance of the body, Picasso could reinterpret in a personal and subjective way one of the great themes of art, but one given up by most modern

artists. Unlike the symbolic objects in *The Breviary of King Martin of Aragon* (Fig. 426), Picasso's painting does not permit us to interpret and relate all its parts easily. It is possible to identify the crucified Christ and the figure on a ladder nailing a hand to the Cross, the soldiers gambling for Christ's cloak, the mounted centurion who lances Christ's side, and at the far right the draped Magdalen figure with outstretched arms. The fantastic heads with gaping jaws seen in different parts of the painting, which spring from Picasso's previous secular imagery (Fig. 526), may have been introduced to symbolize the animallike brutality of the event; the creature to the left may be a crowing cock illustrating the episode of Peter. The painting's intensity within such a small format results from its hot red and yellow colors, which, like the shapes, are crowded into a restricted space. As much as the drawing, these colors convey Picasso's passionate feeling and, rather than being decorative, add to the emotional dissonance of the conception.

During the 1930s, Picasso was strongly attracted to ancient Greek mythology, partly as a reaction to the futility of rational conduct in the face of the rise of fascism. The result in his art, notably in the etching *Minotauromachia* (Fig. 528), was the formation of private myths rather than literal interpretations of such Greek legends as that of Theseus and the Minotaur. In many drawings, prints, and paintings preceding this etching, Picasso had created fantasies based upon the Minotaur, the bull, and the bullfight. These, coupled with prior themes in his art, were brought together in the *Minotauromachia* with no rational plan or discernible narrative. The whole is a model of the illusionistic Surrealist image built upon instinctive creation (see Chap. 20). The artist responded to obsessive themes mingling the bizarre, the erotic, the violent, and the innocent in free association.

Both in his previous interpretations and in the *Minotauromachia*, Picasso deviated from the original story of the Minotaur. In antiquity, the Minotaur was a destructive being to whom youths were sacrificed. In Picasso's art, the Minotaur was severally shown as a pathetic victim, as a tender abductor or object of love, and as confounded with the person of Theseus. In the *Minotauromachia*, the Minotaur is not a menacing figure but is shown reaching for the light held by a young girl. Just to the left of the Minotaur's legs is a white sail, instead of the black sail signifying the hero's death that in the myth was erroneously kept, resulting in the suicide of Theseus' father Aegeus. The horse and the woman toreador emerge from the earlier bullfight series, and as before, the woman shows evidence of violation. In her dreamlike state, she menaces with the sword the gored horse rather than the Minotaur, who also has been fused with the bull in the bullfight series. The figure ascending the ladder at the left, who looks over his shoulder in the direction of the light, is Christ. The theme of Christ mounting to his death is an old one in Spanish art. Above the scene, in the niche of a blockhouse, are two young girls who are seemingly witnesses to the scene but whose attention is upon two doves. These witness figures also derive from earlier studies of arena combat. The two birds standing before a niche occur in a painting done by Picasso's father before 1900. Rich and fascinating are the etching's myriad references and ambiguous interrelationships of time, place, and action.

In May 1937, Picasso began work on studies for a large canvas to commemorate the bombing on April 26 of the Spanish Basque town of Guernica by Franco's German dive bombers. This was his first painting directly inspired by a specific historical event. Nevertheless, the studies and the completed painting were a logical outlet and summation of his imagery of the late 1920s and 1930s that had dealt with brutality and fantasies on the body. One brilliant sketch (Fig. 529) shows how Picasso became deeply engrossed in the nonpolitical aspects of the project—notably the theme of the human deranged by pain. The woman's head has been completely detached from the body, and each feature's response to pain is shown separately. Even the normally neutral areas of eyelashes, brows, and hair participate aggressively. The eyebrows do not lie passively on the forehead but are cut into it like deep scars. The hair pulls away from the head, resembling rawly exposed nerves, such as are also suggested in the lines from the right eye running down the cheek. The eyes have been pulled apart and transposed into teardrop forms filled with and surrounded by splintering shapes. A large dark patch between the eyes localizes another area of intense aggravation. The nostrils, one almost detached from the nose, are swollen and flared.

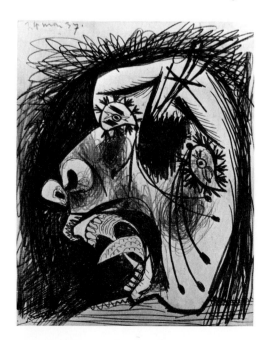

529. Pablo Picasso. *Weeping Head,*
study for *Guernica* (Fig. 530). May 24, 1937.
Pencil and wash on paper, 11¾ × 9″ (29 × 23 cm.)
On extended loan to the Museum of Modern Art, New York,
from the artist's estate.

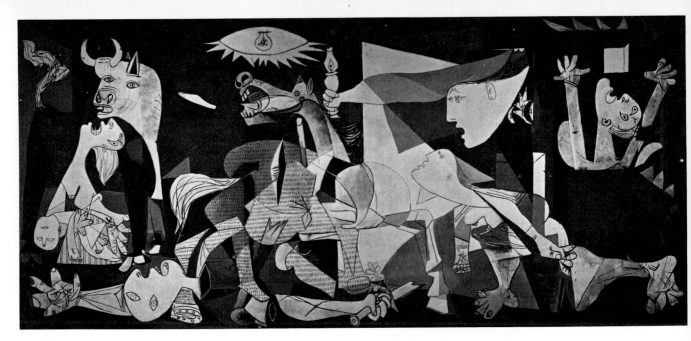

530. Pablo Picasso. *Guernica.* 1937. Oil on canvas, 11′5½″ × 25′5¾″ (3.49 × 7.77 m). On extended loan to the Museum of Modern Art, New York, from the artist's estate.

The entire head seems divested of its cranial skeleton as it is twisted into soft and angular contortions. The climatic feature is the mouth burst open in a scream, the lips peeled back to reveal the irregular and precariously rooted teeth, the lining of the palate, the black cavity of the throat, and the rigidification of the tongue into a sharp cutting tool.

Grünewald's *Isenheim Altarpiece* (Fig. 92) was a source of this drawing. From children's art, Picasso took the use of crayon, and deceptively childish scribbling within the facial contours achieved a graduated series of vaguely defined irritated spots. The drawing betrays the fierce pressure with which crayon was dug into the paper, particularly in the brow and hair. Picasso's sadism, extended to his means as well as to his subject, is frankly manifest.

In the final painting of *Guernica* (Fig. 530), Picasso avoided specific or unmistakable political reference to the locale of the tragedy, to the fascist aggressor, or to modern warfare and focused his attention upon the agonies of the noncombatants. No cipherable links between the figures and groups exist, and while Picasso may have had private symbols in mind, he consistently refused to spell out his intent. At various times in Picasso's art, the bull, like the horse and the dove, signified Franco and the Spanish people. To assign to the bull at the left the role of aggressor is to overlook clear indications that the bull is also a victim. "The bull is a bull and the horse is a horse. They are animals, massacred animals. That is all, so far as I am concerned." In the center is the distended head of the dying horse, with its body pierced by a spear, recalling Christ's death on the cross. (The pathetic horse replaces Christ as the main focal point of a symbolic dream scene in another work by Picasso.) Beneath the horse are segments of a man whose arm clutches a broken sword and a flower. In older

art, the figure fallen under a galloping horse was a victory symbol, but this tradition ended with *Guernica.* The hard lifeless head recalls the plaster figures that had been the subjects of Picasso's drawing since his student days in Barcelona (Fig. 512) and that in the 1920s began to appear in the artist's still lifes. This broken sculpture could signify the death of art. The figure running in from the right is a descendant of earlier paintings of gigantesque nudes racing along a beach, but now the woman's form is swollen and constricted in exteriorization of her internal distress.

Other reminiscences of earlier work are the mother and child and the woman who leans from the window holding the lamp, providing vague connotations of justice. Within Picasso's art, she is a descendant of the young girl who with a lamp suggests innocence (Fig. 528). Her gesture and expressive face relate her to older French images of Liberty and Justice, which Picasso had before his eyes in Paris (Fig. 471; Pl. 24, p. 210). There is ambiguity regarding the interior or exterior locus of the action (the people of Guernica died both indoors and outdoors) and a puzzling redundancy of light sources. *Guernica* is in part a study of panic; the two women at the right, deprived of all reason, are inexplicably drawn to rather than repelled by the center of the disaster.

The great scale of the *Guernica* was new for Picasso, and he made many drawings for the composition and ended by reducing the number of textures and colors. The use of blacks, grays, and whites not only eliminated certain color problems, but also were suitable and dramatic accompaniment to the nightmarish theme. The stippled texture in the horse and the overall black and white, furthermore, resemble the qualities of newsprint and journalistic photos of violence during the turbulent period in which the painting was done. Quite apart from the fact that he did not

work from literal photographic images, Picasso's recourse to the Classical pyramidal composition is not out of character, for he had taken many motifs and devices from Classical art in previous years. He could not, however, accept the Classical insistence upon the pyramid's centrality, symmetry, and stability, and the climax of the pyramid is not an idealized human but a terrorized beast. Picasso was also clearly familiar with the great paintings of war and disaster by Baron Gros, Géricault, and Delacroix in the Louvre (Figs. 320, 371; Pl. 24, p. 210). The pyramid is interlocked with the flanking areas. The part thus tends to predict the whole, since no single figure is shown in the same tone, nor can its shape be detached from that to which it is adjacent.

Guernica was the occasion for Picasso to "clearly express my abhorrence of the military caste which has sunk Spain in an ocean of pain and death." Rather than a chronicle, he created a personal allegory with only the title linking the painting to a specific event. Like Daumier's *Rue Transnonain,* (Fig. 372), *Guernica* was not a prosecuting image with the criminals visible on the witness stand. In Goya's great *Execution of Madrileños* (Fig. 370), we can visualize ourselves as actual witnesses to the firing squad; this is not possible with *Guernica.* Goya painted what were then the greatest imaginable terrors of war. Picasso captured what was so terrifying about modern warfare to its victims, the *un*imaginable. He achieved this as a noncombatant, but from 1939 to 1944, Picasso was to know constant fear for his life.

It is interesting to compare Picasso's commentary on war with a painting by a Nazi artist, *Dive Bombers over England* (Fig. 531). At first, this looks like a painting of a

bright cloud-filled sky over a city, but then the bombers can be seen diving out of the sun toward the brown ruins below. Concern with aerial tactics rather than with human suffering guided the Nazi painter, whose style, ironically, is somewhat indebted to French Impressionism, perhaps the most pacifistic art in history. Nazi paintings should give pause to those people who feel that a democratic, humane art is one that is completely legible.

So many ideas emerged in the process of painting the *Guernica,* as evidenced by changes in the final work, that their momentum was carried over to additional studies that Picasso undertook after the painting was exhibited. One such postscript is a painting of the head of an agonized horse (Fig. 532). Here Picasso continued to build upon the insights generated by the internal experiences of pain. In the painting, he simulated the texture of the animal's smooth flesh and of the roof of the mouth. This single form set against a black ground is like a summation of the total anguish of the larger *Guernica.*

Man With a Lamb During World War II, at great personal peril because of his antifascism, Picasso remained in occupied Paris. Although the Germans forbade exhibition and publication of his work and the Occupation press denounced him as a saboteur and a Jew, in Picasso's view, it was "not a time for the creative man to fail, to shrink, to stop working." He felt an obligation to keep art alive. During the darkest hours of the Occupation, he made the monumental *Man With a Lamb* (Fig. 533). Typically, it was a humble motif, but also an equivocal image, susceptible to more than one explanation. We cannot tell what will hap-

531. George Lebrecht. *Dive Bombers over England.*
1941. Present whereabouts unknown.

532. Pablo Picasso. *Horse's Head,* study for *Guernica* (Fig. 530).
May 2, 1937. Oil on canvas, 25½ × 36¼'' (65 × 92 cm).
On extended loan to the Museum of Modern Art, New York,
from the artist's estate.

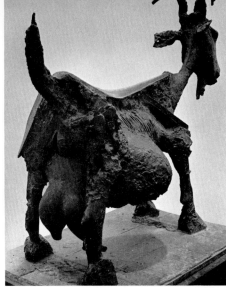

pen to the lamb, whether it will live or die. Although it recalls ancient sculptures of animal bearers, such as the Good Shepherd, this rudely modeled figure was partly autobiographical. Picasso offered an image of the dualistic nature of the self and humanity, their simultaneous twin drives to love and destroy. "I am full of contradictions. I love what belongs to me, yet I have a strong urge to destroy." He justified his own destructive acts on the ground that he had a "duty" to his art that was higher than any morality. At the same time, the work could have been a parable of the war and the countless sacrifices of innocents mankind was being forced to make in order to survive. In 1945, Picasso described himself as "a political being . . . constantly alert to horrifying, passionate or pleasing events of the world, shaping himself completely in their image." Although he never saw himself as mankind's spokesman, the creation of *Man With a Lamb* may have been a fortuitous moment when through its most gifted artist humanity imagined and articulated itself. Picasso knew that the meaning of art could be affected by its location. Viewed in a small town

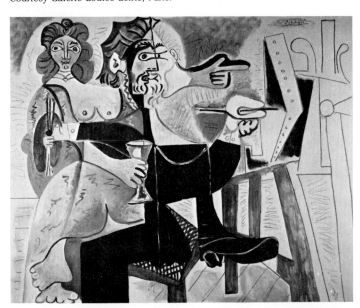

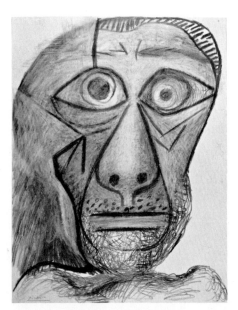

square or garden, his rugged sculpture seems a simple pastoral image. Seen in his Paris studio right after World War II, it appeared to be a hopeful image. Earlier, when it confronted the Gestapo in their periodic visits to get Picasso to inform on his friends in the Resistance, the artist could have been showing them that if they wanted a police informer, a *mouton* (sheep in French slang), he was offering them one!

Picasso's *Goat:* Invention, Economy, and Surprise

Picasso is now recognized as one of the major sculptors in modern art, and after *Guernica,* his substantial work in this medium was perhaps the strongest expression of his premises: "We mustn't be afraid to invent anything. . . . You must always work with economy in mind. . . . I'm out to fool the mind, not the eye." Invention, economy, and surprise were conditions of Picasso's mind and habits of work that overlapped and reinforced one another for the last 65 years of his life as an artist. They are brilliantly summarized in his sculpture entitled *Goat* (Fig. 534), often installed by prudish curators so as to conceal its most interesting view. Finding a palm branch on a sidewalk triggered the realization of an old desire to make a sculpture of a goat. The branch became the animal's spine, and a section of it also served as its forehead. A wicker basket made the frame for the stomach, terra-cotta milk jars the udder, angular tree branches the legs, copper wire the tail and whiskers, and a piece of metal pipe and a folded tin can lid the anus and vagina. All were overlaid with plaster and then cast in bronze for durability. The goat's form resulted from sources as heterogeneous as its proverbial diet. Picasso made no attempt to imitate the hair of the goat, but because of his inventive textures, the mind accepts the surface of the sculpture as analogous to that of a goat.

One of Picasso's gifts was to see things freshly and in terms of art. Goats have always been seen, but seldom so well as in Picasso's sculpture.

Rembrandt and Saskia

As part of his renewal of the self and art, Picasso began making interpretations of old master paintings in his mid-sixties. He explained, "What is a painter after all? A collector who wants to acquire a collection by painting other people's paintings he has admired." Looking at Picasso's version of Rembrandt's *Self-Portrait with Saskia* (Fig. 535) makes clear his next sentence: "That's how I begin, and then it turns into something else." Toward both his own art and older art that he admired, Picasso held that nothing was finished. "Finish" he equated with death. Great paintings such as Rembrandt's offered him the challenge of showing that he could continue an idea from where his predecessor had left off and thereby continue art. As an art student, Picasso had faithfully copied El Greco and Velásquez to learn their technique and find his identity through the resulting differences. At 83, Picasso's motive had changed. He saw himself as part of a fraternity of great artists with license to possess his

colleagues' work without ownership. Picasso's woman (his last wife, Jacqueline Roche) sits on his lap, holding a wine glass and pointing to the painting in progress. We see her partly clothed and partly naked, simultaneously from the front and back, breasts and buttocks. This was Picasso's display of art's power over customary anatomy and logic: on a flat surface art shows the sexually most attractive female features all at once. With one hand holding brushes and palette, the painter claims the woman, and with a mittenlike hand, he paints. The artist's own double profile allows him to keep an eye on his woman and art at the same time. His reworking of Rembrandt's bold self-image in a brothel comes out as the artist's view of the good life—making art and love are the same thing. The artist's genius is in being able to do both at the same time!

Confronting Death Never a self-conscious spokesman for humanity, Picasso imaged his own hopes and fears for well-being. In *Guernica,* he empathized with the fear and frenzy of others, coming as close as he ever had to making propaganda for a cause, while taking a stand against death. Before 1972, he had made witty and poignant indirect commentaries on his own aging and impotence, but at 92, the masks and role-playing were set aside in an unflinching self-image. In his last year, Picasso, who had a lifelong horror of speaking about or preparing for his own demise, faced up to death in a drawing that shows he still had the power to shock as an artist (Fig. 536). His drawing cuts to the bone. Rembrandt painted himself laughing at death. With those great eyes, Picasso stares it down.

With Einstein, Darwin, Freud, and Marx, Picasso was one of the five most influential thinkers in modern history. (As did Einstein, Picasso thought in visual terms.) Not alone, but more than any other single artist, he changed the look of Western art as it had been known since the 15th century. By insisting upon the artist's right to transform, manipulate, and intervene, he established new premises for art. Like other great thinkers, he engaged in constant questioning, refusing to be limited by existing categories or definitions. Picasso always sought possibilities to explore art's power, and as he pointed out, this was best done when there were rules to break. He sought new ways of knowing—about art, life, and the self—and for him, this was what art's power was all about. Picasso was the model of the modern artist who strives to make art more responsive to his personal thought and life. After his youth, he chose not to trade on his considerable imitative skills in favor of giving form to the previously unimaginable, to take art where it had never been before—inside the body, into new spaces and new logic—and to bridge the past and present so as to reflect a personal modern consciousness. His art contributed to the claims of artistic truth for parity with scientific truth. His words of 1937 are a fitting epitaph: "My whole life has been a struggle against reaction and the death of art."

Chapter 20

Imaginative Art

As presented so far, the history of the art until modern times must seem to have been largely a continuous tribute to human reason. We have seen how art performed loyal service to church, state, and society as a whole and how it was frequently dedicated to practical purposes. Mortals and gods have been respectfully and reverently depicted. Our museums and art survey books usually focus selectively upon the good and the beautiful. Art—and therefore its history—also encompass, however, the ugly, the irreverent, and the disrespectful. The night world of dreams and demons has seen the light of day in painting, sculpture, prints, and drawings from antiquity to the present. Under the heading of *imaginative art*, this chapter is concerned with art that derives from sources other than the imitation of the waking, visible world. These other sources include visions, revelations, dreams, reverie, fancy, hallucination, the realm of the bizarre, the grotesque, and the fantastic. Art produced from these origins tells us much about the social and moral histories and tastes of various cultures as well as the individual artists. The history of these subjects helps us to clarify the changes and departures from past traditions that have taken place in the art produced during the last one hundred years.

What seems fantastic to us in older art, because it does not accord with our present frame of logical reference or with our concepts of what is rational, could have been intelligible to the artists and to the public of their time. Thus ferocious African or Polynesian masks are not pure creations of their artists' imaginations; rather, they depend largely upon previous masks and upon the full cultural complex of tribal customs and beliefs reflecting a life view that we are only now beginning to understand. For many years, scholarship has been unraveling pictorial riddles in Western art, with the result that today we must be more cautious about using the word *fantastic*. We must discern and describe different manifestations of the imaginative in art. It is not always easy to separate what was genuinely the result of a dream experience from a symbol the artist may have appropriated from a predecessor. Freudian psychology has been a valuable, risky tool of research. It has led to much unhistorical interpretation of artists of the past and to conclusions drawn without sufficient reference to case histories or knowledge of the art and social context out of which the artists work grew. Evidence that an artist of the past was not entirely inventive in the formation of symbols does not in itself detract from the importance of that artist, for he or she may have sought to preserve a familiar sign language while demonstrating considerable skill and imagination in reinterpreting the acquired symbols. By the same token, the fact that an artist has originated a symbol has not been a guarantee of excellence in art.

Literary and Artistic Sources

The great Western tradition of fantastic art has its roots in antiquity, but the subsequent Middle Ages experienced a more significant and influential expansion and development of painting and sculpture concerned with the de-

monic, the infernal, the unnatural, and the bizarre. From the 12th through the 15th centuries, in manuscripts and the sculptural decoration of architecture, this type of art remained literally and figuratively marginal to the central focus of the religious imagery of Christ, the saints, and the Bible. In Chapter 5, "The Sacred Book," it was pointed out that in the initials and margins of medieval manuscripts, artists introduced monsters and hybrids of human beings and animals unrelated to the text itself (Fig. 537). On the great cathedrals and in the cloisters, sculptors imaginatively adorned column capitals, water spouts or gargoyles, the underside of choir seats, and many other places of importance secondary to the location of significant religious subjects, such as the framing areas of the great western portals. When medieval artists were called upon to give a presence to the Devil or to Hell, or to moralize about vices, they had license to indulge their imagination as well as to reinterpret earlier art that dealt with the same subjects. Medieval imaginative art is largely related to the war of the Church on sin and propagation of its views on the hereafter. As with the making of religious painting and sculpture of a beatific character, the conception of the monstrous and grotesque was tied to prototypes in art. The mouth of Hell, seen as a leviathan's open jaws in a 12th century manuscript (Fig. 538), has precedents in medieval sculptural renderings of the Last Judgment (Figs. 79, 80), but to conclude

that all medieval fantastic art located in religious buildings was intelligible to and rationally justified by those who looked upon it is to ignore a most important witness against such argument. In the 12th century, a great churchman, St. Bernard of Clairvaux, who devoted his life to ecclesiastical reform, wrote a letter to an abbot in which he complained about what he saw in the cloisters:

> But in the cloister, under the eyes of the Brethren who read there, what profit is there in those ridiculous monsters, in that marvelous and deformed comeliness, that comely deformity? To what purpose are those unclean apes, those fierce lions, those monstrous centaurs, those half men, those striped tigers, those fighting knights, those hunters winding their horns? Many bodies are there seen under one head, or again, many heads to a single body. Here is a four-footed beast with a serpent's tail; there a fish with a beasts' head. Here again the forepart of a horse trails half a goat behind it, or a horned beast bears the hinder quarters of a horse. In short, so many and so marvelous are the varieties of divers shapes on every hand, that we are more tempted to read in the marble than in our books, and to spend the whole day in wondering at these things rather than in meditating the law of God. For God's sake, if men are not ashamed of these follies, why at least do they not shrink from the expense.

Although we do not know exactly which sculptures St. Bernard had looked upon, a sufficient number of examples have survived to give us an idea of their appearance

above: 537. "Drolleries," from *Les Heures et Recueil de Prières.* c. 1360. Manuscript illumination. Bibliothèque Nationale, Paris.

right: 538. *Mouth of Hell,* from the *Psalter of Winchester* (Cotton MS. Nero D. iv. f.95). 1161. Manuscript illumination. British Library, London (reproduced by permission).

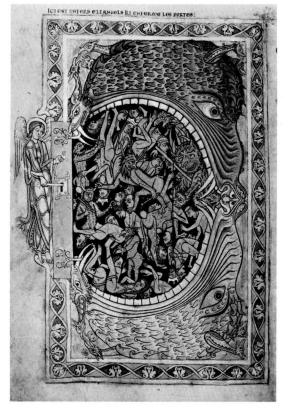

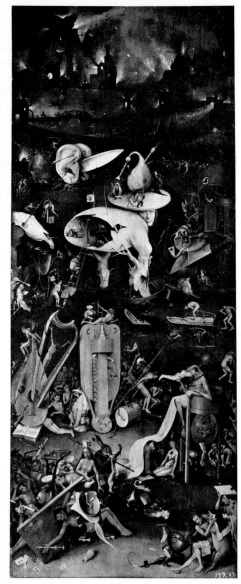

right: 539. Capital, from the crypt of the Church of St-Eutrope, Saintes, France. 1081–96.

far right: 540. Hieronymus Bosch. *Hell,* side panel from *The Garden of Earthly Delights.* c. 1505–10. Oil on panel, height 6′5″ (1.96 m). Prado, Madrid.

(Fig. 539). Ironically, St. Bernard, who protests their existence, gives us a marvelously vivid and exact description of these sculptures, showing how long he had observed so many, and making convincing his closing lament about distraction. It is also evident that the artists and the patrons who commissioned them were not ashamed of "these follies." The sources for the sculptures that St. Bernard described are to be found in both the sculpture and the painting of a much earlier time, some of which survived from antiquity in *bestiaries,* or books on animals.

The Hell of Hieronymus Bosch The belief that the terrible underworld of Hell was a near reality and that the living were surrounded by numberless demons persisted into the 15th and 16th centuries. Demonographers since the 12th and 13th centuries had catalogued the types and symbols of demons, and the 16th century saw ingenious census-taking of the Devil's agents as well as estimates of Hell's physical dimensions. The artist who first made demons and Hell the consistent central focus of high painting was the Netherlandish painter Hieronymus Bosch. His rendering of *Hell,* reproduced as Figure 540, from a three-panel painting entitled *The Garden of Earthly Delights,* has impressed many as a premonition of modern fantastic art. No rational explanation or analogies to modern life are available to viewers today to permit them to "read" the meaning of Bosch's *Hell;* hence the conclusion that this was a work of pure fantasy or dream experienced by the artist. Serious study by many art historians has shown, however, that Bosch drew heavily upon literary and pictorial sources in his inspired work and that it is possible to compile an encyclopedia of meanings for his various symbols. During Bosch's lifetime, and long before, the Church taught that all one saw in the world was symbolic of the invisible, either godly or demonic. Bosch drew from the rich sources on this subject in folklore, popu-

lar sayings, allegorical treatises, and Christian and Jewish religious literature, including medieval encyclopedias, as well as from astrology and writings on alchemy. Despite his preoccupation with sin and his belief that one could attain divine truth through sincere and deep prayer and contemplation, Bosch did not work in the service of the Church. He seems to have been a skeptic in his attitude toward both reason and the divine saving grace promised by the Church. Like many pessimists of his time, Bosch viewed the preponderance of immoral activity and folly about him as positive proof that the Devil had conquered the earth. His painting had a moralizing function—the exposure of human susceptibility to vice and the Devil's temptation—and gave visible form to the nature of evil. Bosch's hero was St. Anthony, whose strength of soul alone gave him the power to triumph over evil.

While Bosch had before him the achievements of advanced Flemish painting of the 15th century, such as perspective, he seems to have consciously chosen an archaic, or pre–Van Eyck style, as more appropriate to his purposes (see Chap. 6). Thus in his panel of *Hell,* the elevated viewpoint permits him to lay out in a vertical format a vast cross section of Hell, climaxed at the top by the vision of burning cities. Bruegel was later to take many pictorial and symbolic ideas from Bosch, such as the burning cities he appropriated for his *Triumph of Death* (Fig. 245). He did not, however, adopt Bosch's moralizing tone, his pessimism, or his view of folly as evil. While historians cannot unanimously agree on the exact meaning or implication of each symbol and allegorical image of the various episodes shown in *Hell,* they can re-create the intellectual atmosphere of Bosch's time, which inspired his choice of imagery. Prominent in Bosch's *Hell* is the compound heretical symbol made up of a human-headed, eggshell-bodied, and barren-tree-stump-legged figure. Within the shell, alchemists (who used eggshells in their recipes), wizards, or intellectuals are served by satanic innkeepers. The bagpipe on a platter above the head signified carnal love and obscenity, thus making a type of signboard for this infernal inn. The figures crucified on or tied to the harp and lute represent remorse, for these musical instruments were identified with praise of the Lord. Sexual references abound, presumably in the form of the knife, key, vases, and lanterns. The severed ears may derive from biblical reference to those who do not hear the word of the Lord. The rabbit devouring a man may have related to both sins of excess and the fear of death.

Charles De Tolnay, whose major study of Bosch has made this painter's work more intelligible to us, believes that the figure of a man leaning over the sides of the great broken eggshell is Bosch himself and that the artist has shown himself daydreaming as if the scene before us originated or was contained with his mind. This would not be the first time we have seen the dreamer and the dreamed in art, for Hugo van der Goes earlier depicted the vision of the descending Christ available only to the dead Virgin and not to the disciples (Fig. 169).

Dream in Dürer's Art In contrast to Bosch's daydream of the night world of Hell, the great German artist Albrecht Dürer in 1525 had a genuine sleeping dream so immanent that he gave it formal representation in a watercolor (Fig. 541). Probably it is the oldest example we have of an artist's attempt to transcribe such a personal experience. When Dürer painted the dream, he also wrote below it a lengthy description:

> In the night between Wednesday and Thursday after Whitsunday, I saw this appearance in my sleep—how many great waters fell from heaven. The first struck the earth about four miles away from me with terrific force and the tremendous

noise, and it broke up and crowned the whole land. I was so sore afraid that I woke from it. Then the other waters fell, and as they fell they were very powerful and there were many of them, some further away, some nearer. And they came down from so great a height that they all seemed to fall with an equal slowness. But when the first water that touched the earth had very nearly reached it, it fell with such swiftness, with wind and roaring, and I was so sore afraid that when I woke my whole body trembled and for a long while I could not recover myself. So when I arose in the morning I painted it above here as I saw it. God turned all things to the best.

What interests us about Dürer's dream is that first he painted it and then felt compelled to write about the vision, immediately translating his irrational experience into a rational and public language. Proceeding with the same intensity of empirical curiosity that he brought to his studies in the psychology of the artistic temperament (Fig. 13), in nature (Fig. 407), and in the phenomena of visual percep-

541. Albrecht Dürer. *Landscape Flooded with Waters from Heaven (Dream Vision).* 1525. Pen and watercolor, 17⅞ × 9'' (45 × 23 cm). Kunsthistorisches Museum, Vienna.

tion, Dürer was careful to comment on such things as distances and velocities and to record his own thoughtful, waking observations of the "natural" scene. Early in the history of the revival of nature painting in Europe, Dürer visualized the earth as a landscape and introduced trees and houses to give scale to his nightmare.

The Temptation of St. Anthony From the Middle Ages to the 17th century; the Church encouraged the grotesque and the bizarre in its concern for the horrors that the Devil could work upon the Christian faithful. In art, these often found demonstation in the "temptation" theme, not just of Christ but of the saints, such as St. Anthony in an engraving (Fig. 542) by the brilliant German printmaker Martin Schongauer (c. 1450–91). In medieval Christianity, beauty was equated with God and ugliness with the Devil. Thus Schongauer

dwelt at length on the pointed and prickly, endowing the demons with a large arsenal of dangerous weapons and repulsive bodies. Fortified by the great developments in naturalism in the 15th century, Schongauer was able to engrave an inventory of the unattractive properties of monsters, and his gift was to make this unnatural event, an aerial kidnaping, plausible to his audience, so that if his monsters could actually be seen walking or flying, they would have the necessary anatomy or equipment to do so. Contrasting with the pugnaciousness and stupidity of his tormentors is St. Anthony, the quietude of his face expressive of stoic resignation and inner strength.

Perhaps the most inspired and persuasive portrayal of the temptation of St. Anthony was that of Matthias Grünewald (Fig. 543). His painting is one of the panels of the *Isenheim Altarpiece* (Fig. 92), whose *Crucifixion* panel was

below left: 542. Martin Schongauer. *The Temptation of St. Anthony.* c. 1480–90. Engraving, 12⅜ × 9⅛″ (32 × 23 cm). National Gallery of Art, Washington, D.C. (Rosenwald Collection).

below right: 543. Matthias Grünewald. *The Temptation of St. Anthony,* from the *Isenheim Altarpiece* (Fig. 92).

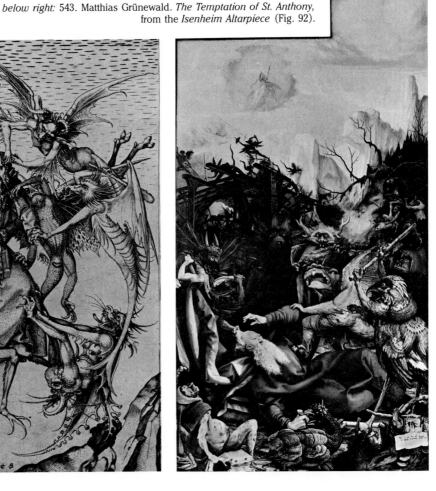

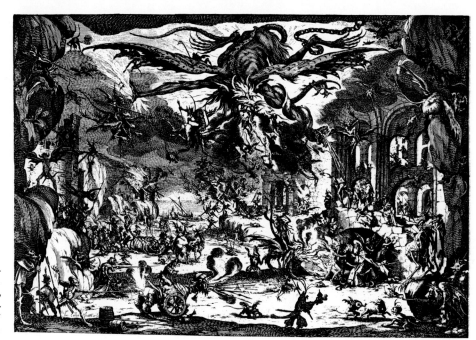

544. Jacques Callot. *The Temptation of St. Anthony.* 1635. Etching (by Israel), 14 × 18¼″ (36 × 46 cm). Indiana University Art Museum, Bloomington.

discussed in Chapter 3, "Images of Gods." Grünewald showed St. Anthony crying out against the attacks of the demons. On a piece of paper in the lower right-hand corner, Grünewald wrote: "Where are you, good Jesus, where were you? And why did you not come and dress my wounds?" This could well be the plaint of the beleaguered saint or of the rotting human corpse in the lower left-hand corner. Dermatologists have identified its sores as syphilitic, a diagnosis that relates the content of this picture to the skin afflictions of the patients who were brought to the altar painting to begin their therapy. Grünewald went beyond Bosch and Schongauer in depicting the surfaces of his monsters as symptoms of their various forms of corruption. Not content with showing the lurid, scaly, feathered, or fleshy covering of the foreground demons, he carried over into the ruined house of the hermit saint the jagged silhouettes and elusive forms of the Devil's legion. Unperceived by the hermit, but apparent to the patient apprehending the painting for the first time, is the Lord looking down on the trials of the saint. Emerging from the radiance about the Lord's throne are luminous armed angels who will disperse the devils of darkness. With the resources of painting, Grünewald was inspired to re-create the transparencies of heavenly light and gangrenous flesh, the opaqueness of dark, demonic bodies, the shine of reptilian scales, and mucous dripping. Many things in Grünewald's painting and Schongauer's engraving are partially traceable both to previous art and to the written text of the "Life of St. Anthony" in Jacobus de Voragine's *Golden Legend,* which dates from the 13th century:

> He went into a hole or cave to hide himself, and anon he found there a great multitude of devils, that so much beat him that his servant bore him upon his shoulders into his house as if he

had been dead. When the other hermits were assembled and wept his death, and would have done his service, suddenly St. Anthony revived and made his servants to bear him into the pit again where the devils had so evil beaten him, and began to summon the devils again . . . to battles. And they came in forms of diverse beasts wild and savage, of whom that one howled, another sniffled, and another cried, and another brayed and assailed St. Anthony, that one with the horns, the others with their teeth, and the others with their paws and claws, and . . . to rent his body that he supposed well to die. Then came a clear brightness and all the beasts fled away.

The great 17th-century French artist Jacques Callot (1592–1635), shortly before the death he knew was coming, made a drawing for a *Temptation* of St. Anthony that was engraved by Israel in 1635 (Fig. 544). Here the temptation theme was completely recast in terms of focus, setting, and characters. Probably inspired by Italian popular theater and the theatrical productions put on in the courts of the Florentine nobility, Callot staged the temptation on an epic scale. Literally stagelike is the device of the framing of the scene by rocky cliffs on either side, the ruins of a tall arcaded stone building at the right, and the cast of thousands that sweeps onto the broad plain of the stage. Overhead the enormous figure of the Devil, chained to the rocks, spews demons and fire into what is now a scene in Hell. Callot joined infernal scenes with those of the temptation, but the effect is more comic than frightening. The devils make war on themselves more than on the saint, who is seen at the right, ringed by other devils, a naked woman, and a fire-belching monster. Perhaps caricaturing the extravagant weapons of war sponsored by the nobility, Callot transformed monsters into cannons, or the reverse. An irreverent religious service is conducted just above St. Anthony, and throughout the print, obscene "services" are rendered

by the demons to one another. By the 17th century, there often was a recession of the heroic or saintly focus (see Chap. 10), and Callot seems to have taken the trials of St. Anthony as the occasion for delivering a commentary, obscure as it may be to us today, on worldly institutions and human practices.

Arcimboldo and Double Imagery The art of the Middle Ages and that of the 16th century provide abundant evidence that religious and secular fantasies could coexist in art. In 1563, the same year that the Council of Trent was preparing a statement on art as part of its war on the Reformation and secularism, an Italian artist, Giuseppe Arcimboldo (c. 1530–93), painted a series of heads composed entirely of nonhuman subjects. In the painting illustrated (Fig. 545), we can see with what ingenuity Arcimboldo found a form of marine life that in a certain position and context and from a distance evoked some aspect of the human head and shoulders. Without repeating himself, the painter was able to assemble an astonishing repertory of crustacean and invertebrate forms, so that the head dissects into a shark, a ray, a starfish, eels, a walrus, and so on. It is a far-from-pleasant assemblage, and at first it suggests a nighmarish experience or aggressive gesture toward human dignity, but Arcimboldo was a famous court painter who did this and other pictures for the Emperor Maximilian II in Vienna. There he served also as a decorator for pageants and set designer for the theater. He was the first Italian painter to make the grotesque more than a marginal or decorative element. Arcimboldo did not have the sin-conscious-

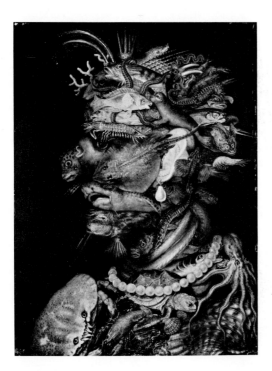

545. Giuseppe Arcimboldo. *Water.* 1563.
Oil on canvas, $26\frac{3}{8} \times 20\frac{3}{8}$ (67 × 52 cm).
Kunsthistorisches Museum, Vienna.

ness of Bosch, and focused his entire image upon the bizarre. There is a rational explanation for what he did, which does not detract from the artist's skill and the cleverness with which he painted this work. The title *Water* relates to his series on the elements and identifies the source from which Arcimboldo drew all his motifs. The precedent for relating nonhuman life to the human body existed in literature, notably philosophical and scientific speculation on the relation of man to nature, and nature to man. The comparison of the earth to a great organism had been made in the previous century and was known to Bruegel, which was pointed out in Chapter 15, "Art and Nature." Man was looked upon by many European intellectuals in the 16th century as the world in miniature, "Man—the little world." Cartographers equated land forms with figure types. Previously, artists had used human forms to symbolize nature and its seasons. Arcimboldo was using natural forms to symbolize man and, at the same time, was catering to his society's taste for metamorphosis. The 16th century produced a curious blending of science and myth; there was inquiry into facts but also tolerance of fantasy. It was a time of "half-science." Particularly in the courts, the medieval taste for allegories, or symbols of all aspects of knowledge, persisted among intellectuals. The accuracy of Arcimboldo's rendering of water denizens, coupled with their substitution for facial features, thus epitomized the duality of thought in his own age.

The Importance of the Self in Modern Imaginative Art After Callot, the next major artist to devote a considerable number of drawings, prints, and paintings to the imaginative was the great Spanish court painter Francisco Goya. In 1799, Goya published a series of prints entitled *Los Caprichos* (Figs. 546, 547), which, though not done in separate sequences, divided roughly into areas of subject matter: examples of human folly, or stupidity, and dishonesty; donkeys enacting the roles of humans; witchcraft and markedly fantastic beings. What is unusual about *Los Caprichos*—which means caprices, fantastic notions, fancy, or whim—is that the titles of the etchings and their inscriptions were added after the works were finished; they do not predate the artist's conceptions. In the work of Bosch, Dürer, Grünewald, and Callot, the title or subject existed before the work of art, which was its illustration. Goya's conceptions often first appeared in his art and then seem to have suggested associations with, for example, popular sayings. The artist was very much aware of folklore and demonology, and scholars of Spanish art and culture like Professor José López-Rey believe that there are many veiled references to individuals, customs, and institutions in *Los Caprichos*, which time has obscured for the modern audi-

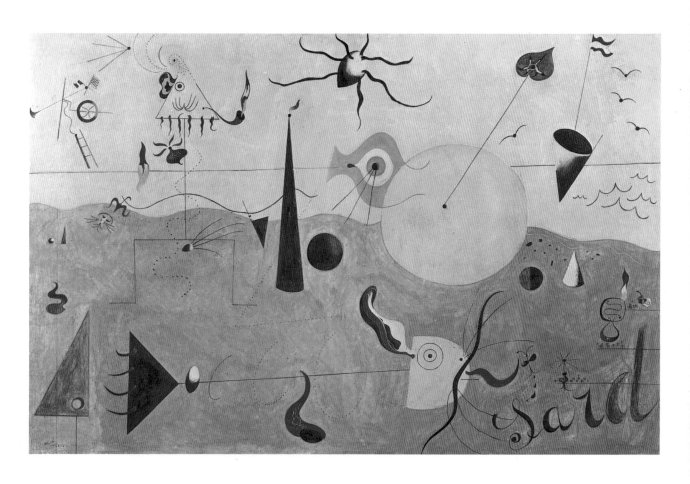

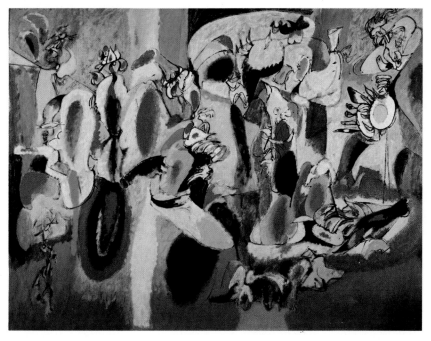

above: Plate 51. Joan Miró.
The Hunter (Catalan Landscape). 1923–24.
Oil on canvas, 25½ × 39½'' (65 × 100 cm).
Museum of Modern Art,
New York (purchase).

left: Plate 52. Arshile Gorky.
The Liver Is the Cock's Comb. 1944.
Oil on canvas, 6' × 8'2'' (1.83 × 2.49 m).
Albright-Knox Art Gallery, Buffalo, N.Y.
(gift of Seymour H. Knox).

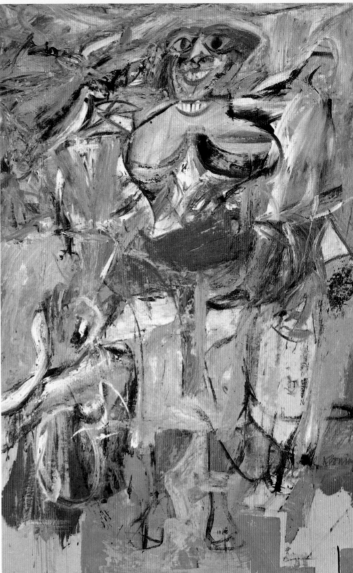

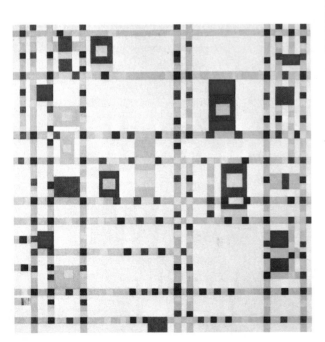

above: Plate 53. Willem de Kooning. *Woman and Bicycle.* 1952–53.
Oil on canvas, 6'4½'' × 4'1'' (1.94 × 1.24 m).
Whitney Museum of American Art, New York.

left: Plate 54. Piet Mondrian. *Broadway Boogie Woogie.* 1942–43.
Oil on canvas, 4'2'' (1.27 m) square. Museum of Modern Art, New York.

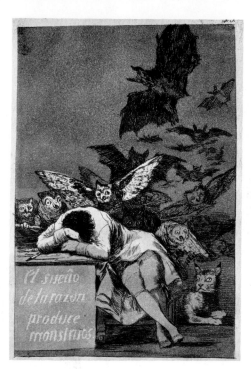

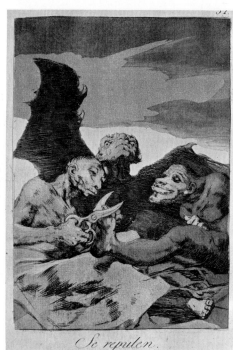

right: 546. Francisco Goya. *The Sleep of Reason Produces Monsters,* from *Los Caprichos.* 1796–98. Etching, 8½ × 6″ (22 × 15 cm). Metropolitan Museum of Art, New York (gift of M. Knoedler & Co., 1918).

far right: 547. Francisco Goya. *They Make Their Toilet,* from *Los Caprichos.* 1797. Etching, 8½ × 6″ (22 × 15 cm). Metropolitan Museum of Art, New York (Rogers Fund, 1918).

ence. Fortunately, Goya published in a newspaper article on February 6, 1799, an announcement of his series of etchings that was accompanied by a statement of purpose:

> A Collection of Prints of Capricious Subjects, Invented and Etched by Don Francisco Goya. Since the artist is convinced that the censure of human errors and vices (though they may seem to be the province of Eloquence and Poetry) may also be the object of Painting, he has chosen as subjects adequate for his work, from the multitude of follies and blunders common in every civil society, as well as from the vulgar prejudices and lies authorized by custom, ignorance, or interest, those that he has thought most suitable for ridicule as well as for exercising the artificer's fancy.
>
> Since the majority of the objects represented in this work are ideal, it may not be too daring to expect that their defects will perhaps meet with forgiveness on the part of the connoisseurs as they will realize that the artist has neither followed the example of others, nor been able to copy from nature. And if imitating Nature is as difficult as it is admirable when one succeeds in doing so, some esteem must be shown toward him who, holding aloof from her, has had to put before the eyes forms and attitudes that so far have existed only in the human mind, obscured and confused by lack of illustration, or excited by the unruliness of passion. . . .
>
> Painting (like Poetry) chooses from the universal what it considers suitable to its own ends; it reunites in a single fantastic personage circumstances and characteristics that nature has divided among many. From such a combination, ingeniously arranged, results the kind of successful imitation for which a good artificer deserves the title of inventor and not that of a servile copyist. (*Diario de Madrid,* translation © by Professor José López-Rey)

This statement is interesting for many reasons, and it is important in the context of imaginative art, because the artist disclaims recourse to the art of others and claims for himself the gift of invention. Living in the Age of Enlightenment, Goya professes to expose the night world of human conduct and imagination to the clear light of reason. One of the most famous of the plates in the series is that in which the artist has shown himself sleeping at his writing table (Fig. 546). Behind and from out of the darkness, presumably of his subconscious, comes a flight of owls and bats. Written on the desk is, "The sleep of reason produces monsters." In the ink drawing for this etching, Goya wrote; "Universal Language. Drawn and Etched by Francisco de Goya. Year 1797." The word "Dream" was also written on the upper part, and below the drawing was added; "The artist dreaming. His only purpose is to banish harmful, vulgar beliefs, and to perpetuate in this work of caprices the solid testimony of truth." Beneath the etching Goya noted; "Imagination deserted by reason, begets impossible monsters. United with reason, she is the mother of all arts, and the source of their wonders." Despite these writings by the artist, the intention of *Los Caprichos* is still open to conjecture. The great number, strength, and inventiveness of these etchings show the artist's obsession with the power of dreams, hallucinations, and visions of superstition, with human subservience to passions, response to impulses, and indulgence in folly (Fig. 370). Goya was tormented by deafness and concern over his own mental equilibrium, and we can only speculate on how much of *Los Caprichos* is personal fantasy. His own mind may have been at times disordered by sickness and anxiety.

The choice of etching, a medium of blacks, grays, and whites, was appropriate for this invisible world. When Goya showed human beings, they often acted like monsters. In his etching *They Make Their Toilet* (Fig. 547), monsters act

with the vanity of humans. The grim and the ludicrous intermingle in this conception of foul creatures preoccupied with what may strike us as hygiene; the inscription reads, "Long nails are so harmful that they are forbidden even among the witches." Goya's *hybrids,* beings that are part human, part animal, and part bird, lack the decipherability of those that appear in the work of such an artist as Bosch. The vague separation between human and animal in the faces of the witches reflects the artist's interest in the old studies of correspondences between certain types of human and animal physiognomy and the belief that physical ugliness was proof of the soul's corruption. Goya's etchings were based on his own drawings, but often the print is stronger in using a motif, such as the witch's nail that is about to be cut, as a menacing shape elsewhere, for instance, in the scissors and wings. The many textural gradients he extracted from the etching process made possible the evocation of convincing textures for wings and flesh, as well as the dark mysterious depths and spaces in which these monsters thrived. Whether or not Goya was in the grip of a vision when he did these drawings and prints, we do not know. Their careful working and reworking in large and small areas does show the artist's persistent consciousness of the necessity of converting the conception into art.

Redon and the Logic of the Invisible After his death Goya's work was greatly admired in France during the 19th century, but only one French artist made comparably imaginative prints. Odilon Redon (1840–1916), though less well known today than such of his contemporaries as Monet, Seurat, and Gauguin, was the great 19th-century French artist of fantasy. His reputation is based on many charcoal drawings, lithographs, and pastels, works that have no resemblance to the art of the 19th century discussed in Chapter 14. From the late 1860s through the first part of the 20th century, Redon refused to direct his vision toward the external world and the production of pleasing subjects after the manner of the Impressionists. He wrote in 1868 that the concerns of Manet and the Impressionists constituted a restricted and paltry research and that while true artists

> recognize the necessity for a basis of *seen* reality, to them true art lies in a reality that is *felt.* . . . We must remember that we have other things than the eyes to satisfy, that we carry in ourselves . . . troubles, joys or pains to which the great artist knows how to address himself.

One can understand Redon's imaginative alternatives to Impressionism by comparing his lithograph showing a window (Fig. 548) with any of the 19th-century window views in Chapters 14 and 21. For Monet, Pissarro, Caillebotte, or Bonnard, the window looked out upon the real world of the city. Redon shows us a segment of brightly illuminated tree through his window. But as we focus on our side of the window, we see that this is no ordinary room and that

below left: 548. Odilon Redon. *The Light of Day,* from *The Dream* series. 1891. Lithograph, 8¼ × 6⅛″ (21 × 16 cm). Bibliothèque Nationale, Paris.

below right: 549. Odilon Redon. *Swamp Flower, a Sad and Human Face,* from *Hommage à Goya.* 1885. Lithograph, 10⅝ × 8″ (27 × 20 cm). Bibliothèque Nationale, Paris.

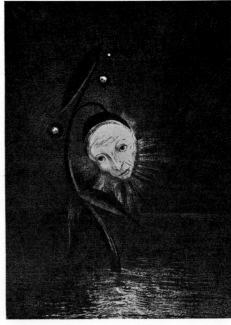

vague, softly luminous shapes hover in the darkness. It is as if Redon were metaphorically showing us the mysterious dark world that exists behind the human eye. What we see through the window we can describe, but what lies in front of it has been only *suggested,* not defined, and this is the goal of his poetic thought. Of his drawings, he wrote that they "inspire yet cannot be defined. They do not determine anything. Like music, they transport us into the ambiguous world of the undetermined."

Redon deliberately cultivated his subconscious as a source for his imagery; he also relied upon the stimulation he received from working in charcoal and lithography. In a letter of 1898, describing how he worked, Redon confessed:

> A sheet of white paper horrifies me. It impresses me disagreeably to the point of making me sterile, of depriving me of the taste for work. . . . I am forced as soon as it is on an easel, to scrawl on it with charcoal, with crayon or any other material, and this operation brings it to life. I believe that suggestive art owes much to the stimulus which the material itself exerts on the artist.

Redon went on to describe how he abandoned himself to fantasy:

> Fantasy is also the messenger of the "unconscious" . . . nothing in art is achieved by will alone. Everything is done by docilely submitting to the arrival of the "unconcious." The analytical spirit must be quick when it appears, but afterwards it is of little importance to remember it.

The fantastic world created by Redon was not intended, as Goya's probably was, to comment on the people and behavior of his time. It is a private world of immeasurable spaces and often of infinitesimal beings. Of great influence on Redon was the work of a gifted French biologist named Armand Clavaud, who introduced the artist to the world of the microscope, of natural history, and, especially, of botany. Redon was obsessed throughout his life with finding a logical structure for his imaginary beings that would parallel the newly discovered laws of biological life. His *Swamp Flower, a Sad and Human Face* (Fig. 549) was part of a series of lithographs that he dedicated to Goya. Rising from an endless expanse of water beneath an infinite black sky, Redon's imaginary growth blossoms into a radiant but lugubrious head, whose like cannot be found in the work of any other artist.

Of great importance for artists who followed him in spirit, among them André Masson (Fig. 557), were such statements by Redon as "My orginality consists in bringing to life, in a human way, improbable beings and making them live according to the laws of probability, but putting— as far as possible—the logic of the visible at the service of the invisible." In 1880, when Monet and his contempories were intent on capturing the painterly equivalences of natural light and on abandoning the human-figure landscape, Redon wrote prophetically of himself and many artists who

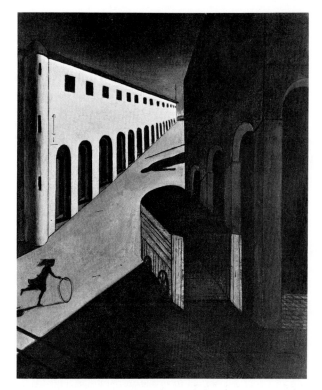

550. Giorgio de Chirico. *The Mystery and Melancholy of a Street.* 1914. Oil on canvas, $34\frac{3}{8} \times 28\frac{1}{2}''$ (88×72 cm). Private collection.

would follow him: "Man is a thinking being. Man will always be there; whatever the role played by light, it won't be able to turn him aside. To the contrary, the future belongs to the subjective world."

De Chirico and Enigma Down to the 20th century, much of fantastic art was obviously involved with the creation of the monstrous, in the form of unnatural hybrids, and of strange inaccessible places existing only in the imagination. While this trend continued in the work of certain modern artists, the sources and character of fantastic art have changed considerably in our time. More and more after 1900, artists followed the precedent of Redon, whether consciously or not, and departed from literature, previous art, and moralizing as sources for their imagery. Chapter 16, "Art, Objects, and the Object of Art," provided an introduction to Giorgio de Chirico's imaginative handling of objects (Fig. 438). In his *Mystery and Melancholy of a Street* (Fig. 550), we again meet this new type of imaginative art in terms of a person and a place. Everything in the painting is recognizable or familiar—the arcades, the open, old-fashioned railroad van, the child rolling a hoop, the projecting shadows. What gives De Chirico's painting the quality of the uncanny is his intentional divorce of such things as light,

shadow, space, and silence from their previous rational associations in pictorial construction. They are transformed into enigmas, or unexpected inversions of what they ought to be. As if through a window or from a balcony, we look down on a scene that is unfolding before us. Things are not as they first seem. Perspective lines of the buildings do not recede to a common vanishing point; the angles of shadows are inconsistent with a single light source; the sky is green. In the painting's context, we tend to read the child against the van, which, while open, is so stationed as to conceal part of its interior. De Chirico is a painter who poses but does not answer questions. He gives us no program notes or literary sources to transcribe his image. His poetic gift is be be haunted by irrational situations, and when he paints these images he preserves their irrationality. The spaces of Dürer, Grünewald, Callot, and Goya are formed according to perspective devices employed in the depiction of rational subjects. De Chirico's illusionistic world is constructed on the basis of an intuitive or irrational use of devices originally evolved for the rationalization of sight. In his memory, De Chirico distilled certain physical, cultural characteristics of his native Italy, and while living in Paris between 1911 and 1914, he painted not a world remembered literally, but one that became a backdrop for mysterious relationships and unexpected encounters. Silence, which he sought to evoke in paintings, had for De Chirico different characteristics, depending upon whether, for example, it existed before or after a catastrophe. Except for Redon, in the previous art of fantasy, noise was assumed or suggested. De Chirico's art was a refuge from or an alternative to the waking world of reality, an art of great personal consolation despite its disturbing qualities. In the same year he did the painting illustrated, De Chirico wrote:

> To become truly immortal a work of art must escape all human limits: logic and common sense will only interfere. But once these barriers are broken, it will enter the regions of childhood vision and dream. Profound statements must be drawn by the artist from the most secret recesses of his being. . . . What I hear is valueless; only what I see is living, and when I close my eyes my vision is even more powerful. It is more important that we should rid art of all that it has contained of recognizable material to date; all familiar subjects, all traditional ideas, all popular symbols must be banished forthwith. . . . We must hold enormous faith in ourselves; it is essential that the revelation we receive . . . which has no sense in itself, which has no subject, . . . means *absolutely nothing* from the logical point of view.

How personal was this world and how reflective of his temperament can be seen when *Mystery and Melancholy of a Street* is compared with a painting done by a Russian-born artist working in Paris at the same time.

Chagall and the Reality of the Interior World The imaginative, private world of Marc Chagall (b. 1887), which he painted in *I and the Village* (Pl. 50, p. 368) while living in

Paris in 1911, differs from that of De Chirico by its abundant qualities of joyfulness, warm sensuality, fragrance, and delightful vertigo. In his private souvenir of a childhood in Vitebsk, Chagall painted a green-faced boy holding a sprig of blossoms and confronted by the transparent head of a donkey. Surface and depth, right side up and upside down, freely interchange—Chagall's picture of loving, pleasurable memories resists translation into the normal language and syntax of rational painting. Both Chagall and De Chirico bring to modern painting the practice of free association whereby the selection and conjuction of objects or motifs are irrationally suggested to the artist during the conception or execution of the work. Chagall felt, however, that these associations also had to work in terms of the structural needs of this painting. The circle and X forms in the lower center of the painting may have had some private symbolism for the artist, but they also serve to unite disparate formal motifs on a common surface. De Chirico restored to painting the dramatic power of deep, clear space, whereas Chagall created an immeasurable, untraversable environment of which one cannot write about solids and voids or the consistent diminution of size related to a fixed viewpoint. Scale, color, and solidity, or transparency of figures and houses are not the function of a detached or objective observer from whose physical vantage point the scene is constructed. Rather, these properties reflect the weight and impulse of feeling and fantasy in the painter. Older artists interpreted another person's vision in pictorial terms that, like the literature in which dream experiences were recorded, served to codify the means of dealing the irrational. Chagall, De Chirico, and the artists that follow their example fight codification or intelligibility on a public level. Years after *I and the Village* Chagall wrote:

> There is nothing anecdotal in my picture—no fairy tales—no literature in the sense of folk legend associations. . . . For me a picture is a plane surface covered with representations of objects—beasts, birds, or humans—in a certain order in which anecdotal illustrational logic has no importance. The visual effectiveness of the painted composition comes first. . . . I am against the terms "fantasy" and "symbolism" in themselves. All our interior world is reality . . . perhaps more so than our apparent world. To call everything that appears illogical, "fantasy," fairy tale, or chimera would be practically to admit not understanding nature. . . . The fact that I made use of cows, milkmaids, roosters and provincial Russian architecture as my source forms is because they are part of the environment from which I spring and which undoubtedly left the deepest impression on my visual memory of any experiences I have known. Every painter is born somewhere . . . certain essence—a certain "aroma" of his birthplace clings to his work. But do not misunderstand me: the important thing here is not "subject" in the sense pictorial "subjects" were painted by the old academicians. The vital mark these early influences leave is, as it were, on the handwriting of the artists.

Both De Chirico and Chagall would have been very different and less effective painters if they had not come to Paris while still very young. At the turn of this century, the

exciting art environment of Paris acted as a liberating force on the imagination as well as on the styles of many young painters (see pp. 307–11, 361–62). Cubism, for example, was the artist's declaration of independence from the world of appearances. Both De Chirico and Chagall were influenced by it, despite the fact that they could not content themselves with imitating the forms of Picasso and Braque, nor be wholly satisfied with Cubism's dark colors and conventional subjects of still life and the figure. When the Cubists broke up the closed character of objects and destroyed rational, measurable space, this was a crucial breakthrough of old boundaries for painters who by inclination believed that the world one sees with the eyes closed should preserve its imaginative qualities in painting.

It is in the 20th century, beginning with such artists as Chagall, that *originality* becomes a conscious aim for the artist. Following the Middle Ages, artists sought individuality, but Chagall wanted an art that did not look like anything that had come before or that could be seen in his time. Goya claimed for himself the title of inventor, but his drawings and prints are at times closer in spirit or form to those of Rembrandt (see Chap. 11) and Callot than are Chagall's paintings to the work of any other artist. This imperative of originality derives largely from the 19th-century ethic of faithfulness to one's own experience in a style personally acquired.

Inside *The Bride* In that period before World War I during which there were so many formal and psychological breakthroughs in modern art, one of the most important innovations was the imaginative interpretation of the internal nature of the human body by denying its surface appearance. More famous for his *Nude Descending a Staircase* of the same year—which was described somewhat pejoratively by President Theodore Roosevelt as resembling "an explosion in a shingle factory"—French-born Marcel Duchamp painted in 1912 *The Bride* (Fig. 551). *The Bride* avoids all that is sentimentally associated with the title—something old, something new, something borrowed, something blue—in favor of showing woman as consisting of a complicated pumping and filter plant. The painting is at once an imaginative dissection of both the body and public taste. With the detached attitude of an anatomist, Duchamp ironically reconstructs the inner organs in terms of mechanical and quasiorganic forms, a network of pipes and filters, painted in a brownish color, with a slick, even slippery, type of surface that, more than the individual objects, conveys a visceral quality to the whole. In *The Bride,* we can see the beginning of this artist's fantasies about sex and science. Unlike the moralizing of Hieronymus Bosch, whose cynical views of man led him to invent human-animal-mechanical hybrids, Duchamp's conception is divorced from a moralistic frame of reference and derives from personal reflections on the nature and purposes of art. He later wrote, "A painting that doesn't shock isn't worth painting."

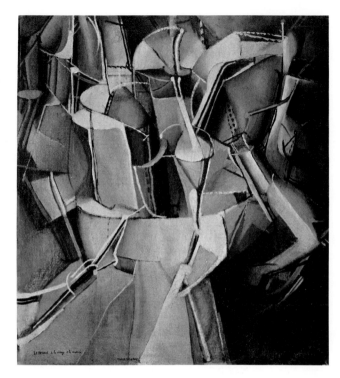

551. Marcel Duchamp. *The Bride (Le Passage de la Vierge à la Mariée).* 1912. Oil on canvas, 23⅜ × 21¼″ (60 × 54 cm). Museum of Modern Art, New York (purchase).

Max Ernst and "No-sense" Art During and after World War I, artists of many nationalities continued to explore the possibilities of art based upon free association, intuition, or the logic of the illogical. Between about 1915 and 1922, there was a loose international confederation of artists who called themselves *Dadaists,* the French word *Dada,* meaning "hobbyhorse," supposedly having been picked by chance from a Larousse dictionary. It was a movement dedicated to art that made no sense, one that championed irreverence and irrationality and disclaimed all system or aesthetic pretensions(which in itself required a system). It was the first movement in art history openly to seek originality and a complete break with the past. Painterly technique and style itself were damned by most of the group, who sought a directness in their imaginative images, thereby opposing what they felt was the cult of painterly virtuosity or individuality. Their appeal to the public was intended to be on the instinctive rather than on the conscious or verbal level. Dada believed that the unexpected was as much a part of life as the predictable and infinitely more stimulating to creativity and audience response. One of the most imaginative and productive of the Dadaists was the German-born Max Ernst (1891–1976). In his desire to move away from Western technical traditions, he developed the collage beyond where the Cubists had taken it and elevated it from a

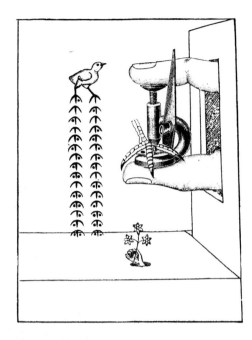

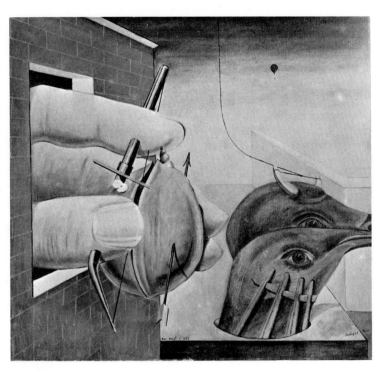

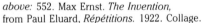

above: 552. Max Ernst. *The Invention,*
from Paul Eluard, *Répétitions.* 1922. Collage.

means to a principle of organization, composition being the
one rule from the past observed by the Dadaists. In his col-
lage *The Invention* (Fig. 552), Ernst cut out 19th-century
wood engravings of objects and pasted them into a new
context. The title may refer to the process of assembling the
picture, for Ernst captioned his works after they were done
according to the ideas suggested to him by the finished
pieces. He transferred to painting the principle of irrational
juxtaposition of familiar objects in unexpected situations or
locations. Ernst liked to repeat a phrase by the 19th-century
poet Isadore Ducasse (known as the Comte de Lautréa-
mont): "Beautiful, like the chance meeting on a dissecting
table of an umbrella and sewing machine." Ernst's painting
Oedipus Rex (Fig. 553) seems to have been based upon *The
Invention,* but now the artist added a new and unpleasant
simulation—while extended through the window, the
fingers are penetrated by the object they hold. The painting
was done with methods that were almost reactionary in
their academic rendering of objects and space, reflecting
Ernst's reaction against the earlier revolutionary styles
of Cubism; they were the basis of his appeal to the good
taste of such artists as Matisse. By these reactionary means,
Ernst was able to achieve the total illusion of his subject
without imposing on the spectator's consciousness evi-
dence of his hand and brush. In this alone was Ernst like
Bosch, for the Dadaists did not set good against evil. The
absurd was a fact of life for them, and they believed art must
accept this condition and act accordingly.

above: 553. Max Ernst. *Oedipus Rex.* 1922. Oil on canvas,
35 × 45¾'' (89 × 116 cm). Private collection.

Dali's Hallucinations Since the 1920s, imaginative art
has polarized around two essentially different modes of
expression. One of these modes has, since the appearance
of Ernst's *Oedipus Rex,* been expressed by artists creating
illusionistic irrational images in painting whose deep, three-
dimensional space approximates, in many respects, that of
older illusionistic art. The objects filling these spaces are
often, either by themselves or in their components, based
upon what is available to us in the external world. For the
Surrealists and their satellites, from 1923, the aim of paint-
ing was to cull scientifically from the subconscious. The
"inner world" was thought to be of a higher reality than the
external world. They adopted the Dadaists' device of work-
ing from free association and making an unpredictable jux-
taposition of the familiar.

The artist whose work epitomizes the illusionistic, imag-
istic, "hand-painted" dream picture of Surrealism is Salva-
dor Dali (b. 1904). He created his most inspired and sincere
works during the late twenties and early thirties. One of
these, *The Persistence of Memory* (Fig. 554), contains sub-
jective, obsessive features such as the rocky coast of
Spain, the arid plain, and the startling confrontation of
"melted" watches with a fetal form and a dead tree posi-
tioned on a blocklike object. Frequently, Dali would paint a

picture in parts, working on individual areas and objects as they appeared to him in hallucinations often induced by the austere act of staring at the blank canvas. The limpid time-pieces may have been punning references to the artist's conceit of bending time to his will or perhaps to childhood regressions in which Dali compared the exposure of his soft tongue to the molten watches. The French word for watch is *montre,* as is the familiar imperative of the verb *montrer* ("to show") used by a doctor asking a sick child to expose his tongue. Dali drew freely upon his own extraordinary and disturbed past for ideas that his mastery of academic drawing enabled him to render with dazzling precision.

The enactment of Dali's psychologically inspired dramas usually takes place in a profound, lucid space. The paradox he loved was this exact transcription of what seemed to make no sense: the juxtaposition or fusion of unrelated objects; inversions of the familiar or of expected properties of the animate and inanimate; double images like those of his own head, but images that resist programmatic translation, unlike those in Arcimboldo's work (Fig. 545); the mingling of animal, vegetable, and mineral motifs into a molten hybrid.

Many Surrealists did not look upon their work as art but as scientific documents in the systematic exploration of their own subconsciousness. They sought to liberate creativity from mechanistic materialism; but, paradoxically, instead of freeing the mind, they established new and strict limits for creativity. Reason was denied any function (which disqualified the Surrealists as scientists), and, in the words of Herbert Muller "the studio in the psyche became an underground dungeon."

Like many movements in modern art, Surrealism was not homogeneous, and many artists accepted only certain aspects of its program. Its great value was in demonstrating the possibilities of instinctive creation and in opening up new sources of imagery, thereby widening to a generous new dimension the *possibilities* available to artists.

Magritte's Dislocations The difficulty with a word like *Surrealism,* as with many art labels, is that it does not describe, illustrate, or explain what the artists identified with it have done. There is little agreement in style, subject, or intent among the various Surrealists, beyond what they will *not* show—the external world in terms of its familiar logic of appearance. The Belgian artist René Magritte (1898–1967) gave us paintings that are exact transcriptions of what he saw as the "unexpected" in the visible world. His *Six Elements* (Fig. 555), for example, shows six framed seg-

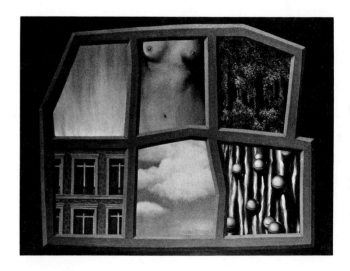

left: 554. Salvador Dali.
The Persistence of Memory.
Oil on canvas, 9½ × 13″ (24 × 33 cm).
Museum of Modern Art, New York (anonymous gift).

above: 555. René Magritte. *The Six Elements.* 1928.
Oil on canvas, 28⅞ × 39½″ (73 × 100 cm).
Philadelphia Museum of Art
(Louise and Walter Arensberg Collection).

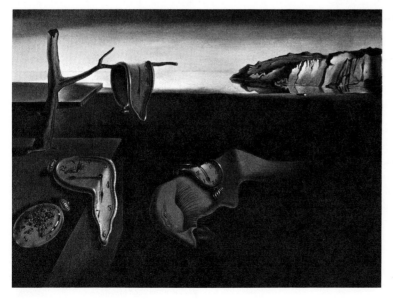

ments of subjects that in themselves are describable, but once we have made this simple, rational observation, we can go no further in explaining why these subjects and scenes are where they are. Magritte used the device of a window frame (or picture frame), which we normally associate with views of the familiar, external world. Yet, in imaginative painting of the 20th century and that dating back to Redon, the window is no longer associated with conscious experience. Even Magritte's framing device is out of joint, inflected or bent in a way that is comparable to the dislocation in the expected sequence of his subjects. Writing about his intentions, Magritte said:

> The art of painting, as I conceive of it, consists in representing through pictorial technique the *unforeseen* images that might appear to me at certain moments whether my eyes are open or shut. . . . I readily avoid explaining the things I love . . . we get no enrichment from a thing explained. In effect, the thing explained drops out of sight in favor of the practical explanation itself or a more or less intelligent hypothesis.

Magritte thus plays against our natural inclination to rationalize what we see. He wants to evoke the mysterious and the unpredictable in the commonplace subjects that we accept every day without second thought (Fig. 448). *What*

he paints is paramount, but Magritte takes little pleasure from the act of painting. Because for this artist painting is the most effective instrument for realizing his revelations, he does not want his work to be viewed primarily for its aesthetic quality.

Still, the possibilities of painting private fantasies have attracted artists who feel passionately about painting itself and who pride themselves on the inventiveness of their forms and color and on the power of their art to move the viewer aesthetically as well as through thought and feeling. Such an artist was Max Beckmann, whose paintings, while not Surrealist, reveal his involvement with some of the major problems confronting modern artists committed to the exploration and use of their own imagination for new and experimental artistic purposes.

Beckmann's *Departure* In adhering to the morality of being true to one's own experiences and needs, many of the most creative artists of this century have, without question,

556. Max Beckmann. *Departure*. 1932–33. Oil on canvas; center 7'3¾'' × 3'9⅜'' (2.15 × 1.16 m), sides 7'3¾'' × 3'3¼'' (2.15 × 1 m). Museum of Modern Art, New York (anonymous gift).

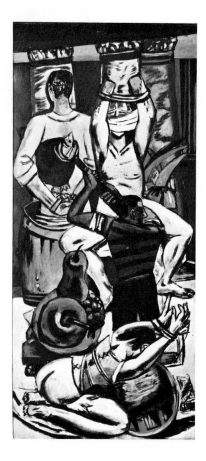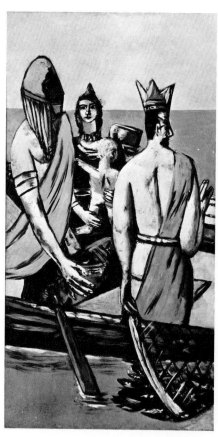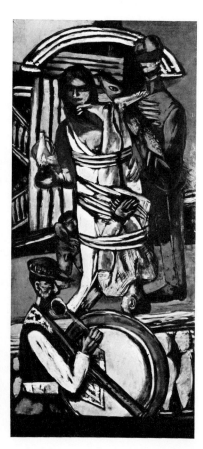

produced works that are largely unintelligible to the general public. Frequently, when artists have wanted to express something of importance to mankind, the very nature of their meaning, which like their form is partly derived from intuition, has been incompletely or inconsistently understood by the public. It is not at all unusual for the meaning of a complex painting to change for the artist while the work is in progress and even subsequent to its completion. One of the most powerful personal statements by a modern painter, expressing the complex of his responses to himself, to his times, and to the history of the human race, is the three-panel painting by Max Beckmann entitled *Departure* (Fig. 556). It was painted in Berlin in 1932 and 1933, following Beckmann's dismissal by the Nazis from his directorship of an art school. Fearing confiscation of his painting, the artist wrote on the back of the canvas, "Scenes from Shakespeare's Tempest." The panels were not, however, the illustration of a literary source. Beckmann's hope was that the sympathetic viewer would meditate upon all three panels at once. He felt that their visual interrelationship would reveal his intentions. Historically, such three-panel paintings had precedents in Christian altarpieces, and it is possible that Beckmann intentionally revived this format, with its religious connotations, as the vehicle for his reflections on human spiritual history. The two flanking panels are narrower, darker, and more congested than the central one and are filled with unpleasant images of torture, noise, and nightmarish situations. By its greater size, its bright spaciousness, and the freedom of movement available to its characters, the center panel immediately establishes a different, more hopeful, but solemn mood and implication. Thus, even before we examine individual figures or speculate on the significance of gestures, we can sense the importance of these fundamental and readily apparent major contrasts, just as T. S. Eliot believed that an artist begins to communicate before he is understood. Like the work of other modern artists who attach symbolic significance to objects and gestures, Beckmann's previous art does not give us the basis for interpreting his imagery, for the German painter has not been consistent from painting to painting in the associations or values he has assigned to the same contents. Each object must be related to its particular context. The brutality in the left panel may relate to Nazi tortures, of which Beckmann was all too well aware. This, however, is not made explicit, and the artist would have considered a more direct statement a limit to the scope of his painting's potential reference. While inventorying the indignities and violence to which the human body has been subjected, not unlike Goya in *May 3, 1808* (Fig. 370) and *Los Caprichos,* Beckmann surprises us by not introducing a plausible weapon or instrument for violence. We cannot even be sure that the stripe-shirted figure is an executioner. The settings of the framing panels are a curious mixture of references to a columned room and a stage. Their ambiguity makes it impossible to localize the action.

There is also an intriguing mixture of clothing that ranges from the uniform of a bellhop and the drummer's ermine collar to the ancient draperies and crown of the central figures. This should remind us that Beckmann does not want to specify the who, when, where, what, and why of *Departure.* In a letter to a friend, he set down his thoughts on the painting:

> The center is the end of the tragedy, but the meaning can only be understood by the three parts together. Life is what you see right and left. Life is torture, pain of every kind—physical and mental—men and women are subjected to it equally. On the right wing you can see yourself trying to find your way in the darkness, lighting the halls and stair-cases with a miserable lamp, dragging along tied to you as a part of yourself, the corpse of your memories, or your wrongs and failures, the murder everyone commits at some time of his life—you can never free yourself of your past, you have to carry that corpse while life plays the drum. In the center, the King and Queen have freed themselves, freed themselves of the tortures of life. They have overcome them. The Queen carries the greatest treasure—Freedom—as her child on her lap. Freedom is the one thing that matters—it is the departure, the new start.

On another occasion Beckmann said, "Departure, yes departure, from the illusion of life toward the essential realities that lie hidden beyond." It is as if he is commenting on the timelessness of oppression, but also on the capacity of the human spirit to overstride evil and to renew itself. Where Beckmann's *Departure* and Picasso's *Guernica* (Fig. 530) share a common ground is in their mingling of violent myth with the contemporaneous fascist movement of the 1930s, in their interpretation of a subject that was topical yet timeless, in the horror they both felt at the forces of inhumanity, in their hope for the survival of the spirit.

Automatism and Imaginative Painting

All the imaginative art illustrated so far in this chapter has had an illusionistic character, its subjects exhibited as if in a three-dimensional world existing behind the surface of the painting or print. Further, it has been possible to relate and identify objects and figures, entities physically complete despite their often hybrid makeup. Shortly after World War I, at about the time the work of the Alsatian artist Hans Arp began to appear, and during the early 1920s, there evolved an immensely fruitful and influential device for the creation of works of art, one that was employed by artists expressing a wide range of temperaments and styles. This was the device known as *automatism,* and it has been adopted in a nonillusionistic context emphasizing the surfaceness of the drawing or painting by such artists as Masson, Miró, Gorky, and Pollock (Pl. 37, p. 297), who produced much of the best art to appear between the two wars. Automatism has had continued, widespread use since 1945, and it is the second of the two major modes that have engaged the interest of artists whose works explore the imagination.

557. André Masson.
Battle of Fishes.
1927. Pencil, oil,
and sand on canvas;
14¼ × 28¾″ (36 × 73 cm).
Museum of Modern Art,
New York (purchase).

The earliest and most important definition of automatism was given by the French writer André Breton, who became the leader, high priest, and chief impresario of Surrealism. Writing in the *First Surrealist Manifesto* of 1924, Breton said, "SURREALISM. Pure psychic automatism by which one seeks to express, be it verbally, in writing or in any other manner, the real workings of the mind. Dictated by the unconscious, in the absence of any control exercised by reason and free from aesthetic or moral preoccupations." Automatism in literature and music would be called "stream of consciousness" and jazz improvisation. The average person practices automatism in "doodling" or saying the first thing that comes into one's head. Many of the artists employing automatism did not live up to its literal definition or to Breton's injunction not to let reason enter into the creative process at all. The artists' previous training and commitment to composition, as well as their taste, undoubtedly played some part in what they did. The historical emergence of automatism was related to the concern of many artists with the problem of how to be truly creative in a mechanistic world and the belief that reason could not tap all the potential important imagery in an artist's makeup. Automatism was thought to be essential to the "liberation" of the subconscious.

The automatist drawings and sand paintings produced by André Masson (b. 1896) between 1924 and 1929 illustrate perhaps the purest utilization of this artistic device. He approached the sheet of paper or canvas with no preconceived image in mind. To stimulate or irritate his imagination, he sometimes fixed sand to the canvas but, again, with no predetermined or definite configuration (Fig. 557). As if in a trance, Masson let his pen or brush move across the surface until he began to see possible images emerging. Thus his "painting" began abstractly and then, with the introduction of certain instantaneous judgments, moved in the direction of a human configuration.

I begin without an image or plan in mind, but just draw or paint rapidly according to my impulses. Gradually, in the marks I make, I see suggestions of figures or objects. I encourage these to emerge, trying to bring out their implications even as I consciously try to give order to the composition.

These decisions did not interrupt the continual movement of his hand, however. When the possibilities of a certain image became apparent, Masson made them more articulate, but he never took his drawing or painting to the stage where it became literal. During the process of evoking the final configuration, the artist was both creator and spectator, observing what resulted from his unconsciously controlled hand movements. Masson and other artists in the mid-1920s considered what they were doing to be "beyond painting," but they were not antiart. Like much that has happened in this century, the history of Masson's work is that after it made, the word *art* was stretched to encompass it. (*Art* is probably the most elastic word in language.)

A second artist who, like Masson, produced many of his most important paintings in the 1920s and worked "automatically," was the Spaniard Joan Miró (b. 1893). We can see the consequences of Miró's assimilation of the automatic method and how it radically altered the look and meaning of his art in two paintings. The first, entitled *The Farm* (Fig. 558), was done in 1921–1922, while the artist was at his home in Montroig, Spain, and then in Paris. For the picture he used souvenirs of his beloved homeland. The intense particularization of all objects in an airless space contributes to their charm and eventual ambiguity. Simultaneously, we are given the diversity and unity of a staggering number of objects, so that we become aware of a conjugated series, of visual puns based on holes and circular patches, scalloped and peaked shapes, radial spoke forms in the trees and grass, parallel diagonals and horizontals in roof and earth. The vivid interest of the painting comes from the even distribution and the avoidance of overlap in a wide range of shapes, from the tiny pebbles through the buildings and trees to the infinity of the sky.

The fantasy incipient in *The Farm* was unchecked in Miró's *The Hunter (Catalan Landscape),* reproduced as

Plate 51 (p. 385). Suspended upon a flat surface of yellow above the pink below is an aggregate of line and shapes derived from the earlier painting. Now, however, the drawing suggests the object, so that the undulating line lives a ubiquitous life as a mustache, the horizon, an animal body, waves, and birds. Certain shapes and lines obsessive to Miró are now dissociated from the objects that generate them. There is a playful mocking of geometry in the use of the ruled line and the triangle. First, the triangle appears in its more familiar state at the lower left, but then it becomes part of the rabbit's tail just to the right and, above, the hunter's head. The pipe-smoking hunter has a large ear, not inappropriate for the chase, an exposed heart, and a scraggly beard whose mossy shapes appear on the wall of the farmhouse in the earlier painting. The dotted trail that he follows meanders playfully against the lines of his body and arms. Influenced by his contact with Cubism, Miró detached a large eye from a head and introduced the letters S A R D, perhaps from the Spanish word *sardana,* a Catalan folk dance. The earlier disposition of elements has become more random and whimsical. The range from minute to large is retained from the earlier work, but here Miró has magnified and reconstituted certain objects, such as the rabbit and insect forms, in a much more arbritary way, according to the weight of the objects in his general awareness of them and the dictates of fantasy. While vestiges of a

scene or a subject remain, they are accompanied by less decipherable elements, and the painting's poetry is more obvious in its rhymes, more arcane in its meaning. There is no longer the intent to follow the logic of nature's appearance. Miró's creatures live only on the surface of the painting. The artist's full conversion to an art based not upon the restraint of reason but upon the encouraged, instinctive, or automatic outpouring of fantasy was complete and moral.

The great stylistic divergence possible in art induced partly by the practice of automatism can be seen in a comparison of Miró's painting with one by the Armenian-born American artist Arshile Gorky (1904–48), entitled *The Liver Is the Cock's Comb* (Pl. 52, p. 385). Miró's motifs are cleanly drawn, and they float in an airless, imaginary, and seemingly limited space or on the painting's surface. Gorky's configurations are still more illegible and difficult to decipher, being tortured twistings that fuse or separate in an intensely congested environment. Color ranges from deep earth tones to hot patches, and none of the color is related to the linear outlines. The artist's technical range in manipulating his paint is far greater and more subtle than Miró's. Gorky derived his imaginative composition from a drawing or, as he thought of it, a blueprint, in which he mingled fantasies about things directly observed in nature, visions of internal human organs, recollections of art he had seen, and a consciousness of the need for composing his crea-

558. Joan Miró. *The Farm.* 1921–22. Oil on canvas, 4'½'' × 4'7¼'' (1.23 × 1.4 m). Private collection.

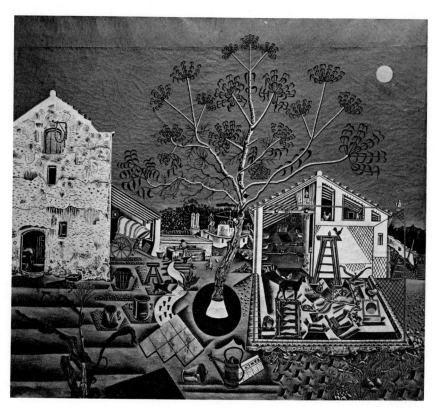

tions so that they made sense in terms of the painting's form. The title of the work is in no way related to the painting's inception and provides no clue to its interpretation. Often Gorky's titles were suggested, at his invitation, by friends. He was not the first artist to rebel against the "tyranny of the title." Gorky demanded an audience that would pay attention to his painting, not to the words by which it was labeled. With Surrealism, as Gorky's biographer Ethel Schwabacher has written, "art entered into man," which implies that artists were exteriorizing through art, as directly as possible, the inner world of their own feelings and imagination. Gorky, in turn, wanted his painting to enter, through sympathetic eyes, into the consciousness and subconsciousness of his audience. With time, one becomes aware not only of the implied violence of the motifs and strong sexual references, but also of the beauty of the drawing, the painter's intimate handwriting, with its delicate or vehement passages, the careful adjustment of colors to one another, and

the shape they share with the linear fabric of the composition. To content oneself with a game of hide-and-seek or a few conclusions about a specific passage is to deny the occasion for seeing and feeling the conception of a Gorky painting as a whole, with its abundance of interrelationships that resist exhaustion throughout a long and continuous association.

It is indeed true that much of modern imaginative art deals with the unpleasant and that for many people its form poses a parallel problem in being contrary to conventional taste. Even our synoptic sampling of older art derived from irrational experience has shown us that there is a precedent for art's contradiction of the polite, the prudish, and the pleasing. Tradition and familiarity make Goya and Bosch acceptable to those who are rankled by Gorky or the French artist Jean Dubuffet (b. 1901). One cannot guess how many times during exhibitions the images in Dubuffet's *Corps de Dame* series (Fig. 559) have been lik-

559. Jean Dubuffet. *Sang et Feu.* 1950. Oil on canvas, 45⅝ × 35⅛″ (116 × 89 cm). Courtesy Robert Elkon Gallery, New York.

ened to a naked woman run over on a newly paved street. Second in frequency might be the comment that they look like something scrawled on a wall in a public rest room. While Gorky paid homage to the "cookery" of brush painting, Dubuffet literally concocted his own recipes for paint and other substances in order to achieve a medium that would stimulate his imagination. By incising his lines with the end of a paintbrush or a stick, he has invited comparison with defacement of walls; in fact, Dubuffet, once a middle-class wine merchant, spent many years in the study of *l'art brut*—the "raw art" or "unschooled, unadulterated art" made by psychotics, children, and the "self-taught" draftsmen who leave their mark in public places. What he finds interesting is the direct, frank character of this type of art, its expression of a repressed side of men and women.

The *Corps de Dame* series (which Dubuffet followed with a comparable treatment of men) submitted the body to brutal handling, not by someone in the painting, as in paintings of anatomy dissections or martyrdoms (Figs. 241, 242), but by the artist himself. Ugly women are to be found in Leonardo's drawings from deformed subjects, in Goya's *Los Caprichos* as symbols of vanity and evil, and in countless caricatures, but Dubuffet's predecessors in Western post-Renaissance painting located their gruesome subjects in a world of space and light and sought to make them appear as lifelike as possible. Dubuffet has said that in doing the series, he was working with "a general concept," which prevents our assuming he intended moralizing caricature or scientific investigation. Dubuffet has said his women exist in "a state of immateriality"; they are made of and live in the substance of the medium used. One can only conjecture whether Dubuffet's conception is a personal antidote to the popular notion of "woman" created in France by contemporary mass media.

In the same year that Dubuffet was doing his *Corps de Dame* pictures in Paris, the Dutch-born American Willem de Kooning (b. 1904) began in New York a series called *Woman*, which he continued for the next three years and intermittently thereafter to the present time (Pl. 53, p. 386). Despite the coincidence of dates, no conscious influence occurred between the two. De Kooning's *Woman* series grew out of paintings he had done in the 1940s involving both the subject of the feminine form and abstraction. Sometimes referred to as *Abstract Surrealism,* De Kooning's work depends in part upon automatism and the spontaneous release of ideas. In it, however, the ideas are continually subjected to destruction and reconstruction during vigorous painting operations, so that there is no point at which the image is completely or irrevocably finished. The painting grows or fades according to the artist's life at the moment he confronts it or is involved with it. De Kooning's series and subsequent abstractions are really one continuous painting tied to his own changing moods, like a personal diary of partially eradicated entries. As with Dubuffet, the violence of De Kooning's art lies not in any action de-

picted, but in the action of making and remaking the painting by means of assaults on the canvas. In *Woman and Bicycle* (Pl. 53, p. 386), the subject seems all eyes, teeth, and breasts, standing passively by her conveyance. Her form materializes from and is threatened by the painter's slashing applications of paint to the surface. She does not intentionally symbolize, allegorize, or allude specifically to any one person or public concept. She belongs to the reality of a painted surface and is a recurring hallucination for the painter. The artist has described his obsessive image and suggested the intervention of his inner feelings and subconscious during its realization: "I always started out with the idea of a young person, a beautiful woman. I noticed them change. Somebody would step out—a middle-aged woman. I didn't mean to make them such monsters." On another occasion he said, "Women irritate me sometimes. I painted that irritation in the *Woman* series, that's all." De Kooning is a reactive artist, potentially irritated by a wide variety of sensations and visual suggestions from all over. In one sense, his painting is antidotal to the disease of emotional insincerity in society and its public glorification of women within the context of cleanliness, motherhood, happiness, youthfulness, and sex. De Kooning's method of working on *Woman and Bicycle,* and the other pictures in the series, was to build up an unpremeditated image from scrap of his earlier drawings, cutouts from newspapers or photographs, freehand drawings of letters, and the dictates of emotion, lacing it all with technical preoccupations relating to his craft. Like Frankenstein's monster, *Woman and Bicycle* is a synthetic concoction of used parts. "Whatever I see becomes my shapes and my condition. The recognizable form people sometimes see in the pictures after they are painted I see myself, but whether they got there accidentally or not, who knows?"

The Limits of Reason

Although he died in 1940, it is fitting to conclude this chapter with a work by Paul Klee, the most gifted and consistently excellent creator of imaginative art in this century. In Chapter 16, "Art, Objects, and the Object of Art," the reader was introduced to some of Klee's ideas regarding creation (Pl. 35, p. 264). An artist endowed with both whimsy and wisdom, who worked with facts, fables, and fantasy, Klee devoted his art to the rendering of the world seen with closed eyes. His hundreds of paintings reveal how he could preserve the special qualities of images of the mind. Klee invented his own modes of drawing, charted new spaces, and enacted fresh artistic laws for light and gravity. In his contacts with the external world, with what he saw, heard, and read, Klee consistently nourished the sources of his imagination. Science, philosophy, and art fuse in his images. Klee could reinterpret an old idea, one that had a verbal or established visual history, and give it new dimensions marked by his personal touch. Consider his *Limits of*

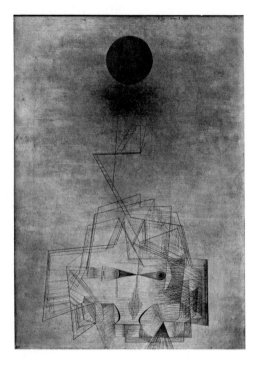

far left: 560. Paul Klee.
The Limits of Reason.
1927. Oil and watercolor,
21⅝ × 16⅛″ (55 × 41 cm).
Private collection.

left: 561. E. J. Sullivan.
Sartor Resartus. 1898.
Wood engraving.

Reason (Fig. 560) and a late 19th-century wood engraving by E. J. Sullivan from Thomas Carlyle's *Sartor Resartus* (Fig. 561). Sullivan shows that the human race ascends the heights of knowledge on a mountain of books. The path to enlightenment is paved with the written word. One could read this description and in the absence of Sullivan's print conjure the image in one's mind. But how difficult to evoke through words Klee's conception! The linear contraption at the bottom of his picture broadly suggests modern technological inventions, the means by which we aspire to reach what Klee shows to be ultimately unattainable via the ladders of reason. In Bruegel's time and even earlier in the Middle Ages, the analogous commentary on folly was the depiction of the building of the Tower of Babel. Made in 1927, Klee's conception prophesied present-day devices by which we are seeking to explore the unknown spaces of the universe itself.

Broadly speaking, the major differences between older and modern imaginative art begin with the proposition that in the past imagination was in the service of reason, but starting with Redon, reason was in the service of imagination. Where previously imaginative art often moralized, modern imaginative art makes no moral judgments. As opposed to the frequent textual basis of visionary subjects in older art, those in modern art stem from the self and experiences unparaphrasable in any medium other than the visual arts. Where for centuries the style of imaginative art depended upon culture-wide conventions of painting and sculpture, since the 19th century, artists have broken with norms, transforming the very conditions of making art in order to be faithful to the unique qualities of their own personal experience.

Just as there is no objective way to prove good and bad values for art, so is it in many cases impossible even for the artist to verify the meaning of his work. Meyer Schapiro admirably summed up the situation for many modern painters when he wrote:

> The artist does not wish to create a work in which he transmits an already prepared and complete message to a relatively indifferent and impersonal receiver. The painter aims rather at such a quality of the whole that, unless you achieve the proper set of mind and feeling towards it, you will not experience anything of it at all.

Max Beckmann realized that there were many in his audience who could not understand his work. He hoped that viewers would employ their own inner "creative sympathy" when looking at his paintings: "I can only speak to people who, consciously or unconsciously, already carry within them a similar metaphysical code." Contrary to what the public and many art educators may wish, art is not for everyone, just as everyone is not for art. Both creating and communing with art involve the experience and training of the imagination.

Chapter 21

Abstract Art

By creating dramatic new options for artists, abstract art constituted one of the great revolutions in art and Western culture. The emergence of abstraction after 1909 with its premise that the representation of the visible world was dispensable to the expression of truth, reality, and even beauty was an exciting challenge to artists to transform or reinvent art itself, to engage in risky formal adventures while seeking out new spiritual expression. Rather than as an escape from reality and the competition of photography or from a perception that representational art was exhausted, the pioneers turned to abstraction for positive reasons: it could give new form to their *modern* consciousness and was appropriate to a new century in which, largely because of science, the world had indeed become a different place. Abstract art evolved from roots in the most sophisticated representational art, notably Impressionism, and its antithesis, late-19th-century art that reacted against positivism and the imitation of nature in favor of using the expressive potential of the elements of art to project the intuited and felt. Where Realism and Impressionism helped connect the external world with the private life of the individual, Counter-Impressionism did the reverse by uniting the inner world of the artist with the external surroundings. The moral imperatives of making art more faithful to vision, thought, and feeling on the artist's own terms thereby sired different forms of abstraction.

Abstraction did not bring to an end art's historical purpose of giving aesthetic form to humanity's hopes for well-being. In the work of many, it continued the drive of the previous century for unification between the self and the world. The major difference was that modern artists, as discussed in the preceding chapters, believed they had to proceed from personal rather than collective values and hope that others would come to recognize and share their convictions. Since abstraction resists verbal paraphrase, this sharing between artist and sympathetic viewer had to be on an intuitive plane.

The City and Abstract Art The term *abstract* can be misleading when it connotes cut off from life. Just as the evolution to abstraction was dependent upon land and city views, so even present-day abstraction carries within it experiences the artist has had of nature and urban life. Artists committed to making painting based on rigorous structure and color have often been attracted to cities. This was the case in 17th-century Holland, where artists such as Vermeer developed an entire genre of cityscapes. Vermeer's *View of Delft* (Fig. 562) mingles pride and pleasure in his native city and is painted with the accuracy and reverence one might expect an artist of that time to have expended upon the Heavenly Jerusalem. Just as the Dutch constructed their cities to last, so did Vermeer construct his painting to capture and preserve all the variety, coherence, and interest of the urban good life. His painting is descriptive art at its best, every passage carefully observed and reflected upon. Vermeer expected the viewer, like a visitor to Delft, to inspect quietly and patiently his painterly equivalent of urban construction. By choosing a prospect of Delft across a canal,

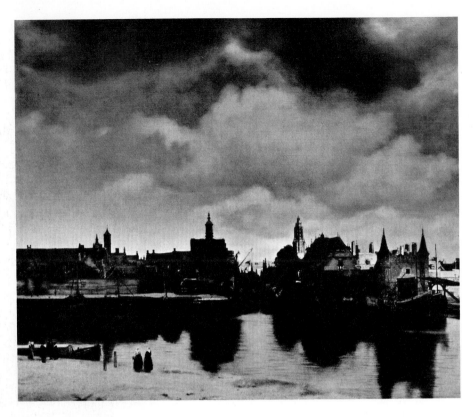

562. Jan Vermeer.
View of Delft. c. 1658.
Oil on canvas,
38½ × 46″ (98 × 117 cm).
Mauritshuis, The Hague.

Vermeer has the opportunity to invert and soften the reflected image of the city and also to contrast the stately random order of the towers and roofs with the softer, less isolable clouds.

Three hundred years later, another Dutch artist, Piet Mondrian, closed a distinguished painting career with a brilliant work called *Broadway Boogie Woogie* (Pl. 54, p. 386), which expressed his admiration for the modern American city that gave him welcome as a refugee. Even without the title, the image has strong musical suggestions, evoking the improvisation and underlying discipline of modern jazz, listened to and loved by this quiet and reserved Dutchman in the cities where he lived. His earlier writing about the modern city, with which Vermeer might have agreed, helps us to understand why Mondrian felt a nondescriptive evocation would best capture the urban qualities he admired:

> The genuine modern artist sees the metropolis as abstract living converted into form: it is nearer to him than nature In the metropolis the natural has already been stiffened up, ordered by the human spirit. The proportion and rhythm of patch and line in architecture will speak a more direct language to him than the capriciousness of nature. In the metropolis beauty expresses itself more thematically.

No abstract artist sought more than Mondrian to bring profound joy to others, to present that rare experience in life, an image of perfect balance, of feeling at one with the world. Unlike Vermeer, Mondrian believed that the *form* of the image had to evoke a broad reference and a universal response. He wrote, "The art of the past established rhythm . . . veiled by subject matter and particular forms In our time, rhythm is more and more accentuated, not only in art but in mechanized reality and in the whole life." His painting calls forth recollections of the flashing light of cars, advertising signs, and stop lights, the simultaneity of events in New York's Times Square or the heart of any other modern city. The accomplishment of this provocative and highly disciplined personal sign language ironically depended upon such sources as Impressionism, with its acceptance of the modern city and use of intensified color to fix the fugitive aspects of urban flux. More deliberated than even the carefully thought out urban paintings of Monet, Broadway Boogie Woogie disposes bright colors in stiff ribbonlike strings of molecules without a predictable sequence. The vertical and horizontal bands, composed of rectangular color units, overlap or interweave like street patterns seen from above, and they imply an infinitely extensive irregular grid, as might be seen in the detail of an aerial photograph of a modern gridded city. While these comparisons were not the direct source of Mondrian's painting, they remind us that, like Vermeer, he found a style congenial to depicting the city of his time.

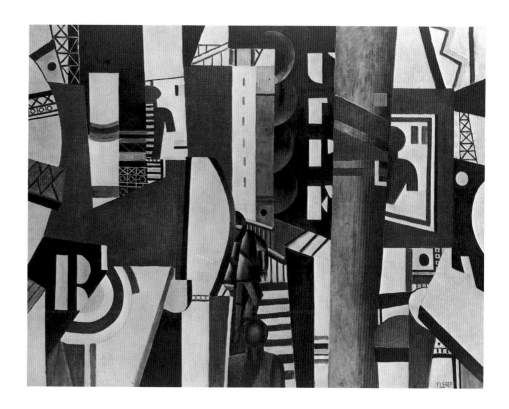

above: Plate 55. Fernand Léger. *The City.*
1919. Oil on canvas,
7'7'' × 9'8½'' (2.31 × 2.96 m).
Philadelphia Museum of Art
(A. E. Gallatin Collection).

left: Plate 56. Josef Albers.
Homage to the Square "Curious." 1963.
Oil on canvas, 30'' (76 cm) square.
Collection R. Alistair McAlpine, London.

above: Plate 57. Frank Stella. *Tahkt-I-Sulayman I.* 1967.
Fluorescent acrylic on canvas, 10 × 20′ (3.05 × 6.07 m).
Private collection.

right: Plate 58. Henri Matisse. *View of Notre-Dame.* 1914.
Oil on canvas, 4′10″ × 3′1⅞″ (1.47 × .96 m).
Museum of Modern Art, New York (purchase).

Plate 59. Richard Diebenkorn. *Ocean Park No. 105.* 1978.
Oil on canvas, 8′4″ × 7′9″ (2.54 × 2.42 m).
Collection Graham Gund.

left: Plate 60. Barnett Newman. *Adam.*
1951–52. Oil on canvas,
7′11⅝′′ × 6′7⅝′′ (2.43 × 2.02 m).
Tate Gallery, London.

below: Plate 61. Mark Rothko.
Ochre and Red on Red. 1954.
Oil on canvas, 7′6′′ × 5′9′′ (2.29 × 1.75 m).
Phillips Collection, Washington, D.C.

563. Claude Monet. *Leicester Square by Night.*
1899–1904. Oil on canvas, 32 × 25″ (81 × 64 cm).
Formerly collection Michel Monet;
present whereabouts unknown.

In Vermeer's age, one usually experienced the city on foot and at eye level. It could be viewed from a second-story window or a steeple and in prints and paintings, but always in terms of one view at a time. Cities were small enough that their distinguishing profiles could usually be captured on a single canvas or sheet of paper. For Fernand Léger, the modern city was experienced and remembered from a greater multiplicity of views and in a greater variety of ways, such as those film and photographs provided. It was too big and too complex to be seen from a window or caught in a camera lens. He passionately loved the machines and the engineering that produced the new metropolis and could condone only a style that captured these new urban characteristics. While he had produced completely abstract paintings by 1913, Léger could not cut himself off completely from the motif in life. He did not see himself as an eye reflecting the visual world, but as a painter-engineer who constructed his image with the same intellectual precision and multiplicity of viewpoints as city builders did their blueprints. Cubism and his own experience with abstrac-

tion provided Léger with a new syntax for presenting in a pictorially connected manner objects that appear to be disconnected. His colors, unlike those of Vermeer or the pure but limited number used by Mondrian, are the strong, pure hues of commercial advertising or those of metal and cement. The textured patterns were inspired by railings, iron stairways, the Eiffel Tower, segments of mass-produced stenciled letters, and billboard figures—everything antithetical to the handmade or traditionally picturesque. The smooth surfaces and hard edges were painted impersonally. Robotlike figures on stairs are the ideal inhabitants of Léger's mechanized metropolis. Natural light, so important in lending poetry to the urban painting of Vermeer and the Impressionists, plays no part in *The City* (Pl. 55, p. 403). The shapes are self-illuminating, rarely tempered by shadings. They are always clear, clean, and hard, unnatural in their edges and juncture. Vermeer and Monet delighted in soft clouds; Léger mechanized smoke into a globular sequence above the stairway figures. For him, smoke symbolized civilization, and, using hard lines, he gave it concrete, solid, mechanical form as an affirmation of his own masculine command.

In giving up illusionism, however, Léger preserved some of its characteristics, notably the importance of contrasts. The visual spice of his painting comes from unpredictable contrasts, such as bright and dull colors or a round column against flat shapes. Contrast of scale depends upon the single tall column that stands against so many medium and small shapes. In moving away from the natural, Léger's shapes tend toward the geometrically curved and angular. Unlike Mondrian, however, he could not restrict himself solely to the rectilinear, since this would have contradicted his ideal of contrast as a life and artistic ethic. For Léger, faithfulness to perception, to the eye as a window, mirror, or camera lens, had to be replaced by art as a conception resulting from intellect and feeling.

Léger once told this author that his own tough style was influenced in part by his reaction against Impressionism, which he found "too sweet and feminine." No question, however, but that the Impressionist discovery of modern Paris helped Léger to confront his own urban place and time. How close Impressionism came to abstraction, while brilliantly conveying a visual experience of the city at night, can be seen in Monet's *Leicester Square* (Fig. 563). The fusion of the intense colors that gives a molten appearance to the scene may have been inspired by the artist's looking through a rain-soaked window. In capturing the reflection of city lights on wet streets, Monet has also blurred distinctions between persons, places, and things, as well as up and down, near and far; space is no longer measurable or transversible. Monet often reworked his pictures when away from the motif he was depicting, and while he had the entire scene in mind, if not in view, he could also orchestrate the color harmonies of the total picture, giving it greater self-sufficiency.

Half a century later, the American painter Joan Mitchell did her *City Landscape* (Fig. 564). Contrary to Monet, she began with an abstract painting and then slowly let it evolve to a point where it suggested the recollection of a landscape or cityscape. One of her incentives was to find in painting the equivalent for her most intense feelings about the motif. What links her work with Impressionism is the physical fabric of the paint surface, the discontinuity and vigor of her touch, the seeming overall randomness of her composition, and the rapid juxtaposition of different colors in a kind of colored drawing. All of these characteristics produce strong optical vibrations not unlike those we experience with Monet's painting. Mitchell's works, like those of Monet, can seem all surface one moment, all depth another.

The window as an imaginative rather than a rational frame for viewing the city became the subject of a series of paintings begun in 1910 by the Parisian painter Robert Delaunay (1885–1941), which culminated in 1912 in abstraction. In a version of his *Fenêtre,* or *Window,* series (Fig. 565), Delaunay gives us a view from an imaginary curtain-framed window overlooking Paris in the direction of the Eiffel Tower, which can be made out in the center. Delaunay loved the Eiffel Tower and the knowledge and skill that had gone into its construction. Like Léger, he wanted to bring to painting the inquisitiveness and objectivity of the engineer and scientist, but ultimately his art was

based on intuition. Although lacking the systematic and consistent method of science, he sought to inquire into the possibilities of light and color and the dissolving effects of their interaction upon solid forms as perceived by the eye. He was also conscious of Cubism's liberation from likeness in these years and the possibilities of constructing rigorous compositions that diminished illusionism and stressed instead the components of painting, notably its color and surfaceness. In a 1911 version of his *Fenêtre* (Fig. 566), reference to a window and distance beyond has been eliminated, as have distinct buildings. What has been preserved are certain segmented curves that recall perhaps the profile of the Eiffel Tower. Color is laid down in large patches that softly vibrate in the viewer's eye. It is as if color were seen through a prism. Delaunay extended his color contrasts beyond the canvas onto the border of the painting itself, thus denying even to the picture frame its traditional enhancement of illusion. We tend to take the picture frame for granted, and for many people it is a surprise to see abstract painting unframed or simply bordered with thin strips of wood. The Impressionists were the first, in the early 1880s, to frame their paintings in simple white borders, thereby reinforcing the intensity of their colors. Seurat painted inner frames with colors that were the complementaries of those in adjacent areas of the canvas to ensure the brilliance of the latter. The traditional black frame of the

below: 564. Joan Mitchell. *City Landscape.* 1955. Oil on canvas, 6′8″ (2.03 m) square. Art Institute of Chicago.
(gift from The Society for Contemporary American Art).
right: 565. Robert Delaunay. *The City.* 1910.
Oil on canvas, 4′9½″ × 3′8″ (1.46 × 1.37 m).
Musée National d'Art Moderne, Paris.

left: 566. Robert Delaunay. *First Simultaneous Window.* 1911. Oil on canvas, 15¾ × 18⅛'' (40 × 46 cm). Kunsthalle, Hamburg.

above: 567. Robert Delaunay. *Premier Disque.* 1912. Oil on canvas, diameter 4'5'' (1.35 m). Collection Mr. and Mrs. Burton Tremaine, Meriden, Conn.

Dutch or the elaborate carved gold frames of the past, familiar in every museum, had been thought not only to establish the worth of the painting and dignify it but also to enforce its illusionism or window character. The death of illusionism in modern art was also the demise of the elaborate picture frame as the setting for painting. The absence of the frame emphasizes the nonprecious character of the art, adds to its concreteness as an object, and asserts that it is by the hand of the artist. In Delaunay's case, the artist may have been signifying that what was in the painting of a specific motif had world reference.

In 1912, Delaunay painted *Premier Disque* (Fig. 567), one of the first abstract pictures in Western art. It had grown out of his urban motifs, studies of color using color wheels, and his desire to achieve a more universal subject. (Next he was to move into cosmic motifs.) To express through color his view of a reality that transcended the mundane, he created an unframed painting that dispensed with the traditional subject and its figure-ground relationships, eliminated conventional drawing and evidence of the forming hand, and discarded differences of texture, light, and shade and traditional devices for signaling depth. To dramatize his exclusive focus on the allover, simultaneous interaction of color that he felt was the dynamic way to express modern reality, Delaunay shaped his colors into concentric, curved bands. To the artist, this structure also helped to express the view that "nature is pervaded by all manner of rhythms."

Seeking a "pure and sublime art" by which to attain spiritual integration with the world, Delaunay developed a format that allowed him to realize his "vision of a complex harmony, a harmony of colors which separated and at the same time join together to form a whole."

Delaunay's conversion to cosmic rather than mundane reference had parallels among other early abstractionists such as Kandinsky and Mondrian, and it reflected these pioneers' optimism that their art could provide a modern spiritual equivalent of the religious art of the past. As if to recapitulate the history of western art, within the history of abstraction has had the tendency to secularize what had previously been spiritual or near-religious in intent. Many artists after Delaunay would base their art on the interaction of color, but without his symbolic or cosmic intent.

Long before the 20th century, painters such as Delacroix (Pl. 24, p. 210) and Poussin (Pl. 32, p. 263) wrote and dreamed of an art whose sole purpose would be to delight the eye. Their painting, however, was always connected with literature and with ideas. It was not until this century that their vision of art was realized. The German-born artist Josef Albers (1888–1976), who taught at the Bauhaus with Klee and Kandinsky and who for many years was an influential teacher, fell in love with the interaction of colors and devoted his life to its study. He did not establish a system or rules in his teaching, but rather encouraged serious students of art to study color, to learn its many properties and

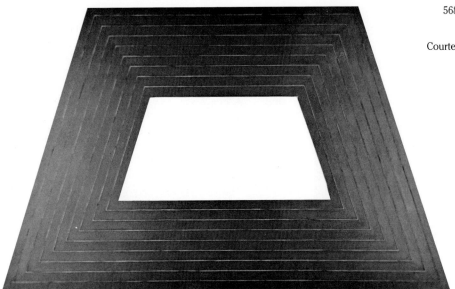

568. Frank Stella. *Ileana Sonnabend.*
1963. Oil on canvas,
7′5″ × 10′7″ (2.26 × 3.23 m).
Courtesy Leo Castelli Gallery, New York.

inexhaustible combinations. For more than fifteen years, in his famous series of over one hundred paintings called *Homage to the Square* (Pl. 56, p. 403), Albers in a sense painted the same picture. His art was a culture of pure relationships. The paintings are approximately the same size, and the basic format is a series of concentric squares (which include the paintings' four edges), with the smallest and innermost square being generally located toward the bottom of the canvas. These squares have a common central axis, but they vary in proportion and size. The greatest variation in Albers' series is seen in his use of color. For him, any combination of colors was possible. His preferred format allowed him to make "colors do something they don't do by themselves" and to study the various properties display colors when they interact and depend upon one another. Painting such as this allows us to see color differently from the ways in which it appears in advertisements, for example, where it is subordinate to the commercial message. Albers wrote, "In visual perception a color is almost never seen as it really is—as it physically is. This fact makes color the most relative medium in art." Like the Impressionists and Seurat (Pl. 29, p. 261), Albers was aware that certain colors produce afterimages, or complementaries of their own color, so that to stare at violet and then to look upon white will suggest yellow to the viewer. In composing his color chords, Albers took this property along with many others into account. He demonstrated that there is no "ugly" color and that our normal prejudices against certain hues may dissolve within the context of his use of colors.

Delaunay's legacy of textureless, banded color set in rigorous structures that echo the shape of the painting support was appreciated by the American artist Frank Stella.

His shaped canvases and one-color symmetrical compositions, such as *Ileana Sonnabend* (Fig. 568), made him one of the most daring, controversial, and influential painters of the 1960s. To create an alternative to the painting of Rothko, Newman, Kline, and De Kooning, which dominated the interest of younger artists in the 1950s, Stella discarded the hallowed idea of painting as warfare—as an emotional struggle in which artists constantly courted the risk of failure so as to bring into being by improvisation a new image each time they confronted the canvas. For many years, Stella made peace with art by letting shapes of his canvases dictate their internal design. For rhythm and contrast, he allowed the raw canvas to show through the colored bands laid on with flat, monochrome commercial paints. In *Ileana Sonnabend,* named for a noted New York–Paris art dealer who supports certain young artists, Stella has made what looks like a rhomboidal picture frame. Whereas illusionistic painting simulated the enclosure of space, this work literally frames space. Imperceptible in reproduction is the reflecting action of the metallic paint and the delicately inconstant interval between the stripes.

Stella sought and achieved *uncomplicated* painting. He was not interested in the earlier "geometries" of European and American painting, which he called "dreary." As arrogantly as he defied the convention of the rectangular canvas, Stella confounded the art world by embracing symmetry, which had been equated in art with all that was dull and unimaginative. He wanted "the force of symmetry," and the center of his image became the center of his canvas. There was no honoring of the traditional balance of unlike elements—Stella was not "trying to jockey everything around." His "schemes" or images were tied to his consciousness of

the flat surface to be painted and to the purity of his commercial colors while still in the can. He wanted us to see the whole idea without any confusion—a pleasurable visual sensation: "What you see is what you see." His model of effective simplicity was a major-league baseball player hitting the ball out of the park.

In 1967, Stella began his Protractor series, one of many moves by the artist to go beyond previous limits he set for himself. One of the most impressive in the series, a wall-size, complex interweave of banded color, is *Takht-I-Sulayman I* (Pl. 57, p. 404), whose title was a reminiscence of a trip to Morocco and the artist's fascination with exotic subjects, including architecture. Forsaking his previous strict alignment of composition with the picture's shape, Stella recomplicated his work by perpetuating symmetry of design but not color. The interlace pattern also reflected the artist's interest in patterns found in early medieval manuscripts (Pl. 7, p. 90), and as in Delaunay's work, the desired effect of the whole depended upon what happened between the pure colors. The vigor of the contrast relies upon the careful selection of color intervals, which are determined by hue, warmth, coolness, and whether the color seems to advance or recede. Some colors are fluorescent. The appearance of overlap is deceptive, because we tend to infer the continuation of a given arc behind another that interrupts it, which is not always the artist's vision of his motif. Overall, Stella sought to produce his version of big, bold, and serious decorative painting that challenges eye and mind. In this, his mentor was not Delaunay, but Henri Matisse; for although he never painted abstractly, Matisse was influenced by abstraction and in turn influenced many abstract artists.

It is a characteristic of modern art in general and of abstraction in particular that it disappoints for being less than the public expects. Since Impressionism, unfriendly critics have complained about less drawing, less subject matter, less composition, less workmanship—in short, less to see. In part, this is to be expected, because modern artists have often asked, what can art do without? What are the minimum means by which to realize an effective work of art—to get the most with the least? Even today, Matisse's 1914 *View of Notre Dame* (Pl. 58, p. 404) may seem unfinished, a sketch (for this painting of a view seen from his window, Matisse had actually done a more detailed sketch). Matisse helped to establish the idea of the artistically complete as opposed to the descriptively finished work of art. What has appealed to many artists about this painting is the duet between linear structure and the suffusion of a single color throughout, unlimited by boundaries. The developing harmony of the whole warranted omissions and distortions. Line and color exhibit a certain independence as well as mutual support. The linear scaffolding of the work does not construct even a schematic perspective, and while it gives us clues as to the subject or location of the scene, depth depends more upon the transparency of the blue color along with the location and juxtaposition of the cathedral and adjacent tree. The whole has a deceptive simplicity, and the surface betrays many reworkings that in the end contribute to the overall fabric of the work. The relocating, redrawing, and repainting of Notre Dame alone signify that Matisse was submitting its complex shape to a simplified refinement in keeping with the mode of the entire picture. Matisse believed that serious decorative painting, such as this, rather than moralistic or historical painting was essential to the well-being of those who were "mental" workers; and he wanted his art to be soothing as a comfortable chair at day's end. For many artists, Matisse's art was and is thrilling for having opened new windows into art and for having established that the aesthetic claims of the image are the artist's charter of freedom.

One of many who have looked at and learned from this painting by Matisse is Richard Diebenkorn. Unlike Stella, Diebenkorn prefers not to prefigure his work; like Matisse, he finds the image as he works and reworks what he has done. *Ocean Park No. 105* (Pl. 59, p. 405) is from a long series whose title tells us where he paints in southern California, an urban place whose remembered openness, contrasts, hazy light, and brilliant colors work their way onto his canvases. In contrast to Stella's use of commercial or polymer paints, Diebenkorn uses oils for the qualities of their color and greater susceptibility to dilution, saturation, and reworking. From Matisse and Mondrian came the irrational geometries made by lines and rectangular colored patches, geometries that divide the surface of the whole in a deductive rather than inductive manner. Diebenkorn is moved by the surprising spaces and their juxtaposition that his colors and linear network give him. As with Matisse, the final work is a series of duets of dualities in which conjoin the impulsive and the calculated, the aerated and the opaque, closed and open, hard and soft. The daily act of painting is for Diebenkorn a constant testing of what art is, a challenge to violate his own notions about how paintings should be made—a struggle to renew and surpass himself. More subtle than the up-front, big-bang approach of Stella, Diebenkorn's voice comes on more softly but just as strongly, and over long periods of time his works reward subtle seeing of color, line, and composition.

More than Four Sides to the Square Until abstraction evolved in the 20th century, shapes such as triangles, circles, and squares had a long history of symbolizing concepts and values. All three of these shapes, for example, have represented God. The Roman philosopher Philo compared God to an infinite circle whose center was everywhere and whose perimeter nowhere. The Chinese spoke of infinity as a square without angles. The circle has stood for eternity, resurrection, the earth and Heaven, the ideal city, perfection, and so on. Pythagoras referred to the triangle as symbolizing human knowledge. In Christianity, the shape has stood for the Trinity, and it has signified hieratic social

569. Leonardo da Vinci. *Study of Human Proportions According to Vitruvius.* c. 1485–90. Pen and ink, 13½ × 9¾″ (34 × 25 cm). Accademia, Venice.

systems. Walt Whitman extolled God in his poem "Chanting the Square Deific." Egyptian priests symbolized the human being as a square. In a drawing reproduced as Figure 569, Leonardo da Vinci used a square and circle to illustrate how these shapes could contain a perfectly proportioned figure. Squares have been associated with talismans against plague, mystical architectural ground plans, games, and puzzles. The square has variously symbolized the four seasons, the elements, the points of the compass, the earth, and the sun. Our language has many idioms that utilize shapes like the square as metaphors to denote, for instance, a social conservative, honesty, true relationships, or the settling of accounts. Behind the symbolism of the square in history and in current vernacular language is the fact that its meanings had a public currency. None of the past public associations with the square, including those of the geometer, have been drawn upon by abstract artists, despite the fact that they intended their art to move the viewer. Beginning in 1913, when the shape first appeared in modern art, each artist, like Walt Whitman, has found by reason, feeling, or intuition his own values in the square. The physical appearance of the square—its size, means of delineation and relative distinctiveness, color, weight, texture, disposition within the field of the paintings, and relation to other shapes or the canvas edges—while unimportant to a geometer or to its previous symbolic effectiveness, has been paramount for many painters. Artists have given a changing face to the square similar to the change seen in the rendering of Christ through the history of art. The shape has been made a personal extension of the artist, so that we would not confuse a square by Mondrian (Pl. 54, p. 386) with one by Rothko (Pl. 61, p. 406). In another sense, being closed or bounded by an edge, a square belongs to the broad class of objects. Its theme and variation in modern art are like those of the bottle, glass, or apple in the history of still-life painting. As with these objects, when set into the personal history and intentions of the artist, the square acquires new dimensions of meaning, but unlike previous meanings of objects, those for the square are often not discursive or verbal.

Enter the Square The entrance of the square into modern art coincides with political upheaval and revolution in Europe. Naturalism and many pre-1914 avant-garde movements such as Cubism and Futurism came to be viewed by political and artistic revolutionaries as the products of social systems responsible for the tragic catastrophe of World War I. In Russia, Holland, Switzerland, and Germany during and after the war, abstraction took hold, and artists linked their efforts with the emergence of new social and political systems. Individuality was viewed by these revolutionaries as inimical to a new society founded upon collective cooperation and maximum utilization of the new technology. In view of present-day Soviet Communism's criticism of abstract art and its insistence upon a socially conscious naturalism in painting and sculpture, it is hard to imagine that during and immediately after the Russian Revolution abstraction was looked upon as the true expression of the new Communist society. But by 1920, there were, in fact, more museums of modern art and abstract artists in Russia than in any other country. Kandinsky (Pl. 36, p. 297) was the first of the Russian abstract artists. The second was Kazimir Malevich (1878–1935), who in 1913 began a series of pencil drawings that departed from his paintings of peasant and Cubist assemblages. One drawing in his abstract series was of a pair of black squares meticulously placed within the white of the paper (Fig. 570). In essays begun in 1915 and published in 1927, *The Non-Objective World,* Malevich reconstructed the circumstances in which he created an art of pure feeling, the feeling of "objectlessness":

When in the year 1913, in my desperate attempt to free art from the ballast of objectivity, I took refuge in the square form and exhibited a picture which consisted of nothing more than a black square on a white field, the critics and, along with them, the public sighed, "Everything which we loved is lost. We are in a desert. . . . Before us is nothing but a black square on a white background!" But this desert is filled with the spirit of

non-objective sensation which pervades everything. Even I was gripped by a kind of timidity bordering on fear when it came to leaving "the world of will and idea," in which I had lived and worked, in the reality of which I believed. But a blissful sense of liberating non-objectivity drew me forth into the "desert" where nothing is real except feeling . . . and so feeling became the substance of my life. This was no "empty square" which I had exhibited but rather the feeling of non-objectivity. . . . The black square on the white field was the first form in which non-objective feeling came to be expressed. The square = feeling, the white field = the void beyond this feeling.

The moving life experiences that Malevich was referring to, in which we do not encounter objects and seem to confront infinity, include those on the sea, the desert, and in the air. Malevich wanted a mystical art that captured feeling induced by the absence of objects and what lay beyond sight. It was an art that did not imitate the appearance of nature but resulted from the inventiveness of the human mind: "Is it not my brain which is the true factory, from which the new iron-transformed world runs. . . . I wish to be the maker of the new signs of my inner movements. . . . I do not wish to copy and spoil the movement of an object and other varieties and forms of nature." In 1918, he did a painting that brought, it would seem, millennia of art to a conclusion or dead end. In his *Suprematist Composition: White on White* (Fig. 571), a white square is seen against or within a white background. The artist wrote, "The blue color of clouds is overcome in the Suprematist system, ruptured and enters white as the true, real representation of infinity, and is therefore freed from the coloured background of the sky." This painting is historically the first one-color conception, achieving its only contrast, tension, or drama by the acute angle at which the inner square is set in relation to its field, as opposed to its symmetrical disposition in the 1913 drawing. Malevich gave up painting for a number of years after this work, and when he returned to it, his style was no longer abstract. The power of the Russian army and the desire of political leaders like Stalin to placate this force brought an end to Communist support of abstraction. Ironically, present-day Communist art has taken its basic stylistic character from styles that were evolved during the 19th century in cultures condemned by institutional Communism as ideologically, economically, and socially decadent.

In many ways, Malevich sought to begin a new tradition for painting. More than 40 years later, Ad Reinhardt, by his own definition of what was exclusive to art, was doing the *last* painting. All that Malevich invested in the black square,

below left: 570. Kazimir Malevich. *Suprematist Elements: Two Squares.* 1913. Pencil; ruled margins 6¾ × 11¼" (17 × 29 cm); sheet 9¾ × 14½" (25 × 37 cm). Museum of Modern Art, New York.

below: 571. Kazimir Malevich. *Suprematist Composition: White on White.* c. 1918. Oil on canvas. 31¼" (79 cm) square. Museum of Modern Art, New York.

Reinhardt removed. Where Malevich at least contrasted the axis of his white square and the white field within which it was set, Reinhardt eliminated all object-ground differences to achieve a unified field having a common color and texture. (By now, the reader must be aware that in some respects modern art has been a succession of emptying out, filling up, and emptying out again.)

When painters such as Ad Reinhardt (1913–67) have talked or written about their work, much of what they say concerns what their painting is not. This is to offset misinterpretation, but it also reflects how much of the history of art they have rejected and how strongly and uncompromisingly they paint for themselves. Reinhardt epitomized the exclusivist or purist view, and he approached invisible painting: "The one thing to say about art is that it is one thing. Art is art-as-art and everything else is everything else." His is the best description of what he has done and not done:

A clearly defined object, independent and separate from all other objects and circumstances, in which we cannot see whatever we choose or make of it anything we want, whose meaning is not detachable or translatable, where nothing can be added and nothing can be taken away. A free, unmanipulated and unmanipulatable, useless, unmarketable, irreducible, unphotographable, unreproducible, inexplicable icon. A non-entertainment, not for art-commerce or mass-art-publics, non-expressionnist, not for oneself.

The difficulties of reproducing Reinhardt's *Abstract Painting* (Fig. 572) are apparent and derive from the fact

572. Ad Reinhardt. *Abstract Painting.* 1960–61. Oil on canvas, 5′ (1.52 m) square. Museum of Modern Art, New York (purchase).

that it is all black; for this reason the artist himself discouraged its reproduction. When we read his statement of 1961, we are reminded of Zola's comment about Manet—looking at Reinhardt's painting with sympathy demands forgetting a thousands things about art. Like all the artists discussed in this chapter, Reinhardt wanted the viewer to look *at,* not into, his painting.

A square (neutral, shapeless) canvas, five feet wide, five feet high, as high as a man, as wide as a man's outstretched arms (not large, not small, sizeless) trisected (no composition), one horizontal form negating one vertical form (formless, no top, no bottom, directionless), three (more or less) dark (lightless) non-contrasting (colorless) colors, brushwork brushed out to remove brushwork, a matte, flat, free hand painted surface (glossless, textureless, non-linear, no hard edge, no soft edge) which does not reflect its surroundings—a pure, abstract, non-objective timeless, spaceless, changeless, relationless, disinterested painting—an object that is self-conscious (no consciousness), ideal, transcendant, aware of no thing but Art (absolutely no anti-art). (1961)

Unlike Malevich, Reinhardt did not give up painting; after his own logic, he continued to paint essentially the same black painting until he died. One of the jokes in the New York art world of the 1960s was that, with regard to painting, "Rothko pulled down the shades, Newman closed the doors, and Reinhardt turned out the light."

Since the late 1940s, one of the most significant developments in painting in the United States has been emphasis on the effects of color, surface, and scale. This focus has led to large-scale paintings in which one, two, or three colors spread out and occupy most if not all of the surface. While brushstroke is unobtrusive, it can be employed to create subtle directions. Usually, no attempt is made to call attention to textures or the physical substance of the medium, and there is no insistence upon arranging a number of different shapes. Color in the work of Barnett Newman (1905–70) and Mark Rothko (1903–70) occupies areas that roughly accord with the rectangular shape of the canvas. Scale is crucial to the painting's effect and is in large part a coefficient of the color chosen. In the past, the scale of a painting might have been determined by a wall, subject, or conventions of public exhibitions and commerce. Newman, Rothko, and others, however, judged scale in relation to themselves—standing in front of the painting as it evolved. Newman's paintings often have a vertical or horizontal interval, a pause or tension, depending upon the individual painting, between rectangular areas of a single color (Pl. 60, p. 406). Geometry was not even thought of as governing the shape of the color area. According to Newman, "It is precisely this death image, the grip of geometry, that has to be confronted. . . . Unless we face up to it and discover a new image based on new principles, there is no hope of freedom." In his final painting, Newman worked out its size, measure between intervals, and the location of these intervals as he painted over the surface, responding to

the energy of the color with which he worked and to his personal associations with it. While it is tempting to think of his large paintings as decorative, they are not intended as background music or to be seen out of the corner of one's eye. Their scale, intensity, and phrasing can compel attention in those who will let the painting work on them. For Newman, color by itself as well as completed paintings conveys strong feelings that have to do with earthly and sublime experiences. "The rich tones of orange to the lowest octave of dark brown," Newman wrote, can express "the majestic strength of our ties with the earth." He chose biblical titles—*Adam* and *Genesis*—as well as heroic ones—*Ulysses* and *Prometheus.* They are not illustrative in the sense of older art; they allude to the artist's own associations with his paintings. With remarkable terseness Newman explained, "An artist paints so that he will have something to look at." More specifically, he saw the rectangle as "a living thing, a vehicle for an abstract thought-complex, a carrier of awesome feelings."

Mark Rothko's painting can be characterized as silent and almost immobile, and it might be described as art based on color sensation. Color and scale are the two basic ingredients of such canvases as *Ochre and Red on Red* (Pl. 61, p. 406). The large size of Rothko's surfaces is necessary to the power of his color sensations. Used in a smaller area, ochre and red do not evoke the same emotional responses that they do when used on the large scale that Rothko employed. The great size allows the beholder to become absorbed in the painting. Rothko, like Newman, was not as dispassionate or liberal in selecting his colors as was Josef Albers (Pl. 56, p. 403). Rothko took over a color and made it his own, after the color proved right for his feeling. His paintings as a group seem less like color demonstrations or exercises than those of Albers, and they attain greater gravity. There are no allusive elements in the painting, only soft, vaporous-edged, rectangular patches hovering against and in front of one another. Color is unconstrained by drawn or hard boundaries; it breathes and finds its own shape. Often the colors are so close in value as to make their reproduction in black and white meaningless. Rothko soaked or stained the canvas in addition to brushing on the color, so that the final effect is not opaque color lying *upon* a surface, but rather the indefinite suspension of absorbent color. For Rothko, color was form and content, the sole carrier of his idea, which varied from painting to painting and which, to oversimplify, may be described as a mood, perhaps, of tragedy, exhilaration, or withdrawal. In the painter's words, he wanted "the elimination of all obstacles between the painter and the ideas, and between the idea and the observer." Objects, forms, marks of the artist's hand would be "obstacles." The variety and drama in Rothko's art comes from the way large color areas interact, so that, for example, the red and ochre colors induce anguish without being translated into a description of a specific situation.

With much of modern painting, we can be assured of the artist's sincerity. The burden of sincerity often rests with the beholder and the way he or she chooses to receive the painting. There is an ethic to viewing a painting as well as to making it, and observers must adapt themselves to the new experiences this art affords. Like artists, viewers must be open and adventurous; they must make decisions and take risks. Rothko expressed his feelings about the life of a painting: "A picture lives by companionship, expanding and quickening in the eyes of the sensitive observer. It dies by the same token." Thus the paintings illustrated in this chapter require that the viewer achieve a communion with what is directly given to the eye.

Sculpture and the Art of Simple Forms With the coming of abstraction to sculpture about the time of the First World War, many artists believed they were confronted with the challenge to reinvent the art form most identified with the human figure and yet dispense with this subject. Thus, historically the advent of abstract sculpture coincides with culture-wide thinking that did not place the human being at the center of the universe nor consider the human figure the most noble and apt symbol of nature. (This was discussed in Chapter 15, "Art and Nature.") Abstract sculpture has built upon fresh investigation of certain physical properties of real materials, often with no art history, in actual space under natural light without excluding symbolic associations. The historical change was from the 19th-century academic definition of sculpture as "the selective imitation of nature in palpable form" to the expression of ideas in tangible form. Much, but by no means all, of modern abstract sculpture has been an art of simple forms that were either literal in meaning or invested with often complex associations. Abstract sculptors have individually sought to discover for themselves the nature of sculpture, the expressive possibilities of shapes, space, structure, and scale. These discoveries have been simultaneous with investigations into materials and the forming or joining process. Modern sculpture leveled the ancient hierarchy of materials and means as well as of subjects so that marble and bronze, carving and modeling became just a few of many options available to the sculptor along with whether or not to employ figural reference. Once relieved of the obligation to treat materials illusionistically, to make stone and bronze evoke flesh and cloth, for example, sculptors could choose whether or not to stress the color, texture, and structural capacities of the substances out of which their images were formed. As with abstract painting, it is the whole effect, the totality of all the foregoing elements experienced simultaneously from successive viewpoints, that is crucial to the experience of the sculptor's revelations of orders and realities not previously found in the visual world.

During the decade of the 1960s in the United States and England, a number of sculptors brought a new authority, intelligence, and sensibility to abstract sculpture. The art-

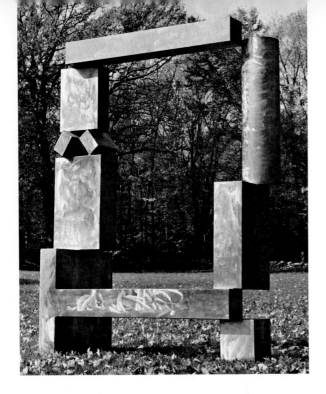

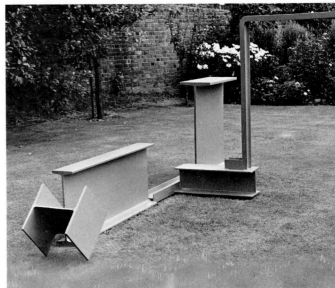

above: 573. David Smith. *Cubi XXVII.* 1965. Steel, height 9'5⅝''
(2.77 m). Solomon R. Guggenheim Museum, New York.

above right: 574. Anthony Caro. *Homage to David Smith.* 1966.
Steel painted red, 4'6'' × 10' × 5'4'' (1.37 × 3.05 × 1.63 m).
Collection Mrs. Mary Swift, Washington, D.C.

ists in this last section share a preference for simple forms
and uncomplicated structures, such as the cube. Like their
counterparts in painting, who made the square the princi-
pal unit of their expression, the new sculptors have invested
the simple cubic form with their artistic ideals, respective
personalities, and vision. Their common cause has been a
literal, formalistic art, devoid of symbol or metaphor, that
forces the beholder to attend to such given physical charac-
teristics as overall shape, scale, and proportion; axes and
edges; surface; and occasionally depth. With the single
exception of David Smith, these sculptors did not employ
artificial bases, an omission comparable to the dismissal of
frames in abstract painting. They preferred to posit their
sculptures directly on the earth or floor, to bring their sculp-
ture down to earth in a figurative and literal sense. The
removal of the base helped separate these sculptures from
illusionistic, heroic public art of the past, while reinforcing
their concreteness as objects and as the personal concep-
tion of the artist. Abstract sculpture, like abstract painting,
teaches us that nonimitative signs can be the carriers of
form and expression.

In the minds of many young American sculptors, David
Smith is still a heroic figure who, more than any sculptor
who developed in the United States, successfully estab-
lished, in his own words, "the full right for the function of
pure esthetics." In the late fifties and sixties, Smith moved

away from explicitly metaphorical sculpture such as *Hudson
River Landscape* (Fig. 418) into an art of simple shapes
composed in purely formal relationships that were embued
with his own belligerent vitality. *Cubi XXVII* (Fig. 573), done
shortly before he died in 1965, is like a gateway, strong in
stance, aggressively occupying and framing space. Its
steel-jacketed Euclidian shapes rudely refuse axial align-
ment. Paradoxically, they still produce a simple overall
form of seeming solidity. The precarious poise of the parts
reflects Smith's lifelong preoccupation with the structures
in human and animal forms.

In common with friends of his generation, such as Kline
and De Kooning, Smith did not completely prevision his
sculptures. He preferred to make adjustments during the
process, to accommodate "intuitive accidents." The final
form was decided upon only when the last shape had been
fitted into place. Smith fought to avoid the predictable and
the ingratiating by seeking "to push beauty to the very edge
of rawness." Smith took pride in his personal toughness
and shunned social polish, characteristics that are mirrored
in his sculptures. Steel appealed to him for many reasons:
"Its associations are primarily of this century. It is structure,
movement, progress, suspension, cantilever, and at times
destruction and brutality . . . its forms of geometry, planes,
hard lines are all constant with my time." For exposure to
the weather and reflection of colorful surroundings, steel
was truly his best material. Its rough burnishing allowed
both emphatic surface quality and depth, strong reflection
and absorption of light that challenge the density and hard-
ness of the steel. Above all, Smith wanted "a structure that
can face the sun and hold its own."

Among the most important artists influenced by David
Smith is the English sculptor Anthony Caro (b. 1914),

whose conversion about 1960 from figural modeling to abstraction came after contact with the American sculptor's work had convinced him of the rightness of abstraction. In *Homage to David Smith* (Fig. 574), Caro incorporated a reference to the door-window gate form of *Cubi XXVII* and also to Smith's use of industrial metals welded together in a deceptively improvisatory way. Caro's idiom distinguishes itself through the artist's disinterest in thick, closed, heavy shapes and through a lively concern with sculpture's "extent," its lateral movement in different directions along the ground. There is no center, no climactic focus in his art. It is not possible to take in all of his sculpture from any single viewpoint. Caro's small London studio does not permit the full erection of his works; they must be assembled outdoors in the mews where he works, which makes his own experience of the large pieces sequential. Whether initially conscious of it or not, Caro accepts the fact that it is impossible for a viewer to take in simultaneously all parts and their relationships in a large, complex work. He avoids making adjustments in a piece so as to facilitate instantaneous reading or simple scanning. This sort of sculpture has come to be called "nonrelational." It differs from Mondrian's grids, in which one feels the artist's intention was to have all axes function in consonance with one another at once. Caro usually applies a single color uniformly to the whole of a sculpture, a color that seems peculiarly appropriate to its individual shapes and their scale. Such use of one hue serves both to unify all the disparate parts and to mute the "corporeality," or actual physical nature, of the material without destroying its substantiality. The additive method of joining similar but unlike shapes results from decisions made in the process of building the form. T-beams of varying lengths and widths and axial placement produce different effects. Caro, like David Smith, does not begin with a final form fixed in his mind, one that would determine his selection of units and their mutual interaction.

Recent abstract sculpture depends upon the world of taste, an admittedly circumscribed audience with the money, leisure, knowledge, and patience to follow closely the ideas and changes within the avant-garde community. The channels of communication in this tight culture are the art magazines, which make new concepts and sculptures available in a period of mere weeks to an audience of international range.

The Ideal of Wholeness A number of young sculptors have learned that modest scale and simple forms raise their expectations for achieving perfection, consistency, and completeness. By comparison with the sculpture of Robert Morris (b. 1931), the work of Smith and Caro seems prolix in its quantity of parts and surface events and muscular in the way the pieces have been assembled. Morris and other sculptors sympathetic to his reasoning felt, in the second half of the 1960s, that a new literal basis for sculpture had to be established as an alternative to illusionism. This attitude

meant reexamining the fundamental characteristics of sculpture and the realization of an undramatic form that was indivisible and dependent on the movements of the beholder. Simple forms did not mean simple experiences for Morris. If the viewers were to come to the piece reproduced in Figure 575 expecting craftsmanship, virtuoso handling, bright color, novel shapes, or exotic textures, they might well find the work monotonous. With unflinching literalness, Morris insisted upon what for him were the concrete facts of sculpture: space, light, and materials that do not constitute themselves into an image of something other than what they are. Because of its neutrality, the color the artist chose does not call attention to itself but fuses with the shape, its configuration, and its surface texture. Morris used a simple polyhedron, a shape easily recognized and remembered and for the artist one not "self-important." He expects the viewer to move around the four shapes. For the viewer, each perspective change introduces new relationships among the forms and produces an intensified sense of his or her own scale. "One's awareness of one's self existing in the same space as the work is stronger than in previous work One is more aware than before that he himself is establishing relationships as he apprehends the object from various positions and under varying conditions of light and context." It is not imagination that Morris appeals to but to aesthetic consciousness.

As did American painters in the sixties—Stella (Pl. 57, p. 404), Lichtenstein (Fig. 442), and Warhol (Fig. 441)—sculptors like Morris and Donald Judd (b. 1928) developed an idiom that contradicted the traditions of European art. Their objective was not to make an "American art" or "reductivist" sculpture, but rather to realize personal visions of

575. Robert Morris. *Untitled.* 1966. Fiberglass, 36 × 36 × 24′′ (91 × 91 × 61 cm). Collection Dwan Gallery, New York. Courtesy Leo Castelli Gallery, New York.

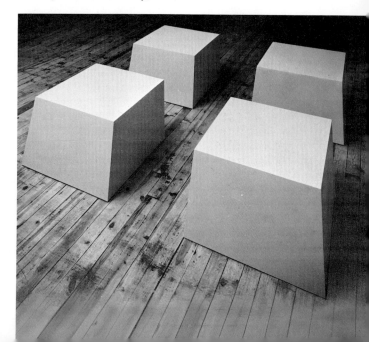

what art could look like. "Art is something you look at," in the words of Judd. Behind Judd's preference for an art of simple forms is a rejection of what he feels to be the public's expectation that sculpture should look "old and heavy." His manipulations of cubes formed in a variety of industrial materials are intended to make them appear new and lighter than they are (Fig. 576). Composition resulting from a complexity of parts, their subtle integration, or asymmetrical order does not interest him. He prefers the box form because it does not look "like order or disorder"—it is neutral. He does not want his sparse sculpture to make extravagant claims on our imagination any more than he intends his means of ordering to symbolize a rationalistic philosophical order outside his work.

> A shape, a volume, a color, a surface is something itself. It shouldn't be concealed as part of a fairly different whole. The shapes and materials shouldn't be altered by their context. One or four box shapes in a row . . . is local order, just an arrangement, barely order at all. The series is mine . . . and clearly not some larger order. It has nothing to do with either order or disorder in general. Both are matters of fact. The series of four or six doesn't change the galvanized iron or steel, or whatever the boxes are made of.

By daring to base their visual statement on a select few parts or just "one thing," these artists, unlike the Cubists, diminish the importance that the act of ordering can have for our experience.

below: 576, Donald Judd. *Untitled.* 1966.
Galvanized iron and aluminum,
3′4″ × 15′10″ × 3′4″ (1.02 × 4.83 × 1.02 m).
Norton Simon Museum of Art, Pasadena
(gift of Mr. and Mrs. Robert A. Rowan).
right: 577. Donald Judd. *Untitled.* 1968. Ink on yellow paper,
17 × 22″ (43 × 56 cm).
Collection Mr. and Mrs. Michael Del Balso.

Morris and Judd make drawings for their works and prepare specifications for designs that technicians execute with great precision in a variety of materials (Fig. 577). Morris has used the telephone to convey instructions to museum carpenters. This division of labor between creator and executor has many precedents in European sculpture. Traditionally, however, the technicians were artists, which permitted them some latitude for interpretation and gained for their skills the recognition of patron and public. By contrast, the carpenters and metalworkers who make boxes for Judd and Morris may have had no other experience with sculpture. Just as the validity of Stella's painting of the sixties does not depend upon the tangibility of the painter's stroke or evidence of "making," the sculpture of Judd and Morris does not take its power from nuance or from the chance effect made by the hand.

The literal, materialistic sculpture of Morris and Judd tended to be exclusive, to shut out much, though not all, of

left: 578. Isamu Noguchi. *The Life of the Cube.* 1962.
Granite, height 10'' (25 cm). Courtesy the artist.

below: 579. Louise Nevelson. *Sky Cathedral.* 1958. Assemblage,
wood construction, painted black; 11'3½'' × 1'6''
(3.44 × .46 m). Museum of Modern Art, New York
(gift of Mr. and Mrs. Ben Mildwoff).

their personal culture, and to minimize the artist's own
presence in the work, as did Ad Reinhardt's painting. In
part, minimalism arose in opposition to the sculpture that
follows and had a serious influence on a whole generation
of artists who felt that minimalism offered a new beginning
after a purification of form. The fabric of history is an inter-
weaving of many strands, however; rather than clear-cut
successions, there is a coexistence of contraries with re-
spect to intentions for an art of simple forms.

**Sculpture as the Reflection of the Artist's Personal
Culture** In the art and person of Isamu Noguchi (b. 1906)
are met the cultures of East and West. Born of an American
mother and a Japanese father, this Nisei artist has always
kept his art open to the cultural traditions of Europe, Amer-
ica, and Japan and to the oldest and newest materials and
techniques for making sculpture. His evolution as an artist
has taken the form of a spiral rather than a linear progres-
sion. The *Life of a Cube* (Fig. 578) was carved in stone,
which for Noguchi is the reassuring direct encounter of
man with matter that has existed since life began. Lacking a
pedestal, it can sit directly and solidly on the earth, thereby
imparting a sense of weight as well as of permanence,
which is part of Noguchi's preoccupation with time. The
subtle shaping of the warped cube gives it the appearance
of having had a history of exposure to internal and external
pressure or the frictions of time. Carved during a stay in
Japan in 1962, the sculpture recalls the culture's reverence
for natural forms and age, for the subtle and unassertive in
art, which is intended to unite humanity and nature.
Planned as an object of meditation, *Life of a Cube* was one
of the works Noguchi had in mind when he wrote, "It seems
to me that the natural mediums of wood and stone . . . have
the greater capacity to comfort us with the reality of our

being In our times we think to control nature, only to
find that in the end it escapes us. I for one return recurrently
to the earth in my search for the meaning of sculpture"—
and, one could add, life itself. For Noguchi, a great purpose
for sculpture in this electronic age is as an antidote to im-
permanence.

Louise Nevelson (b. 1900) does not show Noguchi's rev-
erence for materials such as wood and his attachment to
the earth and to world culture. Her *Sky Cathedral* (Fig. 579)
comes out of her personal urban experience in New York
and is a recycling of that city's discards from demolished
buildings. Those who have lived in old New York "brown-
stone" buildings can recognize fragments of stair bannisters
and newel posts, struts from "bat catcher" grills that hung
from ceilings as partial room dividers, strips of lathe used in
wall partitions, door or wall moldings, and wooden Indian
clubs discarded from some German athletic *Verein* (athletic
club). They and other shapes constitute a mosaic of remem-
berances of things past. Vaguely resembling a great altar-
piece from some old cathedral, Nevelson's sculpture con-
sists of frontally aligned, stacked boxes that serve as
settings for the staging of encounters between found ob-

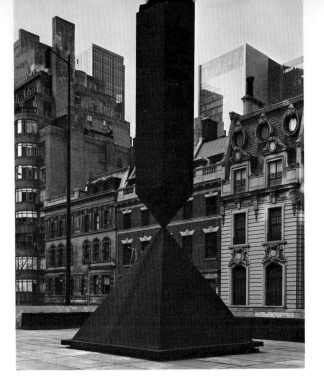

580. Barnett Newman. *Broken Obelisk*. 1963–67. Cor-Ten steel in two parts; 25'5'' × 10'6'' × 10'6'' (7.75 × 3.2 × 3.2 m). Museum of Modern Art, New York (anonymous gift).

genius was to conceive of these two age-old symbols of life and death as coming together like the dramatic union of two powerful forces—like the meeting of the sky and the earth. For Newman, their coming together could have signified creation, a metaphor of art as well as life. Since it was done at the time of the 1967 Arab-Israeli war, it is conceivable that the translation of these shapes into cor-ten steel reflected the sculptor's meditations on the victory of the Israelis in the aerial warfare over the land of his ancestors and that of the pharaohs. Given its original destination in Texas, the artist once spoke of wanting a form that, like a gigantic punch coming out of the sky, would "break the horizon" in Houston. Ironically, it was modern science and technology that permitted this provocation union of obelisk and pyramid. In the jagged top of the obelisk, Newman even used the device of engineers to signify infinite extension of an element. For the artist, the broken obelisk may thus have symbolized infinity or extension to the very stars.

From the time of Ghiberti, art was considered the appropriate expression of an artist's learning, and it was desirable that artists be learned. Until this century, sculpture and painting would literally illustrate their makers' culture—their knowledge of history, religion, and literature, for example. Newman's art is not an obvious expression of his learning, but *Broken Obelisk* is unthinkable without his meditations on history, religion, and the history of art.

No question but that abstract art shut out of painting and sculpture many important life experiences involving persons, places, and things that had been depicted in representational art. In compensation, abstraction increased the intellectual reach of many artists, allowing them to take art and thought into areas they had never been in before. The result was to make available to us new experiences of previously unimagined order and realities. Abstract art has accommodated a wide range of intellects and temperaments as well as tastes. From the start, many found abstraction the most direct and intense way to personalize art and make it responsive to the self. Others have admired the way abstraction could make possible impersonal-looking creation, treat a culture of purely formal relationships, or focus upon the purely aesthetic experience of art.

In the past, the power of art was thought to be its capacity to bring the dead to life and to allow artists and patrons to triumph over earthly oblivion after death. From the origin of the Pygmalion myth, artists dreamed of having an art with the power to re-create life. For modern abstract artists, art's power has included the marvelous capacities of art's elements to project the never before seen, thought, or felt—in short, the invisible made visible. They have sought to create new and meaningful experiences that are additions to life. Where for some, abstraction was the ideal means of turning away from history and confronting the here and now, others found that abstraction gave them the truly modern means to fuse effectively past and present.

jects. All elements are painted black, giving them a new identity and a unity to the whole. Nevelson's gift is to establish dialogues between disparate shapes, to conduct a chorus of rhythms and textures, and, in her terms, to be "an architect of shadows." On occasion, she has extended her walls in relief around entire rooms, creating an intimate and mysterious environment. The impetuous and deliberate assemblage of these heterogeneous wooden elements over a long period of time evokes deep personal associations between the artist and her past; for she has hoarded experiences along with urban wooden detritus: "I take my experience of the past with me." Just like poetry, her art rejects verbal paraphrase and decipherment. Unlike Noguchi, she minimizes craft (being only an adequate carpenter) and draws no attention to niceties of making to absorb the beholder in the imagery. Her poetic titles are invitations to distill one's own experience as prompted by the sculpture.

One of the most dramatic examples in modern art of an artist giving new life to "dead forms" is Barnett Newman's *Broken Obelisk* (Fig. 580). The pyramid is one of the oldest of simple forms, a heavily laden cultural symbol out of the past that one would have expected never to reappear in art. From his own rich personal culture that was formed in part by a lifetime of reading and study, Newman was aware that the pyramid had symbolized a "Place of Ascent," where the pharaoh's soul would rise to join the sky god, and that the obelisk, which was the first structure to catch the rays of the morning sun, was also a symbol of new life. Newman's

Chapter 22

Coda: The Modern Artist

Until recent times the role of artists in their cultures and in their service to patrons—whether tribal chief, bishop, prince, or town council—was clear, as Saul Steinberg wittily epitomized in his depiction of the statue's evolution (Fig. 511). Art was an instrument of political or religious rule and ritual, moralizing and myth-making, philosophizing and pageantry. It mediated between the visible and invisible forces that governed people's lives. The artist was expected to gratify the patron and to enhance the community by a celebration of its heroes and values, to educate the unlettered, delight the intellectual and connoisseur, and satisfy the financial speculator. At various times in history the artist has played the role of magician and scientist, propagandist and ambassador, decorator and entertainer, visionary and prophet. For the most part, until the 19th century the artist imaged the world as others would have it.

The Self and Portraits of the Artists One of the most important developments in the art of the last hundred years has been the effort of artists to bring art closer to its sources in the self, to affirm their identities and those of their means and materials. The self-portrait offers the most dramatic and candid revelation of this intimacy, as seen in an analysis of works by several 20th-century artists.

For many artists Van Gogh is the modern equivalent of Pygmalion and St. Luke, not only as a hero and saint, but as a martyr to the profession. No previous artists so staked their sanity on art nor claimed as did Van Gogh: "I paint or I die." His own portrait (Fig. 581), done while in the asylum

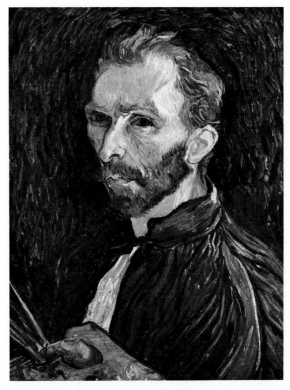

581. Vincent van Gogh. *Self-Portrait.* 1889.
Oil on canvas, 22½ × 17¼″ (57 × 44 cm).
Collection of Mr. and Mrs. John Hay Whitney.

at St. Remy, was part of his self-monitoring between bouts with what he termed "mental disease." Aware that other artists before him had so suffered, Van Gogh wrote: "I feel myself that this does not prevent one from exercising the painter's profession as if nothing was amiss." The intense work of portraiture was part of his hope for a cure. Mastery of his own art was to "be the best lightning conductor of my illness." At once deeply personal and detached, Van Gogh was probing his condition and sharing what he felt was his "saner" state with his brother Theo, to whom the portrait was sent.

The confessional nature of much of modern art is mirrored in self-portraits such as Chagall's exuberant narcissistic image done shortly after his arrival in Paris from Russia just before World War I (Fig. 582). The painting joyfully mingles the sights of Paris and memories of his beloved Vitebsk. The whole is like a lover's bouquet. Dressed as a gentlemen, Chagall suggests his perfumed fragrance as well as his striking looks. Obsession with the miracles of art performed by his hand responding to his imagination may have caused him to endow it with seven fingers. The painting on the easel, inspired by his homeland, alerts the beholder to the fact that Chagall painted with both his head and his heart.

At the time of Chagall's painting, the Austrian artist Egon Schiele was imprisoned on the charge of producing obscene art, some of which the judge actually burned during the trial. Following his release, Schiele lived a solitary life in Vienna and drew himself as the martyred St. Sebastian, robed as a monk (Fig. 583). The arrows relate to Schiele's

above: 582. Marc Chagall. *Self-Portrait with Seven Fingers.* 1912. Oil on canvas, 4'1⅝" × 3'6⅛" (1.26 × 1.07 m). Stedelijk Museum, Amsterdam.

below: 583. Egon Schiele. *Self-Portrait as St. Sebastian.* 1914. Pencil, 12¾ × 19" (32 × 48 cm). Private collection, New York.

below right: 584. Paul Klee. *Absorption (Self-Portrait).* 1919. Lithograph, 9¼ × 6¼" (23 × 16 cm). Paul Klee Foundation, Kunstmuseum, Bern.

view of his rejection by society following loss of a painting competition. The artist later defiantly exhibited this self-portrait, knowing its postural analogy with the crucified Christ would incense the public. In sum, the drawing exemplifies the suffering and alienated artist.

During the German post–World War I revolution, Paul Klee drew his own portrait, *Absorption,* in which he dramatizes the effort to shut out the external world in order to concentrate on the inner visions that nourished his art (Fig. 584). For this powerful image of withdrawl, Klee drew the features as if they had never been drawn before, so that they resemble fibrous and wirelike substances. The image of an artist who claimed he was privy to secrets of soil and cosmos is one of the most telling in art's history with respect to showing the intensity and anguish that accompanies creative effort.

The internalizing of the modern self-portrait found explosive expression in a drawing by Joan Miró (Fig. 585). This hallucinatory image dates from a period when Miró knew poverty and hunger. Drawing from a reflection in a convex mirror, he gave free play to fantastic associations induced by the sight of his own features. There was no feature toward which he remained neutral, and his fantasies were not imposed upon but actually formed the face. Shape, texture, weight, and tangibility of every facial part have all been transformed, and the artist deliberately parodied or inverted their functions. He was drawn to openings in the head, and so he accented their existence, at the same time suggesting their relatedness to other parts of the body. The head seems unable to contain the wealth of ideas and

sensations there induced, and certain shapes encompass areas both within and without the face.

The modern self-portrait, so often probing, pitying, narcissistic, and invariably passionate, is less frequently encountered after World War II. Since about 1960 artists have tended to avoid, for example, dramatic displays of anguish and intimate revelations from the subconscious in favor of more detached, ironic, and even witty self-images. Robert Rauschenberg's *Booster* (Fig. 586) seems such an ironic continuation of the earlier modern drive to reveal the inner life of the artist. As if answering the question, "What is the artist really like deep down inside?," Rauschenberg shows us—by means of a silkscreen transfer process—his own X-rays.

left: 585. Joan Miró. *Self-Portrait.* 1937–38. Pencil, crayon, and oil on canvas; 4'9¼'' × 3'2¼'' (1.46 × .97 m). Collection James Thrall Soby, New Canaan, Conn.

right: 586. Robert Rauschenberg. *Booster.* 1967. Color lithograph and silkscreen, 6 × 3' (1.83 × .91 m). Courtesy Leo Castelli Gallery, New York.

The self-conscious role-playing of contemporary artists has its wittiest expression in Claes Oldenberg's self-portrait (Fig. 587) and his own parody of an art-historical analysis:

> The face is divided in half vertically. One side shows the kindly aspect of the artist; the other his brutal one . . . the tongue . . . doubles as heart and foot. The stare is partly the result of the working conditions of making a self-portrait—one hangs up a mirror and stares into it—but also emphasizes the artist's reliance on the eyes. . . . The Ice Bag on the head signifies that subject was on my mind. It doubles as a beret—attribute of the artist. The objects are shown in the order in which they were made . . . from the *Good Humor Bar* of 1963 through the *Geometric Mouse* of 1969. They circulate about the artist's head like the representation of unconsciousness in the comics, or the astrological signs on the hat of Merlin the Magician—deflated to an Ice Bag. I alternated between the image of a magician and that of a clown, trying to make a combination of the two.

Chosen for its high visual impact, the large-scale, photographically based self-portrait by Chuck Close paradoxically is neither a concession to the realism of photography nor a deliberate means of self-analysis (Fig. 588). The photo is merely a "sketch," which, when transferred to canvas by means of numbered grids, inspires the invention of marks, including his fingerprints, to thereby transpose "information" into art. Close' own head realized by his stamped fingerprints is thus a double self-portrait impossible to forge. Close accepts the fact that his face as fixed in the photo is like a "road map" of his life, but his conscious purpose is to take the familiar shapes presented by the print and to make "shapes that I have never seen before." The paradox that sustains this activity for Close includes the discrepancy between the mark itself and the final portrait effect. Exploring visual rather than psychological interpretation is thus his primary motive.

These last three portraits exemplify the ways by which many American artists in recent times have not rejected science, technology, mass-produced objects, and photography, but rather used them as resources for their own art while cloaking their private natures unlike their predecessors. Connecting all the portraits is not only the subject, but the artists' self-conscious exploration of art's potential.

Who Is an Artist? One of the most dramatic developments in the recent history of art has been the questioning of the artist's identity. Who is an artist? The problem never would have occurred to anyone before 1900. With few exceptions, an artist's credentials for the profession were clear and traditional. They included craft and art school training, the making of objects, and their exhibition where other artists also showed their work. To be sure, there was a long tradition—going back to ancient Rome—of dilettantes, talented amateurs who worked at art as an avoca-

below: 587. Claes Oldenburg. *Symbolic Self-Portrait with Equals.* 1970. Collage and pencil on graph and tracing paper, 11 × 8¼″ (28 × 21 cm). Moderna Museet, Stockholm.

below right: 588. Chuck Close. *Self-Portrait.* 1980. Stamp pad ink on paper, 15¾ × 11½″ (41 × 29 cm). Courtesy The Pace Gallery, New York.

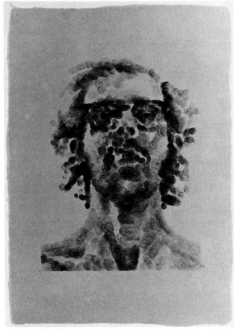

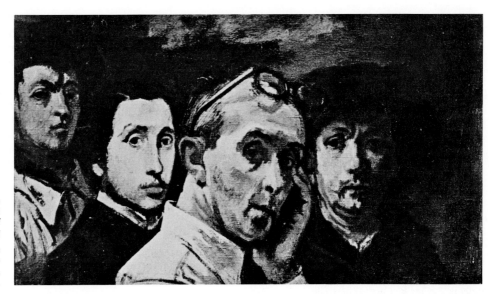

589. Raphael Soyer. *Self-Portrait with Self-Portraits of Rembrandt, Corot, and Degas.* 1959. Oil on canvas, 11½ × 20½″ (29 × 52 cm). Collection Lois Budman, Detroit.

tion. With the development of modern oil paints available in tubes and the Impressionists' scorn of drawing or work based on the imitation of older art, painting became physically and psychologically more accessible to amateurs such as Gauguin (Pl. 30, p. 261). The collage (Fig. 436), which included photographs and vernacular material, reduced further the emphasis on drawing and imitative skills, and the use of "readymades" sanctioned by Duchamp struck blows against originality and the hand-fashioned (Fig. 443). All that has minimized craft and skill of execution in this century has encouraged untrained individuals to put their minds if not their hands to art.

The decision about who is an artist today is made basically the same way as in the past—by artists. To a jury of peers, it is the art he or she makes that establishes an artist's credentials. An additional modern criterion is whether or not the candidate is "sincere." For many among the public, in the absence of clear, objective and published standards, peer accreditation is not enough. (Being able to "draw a straight line" is still for many a minimum criterion.) Art seems to have been debased and the profession opened to charlatans. For others, including the law courts, peer evaluation is a realistic adjustment to historical evolution. The more challenging question is not who are the artists, but who are the good ones?

When one recalls the major artists of this century—such as Picasso, Matisse, Klee, Mondrian, Kandinsky, Duchamp, Miró, Brancusi, Moore, Pollock, and Rothko—it is apparent that the new permissiveness of entry into the profession has not yet produced artists of their stature. Those mentioned all experienced some art school training or instruction from artist-teachers and otherwise carried traditional credentials. At the turn of the century there were a few important artists, such as Gauguin and Duchamp-Villon (Fig.

482), who were self-taught. Although the idea was not new, it was Courbet (Figs. 24, 403, 404) who most dramatically proclaimed that art could not be taught either in art schools or by teachers. Earlier artists had argued that the art schools stifled genius, but reform within the educational system was usually the objective. Since the second half of the last century the most venturesome artists have felt that art schools could not provide inspiration.

Whether or not they have had formal training, most artists prefer to study the art that interests them most on their own, in museums and galleries. Raphael Soyer (b. 1899) had formal training, and his *Self-Portrait With Self-Portraits of Rembrandt, Corot, and Degas* (Fig. 589) is a candid crediting of his sources and a touching reminder that, in terms of owing a debt to the past, the artist is never solitary in the studio.

Cézanne (Fig. 457; Pl. 33, p. 263; Pl. 41, p. 315), who had formal training, and many artists influenced by him after 1900 saw themselves as the new "primitives," confronting art and nature in an unprejudiced way. In the last few years, many artists have become involved in technology and materials not previously deemed suitable for art, with the result that the general attitude has been to learn what one must learn on one's own to get the job done. There is no way to codify into curricula all that today's artists need to know. For artists who would educate themselves, art exhibitions and periodicals, with their international circulation, serve as source books, replacing the prints, drawings, and plaster casts of the classical academies.

What Is Art? The short answer to this questions is: What artists make with the intention that it be art. Validation of the result depends primarily upon artists, and then art dealers, critics, curators, collectors, and historians. That the

question is so often posed today by the public is a recent phenomenon in history. Its cause comes from critical thinking by artists.

In our own century, for the first time, there has been a prolonged questioning by artists of what art is. Many individuals and groups have attempted either to push back its traditional limits or to go beyond them, while not claiming that what they have done is art. The 20th century has witnessed a drastic shrinkage of what is *not* art. In the decade of the 1960s artists began to build upon premises established by Duchamp (who questioned that anything man-made was not art), Picasso, the Dadaists, and Dubuffet, to name a few (see Chap. 20), with results that seem to have stripped the word "art" of all meaning. When painters set aside the picture frame and sculptors eschewed the pedestal and base so as to make their works more tangible or concrete as aesthetic objects, we saw the contravening of art's tradition of illusion and preciousness.

Many young artists today speak of "demythologizing" art, taking it out of the realm of "inspired genius" where it was put during the Renaissance, and renouncing "miracles" of the hand. We have defined "art" as the skillful interpretation of human experience in a man-made object capable of producing an aesthetic response. When an artist like Picasso (see Chap. 19) minimizes his skill, when a sculptor like Judd (Fig. 576) turns the execution of his work over to industrial metalworkers, it is evident that the viewer's enjoyment of skill or craft is not something the artist desires or anticipates. The interpretation of human experience, with its connotations of symbolism, metaphor, and analogy, has been increasingly set aside by many young artists who make "specific" objects to be taken literally and at face value. The desirability of inducing an aesthetic response or appealing to taste has also fallen before the onslaught of countless artists throughout the world, who see beauty as something "irrelevant," "elitist," and smacking of "class" or "establishment" snobbery. Beauty, to them, is less interesting than what they are doing. One can be interested or deeply moved by an artist's work even though it is not beautiful, as Picasso, Pollock, and De Kooning (Pl. 53, p. 386) have taught us. In the case of these three artists, however, it could be argued that in their search for truth in art they have established a new aesthetic of the brutal or violent.

The work of art as an object that is permanent, negotiable, and precious because of its uniqueness and the skill lavished on it no longer interests the artist preoccupied with motion, concepts, and the ephemeral. Artists who use technology to produce works that actually move or who employ machines and systems for their effects—works that plug into a wall socket or depend on the postal service, medical check-ups, and earth movers, for example—have no patience with the hard and fast. The premise that a work of art must be visible is rejected by conceptual artists who believe that art comes into being in the artist's mind and that the intermediary with an audience can be a diagram or words.

Artists who place more value on the making or the process of assembling vernacular materials that may or may not be keyed to a certain site set no store by a finished art object. After the artist has stopped or the show is over, the work is disassembled or destroyed. Order or composition leading to "good form," which was one of the last ties to traditional art, is scrupulously avoided by certain artists who refuse either to arrange their materials consciously or to repeat themselves, for the latter would imply the development of a style. Obviously, what has been described is usually unsalable, uncollectable, and even hard to document photographically.

Many young people are rebelling against the notion of art earning a profit for the owner rather than the artist. Instead, they seek fees or commissions as a means of sponsoring their artistic ephemera. Owning but not possessing is a condition that some patrons are learning to live with. About all that remains of the tradition of at least the last century of Western art is that, for many contemporary artists, art is an expressive activity in which the product or result is useless for any other purpose.

The Lessons of Artistic Freedom In modern times humanity's hope has included being able to choose and pursue purposes, the condition we call freedom. The artist's profession offers us important, if not unique, examples of the paradoxes and responsibilities that accompany the right of choice.

Today in Western societies, artists enjoy unprecedented freedoms, both positive and negative: they are free *to* choose and pursue purposes and free *from* such obstacles to the realization of their purposes as government censorship. It is one of history's lessons, however, that freedom as we think of it has not always been synonymous with creativity. As we have seen, great artists of the past were able to manifest their independence of spirit and vision both despite and because of working under what we view as intolerably restrictive conditions. Throughout most of history, the artist's profession did not champion the right of total self-expression. Artists' purposes were aligned with their authoritarian patrons. Conversely, once society had come to know political and intellectual liberty, perhaps spurred by art, and artists were supposedly free of external constraints, they have acted on their own to circumscribe freedom by imposing external and internal braking systems. Modern art has involved successive exchanges of one set of constraints for another.

External Limits on the Modern Artist's Freedom Under Stalin and Hitler, among those groups who willingly and energetically carried out repressive activities against their more venturesome colleagues were artists. Adolph Zeigler, a German painter known for his meticulously painted naked women, vigorously implemented Hitler's policies on "degenerate" modern art. His efforts led to the removal of

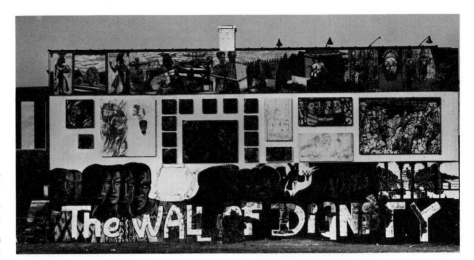

right: 590. The Wall of Dignity, Detroit.

below: 591. Romare Bearden. *Blue Interior, Morning.* 1968. Collage, 3'8'' × 4'8'' (1.12 × 1.42 m). Collection Chase Manhattan Bank, New York.

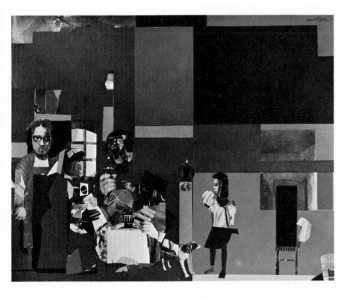

distinguished artists such as Max Beckman from teaching positions that were than filled by conservative artists sympathetic to the Nazis; the prohibition of many modern artists from working as artists; and the confiscation and destruction of many examples of modern art in German museums. Now, as during the Stalin era, it is artists in Russia who officially censor other artists.

In the 1950s during the McCarthy era in the United States, it was not only reactionary politicians but conservative artists' groups as well that denounced politically suspect artists and prevented government-sponsored exhibition of their work. As a form of externally imposed constraint on artistic freedom, imagined or actual unofficial peer pressure should not be underestimated.

Two ideas that have exerted pressure on artist's right of choice are the concepts of the *avant garde* and *relevance.* In the 19th century, there developed the concept of artists who were believed to be in advance of society, but in the "mainstream" of great artistic traditions—pioneers or "breakthrough" artists. Certainly in the United States after World War II and until the last few years, there was a bandwagon mentality in the art world. The notion of "relevance" posited the idea that short-term or immediate interests were what should guide artists. They were under considerable pressure to keep up with the passions or mania of the critics and other artists for the new. In their lifetimes, Calder, Henry Moore, and Picasso heard themselves pronounced irrelevant. Repeatedly, artists as well as critics have proclaimed that easel painting is dead, abstraction exhausted, sculpture as an object obsolete, and that art's future lay in systems and conceptual art. The tradition of teaching by working directly from the human figure almost disappeared in art schools in England and the United States. Impressionable students in art schools have often confined their choices to those presented by certain art magazines, critics, and artists regarded as prophets.

Related to relevance was the widespread constraint on artists imposed, starting in the late sixties and early seventies, by ethnic and feminist groups consisting not just of political and social activists but also of artists. Black artists were enjoined to express the experience of their race and to portray what it is like to live in a predominantly white society. For some black artists, this translated into explicitly racial subject matter, such as the *Wall of Dignity* in a Detroit ghetto (Fig. 590). Their goal was to establish racial pride through chronicle and commentary, daily reminders of heroism and injustice. Other black artists, working privately for their race, sought as professionals to develop to the fullest extent the broad options opened by modern art. Bearden's *Blue Interior, Morning* (Fig. 591) expresses "the life I know best, those things common to all cultures." The ancestry of his art includes African sculpture, Dutch 17th-century paint-

592. Miriam Schapiro. *Heart of Diamonds.* 1979.
Fabric and acrylic on paper, 36″ (91 cm) square.
Courtesy Barbara Gladstone Gallery, New York.

ing, abstraction, collage, and photographic documentaries, as well as his experience of living in the South, Manhattan, and Paris.

Starting in the early 1970s, women artists have been encouraged by feminist groups to cast off styles evolved to win acceptance in a "male-dominated" art world and to portray in their art the nature of the female experience. One of the most important converts to feminism in art is Miriam Schapiro, who after 1970 radically transformed her style and subject matter so that she could address her art to a female audience (Fig. 592). As part of consciousness raising, feminists urge women to rediscover, respect, and continue a tradition of decorative art, notably in the area of patterns, with which women have been associated throughout history. There are many women artists who take issue with this view, arguing that they are artists who happen to be women and want to be first thought of as artists. Further, the latter group points out that today women have won equal status in the art world and that many of the most influential dealers, critics, curators, and collectors have been and are women. The obstacles to success in the present are seen by many women as equally difficult for both sexes. Among older successful artists, there is often the feeling that art and artists cannot be separated by sex and that the emotions the artist draws from are inherited from all humanity.

Artists always have been their own worst enemies when it came to competition. In the past, they competed for commissions, status in the guild, appointments at court, government prizes, and free entry into official annual exhibi-

tions. Today artists still compete for exposure, purchases, and commissions, as well as for jobs and fellowships or grants. Their profession is often as competitive as business. Rich artists are freer and far less numerous than poor artists, and the latter often see the art world as dominated by the former; but occasionally an artist's most respected friends can reduce him or her to paralysis by their antagonistic reception of new work. In the name of balance, however, it should be said that artists are generally supportive of one another in terms of education, critical and moral encouragement, and assistance in getting public exposure.

When we read the writings of modern artists, we are surprised to see how much of their thinking is injunctive and proscriptive. The modern phenomenon of the artist's manifesto is the equivalent of Jehovah's Commandments given to Moses. From Daumier to the present, "to be of one's own time" has been a moral imperative. Such statements as Cézanne's "We must render the image we see" or Brancusi's "Direct cutting is the true way to sculpture" have the tone of academic certitude and remind us that it was the academy that imparted to revolutionary artists that sense of absolutes and discipline with which they carried out their revolt. Modernism has involved a trade-off of freedoms and constraints with its more conservative predecessors. Matisse was just as dogmatic about what art should and should not be as any academician. No political tyrant could have been more dictatorial than Matisse (Fig. 593), Cézanne, and other modern artists in shutting out of art the depiction of the subject's feelings in favor of expression as derived from the whole arrangement of the painting or sculpture.

A revelation to the public is the psychological domination—in fact, tyranny—of art over the minds of "free" artists. The single most powerful tenet in the theology of modern art is that the work of art possesses its own necessity, logic, spirit, personality, or music. Matisse spoke for many when he said, "I must interpret nature and submit it to the spirit of the picture."

Modern artists often have been the ungrateful beneficiaries of one another's achievements; what was liberating to their elders has been seen as intellectual and aesthetic bondage by the next generation. Gauguin decried the Impressionists' commitment to visual experience as being shackled to probability. The Fauves reacted against the esoteric and intuitive symbolism of Gauguin and his group in favor of a lusty and sensuous response to nature. Marcel Duchamp, who had learned from the Fauves, rejected the "physical" and sensuous side of painting and sought to return it "to the service of the mind." Marc Chagall wrote that "Cubism seemed to limit pictorial expression unduly . . . I felt painting needed greater freedom than Cubism permitted." The juries that rejected avant-garde artists from Manet to Brancusi were composed of artists. As a juror, Matisse turned thumbs down on the Cubists. Even when dead, artists are fair game for rejection by other artists. Repeatedly

above: 593. Henri Matisse. *Self-Portrait.* 1937. Charcoal, 18¾ × 15⅝″ (48 × 39 cm). Baltimore Museum of Art (Cone Collection).

below: 594. Jackson Pollock at work in his studio, East Hampton, N.Y. 1951.

during the history of modernism, groups such as the Futurists and individuals such as Géricault, Pissarro, and Cézanne have variously called for repainting the contents of museums, closing them down, or even burning them. The last two artists felt that museums dissuaded the artist from looking at nature.

Self-Imposed, Internal Constraints on the Artist's Freedom In older art, it was often thought that the gifted artist was inspired by a muse, and as with the Evangelist shown writing the Gospel with his symbol hovering nearby, a sort of divine dictation occurred. The artist was but a mortal medium for a divine message. If we grant that acting upon impulse or by some form of irrational internal dictation—as in modern automatism—does not constitute the condition of being able rationally to choose and pursue purposes, then many artists have rejected full freedom to create. Gauguin was one of the first to urge other artists "to dream before the painting" in order to arrive at realities available only through art. The practice of unpremeditated or spontaneous generation of images by artists as varied as Arp and Jackson Pollock (Fig. 594) was meant to unlock previously closed off sources of creativity and was seen as a guarantee of truth and sincerity in art; but Arp and Pollock did not make themselves over totally into mediumistic stenographers, since they did exercise critical judgment in the final stages of their work. Whether the artist has responded

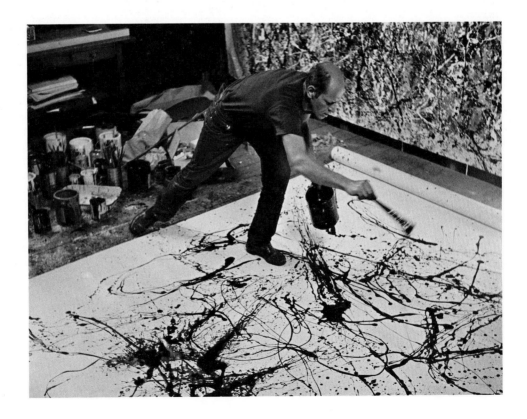

to the dictates of nature, art, or the spirit, there has been a cost of freedom. Creativity has not been synonymous with total freedom.

It is artists themselves who help us to understand the paradox of curtailing freedom in order to be liberated. Essentially, artists recognize that, in the welcome words of the German artist Ernst Schwitters, "Freedom is not lack of restraint, but the product of strict artistic discipline." The great French painter Georges Braque made one of the most influential declarations for artists when he discussed this subject: "In art, progress does not consist in extension, but in the knowledge of limits. Limitation of means determines style, engenders new form, and gives impulse to creation."

Perhaps the key in the foregoing statement is the concept that inspiration can come from self-imposed limitations. Far from overthrowing all rules, modern artists— those "free spirits"—have never hesitated to impose them and welcomed their prior existence as something to rebel

against. In old age, Picasso complained, "The thing that is wrong with modern art . . . is the fact that there isn't any longer a strong powerful academic art worth fighting against. There has to be a rule, even if it's a bad one, because the evidence of art's power is in breaking down the barriers. But to do away with obstacles—that serves no purpose other than to make things completely wishy-washy, spineless, shapeless and meaningless, zero." Picasso was just as sincere when he wrote, "Art is something subversive. It is something that should not be free. Art and liberty, like the fire of Prometheus, are things one must steal, to be used against the established order. Once art becomes official and open to everyone then it becomes academism" (Fig. 595). Today in a totally permissive art world, thoughtful instructors may even tell art students to make up rules if necessary, to have something to push off from.

What is fascinating is the way in which each artist limits his or her own freedom to lighten the continuing burden of creativity. One of the classic ways in which artists have lightened the creative load is by using theme and variation, resisting the old tradition of the masterpiece or single summation of a life's work. Others resist doing a "perfect" or "finished" work. (Picasso had a horror of the concept of finish, equating it with death and preferring to see his art as a continuum.) Many contemporary painters who reject finish and beauty as objectives seek to give each work a sort of clumsy

below: 595. Pablo Picasso. *The Prisoner,* 1901. Brush and india ink, 12⅜ × 8½'' (32 × 22 cm). Musée Picasso, Paris.

below right: 596. Robert Indiana exulting after finishing the painting of the basketball court for the Milwaukee County Arena. 1977.

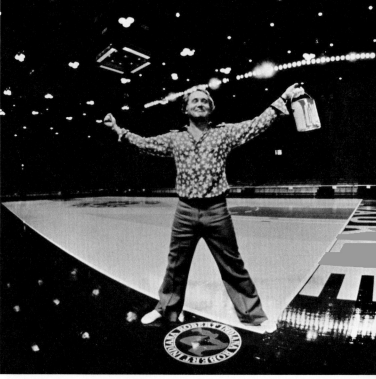

look or one that suggests the painting is leading to something else. Artists such as the Impressionists and Cézanne did not sit in their studios waiting for inspiration to come, but let encounters with nature provide the inspiration. The constant discipline of working directly from the model partly accounted for the great productivity of Matisse (Fig. 469) and Rodin. Henry Moore deliberately limits the postures of his figures to three, in order to concentrate on formal adventures. Albers painted basically the same picture for much of his life. Jasper Johns confines his painting motifs to those from the visible world that are flat, thereby meeting at least the physical conditions of his work.

Artists may rely upon accident and chance or found objects of a certain type to initiate a work. To break through what for many is the terrible white barrier of the canvas, some artists will make random marks or letters on the surface and then will paint them out. Creativity in art is like other complex human activities, such as problem solving, and the artist must learn how to do tough things with ease.

Problem solving and facility often come with advancing age, but the aging process itself it is frequently the artist's worst enemy. Above all, artists want to avoid repeating themselves. The problem is not just to find new answers to old questions, but to renew and transform one's self by risk taking. Late in life, Calder loved the challenges offered him by imaginative patrons who wanted a mosaic sidewalk in Manhattan or a painted airplane for Braniff airline. Nothing is more coveted but also deadly to many artists than a museum retrospective of their work. Frank Stella, who had a major retrospective while he was young, thereafter engaged in a heroic attempt to transform his art by almost systematically countering all his previous rules for painting (Pl. 57, p. 404). No artists want to be prisoners of their own pasts in either their minds or the public's.

Artists, like composers and poets, are very much aware that freedom is a dangerous thing and creative use may be made of freedom's limitations. The absence of psychological and moral constraints, they realize, would produce chaos or creative paralysis. They must eliminate, shut out, avoid various options in order to focus thought and feeling to function effectively in their profession. There is no organized system in nature without inhibitors, or brakes, or a filtering system to shut out certain stimuli. Artists' curtailment of their own freedom is natural, desirable, and a dramatic manifestation of their humanity, but not their uniqueness. No one better understood the problems and nature of freedom than Pablo Picasso. At 85, Picasso reflected, "Freedom, one must be careful of that. In painting as in everything else. Whatever you do, you find yourself once more in chains. Freedom not to do one thing requires that you do another, imperatively. And there you have it, chains."

Purposes of Art Today Let those who argue that art no longer serves any serious purpose explain why in many countries art is still severely censored or suppressed and

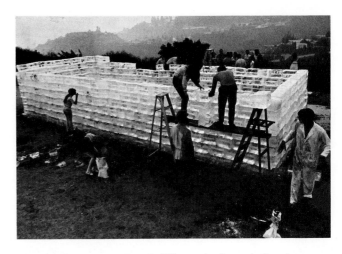

597. Alan Kaprow and others building an ice house in Pasadena, Calif., as part of the artist's *Fluids* project. 1967. (Photograph by Dennis Hopper.)

why these conditions are abhorrent to thinking people. When artists are not free to choose and pursue purposes, who else in that society is truly free?

For some artists, art's purpose is to hold a mirror up not to nature, but to art itself. Conceptual artists, for example, believe that the object or work of art is dispensable and that the artist should today engage only in the constant redefinition of art. Thereby, art is reduced to words or, ideally, to mental telepathy. At the other extreme are thousands of artists in Russia, China, and Cuba who firmly believe that the artist's role is still to give aesthetic form to their government's political ideology. There are also signs that many American artists are again willing to work for governments if the terms are agreeable (Fig. 596). Between these poles reside thousands of artists who practice their profession because it is personally gratifying, affording them the rare opportunity to conceive and execute a work entirely on their own. The work of art as a means of inventing, dramatizing, or just plain satisfying the self has led to the making of the last handmade objects of value in our culture. To the cynic, art's purpose in a capitalist society is the personal gratification of those investors who are searching for "collectibles" as a social status symbol and a hedge against inflation.

The good life may no longer be art's subject, but the practice of self-expression in aesthetic form, of being creative and constructive, has itself become a model of the good life. For many artists in this century, beginning with Paul Klee and Jean Arp, art's purpose has been to restore innocence and joy to life. Alan Kaprow sees the provisions for *fun* as art's last valid purpose, and he teaches his students how to involve people in noncompetitive play (Fig. 597). For Christo, who was born and trained in a Communist country, art involves bringing together people from all

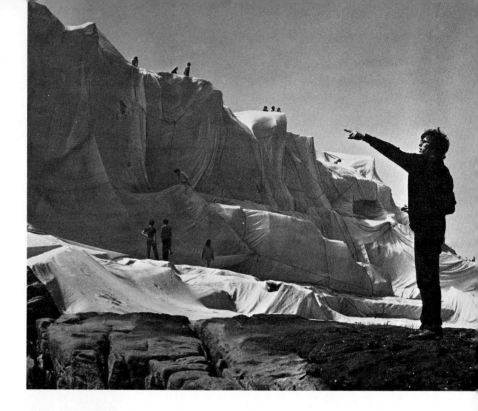

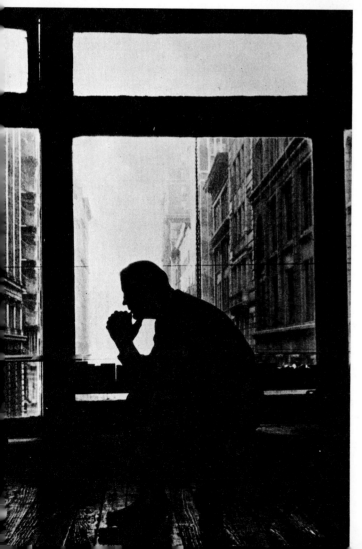

above: 598. Christo supervising the construction of
Wrapped Coast, Little Bay, Australia. 1969.

left: 599. Ad Reinhardt in his studio. 1961.
Courtesy Jewish Museum, New York.
© Marvin Lazarus.

walks of life and engaging the political as well as cultural
system to effect temporary but spectacular projects that
become indelible in the memory of those who witness them
(Fig. 598). For artists like Noguchi, however, art's perma-
nence is a necessary and comforting counterbalance to
ephemerality.

A striking photograph of the late Ad Reinhardt (Fig. 599)
calls to mind the phenomenon of the modern artist who
carries within memory the history of art but who, in order to
extend it meaningfully, must learn from and then reject
what has gone before. The photograph, which frames the
artist against a window, squared like his canvases, shows
him inactive but contemplative, reminding us of the impor-
tance of creative idleness. Whether the goal is effecting so-
cial change, uniting one's internal life with the external
world, exploration of the expressive potential of art's ele-
ments, or perpetuation of art itself, each time artists are
alone in the studio confronting their materials, they are
born and live again. Art remains an act of love, a potent
gesture of life, a fist clenched against death.

Bibliography

The following books and articles were consulted in the preparation of the text. This bibliography is by no means an attempt to list all the material available on these subjects.

Suggested General Readings in the History of Art

Butler, R., *Western Sculpture: Definitions of Man.* New York: Harper & Row, 1979.

Clark, K. M., *The Nude: A Study in Ideal Form.* New York: Pantheon Books, 1956.

———, *Civilization: A Personal View.* New York: Harper & Row, 1969.

Gombrich, E. H., *The Story of Art.* New York: Phaidon, 1958.

———, *Art and Illusion: A Study in the Psychology of Pictorial Representation.* New York: Pantheon, 1960.

Hibbard, H., *Masterpieces of Western Sculpture: From Medieval to Modern.* New York: Harper & Row, n.d.

Hauser, A., *The Social History of Art,* 4 vols. New York: Vintage, 1957–58.

Janson, H. W., *The History of Art,* rev. ed. New York: Abrams, 1978.

Lee, S., *A History of Far Eastern Art.* New York: Abrams, 1964.

Pevsner, N., *An Outline of European Architecture.* Baltimore: Penguin, 1960.

Schapiro, M., "Style." *Anthropology Today* (ed. by A. Kroeber). Chicago: U. of Chicago Press, 1953.

———, *Modern Art: 19th and 20th Centuries.* New York: Braziller, 1978.

Wittkower, R., and M. Wittkower, *Born Under Saturn.* New York: Random House, 1966.

The Artist

Boime, A., *The Academy and French Nineteenth Century Painting.* London: Phaidon, 1971.

Burford, A., *Craftsmen in Greek and Roman Society.* Ithaca: Cornell U. Press, 1972.

Burke, P., *Culture and Society in Italy, 1420–1540.* New York: Scribners, 1972.

Chambers, D. S., *Patrons and Artists in the Italian Renaissance.* Columbia: U. of South Carolina Press, 1971.

Chipp, H., et al., *Theories of Modern Art.* Berkeley: U. of California Press, 1969.

Clapp, J., *Censorship.* Metuchen, N.J.: Scarecrow Press, 1972.

Easton, M., *Artists and Writers in Paris: The Bohemian Idea.* New York: St. Martin's, 1964.

Egbert, D. D., *Social Radicalism and the Arts.* New York: Knopf, 1970.

Harris, A., and L. Nochlin, *Women Artists, 1500–1950.* Los Angeles: Los Angeles County Museum of Art, 1976.

Haskell, F., *Patrons and Painters: A Study in the Relations between Italian Art and Society in the Age of the Baroque.* New York: Knopf, 1963.

Hauser, A., *The Social History of Art,* 4 vols. New York: Vintage, 1957–58.

Hess, T., and J. Ashbery, "The Academy." *Art News* Annual, 1967.

Kris, E., and O. Kurz, *Legend, Myth and Magic in the Image of the Artist.* New Haven: Yale U. Press, 1979.

Larner, J., *Culture and Society in Italy, 1290–1420.* New York: Scribners, 1971.

Martindale, A., *The Rise of the Artist in the Middle Ages and the Renaissance.* New York: McGraw-Hill, 1972.

Pelles, G., *Artists and Society: Origins of a Modern Dilemma.* Englewood Cliffs, N.J.: Prentice-Hall, 1963.

Pevsner, N., *Academies of Art.* London: Cambridge U. Press, 1940.

Sources and Documents, Prentice-Hall series. Invaluable for artists' statements.

White, H. C., and A. C. White. *Canvases and Careers: Institutional Change in the French Painting World.* New York: Wiley, 1965.

Wittkower, R., and M. Wittkower, *Born Under Saturn.* New York: Random House, 1963.

Art as a Matter of Life and Death

Cole, H. M., *African Arts of Transformation.* Santa Barbara: Art Galleries, University of California at Santa Barbara, 1970.

Elisofon, E., W. Fagg, and R. Linton, *The Sculpture of Africa.* London: Thames and Hudson, 1958.

Fagg, W., *African Sculpture:* Loan Exhibition. Washington: International Exhibitions Foundation, 1970.

Fraser, D., *Primitive Art.* New York: Doubleday, 1962.

Groenewegen-Frankfort, H. A., *Arrest and Movement.* New York: Humanities, 1951.

Guiart, J., *The Arts of the South Pacific.* New York: Golden Press, 1963.

Gunther, E., *Art in the Life of the Northwest Coast Indian.* Portland, Oreg.: Portland Art Museum, 1966.

Herskovits, M. J., *The Backgrounds of African Art.* Denver: Denver Art Museum, 1946.

Lévi-Strauss, C., *The Savage Mind.* Chicago: University of Chicago Press, 1968.

Schapiro, M., "On Some Problems in the Semiotics of Visual Art: Field and Vehicle in Image Signs." *Semiotica* 1: 3, 1969.

Schilder, P., *The Image and Appearance of the Human Body.* New York: International U. Press, 1950.

Sieber, R., "Masks as Agents of Social Control." *African Studies Bulletin* 5: 8–13, May 1962.

———, and A. Rubin, *Sculpture of Black Africa: The Paul Tishman Collection.* Los Angeles: Los Angeles County Museum of Art, 1968.

Thompson, R. F., *African Art in Motion: Icon and Act.* Washington: National Gallery of Art, 1974.

Ucko, P. J., and A. Rosenfeld, *Paleolithic Cave Art.* New York: McGraw-Hill, 1967.

Images of Gods

Apollo

Guthrie, W. K. C., *The Greeks and Their Gods.* Boston: Beacon Press, 1955.

Hirmer, M., and R. Lullies, *Greek Sculpture* (tr. by M. Bullock). New York: Abrams, 1957.

Kitto, H. D. F., *The Greeks.* Baltimore: Penguin, 1951.

Murray, G., *Five Stages of Greek Religion.* Boston: Beacon Press, 1952.

Richter, G. M. A., *The Sculpture and Sculptors of the Greeks,* rev. ed. New Haven: Yale U. Press, 1950.

Buddha

Bowie, T. (ed.), *The Arts of Thailand.* Bloomington: Indiana U. Press, 1961.

Coomaraswamy, A. K., *The Transformation of Nature in Art.* New York: Dover, 1957.

Kramrisch, S., *The Art of India through the Ages.* New York: Phaidon, 1954.

Less, S., *A History of Far Eastern Art*, rev. ed. New York: Abrams, 1964.

Rowland, B., Jr., *The Art and Architecture of India*. Baltimore: Penguin, 1953.

———, *Art in East and West*. Cambridge, Mass.: Harvard U. Press, 1955.

——— (ed.), *The Evolution of the Buddha Image*. New York: Abrams, 1963.

Christ

Barr, A. J., Jr., *Matisse, His Art and His Public*. New York: Museum of Modern Art, 1952.

Grabar, A., *Byzantine Painting*. Geneva-New York: Skira, 1953.

———, *Christian Iconography: A Study of Its Origins* (tr. by T. Grabar). Princeton, N.J.: Princeton U. Press, 1968.

Hartt, F., *History of Italian Renaissance Art*, 2nd ed. New York: Abrams, 1979.

Kayser, S. S., "Grünewald's Christianity." *Review of Religion* 5: 3–35, Nov. 1940.

Male, E., *L'Art religieux du XIIe siècle en France*. Paris: Colin, 1953.

Pevnser, N., and M. Meier (eds.), *Grünewald*. New York: Abrams, 1958.

Schapiro, M., "The Romanesque Sculpture of Moissac," Parts I and II. *Art Bulletin* 13: 248–351, 464–531, Sept.–Dec., 1931.

Thoby, P., *Le Crucifix des origines au Concile de Trente*. Nantes: Bellanger, 1959.

Von Simson, O. G., *Sacred Fortress: Byzantine Art and Statecraft in Ravenna*. Chicago: U. of Chicago Press, 1948.

Religious Architecture

The Parthenon

Berve, H., and G. Gruben, *Greek Temples, Theaters and Shrines*. New York: Abrams, 1963.

Dinsmoor, W. B., *The Architecture of Ancient Greece*. London: Batsford, 1950.

Lawrence, A. W., *Greek Architecture*. Baltimore: Penguin, 1957.

Pollitt, J. J., *Art and Experience in Classical Greece*. Cambridge: Cambridge U. Press, 1972.

Robertson, M., and A. Frantz, *The Parthenon Frieze*. New York: Oxford U. Press, 1975.

Scranton, R. L., *Greek Architecture*. New York: Braziller, 1962.

Scully, V. J., *The Earth, the Temple and the Gods: Greek Sacred Architecture*. New Haven: Yale U. Press, 1962.

Stevens, G. P., *Restorations of Classical Buildings*. Princeton, N.J.: American School of Classical Studies at Athens, 1958.

The Gothic Cathedral

Branner, R., *Gothic Architecture*. New York: Braziller, 1961.

———, *Chartres Cathedral*. New York: Norton, 1969.

Dow, H. J., "The Rose Window." *Journal of the Warburg and Courtauld Institutes* 20: 248–97, July, 1957.

Frankl, P., *The Gothic*. Princeton, N.J.: Princeton U. Press, 1960.

———, *Gothic Architecture*. Baltimore: Penguin, 1963.

Gimpel, J., *The Cathedral Builders*. New York: Grove, 1961.

Harvey, J., *The Gothic World*. London: Batsford, 1950.

Henderson, G., *Chartres*. Harmondsworth, Eng.: Penguin, 1968.

Holt, E. G. (ed.), *A Documentary History of Art, Vol. 1: The Middle Ages and the Renaissance*. New York: Anchor, 1957.

Horn, W., and E. Born, *The Aisled Medieval Timbered Hall: A Study of Its Origins, Development and Survival*. Berkeley: U. of California Press.

Hurliman, M., and J. Bony, *French Cathedrals*, rev. ed. New York: Viking, 1961.

James, J., "The Contractors of Chartres." *Architectural Association Quarterly* 4: 2, 1972.

Johnson, J. R., *The Radiance of Chartres*. New York: Random House, 1965.

Katzenellenbogen, A., *The Sculptural Programs of Chartres Cathedral: Christ-Mary-Ecclesia*. Baltimore: Johns Hopkins Press, 1959.

Knoop, D., and G. P. Jones, *The Medieval Mason*. Manchester: Manchester University Press, 1933.

Kraus, H., *The Living Theater of Medieval Art*. Bloomington: Indiana U. Press, 1967.

———, *Gold Was the Mortar: The Economics of Cathedral Building*. London: Routledge and Kegan Paul, 1979.

Macaulay, D., *Cathedral: The Story of Its Construction*. Boston: Houghton Mifflin, 1973.

Panofsky, E., *Abbot Suger on the Abbey Church of St. Denis and Its Art Treasures*. Princeton, N.J.: Princeton U. Press, 1946.

———, *Gothic Architecture and Scholasticism*. New York: Meridian, 1957.

Pevsner, N., "The Term 'Architect' in the Middle Ages." *Speculum* 17: 1942.

Smith, B., *Architectural Symbolism of Imperial Rome and the Middle Ages*. Princeton, N.J.: Princeton University Press, 1956.

Von Simson, O., *The Gothic Cathedral*. New York: Pantheon, 1956.

The Pompidou Center

Centre Georges Pompidou. New York: Rizzoli, 1977. In French and English; a collection of essays.

Notre Dame du Haut, Ronchamp

Le Corbusier, *Towards a New Architecture* (tr. by Etchells). New York: Praeger, 1946.

———, *The Chapel at Ronchamp* (tr. by J. Cullen). New York: Praeger, 1958.

The Sacred Book

Alexander, J. J. G., *The Decorated Letter*. New York: Braziller, 1978.

Beckwith, J., *Early Medieval Art*. New York: Praeger, 1964.

Diringer, D., *The Illuminated Book: Its History and Production*. London, 1967.

Grabar, A., and C. Nordenfalk, *Early Medieval Painting*. Skira, 1957.

———, *Romanesque Painting*. Skira, 1958.

Metz, P., *The Golden Gospels of Echternach* (tr. by I. Schrier and P. Gorge). New York: Praeger, 1957.

Nordenfalk, C., *Celtic and Anglo-Saxon Painting*. New York, 1977.

Porcher, J., *Medieval French Miniatures*. New York: Abrams, 1959.

The Synthesis of Heaven and Earth in 15th-Century Art

Flemish Art

Cuttler, C., *Northern Painting from Pucelle to Bruegel: 14th, 15th and 16th Centuries*. New York: Holt, Rinehart and Winston, 1968.

De Tolnay, C., *Hieronymous Bosch*. Bale: Editions Holbein, 1937.

Elst, J. J. M. I., *Last Flowering of the Middle Ages*. New York: Doubleday, 1944.

Flanders in the Fifteenth Century: Art and Civilization. Detroit Institute of Arts, 1960.

Freeman, M. B., "Iconography of the Merode Altarpiece." *Bulletin of the Metropolitan Museum of Art* 16: 130–39, Dec. 1957.

Gaunt, W., *Flemish Cities: Their History and Art.* New York: G. P. Putnam's Sons, 1969.

Gilbert, C., *History of Renaissance Art: Painting, Sculpture, Architecture Throughout Europe.* New York: Abrams, 1972.

Gomez-Moreno, C., *Medieval Art from Private Collections.* New York: Metropolitan Museum of Art, 1969.

Held, J. S., review of E. Panofsky's *Early Netherlandish Painting.* Art Bulletin 37: 205–34, Sept., 1955.

Huizinga, J., *The Waning of the Middle Ages.* London: E. Arnold & Co., 1937.

Meiss, M., "Light as Form and Symbol in Some 15th Century Paintings." *Art Bulletin* 27: 175–81, Sept., 1945.

Oman, C. C., *Medieval Silver Nefs.* Victoria & Albert Museum, Monograph No. 15. London: H. M. Stationery Office, 1963.

Panofsky, E., *Early Netherlandish Painting,* 2 vols. Cambridge, Mass.: Harvard U. Press, 1954.

Rousseau, T., "Merode Altarpiece." *Bulletin of the Metropolitan Museum of Art* 16: 117–29, Dec., 1957.

Schapiro, M., "Discipula Diaboli: The Symbolism of the Merode Altarpiece by the Master of Flémalle." *Art Bulletin* 27: 182–87, Sept., 1945.

Von Simson, O., "Compassion and Co-Redemption in Rogier van der Weyden's *Descent from the Cross*." *Art Bulletin,* Vol. 35, March 1953.

Wittkower, R., and M. Wittkower, *Born Under Saturn.* New York: Random House, 1963.

Italian Art

Baxandall, M., *Painting and Experience in 15th Century Italy.* Oxford: Clarendon Press, 1972.

Clark, K., *Leonardo da Vinci.* New York: Macmillan, 1939.

———, *Piero della Francesca.* New York: Phaidon, 1951.

Eisler, C., "The Athlete of Virtue: The Iconography of Asceticism." *Essays in Honor of Erwin Panofsky,* 2 vols. New York: New York U. Press, 1961.

Gilbert, C., *History of Renaissance Art:*

Painting, Sculpture, Architecture Throughout Europe. New York: Abrams, 1972.

Hartt, F., *History of Italian Renaissance Art: Painting, Sculpture, Architecture.* New York: Abrams, 1969.

Janson, H. W., *The Sculpture of Donatello,* 2 vols. Princeton, N.J.: Princeton U. Press, 1957.

Krautheimer, R., and T. H. Krautheimer, *Lorenzo Ghiberti.* Princeton, N.J.: Princeton U. Press, 1956.

Lavin, M., "Piero della Francesca's *Flagellation:* The Triumph of Christian Glory." *Art Bulletin* 4: 321–42, Dec. 1968.

Levy, M., *Early Renaissance.* Harmondsworth: Penguin, 1967.

Meiss, M., *Giovanni Bellini's St. Francis in the Frick Collection.* Princeton, N.J.: Princeton U. Press, 1964.

Offner, R., "Giotto, Non-Giotto." *Burlington Magazine,* 74: 258–69; 75: 96–109, June, Sept., 1939.

Panofsky, E., *Renaissance and Renascences in Western Art.* Stockholm: Imqvist & Wiksell, 1960.

Pope-Hennessy, J., *The Complete Work of Paolo Uccello.* New York: Phaidon, 1950.

Stubblebine, J., *Giotto: The Arena Chapel Frescoes.* New York: Norton, 1969.

Tietze-Conrat, E., *Mantegna.* New York: Phaidon, 1955.

White, J., *The Birth and Rebirth of Pictorial Space.* New York: T. Yoseloff, 1958.

———, *Art and Architecture in Italy, 1250–1400.* Harmondsworth: Penguin, 1966.

Michelangelo

Ackerman, J. S., *The Architecture of Michelangelo,* 2 vols. New York: Viking, 1961.

Blunt, A., *Artistic Theory in Italy, 1450–1600.* New York: Oxford, 1962.

Clark, K. M., *The Nude: A Study in Ideal Form.* New York: Pantheon, 1956.

Condivi, A., *The Life of Michelangelo* (tr. by H. P. Horne). Boston: Merrymount Press, 1904.

De Tolnay, C., *The Art and Thought of Michelangelo.* New York: Pantheon, 1964.

Gilbert, C., *Complete Poems and Selected Letters of Michelangelo.* 2nd ed. New York, 1965.

Hartt, F., *Michelangelo.* New York: Abrams, 1965.

Hibbard, H., *Michelangelo.* New York: Harper & Row, 1974.

Panofsky, E., *Studies in Iconology: Humanistic Themes in the Art of the Renaissance.* New York: Oxford, 1939.

Steinberg, L., "Michelangelo's Florentine *Pietà:* The Missing Leg." Art Bulletin 4: 343–53, Dec. 1968.

———, "Michelangelo's *Last Judgment* as Merciful Heresy." *Art in America,* 49–63, Nov.–Dec., 1975.

The Synthesis of Heaven and Earth in 16th- and 17th-Century Art

Blunt, A., *Artistic Theory in Italy, 1450–1600.* New York: Oxford, 1962.

Bosquet, J., *Mannerism: The Painting and Style of the Late Renaissance* (tr. by S. W. Taylor). New York: Braziller, 1964.

De Tolnay, C., *Pieter Bruegel l'ancien.* Bruxelles: Nouvelle Societé d'Editions, 1935.

Dvořák, M., "El Greco and Mannerism" (tr. by J. Coolidge). *Magazine of Art* 46: 14–23, Jan., 1953.

Friedländer, W. F., *Caravaggio Studies.* Princeton, N.J.: Princeton U. Press, 1955.

Hinks, R. P., *Michelangelo Merisi da Caravaggio.* New York: Beechhurst, 1954.

Hibbard, H., *Bernini.* Baltimore: Penguin, 1965.

Male, E., *L'Art religieux de la fin du XVIᵉ siecle.* Paris: Colin, 1951.

Wethey, H. E., *El Greco and His School.* Princeton, N.J.: Princeton U. Press, 1962.

Wittkower, R., *Gian Lorenzo Bernini.* New York: Phaidon, 1955.

———, "El Greco's Language of Gestures." *Art News* 56: 44–49, Mar., 1957.

———, *Art and Architecture in Italy, 1600–1750.* Baltimore: Penguin, 1958.

Wölfflin, H., *Principles of Art History* (tr. by M. D. Hottinger). New York: Dover, 1950.

The Good Life in Baroque Secular Art

Blunt, A., *Art and Architecture in France, 1500–1700.* Baltimore: Penguin, 1954.

Bousquet, J., *Mannerism: The Painting and Style of the Late Renaissance* (tr. by S. W. Taylor). New York: Braziller, 1964.

De Tolnay, C., "Vermeer's *The Artist Studio.*" *Gazette des Beaux-Arts*, s. 6, 41: 265–72, 292–94, Apr., 1953.

Fêtes de la palette, catalogue of an exhibition. New Orleans: Isaac Delgado Museum, 1963.

Friedländer, M. J., *Landscape, Portrait, Still Life* (tr. by R. F. C. Hull). Oxford: Cassirer, 1949.

Furness, S. M., *Georges de la Tour of Lorraine.* London: Routledge & Kegan Paul, 1949.

Gilbert, C., *Figures at a Table*, catalogue of an exhibition. Sarasota: John and Mable Ringling Museum of Art, 1960.

Held, J. S., *Flemish Painting.* New York: Abrams, 1953.

Highet, G., "Bruegel's Rustic Wedding." *Magazine of Art* 38: 274–76, Nov. 1945.

Kahr, M., *Dutch Painting in the 17th Century.* New York: Harper & Row, 1978.

Lopez-Rey, J., *Velázquez.* London: Faber, 1963.

Puyvelde, L. van. *Jordaens.* Paris, New York: Elsevier, 1953.

Spear, R., *Caravaggio and His Followers.* Cleveland: Cleveland Museum of Art, 1971.

Swillens, P. T. A., *Johannes Vermeer* (tr. by C. M. Breuning-Williams). Utrecht: Spectrum, 1950.

Thuillier, J., and A. Châtelet, *French Painting from Le Nain to Fragonard.* Geneva-New York: Skira, 1964.

Rembrandt

Benesch, O., *Rembrandt H. van Rijn, Selected Drawings.* New York: Phaidon, 1947.

————, *Rembrandt* (tr. by J. Emmons). Geneva-New York: Skira, 1957.

Clark, K. M., *Rembrandt and the Italian Renaissance.* New York: New York U. Press, 1966.

De Tolnay, C., "The Syndics of the Drapers' Guild by Rembrandt: An Interpretation." *Gazette des Beaux-Arts*, s. 6, 23: 31–38, Jan., 1943.

Fromentin, E., *Masters of Past Time* (tr. by A. Boyle). New York: Dutton, 1913.

Gerson, H., *Rembrandt's Painting.* New York: Morrow, 1968.

————, *Rembrandt Harmenszoon van Rijn.* London: Phaidon, 1969.

Hekscher, W. S., *Rembrandt's Anatomy of Dr. Nicolaas Tulp.* New York: New York U. Press, 1958.

Held, J. S., "Rembrandt: The Self-Education of an Artist." *Art News* 40: 10–19, Feb. 1, 1942.

————, "Rembrandt's Polish Rider." *Art Bulletin* 26: 246–65, Dec. 1944.

————, "Debunking Rembrandt's Legend." *Art News* 48: 20–24, Feb. 1950.

————, *Rembrandt and the Book of Tobit.* Northampton, Mass.: Gehenna Press, 1964.

Kahr, M., *Dutch Painting in the 17th Century.* New York: Harper & Row, 1978.

Münz, L. (ed.), *Rembrandt H. van Rijn, Etchings,* 2 vols. New York: Phaidon, 1952.

Rosenberg, J., *Rembrandt.* New York: Phaidon, 1964.

Slive, S., *Rembrandt and His Critics, 1630–1730.* The Hague: Nijhoff, 1953.

White, C., *Rembrandt and His World.* London: Thames and Hudson, 1964.

————, *Rembrandt as an Etcher: A Study of the Artist at Work.* London: Zwemmer, 1969.

Images of Authority

Blunt, A., *Art and Architecture in France, 1500–1700.* Baltimore: Penguin, 1954.

Brilliant, R., *Roman Art.* Oxford: Phaidon, 1969.

Clark, K. M., *Piero della Francesca.* New York: Phaidon, 1951.

De Kooning, E., "Painting a Portrait of the President." *Art News,* Summer 1964.

Frankfort, H., *Kingship and the Gods: A Study of Ancient Near Eastern Religion as the Integration of Society and Nature.* Chicago: U. of Chicago Press, 1948.

————, *Art and Architecture of the Ancient Orient.* Baltimore: Penguin, 1954.

Ghirshman, R., *Iran: Parthes et Sassanides.* Paris: Gallimard, 1962.

Grabar, A., *L'Empereur dans l'art byzantin.* Paris: Les Belles Lettres, 1936.

Groenewegen-Frankfort, H. A., *Arrest and Movement.* New York: Humanities, 1951.

Hamberg, P. G., *Studies in Roman Imperial Art.* Copenhagen: Munksgaard, 1945.

Held, J., "Le Roi à la chasse: Van Dyck's Portrait of Charles I." *Art Bulletin* 40: 139–49, June 1958.

Hibbard, H., *Bernini.* Baltimore: Penguin Books, 1965.

Jenkins, M. D., *The State Portrait.* Art Bulletin Monograph, 1947.

Lehman-Haupt, H., *Art Under a Dictatorship.* New York: Oxford, 1954.

Lipman, J. H., "The Florentine Profile Portrait in the Quattrocento." *Art Bulletin* 18: 54–102, Mar., 1956.

Liudprandus of Cremona, *Works.* London: Routledge, 1930.

Mattingly, G., *The Armada.* Boston: Houghton Mifflin, 1959.

Strong, E., *Apotheosis and After Life.* London: Constable, 1915.

Tietze, H., *Titian: Paintings and Drawings.* New York: Phaidon, 1937.

Trevor-Roper, H., *The Plunder of the Arts in the 17th Century.* London: Thames and Hudson, 1970.

Wittkower, R., *Gian Lorenzo Bernini.* New York: Phaidon, 1955.

Yuzan, D. S., *The Beginner's Book of Bushido* (tr. by A. L. Sadler). Tokyo: Kokusai Bunka Shinkokai, 1941.

Architecture of Authority

Ackerman, J., *Palladio.* New York: Penguin, 1977.

Anderson, J., and R. P. Spiers, *The Architecture of Greece and Rome.* Vol. 2: *The Architecture of Ancient Rome* (revised and rewritten by T. Ashby). London: Batsford, 1927.

Blunt, A., *Art and Architecture in France, 1500–1700.* Baltimore: Penguin, 1954.

Brown, F. E., "Roman Architecture." *College Art Journal* 17: 105–14, 1958.

Drexler, A., *The Architecture of Japan.* New York: Museum of Modern Art, 1955.

Evenson, N., *Chandigarh.* Berkeley: U. of California Press, 1966.

Frankfort, H., *Art and Architecture of the Ancient Orient.* Baltimore: Penguin, 1954.

Gropius, W. K., K. Tange, and Y. Ishimoto, *Katsura: Tradition and Creation in Japanese Architecture.* New Haven: Yale U. Press, 1960.

Hitchcock, H. R., *Temples of Democ-*

racy. New York: Harcourt Brace Jovanovich, 1976.

Masson, G., *Italian Villas and Palaces.* London: Thames and Hudson, 1959.

McCue, G., "The Arch: An Appreciation." *AIA Journal* 67 (2), 1978.

Mylonas, G. E., *Ancient Mycenae, the Capital City of Agamemnon.* Princeton, N.J.: Princeton U. Press, 1957.

Pevsner, N., *An Outline of European Architecture.* Baltimore: Penguin, 1960.

———, *Building Types.* Princeton, N.J.: Princeton U. Press, 1976.

Schapiro, M., "Taste." *Encyclopedia of the Social Sciences,* Vol. XIV, pp. 523–25. New York: Macmillan, 1934.

Smith, E. B., *Egyptian Architecture as Cultural Expression.* New York: Appleton-Century, 1938.

Von Eckhardt, W., "A Daring Design That Paid Off" (Boston's City Hall). *San Francisco Chronicle,* Feb. 17, 1969.

Wittkower, R., *Art and Architecture in Italy, 1600–1750.* Baltimore: Penguin, 1958.

Wright, F. L., *On Architecture: Selected Writings, 1894–1940* (ed. by F. Guttheim). New York: Grosset & Dunlop, 1959.

———, *Writings and Buildings* (sel. by F. Kaufmann and B. Raeburn). New York: Meridian, 1960.

The Synthesis of Past and Present in 19th-Century Art

Adhémar, J., *Daumier.* London: Zwemmer, 1954.

Boggs, J., *Portraits by Degas.* Berkeley: U. of California Press, 1962.

Cooper, D., *Toulouse-Lautrec.* New York: Abrams, 1956.

Elsen, A. E., *Rodin's Gates of Hell.* Minneapolis: U. of Minnesota Press, 1960.

Friedländer, W. F., *David to Delacroix* (tr. by R. Goldwater). Cambridge, Mass.: Harvard U. Press, 1952.

Goldwater, R., *Gauguin.* New York: Abrams, 1957.

Hoffmann, W., *The Earthly Paradise.* New York: Braziller, 1961.

Honour, H., *Neo-Classicism.* Harmondsworth: Penguin, 1968.

———, *Romanticism.* New York: Harper & Row, 1979.

Johnson, L., *Delacroix.* New York: Norton, 1963.

Lövgren, S., *The Genesis of Modernism.* Bloomington: Indiana U. Press, 1971.

Reff, T., *Degas: The Artist's Mind.* New York: Harper & Row, 1976.

Rewald, J., *Pierre Bonnard.* New York: Museum of Modern Art, 1948.

———, *Post-Impressionism from Van Gogh to Gauguin.* New York: Museum of Modern Art, 1959.

———, *The History of Impressionism,* rev. ed. New York: Museum of Modern Art, 1980.

Rosenblum, R., et al., *Edvard Munch: Symbols & Images.* Washington: National Gallery of Art, 1978.

Russell, J., *Seurat.* New York: Praeger, 1965.

Schapiro, M., *Vincent Van Gogh.* New York: Abrams, 1950.

———, "New Light on Seurat." *Art News,* April, 1958.

Seitz, W., *Monet.* New York: Abrams, 1960.

Shikes, R. E., and P. Harper, *Pissarro: His Life and Work.* New York: Horizon Press, 1980.

Tannenbaum, L., *James Ensor.* New York: Museum of Modern Art, 1951.

Wildenstein, G., *Ingres.* New York: Phaidon, 1954.

Art and Nature

Blunt, A., *Art and Architecture in France, 1500–1700.* Baltimore: Penguin, 1954.

Burnham, J., "Hans Haacke: Wind and Water Sculpture." *Tri-Quarterly Supplement,* No. 1, Spring 1967. Northwestern U. Press.

Clark, K. M., *Leonardo da Vinci.* New York: Phaidon, 1955.

———, *Landscape Into Art.* New York: Harper & Row, 1979.

Elsen, A. E., *Modern European Sculpture, 1918–1945: Unknown Beings and Other Realities.* New York: Braziller, 1979.

Friedländer, M. J., *Landscape, Portrait, Still Life.* Oxford: Cassirer, 1949.

Geist, S., *Brancusi: A Study of the Sculpture.* New York: Grossman, 1968.

Grohmann, W., *Paul Klee.* New York: Abrams, 1954.

Haftmann, W., *The Mind and Work of Paul Klee.* London: Faber, 1954.

Lee, S., *A History of Far Eastern Art.* New York: Abrams, 1964.

Panofsky, E., *The Life and Art of Albrecht Dürer.* Princeton, N.J.: Princeton U. Press, 1955.

Rowley, G., *Principles of Chinese Painting.* Princeton, N.J.: Princeton U. Press, 1947.

Rubin, W. R., *Matta.* New York: Museum of Modern Art, 1958.

Schapiro, M., *Vincent Van Gogh.* New York: Abrams, 1950.

———, *Paul Cézanne.* New York: Abrams, 1952.

Sickman, L., and A. Soper, *Art and Architecture of China.* Baltimore: Penguin, 1956.

Sirén, O., *Chinese Painting.* Pt. 1: Vol. 1, *Early Chinese Painting;* Vol. 2, *The Sung Period.* New York: Ronald, 1956.

Smithson, R., "The Spiral Jetty," in *Arts of the Environment* (ed. by G. Kepes). New York: Braziller, 1972.

Spies, W., *Christo, The Running Fence.* London: Thames and Hudson, 1977.

Stechow, W., *Dutch Landscape Painting of the 17th Century.* London: Phaidon, 1966.

Sweeney, J. J., *Alexander Calder.* New York: Museum of Modern Art, 1943.

Art, Objects, and the Object of Art

Barr, A. H., Jr., *Matisse: His Art and His Public.* New York: Museum of Modern Art, 1951.

"*Batcolumn:* 200 Tons, 100 Feet Tall, $100,000." *American Institute of Architects Journal* 66, 1977 (On Claes Oldenburg.)

Bergstrom, I., *Dutch Still-Life Painting in the Seventeenth Century* (tr. by C. Hedstrom and G. Taylor). London: Faber and Faber, 1956.

Coplans, J., *Roy Lichtenstein.* Pasadena: Pasadena Art Museum, 1967.

———, *Andy Warhol.* New York: New York Graphic Society, n.d.

Fêtes de la palette, catalogue of an exhibition. New Orleans: Isaac Delgado Museum, 1963.

Friedländer, M. J.: *Landscape, Portrait, Still Life.* Oxford: Cassirer, 1949.

Hultén, K. G. P., *The Machine, As Seen at the End of the Mechanical Age.* New York: Museum of Modern Art, 1968.

Lebel, R., *Marcel Duchamp.* New York: Grove, 1959.

"Oldenburg Bats a Chicago Homerun." *Progressive Architecture* 58, 1977.

Rowley, G., *Principles of Chinese Painting*. Princeton, N.J.: Princeton U. Press, 1947.

Rubin, W. R., *Dada, Surrealism and Their Heritage*. New York: Museum of Modern Art, 1968.

Schapiro, M., *Vincent Van Gogh*. New York: Abrams, 1950.

———, *Paul Cézanne*. New York: Abrams, 1952.

———, "The Apples of Cézanne: An Essay on the Meaning of Still-Life," in *Modern Art: 19th and 20th Centuries*. New York: Braziller, 1978.

Soby, J. T., *Giorgio de Chirico*. New York: Museum of Modern Art, 1955.

Solomon, A. R., *Robert Rauschenberg*. New York: The Jewish Museum, 1964.

Soria, M. S., *Francisco Zurbarán*. New York: Phaidon, 1953.

Steinberg, L., *Jasper Johns*. New York: Wittenborn, 1963. (This essay is also found in Steinberg's *Other Criteria*, New York: Oxford U. Press, 1972.)

Sterling, C., *Still-Life Painting: From Antiquity to the Present Time*, rev. ed. New York: Universe Books, 1959.

The Portrait in Painting, Sculpture, and Photography

Ambler, E., *A Coffin for Dimitrios*. New York: Dell, 1957.

Elsen, A. E., "Rodin's Portrait of Baudelaire," No. 25, *A Catalogue and Collection of Essays Honoring Henry Hope*. Bloomington: Indiana U. Press, 1966.

Friedländer, M. J., *Landscape, Portrait, Still Life*. Oxford: Cassirer, 1949.

Geist, S., *Brancusi: A Study of the Sculpture*. New York: Grossman, 1968.

Held, J., *Peter Paul Rubens*. New York: Abrams, 1953.

Hoffman, E., *Kokoschka: Life and Work*. London, Faber, 1947.

Lange, K., and M. Hirmer, *Egypt: Architecture, Sculpture, Painting, in Three Thousand Years*. New York: Phaidon, 1956.

Levey, M., "A Prince of Court Painters: Bronzino." *Apollo* 76: 165–72, 1962.

Lipman, J. H., "The Florentine Profile Portrait in the Quattrocento." *Art Bulletin* 18: 54–102, March, 1936.

Miller, M., "Géricault's Portraits of the Insane." *Journal of the Warburg and Courtauld Institutes* 4: 151–63, Apr.–July, 1940–41.

Panofsky, E., *Early Netherlandish Painting*, 2 vols. Cambridge, Mass: Harvard U. Press, 1954.

Schapiro, M., *Vincent Van Gogh*. New York: Abrams, 1950.

———, *Paul Cézanne*. New York: Abrams, 1952.

Simmel, G., "The Aesthetic Significance of the Face." *Essays in Sociology, Philosophy and Aesthetics* (ed. by K. Wolff). New York: Harper Torchbooks, 1965.

Sylvester, D., *Alberto Giacometti*. London: Arts Council of Great Britain, 1955.

Photography

Arbus, D., *Diane Arbus*. Millerton, N.Y.: Aperture, 1972.

Capote, T., *Avedon: Some Observations*. New York: Simon and Schuster, 1959.

Durrell, L., *Brassai*. New York: Museum of Modern Art, 1968.

Ford, C., *The Cameron Collection*. New York: Van Nostrand Reinhold, 1975.

Gernsheim, H., *Julia Margaret Cameron: Her Life and Photographic Work*. Millerton, N.Y.: Aperture, 1975.

Newhall, B., *The History of Photography*. New York: Museum of Modern Art, 1964.

Rosenblum, W., N. Rosenblum, and M. Trachtenberg, *America and Lewis Hine*. Millerton, N.Y.: Aperture, 1977.

Sontag, S., *On Photography*. New York: Farrar, Straus & Giroux. 1972.

Steichen, E., *My Life in Photography*. Garden City, N.Y.: Doubleday, 1963.

Stryker, R., and N. Wood, *In This Proud Land: America 1935–1943 As Seen in the FSA Photographs*. New York: New York Graphic Society, 1973.

Szarkowski, J., *The Photographer's Eye*. New York: Museum of Modern Art, 1966.

———, *Looking at Photographs*. New York: Museum of Modern Art, 1973.

Varnedoe, J. K. T., et al. *Modern Portraits: The Self & Others*. New York: Wildenstein, 1976.

Von Hartz, J., *August Sander*. Millerton, N.Y.: Aperture, 1972.

The Figure in Sculpture

The Figure in Older Sculpture

Butler, R., *Western Sculpture: Definitions of Man*. New York: Harper & Row, 1979.

Clark, K. M., *The Nude: A Study in Ideal Form*. New York: Pantheon, 1956.

Janson, H. W., *The Sculpture of Donatello*, 2 vols. Princeton, N.J.: Princeton U. Press, 1957.

Kramrisch, S., *The Art of India*. New York: Phaidon, 1954.

Panofsky, E., "The History of the Theory of Human Proportions as a Reflection of the History of Styles." *Meaning in the Visual Arts*. New York: Anchor, 1955.

Schapiro, M., "The Sculptures of Souillac," in W. R. W. Koehler. *Medieval Studies in Memory of Arthur Kingsley Porter*. Cambridge, Mass.: Harvard U. Press, 1939.

Wittkower, R., *Gian Lorenzo Bernini*. New York: Phaidon, 1955.

The Figure in Modern Sculpture

Elsen, A. E., *Rodin*. New York: Museum of Modern Art, 1963.

———, *The Partial Figure in Modern Sculpture: From Rodin to 1969*. Baltimore: Baltimore Museum of Art, 1969.

———, *The Sculpture of Henri Matisse*. New York: Abrams, 1973.

———, *The Origins of Modern Sculpture: Pioneers and Premises*. New York: Braziller, 1974.

———, *Modern European Sculpture, 1918–1945: Unknown Beings and Other Realities*. New York: Braziller, 1979.

Geist, S., *Brancusi: A Study of the Sculpture*. New York: Grossman, 1968.

Goldwater, R., *Jacques Lipchitz*. New York: Universe Books, 1959.

Hohl, R., *Alberto Giacometti*. New York: Abrams, 1971.

Nordland, G., *Gaston Lachaise*. New York: Braziller, 1974.

Reff, T., *Degas: The Artist's Mind*. New York: Harper & Row, 1976.

Soby, J. T., *Jean Arp*. Garden City, N.Y.: Doubleday, 1958.

Steinberg, L., "Rodin," in *Other Criteria*. New York: Oxford U. Press, 1972.

Sylvester, D., *Henry Moore*. London: Arts Council of Great Britain, 1968.

Varnedoe, J. K. T., "Duane Hanson: Retrospective and Recent Work." *Arts,* Jan. 1975.

Picasso

Ashton, D., *Picasso On Art: A Selection of Views*. New York: Viking, 1972.

Blunt, A., *Picasso's Guernica.* London/ New York: Oxford, 1969.

———, and P. Pool, *Picasso: The Formative Years.* New York: New York Graphic Society, 1962.

Brassai, *Picasso & Co.* Garden City, N.Y.: Doubleday, 1966.

Elsen, A. E., "Beyond Good and Evil: Picasso's *Man With a Sheep*." *Art International,* March–April, 1977.

Gilot, F., and C. Lake, *Life With Picasso.* New York: Signet, 1965.

Penrose, R., *Picasso, His Life and Work.* New York: Harper, 1959.

———, J. Golding, et al. *Picasso in Retrospect.* New York: Praeger, 1973.

Rosenblum, R., *Cubism and Twentieth-Century Art.* New York: Abrams, 1961.

———, "Picasso and the Anatomy of Desire," in *Studies in Erotic Art* (ed. by T. R. Bowie and C. Christenson). New York: Basic Books, 1970.

Rubin, W. R., *Picasso in the Collection of the Museum of Modern Art.* New York: Museum of Modern Art, 1972.

Spies, W., *Sculpture by Picasso.* New York: Abrams, 1971.

Steinberg, L., "The Philosophical Brothel: Picasso's *Desmoiselles d'Avignon*." *Art News,* Sept. and Oct., 1972.

Imaginative Art

Bousquet, J., *Mannerism: The Painting and Style of the Late Renaissance.* New York: Braziller, 1964.

Combe, J., *Jerome Bosch.* Paris: Tisné, 1957.

Dali, S., *The Secret Life of Salvador Dali.* New York: Dial, 1942.

Daniel, H., *Devils, Monsters and Night- mares.* New York: Abelard-Schuman, 1964.

De Tolnay, C., *Hieronymous Bosch.* Bale: Editions Holbein, 1937.

Grohman, W., *Paul Klee.* New York: Abrams, 1954.

Harris, T., *Goya, Engravings and Lithographs,* 2 vols. Oxford: Cassirer, 1964.

Hess, T. B., *Willem de Kooning.* New York: Braziller, 1959.

Lebel, R., *Marcel Duchamp.* New York: Gravoe, 1959.

Lieberman, W. S., *Max Ernst.* New York: Museum of Modern Art, 1961.

Lopez-Rey, J., *Goya's Caprichos,* 2 vols. Princeton, N.J.: Princeton U. Press, 1953.

Mellerio, A., *Odilon Redon.* New York: Da Capo Press, 1968.

Meyer, F., *Marc Chagall.* New York: Abrams, n.d.

Panofsky, E., *The Life and Art of Albrecht Dürer.* Princeton, N.J.: Princeton U. Press, 1955.

Rubin, W. R., *Dada, Surrealism and Their Heritage.* New York: Museum of Modern Art, 1968.

Schwabacher, E., *Arshile Gorky.* New York: Macmillan, 1957.

Seitz, W. C., *René Magritte.* New York: Museum of Modern Art, 1965.

Selz, P., *The Work of Jean Dubuffet.* New York: Museum of Modern Art, 1962.

———, et al., *Max Beckmann.* New York: Museum of Modern Art.

Soby, J. T., *Giorgio de Chirico.* New York: Museum of Modern Art, 1955.

Abstract Art

Albers, J., *Interaction of Color.* New Haven: Yale U. Press, 1963.

Battcock, G., *Minimal Art: A Critical Anthology.* New York: Dutton, 1968.

Buck, R., et al., *Richard Diebenkorn, Paintings and Drawings, 1943–1976.* Buffalo: Albright-Knox Art Gallery, 1976.

Friedman, M., *Nevelson Wood Sculptures.* New York: Dutton, 1973.

Gray, C., *David Smith by David Smith.* New York: Holt, Rinehart and Winston, 1968.

Hess, T. B., *Barnett Newman.* New York: Walker, 1969.

Jaffe, H. L. C., *De Stijl, 1917–1931: The Dutch Contribution to Modern Art.* Amsterdam: Meulenhoff, 1956.

Malevich, K. S., *The Non-Objective World.* Chicago: Theobald, 1960.

Mondrian, P., *Plastic Art and Pure Plastic Art.* New York: Wittenborn, 1945.

Noguchi, I., *Isamu Noguchi: A Sculptor's World.* New York: Harper & Row, 1968.

Reinhardt, A., statements in D. C. Miller's *Americans, 1963.* New York: Museum of Modern Art, 1963.

Rosenberg, H., "Barnett Newman: The Living Rectangle," in *The Anxious Object.* New York: Horizon, 1964.

Rubin, W. R., *Frank Stella.* New York: Museum of Modern Art, 1970.

———, *Anthony Caro.* New York: Museum of Modern Art, 1975.

Sandler, I., *The New York School: The Painters and Sculptors of the Fifties.* New York: Harper & Row, 1979.

Schapiro, M., "The Liberating Quality of Avant Garde Art." *Art News,* June 1957.

———, "The Liberating Quality of Abstract Painting," in *Modern Art, 19th and 20th Centuries.* New York: Braziller, 1978.

Glossary

Boldface terms within definitions are themselves defined in the glossary.

aesthetic Having to do with the pleasurable and beautiful as distinguished from the useful, scientific, etc. The distinctive vocabulary of a given style. An **aesthetic response** is the perception and enjoyment of a work of art.

aesthetics The branch of philosophy having to do with the nature of beauty and its relation to human beings.

agora In ancient Greece, a market place of spiritual, legal, and commercial significance that in Roman times became the **forum.**

aisle In **basilican** architecture, the longitudinal **spaces** situated parallel to the **nave** and formed by walls, **arcades,** and **colonnades.** The nave itself, having a similar form, is sometimes considered to be an aisle.

altarpiece A painting, sculptural group, or **bas relief** prepared for and placed above and behind an altar.

ambulatory Literally a place for walking, hence an **aisle** bent around the **apse** of a church allowing circulation behind the high altar.

anthropomorphic Human characteristics attributed to nonhuman things.

apotheosis Elevation to divine status; deification; glorification; exaltation; a glorified ideal.

apse A semicircular **space, domed** or **vaulted,** extending the interior space of such architectural forms as Roman and Christian **basilicas;** in Western Europe most often found at the eastern end of the **nave** and serving to house the high altar.

aquamanile A medieval pitcher or jug, often made in grotesque animal forms.

arcade A series of **arches** supported by **piers** or **columns;** passageways with arched roofs.

arch The **structural** principle of the arch is such that it permits the spanning in stone or wood of a greater space between supporting members than could a **lintel,** due to the capacity of the curved form of the arch to divert the load—the compression of weight sustained—to the sides and downward toward the supporting uprights.

architectonic In **design** and **composition,** that which is **structural.**

architrave The **lintel** or lowest division of the **entablature** that in **post-and-lintel** architecture rests directly on the **capitals** of **columns.**

archivolt The molding that frames an arch.

atmospheric or aerial perspective A perspective system developed in northern Europe, reviving pictorial techniques of spacial representation used by the Romans, Chinese, and Japanese painters, including the blurring of outlines, loss of detail, alternation of hues toward cool colors, and the diminution of color saturation and value contrast, all increasing with the apparent increase of distance of objects from the viewer.

atrium A Roman **form** that is an open court constructed within or in relation to a building.

avant-garde A French term meaning "advanced guard," used to designate innovators whose experimental art challenges the values of the cultural establishment or even those of immediately preceding avant-garde **styles.**

axis An imaginary **line** passing through a figure, building, or groups of **forms** about which component elements are organized, their direction and focus actually establishing the axis.

basilica A rectangular plan building, with an **apse** at one or both ends, originating in Roman **secular** architecture and early adopted as the **form** most suited to the needs of Christian worship.

batter The inward tilt of a **wall** from the base upward.

Bodhisattva In Mahayana Buddhism, an enlighted being who compassionately refrains from entering **nirvana** so as to save others. A potential **Buddha** and worshiped as a deity.

bronze An alloy of copper and tin and the metal most frequently used in cast sculpture.

the Buddha Gautama Buddha (563?–483 B.C.), the great religious teacher of Asia whose message was that suffering is inherent in life and that one can be best liberated from it by mental and moral self-purification. A major **subject** in Asian art.

buttress An upright structural element that can be made to supplement walls and posts in their support of the overhead load.

calligraphy The art of beautiful writing, but, more broadly, any controlled, flowing, continuous use of **line** in painting, drawing, and sculpture; the character and quality of an artist's linear work; the **graphic** evidence of gesture in the visual arts.

campanile In Italy, a bell tower, especially one that is **freestanding,** often next to but separate from a church building.

canon A body of principles, rules, standards, or norms; a criterion for estabishing measure, **scale,** and proportion.

cantilever A **lintel** extending beyond its supports.

capital The upper member of a **column,** serving as transition from **shaft** to **lintel** or **architrave.**

cartoon A full-scale, preparatory drawing for a **pictorial composition,** usually a large one such as a wall painting or a tapestry. Also a humorous drawing or caricature.

casting A process using plaster, clay, wax, or metal that, in a liquid form, is poured into a **mold.** When the liquid has solidified, the mold is removed, leaving a replica of the original work of art from which the mold was taken.

catacomb Associated with Early Christian Rome, an underground burial place consisting of **galleries** with recesses containing tombs.

cathedral The official church of a bishop containing his "cathedra" or throne; a church that traditionally has been given **monumental** and magnificent architectural form.

cella An enclosed chamber, the essential feature of a **Classical** temple, in which the cult statue usually stood.

ceramics Objects made of clay that have been baked into a permanent **form;** often decorated with **glazes,**

then fired to fuse the glazes to the clay body.

chevet The **apse** or **choir** of a **basilican**-plan church surrounded by an **ambulatory** and a series of radiating chapels.

chiaroscuro Literally "light-dark"; in art, the use of **value** contrasts to represent the effects of light and shadow.

choir The complex at the east end of a **basilican**-plan church beyond the **crossing,** which could include **apse, ambulatory,** and radiating chapels. See **chevet.**

civilization A **culture** in an advanced state of self-realization, thought to be characterized by marked efficiency and achievement in such realms as art, science, and letters, as well as in personal security and dignity.

Classical The art of ancient Greece and Rome and subsequent stylistic imitations of Western antiquity. With a lowercase "c," classic can mean established excellence, whatever the period, **style,** or **form.**

clerestory A row of windows in the upper part of a **wall;** also, in church architecture, the upper portion of the interior walls pierced by windows for the admission of light.

cloister In monastic architecture, a court bounded by covered walks that usually have **arcades** or **colonnades.**

codex A manuscript prepared on leaves or pages and bound together like the modern book. It replaced the scroll form, or rotulus, of antiquity.

coffer In architecture, a recessed panel in a ceiling. Coffering can lighten the weight of a massive-looking ceiling.

collage From **papiers collés,** the French for "pasted papers"; a **composition** deriving from Cubism and made by pasting together on a flat surface such originally unrelated materials as bits of newspaper, wallpaper, cloth, cigarette packages, and printed photographs.

colonnade A row of **columns,** usually spanned or connected by **lintels.**

colonnette A small **column,** performing a decorative as well as a **structural** function.

color A combination of hue, satura-

tion, and value. **Hue** is the property that gives color a name, such as red or green. **Saturation** refers to the purity, vividness, or intensity of a color. **Value** is the technical name for shading, which gives color the quality of seeming light or dark. **Local color** is the natural color of a **subject.**

column A cylindrical post or **support** that often has three distinct parts: base, **shaft,** and **capital.**

composition The ordering of parts to each other and to the whole, or the imaginative disposition of all elements of subject and form to produce an intellectual and visual coherence.

connoisseurship A discriminating knowledge of the qualities of art works and their **styles.**

construction The process of making a sculpture by assembling and joining a wide variety of materials, such as wood, cardboard, plastic, paper, and metal.

contour In the pictorial arts, an outline that forms the boundary of one **shape** and defines it in relation to other shapes and is expressively handled so as to suggest fullness and recession of **forms** and varieties in **texture,** such as those in bony structure and soft tissue. Contrasts with simple outline, which is no more than the boundary of a form defining a silhouette.

Corinthian The most elaborate of the three **Classical orders** of temple architecture, characterized by slender **fluted columns** topped by highly carved, ornate **capitals** decorated with forms derived from the acanthus leaf. See also **Doric** and **Ionic.**

cornice Any horizontal architectural member projecting from the top of a **wall;** in **Classical** architecture the crowning member of the **entablature.**

Counter-Reformation A 17th-century movement within the Roman Catholic Church made in opposition to the Protestant Reformation of the 16th century.

crossing In a **cruciform** church, the space formed by the intersection of the **nave** and the **transept.**

cruciform Arranged or shaped like a cross.

crypt A **vaulted** chamber, wholly or

partly underground, that usually houses a chapel and is found in a church under the **choir.**

culture The values and the system of their interrelationships that inform a society, motivate its behavior, and cause it to be functional to the general satisfaction of its members and to have a distinctive quality and character.

design The patterned organization of a **composition,** usually seen in the arrangement of **lines** or the light-and-dark elements, rather than in **color.**

dome A hemispherical vault that transmits its weight evenly all along its circular base.

Doric The oldest of the **Classical styles** of temple architecture, characterized by simple, sturdy **columns** that rise without a base to an unornamented, cushionlike **capital.** See **Ionic** and **Corinthian.**

earth work An intervention in open nature by the artist for no purpose other than the enactment of his own ideas of art.

empirical Based on experiment, observation, and practical experience without regard to science and theory.

enamel Colored glass applied to metal in powder or paste form and fused by firing.

engaged column A columnlike form projecting from a **wall** and articulating it visually.

entablature In architecture, that portion of a building between the **capitals** of the **columns** and the roof, including in **Classical** architecture the **architrave, frieze,** and **cornice.**

entasis An almost imperceptible swelling in the **shaft** of a **column.**

Epiphany January 6, the anniversary of the coming of the Wise Men to Christ at Bethlehem.

eurythmy Harmonious proportion or movement.

Evangelist One of the authors of the four Gospels in the Bible: Matthew, Mark, Luke, and John. Respectively their symbols are an angel, a lion, an ox, and an eagle, all derived from Revelations 4:6–10.

expressive content The meaning and significance of art produced by the fusion of **form** and **subject.**

fenestration The arrangement of

windows, or all openings, in the **walls** of a building.

figural, figuration In painting and sculpture, **subject** and **form** that have been derived from the human or animal form. In contemporary abstract and nonrepresentational art, the term also signifies a general preoccupation with the **shapes** of **forms.**

figure-ground In the pictorial arts, a phrase referring to an ambiguous, interdependent spatial relationship between forms and the backgrounds against which they have been placed.

fluting Vertical channeling, roughly semicircular in section and used principally on **columns** and **pilasters.**

flying buttress A **masonry** strut or segment of an **arch** that carries the **thrust** of a **vault** to a **buttress** positioned away from the main portion of the building; an important structural element in the architecture of Gothic cathedrals.

form (1) A **shape** or a **mass,** or, more comprehensively, the total configuration of the shapes, structure, and expressiveness that make an art work. (2) That which is given the visual arts by the various physical factors such as **line, plane, color,** shading, **texture, shape, mass** or **volume, scale, space,** and **composition,** the last being the organization the artist imposes on the materials and processes.

form and **style** In commentary on the way an artist works, form consists of the **shapes, structure,** and **expressiveness,** the total configuration of the work of art. Meyer Schapiro has offered this definition: "Style is the constant form, qualities, and expression in the art of an individual or group."

forum A precinct that as developed in ancient Roman cities provided for public assembly of a religious, commercial, judicial, and educational sort.

fresco A process of painting on plaster, either dry or wet, wherein the pigments are mixed with water and become chemically bound to the plaster; a medium perfected during the Italian Renaissance.

frieze The central portion of the

entablature between the **architrave** and the **cornice;** any horizontal decorative or sculptural band.

gallery A long and narrow room or passage, such as that in the **nave walls** above the **aisles** of a **basilican plan** church or that in a **catacomb.**

genre In the pictorial arts and sculpture, the representations of everyday life and surroundings for their own sake.

glaze In **oil painting,** a transparent film of paint laid over dried underpainting; in **ceramics,** a thin vitreous coating fused to a clay body by firing in a kiln.

Gospels Ascribed to Matthew, Mark, Luke, and John, the four Biblical accounts of the birth, life, death, and resurrection of Jesus Christ.

gouache **Watercolor** rendered opaque by the addition of a filler such as zinc white.

graphic arts Vaguely related to the linear element, a term that identifies the visual arts of drawing, printmaking, typographic design, advertising design, and the technology of printing.

graphic Demonstration and description by visual means.

Greek cross A cross in which all the arms are the same length.

groin vault Tunnel **vaults** intersecting at right angles.

ground plane In the pictorial arts, the surface represented as that on which figures seem to stand.

hatching A **graphic** device by which a series of closely spaced parallel **lines** serve to indicate a shaded area.

hieroglyphic A picture or a **symbol** of an object standing for a word, idea, or sound; developed by the ancient Egyptians into a system of writing.

icon Greek for "image," used to identify panel paintings made under Greek Orthodox influence that represented the image of a holy person—Christ, Mary, or a saint; such works often imbued with sanctity.

idealization The representation of objects, individuals, and events according to a **stylized,** perfected, preconceived model; a kind of **aesthetic** distortion of perceived reality.

idol A representation or **symbol** of a

deity used as an object of worship.

illumination The medieval art of decorating the pages of manuscripts with ornamental initials, patterns, and illustrations, often in gold, silver, and bright color.

illusionism The endeavor of the artist to represent as completely as his formal means may permit the visual phenomena of the real world.

incising Cutting into a surface with a sharp instrument.

Inquisition A former Roman Catholic tribunal established to discover and suppress heresy.

intarsia Inlay work, primarily in wood and sometimes in mother-of-pearl, marble, etc.

intercolumniation The space or the system of spacing between **columns** in a **colonnade.**

Ionic One of the Greek **Classical** styles of temple architecture, which developed in Ionia in Asia Minor and is distinguished by slender **fluted columns** and by **capitals** decorated with volutes and scrolls. See also **Doric** and **Corinthian.**

jamb The upright piece forming the side of a doorway or window frame; on the **portals** of Romanesque and Gothic church architecture, the locus of figural sculpture.

keep The massive central tower and strongest part of a castle, used as a dwelling place and, in case of attack, as a final point of defense.

keystone The topmost stone and the last to be placed in an **arch.**

kiln An oven capable of controlled high temperatures in which clay objects are baked.

labyrinth A place full of intricate passageways and blind alleys; a maze.

landscape In the pictorial arts, the representation of scenery in nature.

Latin cross A cross in which the vertical member is longer than the horizontal member, through whose midpoint it passes.

line The mark left in its path by a moving point. Also, the edge of a flat **shape,** the **contour** of a solid object, and the implied **axis** *of* a shape or *through* a group of forms.

linear perspective An **aesthetic** system intended to create an independent order of reality, a pictorial world that is to be an idealized

equivalent of the real world; as such, it is the means for making the picture **space** appear to be a continuation of actual space.

liturgy A rite or body of rites prescribed for public worship.

mahlstick A light, inflexible wooden rod, three or four feet long, which the painter uses as a support or rest to steady his brush or hand while executing particularly detailed and exacting work.

masonry In architecture, stone- or brickwork.

mass Mass may be construed as the actual or implied physical bulk, weight, and density of three-dimensional **forms** occupying real or suggested **spatial** depth.

megaron In Minoan and Mycenaean times, a large, rectangular living hall with a hearth at the center and four columns supporting the roof, the space approached through a porch supported by two **columns** and a vestibule.

memento mori Latin for "remember that you must die"; a reminder often symbolized by a skull.

metope In the **frieze** of a **Doric entablature,** the panel between the **triglyphs,** often a surface decorated with **relief** sculptures.

miniature Broadly, any very small work of pictorial art, especially drawing and painting in an **illuminated** manuscript.

Minotaur The issue of union between Pasiphaë, the wife of King Minos of Crete, and a sacrificial bull given to Minos by Poseidon, the Greek god of water; a monster with a bull's head and a man's body kept in the **Labyrinth** built on Crete by the architect Daedalus.

module A basic unit of measure taken as a principle for determining the major divisions and proportions of an object, figure, building, or site.

mold A hollow, or negative, container that produces a cast by giving its form to a substance placed within it and allowed to harden.

monastery A dwelling place where monks live in community for spiritual purposes.

monochrome A single **color** or the value variations of a single hue.

montage A **composition** formed of pictures or portions of pictures pre-viously photographed, painted, or drawn.

monumental A work of art or architecture that is grand, noble, timeless, and essentially simple in **composition** and execution, whatever its **size.**

mosaic An art medium requiring the use of small pieces of colored glass or stone **(tesserae)** fixed to or imbedded in a background material, such as cement or plaster.

motif The **subject** or idea of an art work, such as **still life** or **landscape,** or an individual feature of a **subject** or **form,** usually one that recurs or predominates in the **composition.**

mudra Any of a series of subtle hand gestures in the figural art and classical dancing of India, made to represent certain feelings.

mural A painting on a **wall,** usually large in **size.**

mystical Having a spiritual meaning or reality that can be known only by intuition, insight, or similar subjective experience.

myth A legend or story that seems to express the world view of a people or explain a practice.

narthex A porch or vestibule of a church.

nave The great central **space** in a church; in **basilican** plans the space extending from the entrance to the **apse,** or to the **crossing** or **choir** if these exist.

nef A silver or gold table furnishing made in the form of a ship and intended to hold small quantities, such as salt, and utensils or simply to be decorative.

nirvana The **Buddhist** idea of heavenly peace; the final beatitude that transcends suffering through the extinction of desire and individual consciousness.

oil painting The process of painting with a medium formed of ground colors held together with a binder of oil, usually linseed.

order In **Classical** architecture, a style represented by a characteristic design of the **column** and its **entablature;** see **Doric, Ionic,** and **Corinthian.** Also the arrangement imposed upon all elements within a **composition;** in addition, a harmonious arrangement.

pediment In **Classical** architecture, the triangular **space** (gable) at the end of a building, formed by the ends of the sloping roof and the **cornice;** also an ornamental feature having this shape.

pendentive A concave, triangular piece of masonry (a triangular section of a hemisphere), four of which can be made to support a **dome** over a square **structure.**

peripheral vision The ability to see to left and right so that objects outside the direct line of vision register on one's consciousness.

pictograph A prehistoric drawing or painting on a rock wall; a picture or image, usually **stylized,** that represents an idea; also writing using such means.

pier A **mass** of **masonry** rising vertically to support an **arch, vault,** or other roofing member.

pietà A devotional image of the sorrowing Virgin holding the dead Christ.

pilaster In architecture, a shallow, flat vertical member projecting from a **wall** surface and, like a **column,** articulated as a base, **shaft,** and **capital.** Usually more decorative than **structural.**

pillar Any vertical architectural member—**pier, column,** or **pilaster.**

plane A flat surface, measurable in two dimensions, that can be made to move into depth and to give the illusion of functioning in three-dimensional **space.** The **picture plane** is that which is assumed to be at the front surface of a painting.

polychrome Several **colors** rather than one **(monochrome).**

portcullis A strong gate or grating of iron made to slide up and down in grooves and used to close the gateway of a castle or fortress.

portal An imposing door and the whole architectural **composition** surrounding it.

portico A porch in the **Classical** manner, having a roof supported by **columns** and usually having an **entablature** and a **pediment.**

post-and-lintel A method of construction that is a combination of uprights supporting a crosspiece.

pottery See **ceramics.**

psalter A book of the Psalms found in the Bible.

pylon The major entrance to an Egyptian temple, having in its developed form **battered walls** divided into twin towers capped with large cavetto moldings.

reinforced concrete A building material composed of concrete with rods or webs of steel imbedded in it.

reliquary A small box, casket, or shrine for keeping sacred relics, usually made of and decorated with precious materials.

rhythm The regular repetition of a **form.**

rustication The method of cutting and laying **masonry** so as to emphasize the joints and recesses between blocks.

sanctuary A consecrated, sacred, or holy place; in Christian architecture, that part of the building where the altar is placed; also a refuge.

sarcophagus A stone coffin.

scale Relative or proportional **size.**

schematize The process of reducing the identifying characteristics of a **form**—the human head, a plant, a building, etc.—to its diagrammatic essentials; a process of abstraction.

scriptorium The workroom in a medieval monastery for the copying and the **illumination** of manuscripts.

sculpture, freestanding and **relief** Most sculptures either stand free or project from a background. The latter are called **relief sculptures.** Pronounced sculptural projection from a background is known as **high relief;** modest projection as **low** or **bas relief.**

secular Not religious, but relating to the wordly or temporal.

shaft The part of a **column** between the **capital** and the base.

shape A shape is an area or plane with distinguishable boundaries, such as a square. It can be formed whenever a **line** turns or meets, as in an S shape. In three-dimensional forms, shape is defined by outline or silhouette.

Siva One of the Hindu triad of gods—Brahma, Vishnu, and Siva—who represents the principle of destruction and is worshiped as the gracious creator sustaining the world.

size The physical magnitude of objects, elements, and quantities.

space An extent, measurable or infinite, that can be understood as an area or a distance. It can be seen as a hollow **volume** available for occupation by a **form,** but can be thought of as able to be used positively or negatively.

squinch A **lintel** constructed to span the **space** between two **walls** that meet at right angles to form a corner, for the purpose of bridging the gap between the square **shape** of a building and a round **dome** that covers it. The squinch thus formed is often supported from below by a small **arch.**

statue A **freestanding figural** sculpture.

stigmata Marks resembling the wounds of the crucified Christ; in holy persons, such as St. Francis of Assisi, the physical manifestation of a deep mystical union with the suffering of Christ.

still life In the pictorial arts, an arrangement of inanimate objects—fruit, flowers, pottery, etc.—taken as the **subject** or **motif** of a work of art.

stoa In the **agoras** of ancient Greece, a building of one or two stories in the form of a **colonnade** or roofed portico providing space for a walkway and shops, offices, and storerooms.

string course In architecture, a horizontal band or molding used as a decorative element on an exterior **wall,** usually reflecting interior **structure.**

structure The **compositional** relationships in an art work; a building or other constructed architectural unit; the operative framework that supports a building.

stylize To simplify or generalize forms found in nature for the purpose of increasing their **aesthetic** and **expressive** effect.

stylobate In Greek temple architecture, the upper step of the base that forms a platform for the **columns.**

subject matter The identifiable objects, incidents, and situations represented in a painting or **sculpture,** or, in modern abstract art, experience not actually represented but implied or referred to.

symbol A **form,** image, sign, or **subject** standing for something else; in the visual arts, often a visible suggestion of something invisible.

synoptic Affording a general, comprehensive, broad, or common view.

synthesis The deduction of independent factors or entities into a compound that becomes a new, more complex whole.

tabernacle A receptical for a holy or precious object; a container placed on the altar of a Catholic church to house the consecrated elements of the Eucharist.

taste The evidence of preference having to do with enjoyment and appreciation.

tempera A painting technique using as a medium pigment mixed with egg yolk, glue, or casein.

terra-cotta Baked clay used in **ceramics,** sculpture, and architectural decoration; also a reddish-brown **color** similar to the color of baked clay.

tesserae The bits of colored glass and stone used in **mosaic.**

texture The actual or implied tactile quality of a surface, such as smooth or rough, slick or grainy, soft or hard.

thermae Public bathing establishments in ancient Rome providing not only swimming facilities but also all the resources and opportunities of a superior social club.

thrust A strong continued pressure, as in the force moving sideways from one part of a **structure** against another.

tone The general coloristic quality of an art work; color gradations as these might be expressed in degrees of saturation and value.

transept In a **cruciform** church, the whole arm set at right angles to the **nave,** which makes the **crossing.**

triforium In church architecture, an **arcaded** area in the **nave wall** system that lies below the **clerestory** and above the **gallery,** if there is one, and the **nave arcade.** It can be open like a gallery or be sealed (blind).

triglyph In the **frieze** of the **entablature** of the **Doric order,** the grooved vertical stone tablet that alternates with the metopes.

trumeau An upright structural member placed in the center of a **portal** to support the **lintel** spanning the **space** between the two main lateral uprights; in medieval architecture often has sculptural decoration.

tympanum In medieval architecture, the surface enclosed by a **lintel** and an **arch** over a doorway; in **Classical** architecture, the recessed face of a **pediment.**

vault An arched roof fashioned of stone, brick, or concrete. The tunnel or barrel vault is an extension of the round **arch,** and to stay aloft it requires continuous **buttressing** along its two sides.

vellum Calfskin prepared as a support for writing or painting, especially in medieval manuscripts.

verisimilitude The appearance of being true to the reality of the tangibly present world.

void A hollow or empty **space.**

volume Any three-dimensional quantity that is bounded or enclosed, whether solid or void—as in positive (solid) or negative (hollow) volumes.

votive Something offered in devotion, in supplication, or in fulfillment of a vow.

watercolor Pigments mixed with water-soluble gum. Works executed in watercolor are characterized by the transparency of the washes possible in the medium and brilliance produced by the white paper showing through the transparent films of color.

Zeus The supreme god of the ancient Greek religion; the great father of gods and men who enforced the moral law and punished all who defied him.

Index

References are to page numbers. Italic type identifies pages on which illustrations appear. (Pl.) following an italicized number indicates a color plate and the page where it can be found. The terms defined in the glossary have not been cited in the index.

Photographic Sources

References are to figure numbers unless indicated Pl. (plate).

A.C.L., Brussels (450); A.C.L./Editorial Photocolor Archives, New York (163, 169, 177–179, 252, 335); Agraci/Editorial Photocolor Archives, New York (24, 275, 373, 376, 380, 382); Alinari/Editorial Photocolor Archives, New York (3, 9–11, 91, 143, 164–165, 168, 183, 186–187, 190–192, 198–200, 203, 208, 210, 216–218, 222, 225–226, 230, 235–236, 246–247, 249, 251, 256, 312–313, 316, 328, 336, 339, 342, 352, 368, 375, 378, 458, 474); Anderson/Editorial Photocolor Archives, New York (17, 78, 180–182, 184–185, 201–202, 205, 213, 219, 223–224, 229, 231, 234, 245, 315, 341, 370, 424, 487); Archives Photographiques, Paris (23, 77, 79–80, 156, 196, 428, 451, 478, 489, 539); Art Reference Bureau/Editorial Photocolor Archives, New York (2, 5, 157, 280, 295, 390, 541, 548–549); J. Edward Bailey III, Detroit (590); Oliver Baker, New York (418, 513); Carl F. Barnes, Jr., and Archives Photographiques, Paris (107); Brogi/Editorial Photocolor Archives, New York (167, 188–189, 206, 221, 340, 502); Bruckmann/Editorial Photocolor Archives, New York (92, 237–238, 244, 253, 257, 276, 396); Bulloz, Paris (484); Bulloz/Editorial Photocolor Archives, New York (471); Rudolph Burckhardt, New York (439, 497); Rudolph Burckhardt, New York, and Leo Castelli Gallery, New York (323); Leo Castelli Gallery, New York (440, 442, 587); Geoffrey Clements, Staten Island, N.Y. (507, 577); A. C. Cooper Ltd., London (21); Courtauld Institute of Art, London (563); George Cserna, New York (337); Dominique Darbois, Paris (51); A. Dingjan, The Hague (562); A. E. Dolinski, San Gabriel, Calif. (524); Eliot Elisofon (52); R. B. Fleming & Co., London (102–103); Fototeca Unione, Rome (301, 330, 333–334); Fototeca Unione/Editorial Photocolor Archives, New York (343, 425); French Government Tourist Office, New York (120); French Institute of Indology, Pondicherry, India (62); German Archeological Institute, Athens (56); German Archeological Institute, Istanbul (142); Giraudon, Paris (25, 117, 273, 277, 306, 309, 317, 319–320, 433, 452, 486, Pls. 24, 26); Solo-

mon R. Guggenheim Museum, New York (444); Gundermann, Würzburg (477); Hans Hammarskiöld and Tiofoto, Stockholm (445); O. K. Harris Gallery, New York (509); Hedrich-Blessing, Chicago (354, 356); André Held, Ecublens, Switz. (67–68, 71, 73); Lucien Hervé, Paris (93, 127); Hirmer Fotoarchiv, Munich (57, 72, 75, 84, 95, 294, 307, 324); George Holton/Photo Researchers, Inc., New York (121); Walter W. Horn, Berkeley, Calif. (113); Editions Houvet, Chartres (7); IRPA-ACL, Brussels (6); Jan Jachniewicz, New York (591); Errol Jackson, London (503); John F. Kennedy Library, Boston (558); Luc Joubert, Paris (475); Ralph Kleinhempel, Hamburg (566); M. Knoedler & Co., New York (Pl. 59); Randolph Langenbach (338); Library of Congress, Washington, D.C. (357); Louis Loose, Brussels (Pl. 17); Los Angeles County Museum of Art (31); Studio Lourmel 77, Paris (22); Galerie Maeght, Paris (434); Marburg/Editorial Photocolor Archives, New York (114, 153, 282, 327, 543); Marlborough Gallery Inc., New York (470); MAS, Barcelona (308, Pl. 10); MAS/Editorial Photocolor Archives, New York (540); Robert E. Mates, New York (410, 473, Pl. 36); William McCracken, New York (322); P. and E. Merkle, Basel (122); Buck Miller, Milwaukee/TIME Magazine, New York (596); Minirel Creation, Chenove, France (148); Ralph Morse, Life Magazine, © Time Inc., New York (27, 493, Pl. 1); Moscioni/Editorial Photocolor Archives, New York (74); Al Mozell, New York (588); National Gallery of Art, Washington, D.C. (45); New York Public Library (214); R. Nohr, Munich (560); Claude O'Sughrue, Montpellier, Fr. (403); Josephine Powell, Rome (81–82); Mavis Pudding Publishers, Inc., Croton-on-Hudson, N.Y. (1); Rheinisches Bildarchiv, Cologne, W. Ger. (293); Roger-Viollet, Paris (215, 392); Walter Rosenblum, Long Island City, N.Y., and Leo Castelli Gallery, New York (446); Earl E. Rosenthal, Chicago (211); Jean Roubier, Paris (83, 108); St. Louis Convention and Visitors Bureau (367); Sakamoto Photo Research Laboratory, Tokyo (310); Scala/Editorial Photocolor Archives, New York (232, 393, 429, Pls. 3, 11–14, 16, 18, 32); John D. Schiff, New York (419, 581); Service de Documentation Photographique de la Réunion des Musées Nationaux, Paris (314, 413, 595, Pl. 41); Shunk-Kender (598); Sindhöringer, Vienna (20, 318); Udo F. Sitzenfrey, Vienna (545); Walter Steinkopf, W. Berlin (402); Stoedtner-Prothmann Associates, Baldwin, N.Y. (332); Soichi Sunami, New York (408–409, 437, 516, 519, 521, 523,

526, 532, 551, 553–554, 556–557, 570–571, 583, 585); J. t'Felt, Antwerp (388); Frank L. Thomas, Los Angeles (576); Towne Studio, Buffalo, N.Y. (404); Trans-World Airlines, New York (329); U.S. General Services Administration, Chicago (447); Otto Vaering/Editorial Photocolor Archives, New York (391); Kirk Varnedoe, New York (589); Mark Vaux, Paris (565); Wolfgang Volz, Essen, W. Ger. (421); Leonard von Matt, Buochs, Switz. (227); William E. Ward, Solon, Ohio (87); A. J. Wyatt, Philadelphia (387, 416, 436); O. Zimmermann, Colmar, Fr. (92).

Fig. 150 from *Dictionnaire des Miniatures du Moyen Age et de la Renaissance* by Erhard Aeschlimann (Milan: Ulrico Hoepli, 1949; reprinted Nendeln: Kraus-Hoepli, 1969). Fig. 363 from *Le Corbusier 1910–1965, the Complete Works,* edited by Willy Boeser and Hans Girsberger (Zürich: Verlag für Architektur Artemis, 1967). Figs. 359–362, 366 from *Chandigarh,* by Norma Evenson (Berkeley: University of California Press, 1966). Fig. 115 from *A History of Architecture on the Comparative Method* (18th edition), by Sir Banister Fletcher (London: The Athlone Press, 1975). Fig. 109 from *Architectural Symbolism of Imperial Rome and the Middle Ages,* by E. Baldwin Smith (copyright © 1956 by Princeton University Press). Figs. 347–351 from *Katsura: Tradition and Creation in Japanese Architecture* by Kenzo Tange (Tokyo: Zokeisha Publications Ltd.).

Works by Arp, Brancusi, Braque, Chagall, Dali, Delaunay, Dubuffet, Duchamp, Duchamp-Villon, Giacometti, Gris, Kandinsky, Klee, Magritte, Masson, Miro: © A.D.A.G.P., Paris 1981. Works by Mondrian: © BEELDRECHT, Amsterdam/V.A.G.A., New York 1981. Works by Chirico: © S.I.A.E., Italy/V.A.G.A., New York 1981. Works by Ensor: © ARAPB, Brussels/V.A.G.A., New York 1981. Works by Kokoschka: © COSMOPRESS, Geneva 1981. Works by Beckmann: © BILD-KUNST, West Germany/V.A.G.A., New York 1981. Works by Bonnard, Degas, Léger, Maillol, Matisse, Monet, Picasso, Redon, Renoir, Rodin: © S.P.A.D.E.M., Paris/V.A.G.A., New York 1981. Estate of Max Ernst: © S.P.A.D.E.M., Paris/V.A.G.A., New York 1981.

Fig. 442: © Roy Lichtenstein 1981. Fig. 594: © Hans Namuth 1981. Figs. 323, 440, 586: © Robert Rauschenberg 1981. Figs. 418, 573: © Estate of David Smith 1981. Fig. 441: © Andy Warhol 1981.